Gifts of the Sultan

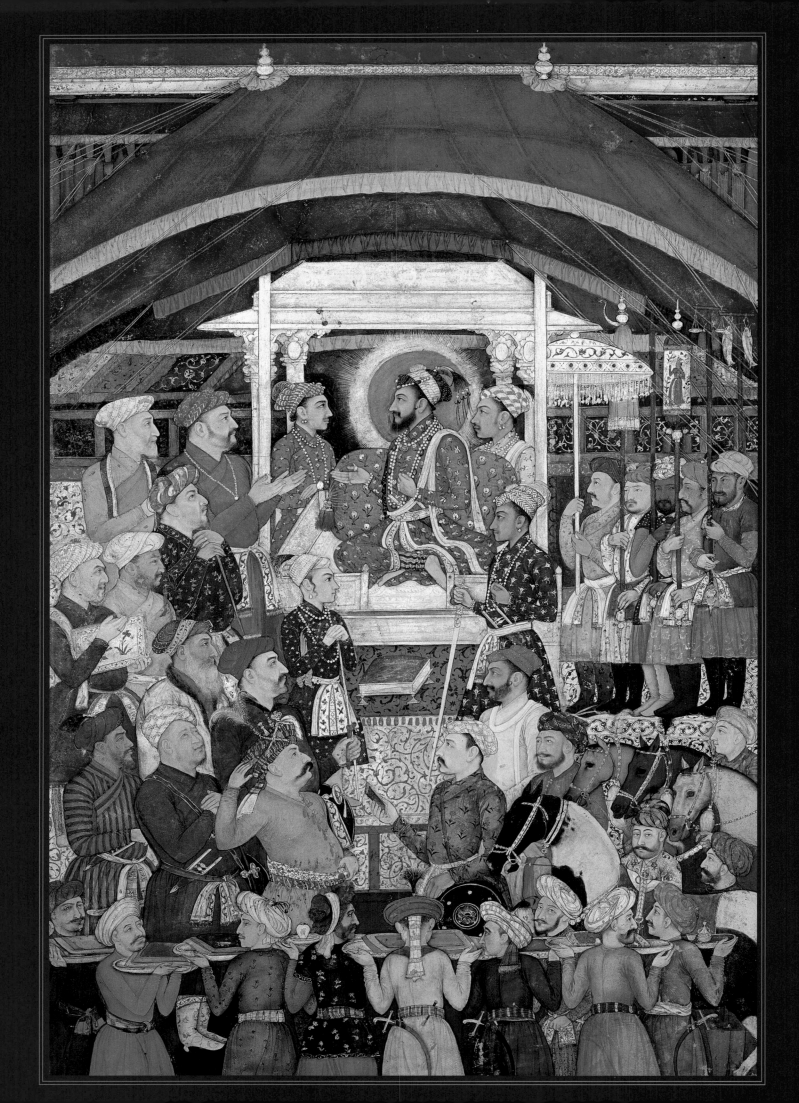

Gifts of the Sultan

The Arts of Giving at the Islamic Courts

Linda Komaroff

with contributions by

Sheila Blair

Jonathan Bloom

Anthony Cutler

Aimée E. Froom

Abdallah Kahil

Edward Kasinec and Robert Davis

Ralph Kauz

Francesca Leoni

Michael Morony

Ilber Ortayli

Keelan Overton

Avinoam Shalem

Marianna Shreve Simpson

Tim Stanley

Susan Stronge

Wheeler Thackston

Lale Uluç

Olga V. Vasilyeva

Los Angeles County Museum of Art

Yale University Press, New Haven and London

The exhibition *Gifts of the Sultan: The Arts of Giving at the Islamic Courts* was organized by the Los Angeles County Museum of Art, with support from the Museum of Fine Arts, Houston. It was made possible by the National Endowment for the Humanities and Camilla Chandler Frost. It was supported in part by the E. Rhodes and Leona B. Carpenter Foundation and by an indemnity from the Federal Council on the Arts and the Humanities

The Los Angeles presentation was made possible in part by LACMA's Wallis Annenberg Director's Endowment Fund.

This publication was made possible by the Hagop Kevorkian Fund. Additional support was provided by the Andrew W. Mellon Foundation.

Exhibition itinerary:
Los Angeles County Museum of Art
June 5–September 5, 2011

The Museum of Fine Arts, Houston
October 23, 2011–January 15, 2012

Distributed by Yale University Press, New Haven and London

Library of Congress Cataloging-in-Publication Data

Gifts of the Sultan : the arts of giving at the Islamic courts / edited by Linda Komaroff. -- 1st ed.
 p. cm.
 Catalog published in conjunction with an exhibition held at the Los Angeles County Museum of Art, June 5-Sept. 5, 2011 and at the Museum of Fine Arts, Houston Oct. 23, 2011-Jan. 15, 2012.
 ISBN 978-0-300-17110-5 (hardcover)
 1. Islamic art objects--Exhibitions. 2. Gifts--Religious aspects--Islam--Exhibitions. 3. Islamic countries--Social life and customs--Exhibitions. I. Komaroff, Linda. II. Los Angeles County Museum of Art. III. Museum of Fine Arts, Houston. IV. Title: Arts of giving at the Islamic courts.
 NK720.G54 2011
 709.17'6707479493--dc22
 2010053435

ISBN: 978-0-300-17110-5

Los Angeles County Museum of Art
Head of Publications: Nola Butler
Editor in Chief: Thomas Frick
Editor: Chris Keledjian
Designer: Katherine Go
Supervising Photographer: Peter Brenner
Production Manager: Karen Knapp
Rights and Reproductions Coordinator: Cheryle T. Robertson
Proofreader: Dianne Woo
Indexer: Kathleen Preciado
Printing and Binding: CS Graphics, Singapore

© 2011 Museum Associates
Los Angeles County Museum of Art
5905 Wilshire Boulevard
Los Angeles, CA 90036

Notes to the Reader:

Throughout the text the reader will find note references to publications that are fully cited in the Bibliography, which begins on page 304.

Figure captions for works or objects in the exhibition provide only partial information; additional data can be found in the Catalogue of the exhibition, which begins on page 207.

The text contains references to years based on both the Islamic and Gregorian calendars and often in combination, for example, AH 1213/1798–99 (AH stands for anno Hegirae, or "in the year of the Hegira," equivalent to AD 622).

Abbreviations: c. = circa or about; fl. = flourished; r. = reigned; h. = height; w. = width; d. = depth; diam. = diameter; wt. = weight; g = gram.

Transliterations of Arabic, Persian, and Turkish names and terms have each been carried out according to the language of the original. Except for the 'ayn and hamza, most diacritics have been eliminated, as is currently standard practice. Transliteration of Chinese follows the pinyin system.

Page 2: Fig. 1 (cat. no. 176). *Shah Jahan Receives the Persian Ambassador, Muhammad 'Ali Beg*, folio from the Windsor *Padshahnama*, India, c. 1633. The Royal Collection, Windsor (RCIN 1005025).

Interpreting Gifts of the Sultan: The Arts of Giving at the Islamic Courts

Three highly innovative artists with roots in the Islamic world, Sadegh Tirafkan, Shahzia Sikander, and Ahmed Mater, frequently draw inspiration from their own cultural traditions, using techniques and incorporating imagery and ideas from earlier periods. They were each commissioned to produce new work interpreting the overarching theme of *Gifts of the Sultan*. This supplement to the catalogue is intended as a record of their important contributions to the exhibition.

Always in Our Thoughts

2011

Sadegh Tirafkan (b. 1965, Iraq, active Iran)

Metal wire, cloth, glass, mirror, and digital-print photographs
Each piece: h., 82 ⅝ in. (210 cm); diam., 22 in. (56 cm)
Courtesy of the artist

Deported from Iraq to Iran at the age of six, and a member of the youth militia in the Iran-Iraq war as a teenager, Sadegh Tirafkan experienced loss at an early age. In this remarkable piece, he remembers those lost to him by referencing the *hijlah*, an Iranian tradition of erecting temporary shrines to commemorate the dead. Tirafkan characterizes it as a gift from the living to the deceased to preserve their memories. The commemorative structure is suggested here by, among other things, the use of colorful strips of cloth, which allude to bits of fabric tied by visitors to the *hijlah* in remembrance of the loved one.

Untitled

2011

Shahzia Sikander (b. 1969, Pakistan, active United States)

Gold, ink, and gouache on prepared paper in a box frame
72 x 120 x 6 in. (182.9 x 304.8 x 15.2 cm)
Courtesy of the artist and Sikkema Jenkins & Co., New York

Shahzia Sikander trained in the traditional art of Indo-Persian miniature painting at the National College of Arts in Lahore, Pakistan, and went on to receive an MFA from the Rhode Island School of Design. Representing a fusion of East and West, her work often evokes the art of miniature painting but in an entirely original manner. As in this monumental example, she plays with scale, applying color and text to a large panel to suggest the facing pages of a book. The text roughly inscribed in gold quotes from a verse by the Urdu poet Faiz Ahmed Faiz. Here, following tradition, the poem is the gift, one both personal and partisan.

Illumination Diptych (Ottoman *Waqf*)

2010

Ahmed Mater (b. 1979, Saudi Arabia)

Gold leaf, tea, pomegranate, Dupont Chinese ink, and offset X-ray film print on paper
Each piece: 40 x 60 in. (101.6 x 152.4 cm)
Los Angeles County Museum of Art, gift of the artist and Edge of Arabia, M.2010.159a–b

Ahmed Mater studied medicine in Abha, Saudi Arabia, while continuing to pursue an interest in art. Today he is a practicing physician and an artist. In his *Illumination* series, to which this beautiful diptych belongs, Mater draws inspiration from the Islamic arts of the book, in particular manuscripts of the Qur'an, whose pages were decorated with illuminated borders, headings, and verse markers. He includes the word *waqf*, a notation often found in manuscripts of the Qur'an, which designates a charitable donation. Generally a small-scale and intimate art form, Mater radically magnifies his illuminated page, creating instead a new sense of intimacy by using his pages to frame human X-rays.

Bibliography

Porter, Venetia et al. *Ahmed Mater*. London: Booth-Clibborn Editions, 2010.

Prince, Nigel, ed. *Shahzia Sikander Intimate Ambivalence*. Birmingham, UK: Ikon Gallery, 2008.

Shayegan, Daryush, and Christian Caujolle. *Sadegh Tirafkan Iranian Man*. Brussels: La Lettre Volée, 2005.

What rule of legality and self-interest…compels the gift that has been received to be obligatorily reciprocated? What power resides in the object given that causes its recipient to pay it back?

Marcel Mauss, *The Gift*

CONTENTS

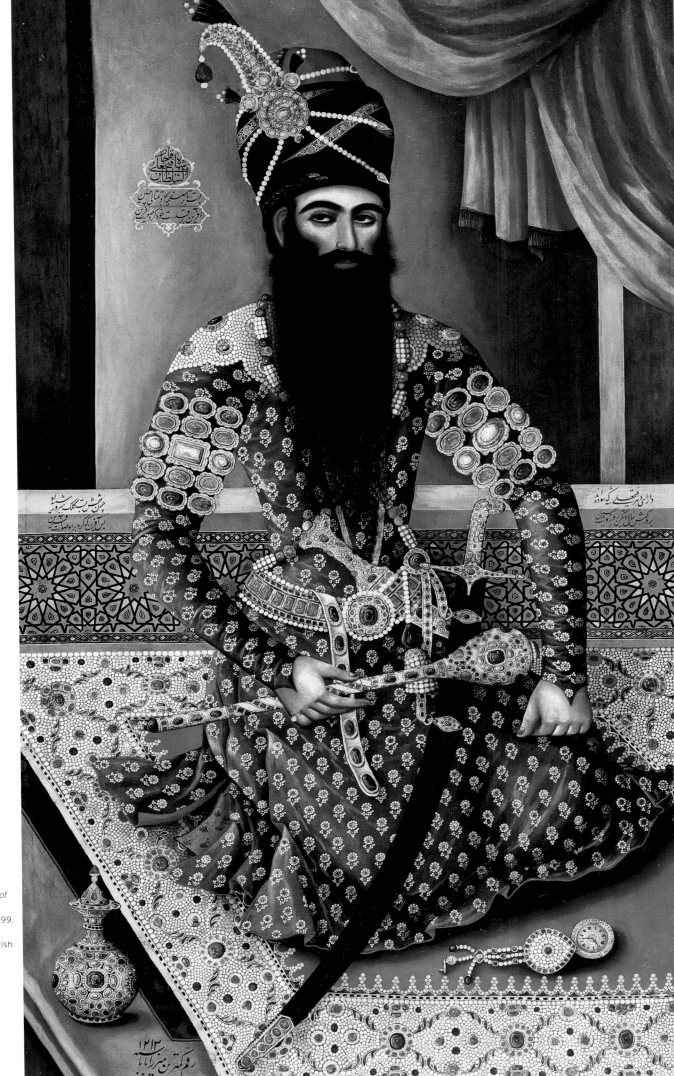

Fig. 2 (cat. no. 185). *Portrait of Fath 'Ali Shah*, Mirza Baba, Iran, Tehran, AH 1213/1798–99. Oriental and India Office Library Collections, The British Library, London (F.116).

FOREWORD

The "gifting" of art is standard practice in the museum world—indeed, where would we be without it? But long before such works were given to museums, many of them were created as or were subsequently transformed into gifts. Such information is an essential part of the object's intrinsic story, yet it is sometimes lost amid discussions of artistic style, dating, and provenance, or else is relegated to a footnote. By contrast, *Gifts of the Sultan: The Arts of Giving at the Islamic Courts* places at the forefront the often fascinating history of individual works of art by specifically examining the complex interplay between artistic production and gift exchange. Indeed, the exhibition and accompanying catalogue represent the first systematic investigation of the impact of gift giving on the development of Islamic art.

Gifts of the Sultan is a pan-Islamic exhibition that spans the eighth through nineteenth centuries and includes more than 250 works of art representing a rich variety of media from three continents. The exhibition and wonderfully illustrated catalogue introduce an American audience to Islamic art and culture with objects of undisputed quality and appeal examined through the universal tradition of gift giving. We expect *Gifts of the Sultan* to be a transformative exhibition, one that coincides with a new American initiative in global relations emphasizing a shared humanity rather than our singular histories.

As an important signifier of the human condition, gifts ease social relations, defuse political tensions, fulfill religious obligations, denote status, connect individuals, and mark a full array of events ranging from birth to death. In the context of this exhibition, gift giving is also closely connected to the fine art of international relations, demonstrating that from early Islamic times the default was not war but rather peaceful mediation, and that, just as today, ambassadors traveled long distances, engaging in the precursor of modern shuttle diplomacy.

We are grateful for the efforts of Linda Komaroff, curator of Islamic art and head of the Art of the Middle East Department, who conceived and organized the exhibition and who traveled tirelessly and worked relentlessly on its behalf. We wish to express our sincere appreciation to the National Endowment for the Humanities, dedicated to expanding American understanding of history and culture, for its important contribution to this project. The exhibition is supported by an indemnity granted by the Federal Council on the Arts and the Humanities. As always, we are deeply indebted to LACMA trustee and benefactor Camilla Chandler Frost for her substantial support. Our profound gratitude goes to the Hagop Kevorkian Fund for its generous support of the catalogue. We are also grateful to Aramco and the E. Rhodes and Leona B. Carpenter Foundation. For their support of public programs related to the exhibition, we would like to thank Karl Loring and the Farhang Foundation.

LACMA is very excited to present this major international loan exhibition on Islamic art that breaks new ground in its emphasis on a practice shared by all cultures—gift exchange—and in highlighting by analogy our own sense of delight in receiving gifts and satisfaction in performing acts of generosity. I believe that *Gifts of the Sultan* achieves that rare combination of an exhibition that both satisfies the popular imagination and informs the psyche.

Michael Govan
CEO and Wallis Annenberg Director
Los Angeles County Museum of Art

ACKNOWLEDGMENTS

Gifts of the Sultan: The Arts of Giving at the Islamic Courts is the result of several years of planning, research, and a great deal of travel. An undertaking of this nature, with more than 250 loans from Europe, the Middle East, and the United States, could not take place without the cooperation and great generosity of numerous institutions and individuals. It is my enormous pleasure to be able to acknowledge them here, especially insofar as generosity is not only the theme of this exhibition but its underpinning as well.

We are deeply indebted to the forty-two lenders in thirteen countries who so graciously agreed to part temporarily with works from their collections for the purpose of this exhibition. We therefore would like to gratefully acknowledge the following public and private institutions and collections and their directors, curators, and key administrative staff (given in alphabetical order by city): at the Benaki Museum, Athens, Angelos Delivorrias, Mina Moraitou, and Anna Ballian; at the Museum für Islamische Kunst, Berlin, Stefan Weber (and his predecessor Claus-Peter Haase), Gisela Helmecke, Miriam Kühn, and Jens Kröger; at the Museum of Fine Arts, Boston, Malcolm Rogers, Jane Portal, Thomas Michie, Laura Weinstein, Kim Pashko, and Angie Simonds; at the Danish Museum of Art and Design, Copenhagen, Bodil Busk Laursen and Kirsten Toftegaard; at the David Collection, Copenhagen, Kjeld von Folsach and Mette Korsholm; at the Museum of Islamic Art, Doha, Oliver Watson, Franak Hilloowala, and Shaikha al-Mayassa bint Hamad al-Thani and Roger Mandle of the Qatar Museum Authority; at the Chester Beatty Library, Dublin, Michael Ryan, Elaine Wright, and Sinéad Ward; at the Aga Khan Museum Collection, Geneva, His Highness the Aga Khan, Luis Monreal, and Benoît Junod; at the Millet Manuscript Library, Istanbul, Melek Gençboyaci; at the Museum of Turkish and Islamic Art, Istanbul, Seracettin Şahin, Ali Serkander Demirkol, and Yeliz Çetindoğ Kuşan; at the Topkapi Palace Museum, Istanbul, Ilber Ortayli, Selin Ipek, Emine Bilirgen, Feza Çakmut, Tuba Kurtulus, Sibel Arca, and Esra Müyesseroğlu; at the Dar al-Athar al-Islamiyyah, Kuwait, Shaikh Nasser Sabah al-Ahmad al-Sabah and Shaikha Hussah Sabah al-Salim al-Sabah, Sue Kaoukji, Manuel Keene, and Budour Al-Qassar; at the Museu Calouste Gulbenkian, Lisbon, João Castel-Franco Pereira, Maria Fernanda Passos Leite, and Maria Queiroz Ribeiro; at the British Library, London, Colin Baker, John Falconer, Barbara O'Connor, and Robert Davies; at the British Museum, London, Neil MacGregor, Venetia Porter, Vesta Curtis, Jan Stuart, Jessica Harrison-Hall, and Philippa Kirkham; at the Nasser D. Khalili Collection of Islamic Art, London, Nasser D. Khalili and Nahla Nassar; at the Royal Asiatic Society, London, Alison Ohta and Helen Porter; at the Victoria and Albert Museum, London, Mark Jones, Tim Stanley, Susan Stronge, Ming Wilson, Elizabeth Miller, Helen Persson, Rowan Watson, Julius Bryant, Rebecca Wallace, and Peter Ellis; at the Catherine and Ralph Benkaim Collection, Los Angeles, Catherine Benkaim; at the Getty Research Institute, Los Angeles, Thomas W. Gaehtgens, Frances Terpak, Isotta Poggi, Irene Lotspeich-Phillips, and Sarah Sherman; at the Omar Haroon Collection, Los Angeles, Omar Haroon and Nasreen Haroon; at the University of California, Los Angeles, Genie Guerard and Octavio Olvera; at the State Historical Cultural Museum Preserve, Moscow Kremlin, Elena Gagarina, Zelfira Tregulova, Olga B. Melnikova, Olga I. Mironova, Inna I. Vishnevskaya, E. A. Yablonskya, and Yana Zhvaginsh; at the Asia Society, New York, Melissa Chiu, Adriana Proser, and Clare McGowan; at the Brooklyn Museum of Art, New York, Arnold Lehman and Joan Cummins; at the J. Pierpont Morgan Library, New York, William M. Griswold, William M. Voelkle, John Bidwell, and John D. Alexander; at the Metropolitan Museum of Art, New York, Thomas

Fig. 3 (cat. no. 223). *Dara Shikoh Riding an Albino Elephant*, India, c. 1628–30. Museum of Islamic Art, Doha (MS 51).

Campbell, Sheila Canby, Navina Haidar, Peter Barnet, Helen Evans, George R. Goldner, and Nadine Orenstein; at the New York Public Library, Paul LeClerc (and his predecessor Ann Thornton), Michael Inman, and Deborah Straussman; at the Bibliothèque nationale de France, Paris, Bruno Racine, Thierry Delcourt, Michel Amandry, and Françoise Simeray; at the Musée du Louvre, Paris, Henri Loyrette, Sophie Makariou, Carel van Tuyll, and Isabelle Luche; at the Musée national des Arts asiatiques–Musée Guimet, Paris, Jacques Giés and Amina Okada; at the Philadelphia Museum of Art, Timothy Rub, Felice Fischer, and Sally Malenka; at the Museum of Art, Rhode Island School of Design, Providence, Ann Woolsey, Jan Howard, Georgina E. Borromeo, and Tara Emsley; at the Asian Art Museum, San Francisco, Jay Xu, Forrest McGill, Michael Knight, and Sharon Steckline; at the National Library of Russia, St. Petersburg, the late Vladimir Zaitsev, Anton Likhomanov, and Olga V. Vasilyeva; at the State Hermitage Museum, St. Petersburg, Mikhail Piotrovsky, Vladimir Matveev, Natalia Koslova, Anatole A. Ivanov, Adel T. Adamova, Galina A. Mirolyubova, Galina A. Serkina, Maria L. Menshikova, and Daria Vasilyeva; at the Keir Collection, Surrey, the late Edmund de Unger and Richard de Unger; at the Royal Collection, Windsor, Her Majesty Queen Elizabeth II, the

Honorable Lady Jane Roberts, Theresa-Mary Morton, David Westwood, and Sarah Murray; and at the Worcester Art Museum, James A. Welu, Louise Virgin, Rita Albertson, and Deborah Diemente.

Because of the different fields covered by *Gifts of the Sultan*, an interdisciplinary and international team was assembled to contribute to the catalogue. These exemplary scholars are Jonathan Bloom and Sheila Blair, Norma Jean Calderwood Professors of Islamic and Asian Art, Boston College, and Hamad Bin Khalifa Professors of Islamic Art, Virginia Commonwealth University, Richmond; Ralph Kauz, professor, Bonn University, Institute for Oriental and Asian Studies, Department of Chinese Studies; Wheeler Thackston, professor emeritus, Near Eastern Languages and Civilizations, Harvard University; Anthony Cutler, Evan Pugh Professor of Art History, Pennsylvania State University; Aimée Froom, independent scholar of Islamic art, Paris; Edward Kasinec, staff associate, Harriman Institute, Columbia University, New York, and Robert Davis, Russian, Eurasian, and East European Studies librarian, Columbia University, New York; Abdallah Kahil, assistant professor of the history of art and architecture, Lebanese American University in Beirut, and director of the Institute of Islamic Art and Architecture at Lebanese American University in Beirut; Francesca Leoni, assistant curator of Islamic art, Houston Museum of Fine Arts; Michael Morony, professor of Islamic history, University of California, Los Angeles; Ilber Ortayli, president of Topkapi Palace Museum, Istanbul, and professor of history, Galatasaray University, Istanbul, and Bilkent University, Ankara; Keelan Overton, doctoral candidate, University of California, Los Angeles; Avinoam Shalem, professor, Ludwig-Maximilians-Universität, Institut für Kunstgeschichte, Munich, and Max Planck Fellow, Kunsthistorischen Institut, Florence; Marianna Shreve Simpson, independent scholar of Islamic art, Baltimore; Tim Stanley, senior curator for the Middle Eastern collections, Victoria and Albert Museum, London; Susan Stronge, senior curator for Indian and South-East Asian art, Victoria and Albert Museum, London; Lale Uluç, instructor, Boğaziçi University, Istanbul; and Olga V. Vasilyeva, curator of Oriental collections, Manuscript Department, National Library of Russia, St. Petersburg. I am grateful to all of the authors not only for their important contributions to the catalogue but also for the generosity of their time and their good-natured collegiality. Extra special thanks go to Sheila Blair, Jonathan Bloom, and Wheeler Thackston for their intellectual companionship and their many solicitous acts.

At the Los Angeles County Museum of Art, my sincere thanks to Michael Govan, LACMA's CEO and Wallis Annenberg Director, for the generosity of his time and energy in support of *Gifts of the Sultan*. I am grateful to many LACMA colleagues whose efforts have borne fruit in the exhibition and its catalogue. I would like to express my gratitude to Zoe Kahr, Marciana Broiles, and Liz Andres of the Exhibitions Program; in the Art of the Middle East Department, Sabrina Lovett, curatorial administrator, gave unstinting and good-humored support with matters both large and small; special thanks to Keelan Overton, research assistant, whose learning curve, if it is proportional to the amount of assistance rendered, will be very high indeed; thanks also to Ali Mousavi, assistant curator of ancient Iranian and Near Eastern art; and I am especially grateful to our many interns, Azad Amanat, Shahin Badkoubei, Meagan Blake, Jeffrey Carlson, Kelly Engle, Sheida Koufigar, and Kira Shewfelt, who gave valuable assistance. In the Conservation Center, I am grateful to Mark Gilberg and Jean Neeman and to Catherine McLean, Susan Schmalz, and Mellon intern Nicole Bloomfield in Textile Conservation; Janice Schopfer, Soko Furuhata, Chail Norton, and Jennifer Badger in Paper Conservation; John Hirx, Don Medvig, Natasha Cochran, Silviu Boariu, and Jeff Ono in Objects Conservation; and Frank Preusser and Charlotte Eng in Research. In Costume and Textiles, my thanks

to Sharon Takeda and Fionn Lemon. In Development, Melissa Bomes, Stephanie Dyas, Amanda Lipsey, and Diana Veach were most helpful. Thanks to Emily Horton, Suzan Sengoz, Robin Chung, Sharon Robinson, and Amy Wright in the Registrar's Office. As always, special thanks to Samara Whitesides in the Director's Office. I am grateful to Peter Brenner, Steven Oliver, and Breanne Sallee in Photographic Services. Thanks to Piper Severance in Rights and Reproductions. In the Research Library, Alexis Curry, Tracy Kerr, and Douglas Cordell provided valuable assistance. In Risk Management and Collections Information, I am most grateful to Renee Montgomery, Del Magpantay, and Jonathan Alfi; thanks as always to Jane Burrell, vice president of Education and Public Programs, and Kristin Bengston in the Education Department, and to Amy Heibel in Web and Digital Media; in Communications, Barbara Pflaumer, Miranda Carroll, and Christine Choi were very helpful. I am grateful to Jeff Haskin and the Art Preparation and Installation team, and to John Bowsher, Victoria Behner, Bill Stahl, and Bernard Kester in Operations. Very special thanks go to Sara Cody, Nola Butler, and Thomas Frick in Publications, and to Gregory A. Dobie and in particular to Chris Keledjian, who edited this catalogue so skillfully. In Graphic Design, thanks to Amy McFarland and Karen Knapp, and especially to Katherine Go for the beautiful design of this catalogue. I extend my gratitude also to Stephen Saitas, the exhibition designer, with whom I look forward to working again in the future.

At the Museum of Fine Arts, Houston, I am grateful to the late Peter Marzio, and to Francesca Leoni and Karen Vetter. I would also like to recognize the assistance, in various places and capacities, of Jude Ahern, Sarah M. Al-Faour, Abdullah Al-Turki, Dita Carhart, Arif Çelik, Laura Condon, Massumeh Farhad, Rita Freed, Vanessa Fusco, Semra Geyik, Asieh Ziai Gharagozlou, Edward Gibbs, Can Gönensin, Khosrow Jamali, Funda Kinalioğlu, Sharon Littlefield, Gillian Malpass, Alnoor Merchant, Mrs. William H. Moore, Aya Mousawi, Nazy Nazhand, Rafi Portakal, Julian Raby, Simon Ray, Anousheh and Ali Razi, William Robinson, Natalie Royer, George Saliba, Larissa Sarkisian, Abolala Soudavar, Stephen Stapleton, and Edith Welch. I am grateful to Ahmed Mater, Shahzia Sikander, and Sadegh Tirafkan for their interest in and important contributions to the exhibition. The Getty Foundation supported exhibition travel through a Curatorial Research Fellowship.

Special thanks to Hakan Tekin, Turkish consul general, Los Angeles, who helped to ease some of the complexities of arranging loans from Turkey, and in Ankara, Nilufer Ertan, director of Cultural Activities and Foreign Relations Section, General Directorate for Cultural Heritage and Museums, Ministry of Culture and Tourism, Republic of Turkey. In this regard my profound gratitude goes to my dear friend Hulya Karadeniz, who worked tirelessly to make the Turkish loans happen and good-naturedly housed and fed me during my frequent trips to Istanbul; no matter what we encountered, we always found something to laugh about. I am grateful to Ralph Minasian of the Kevorkian Fund for his continued support and avuncular advice. I am deeply indebted to Camilla Chandler Frost for her sustained interest in this exhibition and especially for her friendship. Finally, thanks go to various Komaroffs for their love, humor, and support and for making me at home in their homes.

Linda Komaroff

Pages 14–15: Fig. 4 (cat. no. 92). Double frontispiece from part 12 of a 30-volume Qur'an, Egypt, probably third quarter of the 14th century. © Trustees of the Chester Beatty Library, Dublin (Is 1465).

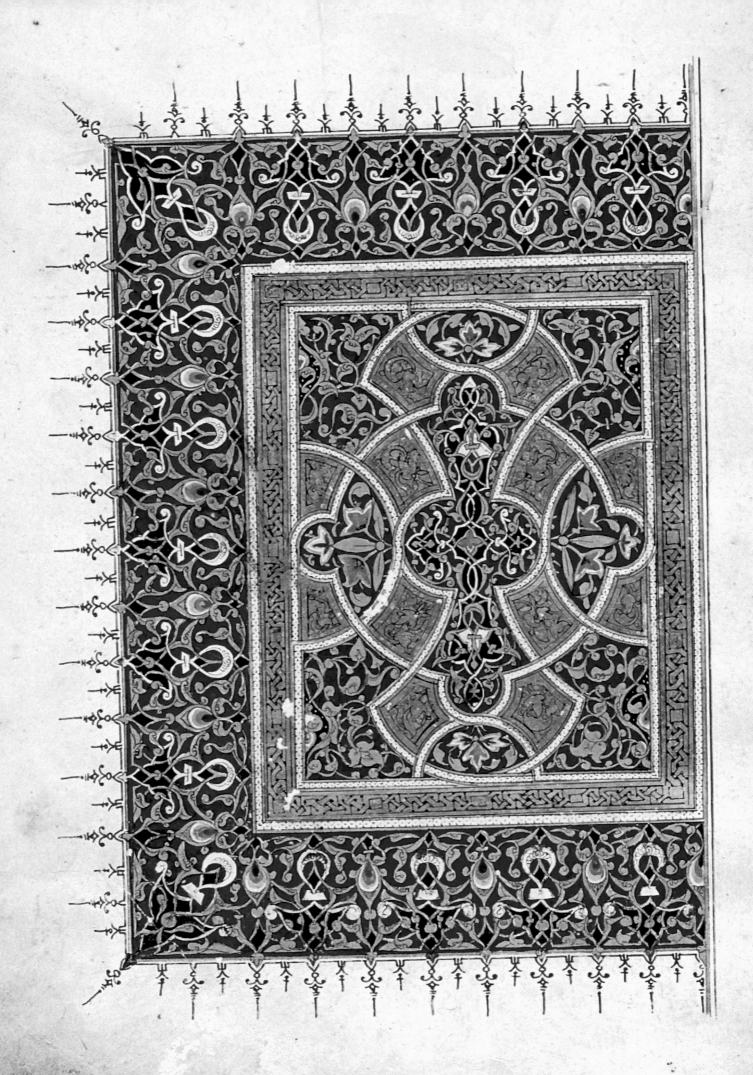

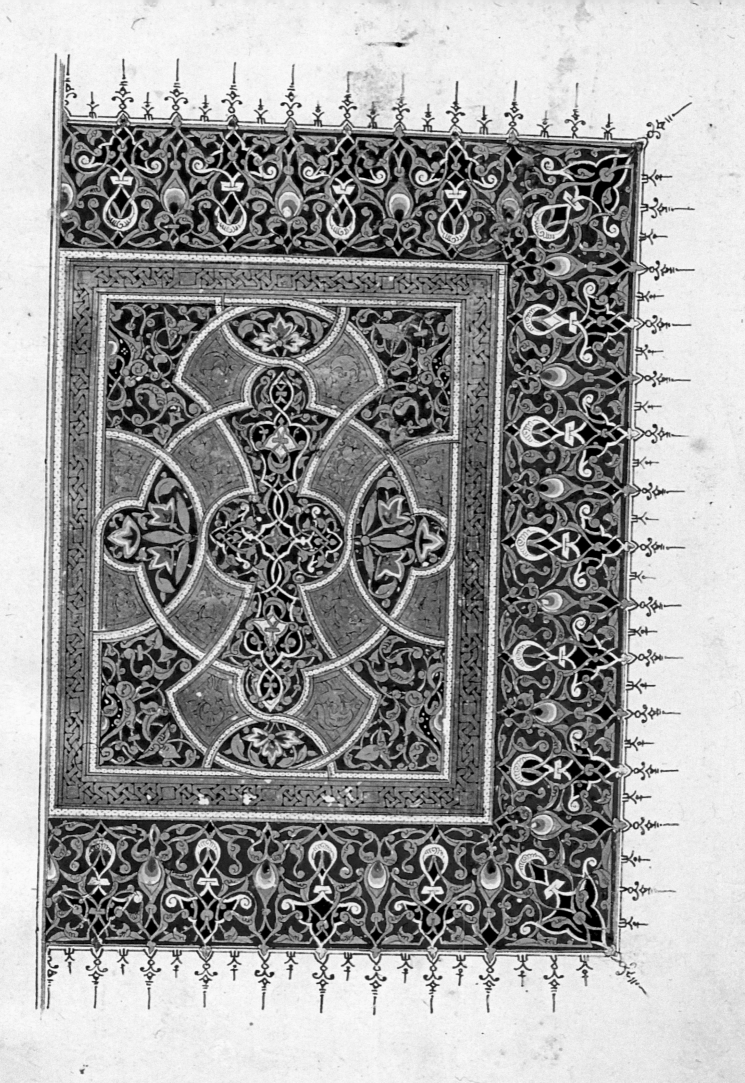

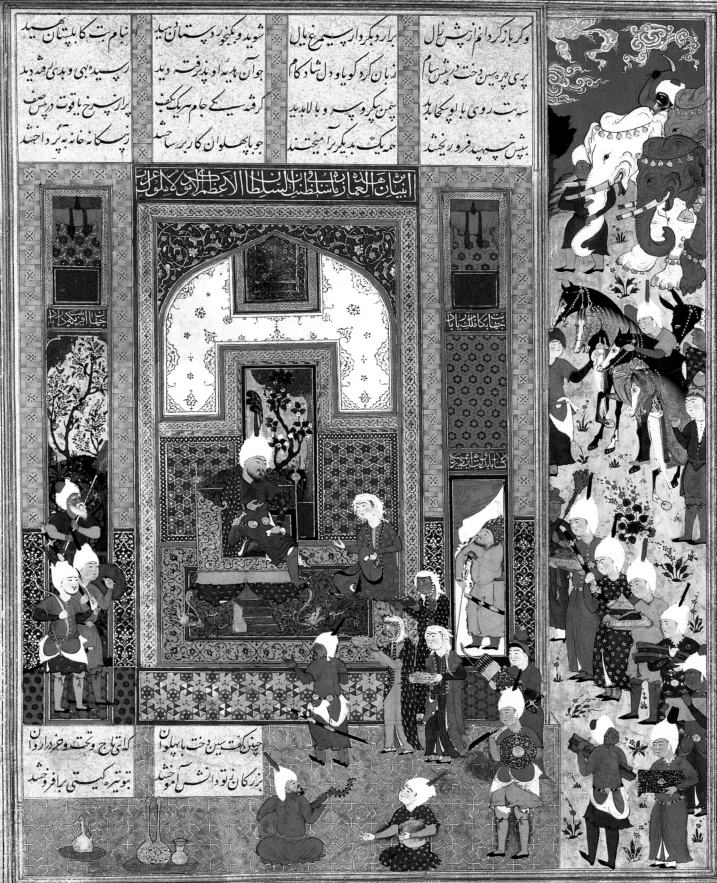

The Art of the Art of Giving at the Islamic Courts

Linda Komaroff

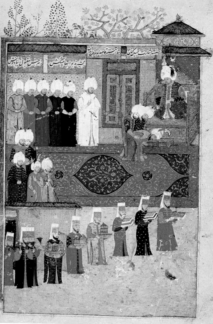

Opposite: Fig. 5 (cat. no. 144). *Sindukht Comes to Sam Bearing Gifts*, folio from the *Shahnama* of Shah Tahmasp, Iran, Tabriz, 1525–35. Aga Khan Museum Collection, Geneva (AKM00496).

Left: Fig. 6. *Presentation of Gifts by the Safavid Ambassador to Selim II at Edirne*, double-page painting from the *Şehname-i Selim Han*, Turkey, AH 988/ 1591. Topkapi Saray Museum Library, Istanbul (A.3595, fols. 53b–54a).

The emperor, indicating his approval, headed slowly outside.
The gatekeepers brought forth gifts (pishkash) of every acceptable sort, beautiful and fine.

First was a gilded Qur'an, bound and enormously bejeweled.
There were acceptable books and Shahnamas [written] in order and [containing] illustrations.[1]

SETTING THE STAGE

Early in the year 1567 the emissary of the Safavid shah Tahmasp (r. 1524–76) arrived at the Ottoman court in Edirne, where Sultan Selim II (r. 1566–74) was wintering. He carried a letter from the shah expressing friendship and wishing the recently installed sultan good fortune in his reign; more importantly for our present purposes, the Iranian envoy brought with him "rare and propitious gifts" carried in state by thirty-four heavily laden camels.[2]

From the Safavid perspective, everything about this diplomatic mission was intended to make a specific statement, including the choice of Shah Quli, a prominent military figure, as the bearer of felicitations and gifts; the large size of the embassy, which comprised more than seven hundred people and innumerable pack animals; and of course the choice of the gifts themselves, of which more will be said shortly.[3]

For the Ottomans, their reception of the Safavid entourage and its gifts was just as carefully orchestrated. The text cited at the head of this chapter conveys the official reaction and enumerates some of the gifts received, while the accompanying double-page illustration (fig. 6) helps visually to fill in details about the presentation of the gifts. Held on either side by an Ottoman official, Shah Quli bows before the sultan. He and the other members of the Safavid embassy are identifiable by their distinctive headdresses (less bulbous than the

Fig. 7 (cat. no. 148). *Part Nine of a Multivolume Manuscript of the Qur'an*, Abbasid caliphate, 9th–10th century. Private collection.

Ottoman turban but with a tall, projecting baton and a feathery plume at the top). They each seem already to have received from the sultan the traditional gift of a robe of honor (in Arabic, *khil'a*; plural, *khila'*), as they are depicted here in Ottoman attire (see fig. 8). The Iranians' wearing of the Ottoman robes and the subservient posture of Shah Quli suggest an Ottoman comprehension of the shah's gifts as a form of tribute rather than an exchange between equals, as indicated by the use of the Persian word *pishkash* in the adjacent text.[4]

In the foreground of the painting, janissaries, members of the Ottoman military elite, carry the proffered gifts presumably arrayed in order of significance: the first janissary holds a single large book, and the second and third each carry two volumes; behind them their fellows bear golden boxes, turban ornaments, and textiles, while larger boxes, rolled carpets, and perhaps a dismantled tent are set on the ground. The first gifts pictured are in

accord with the associated text, which mentions the Qur'an followed by "acceptable books" including illustrated *Shahnama*s; the carpets as well as other luxury items are enumerated in contemporaneous lists, confirming the primacy of the Qur'an manuscript, which in one such account is said to be by the hand of 'Ali, the man to whom all Islamic calligraphers trace their lineage. Next in prominence is a singular manuscript of the *Shahnama*, described in another list as bearing the name of Shah Tahmasp and having 259 [*sic*] illustrations.[5]

That the Ottomans acknowledged the importance of the Qur'an and the *Shahnama* is clear—in one list arranged by monetary value, the two manuscripts trump a ruby the size of a pear and two large pearls.[6] But did they recognize the probable intended message? A Qur'an ascribed to 'Ali though not at all likely to be by his hand would nonetheless have had added value to the Safavids on account of 'Ali's special status as the rightful successor to the

Prophet Muhammad and the first Imam in the Shi'ite tradition.[7] Unlike the Sunni Ottomans, the Safavids were Shi'ite Muslims, which from their own perspective enhanced their legitimacy to rule.[8] Profusely illustrated and a royal commission, the manuscript of the *Shahnama*, or Book of Kings, also would have had its own intrinsic meaning for the Safavids. The text emphasized the long-standing tradition of Iranian kingship while its illustrations depicted ancient kings in the guise of the sixteenth-century Safavid court. Taken together, the two manuscripts certainly imply a Safavid assertion of legitimacy, and perhaps their selection as gifts was intended as a subtle way of dismissing the Ottomans as mere upstarts.[9] Given their proven military superiority, however, the Ottoman interpretation suggested by the previously described painting and its text (fig. 6) is closer to the realpolitik.

That profusely illustrated manuscript presented to Selim is today the notorious Shah Tahmasp *Shahnama*, with its original 258 illustrations scattered among collections throughout the world, though several are reunited in the present exhibition and catalogue.[10] As for the still more highly valued Qur'an, some have proposed that it may be identified with a ninth- or tenth-century manuscript, of which a section is represented in these same contexts (fig. 7).

METHODOLOGY AND SCOPE

To introduce a discussion of gift giving at the Islamic courts with this sixteenth-century incident may seem a bit like beginning in the middle of the story, but the shah's presentation to the sultan is not only exceptionally well documented, it is also paradigmatic of what came before and what would follow. It demonstrates or suggests concepts key to understanding an admittedly diverse topic, as the gifted objects and the essays presented in this volume attest.

- Gifts could serve to convey messages, so their selection was rarely arbitrary.[11]
- Their presentation, including the gift bearers,[12] was part of the message, and the procession and even display of gifts, along with the presentation and the wearing of countergifts such as the robes of honor, were all a form of communication, sometimes quite public.[13]
- As part of the presentation, and size permitting, gifts could be extravagantly packaged and even wrapped in fabric.[14]
- The monetary value of the gift mattered greatly; indeed this seems to be a culture of gift giving in which the price tags were left on.[15]
- Rare, beautiful, and historically significant objects were prized and could, just as today, be assigned a monetary value.[16]
- Highly valued objects need not and very often were not specifically made for the purpose of presentation but rather may have been converted into gifts.
- There was no stigma attached to giving something already used; on the contrary, its previous associations could give the gift further value.[17]
- As part of its conversion process, a religious object could be secularized (as in the Qur'an manuscript transformed into a state gift as noted above) while the opposite case pertains as well (a secular object might be transferred to a religious context).
- Luxury objects were circulated as part of a gifting cycle and at times were even transformed physically in the process.[18]

Viewing Islamic art through the lens of gift giving is a relatively novel idea and one that has not previously been employed in a comprehensive manner.[19] Gift theory has been used far more extensively in the analysis of western medieval and Renaissance material culture, where it has relied heavily on the seminal work of the twentieth-century anthropologist Marcel Mauss (d. 1950).[20] He was the first to characterize gift giving as an essential component of human relations. But Mauss's observation that gifts are part of a reciprocal and obligatory tripartite system of giving, receiving, and giving

again does not always apply universally and certainly not necessarily to Islamic court culture over a period of nearly 1400 years.[21] A theory of Islamic gift giving and gift exchange perhaps remains to be formulated. Indeed, the present volume and the subsequent studies that it may engender will determine the efficacy of this notional view of Islamic art.

This consideration of the totality of Islamic art within the frame of gift giving does not preclude the existing taxonomies in the field based largely on chronological and geographic considerations, as it goes without saying that styles, tastes, materials, patronage, and circumstances changed across time and space. Rather it maintains that the underlying motivations behind gift giving remained consistent especially within the broad milieu of courtly culture, which continued to appreciate certain types of high-status objects defined by their rarity, costliness, and portability. Although the preponderance of extant and relevant material postdates the fifteenth century, the analysis and assembly here of a smaller group of early medieval objects alongside the more plentiful later works may help intellectually to fill in some of the obvious gaps.

This approach seems germane to the study of Islamic art, as gift giving was a fundamental activity at the great Islamic courts not only for diplomatic and political purposes, as reward for services rendered, or to celebrate annual events like the New Year or more personal occasions such as weddings, birthdays, and circumcisions, but also as expressions of piety often associated with the construction or enhancement of religious monuments. Indeed, many of the most spectacular and historically significant examples of Islamic art can be classified as gifts.

Gifts could serve a wide variety of sophisticated and complex purposes as Mauss has shown, and this is certainly the case in the Islamic world, where gift giving was an integral part of the social fabric, especially as a means of formalizing alliances, as a signifier of power and expression of political aspirations, or as an instrument to obtain salvation. Its importance is demonstrated in language through the numerous and nuanced Arabic and Persian words for "gift," which can specify the hierarchical relationship of the benefactor and the recipient,[22]

as well as by a genre of literature on gifts and rarities.[23] Gift giving intended to further princely ambitions or diplomatic goals, to seal peace treaties, to promote devotion, or to reward loyalty was integral to maintaining a vast network of personal, social, political, economic, and religious relationships, and rare, costly, and aesthetically pleasing objects were at its core.

Such gifts came in many guises, including textiles in the form of robes of honor often inscribed with the name of the ruler or of sumptuous cloth of silk woven with gold; gemstones and gold jewelry such as crowns, rings, necklaces, and bracelets; rock crystal and carved ivory containers; arms, armor, and equine equipment, often more decorative than practical; ephemera such as spices, sweetmeats, musk, and camphor, whose extant containers are today of more concern than their original contents, and living creatures, both animal and human; and examples of the arts of the book, including elaborately illustrated manuscripts. Pious gifts, many of which came under the heading of *waqf* (a legal term referring to a charitable trust), would carry on the memory of the donor and help pave his or her path to heaven. In earthly terms, this type of largess was also a hallmark of wealth and social status while often containing political implications.[24] When presented to or fabricated specifically for a religious monument, the gift might take the form of opulent implements and furnishings such as enameled and gilded glass lamps, candlesticks and lamp stands of precious and base metals, enormous sumptuous carpets, or brilliantly illuminated manuscripts of the Qur'an.

Scope, Resources, and Organization

In considering the very substantial and diffuse theme of gift giving at the Islamic courts, this exhibition and accompanying catalogue cast a wide net not only in terms of the time frame but in the concept of "gift." The latter, broadly defined, encompasses gifts freely given (perhaps an oxymoron especially from Mauss's perspective) and gifts taken, including tribute and booty.[25] Because relevant gifts were exchanged beyond the amorphous boundaries of the Islamic world, this investigation also considers some non-Islamic sources and materials.[26]

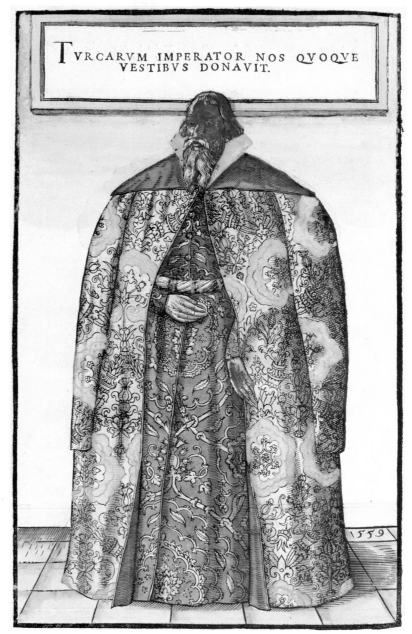

Fig. 8 (cat. no. 233). *Siegmund von Herberstein Dressed in the Khil'a Robe He Received from Süleyman I*, attributed to Johann Lautensack, Vienna, 1560. Victoria and Albert Museum, London (L.482-1880).

Above: Fig. 9 (cat. no. 106). *Qiran-i Sa'dayn of Amir Khusraw Dihlavi*, copied by Sultan Muhammad Nur, Iran, 1515. Museu Calouste Gulbenkian, Lisbon (LA 187).

Opposite: Fig. 10 (cat. no. 211). *Gurdiya Presenting an Equestrian Cat to Khusraw*, folio from a manuscript of the *Shahnama*, Iran, 1648. The Royal Collection, Windsor (RCIN 1005014).

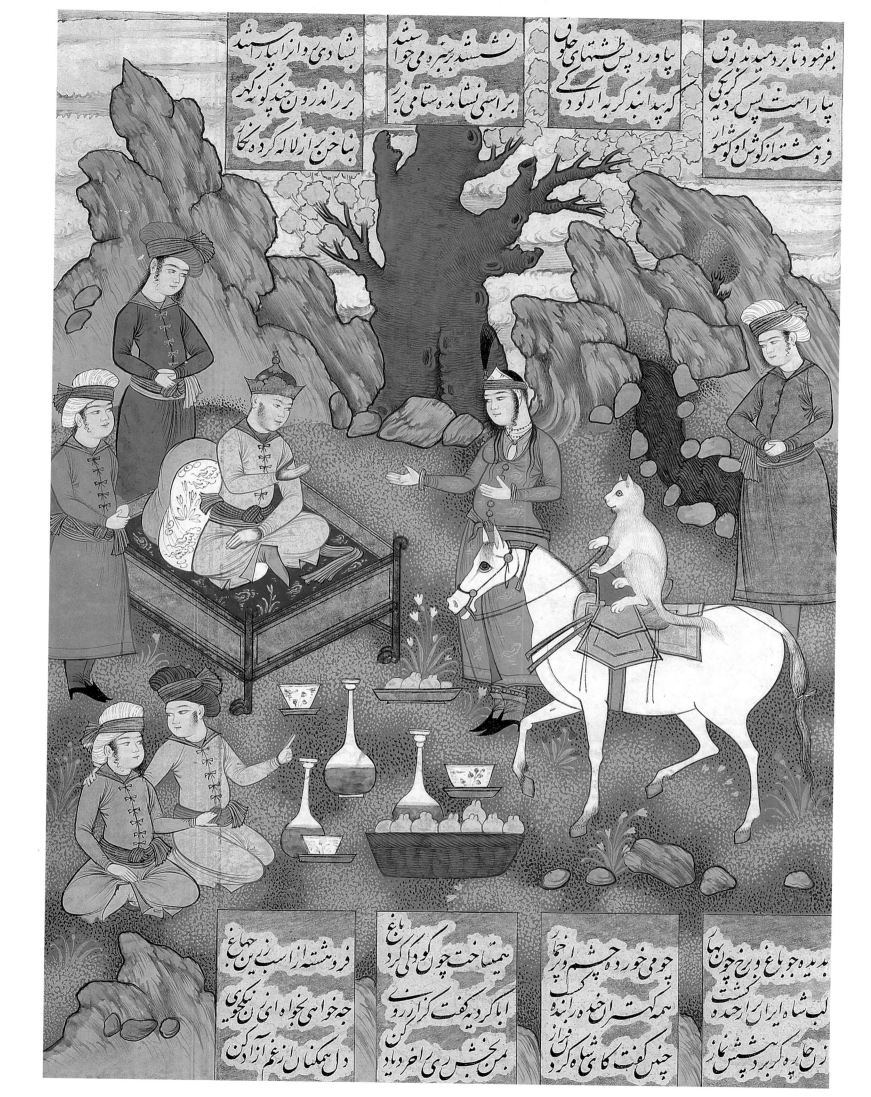

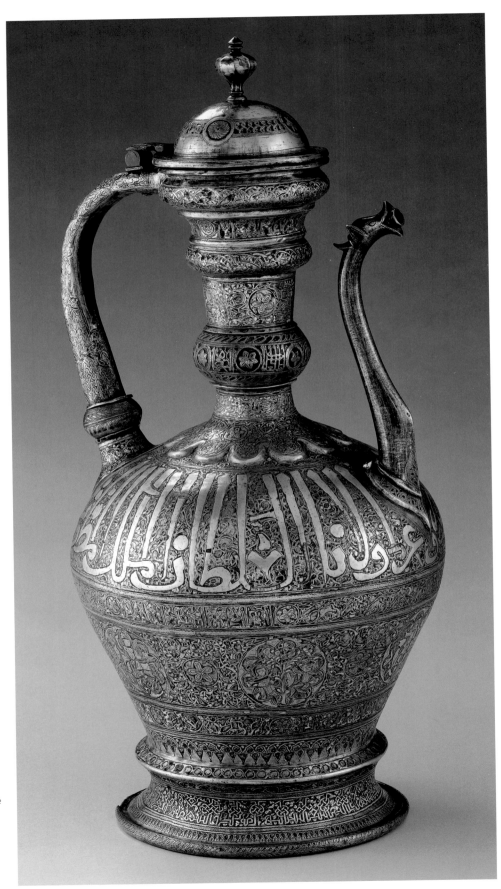

Right: Fig. 11 (cat. no. 130). *Ewer*, 'Ali ibn Husayn al-Mawsili, Egypt, Cairo, AH 674/1275–76. Musée du Louvre, Paris (Ucad 4412).

Opposite, top: Fig. 12 (cat. no. 43). *Landscape with Animals and Dedication Inscription*, folio from the "Nadira Banu Begam Album," India, 1640–41. The British Library, London (Add. Or. 3129).

Opposite, bottom: Fig. 13 (cat. no. 44). *A Lady Holding a Cup and a Bottle*, folio from the Nadira Banu Begam Album, India, 1640–41. The British Library, London (Add. Or. 3129).

Resources that have informed this study are:

1) Textual sources, including books on etiquette and comportment, encyclopedic works, and a broad array of historical works, such as memoirs, biographies, travelers' accounts, diplomatic reports and communiqués, and inventories; archival materials for later Islamic times; and deeds, registers, and inventories of endowments for gifts associated with religious and charitable institutions.

2) Works of art that can be identified as gifts from textual or archival resources or from their own inscriptions, or those objects that are similar to examples described by the written sources, and works of art, primarily manuscript illustrations, that depict the presentation or reception of gifts or indeed the gift itself or even the bearer of a gift. At times, the gift was ephemeral—food, medicine, spices, or aromatics—and only the container, a luxury object in its own right, has survived.

Clearly it is the second class that provides the visual focus, while the first provides the documentary framework. As already indicated, many works of art identified as gifts were not made for this purpose; their gift status is revealed only by unraveling their life story or "biography," which is essentially concerned with how they were viewed or received, very often beyond the context of their original creation. It is these "biographical" details that form the link between the two groups.[27]

While there is more than one way to consider the macrocosm of Islamic gift giving, the approach here is one that takes into account three broad—though not necessarily mutually exclusive—categories:[28]

Personal Gifts

Most of the works of art that constitute this category were produced in a courtly context and may have been given or received by royalty; they are classified as personal because they suggest a more intimate connection as compared with state and diplomatic gifts. They include objects of personal adornment such as jewels and jewelry, belts and garments, and

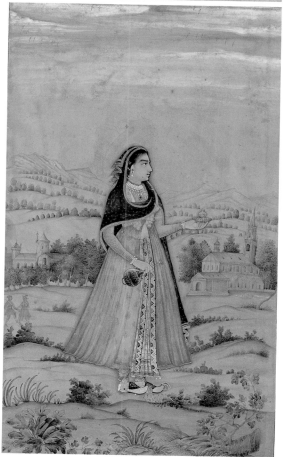

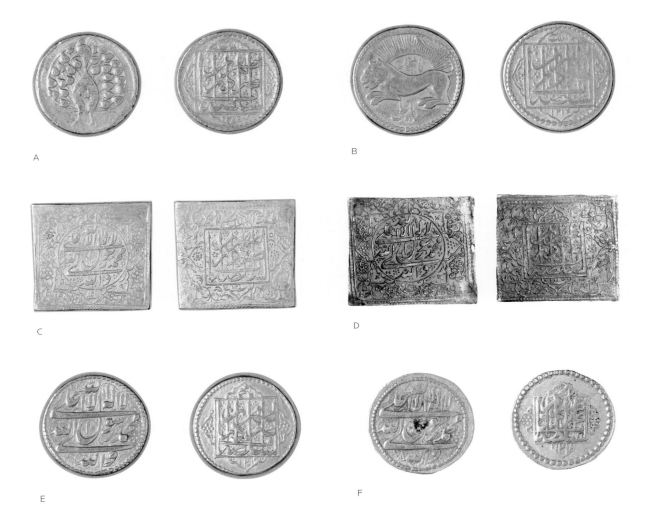

A: Fig. 14 (cat. no. 204). *20 Tomans*, in the name of Agha Muhammad Shah (r. 1779–97), Iran, Tehran, AH 1210/1795–96. Nasser D. Khalili Collection of Islamic Art, London (AV 1088).

B: Fig. 15 (cat. no. 205). *20 Tomans*, in the name of Agha Muhammad Shah (r. 1779–97), Iran, Tehran, AH 1210/1795–96. Nasser D. Khalili Collection of Islamic Art, London (AV 1030).

C: Fig. 16 (cat. no. 203). *50 Tomans*, in the name of Agha Muhammad Shah (r. 1779–97), Iran, Tehran, AH 1210/1795–96. Nasser D. Khalili Collection of Islamic Art, London (AV 1029).

D: Fig. 17 (cat. no. 200). *50 Tomans*, in the name of Agha Muhammad Shah (r. 1779–97), Iran, Tehran, AH 1210/1795–96. The State Hermitage Museum, St. Petersburg (ON-V-Az-1831).

E: Fig. 18 (cat. no. 207). *10 Tomans*, in the name of Agha Muhammad Shah (r. 1779–97), Iran, Tehran, AH 1210/1795–96. Nasser D. Khalili Collection of Islamic Art, London (AV 1031).

F: Fig. 19 (cat. no. 206). *20 Tomans*, in the name of Agha Muhammad Shah (r. 1779–97), Iran, Tehran, AH 1210/1795–96. Nasser D. Khalili Collection of Islamic Art, London (AV 1087).

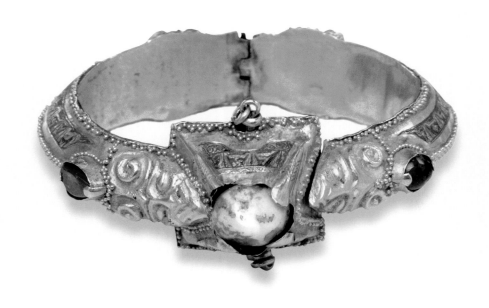

Fig. 20 (cat. no. 12). *Bracelet*, Greater Iran, 12th century. The Metropolitan Museum of Art, New York (59.84).

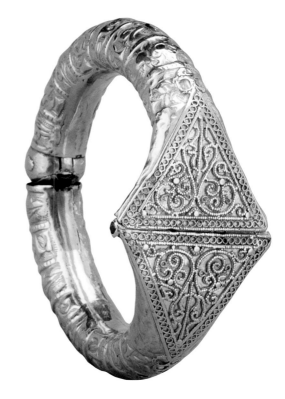

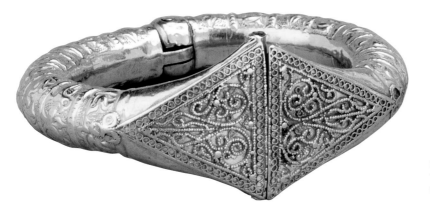

Fig. 21 (cat. no. 10). *Pair of Bracelets*, Syria or Egypt, 11th century. The al-Sabah Collection, Dar al-Athar al-Islamiyyah, Kuwait (LNS 7 Jab).

precious yet utilitarian objects such as vessels of silver, jade, and even emeralds, and paintings, albums, and manuscripts.

Pious Donations

This group includes architectural elements, furnishings, and manuscripts of the Qur'an that were part of the endowment of the religious institution, the endowment deed itself, and objects, often of a secular nature, that were specifically gifted to the mosque or shrine at times long after their creation.

State and Diplomatic Gifts

Many of these objects may have been made for or were kept in royal treasuries.[29] They represent a very broad array of types and materials ranging from rock crystal pieces and courtly regalia, including jewel-encrusted horse trappings, to places of habitation such as a palace façade or a tent. Gifts of living creatures are personified here by their depictions in a variety of media, while the ambassadors who transported these state gifts are represented by their portraits.

Given the highly mutable nature of the work of art as gift and even "regift," the different classes of object types often transcend this system of classification. For example, a Persian illustrated text (see figs. 9, 59, 234) or a Chinese porcelain (see fig. 57) suitable as a personal or a state gift may instead have ended up as part of an endowment to a religious institution or, as already noted, a manuscript of the Qur'an may have been transformed into a gift of state (fig. 7). Jewelry (figs. 21, 89, 150) and large gold coins (figs. 156–57) may have been either personal or state gifts, while the same may be said for ephemera such as musk or birds of prey. That said, these categories nonetheless provide a useful taxonomy for examining the concept of gift giving in Islamic art.

All three categories are united by the fact that they comprise what may be termed elite objects. This is not to say that less extravagant works were not exchanged as personal gifts or endowed to religious foundations, but it was the deluxe items made by the best artists and fabricated of rare and expensive materials that circulated in courtly

عمل عبد الصمد

Above: Fig. 22 (cat. no. 228). *Horse and Groom*, attributed to 'Abd al-Samad, Iran, Tabriz, c. 1530s. Los Angeles County Museum of Art, the Edwin Binney 3rd Collection of Turkish Art (M.2010.54.2).

Opposite: Fig. 23 (cat. no. 136). *Saddlecloth*, Turkey, Bursa, 16th–17th century. Benaki Museum, Athens (3784).

environments and were thereby preserved or else were donated to religious institutions (both Muslim and Christian) where they were respected and retained. In addition, because of their importance, it is these types of objects that were written about and whose accounts have survived. Such works of art also help to demonstrate cross-cultural interactions between Islam and Byzantium and with western European and east Asian courts. The exchange of these luxury objects, reflecting a real or an assumed princely taste, reveals a central process by which artistic forms and ideas were circulated, emulated, and assimilated.[30] In the end, perhaps, it is not necessarily the thought that counts but the price tag.

Notes

1 *Şehname-i Selim Han*, fols. 53b–54a. I am here as elsewhere in this volume indebted to Wheeler Thackston. It is my great good fortune to have him as a friend and colleague and his bad fortune to have been plagued by me so incessantly. His response, as always, was most gracious and generous.

2 See Dickson and Welch, *Houghton Shahnameh*, 270–71. There is some confusion in the related literature about which year the gifts were delivered, but 1567, not 1568, seems to be the correct year.

3 See Çağman and Tanindi, *Topkapi Saray Museum*, 211–12.

4 See Lambton, "Pīshkash." By wearing the robes, the members of the Safavid embassy were acknowledging the sultan as their overlord; see, for example, Sanders, "Robes of Honor in Fatimid Egypt." Presumably, they would not have worn these robes once back in Iran. European recipients of such robes did wear them back at home but likely not out of fealty to their donor; see fig. 8; see also Canby, *Shah 'Abbas*, 56, 59.

5 See Dickson and Welch, *Houghton Shahnameh*, 270–71 and nn3–5. Chinese porcelains were also included among the gift items from Tahmasp; see Raby and Yücel, "Chinese Porcelain at the Ottoman Court," vol. 1, 30. Also, see Tim Stanley's essay in this volume.

6 On Ottoman preferences for receiving manuscripts of the Qur'an and the *Shahnama*, see Lale Uluç's text in this volume.

7 On spurious attributions of Qur'ans to 'Ali ibn Abi Talib, see Blair, *Islamic Calligraphy*, 105.

8 Ibid., 102. See also Canby, *Shah 'Abbas*, 200–201, for other Safavid gifts of Qur'ans "by" 'Ali and his son Husayn to religious institutions.

9 That the Ottomans understood the value of such a visual message is indicated by their own production of richly illustrated dynastic histories from about the mid-sixteenth century. See Atasoy and Çağman, *Turkish Miniature Painting*, especially 31 ff., but for a recent study on one such manuscript, namely the history of the reign of Selim referenced here, also see Fetvaci, "Production of the Şehnāme-i Selim Hān."

10 For the most recent summation of the dismemberment of this remarkable manuscript beginning in 1970, see Gross, *Rogues' Gallery*, 362–64.

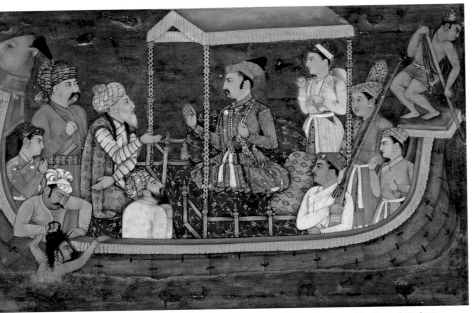

Above: Fig. 24 (cat. no. 184). *The Dunking of the Slave*, folio from a manuscript of the *Gulistan* of Sa'di, India, AH 1038/1628–29. © Trustees of the Chester Beatty Library, Dublin (In. 22).

Opposite: Fig. 25 (cat. no. 36). *The Simurgh Restores the Child Zal to His Father Sam*, folio from the Muhammad Juki *Shahnama*, probably Afghanistan, c. 1444. The Royal Asiatic Society of Great Britain and Ireland, London (MS.239).

11 On the Safavid determination of state gifts, see Matthee, "Gift Giving in the Safavid Period," 610.

12 On ambassadors and their selection, see the eleventh-century text on behavior in government usually attributed to the famous Saljuq vizier Nizam al-Mulk, *Book of Government*, 94–97.

13 See, for example, Cutler, "Significant Gifts," 91–92.

14 For elaborate containers for ephemeral gifts, see figs. 80–81, 103. The previously noted ruby the size and shape of a pear sent by Shah Tahmasp to Sultan Selim in 1567 was appropriately packaged in a jewel box; see Dickson and Welch, *Houghton Shahnameh*, 270. For pearls wrapped in a red cloth meant to set off the color of the pearls presented to the Umayyad Sulyaman b. 'Abd al-Malik (r. 715–17), see Qaddumi, trans., *Book of Gifts and Rarities*. On the use of textiles as wrappings for gifts, see Rosenthal, "Note on the *Mandîl*," 87–88.

15 Cutler, "Significant Gifts," 91–92. Throughout a broad body of literature ranging from the Fatimid-era *Book of Gifts and Rarities* (see Qaddumi translation) to the memoirs of the Mughal emperor Jahangir (*Jahangirnama*, see Thackston translation), constant reference is made to the equivalent monetary value of the gift. The value not only demonstrated the esteem in which the giver held the recipient but also could be used to determine the choice of a countergift.

16 For example, see Qaddumi, trans., *Book of Gifts and Rarities*, 114, for references to prized saddles in the Fatimid treasury that were said to have belonged to Alexander the Great.

17 Ibid., for example; but robes worn by or horses ridden by the ruler/donor were likewise highly valued. See, for example, Sanders, "Robes of Honor in Fatimid Egypt," 225–27.

18 See, for example, Shalem, "The Second Life of Objects," and especially his "Afterlife and Circulation of Objects" in this volume.

19 Each of the previous studies had a fairly specific focus: Grabar, "The Shared Culture of Objects"; Raby, "The Serenissima and the Sublime Porte: Art in the Art of Diplomacy, 1453–1600"; Shalem, "Made for the Show: The Medieval Treasury of the Ka'ba in Mecca"; and Cutler, "Significant Gifts," whose many other articles on the topic of Byzantine and early Islamic gift giving are cited in the Bibliography in this volume. Also see the contributions by the last two authors in this volume.

20 *The Gift*, first published in French in 1925 as *Essai sur le don: Form et raison de l'échange dans les société archaïques*. Among the numerous gift-related studies focusing on the medieval period see, for example, Cohen and de Jong, eds., *Medieval Transformations*, especially 124 ff.; for the Renaissance, see the excellent monograph by Davis, *Gift in Sixteenth-Century France*, and especially 6–9. Mauss-inspired gift theory has also been applied to the study of Chinese art. See the work of Clunas, especially "Gifts and Giving in Chinese Art" and *Elegant Debts*.

21 Mauss was, after all, largely basing his ideas on North American potlatch and Melanesian gift exchange; for a detailed and thoughtful discussion of this issue, see Geary, "Gift Exchange and Social Science Modeling." Cutler, "Significant Gifts," also considers the same issue in the context of Byzantine and early Islamic diplomatic gift exchange. With regard to the ancient Near East, see Feldman, *Diplomacy by Design*, 113.

22 *Pishkash* (Persian) generally indicates a gift or tribute from a lower-ranking individual to a ruler; see, for example, Lambton, "Pīshkash," but also Matthee, "Gift Giving in the Safavid Period," 609. *Hadiya* (Arabic) denotes a gift exchanged between peers, while '*atiya* (Arabic), *in'am* (Arabic), and *bakhshish* (Persian) indicate a gift from a high official to one of lesser rank. See, for example, Rosenthal, "Gifts and Bribes," but also s.v. "Hiba" (one of the many words for "gift"), *Encyclopaedia of Islam* 2, vol. 3, 342 ff.

23 See the introductory remarks by Oleg Grabar in Qaddumi, trans., *Book of Gifts and Rarities*, vii–ix. Also, see "Gift Giving I: Introduction," *Encyclopaedia Iranica*, 606, for texts on warfare and statecraft that also expound on the values of generosity and gift giving.

24 See, for example, K. Rizvi, "Transformations in Early Safavid Architecture," or Necipoğlu, "The Süleymaniye Complex in Istanbul," to cite just two of a number of such studies.

25 With regard to the issue of gifts versus booty or tribute, see Feldman, *Diplomacy by Design*, 168–69.

26 Though this was not admittedly undertaken in a systematic manner but rather was based in part on the availability of relevant works of art.

27 On the topic of the life story of objects, see Shalem, "Afterlife and Circulation of Objects," in this volume. Also, see Komaroff, "Color, Precious Metal, and Fire," 35–36.

28 The notion of this tripartite division was the common consensus of the catalogue contributors, who attended an NEH-sponsored Advisory Committee meeting at LACMA in September 2008.

29 See, for example, on the famed Fatimid treasury in Cairo, Bloom, *Arts of the City Victorious*, 157–59, as well as that author's contribution in this volume.

30 See Grabar, "Shared Culture of Objects."

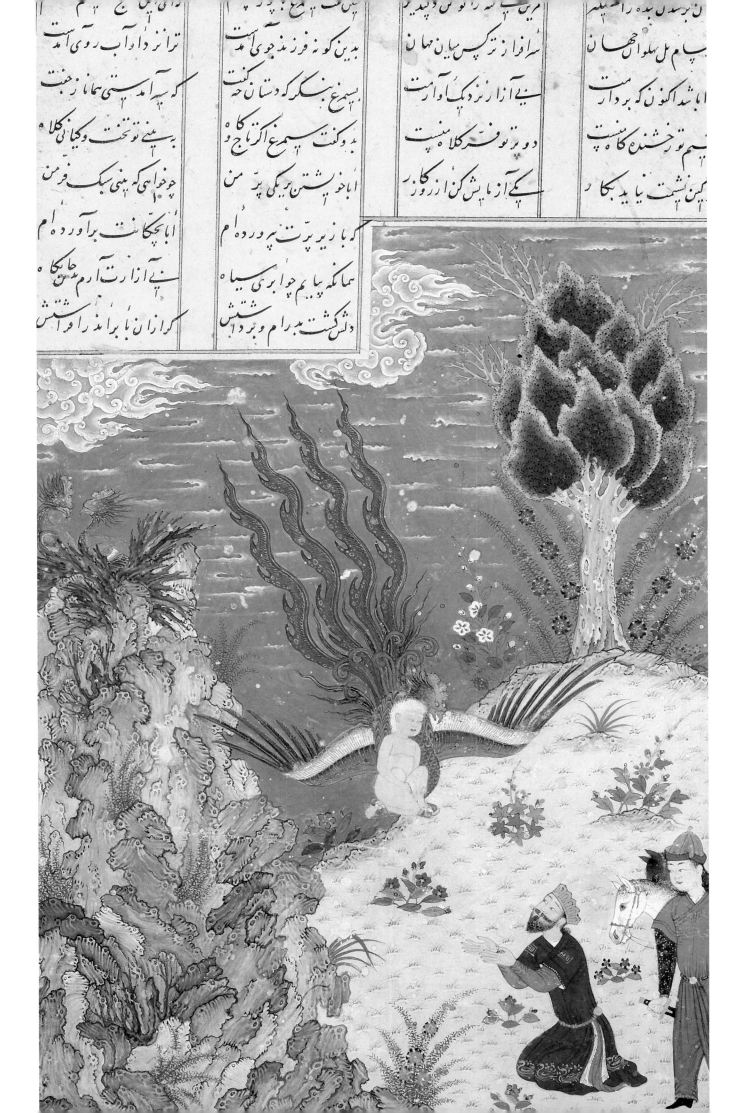

سپردم بدو دل را هم خشم و کین
...
برافراز تا کس نبیند نشان

بیم آزار نزدیک او را مباد
دو پر توفدک سر کلاه منست
چه بنشست بر تخت و کیانی کلاه

سپهر بلند اوج گردان جهان
تو را بد کنون که برد از او کار
هیچم آزایش کن از روزگار

تراز نداد آب روی آمد
بدین کو به فرزند جوی آمد
به سبزی بر آمد همانا زیفت
به تخت ایمنی تخت و کیانی کلاه
چه خواهی که بینی سبک فرمن
...

سپهر بنگک دستان که گفت
بدو گفت سیمرغ کای تاج تو
ابا خویشتن بر یکی پر من
گر بازی پرت بپروده ام
به آنکه پیام جوابری سیاه

تراز داد آب روی آمد
که سپه آمد سیمرغ همانا زرفت
به بنی تخت و کیانی کلاه
چه خواهی که بینی سبک فرمن
ابا حکمانت بر آورده ام
نیای آزارت آرم حالکار
دلش گشت بدرام و برد اش
گر آزان با براند او راوشتش

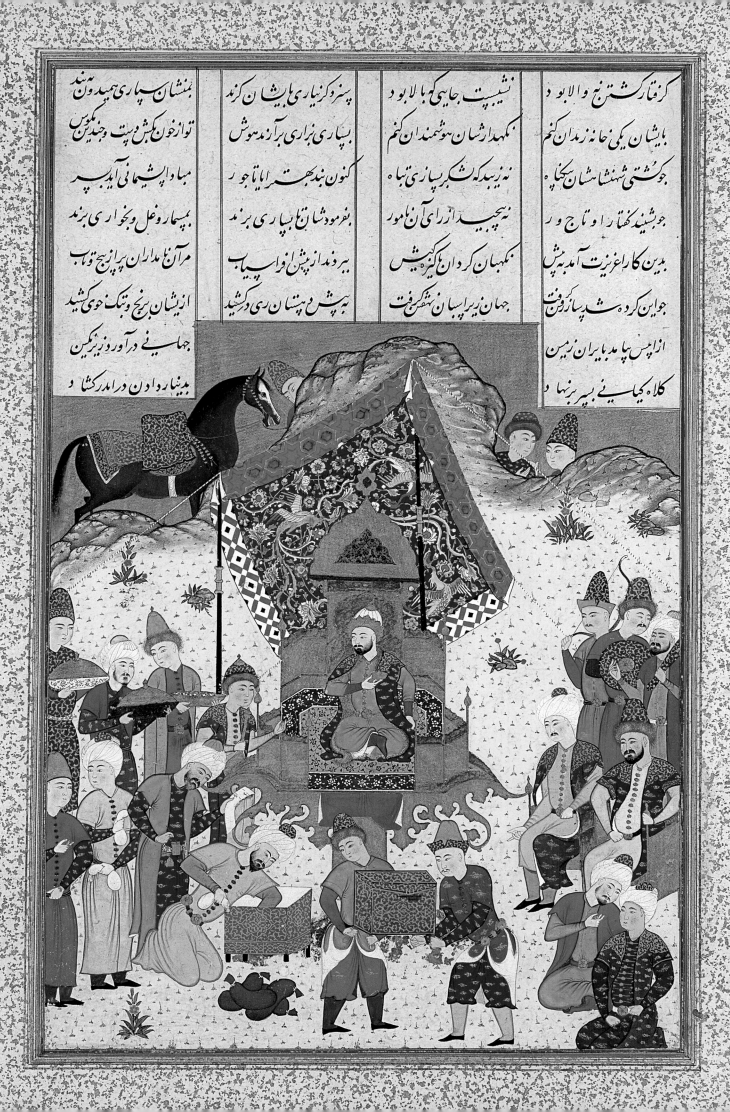

Gift Giving in the Iranian Tradition

Michael Morony

The giving and receiving of gifts played an essential role in pre-modern Iranian society, especially as a political practice, one that extended from ancient times into the Islamic period. Circumstances and the gifts themselves changed with time, but the underlying motivation of gift exchange and its generally asymmetrical nature remained as a constant. Gift giving in the Iranian tradition involves such ideals and concepts of ritual exchange as the equal or greater value of the countergift, honoring a guest or a host, the display of gifts, and regifting. The longevity of gift giving in Iran carried over from antiquity into the period covered by this catalogue. Indeed, these ancient and indigenous practices in Iran are evident in the Zoroastrian sacred text, the *Avesta*, wherein the poet-sacrificer engages in a system of gift exchange with Ahura Mazda, a diety of the Old Iranian religion. This system is actually Indo-Iranian because in the Vedas (the earliest Hindu sacred writings) sacrifice and its divine reward are also seen as an exchange of gifts.[1] Indo-Iranian sacrifice involved a three-way gift exchange between the priest, deity, and patron. The poetry of the priest invited the gods to descend to enjoy the sacrifice. The gods were considered guests, who brought gifts of hospitality to bestow on their host, the patron, who was obliged to reward the priest for his services.[2]

In the *Avesta* the universe was created and organized by Ahura Mazda in a divine sacrifice. Since he gave the ingredients of sacrifice to people in the first place, every sacrifice by humans is a repayment that returns to Ahura Mazda that which he gave the world to use. Thus the ingredients of the sacrifice go back and forth between the divine and human realms as gifts and countergifts. By the rules governing gift exchange, the poet-sacrificer and Ahura Mazda become mutually indebted, and Ahura Mazda, as both friend and host, is obliged to make a countergift that matches or surpasses

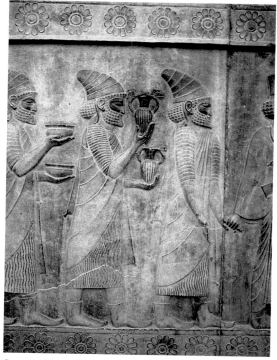

Opposite: Fig. 26 (cat. no. 145). *Afrasiyab on the Iranian Throne*, folio from the *Shahnama* of Shah Tahmasp, Iran, Tabriz, 1525–35. The Metropolitan Museum of Art, New York (1970.301.16).

Above: Fig. 27. *The Delegation of Lydians*, located on the southern flight of the eastern staircase of the Apadana at Persepolis, Iran, 5th century BC.

in value the gift of his friends, the poet-sacrificer and his community. Failure to do so would cancel the relationship and let chaos replace order. Thus a continuous process of gift and countergift is established. The poet-sacrificer repays his debt to the god with sacrifices and praises that confer fame and the royal command on Ahura Mazda, who must then repay this new debt to the world by using his command to regenerate it.[3]

It is reasonable to suppose that what went on between the poet-sacrificer and Ahura Mazda is a reflection of expectations in ancient Iranian society, particularly in terms of mutual obligations, guest-friend relations, and the equal or greater

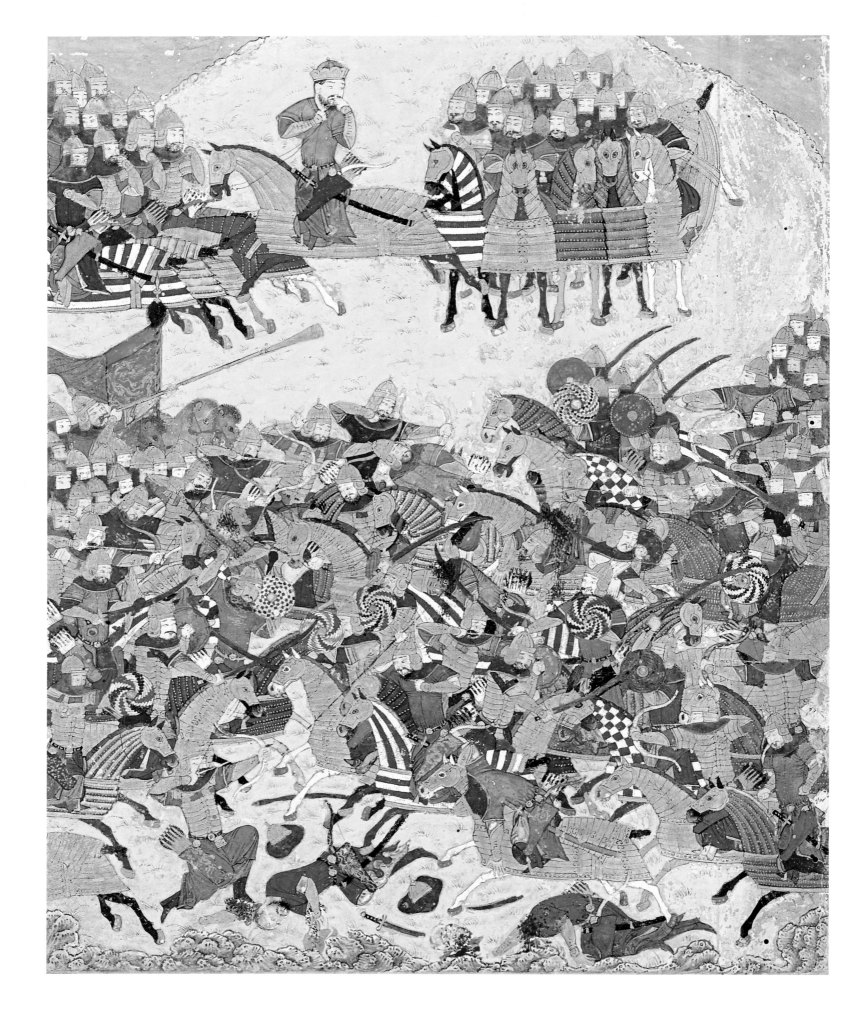

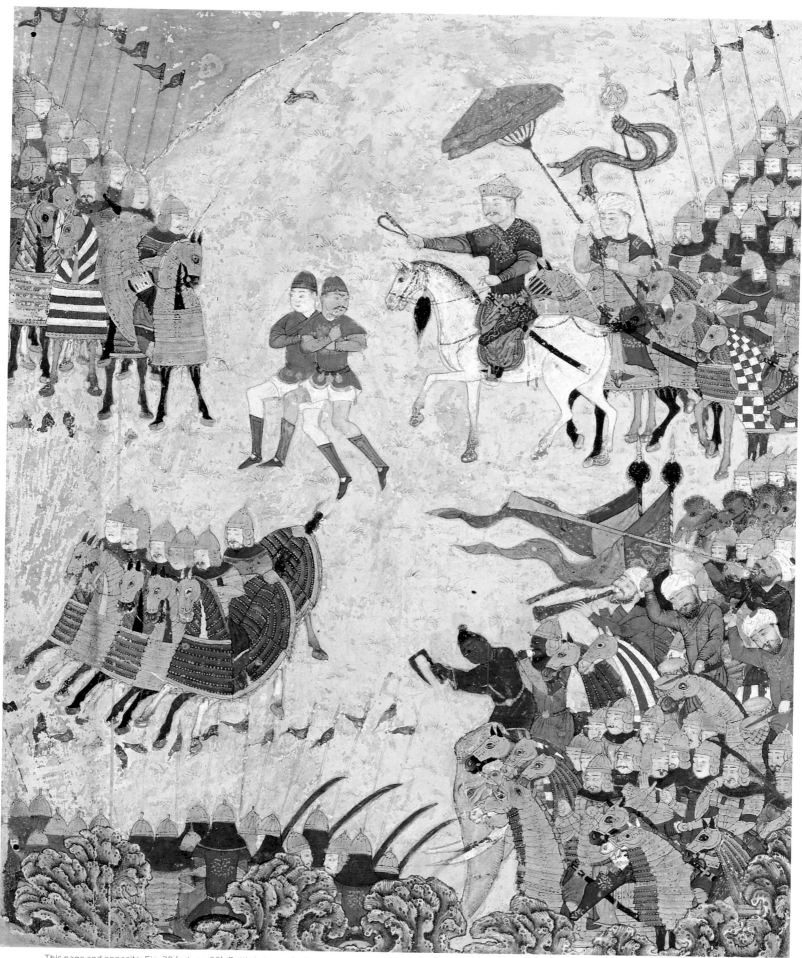

This page and opposite: Fig. 28 (cat. no. 38). *Battle between Gushtasp and Arjasp*, double-folio composition from a manuscript of the *Shahnama*, probably Afghanistan, c. 1440. The Royal Asiatic Society of Great Britain and Ireland, London (MS. 239).

Fig. 29 (cat. no. 21). *Tiraz* (detail), Egypt, AH 371/981. Los Angeles County Museum of Art, Madina Collection of Islamic Art, gift of Camilla Chandler Frost (M.2002.1.30).

value of the countergift. There is clearly the political significance and the need for good rulers to be strengthened by the praise and gratitude of their subjects and to reward them in turn by preserving their well-being.[4] Such expectations, illustrated for instance in the famous processional reliefs at Persepolis (fig. 27),[5] have survived among Zoroastrians ever since.

By the Sasanian period (224–651) royal traditions of gift exchange had been institutionalized. Gifts were offered to the king at the festivals of Nawruz (the vernal equinox, which was the start of their new year) and Mihrajan (the autumnal equinox).[6] According to an anonymous ninth-century Arabic text called the *Book of the Crown*, which purports to record Sasanian usages, on those days people brought the king what the giver loved the most. Members of the upper class gave musk, amber, cloth, and luxurious clothing. A cavalryman gave a horse, lance, or sword; an archer gave arrows. The rich gave gold or silver; a poet gave verses; an orator gave a speech; a close friend gave a precious object or rarity.[7] If a gift was worth ten thousand dirhams, it was registered in the court *diwan*, and then, when a son of the giver was married, or a daughter conducted to her husband, the *diwan* was consulted. If his gift had been worth ten thousand dirhams, he was given double that amount.[8]

It is also said that the Sasanian rulers Ardashir I (r. 224–41), Bahram V (r. 420–438/9), and Khusraw I (531–79) gave out all the clothing in their treasuries at Nawruz and Mihrajan to their courtiers and favorites first and then to other people according to their rank. At Mihrajan the Persian king gave away his summer clothing because he did not need it anymore, and likewise at Nawruz he gave his winter clothing away. In the Islamic period, the only one who is said to have followed the example of the Persian kings in this matter (at least by the ninth century) was 'Abdallah ibn Tahir, the Muslim governor of Khurasan (r. 828–45), who distributed clothing at Nawruz and Mihrajan until there was none left in his treasury.[9]

Poetic praise functioned as part of the gift-exchange system. The custom of bestowing a robe of honor (*khil'a*) upon poets to reward them for their verses was already established among pre-Islamic Arabs. Gift-exchange theory has been applied to the analysis of two events in which panegyric verse served as valuable commodities. In one of them 'Alqamah, a poet famous for receiving the robes of kings, was presented with a gift of ransomed prisoners by the Ghassanid king al-Harith ibn Jabala (r. about 529–69) in return for his poem.[10] The other is the famous occasion when the poet Ka'b ibn Zuhayr converted to Islam by presenting a poem to Muhammad, and the Prophet gave Ka'b his own mantle (*burda*) in return. The poem functioned as a symbolic gift in a ritual of allegiance while the mantle became the symbolic countergift,[11] but this

would have been in the pattern of contemporary rulers. It is said that Muhammad never refused a gift from anyone and that he gave rewards in return.[12]

Otherwise, Persians themselves introduced Muslim Arabs to Iranian gift-giving customs during and after their conquest of Iran. In 642 a Persian notable called Dinar was taken captive at the city of Nihavand by Simak ibn ʿUbayd al-ʿAbsi. Dinar offered Simak anything he might ask in return for sparing his life, and after his request was granted, he brought Simak gifts.[13] There was some ambivalence among Muslim Arabs about Iranian gift-giving traditions at first. At Balkh, in 652, al-Ahnaf ibn Qays had appointed his nephew, Asid ibn al-Mutashammis, to collect the tribute. While he was doing so, the festival of Mihrajan came around and the people of Balkh gave Asid gifts of gold and silver vessels, dinars and dirhams, furniture, and garments. When he asked them if that was part of the tribute, they answered, "No, this is rather something that we do on this day for our ruler in order to conciliate him." He asked them what day it was; they told him "Mihrajan," and he said, "I don't know what that is." But he hated to refuse the gifts, because they might rightfully be his, so he took them, put them aside, and told al-Ahnaf about it when he arrived. The people of Balkh told al-Ahnaf the same thing, so he took the gifts to his commander, Ibn ʿAmir, and told him about them. Ibn ʿAmir told al-Ahnaf they

were his and he should keep them. When al-Ahnaf responded, "I have no need of them," Ibn ʿAmir said, "Take them for yourself."[14] The caliph ʿAli (r. 657–61) is said to have refused to accept the gifts brought to him by the Persian landlords (*dahaqin*; singular, *dihqan*) of al-Madaʾin prior to the Battle of Siffin in 657. When they asked him why, he told them, "We are more wealthy than you; in truth, it is more fitting for us to pour out [our wealth] upon you."[15]

Al-Hajjaj ibn Yusuf (r. 694–714), governor of Iraq and the Islamic lands east of it, is said to have started the practice among Muslims of offering gifts on Nawruz. The Umayyad caliph ʿUmar II (r. 717–20) abolished the Nawruz and Mihrajan gifts, but these were restored by Yazid II (r. 720–24).[16] By then the Arab governors in the east had it figured out and adopted Persian gift-giving customs as an added source of income. There is a detailed description of the gifts presented to Asad ibn ʿAbdallah al-Qasri when he attended the feast of Mihrajan at Balkh in the fall of 738. Asad sat on a raised seat with the notables of Khurasan arranged on chairs, while the amirs and *dahaqin* brought him presents. Among them were Ibrahim ibn ʿAbd al-Rahman al-Hanafi, Asad's governor of Herat and Khurasan, and the (unnamed) *dihqan* of Herat, who came forward together and presented their joint gift to him. They set down a "fortress of silver and a fortress of gold" (scale models) on the cloth spread out in front of

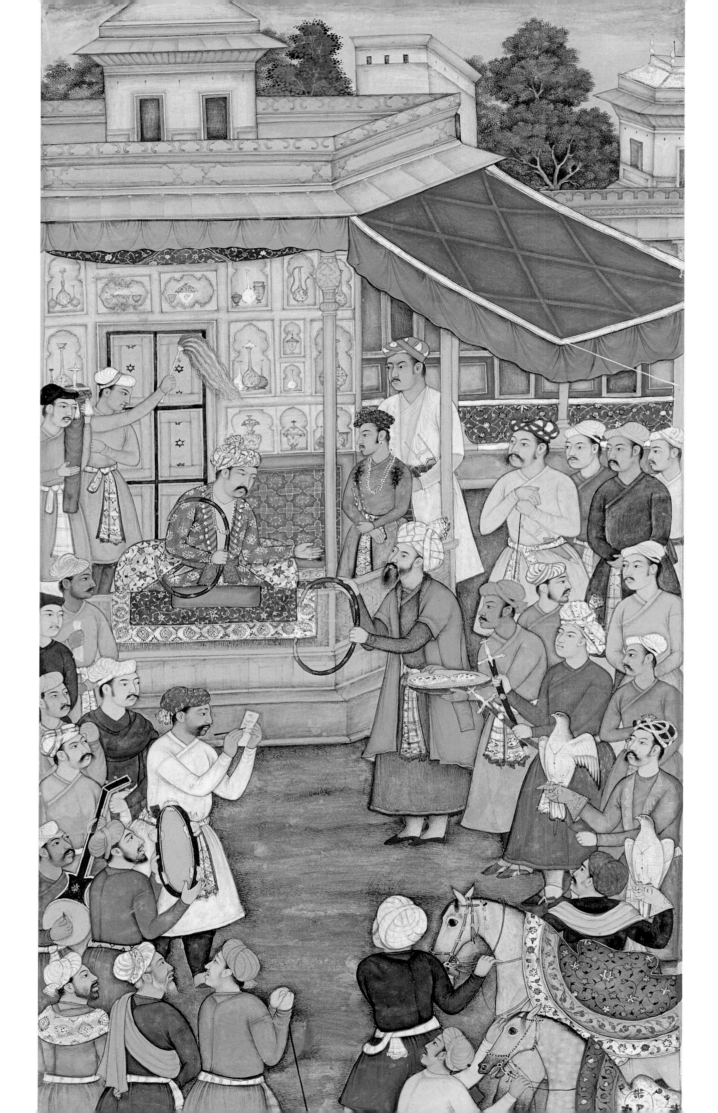

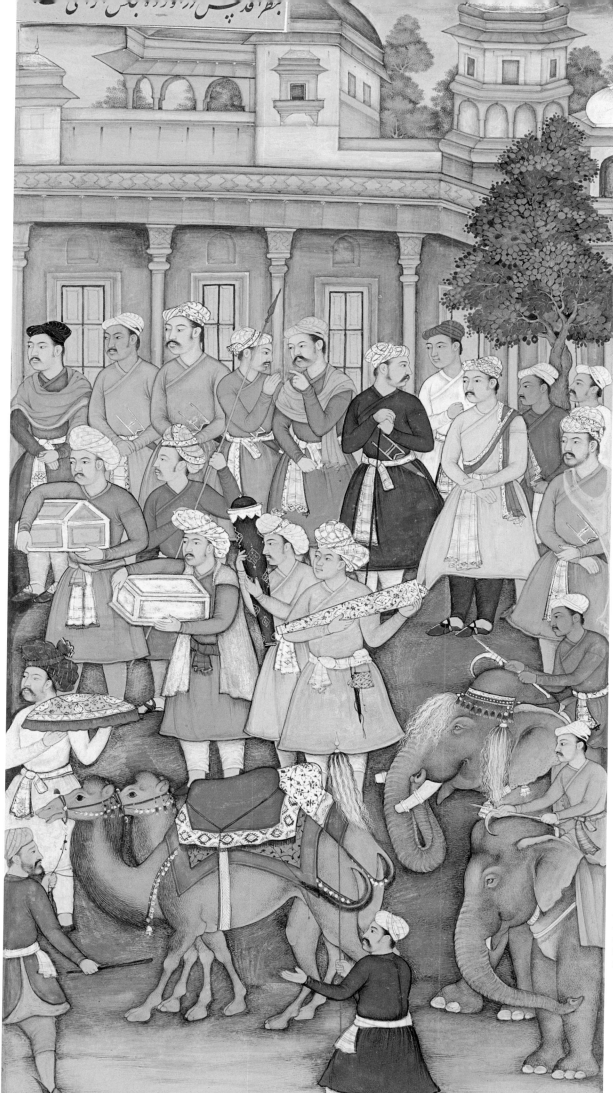

Fig. 30 (cat. no. 178). *Akbar Receives the Badakhshanis*, double-folio from a manuscript of the *Akbarnama*, India, c. 1603–5. © Trustees of the Chester Beatty Library, Dublin (In 03.53b and In 03.54a).

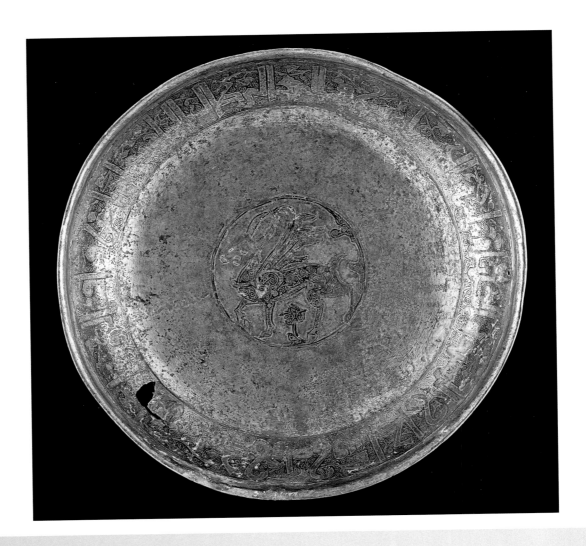

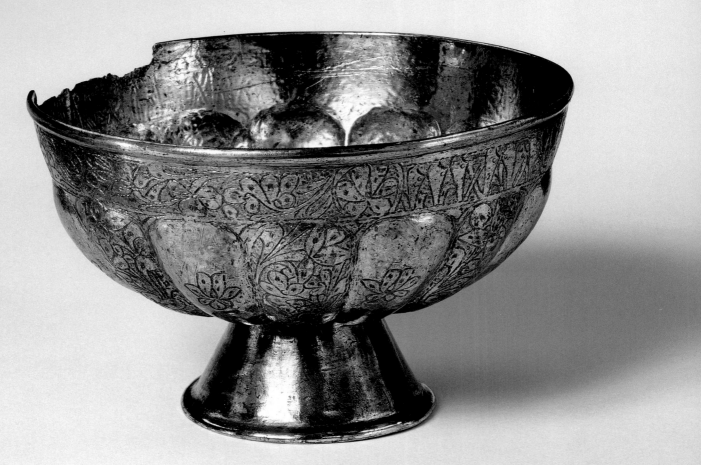

Asad. Behind them they put gold and silver pitchers, then large gold and silver dishes and silk garments until the cloth was filled. The entire gift was worth one million dirhams. The *dihqan* also gave Asad a ball of gold and delivered a speech on the qualities of rulers. When he was finished, Asad told him he was the best *dihqan* in Khurasan and the most excellent in giving and gave him an apple he was holding, whereupon the *dihqan* of Herat prostrated himself before Asad. Asad then looked at the gifts silently and then ordered someone to carry off the gold fortress and someone else to take the silver fortress away. He told first one and then another to take a pitcher and gave away all the large dishes and the silken garments to lesser officials and to those whose performance in war had been outstanding until he had given away everything that was on the cloth spread on the ground.[17]

The first remarkable thing about this account is its description of the public display of the gifts. Anthony Cutler has pointed out that rulers often exhibited gifts in public before redistributing them, thus turning symbols of submission into signs of grandeur.[18] The public display of gifts exchanged between rulers was an important aspect of diplomacy (e.g., see fig. 6).

The second thing that is significant about this account is that it is an example of regifting. It was, and is, common for presents to be regiven to third parties. When the Byzantine governor of Egypt, al-Muqawqis, sent Muhammad four slave girls, a mule, a donkey, a horse, a thousand *mithqals* of gold, twenty pieces of Egyptian linen, honey, and an Alexandrian basket, Muhammad is said to have regifted three of the slave girls and gave the money as alms.[19] When Mu'awiya (r. 661–80) gave 'A'isha a gold pyxis containing precious gems worth a hundred thousand dirhams, she distributed them among the other widows of the Prophet.[20] In this tradition, presents can continue to go from one person to another, and Cutler uses this to revise Mauss's seminal hypothesis that objects have a spiritual impulse to return to their owners.[21]

By the early Abbasid period both Nawruz and Mihrajan were occasions for exchanging gifts in Muslim society.[22] Caliphs and viziers at Baghdad and Samarra sat in their chambers to receive

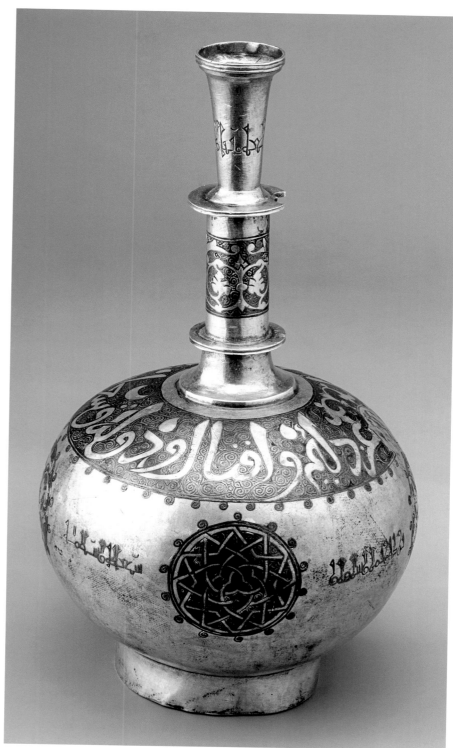

Opposite, top: Fig. 31 (cat. no. 17). *Bowl*, Iran, c. 1029–49. Los Angeles County Museum of Art, the Nasli M. Heeramaneck Collection, gift of Joan Palevsky (M.73.5.149).

Opposite, bottom: Fig. 32 (cat. no. 19). *Footed Bowl*, Iran, 13th–14th century. The David Collection, Copenhagen (47/1979).

Above: Fig. 33 (cat. no. 18). *Flask*, Iran, late 11th–early 12th century. The State Hermitage Museum, St. Petersburg (S 504).

Fig. 34 (cat. no. 14). *Dinar*, Caliph al-Musta'sim (r. 1242–58), Iraq, Baghdad, AH 642/1244–45. Omar Haroon Collection, Los Angeles.

Fig. 35 (cat. no. 15). *Dinar*, Sultan Baybars (r. 1260–77), Egypt, Cairo, probably AH 665/1266–67. Omar Haroon Collection, Los Angeles.

Opposite: Fig. 36 (cat. no. 23). *Akbar Gives a Robe of Honor in 1560*, folio from a manuscript of the *Akbarnama*, Govardhan, India, c. 1603–5. © Trustees of the Chester Beatty Library, Dublin (In 03.49b).

presents from people of all ranks. High-ranking officials and wealthy people offered perfumes, jewels, and pearls. Merchants presented carpets, clothing, or slave girls. Poets offered their poems, and common people brought gifts of flowers or fruit. The caliphs gave their visitors valuable gifts in return.[23] For instance, the caliph al-Mutawakkil (r. 847–61) sat in his chamber from morning until noon worship on Nawruz to receive the presents offered to him by his high officials,[24] while his concubines celebrated Mihrajan by presenting him with precious gifts.[25]

These customs were observed by the Abbasid caliphs at least until the early tenth century and then survived among the rulers of the successor states to the Islamic Empire. Bayhaqi, the renowned Persian historian, recorded how gifts were brought to the Ghaznavid court on Nawruz and Mihrajan from outlying parts of the kingdom in eastern Iran and Afghanistan in the 1030s as *pishkash* (a present from someone of inferior status). Such gifts to the ruler and his officials were transformed into taxes or dues as irregular levies began to increase under the late Saljuqs and Khwarazmshahs during the twelfth century and then proliferated under the Mongol Ilkhans. By the fifteenth century *pishkash* had come also to mean a due or tribute owed to the ruler or his officials.[26]

Important political events were also occasions for giving gifts. When the caliph appointed his heir apparent, poets were rewarded with robes of honor for their formal expressions of praise for the soon-to-be-departing present ruler.[27] On the day of the new caliph's accession, when he received the oath of allegiance (*bay'a*), he distributed gifts and robes of honor to the high dignitaries.[28] At victory celebrations the caliph also gave his generals robes of honor.[29] Viziers gave presents to the visitors who congratulated them on their appointments.[30] Gifts normally accompanied diplomatic negotiations with other rulers for treaties, armistices, alliances, prisoner exchanges, or commercial rights.[31]

In general gifts were given on all sorts of special occasions, both public and private: blood-letting for medical purposes, childbirth, circumcisions, graduations, hospitality, journeys, religious holidays, and weddings.[32] We hear most about these things when they involve the ruling class. Muslims gave each other presents on 'Id al-Adha (the Feast of the Sacrifice, which ends the annual Pilgrimage and is one of the two major Muslim holidays),[33] while the Christian secretary of al-Mutawakkil's mother sent the caliph Lenten food in precious vessels at an expense of three thousand dinars.[34] Weddings usually involved giving presents from the royal groom to the guests, but there is evidence of a gift to the bride from either the groom or the new father-in-law.[35] On the famous occasion of the marriage of the caliph al-Ma'mun (r. 813–33) to Buran, the daughter of his vizier, al-Hasan ibn Sahl, in 825, on the day the marriage contract was signed the bride's father showered the guests with balls of ambergris containing slips of paper upon which the designations of gifts were written. A king of India

وفيون طغايي ميرزا حسمد حكيم ماحمعت وراوان وسپاسي سيار نارح مست وحكم شهر بور ماه الهي موفق
دوشنبه بنزدهم ذي الحجه نشرف بساطبوس سرفراز شد ومشمول تربيت شانشاهي كرديد ومنصب عالي وكال
وشرف خطاب خان خاناني خلعت افتخار در بركرد

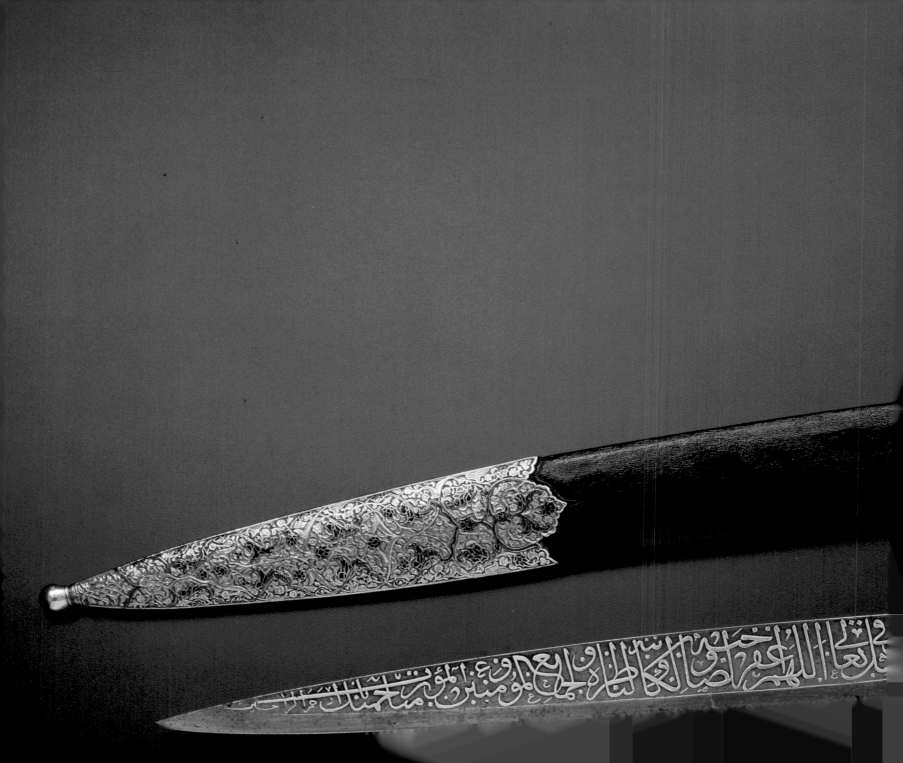

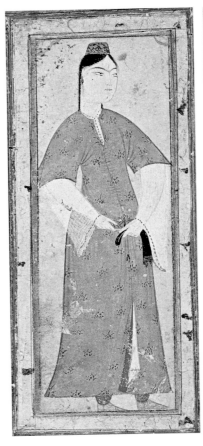
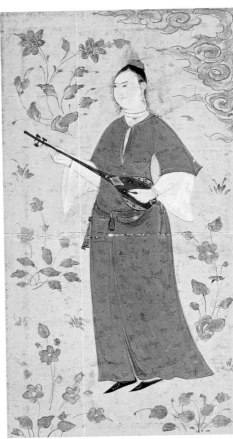

Left: Fig. 38 (cat. no. 214). *Young Woman in Blue*, Turkey, late 16th century. Los Angeles County Museum of Art, the Edwin Binney 3rd Collection of Turkish Art (M.85.237.30).

Right: Fig. 39 (cat. no. 215). *Woman with a Lute*, Iran, Isfahan, c. 1600–1610. Los Angeles County Museum of Art, the Nasli M. Heeramaneck Collection, gift of Joan Palevsky (M.73.5.457).

sent gifts to the father of the bride, al-Hasan, and, when al-Ma'mun consummated his marriage with Buran, he gave her father ten million dirhams, or one million dinars, which al-Hasan promptly gave away to al-Ma'mun's officers and entourage. Al-Ma'mun also gave Buran's brother one million dirhams and a land grant worth eighty thousand dinars. All of the guests got robes of honor.[36]

The birth of a child in the caliph's household was an occasion for the caliph and members of his family to give valuable presents to everyone, both rich and poor, while poets and dignitaries got the usual robes of honor.[37] There are also cases of the father giving presents to the mother and of an outsider sending valuable gifts to the father.[38] The circumcision of a caliph's son was a major event. At the banquet held by al-Mutawakkil (r. 847–61) for the circumcision of his son al-Mu'tazz (r. 866–69) the guests received a considerable amount of dinars and dirhams, and each of them got three robes of honor. Al-Mutawakkil freed a thousand slaves and gave each of them a hundred dirhams and three

pieces of cloth. The female singer and the dancers in the courtyard got one million dirhams, while dirhams were showered on the barber, slaves, bodyguards, household managers, and servants. The barber received more than eighty thousand dinars plus jewelry, property, and other gifts.[39] At the banquet that celebrated the circumcision of the son of the caliph al-Muktafi (r. 902–8) in 907, the guests were given robes of honor with slips of paper in the pockets that assigned them an inner garment, while the vizier gave each guest a bouquet of roses.[40] In 914, when the caliph al-Muqtadir (r. 908–32) had his five sons circumcised on the same day, he showered five thousand dinars and a hundred thousand dirhams on them. Prior to that, he had had a group of orphans circumcised and distributed dirhams and clothing among them.[41] Gifts were also given to the guests at the celebration when a son of the caliph had mastered the entire Qur'an. Al-Mutawakkil showered precious gems on the tutor, generals, officers, and other dignitaries for his son, al-Mu'tazz, on that occasion.[42]

In the context of hospitality to a ruler, gifts conferred honor on the giver as well as the recipient.[43] When the caliph Sulayman (r. 715–17) arrived in Medina in 716 on his pilgrimage to Mecca, Kharijah ibn Zayd ibn Thabit gave him a present of a thousand bunches of bananas, a thousand gourds filled with white honey, a thousand sheep, a hundred geese, a thousand chickens, and a hundred camels for slaughtering. Kharijah told him it was a meal for a guest. But Sulayman regarded it as a gift and settled Kharijah's debts of twenty-five thousand dinars and gave him ten thousand dinars.[44] A traveler returning from a journey might also be met with presents.[45]

In general, apart from diplomacy, gift giving in the Iranian tradition has been tied to annual events and momentous personal occasions. When rulers were involved, it was most often the celebrant who gave the gifts and the guests who received them. As this catalogue and the exhibition it accompanies demonstrate, this long-standing practice of gift giving led to the creation or repurposing of many spectacular works of art, while the circulation of such objects, especially as diplomatic gifts, helped to extend the cultural influence of Iran far beyond its borders.

Notes

1 Keith, *Religion and Philosophy of the Veda and Upanishads*, vol. 1, 259.

2 Hintze, "'*Do ut des*'," 27, 29.

3 Skjærvø, "*Tahadi*," 493–520.

4 Ibid., 519.

5 On the reliefs with gift bearers, see Schmidt, *Persepolis*, vol. 1, 84–90.

6 Pellat, trans., *Le livre de la couronne*, 165; Qaddumi, trans., *Book of Gifts and Rarities*, 62.

7 Pellat, trans., *Le livre de la couronne*, 165–66.

8 Ibid., 167.

9 Ibid., 168–69.

10 Stetkevych, "Pre-Islamic Panegyric," 1, 3–4, 16, 42.

11 Ibid., 2, 42.

12 Qaddumi, trans., *Book of Gifts and Rarities*, 64.

13 Baladhuri, *Futuh al-buldan*, 306.

14 Tabari, *Ta'rikh al-rusul wa-l-muluk*, vol. 1, 2903-4; Tabari, *Crisis of the Early Caliphate*, 106–7.

15 Ya'qubi, *Ta'rikh*, vol. 2, 218.

16 Muhammad Ahsan, *Social Life under the Abbasids*, 287; Qaddumi, trans., *Book of Gifts and Rarities*, 250–51.

17 Tabari, *Ta'rikh al-rusul wa-l-muluk*, vol. 2, 1635–38.

18 Cutler, "Significant Gifts," 91–93. See also texts by Anthony Cutler and Avinoam Shalem in this volume.

19 Qaddumi, trans., *Book of Gifts and Rarities*, 63–64.

20 Ibid., 66.

21 Cutler, "Significant Gifts," 90.

22 Qaddumi, trans., *Book of Gifts and Rarities*, 250–51.

23 Ahsan, *Social Life under the Abbasids*, 288, 290.

24 Ibid., 287.

25 Qaddumi, trans., *Book of Gifts and Rarities*, 78.

26 Lambton, "Pīshkash," 145, 147.

27 Ahsan, *Social Life under the Abbasids*, 295.

28 Ibid., 294–95.

29 Ibid., 296.

30 Ibid., 295.

31 Qaddumi, trans., *Book of Gifts and Rarities*, 61, 109; Cutler, "Significant Gifts," 81, 83–84, 87, 88.

32 Lambton, "Pīshkash," 145–46.

33 Ahsan, *Social Life under the Abbasids*, 283.

34 Qaddumi, trans., *Book of Gifts and Rarities*, 78–79.

35 Ibid., 62–63, 121, 123.

36 Ahsan, *Social Life under the Abbasids*, 293–94; Qaddumi, trans., *Book of Gifts and Rarities*, 80, 126–27.

37 Ahsan, *Social Life under the Abbasids*, 292.

38 Qaddumi, trans., *Book of Gifts and Rarities*, 79–90.

39 Ibid., 137–38, 140.

40 Ibid., 143–44.

41 Ahsan, *Social Life under the Abbasids*, 293; Qaddumi, trans., *Book of Gifts and Rarities*, 144.

42 Ahsan, *Social Life under the Abbasids*, 296; Qaddumi, trans., *Book of Gifts and Rarities*, 141.

43 Lambton, "Pīshkash," 149.

44 Qaddumi, trans., *Book of Gifts and Rarities*, 66.

45 Ibid., 79–80.

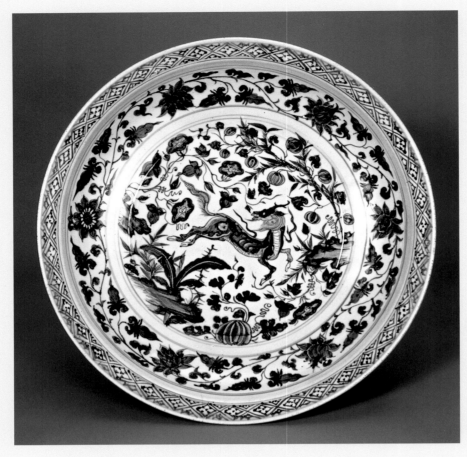

Left: Fig. 40 (cat. no. 30). *Large Dish*, inscribed with the name of Shah Jahan (r. 1628–57) and dated AH 1064/1653–54, China, Yuan dynasty, c. 1350–1400. Asia Society, New York: Mr. and Mrs. John D. Rockefeller 3rd Collection (1979.151).

Opposite: Fig. 41 (cat. no. 230). *Horse and Groom*, India, Bijapur, c. 1590. Victoria and Albert Museum, London (IS.88-1965).

Ta'rikh-i Bayhaqi Excerpt

This text, written in the eleventh century by the famous Persian historian Bayhaqi, refers to a large gift sent by the governor of Khurasan, 'Ali b. 'Isa, to the caliph Harun al-Rashid (r. 786–809) in Baghdad.

"The gifts were brought into the field. There were a thousand Turkish slaves, each carrying two multicolored robes of various brocades and other stuffs. The slaves stood with these robes. After them came a thousand Turkish maids, each carrying a golden or silver bowl full of musk, camphor, ambergris, and other perfumes and delicacies from various places. There were a hundred Indian slaves and a hundred extremely beautiful Indian maids wearing expensive muslin. The slaves had Indian blades of the finest sort, and the maids had gossamer muslins in baskets finer than linen. With them they brought five male and two female elephants, the males with gold- and silver-brocade trappings and the females with golden howdahs with straps and trappings studded with rubies and turquoise. There were horses from Gilan, two hundred horses from Khurasan with brocade saddlecloths. They also brought twenty eagles, twenty hawks, and a thousand camels, two hundred outfitted with silk brocade saddlecloths and halters and loaded with highly ornamented saddlecloths and sacks, and three hundred camels with howdahs worked with gold. There were five hundred thousand three hundred pieces of crystal of every type, one hundred pairs of oxen, twenty necklaces of very valuable pearls, three hundred thousand pearls, and two hundred pieces of Chinese porcelain—plates, bowls, etc.—each of which was finer than anything that had ever been seen in any ruler's possession. There were another three hundred pieces of porcelain, chargers and large bowls, large and small Chinese wine vats, and other sorts. There were three hundred canopies, two hundred carpets, and two hundred *mahfūrīs*. When these items of bounty arrived at the caliphal assembly in the field, a cry of *Allāhu akbar* arose from the soldiers, and they sounded the drums and horns such that no one remembered ever hearing or reading of such a thing. Harun al-Rashid turned to Yahya Barmaki and said, "Where were all these things during the time of your son Fadl?"

"Long live the Commander of the Faithful!" replied Yahya. "During the time of my son's ascendancy these things were in the houses of their owners in the cities of Iraq and Khurasan."

Harun al-Rashid was so taken aback by this answer that the gifts soured for him. He frowned, stood up, and left the meadow. All the items were removed from the assembly and field."

Translated by Wheeler Thackston from *Ta'rikh-i Bayhaqi*, ed. Manuchihr Danishpazhu, 631–32.

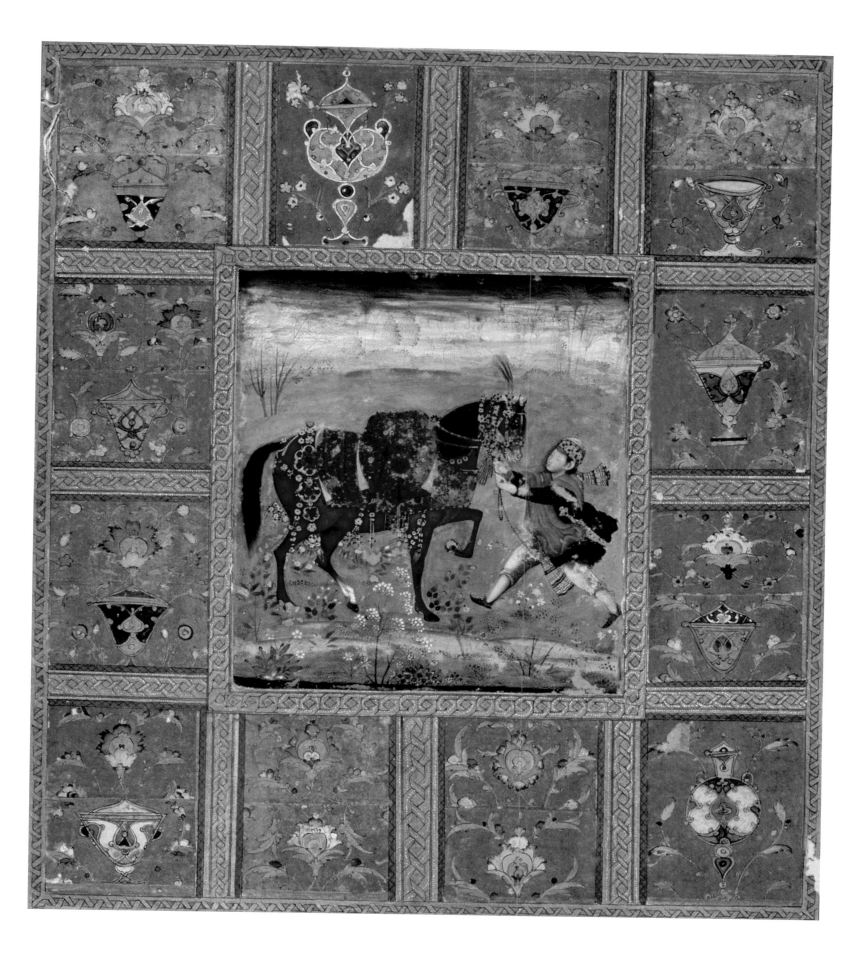

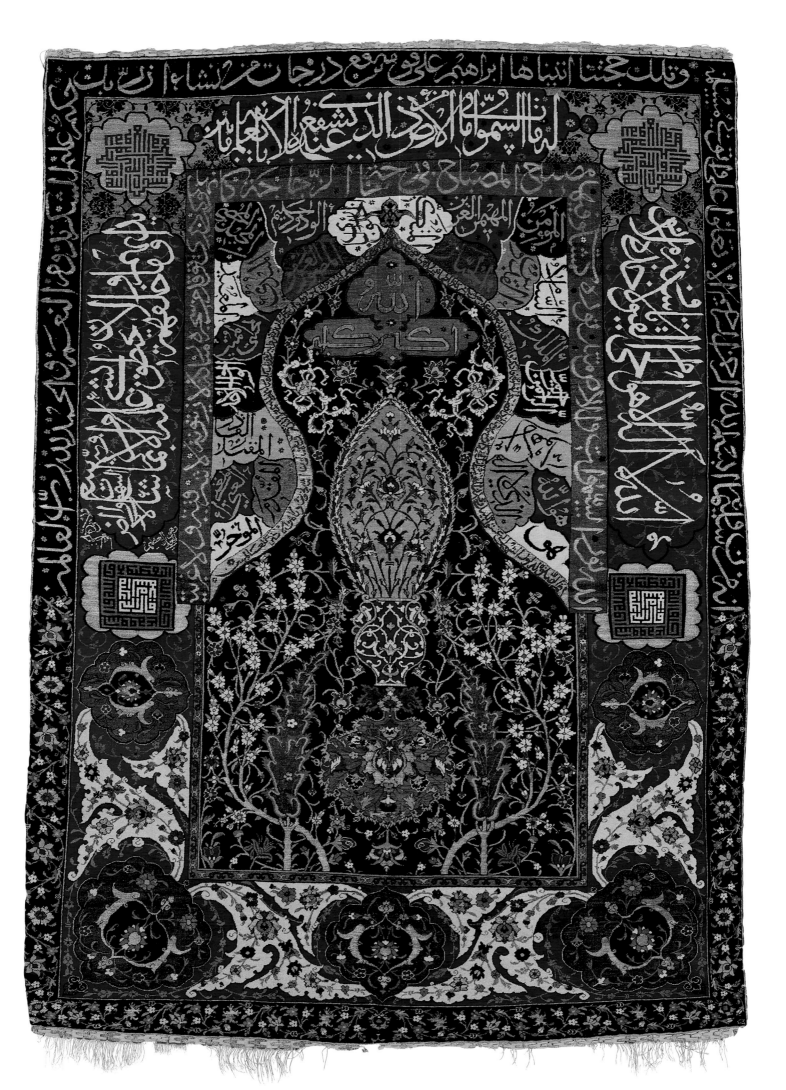

On Giving to Shrines: "Generosity Is a Quality of the People of Paradise"

SHEILA BLAIR

Opposite: Fig. 42 (cat. no. 157). *Prayer Carpet*, Iran, 16th century. Topkapi Saray Museum, Istanbul (13/2040).

Fig. 43 (cat. no. 1). *Bowl with Inscription*, eastern Iran, 10th century. The David Collection, Copenhagen (22/1974).

God is, as the Qur'an says (44:49), the Generous One (*al-karim*),[1] and by the eighth century, scholars of religious sciences interpreted the term "generosity" (*karama*) to mean the favor bestowed by God freely and in superabundance. More precisely, it denoted the "marvels" (*karamat*) wrought by "God's friends" (*awliya*'; singular, *wali*; literally, "those who are near [to God]") that God grants to them to bring about, such as miraculous happenings in the corporeal world, predictions of the future, interpretations of the heart's secrets, and the like.[2] These "friends of God" comprise a range of people, from Prophets including Muhammad, his descendants and

relatives, and other heroes from early Islamic history such as Abu Ayyub al-Ansari or Qutham ibn 'Abbas to Sufis or mystics.[3] Sites associated with their lives, especially their deaths, often became shrines,[4] where pilgrims sought the "friend's" blessing (*baraka*) or his intercession (*shafa'a*) with God on their behalf.[5] Some shrines also provided sanctuary or asylum (Persian *bast*), as they were considered inviolable.[6]

By medieval times shrines had become so widespread in the Muslim lands[7] that the Moroccan globetrotter Ibn Battuta could travel for nearly thirty years (1325–54), across some seventy-three

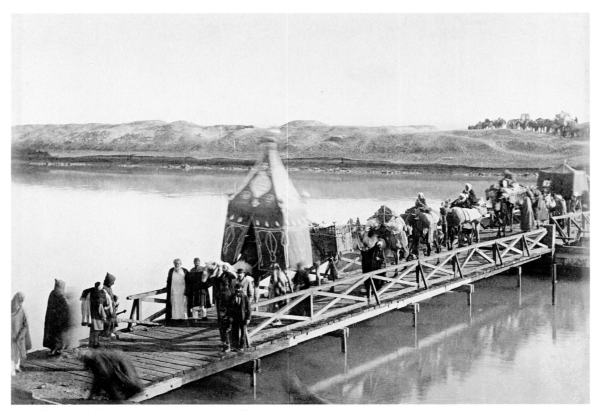

Fig. 44 (cat. no. 111). *Pilgrims on Route to Mecca*, unidentified photographer, late 19th century. Getty Research Institute, Los Angeles (2008.R.3.4068).

thousand miles (the equivalent of some forty-four modern countries), lodging at them regularly; his long travelogue (*rihla*) gives a good idea of how rich their accoutrements were. One of the most elaborate shrines that Ibn Battuta described was the one at Najaf for the Prophet's son-in-law 'Ali ibn Abi Talib, a person revered by Shi'ites, who believe that legitimacy passes through the Prophet's family. As an orthodox Sunni of the Maliki school, Ibn Battuta had no truck with such beliefs, regularly labeling Shi'ites as *rafidis*, or "turncoats," yet even he felt it necessary to visit the shrine and give a long, sober, and therefore presumably balanced description of its furnishings:

> One enters through the Bab al-Hadra into a vast college, inhabited by students and Sufis belonging to the Shi'a…. From this college one gains access to the gateway of the domed shrine [of Imam 'Ali at Najaf], which is guarded by a number of door-keepers, chamberlains, and eunuchs…. They bid him kiss the threshold, which is

of silver, as also are the doorposts. Having done so, he enters the shrine, which is carpeted with various sorts of carpets of silk and other materials and contains candelabra of gold and silver, large and small. In the center [beneath] the dome is a square platform, faced with wood, upon which are carved golden plaques of excellent workmanship, hammered on with silver nails, which have so completely masked the wood that none of it is visible…. On top of it are three tombs, of which they assert the one is the tomb of Adam (upon him be blessing and peace), the second the tomb of Noah (upon him be blessing and peace), and the third the tomb of 'Ali (God be pleased with him). Between the tombs are dishes of gold and silver, containing rose water, musk and various kinds of perfumes. The visitor dips his hand in this and anoints his face with it for a blessing.[8]

Fig. 45 (cat. no. 82). *Frieze Tiles*, inscribed with the name and titles of Abu Sa'id, Iran, c. 1455. Victoria and Albert Museum, London (C.26 and A-1983).

Ibn Battuta's travelogue attests further that rich fittings were common to all shrines, including those for minor figures or relatives. In Shiraz, according to the North African traveler, even shaykhs' sons or wives had tombs in their houses that were decorated with reed mats and carpets, a great number of candles at the deceased's head and feet, and a door with an iron grille onto the street. Household members cared for the tomb, covering it with carpets and lighting lamps over it so that the deceased person was, in the traveler's words, still present.[9]

This essay addresses the kinds of objects donated to these shrines, especially the most important ones, and how these gifts were made and decorated in order to determine who donated them and why.[10] As Ibn Battuta showed, shrines often had the fanciest furnishings available, beginning with their doors, which were often made of carved wood decorated with precious metals, including sheets of silver or gold.[11] Ornate doors were particularly appropriate as they were physically the first thing the visitor saw, metaphorically the point of entry

into the "friend's" spiritual authority (*wilaya*),[12] and linguistically a pun on the concept of shrines as gateways (*dargah*, *bab*) or thresholds (*'atabat*; *astan[a]*).[13]

As the focus of devotion within the tomb, the cenotaph—the box used to mark the spot where the body was interred beneath the ground—was also elaborately decorated, whether carved of wood, as with the one for the shrine of Taj al-Mulk (fig. 47)[14] or revetted with luster tiles, as with the cover for the Suhrawardi shaykh 'Abd al-Samad, buried at Natanz (fig. 46). Luster covers were often part of programs of tiled interiors that included wall and frieze tiles, as in the pair that decorated the walls of an unidentified shrine commissioned by the Timurid sultan Abu Sa'id in AH 860/1455 (fig. 45).[15]

Textiles were an important furnishing in shrines, like other luxury interiors. Ibn Battuta mentioned silk carpets and textiles, and the shrine of 'Ali at Najaf preserves fine examples of both types dating from the opening decades of the seventeenth century.[16] Carpets were often donated

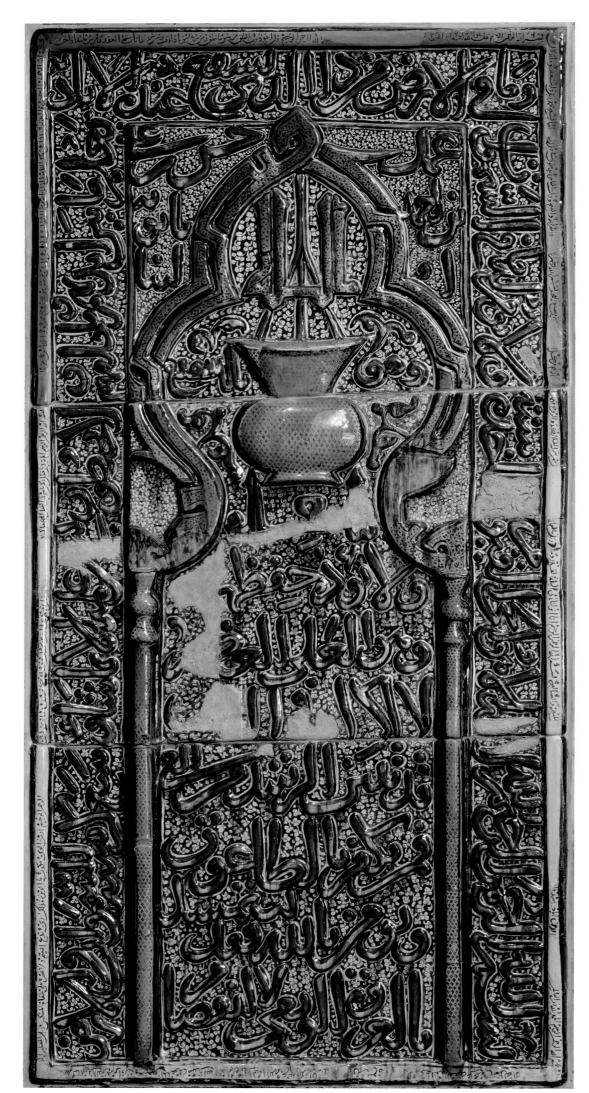

Fig. 46 (cat. no. 81). *Tile Panel*, Hasan ibn 'Ali ibn Ahmad Babavaih and 'Ali ibn Muhammad ibn Fadl Allah, Iran, probably 1310. The Metropolitan Museum of Art, New York, Rogers Fund, 1909 (09.87).

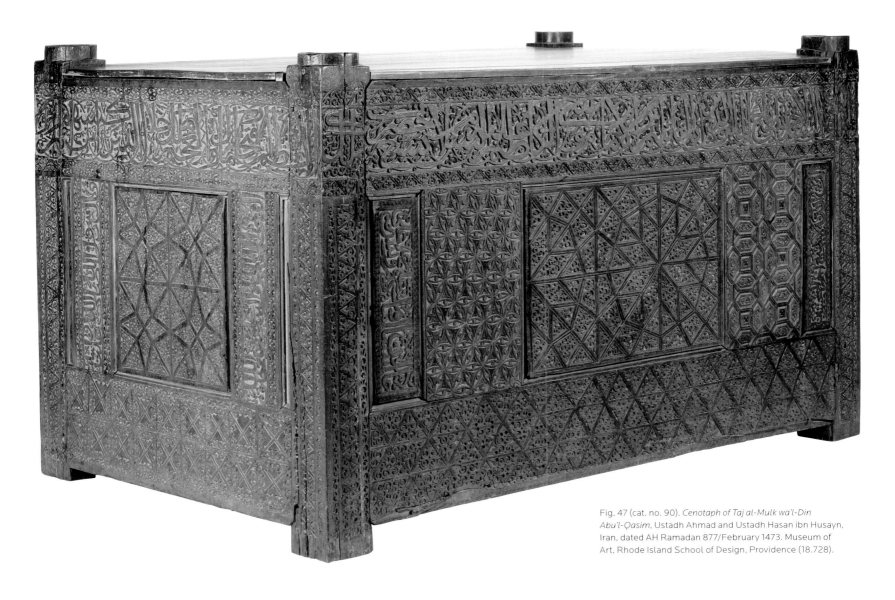

Fig. 47 (cat. no. 90). *Cenotaph of Taj al-Mulk wa'l-Din Abu'l-Qasim*, Ustadh Ahmad and Ustadh Hasan ibn Husayn, Iran, dated AH Ramadan 877/February 1473. Museum of Art, Rhode Island School of Design, Providence (18.728).

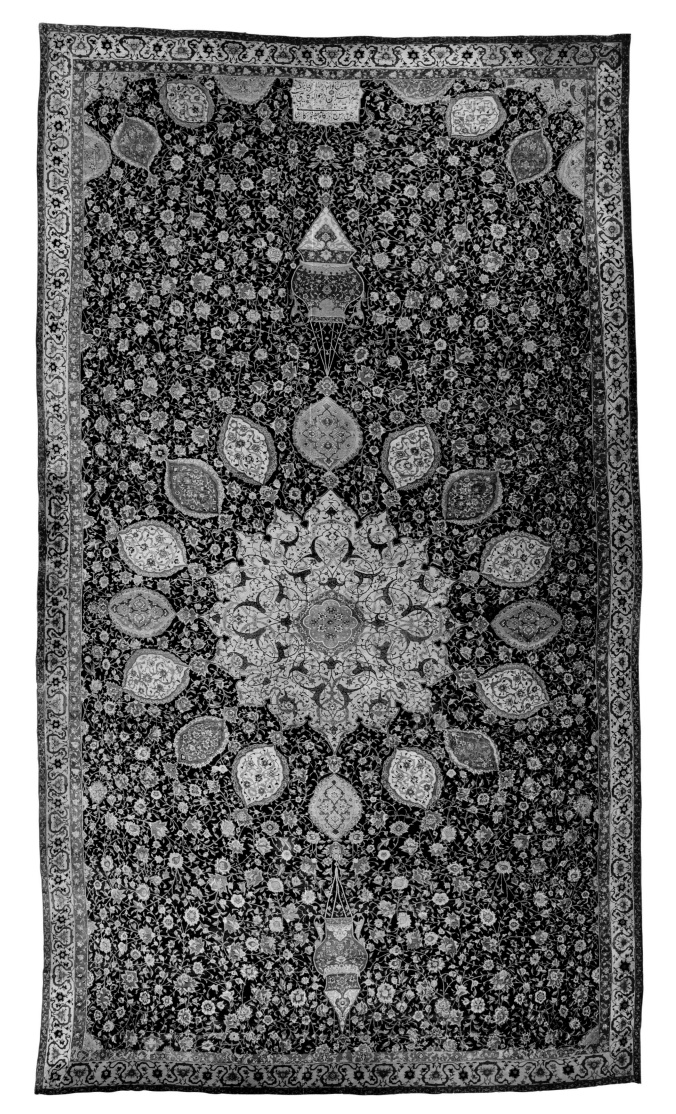

in matched pairs, as in the set given to the shrine of the Sufi shakyh Safi al-Din at Ardabil (fig. 48 and its mate in the Victoria and Albert Museum, London) or the magnificent ones in Najaf that have a border along only one side and were meant to be laid side-by-side together.[17] Prayer rugs, with an arched niche in the shape of a mihrab (figs. 42, 245), were used to indicate the *qibla*, or direction of prayer, and those for shrines often had multiple mihrabs in the so-called *saff* (literally, "row") design.[18] Shrine walls were also draped with rich hangings, and the cenotaph was typically blanketed with a silk cover.[19]

Along with fittings for walls and floors, lighting implements make up a major category of gifts donated to shrines. Some were stands for either giant candles, as in the one endowed to the tomb of the mystic Bayazid Bastami (fig. 49), or oil reservoirs, as in the one commissioned by the warlord Timur as a gift to the shrine of the Sufi shaykh Ahmad Yasavi (fig. 52). Others were hanging

lamps, of metal (e.g., fig. 51 for the shrine of Abu Ayyub al-Ansari), ceramic (commissioned by Süleyman the Magnificent for the Dome of the Rock, fig. 50), or glass (figs. 53–54).

In addition to lamps, another type of implement given to shrines comprises vessels for food and drink. The largest are metal basins, as in the gigantic one that Timur endowed to the shrine of Ahmad Yasavi in 801/1399 (fig. 55).[20] Smaller examples were made of stone, as in the trough (Persian *sangab*) endowed to the shrine for the eighth Imam 'Ali Riza at Mashhad by the Khwarazmshah 'Ala' al-Din Muhammad ibn Tekish (r. 1200–1220) and his vizier Nizam al-Mulk in AH Sha'ban 597/ May 1201.[21] Other implements included large trays, dishes, and vessels to serve groups in communal settings.

A painting from the Great Mongol *Shahnama* (Book of Kings) made in northwest Iran circa 1335 (fig. 56) shows the elaborate furnishings typical of shrines.[22] The scene depicts the mourning for

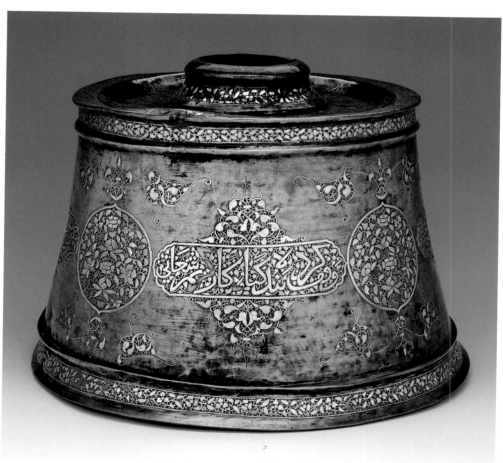

Opposite: Fig. 48 (cat. no. 107). *Ardabil Carpet*, Maqsud Kashani, Iran, possibly Tabriz, AH 946/ 1539–40. Los Angeles County Museum of Art, gift of J. Paul Getty (53.50.2).

Left: Fig. 49 (cat. no. 80). *Candlestick*, Iran, dated AH 708/1308. Museum of Fine Arts, Boston, gift of Mrs. Edward Jackson Holmes (55.106).

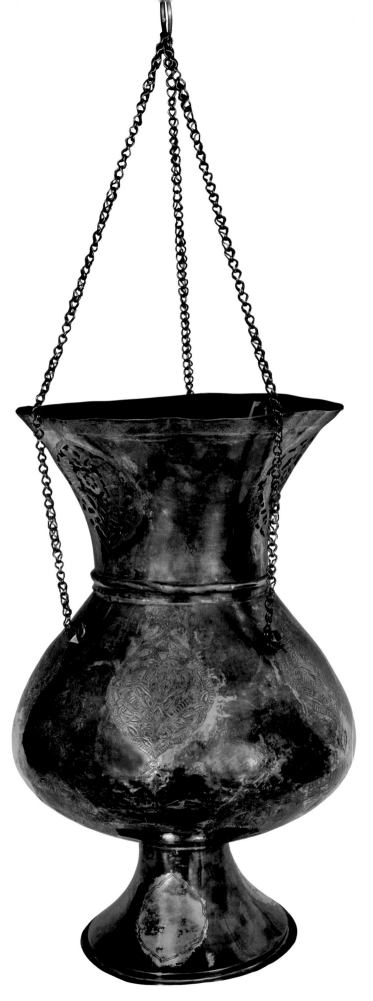

Top: Fig. 50 (cat. no. 89). *Spherical Hanging Component of a Mosque Lamp*, Turkey, Iznik, c. 1549. Benaki Museum, Athens (9).

Left: Fig. 51 (cat. no. 87). *Ottoman Lamp*, Turkey, dated AH 1027/ 1618. Museum of Turkish and Islamic Art, Istanbul, in trust from the shrine of Eyüp (293).

Opposite: Fig. 52 (cat. no. 83). *Oil Lamp*, Central Asia, c. 1401–5. The State Hermitage Museum, St. Petersburg (SA-15931).

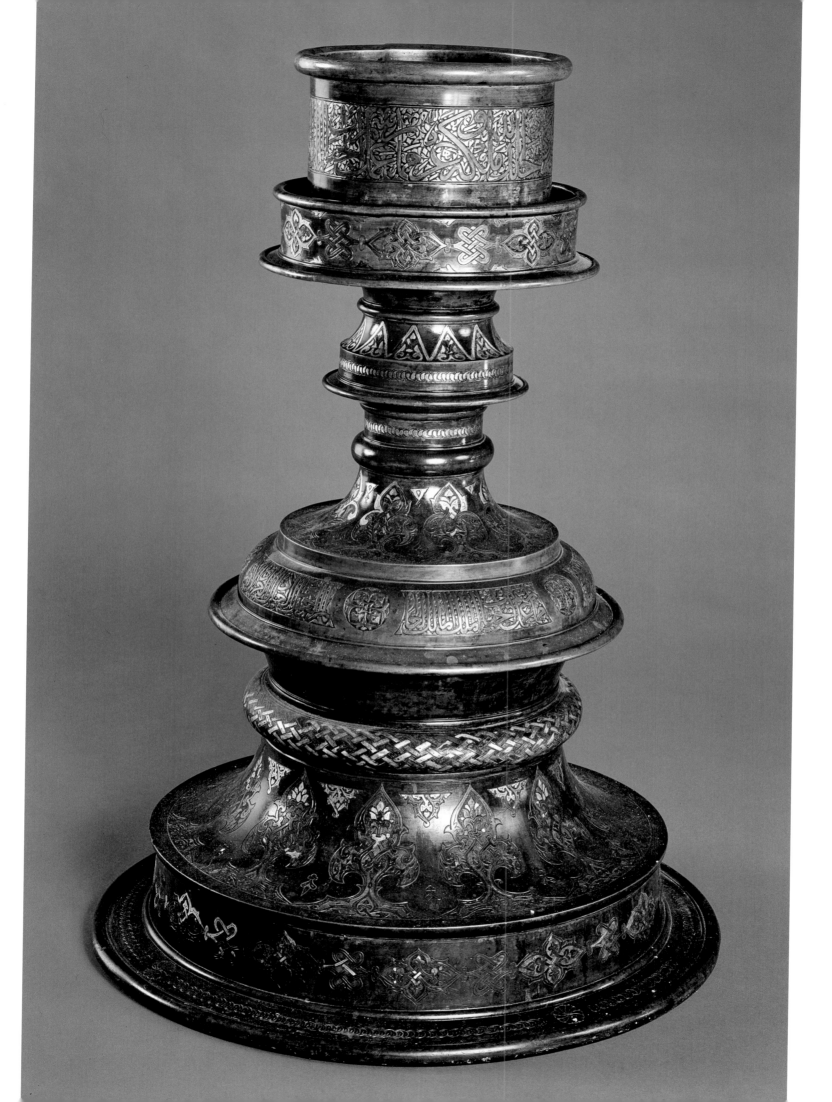

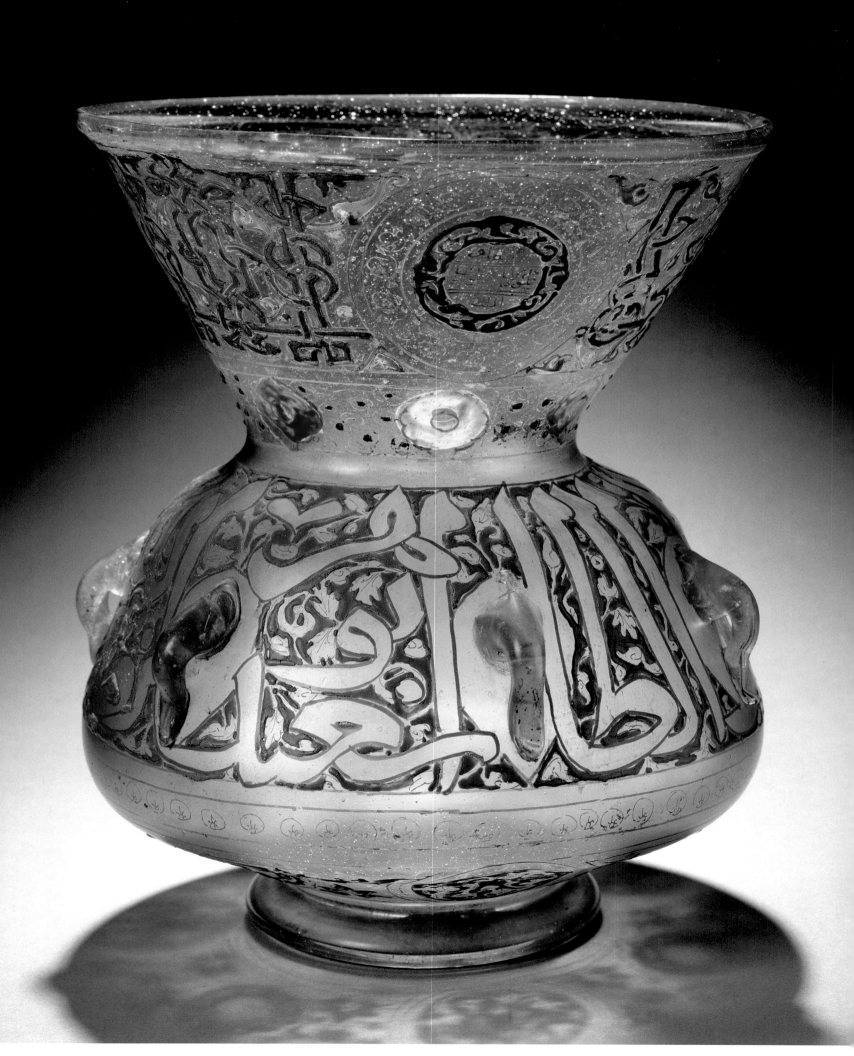

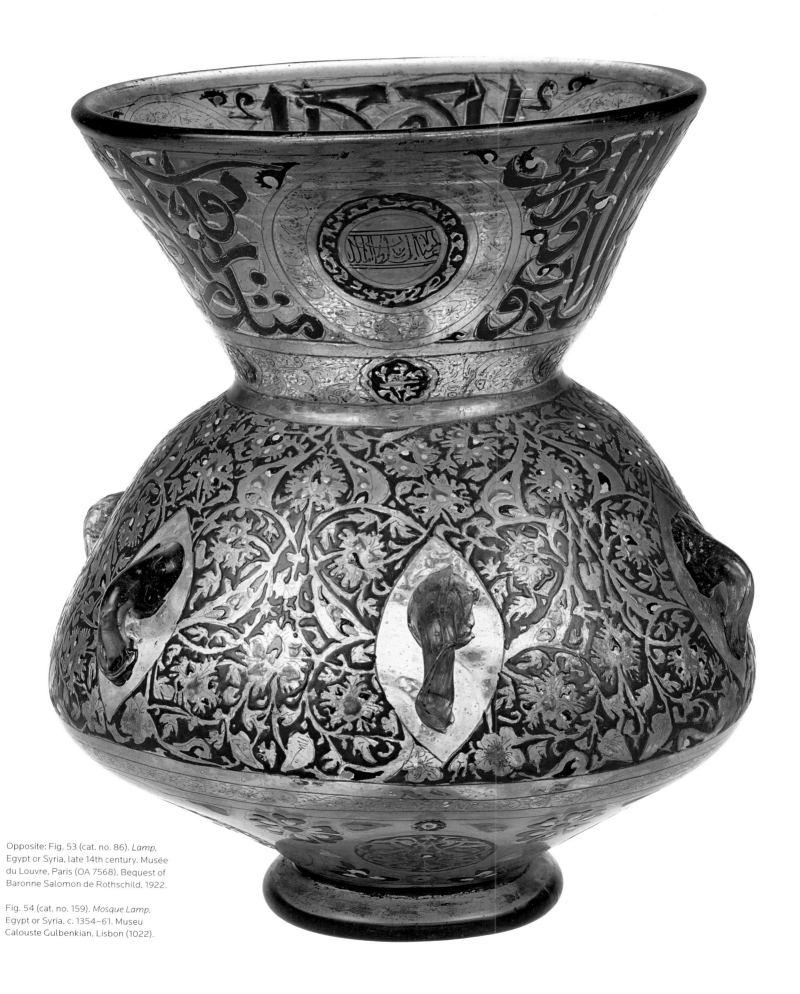

Opposite: Fig. 53 (cat. no. 86). *Lamp*, Egypt or Syria, late 14th century. Musée du Louvre, Paris (OA 7568), Bequest of Baronne Salomon de Rothschild, 1922.

Fig. 54 (cat. no. 159). *Mosque Lamp*, Egypt or Syria, c. 1354–61. Museu Calouste Gulbenkian, Lisbon (1022).

Alexander, with his mother and his tutor Aristotle in the center weeping over the coffin. Probably made of wood inlaid with precious stones, it is set on a large rectangular cenotaph of wood decorated with plaques showing lotus flowers. The cenotaph in turn rests on a large carpet with a knotted design in the field surrounded by various geometric borders, including an outer one with stylized kufic script. Four large candlesticks set on circular mats frame the four corners of the cenotaph, and three lamps hang overhead. The rear wall is decorated with a dado of green tiles surmounted by a painted frieze of blue palmettes. Even the fancy textiles mentioned by Ibn Battuta are shown: the coffin is draped with a silk brocade with an arabesque or geometric design, the kind of silk textile produced in the Mongol period (fig. 109), and curtains with brocaded bands in gold and red frame the scene.[23] Large vases with handles are set to the right and behind the cenotaph; these may well have been vessels for water or even wine. Such large metal vases are also seen in illustrations to a copy of Rashid al-Din's universal history Jami' al-tavarikh, completed in AH 714/1314–15, probably at Tabriz.[24] In fifteenth-century copies of a similar history showing the same scene,[25] the metalwares have been transposed into blue-and-white porcelains, exactly the kind of vessels endowed to the shrine of Shaykh Safi at Ardabil (fig. 57).[26]

Chinese porcelains had long been treasured gifts. The Ghaznavid chronicler Bayhaqi (d. 1077) mentioned them in his list of the gifts the governor of Khurasan sent to the 'Abbasid caliph Harun al-Rashid (r. 786–809) (see Wheeler Thackston's translation on page 48 in this volume). Porcelains were also royal gifts to shrines. The largest bequest was that made by the Safavid shah 'Abbas to the shrine of his eponymous ancestor Shaykh Safi at Ardabil.[27] According to the Safavid court astronomer Jalal al-Din Muhammad Yazdi, the pieces were installed there in the "Porcelain House" (Persian, chini-khana) in AH 1020/1611, some three years after the shah had made the bequest. The original gift amounted to a whopping 1,189 pieces,[28] including at least 58 celadons, 80 white wares, other monochrome and polychrome wares, and, most importantly, 400-odd blue-and-white wares (fig. 235). Shah 'Abbas was not the only ruler to donate Chinese porcelains to Ardabil: so did the Mughal emperor Shah Jahan.[29] And Ardabil was not the only shrine that received porcelains: 'Abbas's great-aunt Mahin Banu, better known as Sultanum (1519–62), endowed a blue-and-white dish to the shrine at Mashhad (fig. 58), along with other porcelains and jewelry.[30]

Adam Olearius, ambassador from the Duke of Holstein who visited the shrine at Ardabil in 1637, reported that three hundred or four hundred of the porcelains were displayed in the niches of the "Jannat Saray."[31] This building was also used as a library, an appropriate function as deluxe books constitute another common category of gifts to shrines. Religious texts, especially multivolume sets of the Qur'an, were popular (fig. 4), but others were histories and literary works, often with elaborate illustrations, illumination, and bindings. Shah 'Abbas, for example, endowed many (e.g., figs. 9, 59, 195, 234) to the shrine at Ardabil[32] (see also Olga Vasilyeva's contribution in this volume) and others to the shrine at Mashhad.

We know that most of these items—from furnishings to the vessels and books used in shrines—were donated because they are inscribed with the Arabic word waqf (see Abdallah Kahil's contribution in this volume). Already by the ninth century, mosques received Qur'an manuscripts as pious donations. One of the earliest identified is

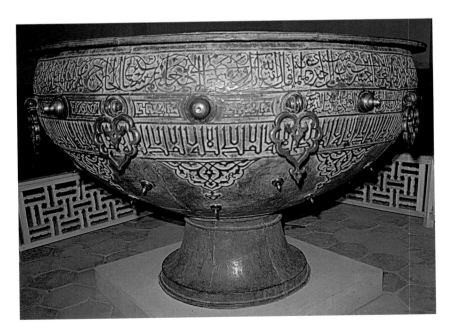

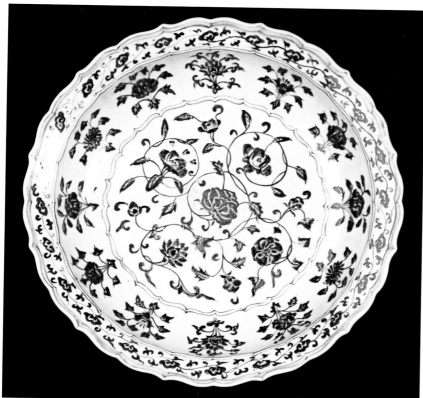

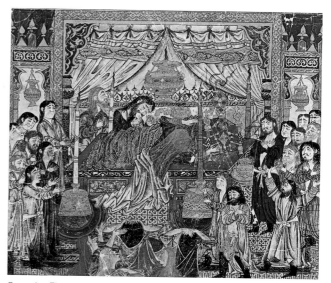

Opposite: Fig. 55. Bronze basin made on the order of Timur for the shrine of Ahmad Yasavi, Kazakhstan, AH 801/1399.

Top right: Fig. 56. *The Bier of Iskandar* (Alexander the Great), folio from a *Shahnama*, Iran, Tabriz, c. 1330–40. Freer Gallery of Art, Smithsonian Institution, Washington, DC: Purchase (F1938.3).

Top left: Fig. 57 (cat. no. 108). *Dish*, China, Jingdezhen, 1403–24. Victoria and Albert Museum, London (1712–1876).

Bottom: Fig. 58 (cat. no. 99). *Large Dish*, inscribed with a dedication to the shrine of Imam Riza, Mashhad (see detail below), China, Xuande era (1426–35). Private collection.

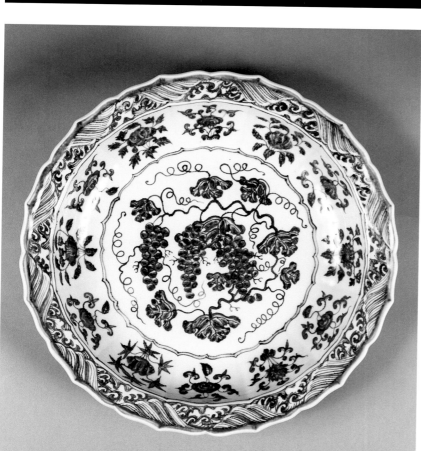

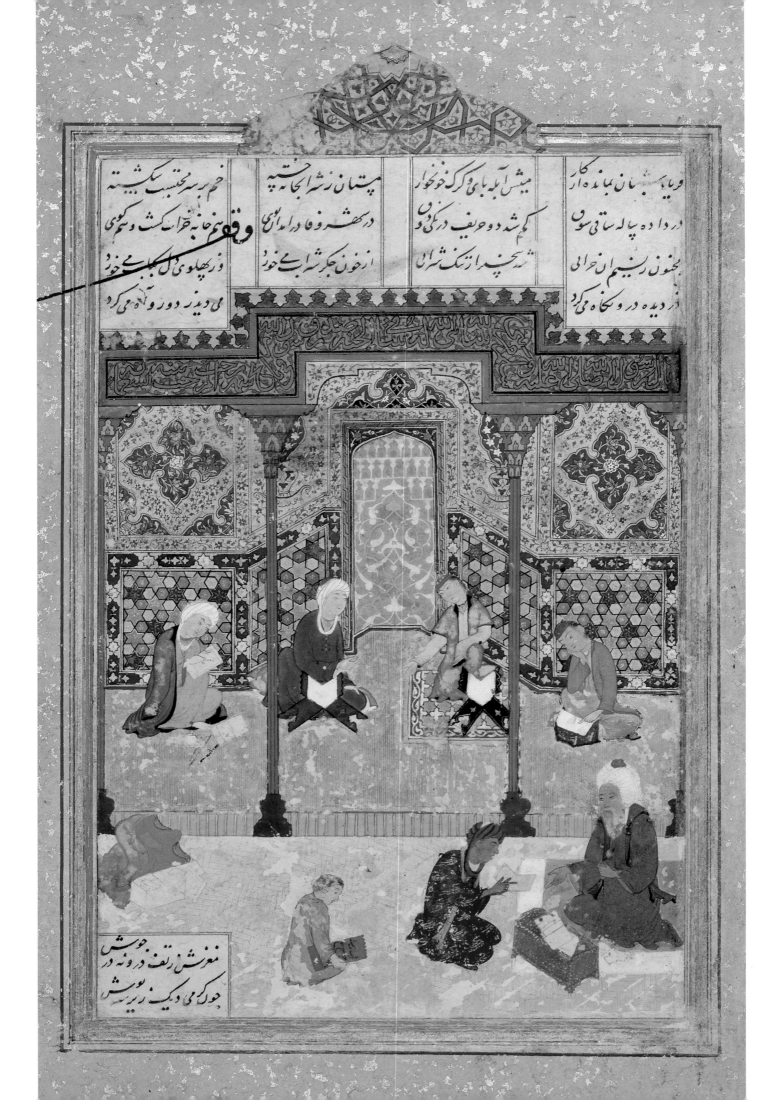

Opposite: Fig. 59 (cat. no. 103). *Layla and Majnun of Amir Khusraw Dihlavi*, manuscript from the Ardabil Shrine, Iran, late 15th century. The National Library of Russia, Saint Petersburg (Dorn 395).

Above: Fig. 60 (cat. no. 91). *Section of a Qur'an*, from *al-Hajj* (The Pilgrimage), 22: 76–78, Syria, before AH Dhu'l-Qa'da 298/July 911. © Trustees of the Chester Beatty Library, Dublin (Is 1421).

the thirty-volume set endowed to the Great Mosque of Damascus in Dhu'l-Qa'da 298/July 911 (fig. 60).[33] It exemplifies the type of multivolume set made for public recitation,[34] and similar sets were soon endowed to shrines. The first recorded donation to the shrine at Mashhad, for example, is a thirty-volume Qur'an manuscript given in AH 363/973–74 by Abu'l-Qasim 'Ali ibn Nasir al-Dawla Abi'l-Hasan Muhammad ibn Ibrahim ibn Simjur, the last known member of the Simjurid line of Turkish commanders and governors in the region.[35] Qur'an manuscripts remain popular gifts to shrines, and the shrine at Mashhad owns hundreds of fine handwritten copies.[36] Such copies were useful for the regular Qur'an recitation. Olearius, for example, describes Qur'an reciters (*huffaz*) at the Ardabil shrine, a dozen ranged on each side of the hall now known as the "Dar al-Huffaz."

One had to be rich to make an endowment, and most of the patrons who endowed luxury objects to shrines were members of the court, whether the ruler himself (e.g., the Khwarazmshah Muhammad ibn Tekesh, the Timurid Abu Sa'id, the Safavid Shah 'Abbas, or the Mughal emperor Shah Jahan), members of the royal family ('Abbas's great-aunt Mahin Banu or his nephew Bahram Mirza), courtiers (the amirs who bestowed the candlestick to Bastam [fig. 49] or the cenotaph tiles to Natanz [fig. 46] or the unidentified "slave"

[*ghulam*] Shirzad, who endowed the silk textile to the sacred shrine [*astana-yi muqaddasa*] [fig. 232]), or governors (the Simjurid who endowed the first Qur'an manuscript to Mashhad).[37]

Many of the objects wealthy patrons bestowed to shrines were commissioned specifically as a pious donation. We can deduce this on several grounds. Some objects have the name of the donor or the person associated with the shrine inscribed prominently within the decoration. For example, on the candlestick endowed to the shrine at Bastam (fig. 49), the endowment text fills the cartouches, and on the *saff* prayer carpets at Najaf, the endowment inscriptions referring to the donor as the "dog of the shrine 'Abbas" are knotted into the pile.[38] The main inscription in the large double-cloth hanging dated AH 1129/1716–17 in the shrine at Najaf contains a poem about 'Ali and his heroic deed at the Battle of the Trench (*khandaq*) in AH 5/627.[39]

Other objects, particularly carpets, were made to fit specific spaces in a particular shrine. The pair woven for the shrine of Shaykh Safi at Ardabil (fig. 48 and its mate in the Victoria and Albert Museum, London), for example, fit precisely inside the large domed building known as the Jannat Saray, and the pair made for the shrine of the Sufi shaykh Nur al-Din Ni'matallah (d. AH 834/1341) at Mahan were made to enclose the cenotaph within the tomb chamber.[40]

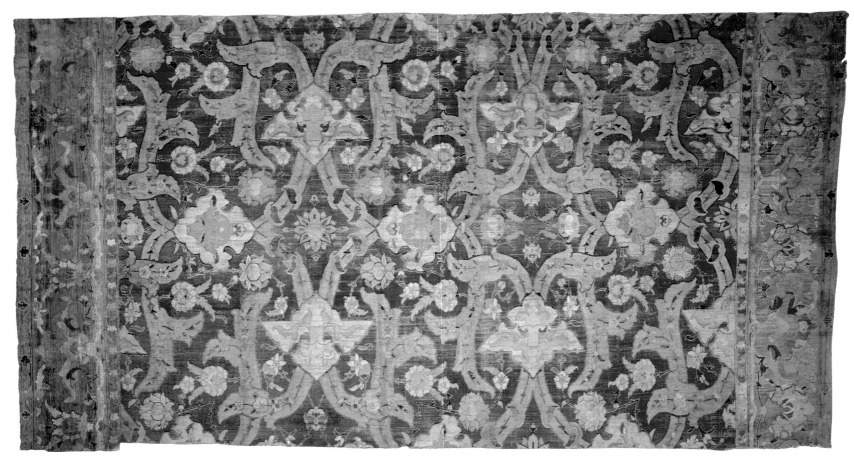

Fig. 61 (cat. no. 101). *Carpet Fragment*, Iran, c. 1600–1625. Victoria and Albert Museum, London (T36-1954).

Yet other objects made for shrines form a distinct stylistic group that sets them apart from contemporary wares. The exquisite gold-and-silk carpets that Shah ʿAbbas endowed to ʿAli's shrine at Najaf share a distinctive color and design with large gold arabesques on a crimson ground and must have been a specific commission that included a similar fragment (fig. 61). The group differs from the typical "Polonaise" carpets with designs of fleshy palmettes knotted in a softer palette of green, blue, yellow, and pink that were often gifted to royalty (fig. 119).[41]

Some objects endowed to shrines, however, were older, and the *waqf* inscriptions had to be added to an already decorated object. The candlestick donated to the mosque of the Prophet (fig. 62), which was made in AH 717/1317–18 for the Ortuqid ruler Shams al-Din Salih but bequeathed only half

a century later by the governor of Baghdad, Mirza Agha, has the *waqf* inscription scratched on the neck. Many of the blue-and-white porcelains that Shah ʿAbbas endowed to the shrine at Ardabil date from the fourteenth or fifteenth century, and some had been owned previously by Qarachaghay and Behbud, officials at his court.[42] According to Jalal al-Din Yazdi, to mark ʿAbbas's donation, a certain Mawlana Muhammad Husayn Haqqaq of Khurasan drilled the endowment text on each piece.[43] Most of the manuscripts ʿAbbas endowed to the two shrines were also older: the illustrated copy of Amir Khusraw Dihlavi's *Layla and Majnun* (fig. 59), for example, was made in the late fifteenth century. Some of the Qurʾan manuscripts ʿAbbas endowed to the shrine at Mashhad were written in kufic script on parchment, a style of manuscript that had gone out of fashion some six centuries earlier.[44] Other luxury

books endowed to the shrine were even imported, as in the Mamluk Qur'an manuscript given to the shrine at Ardabil by Tahmasp's brother Bahram Mirza in AH 946/1539–40.[45]

Why did rich, courtly patrons endow these objects, both new and pre-owned, to shrines? Contemporary sources do not give much information about motivation, but looking at the objects themselves can help us answer this question. Many of the objects are remarkable for their expensive materials. Lamps of silver and gold seem to be the preferred type, and failing that, brass or bronze inlaid with silver and/or gold. Many of the repairs to the shrines were also done in gold. Tahmasp seems to have set the precedent in ordering a gold dome for the shrine of Imam Riza at Mashhad in the 1530s, and gold domes or minarets soon became fashionable for Shi'ite shrines in Iraq and Iran.[46]

Many of the objects given to shrines are also the biggest of their type. Timur's basin at the Yasavi shrine (fig. 55), cast in as many as fifteen separate sections and standing over a meter and a half tall, weighs more than two tons and required the construction of a special railway in 1935 when it was removed from the shrine and taken to St. Petersburg as part of the celebrations of the Third International Congress and Exhibition of Iranian Art and Archeology.[47] The candlestick for Bastam (fig. 49) is said to be the largest of its type from Islamic Iran.

'Abbas's Chinese porcelains too are notable for their large size, expensive materials, fineness, and durability. Many of the dishes measure almost half a meter in diameter, and one now in Tehran is by far the largest Yuan dish known to date, decorated with an unusually wide range of motifs, and one of the few, if not the only, dish inscribed with a brush in Arabic script before firing.[48] Furthermore, it, like many of the Yuan blue-and-white porcelains given to the shrine, is painted in reserve, a technique that requires a lavish use of a cobalt rich in iron oxide, an expensive pigment that was imported from Iran to the kilns at Jingdezhen in southeast China. Other blue-and-white vessels given to the shrine are equally large: they include *meiping* jars some forty centimeters tall and *guan* wine jars fifty centimeters tall.[49] Olearius speculated that some of the blue-

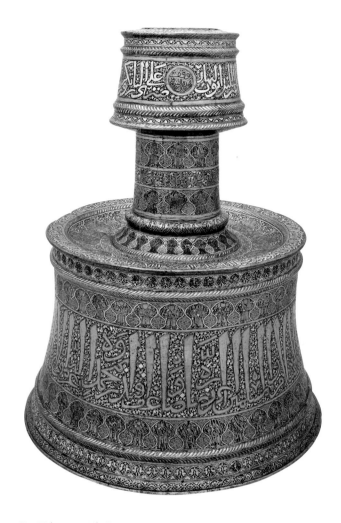

Fig. 62 (cat. no. 119). *Candlestick*, 'Ali b. 'Umar b. Ibrahim al-Sunquri al-Mawsili, probably Syria, AH 717/1317–18. Benaki Museum, Athens (13038).

and-white porcelain vessels he saw might contain forty quarts of liquor. John Pope, curator at the Freer Gallery of Art, found that a similar wine jar in the museum's collection would actually hold seventy-nine quarts, almost twenty gallons.[50] The large Ming plate (diameter 43 cm) that Mahin Banu endowed to the shrine at Mashhad (fig. 58) was striking enough to pass to the hands of the Mughal emperor Shah Jahan, who had it inscribed on the foot ring with his name, the date in both regnal and hijra years (the sixteenth year of his reign, AH 1053/1644), and the exact weight of 251 *tula* (2.91 kilos).[51]

The carpets endowed to shrines are similarly notable for their size and expensive materials. The matched pair for Ardabil (fig. 48) each measured at least 10.51 x 5.35 meters. The two for the shrine for

'Ali at Najaf, whose rich fittings so impressed Ibn Battuta, were similar, measuring 14.03 x 9.56 when viewed as a pair, and they and the smaller fragment with the same design (fig. 61) were woven of silk and gold.[52]

The books given to shrines too were often the finest of their type, with exquisite paintings, illumination, and binding, often with a lavish application of gold. The Mamluk Qur'an transcribed in gold naskh that was endowed to the shrine at Ardabil in AH 946/1539–40 had a sumptuous gold binding added by Shah Isma'il.[53] The illustrated manuscripts often have gold-sprinkled margins (figs. 9, 59, 195, 234).

These large and sumptuous objects were clearly intended to awe visitors to the shrine. We know this not only from their size and materials but also from the reactions of visitors such as Ibn Battuta. Olearius reported that the porcelain dishes at the Ardabil shrine were specially brought out of the tomb to entertain the king and other great lords who passed that way, as residents were not allowed to use gold or silver due to the holiness of the shrine.[54] The position of the waqf inscriptions was also designed for maximum effect: 'Abbas's endowment on the porcelains, for example, was inscribed above the base or on the side, and the text was rubbed with red pigment, often still visible, to contrast with the white porcelain ground and cobalt blue decoration. The endowment text thus differs from the typical owner's mark, which is usually inscribed under the foot and therefore not visible without handling the object. Similarly, the word waqf is scrawled across the illustrations in many of the manuscripts that 'Abbas endowed to the shrine (fig. 59), and other pages are prominently stamped with the shah's seal.[55] Such parading of the donor's name parallels the shah's public display of piety, as in his pedestrian pilgrimage to Mashhad in 1601.[56] The donor clearly wanted his munificence to be recognized, and 'Abbas's gift fulfilled its intended propagandistic intent, for at least three paintings produced from circa 1615 onward show drinking parties of dervishes using these large blue-and-white porcelain vessels and suggest that the royal gift to the shrine was widely known.[57] Given Olearius's statement that such porcelains were reserved for visiting dignitaries and shunned by pious Sufis, the paintings must have been intended as satiric commentaries, a reading underscored by the few Sufis on the fringe of action who engage in pious activities such as prayer while most of the dervishes indulge in drinking and other frivolity.

Gifts to shrines also display the patrons' piety. They often commemorated pilgrimage, and royal visits were often accompanied by lavish gifts, as was the case with Shah 'Abbas's bequests.[58] Many patrons belonged to mystic orders, and some bequeathed works to the shrines of their Sufi masters. Zayn al-Din Mastari, patron of the Suhrawardi shrine at Natanz, for example, is identified in the foundation inscription as khalifa, or follower.[59] Through such gifts, the donor, like the visitor, partook of the baraka associated with the shrine.

There were other reasons for giving to shrines as well. As Patrick Geary showed when discussing the bequeathing of relics in the medieval West, the exchange of high-prestige gifts confirmed the receiver's dependence on the donor.[60] 'Abbas's munificent gifts to the two shrines at Ardabil and Mashhad marked his authority over the Sufi order and the Shi'ite community. His differing donations to each shrine reflect his different allegiances: in general the manuscripts bequeathed to Ardabil, a Sufi shrine, were literary works in Persian, whereas those to Mashhad, a shrine for a descendant of the Prophet, were copies of the Qur'an and other Arabic texts. The former displayed his allegiance to and leadership of the Sufi order that had brought his family to power; the latter, his legitimacy and descent from the Prophet's family, a lineage underscored by the inscriptions added to some kufic manuscripts of the Qur'an with a spurious attribution to the hand of 'Ali ibn Abi Talib and an attestation of authenticity by the leading cleric of the time, Shaykh Baha'i Amuli.[61] Similarly, we can imagine that the Khwarazmshah 'Ala' al-din Muhammad ibn Tekish's donation of the stone basin to Mashhad was part of his anti-caliphal policy, which culminated in his denouncing the 'Abbasid caliph al-Nasir (r. 1180–1225) as unfit to rule and proclaiming an 'Alid (descendant of 'Ali) as anti-caliph.[62]

The endowment inscriptions on these objects confirm these reasons for giving and also help

explain why these specific types of gifts were chosen. Lighting gear, for example, was particularly appropriate for shrines and religious sites because it evokes God's light (*nur*) in giving guidance and revelation. As the famous Light Verse, *Ayat al-nur* or *Surat al-Nur* (Qur'an, 24:35), says, "God is the Light of the Heavens and the Earth," and this is the text most commonly inscribed on glass lamps. Benedictions for the donor often continue this leitmotif, asking God to sanctify the soul and illuminate the tomb, as on the Bastam candlestick (fig. 49).[63] The luster revetments favored in shrines would also have enhanced this sense of radiance, as did the frequent use of gold.

Water, like light, is often considered one of God's fundamental creations.[64] According to the Qur'an 21:30, God "made every living thing of water." It was a particularly evocative symbol for Shi'ites, who hold Sunnis accursed because the Umayyads had denied water to the Prophet's grandson Husayn at the battle of Karbala in AH 61/680. Shi'ites commemorate Husayn's death on 'Ashura, the tenth day of the month of Muharram, by providing water to the thirsty. Hence, vessels for water rank second to lighting implements as gifts to shrines.

The inscriptions on Timur's elephantine basin (fig. 55) play on this idea of the piety inherent in giving water.[65] The large and prominent foundation inscription beneath the rim repeats the word *siqaya* three times in three different ways. The text opens with a Qur'anic passage (9:19) about providing drink to pilgrims (*siqayat al-hajj*). Next is a hadith that whoever builds a place of drinking (*siqaya*) will receive a pool (*hawd*) in heaven. The endowment portion of the text says that the amir Timur bestowed his basin (*siqaya*) to the shrine of the Sufi shaykh Ahmad Yasavi. The repeated use of the word *siqaya* therefore links the warlord's gift to the Qur'an and hadith.[66]

Water relates to the tradition of hospitality, another central value in Islam. Already embedded in the pre-Islamic culture of the region, it became an integral part of the faith. The encyclopedic work by the renowned Sufi scholar al-Ghazali (d. AH 505/1111), *Ihya' 'ulum al-Din* ("Revival of the religious sciences"), includes many traditions and sayings that provide guidelines for all aspects of this

etiquette, from issuing and accepting invitations to the manner of eating and ending the gathering.[67] These values are epitomized in the inscriptions on Samanid wares. The one in the David Collection in Copenhagen (fig. 43) is inscribed "He who believes in recompense [from God] is generous with gifts." For a person of position in the Iranian lands in Mongol times, entertainment of one's superiors, peers, and followers was a primary obligation, and the ability to gather guests and provide suitable fare a sign of success.[68] Thus, it is no surprise that the double frontispiece to the famous copy of Sa'di's *Bustan* ("Orchard") depicts the ruler and patron Sultan Husayn (r. 1470–1506) lavishly entertaining his court with gold and blue-and-white porcelain dishes, seated in a garden in front of a pavilion whose balcony is decorated with niches containing blue-and-white ceramics like those in the shrine at Ardabil.[69]

Gifts to shrines then were multivalent. They expressed piety and humility before God, but they also showed the donors' munificence. They connected donors to the blessings inherent in shrines, but they also manifested donors' authority over the shrine. They were personal but also political and religious, as the patron's generosity reflected that of God and the miraculous power He granted to His "friends."

Notes

1 It is one of God's ninety-nine attributes; see *Encyclopaedia of the Qur'an*: "God and His Attributes." The adage about generosity in my essay's title is found on numerous ceramics made in eastern Iran and Transoxania in the Samanid period; see Ghouchani, *Inscriptions on Nishapur Pottery*, nos. 3, 27, 68, 101, 126, and 139; Pancaroğlu, "Serving Wisdom."

2 *Encyclopaedia of Islam*, 2nd ed.: "Karāma"; on the concept of gifting in the Qur'an, see *Encyclopaedia of the Qur'an*: "Gift-giving."

3 *Encyclopaedia of Islam*, 2nd ed.: "Wali"; *Encyclopaedia of the Qur'an*: "Saint," which reiterates that the idea of chosen people or "saints" is alien to the Qur'an and that the term *wali/awliya'* was developed only in the eighth century.

4 The words used to designate such shrines vary enormously. Arabic terms include *mashhad* ("place of martyrdom") and *'atabat* ("thresholds," designating the Shi'ite shrine cities of Iraq—Najaf, Karbala, Kazimayn, and Samarra—with the tombs of six of the imams as well as a number of secondary shrines and places of visitation). Persian words include *astan[a]* ("threshold"), *qadamqah* ("place of the footstep"), *imamzada* ("descendant of an Imam," and by synecdoche "a tomb for such a person"), *dargah* (literally, "place of a door," usually "royal court or palace" in Persia, but in India with the additional specialized sense "tomb or shrine of a *pir* or shaykh"), *buq'a* (literally, "low-lying region," but metaphorically "tomb"), *ziyaratgah* ("place of visitation"). Turkish

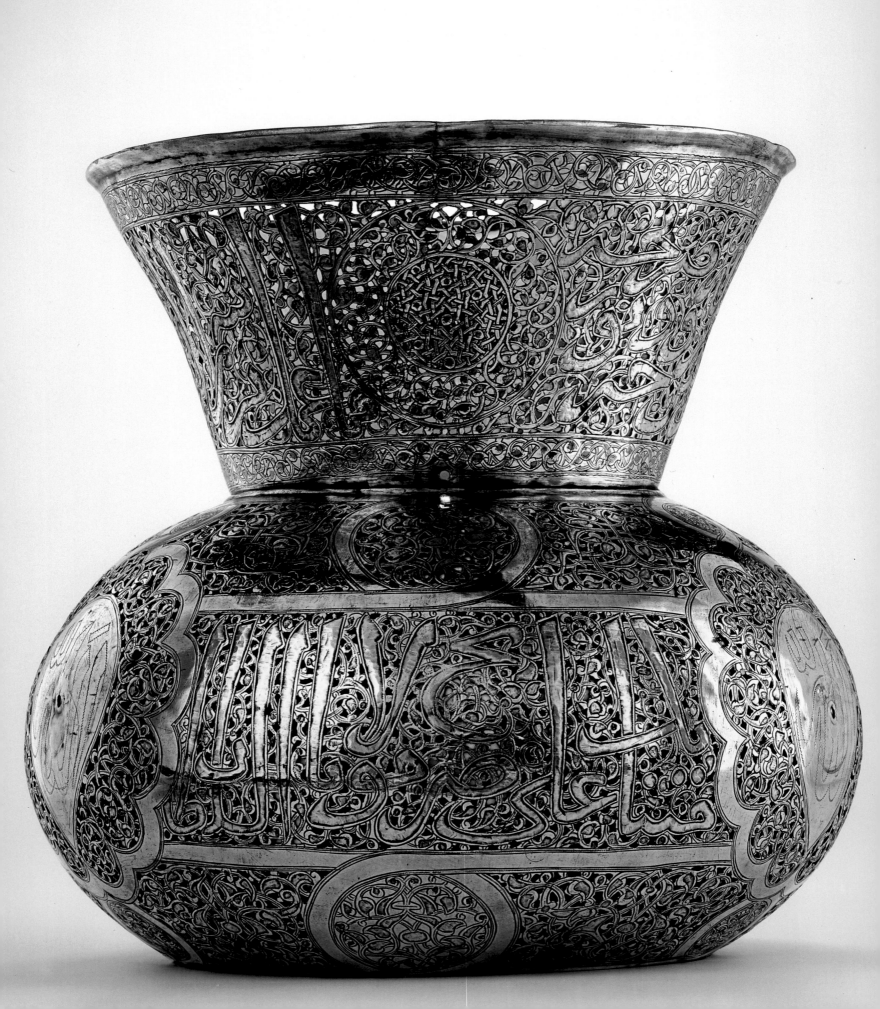

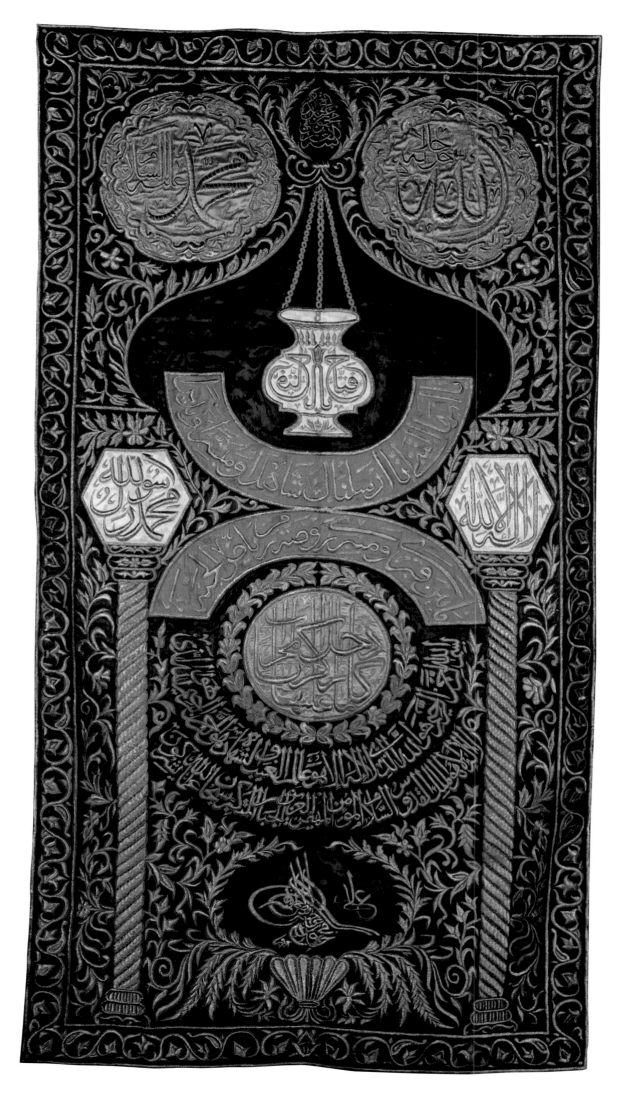

Opposite: Fig. 63 (cat. no. 85).
Lamp, Damascus, Syria, c. 1277.
Museum of Islamic Art, Doha,
MW.117.

Left: Fig. 64 (cat. no. 118). *Sitara
from the Tomb of the Prophet in
Medina*, Egypt, Cairo, 1808–39.
Nasser D. Khalili Collection of
Islamic Art, London (TXT 255).

terms include *baba* used in Anatolia and *ata* in Central Asia (both meaning "father"), as well as *eren* or *ermish* (from *ermek*, "to reach or attain") or *yatır* ("one who settles down") in Anatolia.

5 *Encyclopaedia of Islam*, 2nd ed.: "Baraka."

6 Ibid.: "Bast."

7 Although widespread, such shrines are neither ubiquitous nor universally accepted. Opponents of Sufism such as Ibn Taymiyya (d. AH 728/1328) and the Wahhabis saw these practices as an abomination, a form of idolatry (*shirk*). When expanding their territory, the Wahhabis destroyed these shrines whenever possible.

8 Ibn Battuta, *Travels*, vol. 1, 257.

9 Ibid., vol. 2, 317.

10 This essay concentrates on portable objects, but one might also consider additions or refurbishments to the buildings themselves, as did Canby in her article, "Royal Gifts to Safavid Shrines," on the shrines at Ardabil and Mashhad, and Allan in "Shi'i Shrines of Iraq." I thank James Allan for sharing his article in advance of publication.

11 Allan, "Silver Door Facings." For a color reproduction of the silver door dated AH 1011/1602–3 at Ardabil, see Canby, *Shah 'Abbas*, fig. 53.

12 *Encyclopaedia of Islam*, 2nd ed.: "Wilāya."

13 See above, n4, and *Encyclopaedia of Islam*, 2nd ed.: "'Atabāt"; *Encyclopaedia Iranica*: "Āstāna" and "Āstān-e qods-e rażawī."

14 One of the most elaborate wooden cenotaphs known is that for Shah Isma'il at Ardabil, which is colorfully decorated using many kinds of exotic woods, ivory, brass, silk, and even thread. See the detailed analysis by Hillenbrand, "Sarcophagus of Shah Isma'il." The object is technically not a sarcophagus, which contains a body, but a cenotaph, which is a placeholder for the body that is buried below; see *Encyclopaedia of Islam*, 3rd ed.: "Cenotaph."

15 These two frieze tiles were part of a set that included a pair of arched foundation tiles; see Watson, "Persian Lustre Ware from the 14th to the 19th Centuries," nos. 1–3. The inscription identifies the shrine simply as *'imara* ("building").

16 Aga-Oglu, *Safawid Rugs and Textiles*. The whereabouts of these textiles today is unclear.

17 Ibid., no. I.

18 Ibid., nos. III and IV, which have three and six and a half niches, respectively.

19 Textiles at Najaf (Aga-Oglu, *Safawid Rugs and Textiles*) include a brocaded silk hanging dated AH 1036/1626 showing an ogival lobed arch (no. XVIII) as well as several velvet panels (nos. VII–XI). The large round tomb cover was pieced together of various brocaded fabrics, including several compound twills and double cloths (nos. XII–XVII).

20 Komaroff, *Golden Disk of Heaven*, 238–39.

21 This is the date given in the shrine's guide by Ali Mu'tamadi, *Rahnama*, 21. According to the article on the shrine in the *Encyclopaedia Iranica* ("Āstān-e qods-e rażawī"), the date is AH 599/1203.

22 Grabar and Blair, *Epic Images*, no. 39.

23 Kadoi, "Textiles in the Great Mongol *Shāhnāma*."

24 Notably the scene of Qarun and his tribe swallowed up by the earth. Rice, *Illustrations to the World History of Rashid al-Din*, no. 12.

25 Ettinghausen, "Illuminated Manuscript of Hāfiz-i Abrū," fig. 9.

26 Iranian National Museum 8723; a large vase of *guan* shape with two handles (restored); Canby, *Shah 'Abbas*, no. 61, which mentions other examples including one still in the shrine at Ardabil (no. 29.522); and Pope, *Chinese Porcelains*, pl. 26.

27 Pope, *Chinese Porcelains*. In 1935, the year of the Persian exhibition in St. Petersburg, 805 of the best pieces were taken to the National Museum in Tehran. Some are still on display at the shrine. Others from the National Museum are illustrated in color in Canby, *Shah 'Abbas*, nos. 55–74. On the bequest, see McChesney, "*Waqf* and Public Policy."

28 The numbers vary in the different manuscripts of the *Tarikh-i 'Abbasi*. This is the total used by Misugi, *Chinese Porcelain Collections*, vol. 1, 13, based on British Museum Or. 6263, which he believes is the most accurate.

29 Pope, *Chinese Porcelains*, 56 and 146.

30 Soudavar, "Chinese Dish." The dish is very similar in dimensions and decoration to one that Shah 'Abbas donated to Ardabil (Pope, *Chinese Porcelains*, 29.55, pl. 37; Canby, *Shah 'Abbas*, no. 63).

31 Olearius, *Voyages and Travels*, 178–80, calls it "Tzenetsera" or Jannat Saray, the name used for the octagonal hall at the end of the court; but most scholars (e.g., Pope, *Chinese Porcelains*, 13; Krahl in Thompson and Canby, eds., *Hunt for Paradise*, 258) have assumed that he means the Chini Khana, which preserves wooden niches, although of a different shape than the porcelains they were supposed to have contained.

32 Other manuscripts 'Abbas endowed to Ardabil include deluxe copies of 'Attar's *Mantiq al-Tayr*, transcribed by the master calligrapher Sultan 'Ali Mashhadi for the Timurid sultan Husayn in AH 892/1487 (Metropolitan Museum of Art 63.210; Blair, "Ardabil Carpets in Context," 132–33; Canby, *Shah 'Abbas*, no. 82), and Jami's *Haft Awrang* made for Shah Tahmasp's nephew Ibrahim Mirza between 1556 and 1563 (Freer Gallery of Art no. 46.13; Simpson, *Sultan Ibrahim Mirza's "Haft Awrang"*).

33 It has a note on folio 3b recording that it was given by 'Abd al-Mun'im ibn Ahmad. He has not been identified, but donors of other, similar manuscripts were officials in the Abbasid realm, such as Amajur, governor of Damascus. See Blair, "Transcribing God's Word."

34 On the uses and dating of these early Qur'an manuscripts, see Blair, *Islamic Calligraphy*, chapter 4; n51 mentions the whereabouts of various volumes from this multipart codex.

35 Mashhad shrine ms. no. 3004; Shakiri, *Ganj-i hizar sala*, 29–30 and 60. The Simjurids were governors for the Samanids in Sistan and Khurasan from AH 300/913 to 393/1002; *Encyclopaedia of Islam*, 2nd ed.: "Simdjurids."

36 According to an inventory made in 1977, the library possessed 6,433 manuscripts (whole or part) and 3,100 printed copies of the Qur'an.

37 Common folk too made offerings to shrines, including cloth fragments, locks, and other items tied to the grilles around the cenotaph or hung nearby. These examples of folk art do not usually make it into museum exhibitions, but they did inspire an artistic movement in Iran in the 1960s, the *Saqqakhana*. The term derives from the public drinking fountains traditionally found on street corners. These votive fountains contain many of the same elements given to larger shrines comprising a niche with a water tank and a metal bowl and candlestand, as well as a portrait of one of the Shi'ite Imams. The simple forms, repeated motifs, and bright colors inspired artists like Parviz Tanavoli and Hussein Zenderoudi. See *Grove Encyclopedia of Islamic Art and Architecture*: "Saqqakhana."

38 Aga-Oglu, *Safawid Rugs and Textiles*, nos. III and IV.

39 Ibid., no. XIX.

40 King, "Ardabīl Puzzle Unravelled," first made this identification of the Ardabil carpets; see also Blair, "Ardabil Carpets in Context," 138; Canby, "Royal Gifts to Safavid Shrines," 60.

41 'Abbas gave at least two similar silk tapestries to the shrine at Ardabil that are now in the National Museum, Tehran; see Canby, *Shah 'Abbas*, no. 91.

42 Pope, *Chinese Porcelains*, 50–53.

43 This is the case with all but thirty-one of the porcelains; we do not know why these lack the endowment text. The same text was inscribed on jade cups that 'Abbas donated to the shrine at Ardabil; Canby, *Shah 'Abbas*, no. 75.

44 One is illustrated in Blair, *Islamic Calligraphy*, fig. 1.5.

45 Iranian National Museum 4242. This manuscript exemplifies the difficulty of localizing and dating some of these luxury Qur'an manuscripts. On the final page below the colophon is the ex libris of the Mamluk sultan Qaytbay (r. 1469–95), and the gold binding has another ex libris of the Safavid shah Isma'il (r. 1501–24). The manuscript has been published as both Iranian (Canby, *Shah 'Abbas*, no. 81) and Mamluk (James, *Qur'ans of the Mamluks*, no. 20, with the wrong accession number), but the Mamluk attribution is stronger on the basis of the scribe's name and *nisba* and the style of the script and illumination. James surmised that the manuscript, perhaps made in Syria, was given to Shah Isma'il by Qaytbay's successor, Qansuh, who is said to have given a Qur'an manuscript to the Safavid ruler in AH 917/1511 (James, *Qur'ans of the Mamluks*, note 11, citing the Mamluk chronicler Ibn Iyas).

46 Allan, "Shi'i Shrines of Iraq"; see also Canby, "Royal Gifts to Safavid Shrines."

47 Blair and Bloom, *Art and Architecture of Islam*, 56. The basin was returned to its home in 1989, and UNESCO designated the shrine a World Heritage Site in 2003. Komaroff, *Golden Disk of Heaven*, 21–23, mentions other, smaller metal basins, including one given to the Friday Mosque at Herat in AH 767/1374–75 by a local dervish or *qalandar* and another smaller one (diameter around the rim 67 cm; therefore, circumference 210 cm) given to the shrine at Ardabil by the Jalayirid shaykh Uways (r. 1360–74) and now in the Islamic Museum in Tehran (see also Behrens-Abouseif, "Jalayirid Connection"). The fourteenth-century geographer Hamdullah Mustawfi also mentions a brass vessel in the mosque at Isfarayin that was the largest ever seen and had a circumference of "12 tailors' ells [6 meters?]."

48 Pope, *Chinese Porcelains*, pl. 19; now Iranian National Museum 8713; see Thompson and Canby, eds., *Hunt for Paradise*, no. 11.12, and Canby, *Shah 'Abbas*, no. 58. The one- or two-word inscription on the reserve was probably written by someone who did not know Arabic. Jeremy Johns suggested to me that it reads "Jingdezhen," the name of the site in China where these porcelains were made.

49 Pope, *Chinese Porcelains*, pls. 25–26 and 79; Canby, *Shah 'Abbas*, nos. 60–61.

50 Pope, *Chinese Porcelains*, 13n18; he gave the accession number of the Freer object as 45.35, which now refers to a bowl (F1945.35), but 1945.36 is a large Ming *guan* jar 53.1 cm tall.

51 Soudavar, "Chinese Dish." Shah Jahan did the same with many of his porcelains: see the yellow-glazed dish (fig. 110).

52 Aga-Oglu, *Safawid Rugs and Textiles*; Canby, *Shah 'Abbas*, no. 121.

53 See above, n45.

54 Olearius added that Shaykh Safi was so pious that he ate only off wooden utensils.

55 On the various seals of Shah 'Abbas and their usefulness in dating objects, see Adamova, "On the Attribution of Persian Paintings."

56 Melville, "Shah 'Abbas and the Pilgrimage."

57 Canby, *Shah 'Abbas*, no. 80.

58 Royal visits also occasioned the removal of gifts from shrines. When the Afsharid ruler Nadir Shah (r. 1736–47) visited the shrine at Ardabil, he took an inlaid antivenom cup in order to benefit from its blessed associations (*tayammunan*). This probably refers to the gold-inlaid jade bowl inscribed with Shah 'Abbas's *waqf* now in the Victoria and Albert Museum, London; see Misugi, *Chinese Porcelain Collections*, vol. 1, 26.

59 Blair, *Ilkhanid Shrine Complex*.

60 Geary, "Sacred Commodities."

61 Blair, *Islamic Calligraphy*, fig. 1.5.

62 *Encyclopaedia of Islam*, 2nd ed.: "Khwārazm-shāhs."

63 Melikian-Chirvani, "Lights of Sufi Shrines."

64 *Encyclopaedia of the Qur'an*: "Water." On its associations in Islamic art, see the various essays in Blair and Bloom, eds., *Rivers of Paradise*.

65 See the perceptive remarks in Komaroff, *Golden Disk of Heaven*, 20–22.

66 Similarly on the Kart basin (*mirjal*) in Herat, the inscription refers to God providing a cup of spring water; Komaroff, *Golden Disk of Heaven*, 36nn67–68.

67 *Encyclopaedia of the Qur'an*: "Hospitality and Courtesy."

68 Manz, *Power, Politics and Religion*, 196.

69 Cairo, National Library, Adab Farsi 908; Lentz and Lowry, *Timur and the Princely Vision*, no. 146. The left half of the frontispiece is illustrated in Canby, *Shah 'Abbas*, fig. 39.

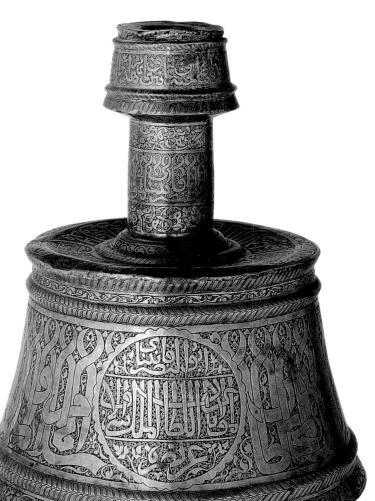

Top: Fig. 65 (cat. no. 116). *Key from the Ka'ba*, Husayn, Egypt, dated AH 815/1412. Musée du Louvre, Paris, gift of J. Peytel, 1914 (OA 6738).

Left: Fig. 66 (cat. no. 120). *Candlestick*, Egypt, AH 887/1482–3. Benaki Museum, Athens (13040).

Opposite: Fig. 67 (cat. no. 117). *Key from the Ka'ba*, probably Mecca, c. 1340. Museum of Islamic Art, Doha (MW.473).

Waqf Documents and Architectural Fittings and Furnishings

Abdallah Kahil

In Islamic law *waqf* (endowment) designates an income or the yielding of properties to benefit a person or an institution. In the Mamluk period (1250–1517) in Egypt the establishment of such charitable trusts was popular among the high officials who constructed religious institutions and designated the revenues of some or all of their possessions to benefit these institutions. A *waqf* document (*waqfiyya*) was written to list the properties and to stipulate how their revenues were to be spent.

Compared with other periods and places, a large number of *waqf* documents have survived from Mamluk Egypt. These documents have provided scholars with ample information about art and architecture, matters related to teaching the religious sciences, and aspects of social, religious, and economic life. The *waqf* documents follow a certain formula consisting of good wishes for the donor, then a list of the endowed properties, a description of the endowed building, and a list of the activities stipulated to take place in that edifice. Many of them detail the properties endowed, whether these were lands in the provinces or stores in the city of Cairo, because most *waqfiyya*s were primarily concerned with listing the properties whose revenues would be used to maintain the expenditures on behalf of the endowed building, be it a mosque, a school (madrasa), a Sufi convent (*khanqah*), or a mausoleum.

The particular details included in descriptions of buildings vary from one document to another. In some instances there is very useful and precise information about the design of the building, its constituent parts and their functions, and its decoration and furnishings, as we find, for example, in the *waqf* documents of the Sultan Hasan complex in Cairo (1357–64).[1] Many *waqfiyya*s specify what kind of marble was to be used in the veneering of various locations in the building. Others indicate the material of doors, whether of wood or bronze. While the *waqf* documents may contain straightforward descriptions of some furnishings, they also contain others that allow sound conclusions and inferences to be made. For example, many *waqf* documents include specifications on the amount of oil or candles that should be dispensed to the occupants of the building or that should be used in the month of Ramadan. This tells us that the building had glass lamps and candlesticks. Many such objects have survived from the Mamluk period, mainly in the form of enameled glass lamps (figs. 53–54) and brass candlesticks frequently inlaid with silver (fig. 66). The candlesticks were often placed on either side of the mihrab. This is known from later representations as well as from some documents.

Other examples of metalwork described in the *waqf* documents are doors. One such *waqfiyya* specifies that the doors are to be made of pinewood and covered with bronze sheets embossed and perforated.[2] Another document refers to the bronze spout of a water fountain used for ablution, which was to be made in the form of

a lion head. The incense burner is yet another type of metal object that was often referred to in the *waqf* documents.

Carpets form another common entry in the *waqf* documents, one of which includes several passages about the use of carpets. It mentions individual carpets used by the Sufis on Fridays.[3] A final and most significant type of item mentioned in the *waqfiyya*s is the Qur'an. Every endowed edifice in Cairo had one or more manuscripts of the Qur'an, often produced as a thirty-volume set. Many of them were of large size, such as those in the complex of Sultan Hasan, the madrasa of Sultan Sha'ban, and the madrasa of Amir Jamal al-Din Yusuf, to name a few. Not all Mamluk manuscripts of the Qur'an seem to have ended up in the buildings for which they were intended, as is the case with a thirty-volume set with an endowment notation in the name of Sultan Faraj (r. 1399–1405; 1406–12), which was likely produced in the early fourteenth century (fig. 4).

Notes
1 See Kahil, *Sultan Hasan Complex*, esp. 191–202.
2 Mentioned in the *waqfiyya* of Sultan Qaytbay; see Ibrahim, "Watha'iq al-Sultan Qaytbay," 389–444.
3 Mentioned in the *waqfiyya* of the madrasa of Amir Jamal al-din Yusuf al-Ustadar; see 'Uthman, *Wathiqat waqf Jamal al-Din*.

Offerings to the Ka'ba

Avinoam Shalem

The custom of sending offerings to the Ka'ba (fig. 236), the nearly cubic stone structure with flat roof located in the center of the main courtyard of the great mosque of Mecca, can be traced back to the pre-Islamic period. This practice continues up to the present day.

One of the most celebrated gifts is the embroidered veil, the kiswa, which was and still is sent each year to drape the Ka'ba (fig. 68). According to tradition, the earliest person to cover this building was Tubba, king of Khimayr in South Arabia, who lived around the last quarter of the fourth century.[1] He first enveloped it with *husuf*, then with *ma'afir*, and later on with *mula* and *wasa'il*;[2] the first two coverings were probably fine woven mats, *mula* was likely a delicate woven cloth, and *wasa'il* was a red-striped woven textile from Yemen. This perhaps marks the origin of manipulating visibility in sacred spaces in Arabia, mainly through the act of concealing venerated objects.

In the early Islamic period, the Ka'ba received drapes of various materials, colors, and techniques. The coverings were made of leather, woven palm leaves, camels' hair, wool, carpets, and even silk.[3] The first to cover the Ka'ba with silk was a woman, the mother of al-'Abbas ibn 'Abd al-Muttalib, progenitor of the Abbasid dynasty.[4] Arabic inscriptions woven into the kiswa fabric were introduced in 775 under the Abbasid caliph al-Mahdi. In terms of color, in the early Abbasid period, for example, the kiswas were usually restricted to green and white.[5] The black kiswa with yellow embroidered

inscriptions first appeared in 1180.[6] This color combination seems to prevail, though with numerous exceptions, and was taken again as a model in the modern era (fig. 68).[7]

Whereas the earliest gifts of coverings to the Ka'ba can be largely regarded as individual votives of pious rationale, with the establishment of an official ritual in which the caliphs sent kiswas once or twice a year to the Ka'ba, the custom became a political concern. 'Uthman ibn 'Affan (r. 644–56) was the first caliph to establish this biannual ritual and to schedule it to the eighth of Dhu'l-Hijja and the twenty-seventh of Ramadan.[8] Through this act the caliph symbolically demonstrated his concern with and interest in the holy site in Mecca and accentuated his important role as the guardian of the Haram (the sacred space and its sanctuaries) in Mecca. The kiswa thereby became a protective mantle, a sort of robe of honor, bestowed upon the Ka'ba. It is likely that the mention of the caliph's name, which usually was embroidered on the kiswa, clearly showed him as the commissioner of the piece, linked him to the most holy sanctuary, and validated his power.

The performative aspect concerning the caliph's endowment of the kiswa seems to be emphasized at the very end of the eleventh century. In 1073, the kiswa was brought to Mecca on a golden carriage by a Persian notable dressed in a black turban with a drum and trumpet in his hands.[9] According to the detailed account of the Andalusian traveler Ibn Jubayr, who left Granada on February 3, 1183, for the pilgrimage, the kiswa was brought by command of the Abbasid caliph to the Haram on four camels

accompanied by nine dignitaries.[10] The celebration of the transport of the kiswa to Mecca and its performative hanging in the Haram seem to culminate during the Mamluk period. The departure of the kiswa from Cairo, its transportation in the company of a specific pavilion-like structure called a *mahmal* (fig. 44), escorted by a lavish parade headed by the Amir al-Hajj (the Commander of the Pilgrimage), and joined by a complementary musical spectacle became an annual ritual. The gifting of the kiswa to the Haram in Mecca became a political event and to some extent a popular folk rite.[11]

But apart from kiswas and *sitaras* (door coverings) (figs. 69, 238), other objects were also sent to the Ka'ba. The tradition of sending lock-and-key sets for securing the main entrance door of the Ka'ba was maintained for centuries (figs. 65, 67). The pre-Islamic king Tubba was the first to put a lock on this house.[12] It is likely that the gifting of this type of item was understood not only as a security concern but also as a sign of the caliph's piety and generosity. His name, which was usually incised on the metal lock sets, symbolized his individual link and permanent devotion to the house of Allah.[13] It should be added that fragrant substances like ambergris and wax candles, candlesticks (fig. 66), and lamps were regularly sent to the Ka'ba as imperial presents.

Another interesting group of Ka'ba gifts involves trophies of war. The majority of these were donated after the Arab conquests of early Islam. But several of these "trophies" were sent from the newly subjected regions as tokens of friendship/tribute and in recognition of Islam. A lengthy

list survives that includes Sasanian precious objects: swords and other weapons, royal insignia, courtly table-ware, and even books.[14] In several instances idols, pagan ritual objects, and even biblical relics, like the horns of the ram substituted for Abraham's sacrifice of his son, found their way to the treasury of the Ka'ba. The pagan objects were usually dismantled for the sake of their valuable materials or destroyed, whereas the biblical relics were ostentatiously displayed.[15] These objects, regardless of their original sacred or secular contexts, were treasured in the Ka'ba as mementos of a heroic Islamic past and manifestations of the supremacy of this religion. The transfer of these trophies from the different regions of the empire and their collection and display at the Ka'ba help underscore the importance of this shrine and Mecca as the center of the Muslim world.

Notes
1 Azraqi, *Akhbar Makka*, 175.
2 Ibn Hisham, *Al-Sira al-Nabawiya*, vol. 1, 20–21, where he indicates that Tubba's first intention was to capture Mecca, sack its treasures, and demolish its temple but was then advised by two Jews to do the opposite. Following their instructions, he accepted the temple of the Ka'ba as the House of God and respected the citizens of this city, suggesting that the Jewish tradition of covering sacred spaces and objects influenced the pre-Islamic tradition of drap-ing the Ka'ba.
3 It is interesting to note that several of these cover-ings were first used for the protection of the animals brought to be sacrificed in Mecca. They were given as donations to the treasury (*khizana*) of the Ka'ba and were used later as coverings; see Azraqi, *Akhbar Makka*, 174.
4 Gouda, "Kiswa der Ka'ba," 27.
5 Ibid., 28 and 35.
6 Ibid., 40, Serjeant, *Islamic Textiles*, 215.
7 For the extant kiswas of the premodern and modern eras, see Tezcan, *Curtains of the Holy Ka'ba*; see also Gaudefroy-Demombynes, "Voile de la Ka'ba"; 'Attar, *Al-Ka'ba wal-Kiswa*; Mortel, "Kiswa"; and Gouda, "Tiraz-Werkstätten der Kiswa."
8 Serjeant, *Islamic Textiles*, 11.
9 Ibn Taghribirdi, *Al-Nujum*, vol. 4, 95.
10 Moreover, the pilgrims appear to have witnessed the draping of the cloth over the Ka'ba. Ibn Jubayr, *Rihlat*, 58.
11 Young, "Ka'ba, Gender, and the Rites of Pilgrimage."
12 Gouda, "Kiswa der Ka'ba," 24. In the early Islamic period, for example, the Abbasid caliph al-Mu'tasim bi-Allah "presented the Ka'ba with a gold lock (*qufl*) weighing a thousand *mithqals*"; Qaddumi, trans., *Book of Gifts and Rarities*, 83.
13 See mainly Sourdel-Thomine, "Clefs et seurrures," and Yilmaz, *Holy Ka'ba*.
14 Azraqi, *Akhbar Makka*.
15 Shalem, "Made for the Show."

Opposite: Fig. 68 (cat. no. 113). *Section from the Belt of the Ka'ba*, Egypt, Cairo, 19th century. Nasser D. Khalili Collection of Islamic Art, London (TXT 251).

Above: Fig. 69 (cat. no. 115). *Sitara for the Internal Door of the Ka'ba*, Egypt, Cairo, dated AH 1314/1897–98. Nasser D. Khalili Collection of Islamic Art, London (TXT 264).

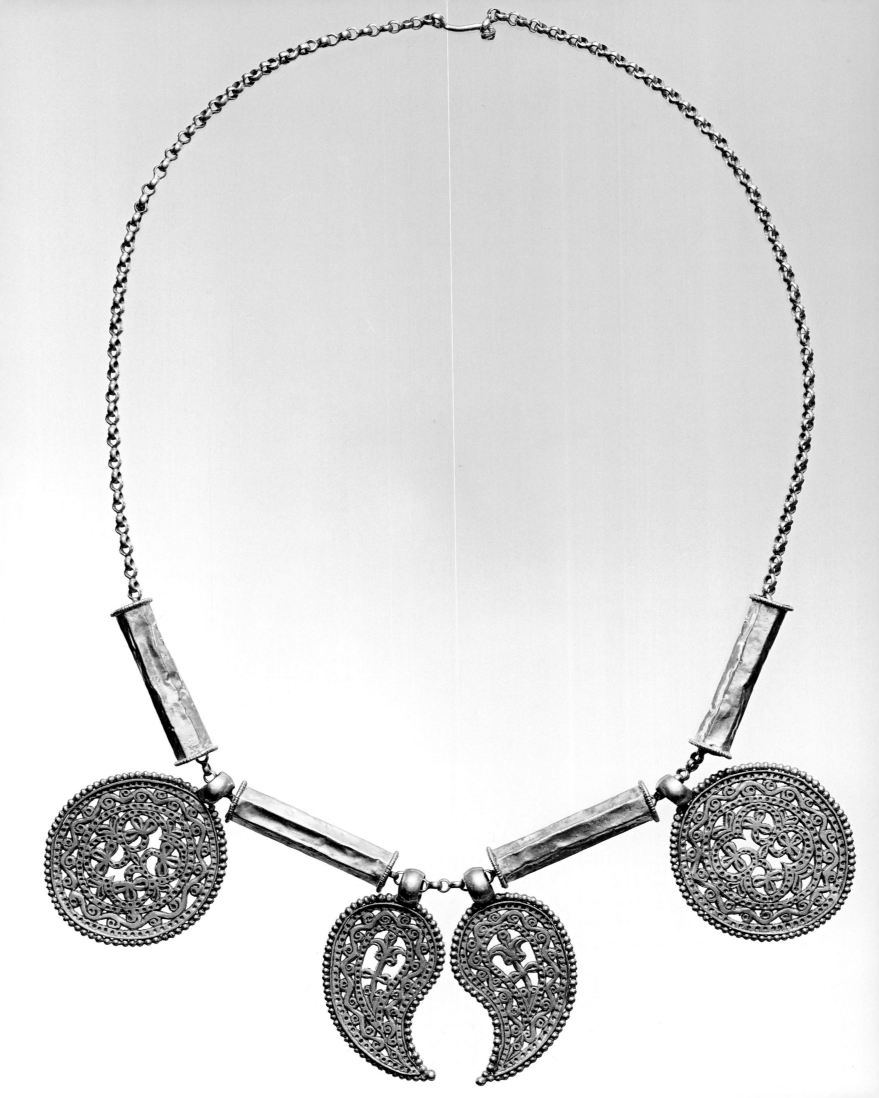

The Enduring Present: Gifts in Medieval Islam and Byzantium

ANTHONY CUTLER

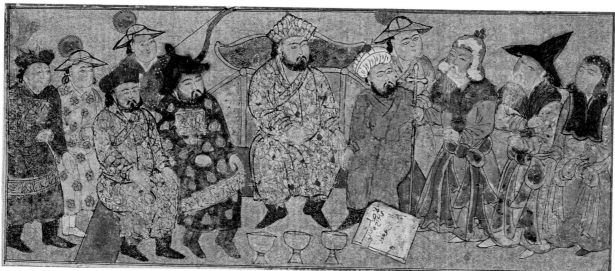

Opposite: Fig. 70 (cat. no. 238). *Necklace with Pendant*, Byzantine, 7th century. The Metropolitan Museum of Art, New York (17.190.1656).

Fig. 71 (cat. no. 237). *Nushirvan Receives Mihras, the Envoy of Caesar*, folio from the so-called first Small *Shahnama*, northwestern Iran or Baghdad, c. 1300–1330. The Metropolitan Museum of Art, New York, purchase, Joseph Pulitzer Bequest, 1934 (34.24.3).

When, in 1503, the Venetian ambassador Beneto Sanudo presented Sultan Bayezid II 6 garments interwoven with gold, 40 others of velvet in various colors, 120 sable furs and other goods that in all are said to have required 110 men to carry them,[1] and when, a generation later, the Grand Vizier Ibrahim Pasha repeatedly demanded that he be sent a white unicorn, a gift he is said ultimately to have obtained,[2] whether they knew it or not they were engaging in rituals much older than Venice and even Islam itself. The offering of diplomatic gifts reverts to ancient Near Eastern practice,[3] while evidence of the presentation of exotic animals—along with a diadem, a basket of gold, and an elephant tusk—appears on an ivory plaque at the Louvre that probably depicts the Byzantine emperor Justinian I (r. 527–65) as their recipient.[4]

At least according to the traditions preserved in Arab gift books, in 627 Muhammad sent a camel-load of gold to a Quraysh leader and received in exchange weapons that the Prophet accepted.[5] Two years later,

Muhammad wrote to the Byzantine governor of Misr (Egypt) and Alexandria, inviting him to become a Muslim. In response, the official sent the Prophet four slave girls "of remarkable beauty...and a completely castrated eunuch, a gray she-mule with saddle and bridle...a gray donkey...one thousand *mithqals* of gold, twenty pieces of Egyptian linen... some honey" and a leather box in which Muhammad later kept his toiletries. Muhammad, we are told, "accepted all that" for "he never refused a gift from anyone, and gave rewards in return."[6]

The caliphs, as successors to the Prophet (the principal meaning of their title), turned what had been gestures of comity into acts of statecraft. Frequently accompanying missions addressed to the delicate business of prisoner exchanges, the Abbasid caliph al-Mutawakkil (r. 847–61), for instance, sent nearly a thousand bladders of musk, silk garments, "an abundance of saffron," and "other curious and novel things" to the Byzantine emperor Michael III (r. 842–67), eventually securing the release of 2,367

persons, including two goldsmiths.[7] This information, recorded by al-Tabari, the late-ninth- and early-tenth-century historian, is interesting in that it picks up the movement of human capital mentioned in earlier Arab sources. The same writer tells, for example, of a hundred workmen sent, along with a hundred thousand *mithqals* of gold and forty loads of mosaic tesserae, by the Sahib al-Rum (Justinian II, r. 685–95 and 705–11) to the Umayyad caliph al-Walid (r. 705–15) for the rebuilding of the Mosque of the Prophet in Medina.[8] More certain than the number of workmen is the widespread transmission of building materials—Syrian marble and mosaics sent in the sixth century to the Sasanian shah Khusraw I (r. 531–79), and tesserae in the mid-tenth to 'Abd al-Rahman III (r. 912–61) for the Umayyad mosque in Cordoba and columns for this caliph's residence at Madinat al-Zahra.[9]

Frequently recalled in medieval Arabic texts is Justinian II's gift of golden chains to the mosque in Medina. The claim is an interesting one, not only in that it attests to gifts that transcend religious difference but also because it exemplifies the ethos of lavishness that was part of a ruler's reputation for magnificence.[10] We have almost no way of measuring a Byzantine emperor's largesse in relation to his other expenses, but the Abbasid world offers a different story. A budget drawn up in 918 by 'Ali ibn 'Isa, the vizier of al-Muqtadir (r. 908–32), records the caliph's personal disbursement of gifts and rewards of 271,520 dinars—slightly more than 10 percent of his total expenditure and nearly twenty times the amount he put into new buildings and repairs.[11] It would be wrong to think of such prodigality as mindless. Rather, we know much of its purpose from a letter written by the Fatimid caliph al-Mansur (r. 946–53) to his *ustadh* (chamberlain) Jawdhar on the arrival of a Byzantine ambassador:

I know how desirous you are that no beautiful thing in this world is not in our possession and our staterooms. I imagine that this leads you to being greedy and to deny to the Christians things like those that we have asked to be sent to us. Do not be like this, for the treasures of the world stay in the world, and we accumulate them only to rival our enemies in splendor and to make known the nobility of our feelings, our magnanimity, and the generosity of our hearts in the gift of those things that one holds jealously and of which one is greedy.[12]

Much is conveyed by these instructions: the desire for exclusivity in one's possessions; the unashamed, proactive requests for gifts;[13] and the competitiveness inherent in their implicit display to one's opponents. The emphasis here is on what now would be called "foreign policy," a domain that included the occasions on which gifts should be sent abroad, those "symbolic marks of respect and the custom of kings." These were the words of the Syriac historian John of Ephesus when he criticized the Persian ruler Hurmazd IV (r. 579–90) for neglecting to recognize the accession of the emperor Maurice (r. 582–602), as Justinian I (r. 527–65) had done when Khusraw I, Hurmazd's predecessor, had come to the throne.[14]

If gifts from overseas were normally presented to the sovereign by ambassadors, other foreigners were no less immune to the requirement. At least in the Mongol Empire it was required of merchants to present what Rashid al-Din called their "audience-offering" when they arrived with goods for sale. A group of Muslim traders from the region of Lake Baikal and Kirghizstan brought "white-footed,

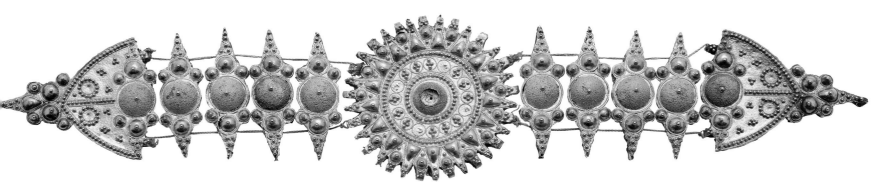

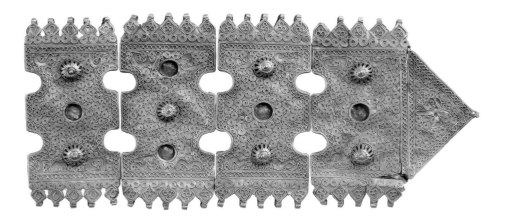

Top: Fig. 72 (cat. no. 4). *Belt Elements*, Syria, late 13th–early 14th century. Benaki Museum, Athens (1900).

Middle: Fig. 73 (cat. no. 2). *Belt Elements*, Iraq, possibly Samarra, 10th century. Benaki Museum, Athens (1856).

Bottom: Fig. 74 (cat. no. 5). *Belt Elements*, Spain, 14th century. Museum für Islamische Kunst, Berlin (I. 4941–4944).

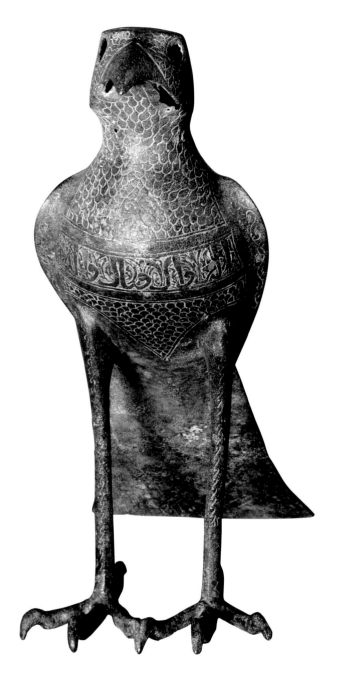

Left: Fig. 75 (cat. no. 50). *Figure of a Hawk*, Iran or Central Asia, 12th–13th century. Museum of Islamic Art, Doha (MW282.2006).

Right: Fig. 76 (cat. no. 51). *Hunting Hawk*, India, c. 1625. Museum für Islamische Kunst, Berlin (I. 4594).

red-beaked gyrfalcons and a white eagle" when they arrived at the court of Qubilai Khan (r. 1260–94).[15] Even "tourists" like Ibn Battuta were charged with the obligation. After 1334, when the North African traveler arrived in Delhi, he was deputed by Sultan Ghiyath al-Din Muhammad Shah ibn Tughlaq (r. 1325–51)—whom he describes as "of all men the most addicted to the making of gifts and the shedding of blood"—to offer a vast present to the "king" of China. Apart from one hundred thoroughbred horses and the same number of male slaves and "Hindu singing-and-dancing girls," he took with him silks, cottons, and robes of honor (khila') "from the Sultan's own wardrobe and ten caps also worn by him."[16]

This was, in fact, a countergift presented in exchange for a similarly sumptuous offering of slaves, velvets, musk, and robes and weapons both studded with jewels that the king had sent with a plea that he be allowed to rebuild an "idol-temple" that the Muslims had sacked. The request was denied on the grounds that the Chinese must first pay the jizya, tribute of the sort that the Byzantines had offered in late antiquity to protect their territories from "barbarian" aggression.[17] "Glorious gifts"—to borrow the phrase of a later Greek chronicler[18]—was a euphemism that persisted throughout the period when the strategy was employed first against the Arabs and then the Turks. In the mid-tenth century, for example, a Byzantine patrician arrived at the court of the Abbasid caliph al-Mu'izz (r. 953–75), bringing not only the tribute that the emperor "had agreed to pay for the country of Calabria" but also many presents—"vessels of gold and silver inlaid with jewels, embroidery, silk, nard [a medicinal ointment of vegetable origin], and other precious articles."[19] The purpose of the mission, according to al-Nu'man, the Fatimid jurist and historian, was the emperor's search for a perpetual truce, a request rebuffed by the caliph on the grounds that jihad (holy war) was enjoined upon Muslims by canon law; even the ambassador's gifts and his plea for a reciprocal mission to Constantinople were rejected with the words "Thanks be to God, we are not aware that we stand in need of anything from your master. Why, then, should we dispatch an envoy to him?"[20]

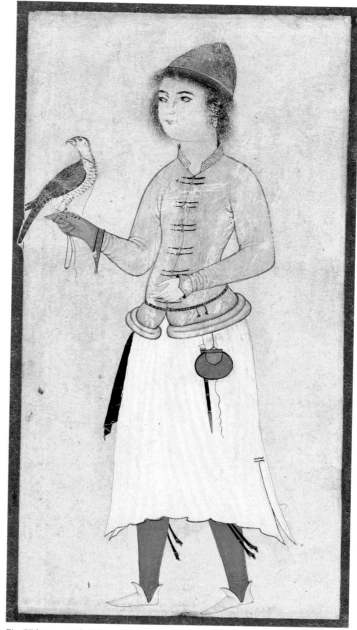

Fig. 77 (cat. no. 52). *Falconer*, Turkey, Ottoman, late 16th century. Los Angeles County Museum of Art (M.85.237.31).

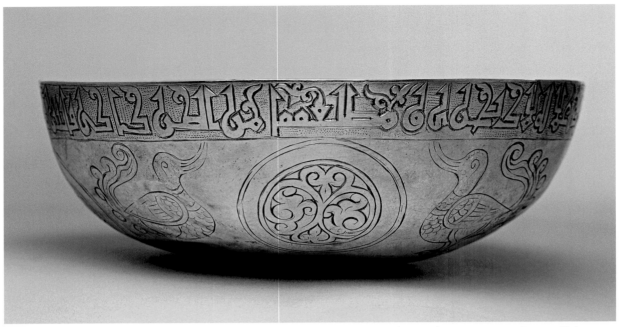

Fig. 78 (cat. no. 16). *Bowl*, Iran, possibly Hamadan, 11th century. The British Museum, London (1938, 1112.1).

Opposite: Fig. 79 (cat. no. 6). *Rudaba Receives a Belt as a Gift from Zal's Messenger*, folio from a manuscript of the *Shahnama*, Iran, Qazvin, 1576–77. The David Collection, Copenhagen (49/1980).

The caliph's words may be apocryphal, but there can be little doubt of either the material splendor of the Greek offerings or the tenor of the Arab response. Proud chauvinism underlay missions in both directions and, given the difference between beneficence and benevolence, the public display of gifts in alien capitals could serve as a strategic weapon. Thus the earlier and more celebrated visit of John the Grammarian (later the patriarch John VII) to al-Ma'mun (r. 813–33), probably in 829–830, involved not only the presentation to the caliph of two gold and gem-encrusted *cherniboxesta* (washing sets as used at the Byzantine court and thus a flattering equation) but also the scattering, "for the sake of ostentation," of more than forty hundredweight of gold to the crowd in Baghdad. This, as Zonaras, the twelfth-century historian, put it, was "to make known to them [the Arabs] the wealth of the Empire."[21]

If gifts alone could not turn an enemy into a friend, their exchange could at least signal the formation of an alliance. A century and a half after John the Grammarian's triumphal visit to the Abbasid capital on behalf of the emperor Theophilos (r. 829–42), another, more adventurous emperor,

John I Tzimiskes, led a campaign in Syria where he encountered Alptekin, the semi-independent Turkish lord of Damascus. Going out to meet the advancing emperor, as was customary practice when faced with an honored visitor, and at the head of three hundred cavalrymen in their finest array, the warlord dismounted before Tzimiskes, agreed that the city would pay a tribute of a hundred thousand dirhams, and put on a solo display of armed horsemanship that is said to have impressed the emperor to the point where he withdrew the demand. With Alptekin back in his tent, Tzimiskes sent him robes of honor and a parade horse and asked the Turk for his horse and lance. Alptekin complied, adding to the gift twenty caparisoned horses, several lances, and a sizable quantity of clothing of all sorts, perfumes, and other presents. The emperor thanked him, accepted only what he had originally requested, and sent him brocade garments, jewels, parade horses, and mules.[22] Distracted by domestic conspiracies and an attempted poisoning, the emperor had to abandon his Levantine adventure, but the tale well illustrates the conspicuous value of gifts in the cultural (and not just the military or political) currency of the era.

همه پلس سرخ یا بود رر

فرستاد و پرده یکی تابان بام

زبان از ستم برگشت چون سندر و

زمان تا زمان پس هین بگذری

بدینی با این و دهم وسام

برسید روی زمین دخت را نو بوس

در آبی ز من نگری

این ر مده بون ملک

زین رجه را که با بوان سینت

بر اند یشه شد جان سین دخت زو

دل رو شنم بر تو شد بد حمان

سین دخت اورا بدید

آب و ز کف از جا بوسی بکو

نگو پی مرا تو زبی یا بحمان

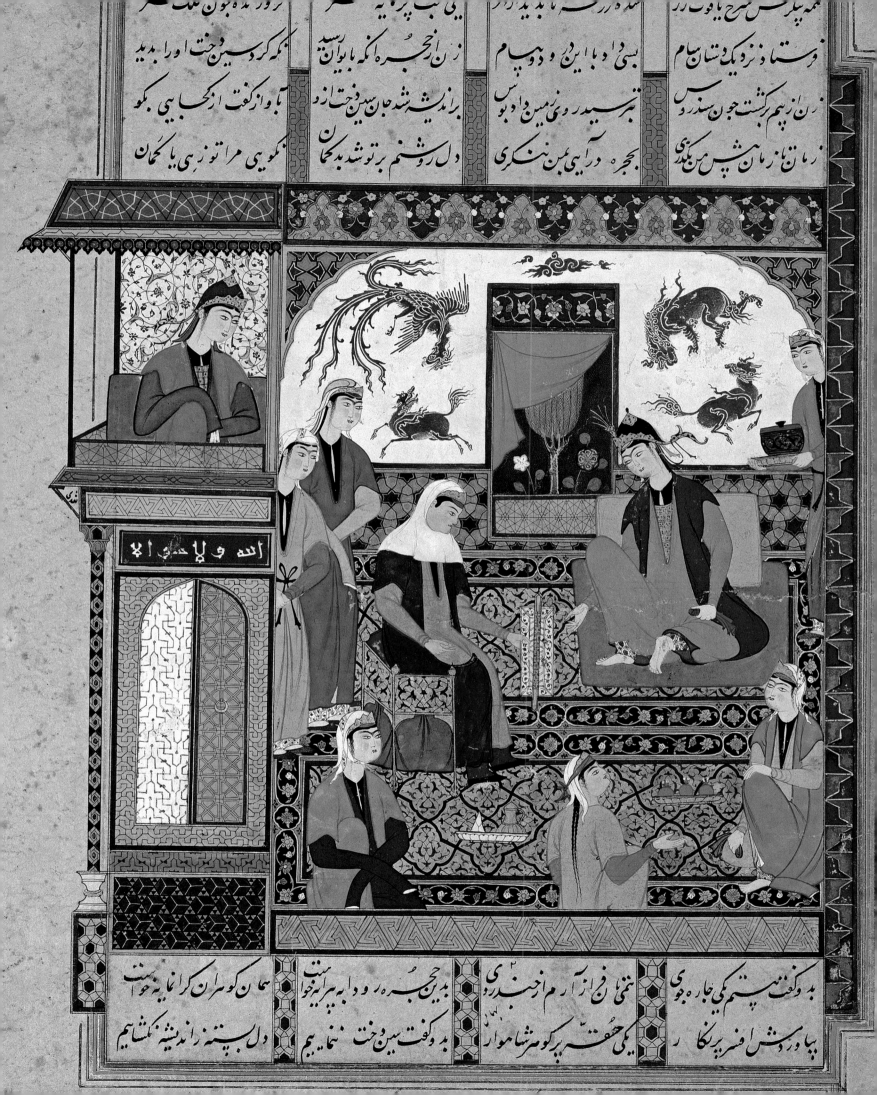

بد و گفت میشم کی بار بوی

بی نما ز رع آرم از هندری

پیا و رزون پس افسر برگنا

دل سپ ننه زند یشه نگشایم

بدین رج حجره رو به بر که خوا

بد و گفت سین دخت شاهوار

سین کوبران کرا نما یه جود

یکی جفتر افر برکو سر شاه وار

نما پم

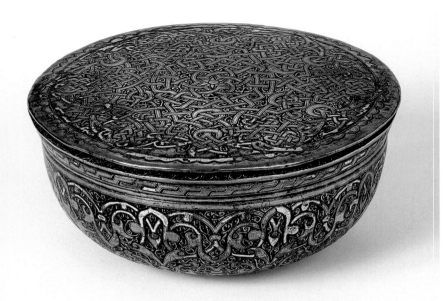

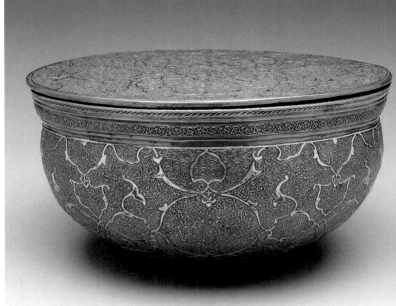

Above: Fig. 80 (cat. no. 55). *Box with Lid*, probably Syria, second half of the 15th century. The David Collection, Copenhagen (24/1970).

Opposite: Fig. 82 (cat. no. 121). *The Vizier Buzurgmihr Solves the Mystery of the Chess Game for Shah Khusraw Anushirvan*, folio from a manuscript of the *Shahnama*, Iran, Shiraz, c. 1550–60. The David Collection, Copenhagen (450/1982).

Above: Fig. 81 (cat. no. 54). *Box with Lid*, probably Syria, second half of the 15th century. The British Museum, London, Henderson Collection (1878 12-30 703).

Indeed, the art historian, confronting what may be their fragmentary remains in the form of objects unattached by either inscription or documented origin to particular occasions or individuals, can only envy the written record in its fullness and its specificity. These qualities belonged not only to the abundance of material artifacts connected with diplomacy in Arab lists but also to perishable things that say more about the human dimensions of presents. The twelfth-century memoirist Usama ibn Munqidh, for example, tells of a lord of Hama in Syria who, having borrowed a goshawk (with the gyrfalcon, a favorite bird of prey) that had belonged to Usama's father for thirteen years, fashioned a coffin for it when it died and arranged a funeral procession.[23] Ibn Battuta, long before his gift-laden expedition to China, relates how he was sent a hamper of dates by a judge in Basra and does not hesitate to say that he resold it, regretting only the three dirhams that the porter took to carry it to market from his home.[24] Such small, usually inter-Arab, events have been all but effaced by the reported panoply of "international" presents.

Among the latter, certainly the longest and probably the most celebrated is the account of the gift in 938 of Romanos I (r. 920–44), his son-in-law Constantine, and Stephen, patriarch of Constantinople, to the caliph al-Radi (r. 934–40). Accompanying a letter that asked for a truce and a prisoner exchange were beakers inlaid with precious stones; a rock crystal vase caged in gilded silver, decorated with gems and pearls and bearing a rock crystal lion on its lid; a silver-gilt jar with an inscription on its spout citing Genesis 1:2 that speaks of God's voice moving upon the waters; and scores of other vessels and precious-metal, bejeweled boxes. There follows a long list of textiles described in terms of their materials, their colors, and their human or animal designs,[25] some of which conform to surviving pieces of Byzantine silk, a congruity that lends credence to the accuracy of the account. Its author begs the reader's pardon that he has not seen the objects, but it is clear that his list is based upon some official inventory. Since the record of the gifts sent almost contemporaneously to Hugh of Provence, king of Italy (r. 924–48),

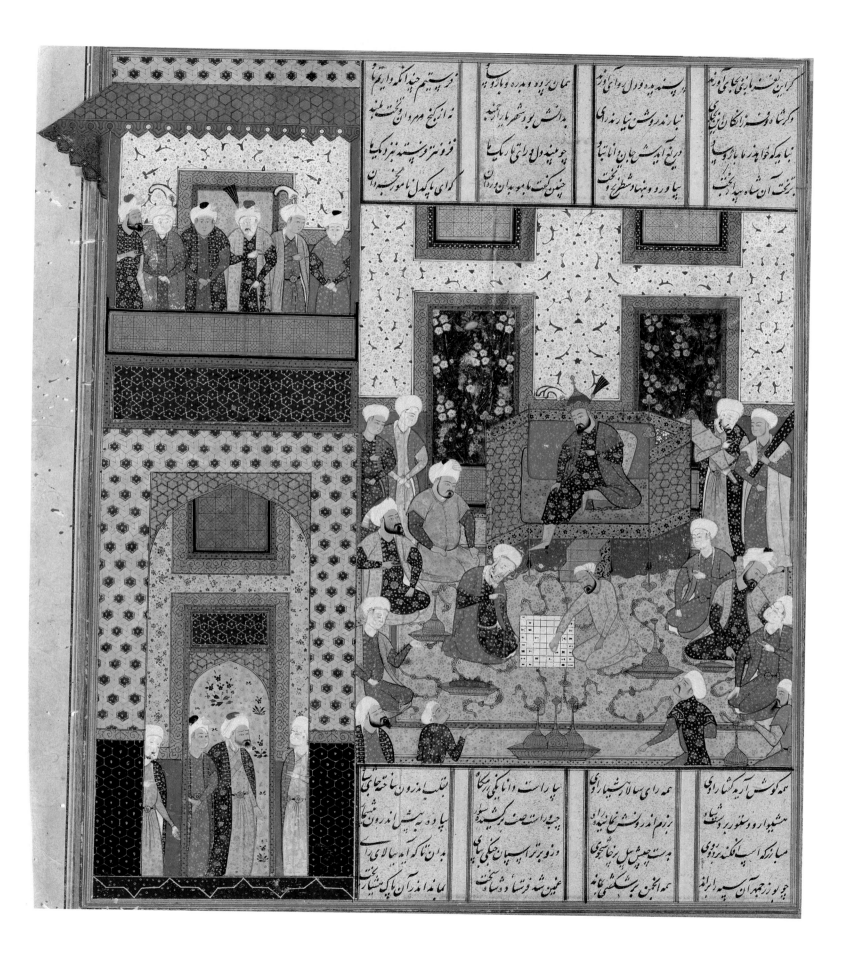

surfaces in the Byzantine *Book of Ceremonies*, ascribed to Constantine VII Porphyrogenitus, it too must be derived from a bureaucratic source. Evident, however, is the disparity between the presents sent to Italy and the plethora that traveled to Baghdad. Romanos's gift to Hugh included an onyx cup, three items of gilded silver, seventeen glass vessels, many silk cloths, incense, and unguents.[26] Striking as these must have been in their own right, in terms of quantity and degree of elaboration they pale beside those that, according to the three-page list, went to the caliph. Both gifts, nonetheless, were surely intended to excite what the early-nineteenth-century critic William Hazlitt called "the prurience of the optic nerve."[27]

As much as generosity or a sense of obligation, the very visuality of such objects accounts for their redistribution, a phenomenon frequently noted in the Arab gift books. Abu al-Musafir, the Sajid amir and governor of Transoxiana for the Abbasids from 898 to his death in 901, sent the caliph al-Mu'tadid (r. 892–902) "Rumi garments of purple brocade with gold [thread] added to them, each of which was worth 2000 dinars and a Rumi girdle placed over a wide black belt. The girdle was fashioned of 2000

mithqals of gold overlaid with enamel that cost 10,000 dinars." While their precise monetary worth is specified in the text, we may suppose their essential significance lay in the fact—reiterated in the primary source—that they were originally gifts from the Byzantine emperor Leo VI (r. 886–912).[28] In other words, for the medieval owner as for the modern museum curator, such a provenance was more than merely an added value.

It is the absence of a historical or legendary origin, of the authorization lent to an object by its claimed antiquity, that distinguishes Early Modern gifts, were they the exchanges between Muslim rulers and Mehmet II after he had conquered Constantinople[29] or those between the Venetian senate and the conqueror's successors,[30] from many that we have considered in this chapter. Generally these were creations ad hoc. Nonetheless, apart from the Ottoman passion for clocks and other automata, both the forms assumed by these new things and the materials that went into their making were those that had been employed across a millennium. These traditions continued, albeit sporadically, into our own time.[31]

Opposite: Fig. 83 (cat. no. 128). *Bottle in the Form of a Lion*, Egypt,
11th century. The British Museum, London (FB Is 12).

Above: Fig. 84 (cat. no. 125), *Chessboard*, Egypt, 14th or 15th century.
Benaki Museum, Athens (10033).

Notes

1 Sanuto, *Diarii*, cited in Carboni, *Venice and the Islamic World*, 370.

2 Ibid., 372.

3 See Feldman, *Diplomacy by Design*, esp. 168–75.

4 Cutler, "Barberiniana," 329–39.

5 Qaddumi, trans., *Book of Gifts and Rarities*, 63, sec. 6.

6 Ibid., 64, sec. 7.

7 Tabari, *Ta'rikh*, vol. 3, 1449–50; Vasiliev, *Dynastie Macédonienne (867–959)*, pt. 2.1, 320.

8 For more on the subject, see Cutler, "Gifts and Gift Exchange," 254. Depending on the primary source, the number of workmen sent varies between eighty and a thousand. See discussion in Flood, *Great Mosque of Damascus*, 20–24. The caliph himself surely provided "money, mosaic, marble, and 80 Greek and Coptic artisans from Syria and Egypt" to his lieutenant in Medina, as Baladhuri, *Futuh al-buldan*, records; see Baladhuri, *Origins of the Islamic State*, 20.

9 Cutler, "Gifts and Gift Exchange," 253–55, with the primary sources.

10 For the operation of this concept in the Greek world, see Cutler, "Magnificence and the Necessity of Luxury."

11 For the exact figures, see Sabi, *Rusum dar al-Khalifah*, 27–33.

12 Jawdhari, *Sirat Ustadh Jawdhar*, 61; Canard, trans., *Vie de l'ustadh Jaudhar*, 88–89.

13 On this topic, see Cutler, "Gifts and Gift Exchange," 255–57.

14 John of Ephesus, *Historiae ecclesiasticae pars tertia*, vol. 2, 243.

15 Rashid al-Din, *Jami' al-Tawarikh*, trans. Boyle, *The Successors of Genghis Khan*, 293.

16 Ibn Battuta, *Travels of Ibn Battuta*, vol. 3 (1971), 657; vol. 4 (1994), 773–74. On the practice of presenting "secondhand" royal clothing, see Cutler, "Emperor's Old Clothes."

17 For artifacts offered as tribute or bribes in late antiquity, see Engemann, "Diplomatische 'Geschenke'." On the *jizya*, see the Qur'an 9:29.

18 *Theophylacti Simocattae Historiae*, 45.

19 Nu'man, *Kitab al-majalis wa al-musayarat*, 366; Stern, "Embassy of the Byzantine Emperor," 244.

20 Nu'man, *Kitab al-majalis wa al-musayarat*, 369; Stern, "Embassy of the Byzantine Emperor," 248.

21 Zonaras, *Epitome historiarum*, vol. 3, 406.

22 Ibn al-Qalanisi, *Dhail ta'rikh Dimashq*, 12–14; Canard, "Sources arabes," 293–95.

23 Usama ibn Munqidh, *Rihla*, 215.

24 Ibn Battuta, *Travels of Ibn Battuta*, vol. 2 (1962), 276.

25 Qaddumi, trans., *Book of Gifts and Rarities*, 99–101, sec. 73.

26 Reiske, ed. *Constantini Porphyrogeniti Imperatoris De cerimoniis*, vol. 1, 661.

27 Hazlitt, *Notes of a Journey*, 222.

28 Qaddumi, trans., *Book of Gifts and Rarities*, 89, secs. 62–63, with notes 1–6.

29 See Ateş, "Istanbul'un Fethine Dair Fatih Sultan Mehmed." I am grateful to Merih Danali for bringing this to my attention.

30 See Sanuto, *Diarii*, cited in Carboni, *Venice and the Islamic World*, 370–72.

31 When, in 1979, Queen Elizabeth II made an eighteen-day goodwill visit to the Persian Gulf, she presented Arab rulers with silver trays engraved with an image of the royal yacht, *Britannia*, each valued at about $30,000. Not to be outdone, the amir of Qatar gave her, among other things, a lapis lazuli bowl mounted on prancing horses encrusted with diamonds and a necklace of gold disks set with gems, valued by the jewel merchants of that land at $2 million. The Saudi king's gift included an amethyst–studded gold tray and a gold coffee jug in the shape of a falcon, its talons carved from the same stones. Finally, some unidentified potentate offered her carpets, handbags, and "a glittering knee-length apron." After all, Elizabeth is a woman! See the *New York Times*, February 26, 1979, A4.

Fig. 85 (cat. no. 234). *Textile Fragment with Simurgh*, Iran, 8th–9th
century. Victoria and Albert Museum, London (8579-1863).

Afterlife and Circulation of Objects
Avinoam Shalem

"When the rule passed to the Abbasids, the Great Pearl (*durrah*) of the Umayyads was also transferred to them. People claimed that they had never seen [any pearl] as enormous as this one and that there was nothing to compare with it in radiance and whiteness. When al-Mahdi became caliph, he gave it to his slave girl Hasamah, who cut it with a lathe (*kharat*) into two pieces (*fassayn*) for backgammon."[1]

This anecdote about a famous pearl called al-Yatima (the orphan) illustrates a type of biographical account of portable and rare objects.[2] These objects of desire, like celebrities of our present time, became famous, traveled from one court to another, experienced different lives and functions in various places but ultimately were lost, disappearing into oblivion or simply destroyed by someone unaware of their exceptionality.

Portable objects are designed to travel. Their size, shape, and even specific features such as handles, grips, and loops for hanging make their transport easier. In fact, through their circulation they become part of the economic system of things and remain commodities of trade having a certain monetary value.[3] The circulation of Islamic objects during the Middle Ages gave them rich, adventurous lives—"a social life" as Appadurai suggests.[4] As portable objects, they were traded, brought from one place to the other with ambassadors, traders of luxury goods, and even pilgrims. These objects were usually sold or given as presents and were sometimes even looted, stolen, and smuggled. In short, they were like medieval nomads, moving from one cultural domain to another. Thus, by recording or orally recounting their biographies and histories—and even if these biographies were sometimes fanciful—a further aspect of the life of objects was emphasized.[5]

Presents circulated between different Islamic courts. In peacetime, they usually moved as diplomatic gifts or tribute, given on specific occasions such as weddings, circumcisions, and the like. But it is likely that numerous objects arrived in treasuries after the conquest of a rich region or the capital of a powerful kingdom. Arabic sources elaborate on the riches that fell into the hands of the Muslims after the capture of Ctesiphon, the summer capital of the Sasanian kings, and Toledo, the capital city of the Visigothic rulers. There was also the aftershock of the big boom that rocked the whole luxury-goods trade of the Mediterranean basin, when a large part of the Fatimid treasury was put on sale most probably between 1061 and 1069, followed by the takeover of Fatimid Cairo by the Ayyubids. In fact, many objects in the treasury of the Topkapi Saray in Istanbul were taken there by the Ottomans after the fall of Mamluk Cairo in 1517.

In other cases, artifacts were explicitly ordered to be transferred from one treasury to the other, usually by the powerful, or were simply stolen. For example, an anecdote related by Ibn al-Zubayr indicates that a small superb turquoise bowl, looted from the Khurasani pilgrims in 1022 in Medina, was brought by 'Azim al-Dawla from Ramla back to Palestine; it was then transferred to the treasury of the governor of Syria, who had "heard about the bowl and took it from him ('Azim al-Dawla)." Later on, after the murder of the Syrian governor, the bowl passed into the hands of the Fatimid caliph al-Zahir (r. 1021–36). One might speculate that this bowl is the glass turquoise vessel in the treasury of San Marco in Venice, the base of which bears the word "Khurasan" carved in kufic script.[6] The story of the famous ring al-Jabal (the Mountain) in the treasury of the Abbasids illustrates how Sasanian royal treasures migrated to the Islamic court and yet retained their miraculous power; it was related that "any king who would have it engraved would be assassinated."[7] And last, the thrilling story of the magnificent Table of Solomon, which was transferred from Toledo to Damascus, illustrates the eastward route of Visigothic treasures.[8]

The intercultural experience of these objects is perhaps one of the most interesting aspects concerning their transient lives. Church treasuries in the Latin West are especially rich in Islamic artifacts.[9] Moreover, according to medieval inventories, an even larger number of Islamic artifacts were known to have been kept in church

Opposite: Fig. 86 (cat. no. 122). *Chess Piece (Knight or Rook)*, Egypt, 8th–9th century. The Metropolitan Museum of Art, New York, Rogers Fund and Mr. and Mrs. Jerome A. Straka Gift (1974.207).

Left: Fig. 87 (cat. nos. 123–24). *Chess Pieces*, Egypt, 10th century. Museum für Islamische Kunst, Berlin (I. 1012 and I. 4827).

treasuries. Sadly, many of them simply have disappeared. Others were sacked, looted, or even destroyed during wars, as, for example, in the French Revolution or during the secularization of Germany at the beginning of the nineteenth century. Nonetheless, quite a few Islamic objects now in public and private collections are known to have originally been kept in church treasuries (fig. 85). Thus, the Islamic objects from the medieval West provide the "archaeological evidence" for intensive East-West relations—they are the mediators of intercultural interactions.

Among these celebrated objects, chess pieces made of carved ivory or rock crystal (figs. 86–87), oliphants (horns made from elephant tusks) (fig. 88), large precious stones with Arabic inscriptions, fine textiles, and other luxurious objects of rare materials and beauty might well have once existed in Islamic lands as luxury gifts. Their "afterlives" in a Christian context—in some cases well documented, in others totally unknown—emphasize their portability and suggest that they traveled different routes within the Mediterranean Basin, mainly westward. Their biographies were enriched, and a new

chapter in their lives was written. These transplanted objects were mainly used in a sacred context, often as relic containers but also as lavish objects for the church service—for example, vessels for wine or water during the Mass, containers for the Host, and incense burners. Regardless of the specific route that these objects took on their westward journey, they were generally accepted and appreciated in Christian Europe. It is likely that medieval European spectators were fascinated by these "foreign" artifacts, though sometimes not aware of their origins. The Islamic objects were mainly judged on an aesthetic basis. Their precious materials, splendid workmanship, radiance, and richness of colors no doubt accounted for their reception in medieval church treasuries. However, in several cases in which their biographies, or rather imagined former lives, were known, the objects were endowed with a certain aura, which we tend to define as exotic. In medieval times as today, cultural interactions, even if restricted to the aesthetic level, give a sort of intellectual injection and foster artistic innovations. It would be proper to end this discussion with a citation from one of the letters of Emperor Constantine VII (r. 913–59): "I marveled

at the Arabic cup, its variegated [beauty], its smoothness, its delicate work."[10]

Notes
1 Qaddumi, trans., *Book of Gifts and Rarities*, 179–80: this late-eleventh-century treatise is ascribed to the Qadi al-Rashid Ibn al-Zubayr.
2 Shalem, "Jewels and Journeys."
3 Kopytoff, "Cultural Biography of Things."
4 Appadurai, *Social Life of Things*.
5 And yet, the common scholarly approach to these objects remains within the traditional parameters of art history, in which the places of origin and the original functions of these traveling artifacts are hierarchically ranked as central and most crucial for understanding. Terms such as "afterlife," "second life," and "shared life" of these artifacts illustrate this notion (see, for example, Grabar, "Shared Culture of Objects"; Hoffman, "Pathways of Portability"; and Shalem, "Second Life of Objects"). It seems as if "the First Life" of these artifacts is always regarded as proper and authentic, whereas the additional lives the object has experienced must be seen and understood from the standpoint and under the shadow of its primary state; see the discussion on *contingentia* in the Middle Ages in Greenblatt, *Cultural Mobility*, 1–23.
6 See Shalem, "New Evidence for the History of the Turquoise Glass Bowl." In another such instance recorded by al-Ghuzuli (d. 1412), the famous rock crystal lamp from the Great Mosque of Damascus was brought by stealth to Baghdad during the reign of al-Amin (809–13), who was a collector of rock crystal; see Ghuzuli, *Matali' al-budur*, vol. 2, 284; Shalem, "Fountains of Light."
7 Qaddumi, trans., *Book of Gifts and Rarities*, 184.
8 Ibid., 177.
9 There are some 80 Islamic rock crystals, 30 cut- and enamelled-glass vessels, 150 carved and painted ivories, and almost 20 metalwares. In addition there are hundreds of textiles and glazed pottery vessels—the so-called *bacini*. See Shalem, *Islam Christianized*.
10 Kalavrezou-Maxeiner, "Cup of San Marco," 173; see also Walker, "Meaningful Mingling."

Fatimid Gifts

Jonathan Bloom

Of all the Islamic dynasties that ruled in medieval times, none appears to us today so preoccupied with gifts as the Fatimids, who governed first in North Africa and then in Egypt between 909 and 1171. The Fatimids, who traced their lineage to the Prophet Muhammad through his daughter Fatima (hence their name), were Isma'ili Shi'ites who believed that not only the Abbasid caliphs of Baghdad but also the Umayyad caliphs of Spain were blatant usurpers and unqualified to rule the Muslim world. The Fatimids claimed that their rule would usher in a new era of peace and prosperity, and they entered into commercial and diplomatic relations with the Byzantine emperors of Constantinople and with the Norman kings of Sicily; European merchants regularly visited their ports ready to acquire the wonders of the East. In 1099 European crusaders invaded the Levant, anxious to wrestle Jerusalem from infidel hands, and they subsequently attacked the Fatimid heartland. The ensuing chaos eventually led not only to the fall of the Fatimid dynasty but also to the recapture of Jerusalem by Ayyubid forces and the realignment of power in the entire region.

The Fatimids had arisen in Ifriqiya (now Tunisia) and in 969 conquered Egypt, where they founded the city of Cairo, in which they built splendid mosques and palaces. Some Fatimid mosques and shrines have survived along with a wide range of ceramics, textiles (figs. 29, 98), jewelry (figs. 21, 89, 101, 201–2), metalwares, and carved rock crystal (fig. 83), ivory (fig. 88), and wood, but the glorious Fatimid palaces are preserved only in the copious descriptions, particularly of their contents, found in medieval accounts of the dynasty and of Cairo, principally those collected by the Egyptian Mamluk historian Taqi al-Din Ahmad ibn 'Ali al-Maqrizi (1364–1442).[1]

According to al-Maqrizi, in the center of Cairo stood the great Fatimid palace in which the caliphs

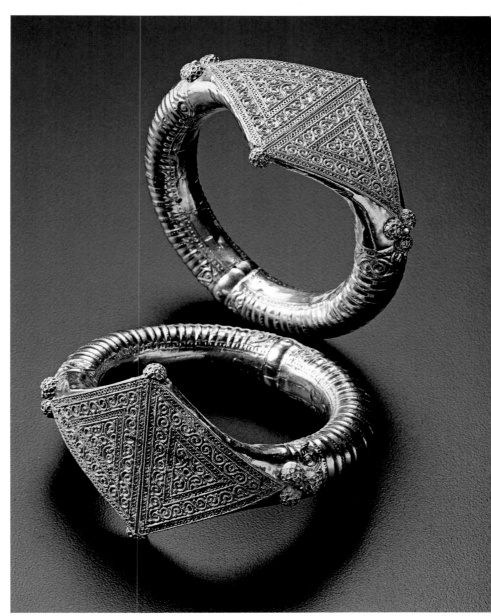

Opposite: Fig. 88 (cat. no. 127). *Oliphant*, Egypt, c. 1000. Museum of Fine Arts, Boston, Frederick Brown Fund and H. E. Bolles Fund (50.3426).

Above: Fig. 89 (cat. no. 9). *Pair of Bracelets*, Syria or Egypt, 11th century. Museum of Islamic Art, Doha (JE.118).

had assembled many treasuries or storerooms (khizana) containing books, banners, weapons, shields, saddles, furnishings, draperies, food, drink, spices, tents, jewels, and fine things, many of which were presumably gifts and tribute. The caliphs used to visit these storerooms regularly; every one had an attendant and was furnished with an upholstered bench.[2] The contents of these treasuries are known from an inventory of sorts made in the late 1060s when the Fatimid troops demanded that the caliph al-Mustansir (r. 1036–94) pay them for services rendered; when he refused they eventually began looting the royal palace. As the goods were brought out from the palace, functionaries recorded who took what against what he was owed in wages. Although the original records are lost, the extravagant descriptions of these fabulous treasures appear in various later works, most based on an eleventh-century account known as the *Book of Gifts and Rarities*. Even allowing for a certain degree of exaggeration, the goods found in the palace were extraordinary, ranging from huge rock-crystal jars filled with precious jewels to intricate curios such as a miniature ornamental orchard made of bejeweled silver.

No single piece from the Fatimid treasury has ever been positively identified as such, apart from two books, although several carved rock-crystal items in European treasuries may have come from there. For example, a ewer in the treasury of San Marco, Venice, bears the name of the caliph al-'Aziz (r. 975–96) and a crescent in Nuremberg bears that of al-Zahir (r. 1021–36).[3] Another ewer from the treasury of the Abbey of St. Denis (now in the Louvre) can probably be identified as the *lagena* (flagon) that Count Thibaut acquired from Roger II of Sicily and gave to Abbot Suger (d. 1151) of Chartres, but where and how Roger got it remains unknown.[4]

Despite the incredible riches they found, the looters must have reached only the outer (al-dakhila) storerooms of the Fatimid treasuries; the inner (al-barraniyya) stores remained intact, for when Saladin eventually extinguished the Fatimids in 1171, he sent Nur al-Din, his overlord in Damascus, an extraordinary gift assembled from what he found, the value of which amounted to 225,000 dinars.[5] Nur al-Din died before he could receive this largesse.

The Fatimid treasures appear quite incredible to us today—and indeed they were in their own times—but they were probably no more splendid than those collected by the Abbasid caliphs of Baghdad in their prime, who were as rich as, if not richer than, the Fatimids. A taste for luxury and excess was neither exclusively Fatimid nor exclusively Egyptian, although no comparable enumeration of the Abbasid treasures has survived. On a broader historical scale, the Fatimid treasures can be compared to the extraordinary jewels, curios, and relics amassed by other Islamic rulers in later times, whether by the Ottoman sultans, the Qajar and Pahlavi rulers of Iran, or the Mughal emperors of India. Many of the Fatimid treasures appear to have been either received as gifts or intended to be given as gifts to courtiers and supporters, rivals and challengers, in an attempt to secure their loyalty and pursue state policies.

The practical nature of Fatimid gifts is evident from the earliest years of the North African period. At the beginning of the tenth century, the Fatimid leader made his way from Syria to Sijilmasa, a remote Moroccan trading center, where he awaited news from his lieutenants active in Tunisia about their preparations for his public accession. Even before he revealed himself as the Mahdi, or "expected one," he is said to have rewarded one of his associates with gifts and sought to acquire the favor of the ruler of Sijilmasa with rich presents.[6] These are not specified in the sources, but later he gave his faithful eunuch Jawdhar a hundred dinars and a suit of honor, indicating that most gifts at that time were either spendable or wearable.[7] Jawdhar records in his memoirs the receipt decades later of a gift of a thousand dinars, which the caliph al-Mansur (r. 946–53) sent to his family's loyal servant whom he had freed and elevated in rank. In the accompanying letter, the caliph wrote that Jawdhar should accept this money as a benediction, for "no riches are purer than the money which I offer." The gift was to be seen not only as tangible wealth but also as a symbol of the esteem in which the ruler held his former servant.

Clothing was perennially a favorite gift, especially when the caliph had worn it himself. Al-Mu'izz (r. 953–75) sent Jawdhar a pair of raw-silk slippers or

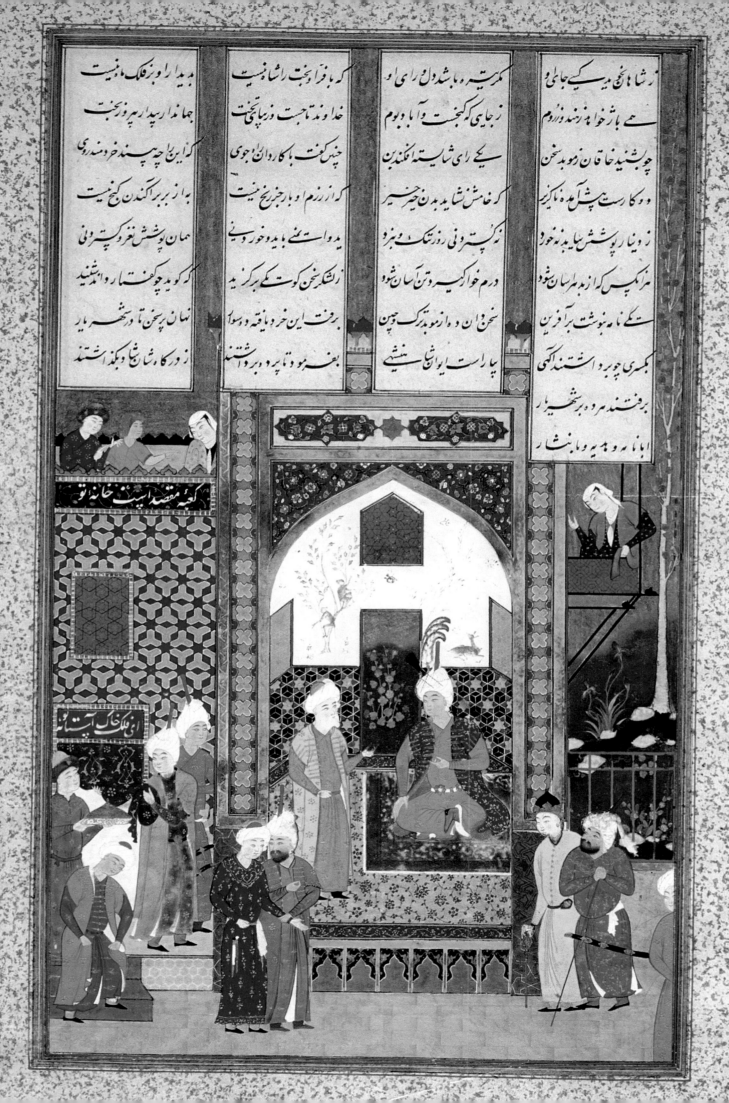

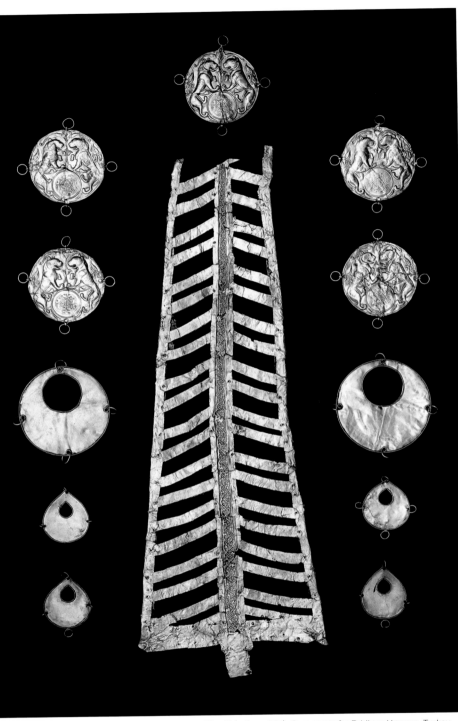

Above: Fig. 91 (cat. no. 134). *Ornaments for Bridle or Harness*, Turkey, 13th century. The David Collection, Copenhagen (3/1976).

Opposite, top: Fig. 92 (cat. no. 135). *Ornamented Bridle*, Spain, Granada, 15th century. The British Museum, London (1890,1004.1).

Opposite, bottom: Fig. 93 (cat. no. 138). *Chest Straps*, Turkey, first third of the 17th century. The State Historical-Cultural Museum Preserve, Moscow Kremlin (K-225).

leggings that both his father, al-Mansur, and then he had worn. The ruler said, "Use them recognizing the blessing and felicity from God on them."[8] Late in life, Jawdhar asked al-Mu'izz for one of his garments to use as a shroud when he died, in order to accrue its blessing. The Fatimid sent back sets of garments from each of his predecessors, including one of al-Mahdi's lined cloaks of monochrome *fakhiti* cloth with a tunic; two tunics, trousers, a turban, and a waist-cord belt of white cloth of al-Qa'im's; a robe of Merv cloth and a tunic of al-Mansur's; and a lined garment of Merv cloth with a tunic from his own wardrobe. He said, "Conserve these garments until the time to which you mentioned, after which God will have prolonged your life so that you will join us in the pilgrimage to the Sacred House of God and the visit of the grave of our ancestor Muhammad—and that this will be a joy to your eyes by the grace of God to his friends, *inshallah*."[9]

A concerted policy of royal gift giving between the Fatimid caliphs and their subjects first appeared during the reign of al-Mansur, when the fledgling Fatimid dynasty was severely challenged by a revolt led by the Berber Kharijite Abu Yazid. Al-Mansur received money, horses, camels, and other animals in tribute from his subjects and provided his supporters with food and clothing in return. He bought—and maintained—the loyalty of important Berber chiefs with gifts of cloth, gold, silver, curios, and treasures "to captivate their souls." He sent one of them, Ziri ibn Manad, robes of honor, perfumes, "kingly curios [*tara'if al-mulukiyya*] of incalculable price and indescribable beauty," and purebred horses whose saddles and bridles were heavy with gold and silver. The ruler himself is said to have amassed the most precious things to be found in his realm and the finest treasures of every kind.[10]

Nevertheless, the major type of gift mentioned in the sources was livestock, particularly riding mounts. In late 946, the Kutama Berber chiefs gave al-Mansur a present, including, among other things, "noble horses (*nujub*), purebred camels, and ordinary horses (*khayl*)."[11] In the same year, the Andalusian 'Ali ibn Hamdun gave the caliph a present of twenty-five horses, twenty-five noble camels, four camels of another type, and a magnificent civet.[12] Aflah al-Nashib, prefect of Barqa (Libya), gave the

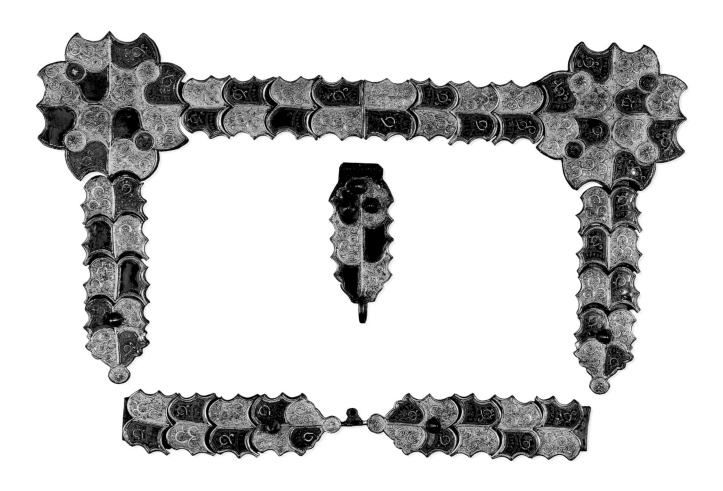

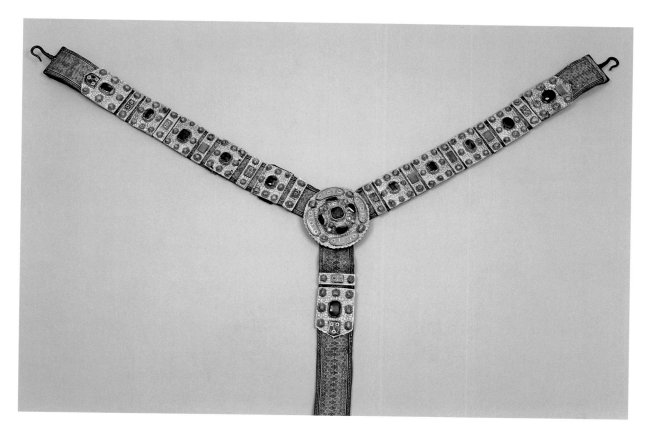

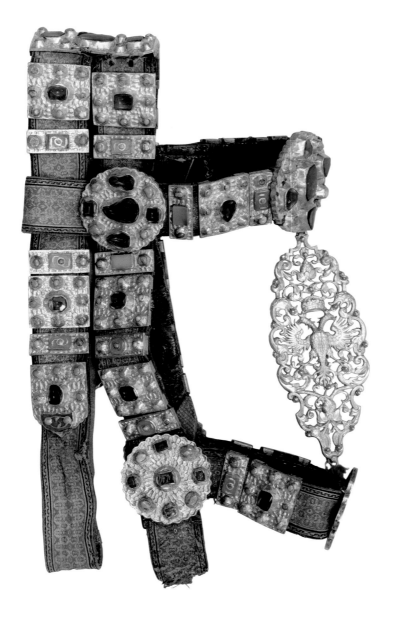

Left: Fig. 94 (cat. no. 137). *Bridle*, Turkey, first third of the 17th century. The State Historical-Cultural Museum Preserve, Moscow Kremlin (K-420).

Below: Fig. 95 (cat. no. 140). *Pair of Stirrups*, Turkey, mid-17th century. The State Historical-Cultural Museum Preserve, Moscow Kremlin (K-216/1–2).

Opposite: Fig. 96 (cat. no. 139). *Saddle*, Turkey, Istanbul, mid-17th century. The State Historical-Cultural Museum Preserve, Moscow Kremlin (K-231).

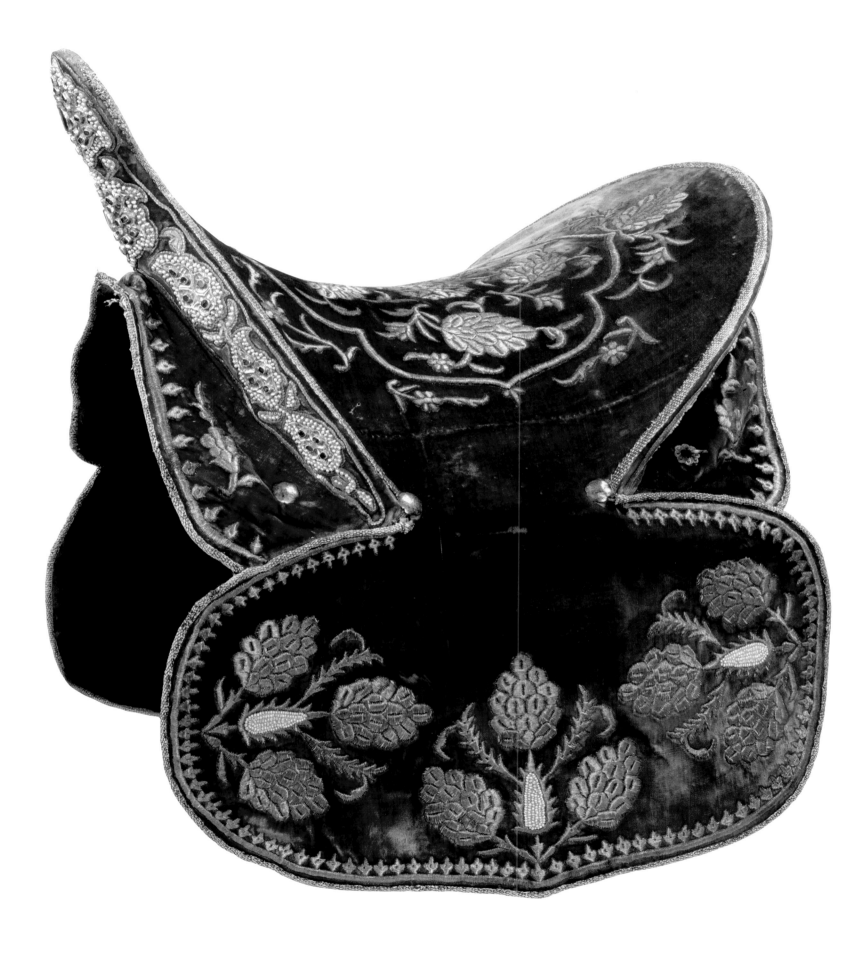

chamberlain Jawdhar about twenty pack animals. Jawdhar claimed that he was not used to receiving gifts—although he had sent Aflah ten camels— so Jawdhar spoke to the caliph al-Mu'izz, who said, "May you continue during our reign to be glorious and illustrious and to reward those who you will by precious gifts, which come to you by God's favor and ours. Generosity is a natural quality, which has at its source nobility of heart and magnanimity."[13] Riding mounts were often given to favored officials because they marked differences in rank among the caliph's followers. Only the elite used horses, and riding a horse that the ruler had ridden, receiving a mount from his stable, or receiving permission to ride in his presence were prerogatives granted by the ruler.[14]

A major occasion for dispensing largesse in this period was the mass circumcision ceremony, in which large numbers of boys throughout the realm participated. In 951–52 al-Mansur's sons were joined by a thousand other boys from Kairouan, the capital city of the region, to whom the ruler distributed new clothes and money.[15] Ten years later, in 962, al-Mu'izz's three sons were circumcised, and the ruler offered free circumcisions throughout North Africa and Sicily. Presents were given according to the family's social status: the sons of courtiers received money and robes of honor according to their fathers' ranks; the children of the townsfolk got between 150 and 250 silver dirhams, while the children of the country people and slaves got only 10.[16]

Once the Fatimids arrived in Egypt, their gifts got larger and finer, primarily because that land was much richer than Ifriqiya. General Jawhar immediately sent back a lavish gift to al-Mu'izz after the army had arrived in Egypt. Along with a group of important prisoners, it included hundreds of camels, mules, and horses, richly caparisoned with brocaded silk textiles and gold and silver fittings decorated with jewels, as well as two enormously long pieces of aloeswood, an odoriferous wood from southeast Asia. The gift was brought down the Nile by boat to Alexandria, whence it was transported overland to Kairouan.[17] Like al-Mansur's earlier gifts to the Berber chiefs, this gift consisted primarily of riding mounts with associated textiles and trappings of precious metal.

After al-Mu'izz arrived in Egypt in 973, he held court in his new palace sitting on a golden throne. Jawhar presented the ruler with the treasures of Egypt, including hundreds of horses, Bactrian camels, dromedaries, and mules, all of them fitted with a variety of fancy harnesses, trappings, and palanquins. In addition there were chests of silver and gold vases, a hundred damascened swords, and caskets of jewels, as well as nine hundred baskets and containers of treasure.[18] In thanks, the caliph gave his general a golden cloth, a red turban, a sword, twenty horses with bridles and saddles, fifty thousand dinars, a hundred thousand dirhams, and eighty chests full of cloth.[19]

The court chronicles of the following two centuries of Fatimid rule in Egypt are replete with many accounts of the receipt and dispatch of various kinds of state and private gifts. These may be subsumed under several categories, ranging from official gifts or tribute from or to regional governors to private gifts to particular individuals.

Gifts or tribute from local governors and officials functioned very much like taxes. In principle, provincial governors, whether in Barqa, the Maghrib, Syria, or Sicily, and tributaries in Nubia sent the ruler every year hundreds if not thousands of horses, donkeys, and camels, complete with saddles, bridles, saddlecloths, baskets, and trappings, as well as chests of money.[20] Black or Slav slaves, servants, and eunuchs were sometimes included in the gift, for example, in 1029, when the North African governor al-Mu'izz ibn Ziri sent al-Zahir twenty "slave girls, the best in form, shape, and size, and one who was superior; they all had silver containers [hiqaq] on their breasts."[21] Sometimes the gift included local products and rare commodities such as wax, saffron, lengths of cloth, and precious stones from the Maghrib or aloeswood and medicines from India. Parasols and cloth coverings (kiswas) for the Ka'ba in Mecca arrived from the Egyptian weaving centers of Tinnis, Damietta, and Farama.[22] Perhaps the most famous was the bakht, or Nubian tribute, which arrived, for example, in the year 993, accompanied by an elephant and a giraffe (fig. 102).[23] In 1023, in addition to the usual riding mounts and slaves, the gift included a lynx, rare birds, monkeys, and elephant tusks (fig. 88).[24] Rare

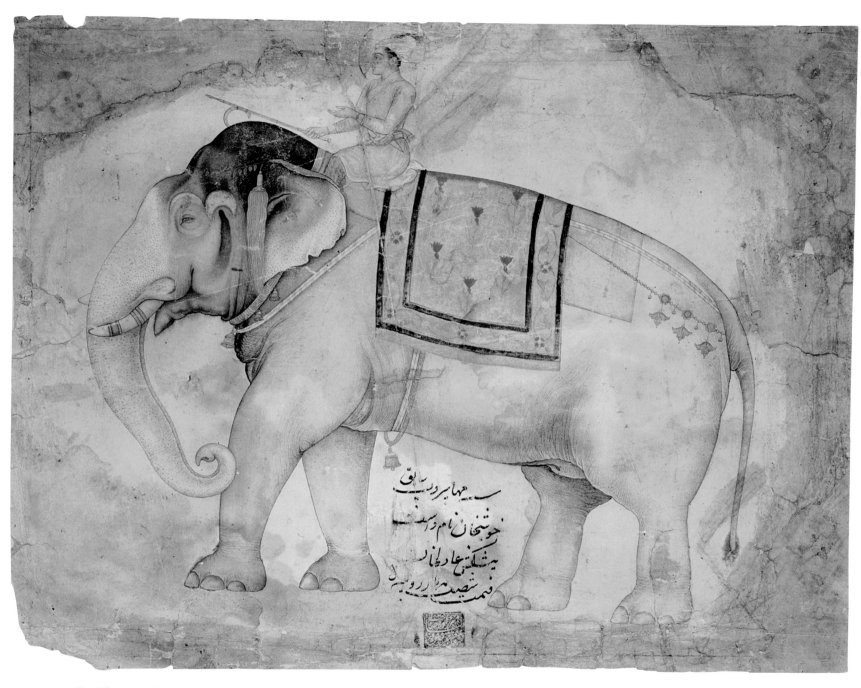

Fig. 97 (cat. no. 222). *Dara Shikoh Riding the Imperial Elephant, Mahabir Deb*, India, c. 1635–50. Victoria and Albert Museum, London (IM 23-1928).

animals, such as lions, leopards, and salukis were sometimes sent from the Maghrib.[25] In return, the caliph gave gifts to cement relationships and ensure continued loyalty, for example, al-Zahir's gift to Mu'izz ibn Badis in 1031 (see Wheeler Thackston's translation on page 110 of this volume).

The caliph presented military commanders with gifts to reward a successful campaign or with material to conduct one. In 978 al-'Aziz presented the commander of the Syrian army with a golden *mandil* (cloth) and a sword decorated with gold; he was carried on a horse; there were four other horses for his procession as well as a hundred thousand dirhams and fifty pieces of colored cloth.[26] In the following year the caliph sent the victorious general al-Fadl ibn Salih a hundred horses, fifty Bactrian camels, a hundred donkeys, a hundred she-camels, robes of honor, a hundred pieces of cloth, and twenty thousand dirhams; he was allowed to ride in parade with five horses before him.[27] In 991 al-'Aziz sent Manjutakin, his general in Syria, a present including robes of honor (e.g., fig. 98), a hundred thousand dinars, a hundred pieces of colored cloth, ten palanquins with coverings, a heavy girdle, crescents, and rugs, along with a more useful supply of fifty banners, ten mangonels, and ten horses.[28] A year later the same general received fifty loads of money, fifty loads of bundled cloth, weapons, and five hundred horses, which he presumably used in his successful campaign against the Byzantine army.[29]

The Fatimid caliphs rewarded their courtiers with lavish gifts. On ordinary occasions courtiers were rewarded with robes of honor, often woven with gold, and riding mounts with all the trappings.[30] When a son was born to the vizier Ibn Killis, al-'Aziz sent him a cradle of sandalwood studded with jewels and three hundred pieces of cloth, ten thousand dinars, and fifteen horses with saddles and bridles, two of them of gold. All that was worth a hundred thousand dinars.[31] When a son was born to the Syrian commander, al-Fadl ibn Salih, al-'Aziz sent him thirty cloths of high quality, ten gowns, ten turbans, gold cloth, a *mandil* a hundred cubits long, a shorter *mandil*, and five hundred dinars. The caliph's wife also sent him a hundred different types of cloth, three hundred dinars, and two cradles, one of ebony plated with gold and the other

of sandalwood plated in silver and niello. Both had covers and pillows and spreads of cloth-of-gold.[32] When the vizier Ibn Killis died in 990, the caliph gave a gift worth ten thousand dinars. It included the grave clothes, fifty pieces of *dabiqi* linen, thirty of them woven with gold thread, golden figured cloths, more *dabiqi* linen with gold, perfumes, a box of camphor, two flasks of musk, and fifty *mann* (quarts) of rose water.[33]

The caliphs exchanged gifts with family members. In 979 al-'Aziz married a woman and settled a hundred thousand dinars on her.[34] Twenty years later, Sitt al-Mulk, al-'Aziz's daughter and sister of al-Hakim, offered her brother gifts including thirty horses with gold stirrups, one of which was studded with jewels; another stirrup made of several pieces of rock crystal; twenty she-mules with their saddles and bridles; fifty eunuchs, ten of them Slavs; a hundred chests containing a variety of splendid garments; a crown studded with precious stones; a gem-studded cap (*shashiyya*); many baskets containing various types of scents; and an ornamental orchard made of silver depicting many different types of trees.[35]

The Fatimid caliphs also exchanged diplomatic gifts with Muslim and non-Muslim rulers. For example, on April 16, 1024, a gift arrived from the Ghaznavid ruler of Khurasan, Abu 'Ali al-Hasan ibn Muhammad, to al-Zahir, but we have no idea of what it contained, although it is possible that some of the items were later "regifted" to the Maghrib.[36] In June 1035 the prince of Aleppo sent a fine gift to al-Zahir.[37] We do know that the gift by Ibn Mujahid, the ruler of Denia in al-Andalus, to al-Mustansir in 1060 was worth a hundred thousand dinars and included a string of pearls valued at ten thousand dinars and beautiful silk fabric with gold threads.[38] Two years later, the same ruler sent furnishings, fabrics, raw silk, slaves, and eunuchs, along with other precious and valuable things including thirty "perfectly straight coral rods as thick as arrows or reed pens, the like of which no one had ever seen before."[39]

Particularly important diplomatic gifts were exchanged with the Byzantine emperors of Constantinople (see also Anthony Cutler's essay in this volume). For example, Basil II (976–1025) sent al-'Aziz (975–96) the magnificent gift of

Fig. 98 (cat. no. 22). *Tiraz*, Egypt, Tinnis, AH 375/985–86. Benaki Museum, Athens (15105).

twenty-eight enameled trays (*siniya*) inlaid with gold (i.e., cloisonné), each one valued at three thousand dinars.[40] In 1045–46 the Byzantine emperor Constantine IX Monomachos sent a gift to al-Mustansir to conclude the renewal of an armistice between the two powers. The gift consisted of one hundred fifty beautiful she-mules and selected horses, each of them covered with a brocade saddlecloth. These were followed by fifty mules carrying fifty pairs of chests, covered with fifty pieces of thin silk brocade. Two hundred Muslim prisoners of war who had been in captivity led them. In the chests were a hundred gold vessels of various kinds inlaid with enamel; a thousand pieces of different kinds of brocade; red Byzantine girdles bordered with gold; high turbans of a fine and resistant fabric embroidered with gold; and drapes and brocade wrappers. The value of the gift amounted to thirty *qintars* (i.e., three hundred thousand dinars or 1,270 kg) of gold.[41]

A few years later in 1052–53, Michael VII Doukas (r. 1050–67) sent an envoy with magnificent gifts to al-Mustansir. Among them were Turkish slave boys and girls; white partridges, peacocks, cranes, herons, ravens, and starlings; huge bears that played musical instruments; and salukis and guard dogs. There were also boxes and chests of rarities and seventeen hundred bottles worth seven dinars each of "special fine drinks enjoyed by the emperor and kept in his wine cellar."[42] Perhaps included in this gift were three enamel on gold

(i.e., cloisonné) saddles, said to be from the trappings of Alexander the Great, and five exquisite bracelets inlaid with five colors of glass—blood red, pure white, pitch black, pure blue, and rich sapphire—for al-Mustansir's mother.[43]

The Fatimids also offered gifts to places of worship. Soon after conquering Egypt, the Fatimids were recognized as caliphs in Mecca and Medina, the holy cities of Arabia. Only a few months after al-Mu'izz had arrived in Egypt, the *shamsa*, a sun-shaped circular ornament, which he had ordered made for the Ka'ba in Mecca, was displayed in the palace for all to see. It measured twelve spans (about nine feet) across. Its background was of red brocade; around it were twelve golden crescents containing a pierced golden sphere, each holding fifty pearls the size of pigeon eggs as well as red, yellow, and blue stones. Around the edge was *Surat al-Hajj* (the pilgrimage chapter, Qur'an 22) written in green emeralds against a ground of huge white pearls. The *shamsa* was filled with powdered musk.[44] Al-Mu'izz is also said to have ordered mihrabs made of gold and silver inscribed with his name for the interior of the Ka'ba.[45] These gifts would have been carried by the annual pilgrimage caravan to Mecca along with supplies of grain, flour, wax, and oil, gifts for the *sharifs* (notables), money, and the kiswa for the Ka'ba.[46]

Other mosques and shrines also received gifts. For example, in 1012 al-Hakim gave 814 copies of the Qur'an to the mosque of Ibn Tulun.[47] In 1046

برشيد وبسعادت بساط بوس ناى بكشت وانراى نامدان وسين ودان مقدار مثل ياذكان برلاسن ميردى بيك وقادا
حسينى ودا دملك برلاسن يبريح محمد طغى بوغابرلاسن وسعادت مور تاثر ودولت مور تواجر وغيرهم يذرهرم يذركاه عالم بناه شتا

Opposite: Fig. 99 (cat. no. 219). *Timur Receiving Gifts from the Egyptian Ambassadors*, left half of a double-page composition from a manuscript of the *Zafarnama* of Sharaf al-Din 'Ali Yazdi, Iran, Shiraz, AH Dhu'l-Hijja 839/ July 15–16, 1436. Worcester Art Museum (1935.26).

Above: Fig. 100 (cat. no. 218). *Timur Receiving Gifts from the Egyptian Ambassadors*, right half of a double-page composition from a manuscript of the *Zafarnama* of Sharaf al-Din 'Ali Yazdi, Iran, Shiraz, AH Dhu'l-Hijja 839/ July 15–16, 1436. Keir Collection, England (PP5).

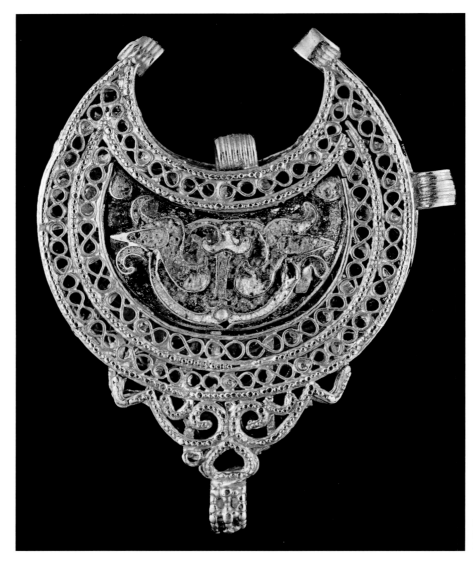

Fig. 101 (cat. no. 11). *Pendant*, Egypt, 11th century. The British Museum, London (19,810,707.2).

al-Mustansir ordered a belt (*mintaqa*) of silver made for the back of the great mihrab of the Mosque of Amr inscribed with his name and two collars of silver for the mihrab's columns.[48] The eleventh-century Persian traveler Nasir-i Khusraw particularly admired a set of silver lamps in the Dome of the Rock in Jerusalem that was a gift of the Fatimid caliph, presumably al-Zahir; they were inscribed around the bottom with the patron's name written in gold.[49] In 1122 the caliph al-Amir (r. 1101–31) used two thousand dinars he received to have cast two candelabra of gold and two of silver, one of each for the shrine of the Prophet's grandson Husayn in Ascalon and the other two for the Fatimid ancestral tomb in the Cairo palace.[50]

The objects in this exhibition and associated catalogue can only hint at the extraordinary riches of Fatimid gifts and of their treasuries, but when looking at these works of art we should remember the abundant textual sources that provide contexts not only for the Egyptian objects of the period but also for objects from other times and places when and where the literary record is not so rich.

Notes

1 For a general overview of the arts of the Fatimid period, see Bloom, *Arts of the City Victorious*.

2 Maqrizi, *Khitat*, vol. 1, 408.

3 Bloom, *Arts of the City Victorious*, 101.

4 Shalem, *Islam Christianized*, 60–61; Johns, *Arabic Administration in Norman Sicily*, 266–67 and n48; Bloom, *Arts of the City Victorious*, 195.

5 Bloom, *Arts of the City Victorious*, 176.

6 Halm, *Empire of the Mahdi*, 129 and 169.

7 Canard, trans., *Vie de l'ustadh Jaudhar*, 51.

8 Ibid., 169.

9 Ibid., 211–12 and n465.

10 Bloom, "Origins of Fatimid Art," 27–28.

11 Ibn Hammad, *Akhbar muluk*, 43.

12 Ibid., 43.

13 Canard, trans., *Vie de l'ustadh Jaudhar*, 141.

14 Sanders, *Ritual, Politics, and the City in Fatimid Cairo*, 22.

15 Ibn Hammad, *Akhbar muluk*, 60.

16 A dinar was a gold coin weighing four and a quarter grams; approximately thirteen and a third silver dirhams were equal to one dinar. In the Fatimid period, two dinars were considered sufficient to support a lower-middle-income family each month. In 1967, S. D. Goitein estimated the economic value of a dinar with approximately a hundred dollars. Adjusting for inflation, a dinar might be equivalent in buying power to a thousand dollars today. Goitein, *Mediterranean Society*, vol. 1, 359.

17 Maqrizi, *Itti'az*, vol. 1, 121, essentially the same as Ibn al-Zubayr, *Kitab al-dhakha'ir*, ed. Muhammad Hamidullah, 67. The North African historian Ibn Hammad (d. 1230) preserves a somewhat different version of the gift, which was worth over six hundred thousand dinars. Ibn Hammad, *Akhbar muluk*, 68.

18 Maqrizi, *Itti'az*, vol. 1, 135, and Maqrizi, *Khitat*, vol. 1, 385.

19 Maqrizi, *Itti'az*, vol. 1, 139.

20 E.g., ibid., 249 and 252.

21 Ibid., 278, 290; vol. 2, 177; Ibn al-Zubayr, *Kitab al-dhakha'ir*, 68 ff.

22 Maqrizi, *Itti'az*, vol. 1, 278, 283, 287, vol. 2, 177; Ibn al-Zubayr, *Kitab al-dhakha'ir*, 81; Qaddumi, trans., *Book of Gifts and Rarities*, 108.

23 Maqrizi, *Itti'az*, vol. 1, 279; on the *bakht*, see *Encyclopaedia of Islam*, 2nd ed., under the word.

24 Maqrizi, *Itti'az*, vol. 2, 134.

25 Ibn al-Zubayr, *Kitab al-dhakha'ir*, sec. 81; Qaddumi, trans., *Book of Gifts and Rarities*, 108. In 991–92 a peasant woman gave al-'Aziz a lion she had suckled, which was the size of a big sheep. See Maqrizi, *Itti'az*, vol. 1, 272.

26 Maqrizi, *Itti'az*, vol. 1, 246.

27 Ibid., 249.

28 Ibid., 269.

29 Ibid., 274; Lev, *State and Society in Fatimid Egypt*, 87.

30 E.g., Maqrizi, *Itti'az*, vol. 2, 133, 135; Maqrizi, *Khitat*, vol. 1, 440.

31 Maqrizi, *Itti'az*, vol. 1, 252.

32 Ibid., 271.

33 Maqrizi, *Khitat*, vol. 2, 7.

34 Maqrizi, *Itti'az*, vol. 1, 252.

35 Ibn al-Zubayr, *Kitab al-dhakha'ir*, sec. 78; Qaddumi, trans., *Book of Gifts and Rarities*, 104.

36 Maqrizi, *Itti'az*, vol. 2, 137.

37 Ibid., 182.

38 Ibn al-Zubayr, *Kitab al-dhakha'ir*, sec. 83; Qaddumi, trans., *Book of Gifts and Rarities*, 109.

39 Ibn al-Zubayr, *Kitab al-dhakha'ir*, sec. 96.

40 Maqrizi, *Khitat*, vol. 1, 415, line 17.

41 Ibn al-Zubayr, *Kitab al-dhakha'ir*, sec. 82; Qaddumi, trans., *Book of Gifts and Rarities*, 108–9; on the value of a *qintar*, see Hinz, *Islamische Masse*, 24–27.

42 Ibn al-Zubayr, *Kitab al-dhakha'ir*, sec. 85; Qaddumi, trans., *Book of Gifts and Rarities*, 110.

43 Ibn al-Zubayr, *Kitab al-dhakha'ir*, secs. 97–98; Qaddumi, trans., *Book of Gifts and Rarities*, 113–14; these do not seem to be the same saddles that were discovered in 1069 in a locked basket found in one of the palace's storerooms while looking for things to take out to sell to pay the men's salaries. The basket was opened and in it were four saddles, one of which was made of black brocade with cast gold sides and stirrups, entirely studded with white jasper of fine quality. The saddle's straps were made of black leather as soft as silk. The metallic parts of the bridle were all made of gold that was also studded with white jasper, and its Sudanese straps were of the best available leather. On it was affixed a note in the handwriting of al-Mu'izz li-Din Allah that read, "The Byzantine emperor offered us this saddle and bridle after we conquered Egypt." And it was one of the six saddles that had belonged to Dhu'l-Qarnayn (Alexander the Great) and were transferred from him to the Byzantine treasuries. Al-Mustansir kept it as it was, making no changes. The three remaining saddles in the basket were made of gold and stuffed with ambergris; they had once belonged to al-Zahir, and twelve thousand dinars worth of gold had been used for each saddle. See Ibn al-Zubayr, *Kitab al-dhakha'ir*, sec. 99, Qaddumi, trans., *Book of Gifts and Rarities*, 114.

44 Maqrizi, *Itti'az*, vol. 1, 140–42; Maqrizi, *Khitat*, vol. 1, 385; Musabbihi, *Tome Quarantième*, 44.

45 Maqrizi, *Itti'az*, vol. 1, 230.

46 Ibid., 222, 230, 246, 253, 279, 289.

47 Ibid., vol. 2, 96.

48 Maqrizi, *Khitat*, vol. 2, 251, lines 4 ff. These were later removed by order of Saladin on AH 11 Rabi' I 567/November 12, 1171.

49 Thackston, trans., *Naser-e Khosraw's Book of Travels*, 32.

50 Maqrizi, *Khitat*, vol. 1, 407–8.

Kitab al-Dhakha'ir Excerpt

And al-Zahir li-I'zaz-dinillah dispatched to al-Mu'izz a magnificent gift including curiosities from India, China, and Khurasan and various perfumes, gems, etc. beyond reckoning. There were costly fabrics from Tinnis, Damietta, and Tuna, clothing, spreads, hangings, banners, flags, and pennants on silver poles decorated with gold and exotic shapes. He also sent him a giraffe of beautiful form, a number of Bactrian camels bearing litters and domes made of ivory, ebony, and sandalwood embossed with gold and silver crescents on top, red gold-shot Khurasani fabric, gold-spun velvets and silks, and others of all sorts and colors. There were also beautiful slave girls singing and dancing and an ample number of handsome man servants in gorgeous costumes. There were also many Arabian horses of great value and marvelous qualities, most with gold and silver saddles, jewels, ambergris, and camphor of unequaled manufacture. There were gilded coats of mail, helmets, breastplates, and bejeweled swords that could not be equaled.

Translated by Wheeler Thackston from Ibn al-Zubayr, *Kitab al-dhakha'ir wa'l-tuhaf* (Book of Gifts and Rarities), ed. Muhammad Hamidullah, sec. 80.

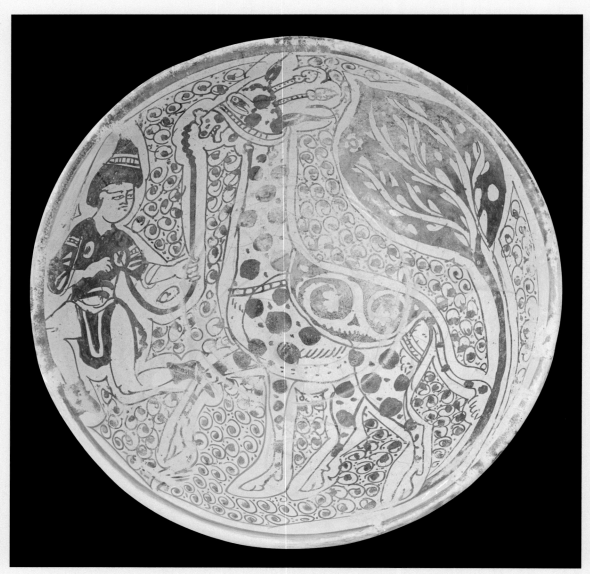

Fig. 102 (cat. no. 217). *Bowl with Giraffe*, Egypt, 11th century. Benaki Museum, Athens (749).

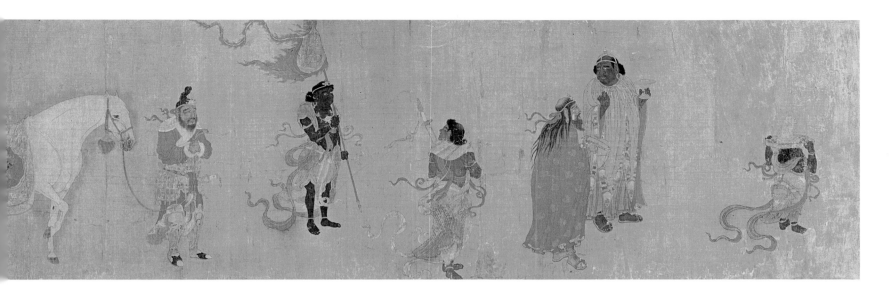

arghumagh horse[2] was exchanged for four sets of colored satin and eight rolls of cheap silk.[3] When the Timurids commenced diplomatic relations with Ming China they obviously wanted to gain their favor and promote relations and trade by presenting comparatively high numbers of horses to the Ming court. Fifteen horses and two camels—another animal that was important as a gift, though not nearly as sought after as horses—were driven to China in 1387, with three hundred horses and two camels in 1388, and probably with another embassy in 1389 an additional two hundred five horses, while the largest such gift was six hundred seventy horses in 1390.[4] This last embassy, however, wanted to sell its horses at the border but was ordered by imperial decree to bring them to the Chinese capital instead—another indication of the intertwining of commercial and official embassies. These horses were either driven all the way from the Central Asian heartlands of the Timurids or were acquired along the way before the envoys reached the Chinese borders. One must remember that the trading of horses for tea was an important activity at the Chinese borders, and the Mongols and other people of the steppes were eager to acquire Chinese goods in this way.[5]

Besides these exchanges, it was obviously also the custom of the Timurid princes and governors to present the Chinese emperors with exceptional horses, which were regarded as excellent tribute items and had personal connotations, because the sender's name was always mentioned. We find several examples of such superb horses in Chinese and Timurid texts. Governor Sayyid Ahmad Tarkhan presented a sorrel horse (*asb-i buri*) to Emperor Zhudi, who found this gift so praiseworthy that he sent back not only many expressions of gratitude but also an excellent painting of the horse to the Timurid governor.[6] This painting has not survived but may have been similar to a Chinese painting mounted in a Persian album (fig. 107). This was not the only painting of a tribute horse sent from the Timurid Empire, because the Ming Annals also mention a black horse, with a white head and white fetlocks, named "Auspicious Piebald" and accordingly portrayed.[7] Timur's grandson Ulugh Beg, governor of Samarqand in the first half of the fifteenth century, had also presented to Emperor Zhudi a horse with white fetlocks that was also highly admired and even ridden by the emperor himself.[8] Such imperial favors, however, could turn sour, as when the same emperor was tossed by a horse sent by the Timurid ruler Shahrukh (r. 1405–47) and hurt his foot. This incident had the potential to become extremely dangerous for the envoys because they could easily have been held responsible for it, but fortunately due to the intervention of Chinese officials, who might themselves have been ambassadors to Herat, the situation was peacefully resolved and the Timurid envoys were

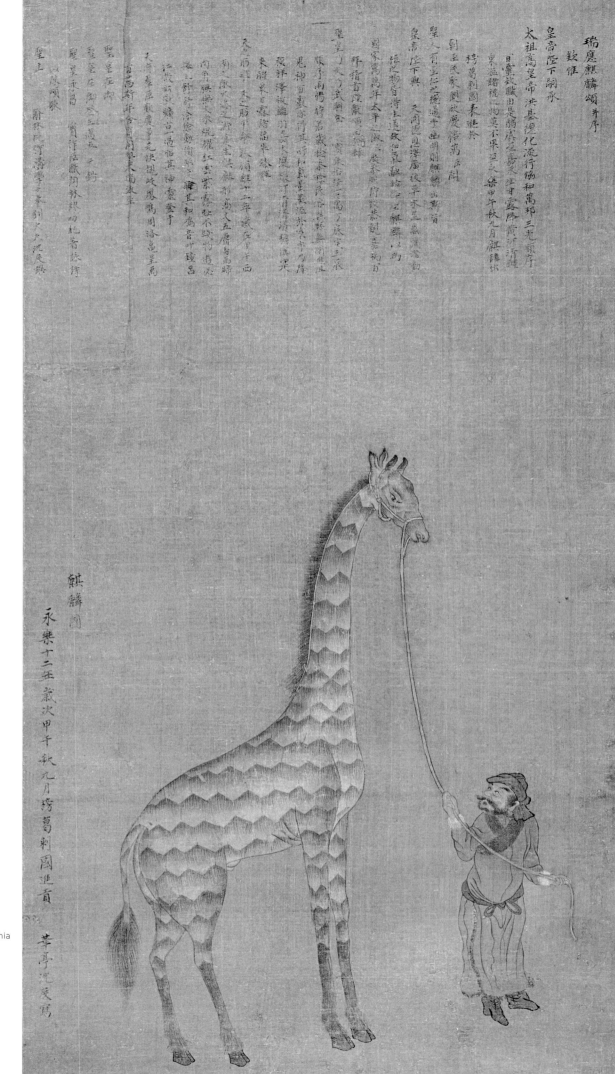

Fig. 106 (cat. no. 220). *Giraffe with Attendant*, China, Ming dynasty (1403–34). Philadelphia Museum of Art, gift of John T. Dorrance, 1977 (1977-42-1).

released. The main argument of these officials was that the ambassadors themselves could not be held responsible for the behavior of horses sent with them as tribute presents by their sovereigns.[9]

As we have already seen, horses were not the only tribute animals brought to China, but also camels and donkeys are mentioned in Chinese texts. In addition to such "useful" animals, lions, leopards, and lynxes were also presented.[10] Such gifts were obviously intended to stock the imperial gardens, together with elephants, rhinoceroses, ostriches, and giraffes—a veritable zoo seems to have existed in the Ming palace (see fig. 106).[11]

Such beasts, however, were not always welcome; their import provided officials who opposed foreign embassies and the expenditures involved in supplying and entertaining them with arguments against the numerous missions. They complained especially about the amount of food these animals were said to consume at great expense. One lion would need one or two sheep per day,[12] two jugs of vinegar, some bitter wine, and even honey with cream.[13] In fact, a lion in captivity needs to eat a maximum of ten kilograms of meat (bones included) each day and thereafter should fast one or two days per week. On a diet of one or two sheep, the lion would be significantly overfed; while wine, vinegar, and honey were not suitable at all. Given this curious mixture of food components, it rather seems likely that the keepers of the lions, who often came from Central Asia, took their "share" of the animals' provisions. At the beginning of the Ming dynasty such beasts were obviously more welcome at court, but in later years the emperors adopted the negative attitude of their officials toward such gifts, and already Xuanzong regarded a giraffe brought by a mixed embassy to the court in 1433 with a pragmatic eye and no longer considered the animal an auspicious symbol.[14] The same may have been true for lions brought from Central Asia. Apart from the live beasts, their skins were also presented to the emperors, but obviously not in very great numbers. The animal tribute can thus be divided into rather practical gifts such as horses, camels, donkeys, and skins, which were in high demand in China, and more ceremonial gifts such as wild beasts and first-rate horses designated for the emperors' personal use.

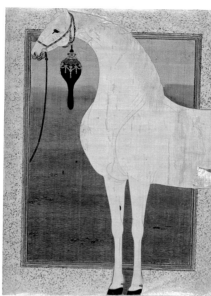

Fig. 107. *Horse and Chinese Grooms*, Ming dynasty, China, 15th century, double-page painting from the Bahram Mirza Album. Topkapi Saray Museum Library, Istanbul (H.2154, fols. 33a-34a).

Besides animals, the Timurids had other things to offer that were summarily labeled as "local products." The administrative handbook of the Ming, the *Da Ming huidian*, enumerates the following tribute brought from Samarqand, the main hub of the Silk Road during that period (for the sake of completeness the animals already mentioned shall also be listed): horses, camels, jade stones, different kinds of pearls, precious stones, crystal bowls, foreign bowls, coral boughs, wood oil, woolens (*suf*), glassware, swords and files made of fine steel, sal ammoniac, lapis lazuli [?], mirrors, horns of antelopes, and furs of ermine and of an unknown animal.[15] Some of these products were obviously not native to Samarqand, coral or jade for example, but were imported from other places or acquired elsewhere. Raw materials prevail, and none of these gifts were precious enough to be given to the emperor.

In the latter part of the dynasty, jade seems to have become the principal tribute item, if the Jesuit monk Benedict Goës, who traveled from India to China in the first years of the seventeenth century, is to be believed.[16] Jade is also reported in the Veritable Records as an important gift from Central Asia. Here it should be noted that it was only acquired en route in the Tarim Basin, because its main source was the area around Khotan; it could also be conveniently

Above: Fig. 108 (cat. no. 235). *Textile Fragment*, China, late
13th–early 14th century. The State Hermitage Museum,
St. Petersburg (LT-449).

Opposite: Fig. 109 (cat. no. 236). *Textile Fragment*, China,
Central Asia, or Egypt, early 14th century. The State Hermitage
Museum, St. Petersburg (EG-905).

exchanged for other, more necessary goods in that area. Poor-quality jade gave Chinese officials reason to complain about the visiting embassies.

But what were the return gifts of the Chinese emperors to the ambassadors and their sovereigns? The answer can be succinctly given: silks, in all possible grades. German geographer Ferdinand von Richthofen named the Silk Road not without reason—silk attained at least partially the status of a currency. The *Da Ming huidian* lists the following kinds of silks given to embassies of Samarqand: fine silk, gauze, woolen silk, white-washed cloth, taffeta, and satin (it also lists vermilion lacquered bowls).[17] Other textiles of linen and cotton were occasionally also given as presents. In earlier times the envoys often received paper money, which had to be spent in China; this sort of reward was certainly not much esteemed, but rather they must have preferred silver, which was often a return gift. Dragon robes with four-clawed beasts (five were reserved for the Chinese emperor) were a very rare gift, one probably not granted to Timurid rulers.[18]

None of the gift items exchanged between the Ming emperors and the Timurid sultans have survived to the present day. The reason was probably the ephemeral nature of most of these gifts. Highly elaborated manufactures were not on the gift lists.

Notes

1 See Maitra, trans., *Persian Embassy to China*.

2 Bretschneider, *Mediaeval Researches*, vol. 2, 264n1071.

3 *Ming shilu, Yingzong*, j. 264, 5623.

4 *Ming shilu, Taizu*, j. 185, 2779–80, j. 193, 2904, j. 197, 2962, j. 199, 2983.

5 Rossabi, "Tea and Horse Trade," 144.

6 Hafiz-i Abru, *Zubdat at-tawarikh*, vol. 2, 665–66.

7 *Ming shi*, j. 332, 8599.

8 Maitra, trans., *Persian Embassy to China*, 106.

9 Ibid., 102–5.

10 A lynx of the caracal variety was also portrayed in a painting but not for the purpose of pleasing an emperor. The local commander of the borders ordered that the painting be made and sent to the court so officials there could determine whether this beast should be sent on. See Bretschneider, *Mediaeval Researches*, vol. 2, 266.

11 Church, "Giraffe of Bengal," 3.

12 *Ming shi*, j. 332, 8600–8601, 8626–27.

13 Ibid., j. 332, 8600.

14 *Ming shilu, Xuanzong*, j. 105, 2341.

15 Li Dongyang et al., *Da Ming huidian*, j. 107, 1609.

16 Yule and Cordier, trans. and ed., *Cathay and the Way Thither*, vol. 4, 218–19.

17 Li Dongyang et al., *Da Ming huidian*, j. 112, 1656.

18 Cammann, "Presentation of Dragon Robes."

Top: Fig. 110 (cat. no. 29). *Dish*, inscribed with the name of Jahangir
(r. 1605–27) and dated AH 1021/1612, China, Hongzhi mark and period
(1488–1505). Victoria and Albert Museum, London (551-1878).

Bottom: Fig. 111 (cat. no. 31). *Dish*, inscribed with the name of Shah
Jahan (r. 1628–57), China, Yuan dynasty, c. 1350–1400. Asia Society,
New York: Mr. and Mrs. John D. Rockefeller 3rd Collection (1979.150).

From Chapter 15 of the *Khataynama* (Book on Khatay), Presented to the Ottoman Court in 1520

About the Peoples Coming from All Directions of the World

The peoples coming by land, from the realms of Islam, are only allowed to come as envoys to the Chinese. Coming from villages or impressive cities, chieftains or mighty shahs, lords or slaves, all are the same, because they do not accept a city and a pasture in the world except of their kingdom.

The gifts which the people who come by land bring are wares such as horses, diamonds, woolens, woolen cloaks, namely broad cloth, jasper, myrtle, coral, ermines, coral, lions, leopards, and lynxes—all these are at the gate of this region.

They accept all pack horses, and hand them over to the frontier guards. They send the good horses along with the master of the horse to the shah, and they give twelve attendants to each of them from one post station to the next, altogether one hundred post stations.

Six of these twelve persons walk with colored lanterns on speckled sticks in the front, the back, left, and right of this horse, and of the six other attendants, three are in his front and three at his back.

A lion gets ten times as much cortege and rations as a horse, and a leopard and a lynx get half of the amount for a lion and rations. The hundred post stations are all the same in this respect.

The presents that they give for a lion are: thirty chests of goods, and in each chest are a thousand pieces of cloth as satin, damasks, stockings, iron bands for saddles, Chinese coverings for saddles, scissors, knives, and even needles, of each sort one piece, altogether one thousand pieces in one box—for a lion thirty boxes, for a leopard and a lynx fifteen boxes, and for a horse one tenth of a lion. They give to each man of the entourage eight webs of satin with an armful of coarse silk, three webs of colored satin to wrap around the head; one web would be enough to clothe two persons.

There is a muslin garment that measures one fathom, for stockings and other things. All these mentioned presents are given regardless of the price. All these are presents and gifts of the emperor of China to each of the Muslims to whom God the Supreme has now given the faith, and the belief to peace has been brought to him, though his ancestors had ruled several thousand years in unbelief.

Translated by Ralph Kauz from Khata'i, *Khataynama*, ed. Iraj Afshar, 143–44.

From the *Ming shilu, Xiaozong* (Veritable Records of the Ming Dynasty)

On June 25, 1490 (third year of the Hongzhi reign, sixth month, *jichou*) Han Ding, vice supervising secretary of the office for scrutiny of the rites, sent a memorial to the throne: "When the people of the four barbarians came to pay tribute, they could see the benefits of the Imperial Government. As the strange things were not esteemed, they could even more see the abundance of the imperial virtues. Recently, the place Samarqand brought lions and other beasts as tribute. Inside, they have no beauty for the palace, outside, they have no use in military matters. Moreover when they come they disturb in a hundred matters, and when they arrive the provisions are innumerable. The inexhaustible provisions are provided with the blood and the fat of the humble folk. What is the use of this? I ask for an imperial decree that the barbarian people who bring tribute from this day forward are not allowed to select strange beasts, scheming to their advantage. Thus let the people from afar know that our emperor does not esteem strange things, that he wants nothing without use." It was decreed that all offices should know this.

Translated by Ralph Kauz from the *Ming shilu, Xiaozong*, j. 39, 823–24.

巳丑，禮科左給事中韓鼎上疏曰『四夷朝貢，固足以見聖治之盛。不貴異物，尤足以見聖德之隆。邇者撒馬兒罕地面貢獅子等獸，內非殿廷美，外非軍旅切用。況來則騷擾百端，至則糜費無算，以小民之膏血供無窮之糜費。果何益之有哉？乞勑，番人今後進貢，不許覓取奇獸，規圖厚利。庶使遠人知我皇上不貴異物，不作無益出於尋常萬萬也』命所司知之。

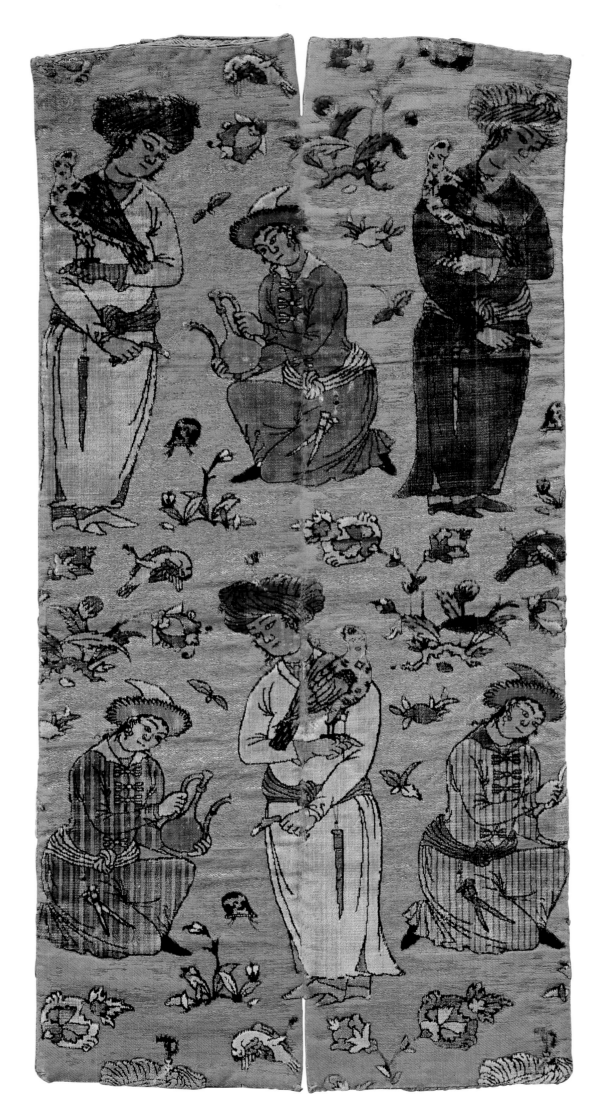

Gifts for the Shah: An Episode in Hapsburg-Safavid Relations during the Reigns of Philip III and 'Abbas I

MARIANNA SHREVE SIMPSON

On June 16, 1618, 'Abbas I, ruler of the Safavid dynasty of Iran (r. 1587–1629), received an embassy sent by Philip III, ruler of the Hapsburg dynasty of Spain and Portugal (r. 1598–1621), in the former capital city of Qazvin. The Hapsburg delegation was led by a Castilian nobleman named Don Garcia de Silva y Figueroa, who, after a ceremonial procession through the streets of Qazvin, presented Shah 'Abbas with several hundred gifts on behalf of King Philip and on his own account. These included weapons, textiles, gold and silver objects, and paintings, as well as dyestuff, spices, and a large dog. The presentation was followed by a dinner al fresco that lasted until midnight.

While the quantity of items brought by Don Garcia may have been worthy of note, there was nothing particularly unusual or original about their variety within the context of early-modern, international gift giving in general and European (specifically Hapsburg) and Iranian (specifically Safavid) diplomatic interaction in particular. Indeed, in many respects Don Garcia's embassy and the accompanying presents exemplified a repeated and complex series of interchanges between the Hapsburg and Safavid dynasties that intensified and culminated during the reigns of 'Abbas I and Philip III. While accounts of these exchanges abound, often in the form of contemporary travel narratives, and the rich documentation they contain is mined increasingly by modern-day scholars of diplomatic, economic, and geopolitical history, relatively little attention has been paid to the place and purposes of the gifts and particularly those that today would be considered works of art, which such east-west/west-east missions invariably involved.[1]

The Don Garcia embassy is especially useful in evaluating the role of gifts as instruments of

Opposite: Fig. 112 (cat. no. 167). *Diplomatic Pouch* (front and back), Iran, Yazd, early 17th century. The Danish Museum of Art and Design, Copenhagen (D1227).

Above: Fig. 113 (cat. no. 216). *Portrait of a Georgian Ghulam (Shahzada Muhammad Beg)*, Riza 'Abbasi, Iran, Isfahan, c. 1620–23. Museum für Islamische Kunst, Berlin (Ms. 4593).

international and intercultural relations between Safavid Iran and Hapsburg Spain and Portugal since the extensive primary and secondary sources, including the ambassador's own account, or *Comentarios*, of his mission, allow us to follow virtually the entire process of gift giving, from the consultations about and choice of types of objects and even specific pieces within the upper echelons of Philip III's court to their transportation from Europe to Iran and their ultimate presentation to 'Abbas I in Qazvin. This sequence of events, which actually stretched out over almost six years, in turn highlights the resources and especially the amount of official time and attention expended in the business of gift giving and finally allows us to measure whether all this effort achieved the desired or anticipated results.

What follows here is little more than an introduction to the Don Garcia chapter in the story of Safavid-Hapsburg gifting, based largely on the exhaustive documentary investigations of the Spanish historians Luis Gil Fernandez and Carlos Alonso.[2] But even a condensed narrative leads inexorably to the dual realizations that, no matter how valuable or luxurious, works of art had limited utility in the construction of early-modern east-west relations and perceptions and that the laborious rituals of gift giving were basically exercises in futility.

BEFORE DON GARCIA

The history of Iranian-European contact was already several centuries old and the driving forces behind this interaction well under way long before Don Garcia arrived in Qazvin.[3] One consistent motivation for western powers to reach out to Iran was the prospect that its Muslim rulers, beginning with those of the Ilkhanid dynasty (1256–1353) and continuing through the reign of Shah 'Abbas, would convert to Christianity. Far more mutually compelling and strategic, however, were the overlapping motivations based on shared military concerns and commercial interests. Iran and Europe alike were threatened by the territorial aggressions of Ottoman Turkey and simultaneously reviled and feared the Turks as agents of evil. The formation of a defensive alliance against this common enemy was regarded by both sides, in turn, as critical for the development of strong trade relations and especially for the

maintenance of secure shipping routes and stable market conditions. These basic incentives, operative as singular factors throughout the fifteenth and sixteenth centuries, coalesced and assumed greater importance in the late 1580s and 1590s with the Hapsburg union of Spain and Portugal on the one hand and the Safavid push for territorial consolidation and economic expansion on the other. The growing recognition of the advantages that could accrue from collaboration and partnership led to the dispatch of an increasing number of gift-bearing delegations, composed variously of missionaries, merchants, courtiers, and adventurers, who journeyed to Iran on Hapsburg business and often returned to the Iberian peninsula on Safavid business during the first decades of the seventeenth century.

This constitutes the general historical situation prevailing at the time of Don Garcia's embassy to Iran. More specifically, however, his mission was an attempt to repair relations that had become severely strained during an earlier one involving Antonio de Gouvea, a Portuguese Augustinian friar who served as a regular emissary and gift bearer between the Hapsburg and Safavid realms over a ten-year period.[4] In 1608 Shah 'Abbas sent Gouvea, along with a Persian officer named Denghiz Beg Rumlu, to various European countries. Upon their arrival at the Madrid court of Philip III early in 1611, the delegates offered the Spanish monarch fifty bales of highly prized Persian silk, which Philip accepted as a gift and in turn gave to his queen, Margaret, who, in her turn, gave it to a local chapter of the Augustinian order.[5] According to the sources for this oft-repeated incident, 'Abbas actually had intended the silk to be sold in Europe, and only Gouvea claimed that it was to be a gift for Philip, later producing a customs declaration from the outward journey to the effect that the bales were not merchandise but rather a present from the Safavid shah for the Hapsburg king. 'Abbas was livid when he heard how badly his envoys had mishandled and misrepresented his interests in Madrid. Besides castigating Gouvea, 'Abbas questioned the friar regarding the monetary worth of his silk in comparison to what Philip had sent him as a gift. Gouvea replied that what he had brought from Spain included pieces of gold and other "curious things with stones of great value,"

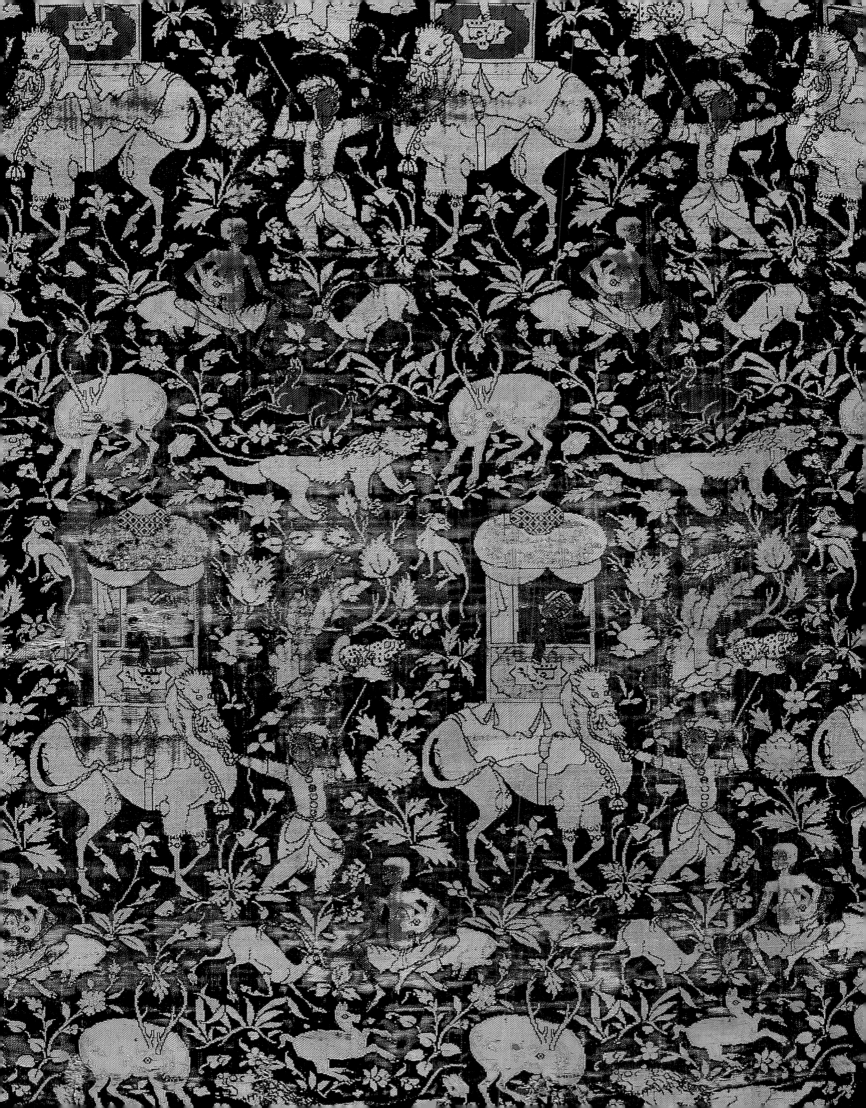

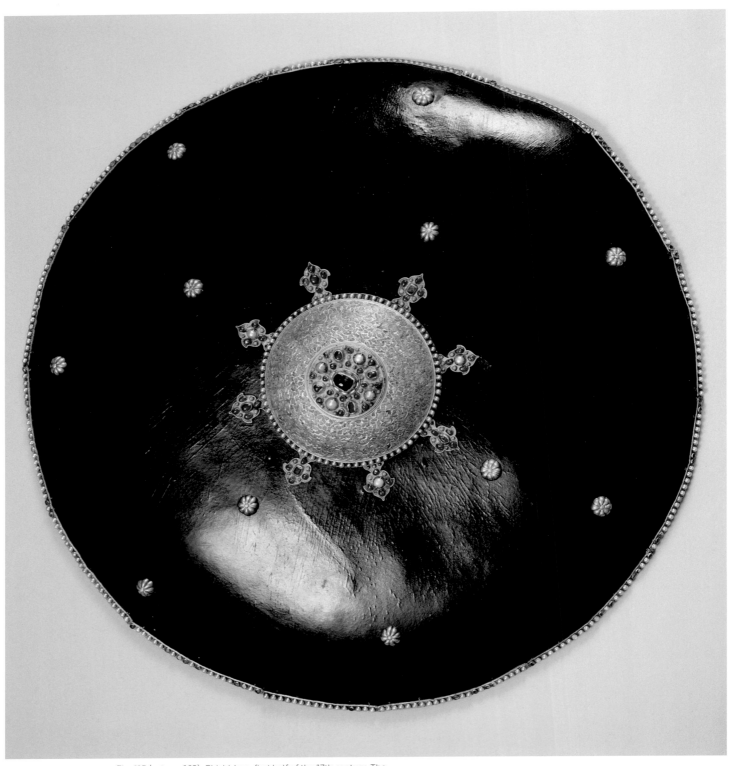

Fig. 115 (cat. no. 163). *Shield*, Iran, first half of the 17th century. The
State Historical-Cultural Museum Preserve, Moscow Kremlin
(OR-169).

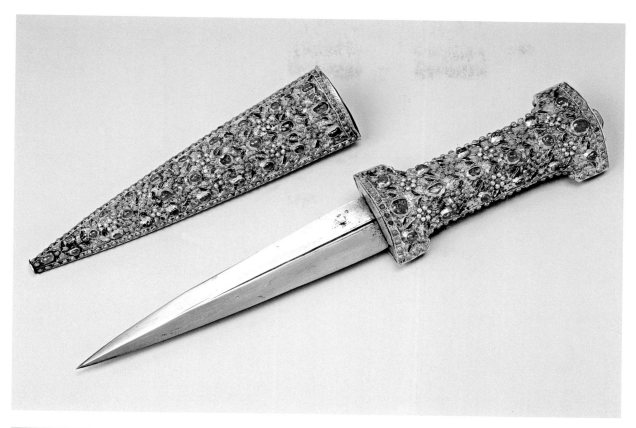

Top: Fig. 116 (cat. no. 141). *Dagger and Sheath*, Iran, first half of the 17th century. The State Historical-Cultural Museum Preserve, Moscow Kremlin (OR-208/1–2).

Bottom: Fig. 117 (cat. no. 164). *Mace*, Iran, mid-17th century. The State Historical-Cultural Museum Preserve, Moscow Kremlin (OR-187).

Above: Fig. 118 (cat. no. 142). *Horse Caparison*, Iran, 17th century, and Turkey, 17th century. The State Historical-Cultural Museum Preserve, Moscow Kremlin (TK-2199).

Opposite: Fig. 119 (cat. no. 154). *Carpet*, Iran, Isfahan, early 17th century. Museu Calouste Gulbenkian, Lisbon (T. 71).

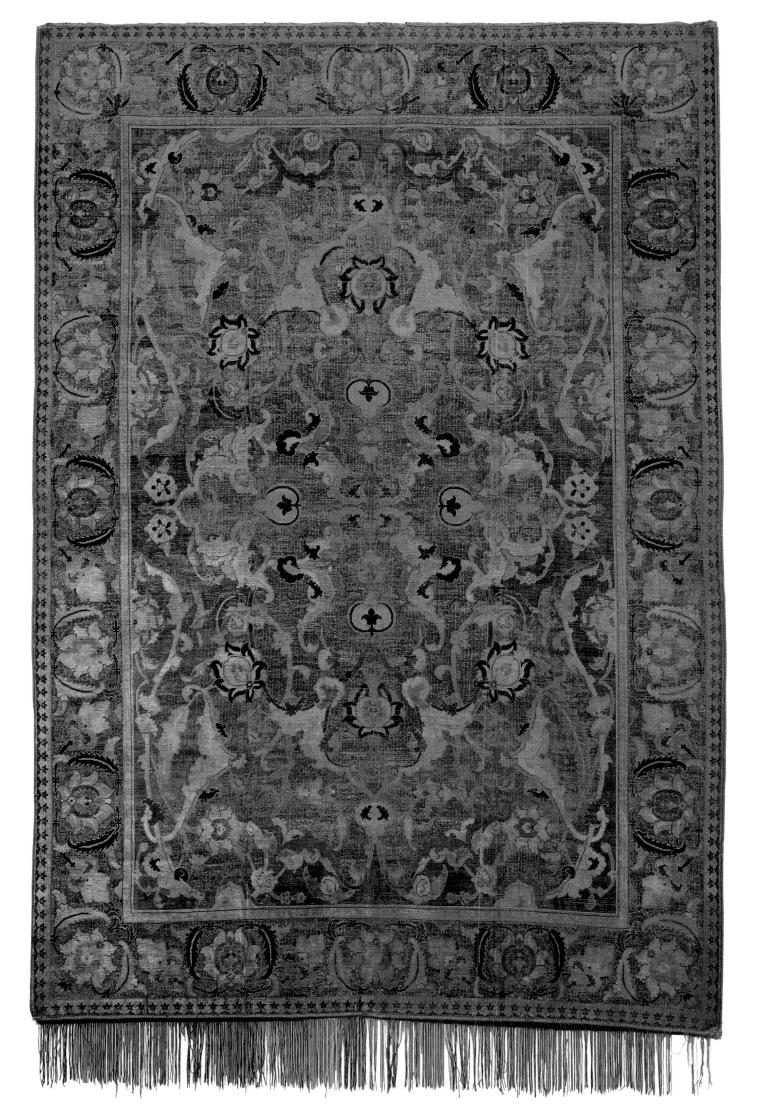

and, furthermore, that the value of the silk bales was equal to that of the Indian spices he had brought ‘Abbas on behalf of the viceroy of Goa. Unmollified, ‘Abbas retorted that what Gouvea brought was not worth half the amount of his silk. The shah took out his full wrath, however, on the hapless Denghiz Beg by ordering the courtier’s execution.[6]

GIFT SELECTIONS FOR DON GARCIA’S EMBASSY

While Gouvea may have either unwittingly or deliberately scuttled the gifting impact of what ‘Abbas sent to Philip and vice versa, he quickly got word back to Spain about the offense taken by the Safavid shah and then just as quickly left the country. Notwithstanding the friar’s possible perfidy, his report seems to have had the effect of influencing Philip III to immediately appoint another envoy—Don Garcia de Silva y Figueroa— and to equip his new ambassador with a large number of costly gifts that might please or at least appease ‘Abbas.[7] This royal appointment, made on October 2, 1612, then precipitated considerable discussion at the highest levels of Hapsburg officialdom about the presents that Don Garcia should take to Iran. At a meeting of the Council of State in August 1613, one ranking member opined that they should be more “adventajado” (seemingly meaning “superior”) than those taken by Gouvea and proposed “several extraordinary or special pieces of antique arms and armor.”[8] Other gift proposals considered by Philip’s counselors at this meeting included a large silver cup, gold chains, a chest or writing desk “like the one in the queen’s treasury…that has everything in it for travel; a very good gold and silk tapestry or hanging; paintings of the king and his sons, and a decorated sword.”[9] This last item met with particular approval, and one official agreed that the sword should be embellished with gold, while another recommended adding some other rich weapons that “are said to belong to His Majesty.”[10]

The process of gift selection continued into the fall of 1613 and even involved Philip III directly. On November 13, while dining in the garden of his chief minister, the king saw an old tapestry, richly embroidered on crimson velvet and called the “Seven Planets,” which he bought from his host for twenty thousand ducats (a bargain given that the piece originally cost a hundred thousand) to add to the gifts for ‘Abbas.[11] Notwithstanding all this activity, however, there was still no final gift list in December, and on the twelfth of that month the head of the royal household was told to provide the treasurer with twenty-four thousand ducats for gift expenses. Any purchases would have to be made in a hurry, or so the reports exhort, since ambassador Garcia was scheduled to leave for Iran in February 1614.[12]

In point of fact, Don Garcia did not set sail until April, by which time presumably all the gifts had been assembled and packed for transport. While the exact number of items varies—between four hundred and six hundred depending on the sources, including several inventories drawn up in January 1614—they do seem to have comprised three separate groups or categories[13] and to have differed in their symbolic and monetary value.

Group one consisted of weapons and other objects that a Safavid agent named Hoggia Sefer had bought for ‘Abbas in Venice and then had to dispose of in Milan when he ran out of money to continue his trip.[14] According to Spanish sources, these failed purchases included fifteen cases of harquebuses (matchlock guns) decorated in gold, silver and gold horse trappings, and various kinds of richly colored textiles, plus “a large and richly worked crystal chest, with gold columns, that the king of Persia sent to have decorated in Italy. The work was so badly done, however, that after it was finished, the chest was pawned for 5,000 or 6,000 ducats.”[15] When news of this unsuccessful bit of Safavid business reached Antonio de Gouvea during his 1611 summertime stay in Lisbon, he evidently sensed an opportunity for one royal to do another a favor and recommended that Philip pay to redeem ‘Abbas’s hocked Italian purchases, “since the objects were greatly appreciated in Persia and it would mean a lot to free them from their confiscation.”[16] This suggestion struck a positive chord and was quickly acted upon by the Hapsburg Council of State. The fate of the chest seemed to have been of particular concern to Philip: “Learning about this, our majesty Felipe III liberated it and sent it as a present to the Persian king.”[17] The decision to redeem this group

of objects, including the harquebuses, also involved high-level debate about the advisability of sending arms to a Muslim country, since such export was strictly forbidden by Spanish law. In the end, the Council of State agreed that the reclaimed armaments could be sent to Iran in good conscience since 'Abbas would be using them against the Turks![18]

The second category of presents for this embassy consisted of objects selected, as already mentioned, through the collective efforts of the king and his counselors and thus constituting the actual royal Hapsburg gift. The 1614 Spanish inventory that lists the majority of these items also gives their monetary worth, totaling altogether 32,100 ducats.[19] What Philip sent 'Abbas included the sword he wore at his wedding (in 1599 to Margaret of Austria); basins, salvers, and ewers in gilded silver; seven pieces of crystal ornamented in gold; an enormous silver brazier, "richly worked and very beautiful"; a very large silver chest or trunk with seventy pieces of gilded silver constituting a dinner service for use when on the road or at the hunt; six beautiful gold and crystal glasses and two others of gold; twenty enameled gold chains; a gold-covered cup decorated with medallions of the emperors paired with a jug shaped like a little lion; one hundred cases with gilded and engraved harquebuses and their embroidered covers; a quantity of emeralds set as small jewels and rings; and many pieces of fine cloth including gold satins and red velvets. In addition to these and other luxury objects, Philip ordered his gift to be augmented by pepper, cinnamon, and other spices from India, as well as by five large barrels with thirty measures of cochineal (a red dyestuff) that was delivered personally to Don Garcia in Lisbon (his departure port) and that "makes the finest crimson color" and at four thousand ducats "is a thing of great value and the most expensive item in the entire present." The royal gift was rounded off by a large and ferocious Spanish mastiff named Roldan "of great generosity and strength" that Philip III esteemed a great deal and that "aroused the admiration of the people."[20]

The records for Ambassador Garcia's gift, the third and final group of presents for Shah 'Abbas, lists a much larger number of items than the second category. Many of the works, however, sound comparable to what King Philip had picked out for 'Abbas, particularly among the impressive array of silver, gold, and gilded vessels, cutlery, and table accessories, including plates (large and medium sized), bowls, salvers, trays, aquamaniles, pitchers, covered cups, spoons, forks, and candlesticks. In addition there was a large and elaborately worked silver table; a little gilded silver coffer described as "curiously worked with figures in relief in which are stored twenty-three enameled gold chains of which ten have large jewels with very fine emeralds and others pearl pendants"; and many other pieces of jewelry. Besides lengths and pieces of different types of cloth, the gift included items of clothing such as a travel costume lined with gold cloth. Don Garcia also brought along four long harquebuses and powder flasks, ornamented with silver and little silver chains, and twelve pikes or lances also adorned with silver, all from the island of Ceylon. Even more distinctive were two portraits of women clothed in Spanish style: one is described as the infanta of Spain and queen of France and thus identifiable as a portrait of Anne of Austria. Finally, there was a present that Don Garcia seems to have selected with 'Abbas's own interests in mind: a small chest containing pieces of iron, steel, mother-of-pearl spoons, hammers, and files of all types that, "since the Persian king is always making war bows and bone rings that he wears on his thumb of his left hand to draw the bow[,]…he will value it a great deal."[21]

To summarize briefly, the gifts in these three categories ranged across the spectrum of the "practical, authoritative, ceremonial, and esoteric."[22] First and foremost, they were truly international, even global, in origin, coming from throughout the far-flung Hapsburg Empire and its territories in Europe, Asia, and the New World. Spain's American colonies, particularly Peru and Bolivia, were clearly the origin for the silver that made up the salvers, ewers, basins, chests, and other precious metal objects that Philip sent to 'Abbas. Indeed, the silver and silver gilt pieces themselves may very well have been fashioned in New Spain, particularly Mexico. Certainly Mexico was the source for the five barrels of cochineal dyestuff that was recorded as the most costly item in Philip III's gift selection. Whether

deliberately or not (since no mention of this appears in the Hapsburg records), the choice of such "exotic" items, including the Indian spices, might have been intended to remind 'Abbas of the extent of both the Hapsburg realm and of its control over precious and sought-after resources such as silver, cochineal, and pepper.

A second general observation about the nature of Safavid-Hapsburg gifts is that their monetary worth was clearly more important than their artistic originality or aesthetic appeal. Shah 'Abbas grilled Antonio de Gouvea about the value of the presents the friar brought from Philip III and took offense that they did not amount to the cost of his gifts to the Hapsburg monarch, not to mention the silk that ended up as an involuntary gift. Hapsburg record-keepers placed precise values on specific items accompanying the Don Garcia embassy: two thousand ducats for gold chains, fourteen hundred for a silver table, fifty-two hundred for a dozen or so silver vessels, and so forth.[23] One court official even calculated the total value of these presents at a hundred thousand ducats and compared this sum with the value of eighty thousand *escudos* placed on the "skeins of silk, rugs, and other things" brought to Spain by Gouvea on 'Abbas's behalf.[24] Clearly the commodity value of the gifts was just as important, both to the donor and to the recipient, as their manifestation of Hapsburg worldwide expanse and power.

Finally, there was an element of noblesse oblige here in Philip's decision to redeem 'Abbas's purchases that had been pawned in Italy. Such a gracious and considerate act was bound to find favor, and indeed, as we shall see, the only remark that Shah 'Abbas is said to have made about the gifts brought by Don Garcia concerned one of the Italian pieces.

GIFT TRANSPORTATION

While itemized lists of the several hundred gifts survive, fewer details are available about their actual movement from Madrid and Milan to Lisbon (the port of embarkation) and from Lisbon to Qazvin.[25] What little is known, however, makes the transportation logistics sound formidable. Don Garcia set sail on April 8, 1614, at the head of a five-galleon fleet, with the gifts shipped in one (or perhaps

more) of these vessels. The ambassador arrived at Goa, his first port of call, in November 1614, and was obliged to stay there until March 1617 due to adverse conditions both there and in Iran. It was evidently during this extremely long "layover" on the Indian coast that Don Garcia obtained the spices that Philip wanted to have added to his gift for 'Abbas. When Don Garcia was finally able to leave Goa, he sailed separately from the gifts and other baggage to the Portuguese-controlled (and thus then Hapsburg) island of Hormuz. He arrived there in May 1617 and over the summer months made the necessary arrangements for the overland passage of all that he had brought for 'Abbas. This involved a long caravan of some four hundred camels, which began its trek from the coastal city of Bandel (Bandar 'Abbas) in October and came to Shiraz in Fars province (a distance of some 450 kilometers) toward the end of November, where the ambassador and his retinue spent the rest of 1617 and the first quarter of 1618. In early April the caravan took off from Shiraz for the Safavid capital of Isfahan, with Don Garcia making a side excursion to visit the ruins of Persepolis, which impressed him enormously. Don Garcia and his baggage entered Isfahan on May 1, 1618; at the time 'Abbas was at his alternative capital of Farahbad on the Caspian Sea and from there sent the Hapsburg embassy instructions to head for Qazvin. The final leg of Don Garcia's journey took about three weeks; his four hundred or so camels laden with luggage and gifts seem to have completed the trip in even less time, having been sent on ahead.

Although there are some discrepancies in the precise dates of Don Garcia's itinerary, and the number of camels in the ambassadorial caravan may be more formulaic than factual, at least four years and multiple modes of sea and land conveyance were required to move and deliver between four hundred and six hundred presents from Hapsburg Spain and Portugal to Safavid Iran. In short, this particular undertaking, though perhaps not one for the all-time gift-giving record books, was an operation involving major logistical planning, management, and support, comparable to the art and science of a modern military supply operation.

GIFT PRESENTATION

Given the many years that he had spent en route and the care and attention necessary to ensure the safe transport and delivery of several hundred presents, it is no wonder that Don Garcia was eager to have them unpacked on the very day of his arrival in Qazvin.[26] Be that as it may, 'Abbas's court chamberlain decreed otherwise, and Don Garcia had to wait another two days before this phase of his mission could be accomplished. Furthermore, Safavid protocol required that each gift, no matter how large or small, be carried by its own porter. Thus it was necessary to assemble between four hundred and six hundred men, with the exact number, like that of the presents, varying according to the sources. Some of the individual gifts required multiple bearers. The large and beautiful silver brazier that formed part of Philip's gift selection, for instance, was so heavy that eight people had to carry it on their shoulders, while the large silver table among Don Garcia's presents required six people.[27]

The cortege of presents and their porters must have made quite a spectacle as it paraded from Don Garcia's lodging through the main streets of Qazvin and toward the residence and garden where Shah 'Abbas was to welcome the Spaniard. An eyewitness account by Fray Hernando Moraga, a member of the ambassador's entourage, provides the processional order.[28] It began with Philip III's sword, intended no doubt as a symbol of Hapsburg might and majesty, pomp and power, followed by the various luxury items identified in the Hapsburg records as selected and sent by Philip. Then came the gold-decorated harquebuses and other pieces originally purchased for 'Abbas in Venice and later sprung from their confiscation on Philip's orders for return to Iran. Don Garcia's own numerous presents were next in line. The procession's rear was brought up by the Spanish mastiff Roldan, although presumably this strong and noble beast (perhaps personifying the Hapsburg dynasty?) walked on its own rather than being carried.

This description sheds little light on Shah 'Abbas's reaction to the gift parade and presentation. In his *Comentarios*, Don Garcia does mention, apropos the large crystal chest with gold columns among the Italian works redeemed by Philip III, that 'Abbas

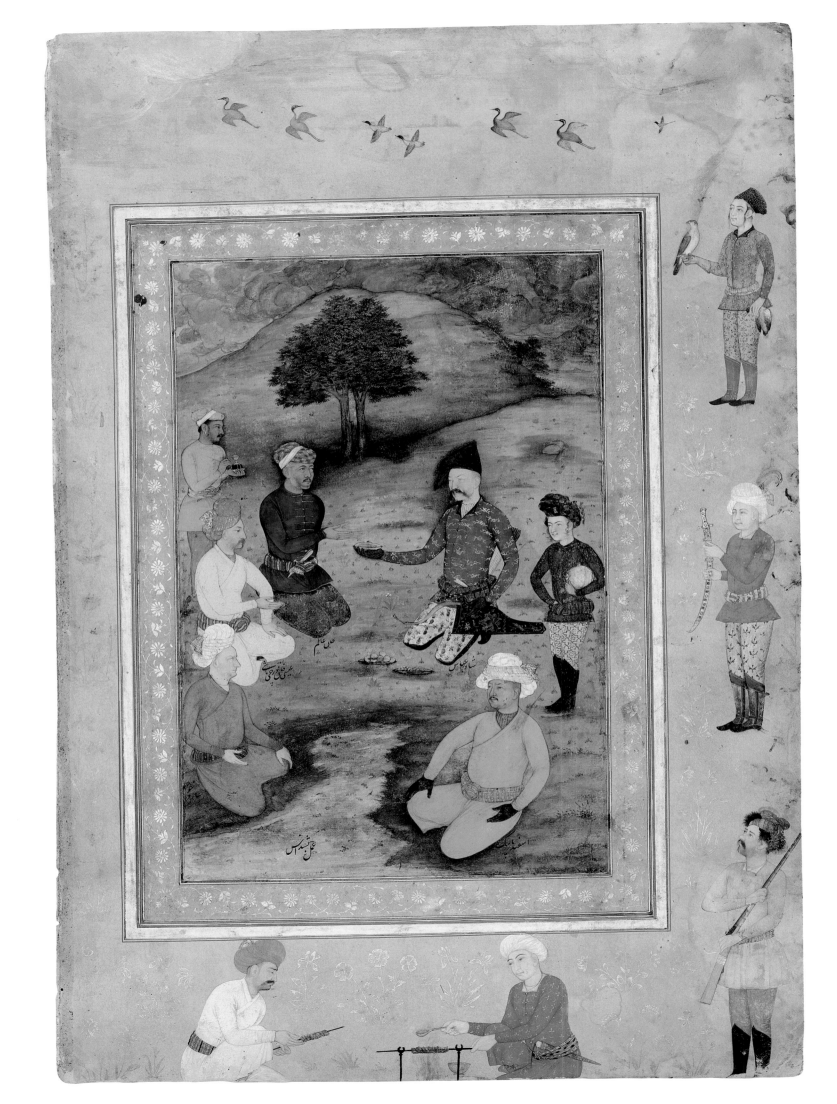

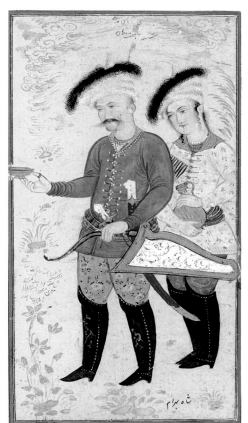

Opposite: Fig. 121 (cat. no. 173). *Khan 'Alam, Ambassador of Jahangir, with Shah 'Abbas in a Landscape*, India, c. 1650, copy after an original work by Bishan Das. Museum of Fine Arts, Boston, Francis Bartlett Donation of 1912 and Picture Fund (14.665).

Left: Fig. 122 (cat. no. 174). *Shah 'Abbas and the Mughal Ambassador Khan 'Alam*, Riza 'Abbasi and Mu'in Musavvir, Iran, c. 1613–1702. Bibliothèque nationale de France, Paris (Arabe 6077).

"was honored by this gesture from the king of Spain and delighted by the gift because he regarded it as a rare and valuable thing."[29] Among the guests at the dinner party that followed the gift delivery was an envoy (or *chaus*) from Ottoman Turkey whom 'Abbas invited deliberately so that he "could see the magnificence of the present sent to him by the king of Spain."[30] Presumably this was to stimulate competition at the Ottoman court.

GIFT IMPACT

The purpose of Don Garcia's embassy was not just to deliver gifts, of course, but to convey messages from Philip to 'Abbas concerning diplomatic and trade matters.[31] In particular Don Garcia was charged with convincing 'Abbas to pursue war against the Turks and to return the Bahrain Islands, formerly belonging to the Portuguese (and thus Hapsburg) kingdom of Hormuz, that the shah had recovered in 1602. Circumstances had changed, however, during the six years since Don Garcia had received his royal instructions and, among other matters, the ambassador now had to protest recent Safavid concessions

made to English merchants that were bound to harm Portuguese trade in Hormuz and India.[32] The ambassador found his situation next to impossible: it was very hard to arrange audiences with the shah, and on the rare occasions he did meet with 'Abbas, the conversation was punctuated with the shah's complaints about European military ineffectiveness, including that Philip deployed the Spanish fleet for privateering rather than attacks against Ottoman strongholds.

Don Garcia was to remain in Iran and to experience a few other similarly frustrating exchanges with 'Abbas, until April 1620, when he finally was able to start his return voyage home. This too was a protracted and sadly unfulfilled trip, involving a stay of almost four years in Goa. After sailing from there in January 1624, the long-suffering ambassador fell ill and died at sea on July 22, 1624.

Don Garcia's account of his mission to Iran occasionally mentions comestibles (such as bread) that he received from 'Abbas in Qazvin but gives no indication of any royal offerings more appropriate to his rank, as, for instance, the magnificent robe of

honor bestowed on the Englishman Robert Sherley not long after his arrival in Iran in late 1598.[33] Nor is there any record of reciprocal gifts being sent by 'Abbas in exchange or appreciation for those sent by Philip. Thus the Spanish ambassador ended his mission and left Iran empty-handed, without either any agreements or understandings on the issues that preoccupied the Hapsburg monarchy or any Persian gifts commensurate to those he had brought the shah. In conclusion, the considerable Hapsburg efforts in the selection, transportation, and presentation of hundreds of expensive and finely wrought gifts aimed at influencing, impressing, and pleasing 'Abbas seem to have been for naught.

Note: One shortcoming in any art historical discussion of the history of Safavid-Hapsburg gifting is the difficulty in matching objects recorded as having been either given or received with specific works of art known today. Doubtless the most famous such match is the medieval French "Picture Bible," containing several hundred brightly painted scenes from the Old Testament, given to Shah 'Abbas by a delegation of Discalced Carmelite fathers who arrived at the Safavid court in Isfahan on a mission from Pope Clement VIII in December 1607. This splendid manuscript, preserved today in the Morgan Library and Museum in New York, so intrigued 'Abbas that he had its leaves inscribed with explanations of the miniatures (see fig. 123).[34]

Notes

1 Floor and Hakimzadeh, *Hispano-Portuguese Empire*; Gil Fernandez, *Imperio Luso-Español*; Matthee and Flores, *Portugal, the Persian Gulf, and Safavid Persia*; Floor and Herzig, *Iran and the World*. The limited scholarly focus on the history of early-modern gifting is comparable to that in medieval studies, as signaled in Cutler, "Significant Gifts," 81. For gifting (apart from religious endowments, or *waqfs*) in the Safavid period, see Rogers, *Islamic Art and Design*, 49–51; Matthee, "Gift Giving"; Matthee, "Between Aloofness and Fascination," 243–44; Matthee, "Negotiating across Cultures," 37–41; Allan, "Early Safavid Metalwork," 203–10; Babaie et al., *Slaves of the Shah*, 70; Arthur M. Sackler Gallery, Smithsonian Institution, *Tsars and the East*, 15–17, and cat. nos. 3–19; Babaie, *Isfahan and Its Palaces*, 231, 236–39, 242–44; also Reindl-Kiel, "East Is East," and Souza, "Gifts and Gift-Giving." My thanks to Willem Floor, Rudi Matthee, and George Souza for bibliographic assistance.

2 Alonso, *Embajada a Persia*; Gil Fernandez, *Epistolario Diplomático*; Gil Fernandez, *Imperio Luso-Español*, vol. 2, 241–358; Gil Fernandez, "Embassy of Don Garcia." These studies make full use of Don Garcia's *Comentarios*. I am indebted to Professor Gil Fernandez for sharing his Don Garcia article in advance of publication.

3 Jackson and Lockhart, eds., *Cambridge History of Iran*, vol. 6, 373–409, for a convenient summary.

4 Alonso, *Antonio de Gouvea*; Matthee, "Gouvea, Antonio de"; Gil Fernandez, *Imperio Luso-Español*, vol. 1, chap. 5; vol. 2, chap. 3; and App. Doc. nos. 4–6; Simpson, "The Morgan Bible," 145–46.

5 Steensgard, *Asian Trade Revolution*, 283–85.

6 Ibid., 291–93; Matthee, *Politics of Trade*, 80–83; Alonso, *Antonio de Gouvea*, 170–72; Alonso, *Embajada a Persia*, 87–88.

7 Alonso, *Embajada a Persia*, 32–76, 288–92; Gil Fernandez, *Epistolario Diplomático*, 290–93; Gil Fernandez, *Imperio Luso-Español*, vol. 2, 247–67, 314–18.

8 Gil Fernandez, *Imperio Luso-Español*, vol. 2, 250.

9 Ibid.

10 Ibid.

11 Ibid., 255–56. It is not certain, however, that this tapestry ever left Madrid.

12 Ibid., 256.

13 Ibid., 314, and Gil Fernandez, "Embassy of Don Garcia," ms. 9.

14 Gil Fernandez, *Imperio Luso-Español*, vol. 2, 150.

15 Ibid., 314–15.

16 Alonso, *Antonio de Gouvea*, 125–26.

17 Gil Fernandez, *Imperio Luso-Español*, vol. 2, 314.

18 Ibid., 213. Gouvea's original intention had been to add the "liberated" purchases to Philip's gifts that he would take back to Iran and present to 'Abbas. Unfortunately, the Italian shipment did not reach Spain until after his departure for Iran in 1612, which is why the harquebuses, chest, and other redeemed objects ended up as a portion of the four hundred to six hundred gift items assembled during the next year for Don Garcia's mission.

19 Ibid., 256.

20 Ibid., 292, 315–17.

21 Ibid., 292–93.

22 Souza, "Gifts and Gift-Giving," 27.

23 Gil Fernandez, *Imperio Luso-Español*, vol. 2, 256.

24 Ibid., 257.

25 Ibid., 269–77, 285–96, 299–310.

26 Regarding gift presentation, see ibid., 309–19.

27 Gil Fernandez, *Epistolario Diplomático*, 292.

28 Gil Fernandez, *Imperio Luso-Español*, vol. 2, 318; Gil Fernandez, "Embassy of Don Garcia," ms. 9. For such parades of ambassadorial gifts in general, see Babaie, *Isfahan and Its Palaces*, 238.

29 Gil Fernandez, *Imperio Luso-Español*, vol. 2, 314–15.

30 Ibid., 318; Gil Fernandez, "Embassy of Don Garcia," ms. 9.

31 Gil Fernandez, *Imperio Luso-Español*, vol. 2, 260–67.

32 Gil Fernandez, "Embassy of Don Garcia," ms. 10–15.

33 Canby, *Shah 'Abbas*, cat. no. 15.

34 Noel and Weiss, *Book of Kings*; Simpson, "Shah Abbas and His Picture Bible."

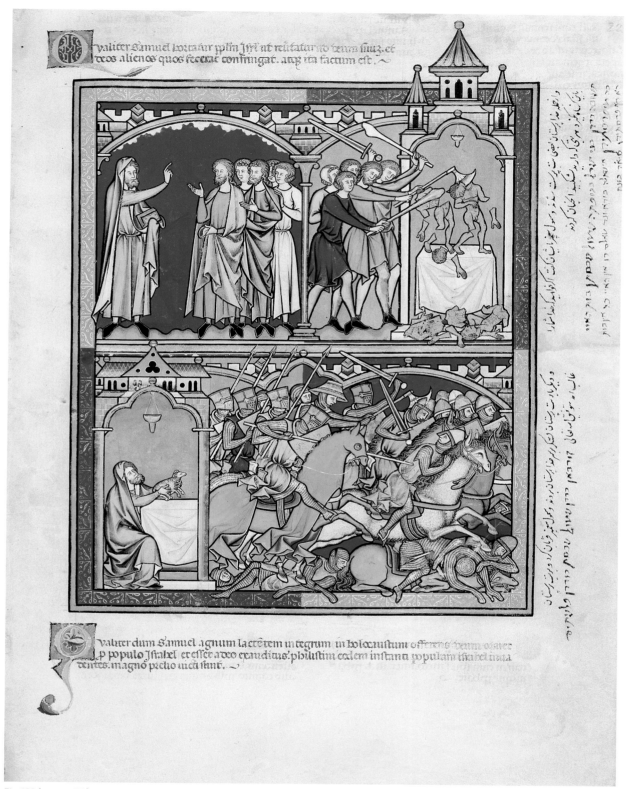

Fig. 123 (cat. no. 170). *The Breaking of the Idols and The Israelites' Victory over the Philistines*, folio from the Morgan Crusader Bible, France, Paris, 1240s. The Pierpont Morgan Library, New York (Ms M.638).

Fig. 124 (cat. no. 239). *Portrait of Mehdi Quli Beg, Persian Ambassador to Prague*, Aegidius Sadeler (Netherlands, c. 1568–1629), Netherlands, c. first quarter of the 17th century. The Metropolitan Museum of Art, New York (49.95.2202).

Fig. 125 (cat. no. 171). *Portrait of a Jesuit Missionary*, Manohar, India, c. 1590. Musée Guimet, Paris (3619 G C).

Ambassadors and Their Gifts
Keelan Overton

Apart from the historical record and the objects themselves, three types of imagery enhance our understanding of diplomatic gift exchange: depictions of gifts, portraits of the ambassadors who transported them, and scenes in which gifts are presented to their recipients. The creation of such images was a tradition shared by Islamic, European, and Chinese artists in a variety of media and formats, including miniature paintings, prints, and scroll paintings.

Esteemed gifts were often the subject of images that, because of their close attention to detail, can almost be classified as portraits. Some of these "portraits" provide invaluable documentation of ephemeral gifts, including animals. A rare example is a Chinese hanging scroll that depicts the giraffe presented by the envoys of the sultan of Bengal to the Ming emperor in 1414 (fig. 106).[1] Nearly a century later, Albrecht Dürer created what is arguably

the best known image of a gifted animal: a woodcut of the rhinoceros presented by Sultan Muzaffar II of Gujarat to Alfonso de Albuquerque in 1515 (fig. 126).[2] The most accomplished "portraits" of state gifts are the chromolithographs preserved in a mid-nineteenth-century Russian album that depict Ottoman and Safavid gifts to the tsars in multiple perspectives (figs. 182–85, 275). One example is a "portrait" of the ceremonial shield offered by Assan-bek, ambassador of Shah 'Abbas II, to Tsar Mikhail Fedorovich between 1641 and 1643 (fig. 275).

Like the gifts they transported, ambassadors were also immortalized in images. Of the many Islamic courts considered in this exhibition catalogue, the Mughals were most inclined to create realistic portraits of ambassadors, those they both received and dispatched. These paintings and drawings were assembled into albums that were appreciated by the courtly elite (figs. 125, 127, 247, 250). By contrast,

in Europe the most common medium of the diplomatic portrait was the print, which circulated widely in books and the popular press. During the early seventeenth century, Flemish printmakers created a number of portraits of the Persian envoys to the court of Rudolph II (fig. 124), and versions of these prints were soon published in portrait albums.[3] Three centuries later, Persian envoys continued to attract global attention, albeit in a new printmaking medium. In the early nineteenth century, Fath 'Ali Shah's envoys to England and Russia were portrayed in lithographs. Abu'l Hasan, who served as Iran's ambassador to England, was the subject of a portrait by the French artist Eugène Delacroix (fig. 253), while the delegation led by Fath 'Ali Shah's grandson, Khusraw Mirza, to St. Petersburg inspired a suite of lithographic portraits (figs. 190–94, 255–57).

Gifts and ambassadors were combined in the third and final type of imagery: depictions of envoys

presenting themselves, and often their royal gifts, to foreign rulers. Most of the Islamic images in this category date to the sixteenth and seventeenth centuries, and Ottoman, Mughal, and Safavid depictions can be readily differentiated. In order to convey their political supremacy, the Ottomans regularly included scenes of contemporary gift exchange in their sixteenth-century illustrated histories. In these paintings, envoys from foreign courts, such as Iran, are forced to bow dramatically before the sultan while rows of seemingly endless gifts are presented (see fig. 6).[4] Contemporary paintings from the Mughal court, such as those in *Akbarnama* manuscripts (fig. 30), follow a similar horizontal format: the enthroned ruler receives the envoy at one end of the composition and gifts dominate the remaining pictorial space. Later Mughal reception scenes favored a vertical format, rigid symmetry, and conspicuous hierarchy.[5] In *Padshahnama* paintings, for example, ambassadors present themselves and their gifts far below the elevated and deified Mughal ruler (fig. 1). Finally, in contrast to both the Ottomans and Mughals, the Safavids situated diplomatic encounters in leisurely settings that emphasized conviviality while simultaneously conveying the shah's authority as the consummate host and benefactor (fig. 128).[6] Considered together, these Ottoman, Mughal, and Safavid paintings underscore the integral relationship between art, diplomacy, and political propaganda. Far from being neutral depictions, all of them reflect the biases and motivations of their makers and patrons.

Notes

1 Church, "Giraffe of Bengal," 1, 4.
2 Dürer's woodcut was based on his drawing preserved in the British Museum. For both versions of the image, see Bartrum, *Albrecht Dürer and His Legacy*, 285–87.
3 For an example of an Augsburg album printed between 1600 and 1602 with portraits of Shah ʿAbbas and his ambassadors to Rudolph II, see Canby, *Shah ʿAbbas*, 257–58.
4 For images of this type, see Uluç, *Turkman Governors*, figs. 354–56 and 359–60.
5 Beach and Koch, *King of the World*, 133–35.
6 For an additional example in this mode, see Aga Khan Trust for Culture, *Spirit & Life*, 102–3.

Above: Fig. 126 (cat. no. 232). *The Rhinoceros*, Albrecht Dürer (Germany, Nuremberg, 1471–1528), Germany, Nuremberg, 1515. The Metropolitan Museum of Art, New York (19.73.159).

Right: Fig. 127 (cat. no. 175). *Portrait of Khan ʿAlam*, India, early 17th century. Musée Guimet, Paris (7180).

Pages 142–43: Fig. 128 (cat. no. 165). *Shah ʿAbbas II Receiving the Mughal Ambassador*, Iran, c. 1663. Aga Khan Museum Collection, Geneva (AKM00110).

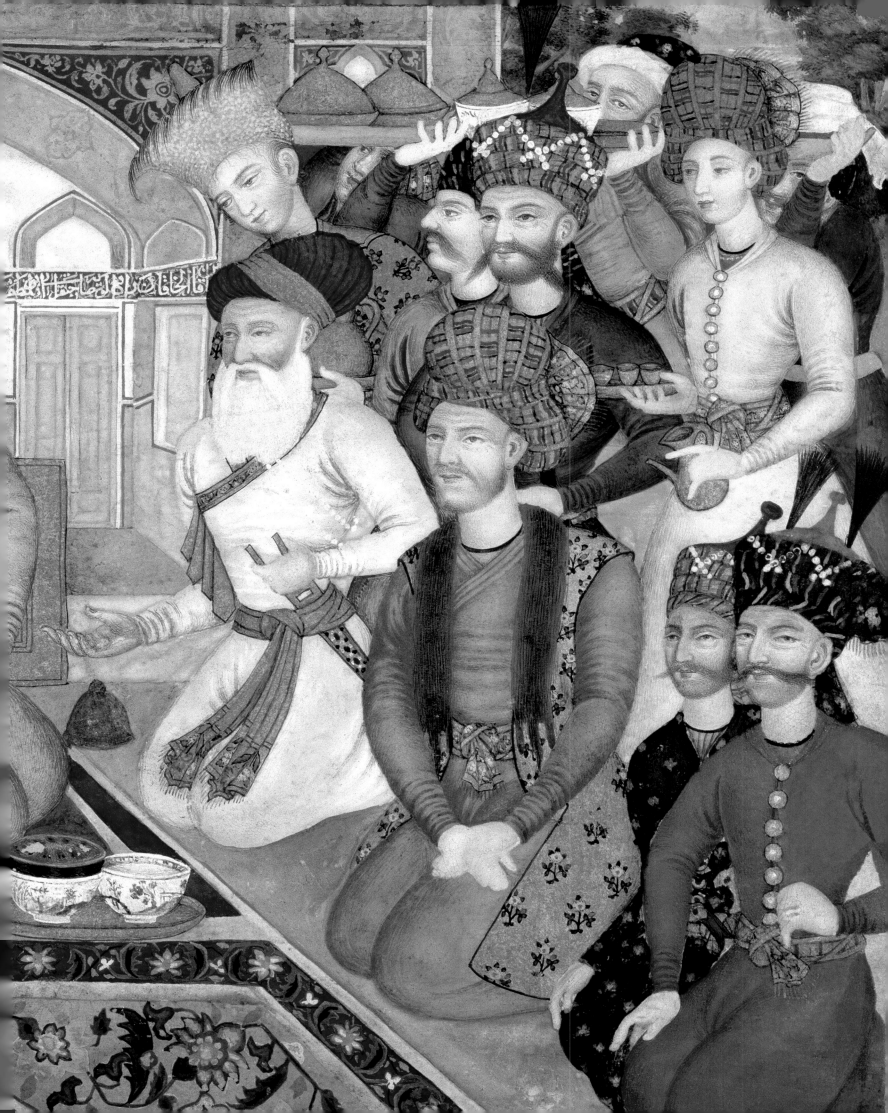

Gifted Manuscripts from the Safavids to the Ottomans

Lale Uluç

Luxury books were ideal vehicles for conspicuous consumption. They were among the most favored Safavid diplomatic gifts to the Ottoman court.[1] The vast majority of these generally large-format manuscripts were produced in the city of Shiraz, an especially prolific book production center (figs. 130–31). Deluxe manuscripts such as these were in high demand during the Ottoman-Safavid conflicts of the years 1514–1600, in which period the published documentary sources record twenty-seven Safavid embassies to Istanbul.[2] Extant manuscripts from Shiraz outnumber their counterparts from all other Safavid centers combined. The most convincing evidence of the prestige that they enjoyed in Ottoman court circles is their existence in large numbers in the holdings of Istanbul libraries, where they constitute 60 percent of the total number of Safavid manuscripts.

Ottoman archival registers provide book lists beginning with multiple copies of manuscripts of the Qur'an and always including the *Shahnama* of Firdawsi, which was the most desirable of the Persian classics. This is also true of Ottoman chronicles that record books among the Safavid diplomatic gifts. We know, for example, that the deposed Timurid prince Badi' al-Zaman presented Selim I (r. 1512–20) with a copy of the *Shahnama*[3] and that the gifts of the brother of the Safavid shah Tahmasp, Alqas Mirza, to Süleyman I (r. 1520–66) included Qur'ans, an illustrated *Shahnama* of Firdawsi,[4] and *kar-i Shiraz* (work of Shiraz) manuscripts.[5] Subsequent Safavid envoys presented Selim II (r. 1566–74) with the royal copy of the *Shahnama* of Firdawsi produced for Shah Tahmasp in 1568,[6] and Murad III (r. 1574–95) with a copy of the *Shahnama* of Firdawsi and more than sixty volumes of *divans* of Persian poets in 1576,[7] as well as with eighteen books on two separate occasions: first, in 1582, for the royal festivities celebrating the circumcision of the Ottoman prince

Şehzade Mehmed,[8] and then in 1590, for the signing of the Ottoman-Safavid peace treaty.[9]

Ottoman documents additionally mention the names of Persian classics and specifically the *Shahnama* of Firdawsi among the gifts presented to the court by high-ranking Ottoman officials. This information is corroborated with manuscripts from the Topkapi Palace Museum Library, a number of which contain flyleaf notes that indicate that they may have been gifts from the sultan's subjects.

Identical notes on two Shiraz manuscripts,[10] "the book that came from the shah" (*Şah'dan gelen kitabdır*) and the date AH 990/1582, are significant since they indicate that these manuscripts were among the eighteen books presented to Sultan Murad III on the occasion of the circumcision festival of Şehzade Mehmed in 1582.

Two other flyleaf notes on Shiraz manuscripts clearly declare that they were gifts. The first reads, "gift of the wife of the late Khwaja Au[ha]d al-Din Mahmud, an official of Shiraz" (*pishkash-i zauja-i marhum-i Khwaja Au[ha]d al-Din Mahmud vazir-i… Shirazi*), and the second reads, "gift of the son of Mir 'Abd-Allah Mahmud Shahristani" (*pishkash-i valad-i Mir 'Abd-Allah Mahmud Shahristani*).[11] The latter also has an ownership note of an Ottoman grand vizier, Sinan Paşa, suggesting that he may have received it as a gift and later presented it to the sultan.

There is also circumstantial evidence that several Shiraz manuscripts—including richly decorated copies of the Qur'an in the Topkapi Palace Museum Library,[12] illuminated in a similar style to the double folio in this exhibition (fig. 129), and a dispersed copy of the *Shahnama* of Firdawsi,[13] which was enlarged and transformed into a large-size luxury manuscript—were completed at short notice on demand specifically to be presented to the Ottoman court. Additionally, a Shiraz manuscript of the Qur'an shown here (fig. 243) includes a *waqf* notation in the name of Sultan Selim II.

Notes

1 For more extensive information about Shiraz manuscripts and their consumption, see Uluç, *Turkman Governors*, chap. 9, and Uluç, "Ottoman Book Collectors."

2 Peçevi İbrahim Efendi, *Peçevi Tarihi*; Selaniki, *Tarih-i Selaniki*; Danişmend, *Osmanlı Tarihi Kronolojisi*; Kütükoğlu, *Osmanlı - İran Siyasi Münasebetleri*; Kütükoğlu, "Şah Tahmasb'ın III. Murad'a Cülus Tebriki"; Göyünç, "Ta'rih Başlıklı Muhasebe Defterleri"; Munshi, *History of Shah Abbas*.

3 Şükri, *Selimname* in the Topkapi Palace Museum Library, H.1597–98, fol. 140r.

4 Peçevi İbrahim Efendi, *Peçevi Tarihi*, vol. 1, 199; Danişmend, *Osmanli Tarihi Kronolojisi*, vol. 2, 259.

5 Fethullah Ali Çelebi (Arifi), *Süleymanname*, in the Topkapi Palace Museum Library, H.1517, fol. 498r.

6 Ahmed Feridun Paşa, *Nüzhetu'l-Ahbar der sefer-i Sigetvar*, dated AH 976/1568, in the Topkapi Palace Museum Library, H.1339, fols. 246v and 247v; see Stchoukine, *La Peinture turque*, vol. 1, pl. XXVI, and Çağman and Tanindi, *Topkapi Saray Museum*, pl. 155.

7 Seyyid Lokman, *Zübdetü't-Tevarih*, dated AH 991/1583, in the Museum of Turkish and Islamic Art, 1973, fol. 91v; Kütükoğlu, "Şah Tahmasb'ın III. Murad'a Cülus Tebriki," 1–24 (in this document, Toqmaq Khan is referred to as Toqmaq Muhammadi Sultan and not yet as khan).

8 Mustafa 'Ali, *Cami' u'l-buhur der Mecalis-i Sur*, dated AH 994/1585–86, in the Topkapi Palace Museum Library, B.203, fols. 24v–36v; Mustafa 'Ali (Gelibolulu), *Cami' u'l-buhur der Mecalis-i Sur*, 23–36 and 127–50; Gökyay, "Bir Saltanat Düğünü," 31–39; Fleischer, *Bureaucrat and Intellectual in the Ottoman Empire*, 107; the gifts listed by Mustafa 'Ali are very close to the official register of gifts from the same occasion preserved in the Topkapi Palace archives (D.9614).

9 Danişmend, *Osmanlı Tarihi Kronolojisi*, vol. 3, 100–102; Kütükoğlu, *Osmanlı - İran Siyasi Münasebetleri*, 187–95; Munshi, *History of Shah Abbas*, vol. 1, 479–83; vol. 2, 587 and 612.

10 H.794 and H.727.

11 H.724 and H.924, respectively.

12 E.H.67 and E.H.48.

13 Uluç, "A Persian Epic, Perhaps for the Ottoman Sultan."

Fig. 129 (cat. no. 152). *Illuminated Facing Pages from a Dispersed Manuscript of the Qur'an*, Iran, Shiraz, third quarter of the 16th century. Los Angeles County Museum of Art (AC1999.158.1 and M.2010.54.1).

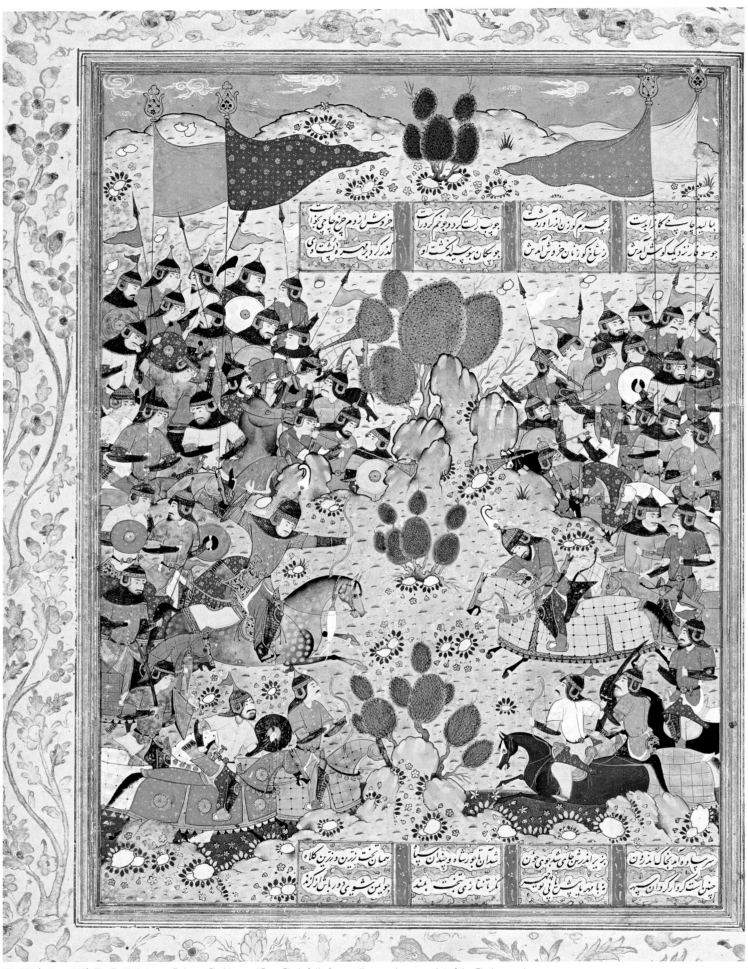

Fig. 130 (cat. no. 149). *The Battle between Bahram Chubina and Sava Shah*, folio from a dispersed manuscript of the *Shahnama*, Iran, Shiraz, c. 1560. Los Angeles County Museum of Art, purchased with funds provided by Camilla Chandler Frost and Karl H. Loring, with additional funds provided by the Art Museum Council through the 2009 Collectors Committee (M.2009.44.1).

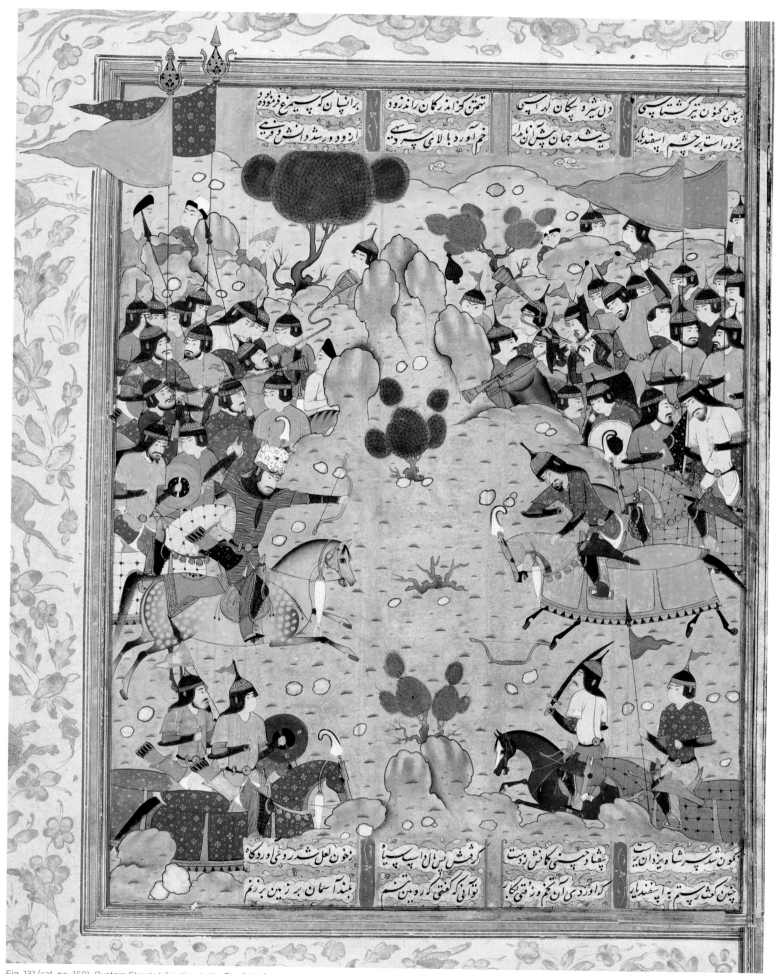

Fig. 131 (cat. no. 150). *Rustam Shoots Isfandiyar in the Eye*, folio from a dispersed manuscript of the *Shahnama*, Iran, Shiraz, c. 1560.
Los Angeles County Museum of Art, purchased with funds provided by Camilla Chandler Frost and Karl H. Loring, with additional
funds provided by the Art Museum Council through the 2009 Collectors Committee (M.2009.44.4).

Ottoman Gift Exchange: Royal Give and Take

Tim Stanley

The Ottoman Empire existed for more than six hundred years, from the late thirteenth century to the early twentieth, and during that very long period it underwent many changes in size and character. Nevertheless, certain forms and customs remained persistent features of life at the Ottoman court over hundreds of years. One of these was the giving of gifts, which was already a well-established tradition when the empire became a world power in the sixteenth century and was still going strong under Sultan Abdülhamid II (r. 1876–1909).

The sultan's position was, in Ottoman theory, based on his relationship with God, who had granted him dominion over humankind. Like other Islamic rulers, the Ottomans were therefore bound to demonstrate their gratitude by using part of their great wealth to benefit the Muslim community. Most notably, many of them erected mosques and other religious buildings on a grander scale than any of their subjects did, donating the finest fittings available to furnish them (figs. 50–51, 133, 229) and magnificent Qur'ans and other manuscripts for use there (fig. 243). Another sign of their unique status was their role as protectors of Islam's holiest sites at Mecca and Medina, which they acquired after the Ottoman conquest of Egypt in 1517. The sultan thereby gained the privilege of sending the textiles with which the holy places were draped (figs. 64, 68–69, 238).

The sultans' privileged relationship with God led them to assume a superiority not only to their own subjects but to all other human beings. This gave their interactions with foreign powers a certain awkwardness, as no other ruler could be allowed equality with the sultan. The relative weakness of the empire, especially in the nineteenth century, eventually undermined this principle, but its working can be detected in the distribution to diplomats of robes of honor, which were also a standard form of gift from the sultans to their own subjects (fig. 132).

Opposite: Fig. 132 (cat. no. 76). *Sakkos of Neophytos, Metropolitan of Nicomedia*, Turkey, Istanbul, before 1629. Benaki Museum, Athens (9349).

Above: Fig. 133 (cat. no. 84). *Candlestick*, Turkey, dated AH 1049/1640. Museum of Turkish and Islamic Art, Istanbul (türbe 93).

The robe of honor was already a long-standing tradition in the Islamic world before it was adopted by the Ottomans, among whom it most often took the form of a caftan made of an expensive silk textile. Receiving a robe from the sultan was an exotic experience for European envoys, who described this ceremony with a sense of awe and commissioned images of themselves dressed in their caftans (fig. 8). As a result, too, robes of honor have been preserved in collections outside Turkey, sometimes in their original form. Yet for the representative of a foreign power, this honor was rather ambiguous, as the acceptance of a robe implied that the recipient accepted the sultan's authority, and wearing it was a sign of allegiance. This would have been clearer when the weave and pattern were distinctively Ottoman, as in the case of the robe given to Gregorovius, the Prussian ambassador at the sultan's court, in 1763 (fig. 135).

It would have been equally unsettling to see an Ottoman sultan or a member of his entourage wearing a robe made from an Iranian silk with figurative ornament of a distinctively Safavid type, as was presumably intended by the Safavid ruler

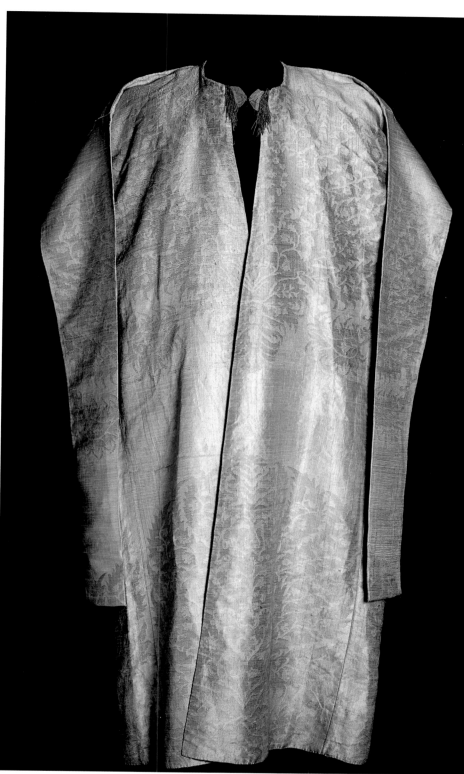

Opposite and left (detail): Fig. 134 (cat. no. 155). *Dark Green Caftan*, Iran, 16th century. Topkapi Saray Museum, Istanbul (13/2088-35/465).

Above: Fig. 135 (cat. no. 24). *Robe of Honor*, Turkey, end of the 17th–first half of the 18th century. Museum für Islamische Kunst, Berlin (I. 6894).

Fig. 136 (cat. no. 78). *Berat of Sultan Süleyman I*, Turkey, Istanbul, AH 963/1556. Millet Manuscript Library, Istanbul (AE Document 1).

Opposite: Fig. 137 (cat. no. 79). *Berat of Sultan Selim II* (detail), Turkey, Istanbul, AH 974/1567. Millet Manuscript Library, Istanbul (AE Document 20).

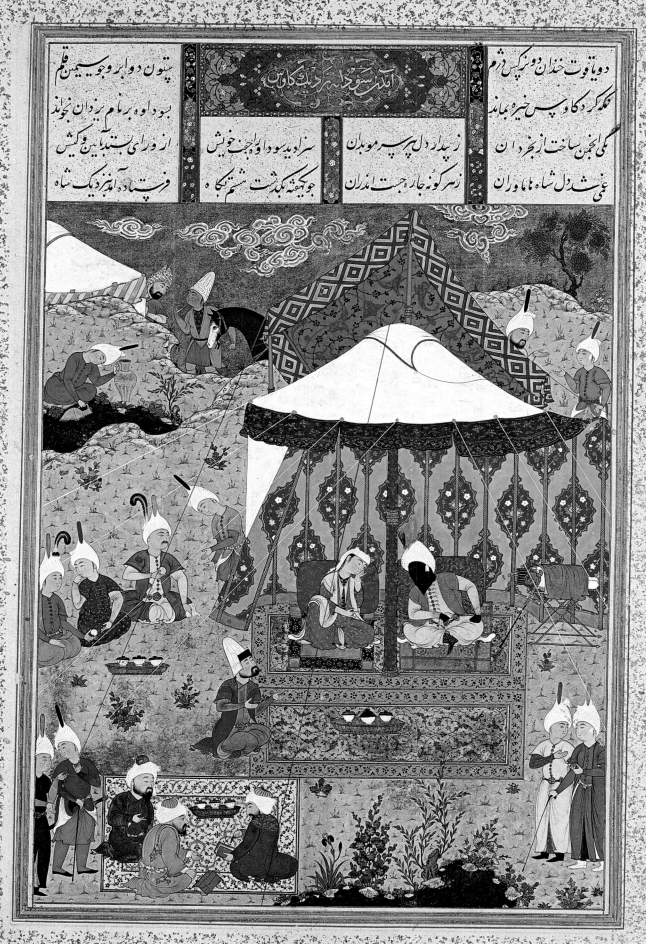

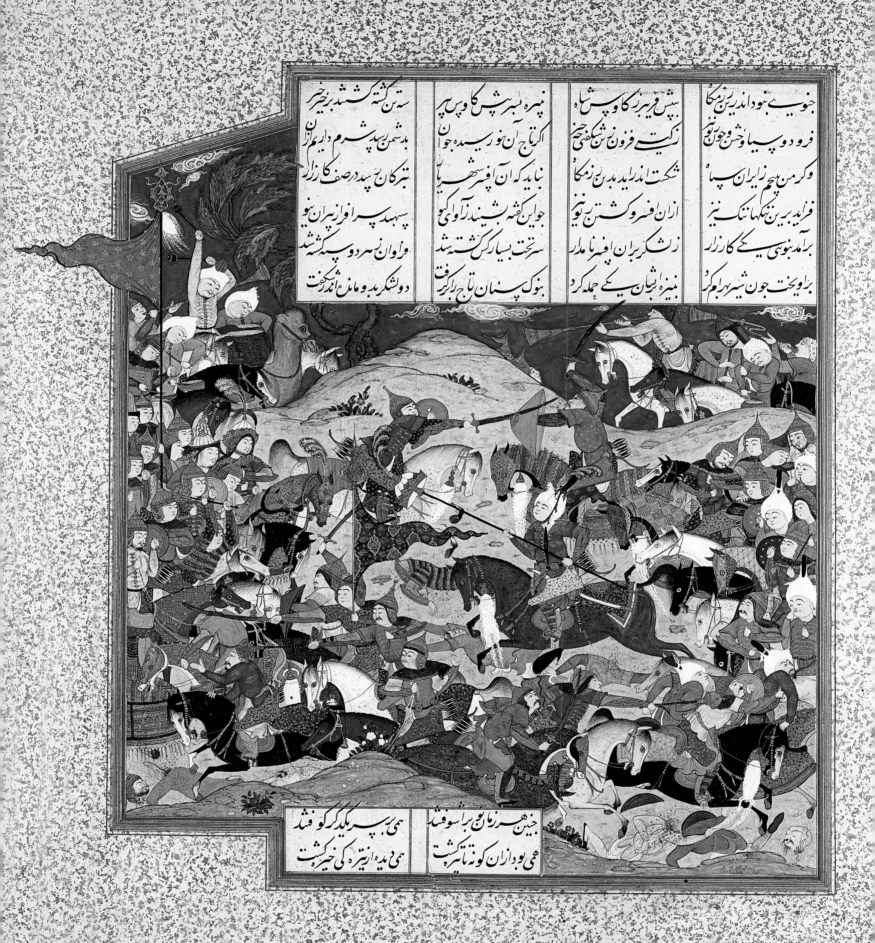

Muhammad Khudabandah when he presented Sultan Murad III with such a robe in 1583 (fig. 134). Even more obviously inappropriate gifts are found among a very large number of small carpets from Safavid Iran, many of which are still in the collection of the Topkapi Palace (fig. 42). Eighteen of them have Shi'ite inscriptions, which would have incurred the displeasure of the Sunni Ottomans, and it may be that the whole group was put to one side on this account. This would explain why so many have come down to us in such good condition.[1]

The inclusion of carpets among the gifts brought from the Safavids in Iran was recorded on several occasions. Those brought after the accession of Sultan Selim II in 1566 were so heavy that they could barely be carried by seven men.[2] No examples large enough to fit this description seem to have survived, and we can conclude that they were considered acceptable for use, which led to their destruction. But, as on other occasions, the gifts to Selim II also included a range of other items, including nineteen pieces of Chinese porcelain, a manuscript of the Qur'an (perhaps fig. 7), and one of the finest illustrated manuscripts ever produced (figs. 5, 26, 90, 138–39).[3]

The presents exchanged at the receptions of foreign ambassadors were, then, many and various, as they had been throughout Islamic history. As a result, the former imperial residence at the Topkapi Palace contains an array of heterogeneous objects that reflect what foreign rulers thought were appropriate gifts for a sultan. Some from the last years of the empire were presented in person by visiting monarchs, including the German emperor Wilhelm II (figs. 150–52; see Aimée Froom's contribution in this volume). The Ottoman sultans also dispatched gifts in large numbers, and in the seventeenth century these were particularly welcome in Russia, where, until the reforms of Peter the Great (r. 1682–1725), the tsars presented themselves as the heirs of the Byzantine emperors and used regalia that reflected contemporary fashions in Istanbul, which had been Constantinople, capital of the Byzantine Empire.[4] The Kremlin Museum Preserve in Moscow still holds large numbers of items that Ottoman ambassadors presented to Peter's father and grandfather, tsars Alexei and Mikhail (figs. 141, 271–73).

Gem-studded objects similar to those now in the Kremlin also circulated among the top members

of Ottoman society as gifts, along with high-value items such as Chinese celadons and blue-and-white porcelain, which were also sometimes set with gems. When a sultan married off his daughter or another female member of the imperial family, for example, she took with her a number of costly items as a sign of her high status. These were removed from the sultan's treasury, which was restocked by several means, including gifts from wealthy subjects and foreign rulers, the reclaiming of the princesses' treasures when they died, and purchases and commissions. The mass of valuable objects still in the Topkapi Palace today, including the large holdings of gem-set pieces and Chinese ceramics, should not be seen as a connoisseur's collection assembled as a single, continuous process over time but as a reservoir of items of imperial quality that could be drawn on for use within the palace itself or other royal residences or for distribution as gifts. The reservoir was constantly depleted and refilled,

and objects that had once been part of it sometimes circulated widely, which is why examples are found in other collections today (fig. 140).[5]

Gift Giving Illustrated

We can see the circulation of gifts taking place in a number of illustrations in Ottoman manuscripts. One particularly well-documented example relates to an event that occurred on September 18, 1720 (fig. 142), the first day of a fifteen-day public festival held by Sultan Ahmed III (r. 1703–30) to celebrate the circumcision of his four young sons. The preparations for the festivities and the proceedings on each day were recorded in a number of narrative texts called "festival books" (*surname*). One of these, composed in the high-flown literary style of Ottoman court literature by the poet Seyyid Vehbi (d. 1736), exists in a copy made for the sultan that was illustrated by his head painter, Levni (d. 1732).

Opposite: Fig. 140 (cat. no. 13). *Comb*, Turkey, late 16th–17th century. The al-Sabah Collection, Dar al-Athar al-Islamiyyah, Kuwait (LNS 7 HS).

Left: Fig. 141 (cat. no. 244). *Bowl*, Turkey, Istanbul, first third of the 17th century. The State Historical-Cultural Museum Preserve, Moscow Kremlin (DK-267).

The fifteen-day celebrations cost a great deal, and they must have required a lot of effort to organize. The person with ultimate responsibility for these undertakings was the grand vizier, Damad Ibrahim Paşa (d. 1730), whom Ahmed III had appointed in 1718. Although Ibrahim was in charge of the realization of the festival, protocol demanded that all credit for the event should go to the sultan, and the grand vizier therefore had to lead the sultan's subjects in expressing thanks for his munificence by presenting him with fine gifts.[6]

The opportunity to present a gift to the sultan was as much an honor as receiving one from him, and Ibrahim Paşa's high status was further confirmed by the timing of his gift giving. This took place on the very first day of the celebrations, like that of the other members of the imperial council, but Ibrahim was given precedence over his colleagues, as his gifts were delivered first and in a separate ceremony. Only members of the two households, imperial and vizieral, took part, and this relative intimacy is indicated by the empty tents seen at the top left in the double-page illustration (see fig. 142). Clearly, Ibrahim Paşa's colleagues, and potential rivals, on the imperial council had been excluded.

The text mentions only two officials concerned in delivering Ibrahim Paşa's gifts, the steward of the grand vizier's household and a court official who had access to the sultan. We can see them together on the left-hand page of the illustration, where the official, in a pink caftan, is shown receiving a jewel-encrusted bowl from the steward, who wears a high white turban. The man in pink was, though, a mere intermediary for a far more important person, with whom it was not appropriate for the steward to have contact, Beşir Ağa, the black eunuch in charge of the sultan's harem. He is shown near the center of the right-hand page, holding what is probably the same gem-set bowl. Beşir Ağa faces the sultan, who sits in the audience tent set up for him on the festival ground. To his left are the three eldest princes, all wearing feathered aigrettes in their turbans; the fourth prince was too young to attend. The grand vizier sits immediately outside the sultan's enclosure, in the tent in the top-left corner of the page.

The order of the gifts in the text is not reflected precisely in the illustration, but painting and prose do match to a surprising degree. Behind Beşir Ağa stand six halberdiers, notable for their tall conical hats. The fifth of these holds the first gift, which is described in these flowery terms:

Firstly, a belt of charming design set with an unblemished diamond of great brilliance and heavy cost, which was more refined than a hundred-petaled rose set with drops of dew, and more brightly burnished and more highly polished than the Moon's crystal orb that is hung in heaven's arc; its world-illuming glint turned the festival crowd into a mob of light, and the estimation of its value made the money-changer of the mind empty the purse of his comprehension.

By comparison, the self-illuminating jewel of the Moon
Is no brighter than a wax candle beside the Sun.
Whoever sees the untarnished glow in that gemstone
Would think it the Silver Stream in the Aqueducts.
Supposing that there was such a thing, only
A gift as exquisite as this would be fit for an emperor.[7]

No other single gift gets quite so much praise, and it is worth noting that a second, less skillfully illustrated copy of Vehbi's text contains an illustration of a later stage of the narrative in which the sultan is shown wearing precisely this type of belt.[8] It may be that, out of pride, Ibrahim Paşa had the painter record the fact that the sultan not only accepted the belt he had given him but actually wore it.

The second gift, "skillfully wrought fastenings set with diamonds and rubies," can be identified with the jeweled frogging held by the halberdier immediately behind Beşir Ağa. Next in the list comes the "gem-set porcelain bowl" held by the black eunuch himself,[9] while the fifth gift is the "gem-set vessel of rock crystal" held by the second halberdier; it is in the form of a tall, lidded drinking jug with a handle.[10]

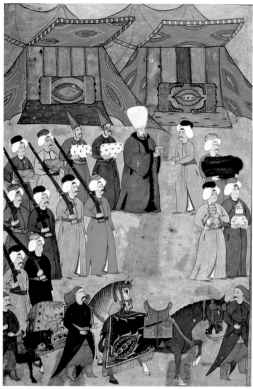
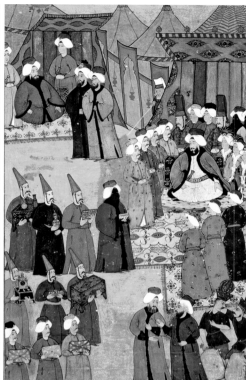

Fig. 142. *Presentation of Gifts from the Grand Vizier Ibrahim Paşa*, double-page painting from the *Surname-i Vehbi*, Turkey, c. 1721–30. Topkapi Saray Museum Library, Istanbul (A.3593, folios 26b–27a).

The third and fourth halberdiers hold two very similar pieces of furniture, which most resemble the low desks Ottomans used for writing on. This seems to be a mistake, as the list mentions only one, "a rare writing desk damascened in gold, fitted with thirteen enameled mounts of Jewish workmanship."[11] The second desk must have replaced the "casket with drawers for jewels, fitted with a mirror, Indian work, gem-set and jeweled, and well-wrought" described in the text. The seventh and eighth gifts are two precious commodities, both used in perfumery, that is, a bottle of attar weighing about 1.25 kilograms and "a piece of ambergris with the same shape as the disk of the full moon" weighing over 850 grams. Both items can be seen on top of the small desk held by the third halberdier, while the ninth gift, "a clock in a gold case," is easily recognizable as the item held by the sixth halberdier.

The list then moves on to furs and textiles. The first item, a caftan of green broadcloth lined with "new black fox fur," is held by the page dressed in orange on the left-hand page. Behind him are two halberdiers carrying the lynx fur and ermines "with musk-black tails" referred to in the text. The

remaining six furs mentioned were presumably held by pages off to the left of the picture, as were most of the textiles. Only five parcels of cloth are shown, although the text lists enough silk brocade, satin, cashmere, and other expensive fabrics to make eighty garments, twenty-five bolts of lighter textiles such as muslin, "and innumerable other varieties of cloth." The remaining gifts listed were two huge jars of sweetmeats; four locally made rifles and one Hungarian gun; three horses, two fully fitted out for riding with saddlecloths and the like (fig. 23); and one baggage animal. In the illustration, however, six guns are shown, while the third horse has been replaced by the pony Ibrahim Paşa gave one of the sultan's sons.

GIFT GIVING RECONSTRUCTED

Of course, many of Ibrahim Paşa's gifts had a relatively short life: the foodstuffs were consumed, the horses died, and the furs and textiles were probably used until they were worn out. It is possible, though, that some pieces, such as the treasury items and the weapons, have survived among the enormous body of material from the period,

Above: Fig. 143 (cat. no. 160). *Mosque Lamp*, Italy, Venice, 16th century.
Topkapi Saray Museum, Istanbul (34/468).

Opposite: Fig. 144 (cat. no. 88). *Ottoman Lamp*, Turkey, c. 1620.
Museum of Turkish and Islamic Art, Istanbul (77).

especially that still kept in the Topkapi Palace.[12] Identifications with objects no longer in the palace have been suggested for two gifts of art historical importance that were presented to a sultan on two much earlier occasions. Both gifts were presented to Sultan Süleyman the Magnificent (r. 1520–66) by the prominent court painter called Şahkulu (d. 1556).

Şahkulu is also known from inscriptions on undated works on paper and from references in narrative sources, as well from documents drawn up by court officials.[13] His name appears in two dated registers of craftsmen's wages, from 1526 and 1545, and an accompanying note in the earlier register tells a good deal of his story.[14] By 1514 he was working as a painter in Tabriz (in northwestern Iran), the capital of the Safavid state and a great center for the production of luxury crafts. In that year the Ottoman sultan Selim I (r. 1512–1520) occupied Tabriz, and before he withdrew, he ordered the deportation of large numbers of craftsmen, including Şahkulu, first to Amasya in central Turkey and then to Istanbul. There the painter was awarded a stipend from the imperial household budget, and in December 1520, soon after the accession of Selim's son Süleyman, he was transferred to the group of painters who had been in the sultan's service before 1514 and who were paid alongside other court craftsmen.

In 1526 Şahkulu was receiving twenty-two silver pence a day—already a relatively high sum.

By 1545 his daily stipend had risen further, to twenty-five silver pence, and he had become head of the large group of painters he had joined in 1520. His importance during this period is also indicated by the regularity with which he was allowed to present gifts to the sultan at one of the two great festivals of the Muslim year, as recorded in three additional documents, all undated.[15] On one occasion, only four painters were afforded this privilege—a small number when compared with the twenty to thirty masters and the large number of apprentices who were members of Şahkulu's group. Those distinguished in this way included a "head painter," who is not named, and who presented the sultan with a "harp with painted decoration."[16] The other three masters, Bayram, Şahkulu, and Büyük Hasan Çelebi, also brought items they had (presumably) decorated themselves, which, in Şahkulu's case, consisted of "one large decorated dish, six small bowls."

On another occasion, Şahkulu was one of six painters who presented gifts. The words "head painter" appear first in the list, but no further details are given; apparently the holder of this position failed to deliver a gift, perhaps because he was ill or had died, or, more embarrassingly, because the gift he had brought was not considered of sufficient quality to be presented. The five other painters appear much farther down the list. Hacebey had brought "a dish and a decorated cover"; Melek Ahmed, "a decorated chest and a staff"; and Şahkulu, "a picture of a peri on paper"; while Büyük Hasan Çelebi and Hüseyin Rumi both gave small caskets they had painted.

Şahkulu was famous in later centuries as the great master of drawing in ink done with a brush, in the Chinese manner, and a number of superb drawings of this type have been attributed to him or his immediate followers. Several depict the benevolent winged creatures called peris, and one (fig. 145) has been identified with Şahkulu's "picture of a peri on paper."[17] The peri was drawn with exquisite skill, in terms of both the overall composition and the rendering of minute details, and there can be no doubt that this work would have been worthy of presentation to the sultan.

The other group of objects that can be associated with Şahkulu are five large ceramic tiles of

Opposite: Fig. 145. *An Angel, Flying, with Cup and Wine Flask*, Şahkulu, Turkey, Istanbul, mid-16th century. Freer Gallery of Art, Smithsonian Institution, Washington, DC: Purchase (F1937.7).

Left: Fig. 146. *Tile Panel*, Topkapi Palace, Sünnet Odasi (Circumcision Chamber), Turkey, Istanbul, c. 1527–28.

similarly exceptional quality that now decorate the façade of the Circumcision Chamber in Topkapi Palace; their enormous size (up to 127.5 by 48 cm) and the graphic nature of their decoration make them outstanding examples of their form (fig. 146, in which two of the five tiles are visible flanking the central panel). Şahkulu had clearly mastered the technique of executing his drawings in cobalt pigment on fritware ceramic, and it is therefore possible that the large dish and six small bowls that he presented to Sultan Süleyman on another occasion were also made of this luxury material. A small group of Ottoman fritware vessels made in the second quarter of the sixteenth century is decorated with patterns featuring the large composite blossoms and long leaves found on the tiles of the Circumcision Chamber and other works by Şahkulu. Here, though, the black outlines of the design are filled with turquoise, green, and purple washes, as well as cobalt blue. One of these vessels, a rimless, shallow dish (fig. 148), shows a brilliance of execution and a coherence of design that sets it apart, and it has been suggested that this dish was the one presented by Şahkulu to the sultan.[18]

In an exchange of gifts between the sultan and members of his establishment (for example, figs. 132, 226), the sultan had to maintain his superiority by outdoing his subjects in the lavishness of his gifts; condescension is expressed in

the term *in'am* used for the sultan's gifts, as the word indicates a favor done to a social inferior. The main component of the "favors" done to the court craftsmen at festival time was cash, and the substantial sums they received in return must have been a significant part of their annual income. A minority of the men also received a robe of honor.

In an undated list of such "favors" that mentions Şahkulu, the sultan presented gifts to 149 craftsmen and an unknown number of apprentices. The fourteen painters among them each received a sum of money ranging between seven hundred and three thousand silver pence, while two received robes of honor: one was the head painter, Hasan, who also received three thousand silver pence, and the other was Şahkulu, who was one of five painters given two thousand silver pence. The robe given to Hasan must have been particularly luxurious, as it is the only one in the whole list described as a velvet caftan. By 1556, when a second list of "favors" was drawn up, Şahkulu had himself become head painter, and he was slated to receive the same level of recompense as his predecessor, namely three thousand silver pence and a velvet robe. But he did not come to collect his rewards, for a note tells us that "he has died."

A later writer, Mustafa 'Ali, tells us that Şahkulu was a particular favorite of Sultan Süleyman,[19] and the consistent manner in which

Above: Fig. 147 (cat. no. 75). *Levha*, designed by Sami Efendi and inlaid by Vasif Efendi, Turkey, Istanbul, dated AH 1314/1896–97. Museum of Turkish and Islamic Art, Istanbul (4086).

Opposite: Fig. 148 (cat. no. 74). *Dish*, Turkey, Iznik, c. 1545–50. Private collection.

the painter is honored in the gift exchanges at festival time, both by being allowed to make gifts and in receiving extra honors from the sultan in return, supports this claim. Gifts were part of a formal dialogue between patron and painter within a system in which the sultan had to maintain his social distance. At the same time, the records of gift giving indicate that the painters, who would have generated many of the designs used in other media, were given a modest precedence over the other craftsmen, if only through the presentation of a velvet robe to the head painter.

Notes

1 On these carpets, see Franses, "Some Wool Pile Persian-Design Niche Rugs." The inscriptions were recorded by Manijeh Bayani in app. D, 118–29. On the gifts to Selim II, see also Linda Komaroff's essay in this volume.

2 Rogers, "The State and the Arts in Ottoman Turkey, Part 2," 307.

3 On gifts of porcelain received, see Raby and Yücel, "Chinese Porcelain at the Ottoman Court," 30–32.

4 For example, see Arthur M. Sackler Gallery, Smithsonian Institution, *Tsars and the East.*

5 See Raby and Yücel, "Chinese Porcelain at the Ottoman Court."

6 Vehbî, *Sûrnâme*, 487–92; the editor's modernized version of this text is on 76–81, and his description of the painting is on 705–6.

7 Translated from ibid., 487; "Silver Stream in the Aqueducts" is a topographical reference.

Fig. 149 (cat. no. 259). *Rosette from the Mshatta Façade.* Mshatta (modern Jordan), 8th century. Museum für Islamische Kunst, Berlin (I. 6166).

8 Topkapi Palace Museum Library, ms. A.3594, fol. 16a; see İnalcık, *Türkiye Tekstil Tarihi*, 49.

9 On Chinese porcelains with Ottoman jeweled decoration, see Raby and Yücel, "Chinese Porcelain at the Ottoman Court," 47–51, and the catalogue in the same publication, Krahl, *Chinese Ceramics*, vol. 2, 833–81.

10 Compare Topkapi Palace Museum, inv. no. 2/8; see Atil, *Age of Sultan Süleyman the Magnificent*, cat. no. 61, illustrated on 130.

11 My translation of *göz*, literally "eye," as "mount" is based on the eleven circular enameled mounts on an eighteenth-century ivory casket in the Topkapi Palace collections, inv. no. 2/3143; see Museum für Angewandte Kunst, *Tulpen, Kaftane und Levnî*, 236–37. The alternative translation is "drawer" or "section."

12 See n10 above for a possible identification of the rock-crystal vessel, for example.

13 Mahir, "Saray Nakkaşhanesinin Ünlü Ressamı Şah Kulu ve Eserleri."

14 For these registers and others mentioned later in this essay, see Meriç, "Bayramlarda Padişahlara Hediye Edilen San'at Eserleri ve Karşılıkları," and Uzunçarşılı, "Osmanlı Sarayı'nda Ehl-i Hıref (Sanatkârlar) Defteri." Some of the data from these registers were collated and translated into English in Atil, *Age of Sultan Süleyman the Magnificent*, 291–99.

15 A third gift, "a pot made from pasteboard," is not discussed here.

16 The word translated as "with painted decoration" is *nakışlı*, which, along with its synonyms *münakkaş* and *alaca*, means "patterned" as opposed to "plain." The translation is therefore circumstantial.

17 Mahir, "Saray Nakkaşhanesinin Ünlü Ressamı Şah Kulu ve Eserleri," 122–23, and figs. 10–12. The image bears a signature, "The work of Şahkulu." The other example cited by Mahir is Freer Gallery of Art, Washington, D.C., inv. no. 33.6 (123–24, and figs. 13–15). For other images of peris, see Denny, "Dating Ottoman Turkish Works in the Saz Style," 114–15, and Atil, *Age of Sultan Süleyman the Magnificent*, no. 48a, illustrated on 103.

18 Atasoy and Raby, *Iznik*, 135, and figs. 221, 352.

19 Mahir, "Saray Nakkaşhanesinin Ünlü Ressamı Şah Kulu ve Eserleri," 114–15.

Gifts and the Topkapi Palace

Ilber Ortayli

For nearly four centuries, until 1853, the celebrated Topkapi Palace in Istanbul was both a royal residence and the administrative center of a great empire. As such, the Topkapi was quite naturally the point of reception and place of storage for the impressive gifts presented to the Ottoman sultans at diplomatic receptions, on state occasions, and during court festivities. But it was also the locus for the production of reciprocal gifts, which were made in the palace workshops or, for arts of the book, in the *nakkaşhane* located in the inner part of the palace.[1] Some of the superb examples of Ottoman court art included in this catalogue and the exhibition it accompanies may have been produced at the Topkapi for presentation to foreign rulers, but the gifts received at the palace are also well represented in the exhibition.

Of the many state gifts offered to the Ottoman sultans and kept at the Topkapi, most belong to the period when it was a royal residence, that is, between the 1460s and the 1850s. One important exception is a gift that pre-dates the establishment of Istanbul as the Ottoman capital in 1453 and the subsequent construction of the Topkapi Palace. This is a famous fourteenth-century glass lamp, which the Mamluk sultan Hasan sent to the sultan Orhan when he congratulated him on the conquest of Gallipoli in 1357.[2] The Mamluks of Syria and Egypt may also have presented the Ottoman sultans with their first examples of Chinese porcelain. The palace is now home to one of the world's best collections in this field. It comprises twelve thousand pieces, including superb examples of Yuan and Ming dynasty blue-and-white and celadon wares, acquired partly as gifts and partly by purchase.[3] Other great ceramics preserved at the Topkapi are rare examples of Sevres porcelains, produced as diplomatic gifts in the French royal factory beginning in the reign of Louis XV.[4]

Gifts brought by foreign envoys are today among the greatest riches of the Topkapi. In addition to the sultan, gifts were presented to the grand vizier and other state officials, their value varying in accordance with the rank of the recipient. Such diplomatic missions were welcomed with great pomp and ceremony, especially the large and ostentatious delegations from Iran and Austria. The grand ambassadorial processions entering the Topkapi attracted the attention of locals and foreigners alike and were recorded by artists. One notable occasion that caused an unusual degree of commotion was the arrival in 1583 of the English ambassador William Harborne, whose ship, the *Susan*, fired a salute offshore from the palace, where the sultan was watching. The envoy's presentation of his credentials to the sultan and the official reception of his sizable delegation were accompanied by the delivery of numerous gifts.[5]

There were some differences between the reception ceremonies of Muslim and Christian envoys. Envoys of the Iranian shahs, Bukharan amirs, and Mughal emperors were welcomed with elaborate formality at Üsküdar, on the Asian side of the Bosphorus, and the Iranian envoys stayed at a mansion near Babiali, the residence of the grand vizier. The Iranian gifts,[6] together with ones from India, are among the most valuable objects in the Ottoman palace, making such an impression that they were described in contemporary chronicles.

Gifted objects in the Topkapi collection dating to the later nineteenth century include not only diplomatic presentations but also offerings to the sultan from imperial institutions. On the twenty-fifth anniversary of Abdülhamid II's accession, for instance, the gifts included a model of the Dome of the Rock in Jerusalem of wood inlaid with mother-of-pearl, presented by the Patriarch of Jerusalem, as well as a silver model of the fountain of Ahmed III, offered by the Water Supply Administration.[7] Palace artists also gave gifts to the sultan at times of feasts and other occasions, and these gifts together with the artists are enumerated in Ottoman registration documents. For example, a fur proffered by the head furrier (*kürkçübaşı*) or a golden horse armband presented by the goldsmith Dervish Mehmed may be mentioned in this regard.[8]

The fact that so many of these gifts are preserved in the Topkapi Palace, which was never subjected to looting and the dispersal of its treasures, is a rare privilege. Gifts presented by ambassadorial delegations were registered in the palace inventory from the onset although without the kind of detail that might satisfy the modern-day curator. Along with inventories and other historical and archival records, the remarkable gifted objects preserved at the Topkapi will continue to provide challenging material for future generations of scholars and appealing subject matter for new exhibitions.

Notes

1 This text was translated from the Turkish by Arif Çelik, deputy vice-consul at the Turkish Consulate in Los Angeles, to whom we are most grateful. In the nineteenth century this task was passed on to the *Fabrika-ı Humayun* (Imperial Factory) founded in Hereke. Today, the National Palaces Administration, under the Turkish Grand National Assembly, administers this institution and prepares gifts for state visits but does not make anything for the market.

2 Topkapi Saray Museum 2/1856; see Bilirgen, *Topkapı Sarayı Hazine-i Hümayun*, 65.

3 See, for example, Krahl, *Chinese Ceramics in the Topkapi Saray Museum*.

4 A joint exhibition between the Topkapi and the National Ceramic Museum at Sevres is currently in preparation.

5 See Reyhanlı, *İngiliz Gezginlerine Göre XVI. Yüzyılda İstanbul'da hayat (1582–1599)*; the gifts included twelve pieces of rare woolen cloth, ten pieces of double-gilded plate, and a chandelier, as well as shepherd dogs, hunting dogs, and rare clocks. Also, see Parker, *Early Modern Tales of Orient*, 48–53, for the reception of the embassy and its gifts.

6 See Topkapi Palace Museum, *Ten Thousand Years of Iranian Civilization*.

7 Some of these later nineteenth-century gifts, however, appear to have been transferred from Yildiz and Dolmabahçe Palaces to the Topkapi. An inventory prepared during the reign of Sultan Mehmed V (r. 1909–18), especially, demonstrates that such a transfer took place; see Bayraktar, "Sultan Abdulhamid'e Gelen 25. Cülus Hediyeleri Defteri." In the nineteenth century the Topkapi Palace became the place of preservation for such property of the sultan, as well as many other belongings transferred from other palaces. It is important not to confuse these items with those connected more directly to the history of the palace, although having such material in the Topkapi Palace has been remarkably beneficial in terms of their preservation.

8 *Ehl-i hiref defteri* (list of the royal artisans), see Uzunçarşili, "Osmanlı Sarayi'nda Ehl-i Hiref (Sanatkarlar) Defteri."

The Sultan and the Kaiser: Gift Exchange between Abdülhamid II and Wilhelm II

Aimée E. Froom

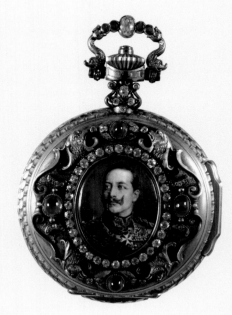

The Mshatta façade (fig. 149), now in the Museum of Islamic Art, State Museums of Berlin, and the German fountain at the northern end of the Hippodrome in Istanbul are the most prominent tangible evidence of the cordial relations between Abdülhamid II (r. 1876–1909), the last effective Ottoman sultan, and Wilhelm II (r. 1888–1918), the last German kaiser and king of Prussia. For each ruler, the relationship served multiple purposes and can be read on political, military, and economic levels. With a crumbling empire, internal factions chafing at the bit of autocratic rule, and the sultan's opposition to the Great Powers (Britain, France, and Russia), Abdülhamid clearly needed Wilhelm more than Wilhelm needed him. Yet, for the Germans, the Ottomans represented an important foothold in the Middle East. The Baghdad Railway concession, in particular, was very important to Wilhelm, who strongly believed in his power of dynastic diplomacy and personal rule, often to his detriment and ultimately to that of the German Empire. The relationship between the two rulers is illuminated by archival sources and illustrated by the material evidence of their rich and generous gift exchange.

When Wilhelm and his wife, Augusta Victoria, arrived on their imperial yacht *Hohenzollern* for their first visit to Istanbul, in early November 1889, they were greeted with much fanfare by their Ottoman host. The shoreside welcoming committee from Dolmabahçe Palace included the sultan and his daughter bearing a floral bouquet for the kaiserin. The weeklong state visit followed the usual diplomatic protocol with appropriately sumptuous receptions, dinners, parades, and visits to important Istanbul monuments, sites, and neighborhoods. What was unusual about the first visit, however, were the elaborate preparations undertaken by the Ottomans. A commission was set up to oversee all details, and the upcoming visit was portrayed positively in the local and international press.[1]

Significantly, Abdülhamid ordered the construction of a residence for the visitors, the Şale Kiosk (chalet pavilion), within the Yildiz Palace complex.[2] No expense or detail was spared as can be witnessed by the Sedefli Salon, which was covered almost entirely in mother-of-pearl. One German observer close to Wilhelm II remarked that the chalet pavilion accommodations were "excessively rich" and a state dinner during the visit was "very elaborate, the table was magnificently arranged, we ate off nothing but gold. The centerpieces on the table were all of gold and bronze, likewise spoons, knives, and forks…. The extravagance which is shown in the Sultan's palace disgusts one because one knows how wretched things are in the country."[3]

The various and plentiful gifts exchanged and orders[4] bestowed as part of the first visit attest to the importance each ruler placed on pursuing relations with the other. Among the notable gifts are the jewel-encrusted gold pocket watch with a portrait of Wilhelm II (fig. 150) and Mauser rifle presented to Abdülhamid, perhaps as a symbol of German technological and military progress and arms sales.[5] The kaiser also presented the sultan with a large rococo clock decorated with figures costing eighteen hundred marks and two nine-branched candelabra worth eleven hundred marks.[6] Not to be outdone, Abdülhamid gave parting gifts of "an extraordinarily costly sabre" for the kaiser and jewelry for the kaiserin, including one piece that alone was valued at ten thousand pounds.[7] Vice Admiral Paul Hoffmann remarked that many of the imperial entourage took offense at the "senseless luxury" and "court flimflam, the humbug about orders, and the miserable business of etiquette" in Istanbul.[8]

Relations between the two realms and their sovereigns continued to deepen during the nine years leading up to the kaiser's second visit. German military officers assisted the Ottoman army after their defeat in the Russian-Turkish War (1877–78). Baron Colmar von der Goltz, for example, spent ten years from the mid-1880s to the mid-1890s advising the Ottoman army on training procedures, staffing, and military organization. The Germans also made much-needed commercial

investments in the Ottoman Empire. The Société du Chemin de Fer Ottoman d'Anatolie, managed by the Deutsche Bank, built the Izmit to Ankara railway line, which was finished in 1892, and the Ekişehir to Konya line, completed in 1896. On a personal level, the sultan and the kaiser corresponded and exchanged birthday wishes and family photographs, and a painting of Queen Victoria, the kaiser's grandmother, was sent to the sultan with a note signed, "your sincere and loyal friend, Wilhelm."[9]

For their second visit to Istanbul, in October 1898, Wilhelm and his wife arrived again by imperial yacht. Istanbul was prepared months in advance for parades and celebrations, and the Ottoman press praised the kaiser as a great statesman and protector of the Ottoman Empire.[10] The imperial couple stayed, as before, at the chalet pavilion, which had been outfitted with electricity,[11] marble from Italy, Bohemian crystal, gold cutlery, crystal service, and an enormous Hereke carpet measuring over four hundred square meters. Clearly, the sultan spared no expense to impress the kaiser. In addition to the usual diplomatic tour stops, the couple visited the Yildiz imperial porcelain factory and the Hereke imperial textile factory. A list from March 1906 details the numerous gifts of imperial porcelain and textiles presented to the kaiser.[12]

The second visit marked a turning point in Turkish-German relations. Precious concessions were granted to the Germans, including the Baghdad railway project and Haydarpasha station construction. Major gifts were also exchanged. To commemorate the visit, the kaiser presented the sultan with an octagonal fountain made of marble, stone, and mosaics shipped in pieces from Germany and reconstructed on-site in the Hippodrome for dedication in 1901. In 1903 Abdülhamid II granted the kaiser's request for the Mshatta façade to go to the new Kaiser Friedrich Museum in Berlin. This extraordinary gift was the result of the Royal Museum's director Wilhelm Bode's petition to the kaiser requesting the relocation of the façade of this

ruined palace, which would become exposed to further despoliation with the completion of the Hijaz railway. Osman Hamdi, Ottoman Archaeological Museum director and architect of the antiquities antitrafficking law, opposed the request. The transfer of the Mshatta façade was made as a personal gift from the sultan, and the Germans sent black thoroughbred horses to the sultan as a thank-you gesture.[13] Clearly, archaeological heritage in Ottoman lands continued to be used to cement economic and political alliances.

The rich and varied evidence of gift exchange points to a valuable relationship that served each empire politically, militarily, and economically. The question remains: can we speak of a close, personal friendship between Sultan Abdülhamid II and Kaiser Wilhelm II? Archival records reveal that personal correspondence even extended to family members: it is recorded that Prince William, the oldest son of the kaiser, sent the sultan a photograph of his wedding. Another document, also from 1904, relates that the sultan conferred the Ottoman order of Osmanlı Nişam on the kaiser's son and the Schefkat Nişam on his daughter.[14] The kaiser even gave the sultan one of his own revolvers with the initial "W" in diamonds on its ivory grip (fig. 152). It is perhaps imprudent, however, to speak of a close personal

friendship considering the erratic, inconsistent personal diplomacy of the kaiser. In sum, the relationship between Sultan Abdülhamid II, the last effective sultan at the twilight of the Ottoman Empire, and Kaiser Wilhelm II, the last emperor and king of an ascendant industrial German Empire, is a fascinating and complex one that produced many gifts (also see fig. 151), served many purposes, and requires further study.

Notes
1 Ottoman archival material, cited in Baytar et al., *Iki dost hükümdar*, 61.
2 The Şale Kiosk was originally built in the 1870s of wood and stone and meant to resemble a two-level Swiss chalet, thus its name. Ibid., 47–57.
3 Paul Hoffmann's entry for November 5, 1889, cited in Röhl, *Wilhelm II*, 115, 125. Vice Admiral Paul Hoffmann traveled with Wilhelm II during the Mediterranean cruise ending up in Istanbul, where he was able to observe Wilhelm closely. See also Baytar et al., *Iki dost hükümdar*, 109–29.
4 Baytar et al., *Iki dost hükümdar*, 64n20.
5 Ibid., 44.
6 Jarchow, *Hofgeschenke*, 35 and 83, cited in Röhl, *Wilhelm II*, 125.
7 Hoffmann diary entry for November 6, 1889, cited in Röhl, *Wilhelm II*, 125n90. See Baytar et al., *Iki dost hükümdar*, 67, for archival lists.
8 Hoffmann diary entry for November 4, 1889, cited in Röhl, *Wilhelm II*, 125n91.
9 Baytar et al., *Iki dost hükümdar*, 68. The correspondence is dated June 2, 1890.
10 Ibid., 72–73.
11 Ibid., 52. Electricity was added in 1898 by the German firm Siemens and Halske.
12 See ibid., 77, for list details.
13 See Shaw, *Possessors and Possessed*, 121–22 and n35, where she references the Ottoman archival document approving the export of the Mshatta façade. See also Marchand, *Down from Olympus*, 10.
14 See Baytar et al., *Iki dost hükümdar*, 76n43.

Opposite, top: Fig. 150 (cat. no. 256). *Pocket Watch*, Germany, c. late 19th century. Topkapi Saray Museum, Istanbul (53/190).

Opposite, bottom: Fig. 151 (cat. no. 258). *Scepter*, Germany, early 20th century. Topkapi Saray Museum, Istanbul (2/1440).

Left: Fig. 152 (cat. no. 257). *Revolver*, Germany, 19th century. Topkapi Saray Museum, Istanbul (2/1188).

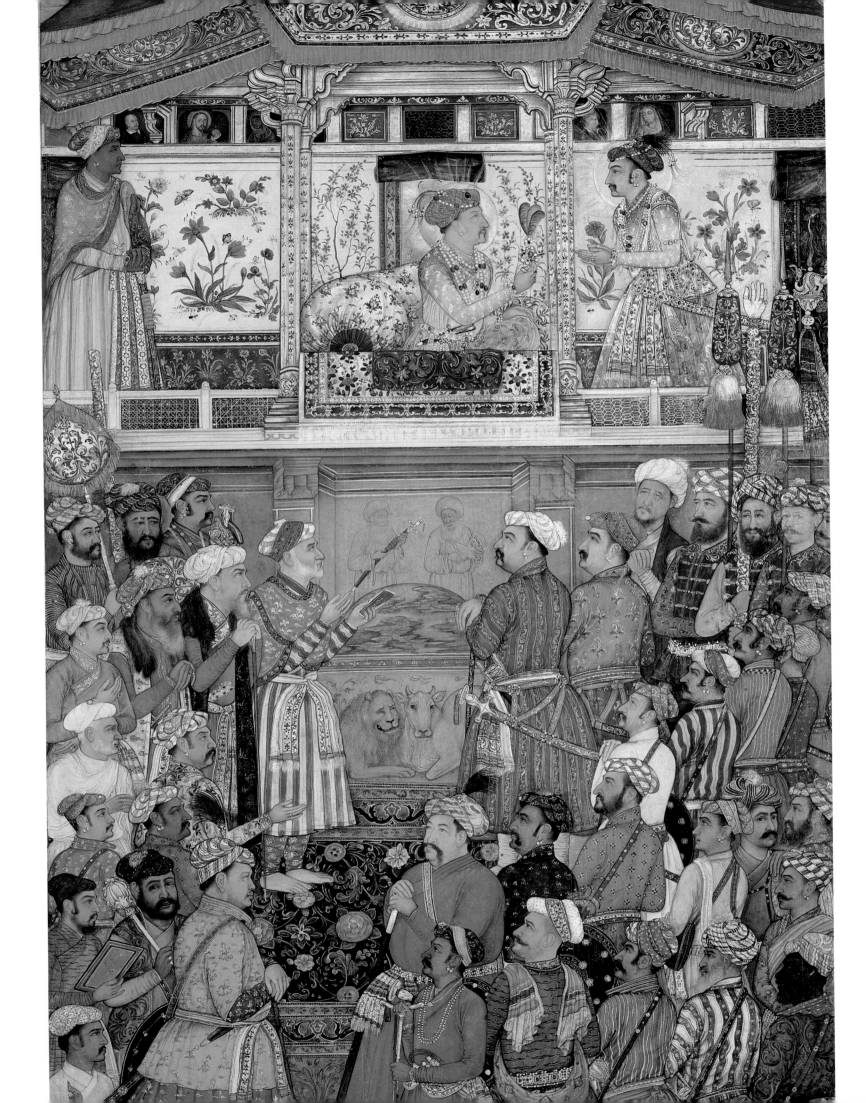

Imperial Gifts at the Court of Hindustan

Susan Stronge

As the reign of the Mughal ruler 'Alamgir (r. 1658–1707; see fig. 160) entered its fourth year in April 1661, the Iranian ambassador Budaq Beg arrived in the empire.[1] He brought a letter from Shah 'Abbas II belatedly congratulating 'Alamgir on his accession to the throne while tactfully avoiding any allusion to the emperor's father, Shah Jahan, whom he had ousted in 1657, or to the subsequent War of Succession. Shah Jahan was now imprisoned in the palace at Agra and the former Prince Awrangzib's brothers either had been killed on his orders or soon would be. Mughal Hindustan was calm, revenues once again were being collected, and most of the usual court rituals and festivities had resumed.[2] The terseness of contemporary historians conceals the fact that in the first years of the reign of an emperor usually remembered for his pious austerity, these continued with customary splendor. In all of the celebrations, the exchange of gifts played a central role.

The Iranian was the most important ambassador yet to be received by 'Alamgir, and careful preparations had been made for his visit, which coincided with the coronation anniversary. As soon as Budaq Beg reached the Mughal province of Multan, he was welcomed by the regional governor, generously entertained, and given nine pieces of precious Hindustani cloth as well as five thousand rupees for immediate expenses.[3] The governor of the neighboring province then took the ambassador and his entourage to Lahore, where Budaq Beg received twenty thousand rupees, a sword and dagger with enameled fittings (saz), and seven pieces of cloth. Hundreds of dishes of food were also provided before the Iranians left for Delhi.

François Bernier, a French physician and philosopher who had been living at court since 1659, saw them arrive at Shahjahanabad, the city built in Delhi by 'Alamgir's father between 1639 and 1648. Senior Mughal grandees rode out with musicians to escort Budaq Beg toward the fortified palace through streets lined with cavalry and bazaars decorated in his honor.[4] He met the emperor in the white marble Hall of Public Audience, presented the shah's letter, and revealed the gifts he had brought.[5] Mughal accounts mention sixty-six Arabian horses, unspecified numbers of Bactrian camels, and a single, perfectly round pearl with a beautiful luster weighing thirty-seven carats. The total value, meticulously recorded according to standard practice, was 422,000 rupees, a sum that would have paid for the construction of the finest mansion in Shahjahanabad two decades earlier.[6] The immense pearl worth sixty thousand rupees must have been remarkable, though the author of the 'Alamgirnama struggled to find a suitable metaphor:

> In truth, the sperm of this kind of gem
> rarely comes down from the loins of the
> Nisan [month] cloud into the oyster of
> possibility, and rarely does a pearl of this
> kind and hue emerge on the shores of the
> Ocean of Creation.[7]

Bernier provides details of other Iranian gifts not specified in the official histories, which refer only to "precious things from Iran" (nafa'is-i Iran).[8] The camels were large racing animals, while the horses with embroidered brocade caparisons were the most beautiful he had ever seen.[9] There were also five or six extremely fine Iranian carpets of prodigious size and lengths of Iranian silk brocade, which he was later allowed to examine, probably through his friendship with the high-ranking noble Daneshmand Khan. Bernier doubted if such delicate floral designs could have been woven in Europe. The ambassador, he added, also presented four damascened swords and daggers with jeweled hilts, horse harnesses embroidered with small pearls and beautiful turquoises, several cases filled with

Opposite: Fig. 153 (cat. no. 34). *Jahangir Presents Prince Khurram with a Turban Ornament*, folio from the Windsor *Padshahnama*, Payag, India, c. 1640. The Royal Collection, Windsor (RCIN 1005025).

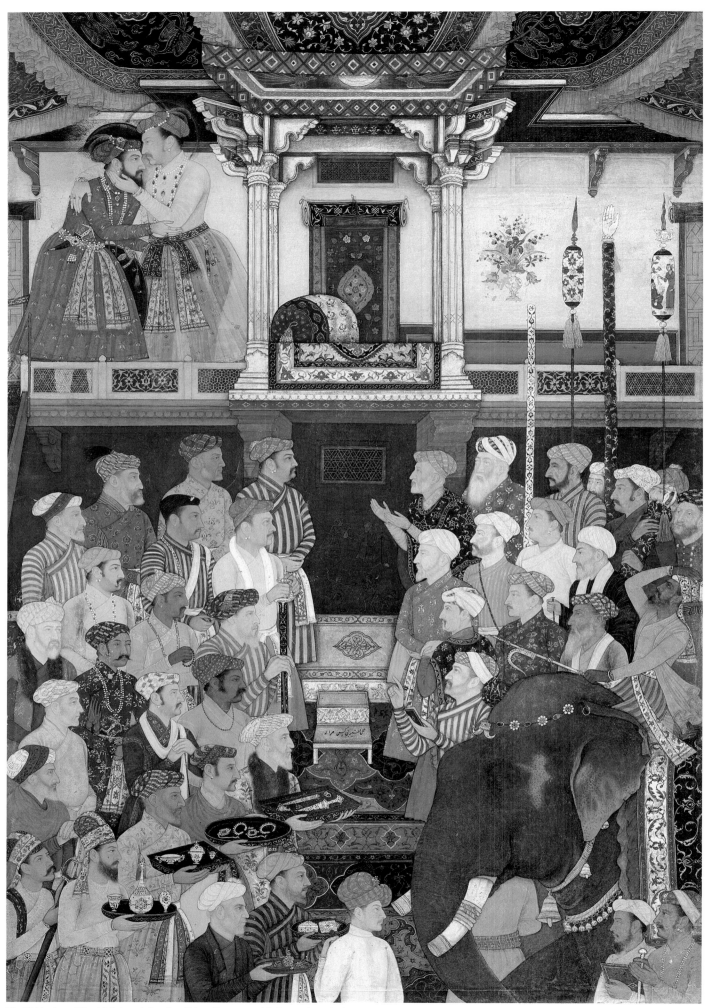

Fig. 154 (cat. no. 33 a–b). *Jahangir Receives Prince Khurram on His Return from the Deccan*, double-page composition from the Windsor *Padshahnama*, right-hand folio by Ramdas, left-hand folio by Murar, India, c. 1640. The Royal Collection, Windsor (RCIN 1005025).

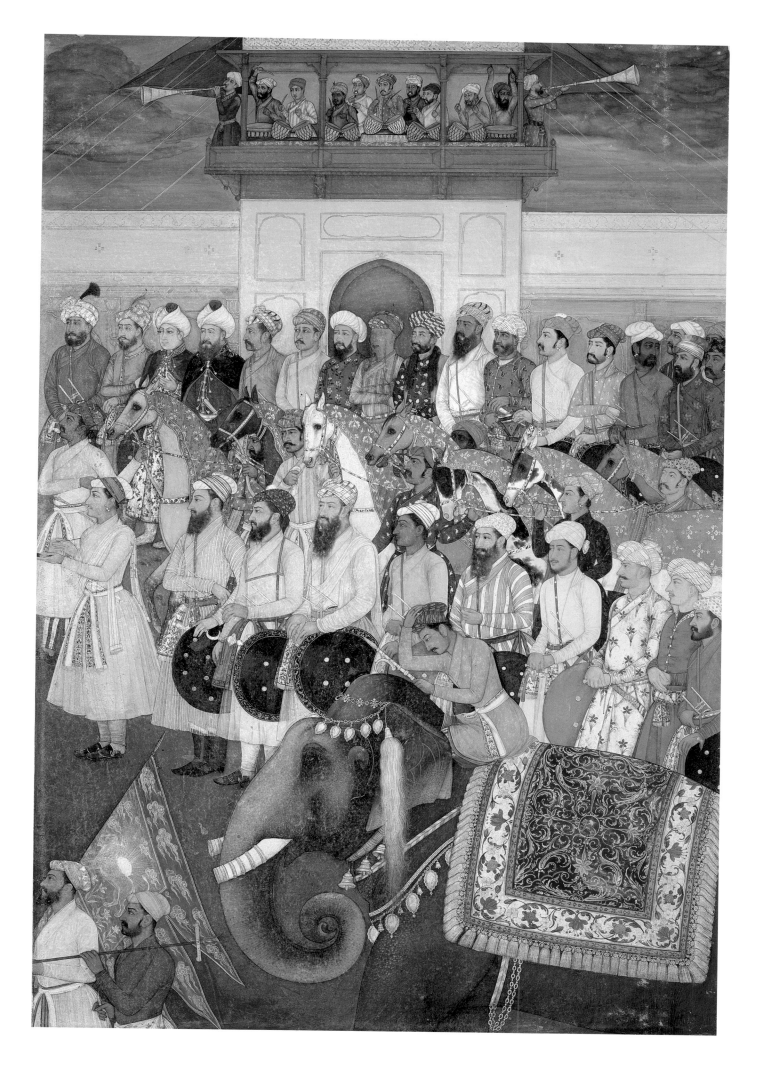

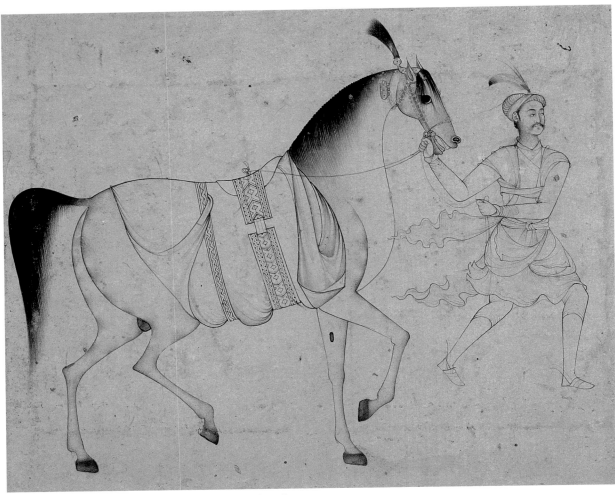

Fig. 155 (cat. no. 231). *Horse and Groom*, attributed to ʿAbd al-Samad,
India. c. 1580–85. Musée Guimet, Paris (3619 L A).

containers of Iran's renowned rose water, and other
cases containing distilled water, which he called
"beidmichk." This transcribes the Persian *bidmishk*,
which Borhan Tabrizi, a lexicographer writing in
AH 1062/December 14, 1651–November 3, 1652,
glosses as a liquor (ʿaraq) made from the blossoms
of this strongly scented variety of willow tree.[10] The
emperor then bestowed on Budaq Beg robes of
honor (khilaʿ), which, Bernier wrote, consisted of a
brocade jacket, a turban, shawl, and a sash with
gold and silver ends, all of which the ambassador
put on in ʿAlamgir's presence.

Other gifts mentioned by the court historians
reflect the political importance of Iran to the Mughals
at a time of rapprochement following earlier military
conflicts over the province of Qandahar, now under

Safavid control. ʿAlamgir gave Budaq Beg a jeweled
turban aigrette (jigha-i murassaʿ) (see fig. 153), an
ornament which at that time could be worn only
by rulers and princes or their representatives.[11]
The envoy also received a jeweled dagger (khanjar-i
murassaʿ), an honor typically given to princes,
high-ranking individuals within the Mughal system,
or important visitors.[12] Some items were tradition-
ally presented to distinguished individuals at times
of celebration: a covered gold cup with matching
salver contained the solid perfume called *argaja* or
argacha (argacha-yi jashn ba piyala wa khwancha-yi tala)
and a gold casket (pandan) contained small pouches
made from edible leaves wrapped around chopped
nuts and spices (pan). When the Iranian ambassador
Muhammad ʿAli Beg arrived at Shah Jahan's court

in 1631, for instance, he too had been given caskets containing *pan* and "festive *argaja*."[13] (See figs. 1, 250.)

Budaq Beg spent the next weeks in the fine *haveli*, or mansion, of a recently deceased member of the court whose estate, like that of many wealthy subjects, had been claimed by the emperor and was now specially furnished with carpets and other items from the imperial storehouse.[14] When he left Hindustan on AH 10 Dhu'l-Hijja 1071/July 27, 1661,[15] the Iranian received another *khil'a*, an enameled dagger with a pearl strap, a horse with a gold saddle and harness, and an elephant with a gold howdah and gold and silver trappings.[16] The court chronicles report that, in total, 535,000 rupees had been expended on the envoy and his entourage during their stay in Mughal Hindustan.

None of these histories, however, suggest what any of the gifts exchanged might have looked like. In previous reigns, paintings illustrate with careful attention to detail the sumptuous jewelry and jeweled artifacts, textiles, and weapons of the court that have mostly disappeared (see figs. 1, 168). Under 'Alamgir painting seems to have fallen out of favor, and depictions of his assemblies are rare. Foreign observers, to whom everything was new and intriguing, occasionally provided more information.

At the highest levels of the court, gifts of richly caparisoned horses were often exchanged (see fig. 155). Contemporary Mughal historians mention only that their trappings (*saz*) were gold, silver, or enameled. The French jewel merchant Jean-Baptiste Tavernier is more precise. The bridles he saw on his sixth visit to the Mughal Empire in 1665 were "very narrow, and for the most part enriched with diamonds, rubies, emeralds, and pearls, while some have only small gold coins. Each horse has upon its head, between the ears, a bunch of beautiful feathers, and a small cushion on the back with the surcingle, the whole embroidered with gold; and suspended from the neck there is a fine jewel, a diamond, a ruby, or an emerald."[17] The similarity of this description to harnesses shown in paintings of Shah Jahan's reign suggests that little had changed.[18]

Within the annual cycle of court ceremonies, 'Alamgir made his coronation anniversary the major

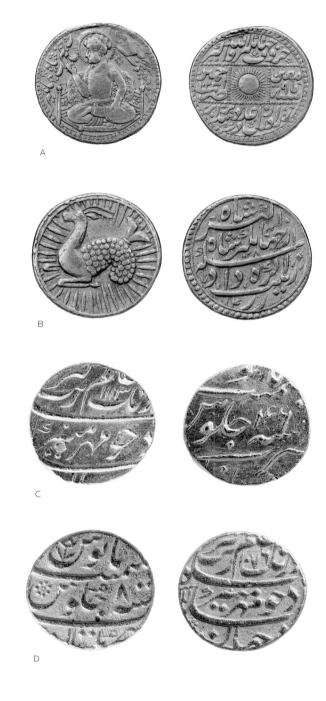

A. Fig. 156 (cat. no. 46). *Mohur*, Jahangir (r. 1605–27), India, Ajmer, AH 1023/1614. The British Museum, London (1854,0529.111).

B. Fig. 157 (cat. no. 47). *Mohur*, Jahangir (r. 1605–27), India, Agra, AH 1028/1618. The British Museum, London (1871,1201.2).

C. Fig. 158 (cat. no. 48). *Mohur*, 'Alamgir (r. 1658–1707), India, Multan, n.d. Omar Haroon Collection, Los Angeles.

D. Fig. 159 (cat. no. 49). *Mohur*, 'Alamgir (r. 1658–1707), India, AH 1113/1701. Omar Haroon Collection, Los Angeles.

festivity. His first coronation had taken place hurriedly in Delhi in June 1658 during a pause in the War of Succession. A second coronation was held on July 21, 1659, coins were struck in his name (see figs. 158–59), and his names and title were read as part of the Friday sermon (*khutba*). It was arguably the most splendid Mughal coronation ever held because 'Alamgir sat on the extraordinary jeweled and enameled throne commissioned by Shah Jahan after his accession.[19] It had taken seven years to complete and was set with the greatest stones in the imperial treasury and in Shah Jahan's personal collection. From this legendary Jeweled Throne (*takht-i murassa'*), with its gold canopy surmounted by two peacocks that inspired its later name, the "Peacock Throne," 'Alamgir showered presents on the court. The chroniclers again provide little detail, simply referring to "suitable rewards and gifts," but adding that "the doors of the imperial treasuries were opened to all people; and the expectations of all, young and old, were fulfilled."[20] The presence of the Jeweled Throne demonstrates that 'Alamgir had seized Shah Jahan's treasury, which held the most precious artifacts created for this extravagant patron as well as his vast store of precious stones.

The regulations governing the royal household and its administration had been formulated in the reign of 'Alamgir's great-grandfather Akbar (r. 1556–1605). As Akbar's territorial control expanded, the empire's wealth rapidly increased. Revenues were efficiently collected, gifts and tribute received, and the treasuries of vanquished enemies seized. By the late sixteenth century, all this was stored in twelve treasuries including one reserved exclusively for precious stones and another for artifacts made of precious materials.[21]

An English merchant, William Hawkins, describes Jahangir's treasury at the beginning of his reign.[22] He wrote that the contents included twenty-two hundred swords with jeweled hilts, two thousand similarly jeweled daggers, five hundred gold saddle drums set with precious stones, a thousand saddles with jeweled fittings, and hundreds of jeweled vases and drinking cups (including some made from a single ruby or emerald). Some of these items would have been acquired as gifts or tribute, but most would have been made in the court

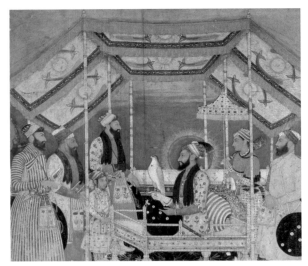

Fig. 160. *The Darbar of Emperor 'Alamgir*, India, c.1660. Museum of Islamic Art, Doha (MS.54.2007).

workshops, to be drawn on as necessary whenever court ritual required presentations to others. Similar items were in 'Alamgir's treasury, as shown by the gifts mentioned throughout his reign.[23]

'Alamgir's first coronation had taken place in Ramadan, and after the second coronation he decreed that each regnal year should be dated from the first day of that month. The anniversary was celebrated in the final days of Ramadan, culminating on the 'Id al-Fitr, and replaced in importance the Iranian New Year (Nawruz) festivies celebrated with enthusiastic extravagance ever since Akbar adopted the Iranian calendar in 1584.[24]

At first, 'Alamgir retained the other major ceremony established by Akbar. The public weighing of the ruler on his birthday was borrowed from Hindu kingship tradition. The Mughal emperor was weighed on his lunar birthday according to the conventional Muslim calendar and on his solar birthday according to the Iranian calendar. Until 'Alamgir abolished the ceremony in 1668, it was held with customary splendor.[25] Like his predecessors, he was weighed in a huge jewel-encrusted gold balance against gold, silver, and other precious commodities that were later distributed to those in need. He then moved to the Jeweled Throne to receive the gifts of the court. His dress was slightly more subdued than that of Jahangir or Shah Jahan on similar occasions, though when Bernier saw him in 1659 'Alamgir wore white satin embroidered in

gold with small flowers and a necklace of large pearls so long that it reached his stomach. His turban aigrette was set with enormous diamonds and a single, dazzling topaz that the learned Frenchman said shone with the brilliance of a small sun.[26]

The leading court figures were obliged to give presents whose value was commensurate with their rank in the precisely codified Mughal hierarchy and included gold vessels encrusted with precious stones as well as unmounted diamonds, pearls, rubies, or emeralds.[27] When Tavernier witnessed the ceremony in 1665, 'Alamgir still sat on the Jeweled Throne to scrutinize the gifts presented over five days.[28] In the preceding weeks, Tavernier states that stones of superlative quality had been released from the imperial treasury so that the court elite could purchase them to present to the emperor. In this way, 'Alamgir not only received the income from the sale but also got his stones back. Tavernier reckoned that "in diamonds, rubies, emeralds, pearls, gold, and silver, as well as rich carpets, brocades of gold and silver, and other stuffs, elephants, camels, and horses, the emperor receives presents on this day to the value of more than 30,000,000 livres."[29]

As a prince, 'Alamgir had grown up in a court where such extravagance marked all the major celebrations. His wedding and those of his brothers followed an almost identical pattern, with similar gifts made to all of them (see fig. 168).[30] The wedding of 'Alamgir's son Muhammad A'zam continued along the same lines. On January 2, 1668, the emperor gave him a special robe, fine Arabian and West Iranian (Iraqi) horses, two elephants with gold trappings, a jeweled sword worth twenty thousand rupees, a turban worth sixty thousand rupees (therefore presumably set with jeweled ornaments), and the stupendous sum of 1.2 million rupees in cash. Some days later, 'Alamgir walked from the fort to his son's mansion across a path covered with "cloth of gold, silver, and plain cloth." The prince had provided a gold throne from where 'Alamgir ordered robes of honor to be distributed to the grandees of the empire from the khil'a store (khil'at khana). He then received jewels and cloth valued at five hundred thousand rupees from Muhammad A'zam before returning to his own apartments.[31]

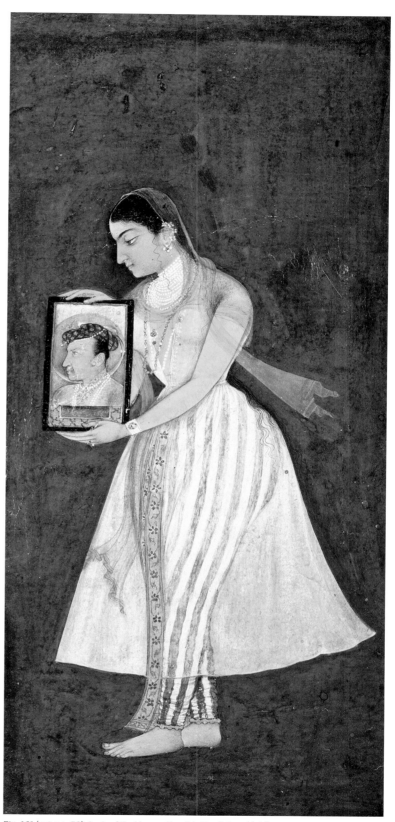

Fig. 161 (cat. no. 59). *Lady of the Harem, Possibly Nur Jahan, Holding a Death Homage of Jahangir*, attributed to Bishan Das, India, c. 1627. Catherine and Ralph Benkaim Collection, Los Angeles.

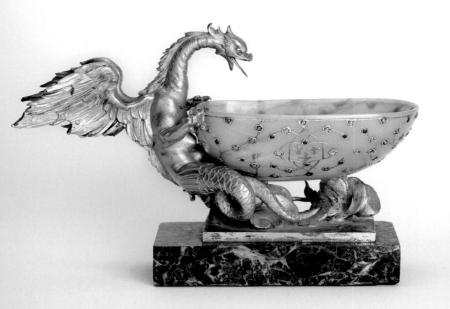

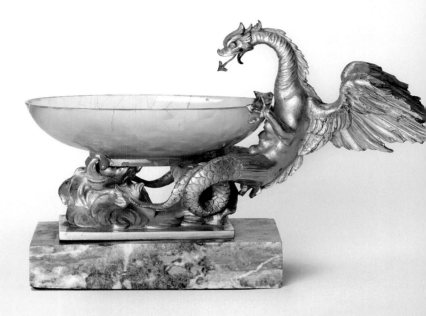

Above: Fig. 162 (cat. no. 213 a–b). *Drinking Cups*, India, 16th–17th century (mounts 19th-century Europe). Aga Khan Museum Collection, Geneva (AKM 00813).

Opposite: Fig. 163 (cat. no. 26). *Wine Cup*, inscribed for Jahangir (r. 1605–27), India, dated AH 1016/1607–8. Brooklyn Museum, Anonymous loan (L78.22).

As in previous reigns, promotions were accompanied by the presentation of robes of honor and cash, jeweled weapons, or richly caparisoned horses or elephants, depending on the nature of the office and the rank of the recipient. Holders of the highest positions received emblems of office when they took up their appointments. When Bernier's friend Daneshmand Khan was made Mir Bakhshi in 1667, he received a jeweled pen case (*qalamdan-i murassa‘*) in addition to a *khil‘a*, as Mir Bakhshis had under Jahangir and Shah Jahan. Similarly, when Asad Khan was made vizier in 1671, he received a jeweled inkwell (*davat-i murassa‘*) and *khil‘a* together worth five thousand rupees.[32]

Foreign merchants quickly discovered that it was impossible to do business at court if gifts were not judiciously distributed. Tavernier's presents to ‘Alamgir on September 12, 1665, were worthy of a royal ambassador.[33] His star item had originally been commissioned by Louis XIII's powerful prime minister Cardinal de Richelieu: the gilt bronze shield was decorated with a scene depicting the legend of Curtius, whose self-sacrificing bravery saved the city

of Rome from peril. It was, Tavernier wrote, "the masterpiece of one of the most excellent workmen in France" and had cost 4,378 livres to make, the gold alone being worth 1,800 livres.[34] The merchant also presented a rock-crystal mace inlaid with rubies and emeralds that was probably more to Mughal taste as it could be used as an emblem of office by court functionaries. His gifts concluded with a Turkish saddle embroidered with small rubies, pearls, and emeralds (see fig. 96) and another saddle embroidered in gold and silver.

The experienced Tavernier was fully aware that other key figures had to receive suitable gifts— without them, mysterious impediments would prevent any business from taking place. The emperor's influential uncle, Ja‘far Khan, was provided with a table and nineteen separate pieces of Florentine *pietra dura* from which a cabinet could be assembled, and a ring set with a perfect ruby. The court treasurer received a watch with emerald-encrusted gold case, cash payments were made to treasury officials, and the emperor's sister was given another watch with a painted case. In total, Tavernier's presents had

cost him 12,119 livres—but neither this European ("*Firangi*") nor his exotic gifts were deemed worthy of mention in the official histories.

Particular gifts made to the Mughal emperor, or tribute sent to him, occasionally modified court fashions. Jade as a raw material is first mentioned in Mughal sources as a gift made to Akbar by Khwaja Mu'in, a visitor from Kashghar in 1562, who brought it from China.[35] No artifacts have so far been convincingly dated to Akbar's reign, but this new material would have presented few difficulties to his lapidaries, who were accustomed to working with other hardstones, notably rock crystal (see fig. 205), and would have used the same tools for jade. By the beginning of Jahangir's reign, as Hawkins's account makes clear, the treasury contained jade cups as well as one *batman* (probably about fifty-five pounds) of uncut jade.[36]

The presence of the craftsman Sa'ida-yi Gilani in Jahangir's service seems to have stimulated the use of nephrite jade, still an extremely rare material, for royal vessels.[37] The multitalented Iranian master was the superintendent of the royal goldsmiths but also a renowned specialist in hardstones who made jade wine cups for the emperor. In Shah Jahan's reign some of the greatest Mughal jades were made by other, anonymous craftsmen, but references to jade artifacts in the histories of either reign are infrequent.

In contrast, 'Alamgir's historians regularly cite the presentation of jade-hilted daggers, turban jewels, rings made of jade (see fig. 167), and jade vessels (see fig. 164). Rock-crystal artifacts are also mentioned with greater frequency.

In part, this apparent escalation of production may be due to substantial supplies of the raw materials having been sent as tribute. In 1665, the emperor made the only visit of his reign to the mountainous province of Kashmir. Bernier went too, in the company of Daneshmand Khan, and wrote detailed letters about the trip. In one, he noted that the ruler of the high mountain country north of Kashmir he calls "Little Tibet" (i.e., Ladakh) heard of the arrival of the huge Mughal encampment and the army that guarded it and feared 'Alamgir was about to invade his kingdom, as Shah Jahan had done in 1638. The valuable tribute sent to propitiate

the emperor included rock crystal, yaks' tails, musk, and "a stone called *jachen* [*yeshim*, the Turki pronunciation of Persian *yashm*, i.e., jade], which is very valuable because it is of extraordinary size. This *jachen* is a greenish stone with white veins that is so hard it can only be worked using diamond powder, and is highly esteemed at the Mughal court." Bernier added that it was used to make cups and other vessels and that he himself had one, set with precious stones.[38]

A substantial new supply of jade and rock crystal was therefore available to the royal workshops, but there was a more significant conclusion to the expedition to Kashmir. A treaty was signed with the ruler of Ladakh allowing the *khutba* to be read and coins struck in 'Alamgir's name and a mosque to be built. Annual tribute was also to be sent to the Mughal court, though Bernier added that no one believed this part of the treaty would be honored once the Mughal army had left Kashmir. However, the new relations meant that direct access to Chinese jade was renewed for the first time since Shah Jahan's reign. Bernier explained that caravans went every year from Kashmir across the mountains through Tibet to "Katay," returning with musk,

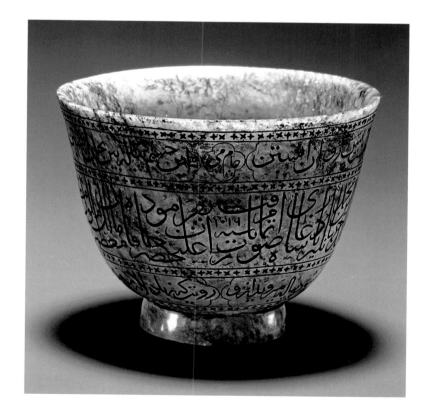

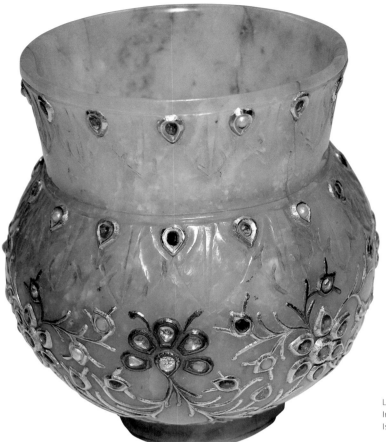

Left: Fig. 164 (cat. no. 133). *Lidless Jar or Pot*, India, 17th century. Topkapi Saray Museum, Istanbul (2/3796).

rhubarb, and other merchandise, as well as rock crystal and jade (which he mistakenly thought came from Little Tibet).[39] After Shah Jahan's attack, all traffic from Kashmir had been banned from the mountainous kingdom, thus blocking a major trade route leading to the Mughal Empire.

The reopening of the border after 1665 perhaps explains the new emphasis on jade and rock-crystal artifacts among the gifts of 'Alamgir's reign. In 1671, when Amanat Khan was made *daftardar* of crown lands, he received a rock-crystal inkpot, and when Muhammad Amin Khan was installed as governor of Kabul in the same year, his presents included a jade dagger with a jeweled hilt and pearl fastening (*khanjar-i yashm-i murrasa' ba 'alagha-yi marvarid*) (see fig. 222).[40] In the following years, turban aigrettes (*jigha*), spittoons (*uguldan*), ink-wells (*davat*), rings (*arsi*), sticks ('*asa*) of jade, and daggers with hilts of jade or jeweled jade were all given to the elite of the empire and to visiting dignitaries. Significant numbers of these have

survived, unlike their equivalents in gold, which would have been melted down.[41]

Eventually, 'Alamgir moved the court from Delhi to Rajasthan and then to the Deccan to conduct protracted military campaigns. Those in the Deccan, where he remained until his death in 1707, were ultimately successful. Victories generated treasure plundered from defeated rulers, which contributed to the costs of war, but essential reductions in expenditures brought a more restrained character to court ceremonials. At the same time, they reflected the emperor's increasing personal austerity.[42] The great festivals were reduced in splendor and then abolished: the weighing ceremony stopped in 1668, and the decorating of the court for the emperor's birthday was suspended in 1670. 'Alamgir abolished the coronation festival in 1677 and began to spend the month of Ramadan in prayer.[43]

Nevertheless, rich gifts continued to be made throughout his reign. The princes were given robes, jewelry, and cash when they married. Royal babies

Above, left: Fig. 165 (cat. no. 64). *Mughal Powder Horn*, India, c. 1650–1700. Musée du Louvre, Paris (R 437), Bequest of Baronne Salomon de Rothschild, 1922.

Above, right: Fig. 166 (cat. no. 65). *Mughal Powder Horn*, India, c. 1650–1700. Musée du Louvre, Paris (R 436), Bequest of Baronne Salomon de Rothschild, 1922,

Left: Fig. 167 (cat. no. 67). *Archer's Ring*, India, 17th century. Victoria and Albert Museum, London (IS 02522).

were typically sent jeweled caps and their mothers valuable pearl necklaces and other jewels.[44] When his grandson Kam Bakhsh finished memorizing the Qur'an in 1676, 'Alamgir rewarded him with a robe, two horses with gold trappings, a jeweled turban ornament (sarpich), a pearl necklace, and a shield with jeweled mounts.[45] A specimen of calligraphy written by another grandson in 1683 was deemed worthy of a turban jewel set with a fine spinel.[46] Ambassadors and envoys were treated as generously as ever. The most frequently mentioned gifts, including robes of honor or special clothes for the rainy season, jewelry, richly caparisoned animals, and cash, were all bestowed on generals, including 'Alamgir's sons, as they departed on military campaigns or returned from battle.

The emperor's remoteness from these luxurious gifts that were an essential part of the rituals of the Mughal court is suggested by a remark he made toward the end of his long life. In 1704, he awarded Mir Khan the hereditary title of Amir Khan held by the noble's father before him. In return, Mir Khan gave 'Alamgir a Qur'an copied by the great calligrapher Yaqut. The emperor told him, "You have made a present which exceeds the world and its contents in price."[47]

Notes

1 Muhammad Saqi, *Ma'asir-i 'Alamgiri*, 35; Sarkar, trans., *Ma'asir-i 'Alamgiri*, 21.

2 See Richards, *Mughal Empire*, 158–64, for the war and its aftermath.

3 Muhammad Qasim, *'Alamgirnama*, 615.

4 Tinguely, ed., *Libertin dans l'Inde Moghole*, 156.

5 Islam, *Calendar of Documents*, vol. 1, 442.

6 Muhammad Saqi, *Ma'asir-i 'Alamgiri*, 36; Sarkar, trans., *Ma'asir-i 'Alamgiri*, 22–23. Dara Shikoh's mansion in Shahjahanabad constructed between 1639 and 1643 had cost four hundred thousand rupees (Blake, *Shahjahanabad*, 75–76). The dwellings of other amirs and princes at the same time cost between a hundred thousand and two million rupees.

7 Muhammad Qasim, *'Alamgirnama*, 620. I am extremely grateful to A. S. Melikian-Chirvani for his translation of the Persian text. The French jewel merchant Jean-Baptiste Tavernier may have seen the same pearl in 1665: he described an exceptional round pearl weighing fifty-six *ratis* that he said, perhaps making a slight mistake, had been sent to the Mughal emperor by Shah 'Abbas I (Tavernier, *Six voyages*, 279; this passage in the 1676–77 French edition is not in the English translation made by Ball, revised by Crooke). On weights of stones, see Ball and Crooke, *Travels in India*, vol. 1, 332–33, and vol. 2, 336.

8 Muhammad Qasim, *'Alamgirnama*, 622.

9 Tinguely, ed., *Libertin dans l'Inde Moghole*, 156.

10 Muhammad 'Abbasi, *Burhan-i Qati'*, 221. I am very grateful to A. S. Melikian-Chirvani for this reference and explanation.

11 Melikian-Chirvani, "Jewelled Objects," 13–14, for the role played by such jeweled items at the Mughal court from the reign of Akbar to that of 'Alamgir.

12 Muhammad Saqi, *Ma'asir-i 'Alamgiri*, 35; Sarkar, trans., *Ma'asir-i 'Alamgiri*, 21–22; Muhammad Qasim, *'Alamgirnama*, 621. For the Mughal ranking system, see Ali, *Apparatus of Empire*.

13 See Stronge, *Made for Mughal Emperors*, 51. *Pan* (pronounced "paan") was widely consumed as a digestif but was also offered to formal audiences as a polite token of dismissal.

14 Muhammad Qasim, *'Alamgirnama*, 621; see Moreland, *From Akbar to Aurangzeb*, 277–80, for a discussion of the custom by which the emperor took over the estates of the nobility.

15 Dates given by Islam, *Calendar of Documents*, vol. 1, 442.

16 Muhammad Saqi, *Ma'asir-i 'Alamgiri*, 36; Sarkar, trans., *Ma'asir-i 'Alamgiri*, 22.

17 Tavernier, *Six voyages*, vol. 2, 271; Ball and Crooke, *Travels in India*, vol. 1, 306–7.

18 Welch et al., *Emperors' Album*, cat. no. 59, 202–3, for an equestrian portrait of Shah Jahan, c. 1627; and Stronge, *Painting for the Mughal Emperor*, pls. 116–17, for horses of Shah Jahan and his sons in paintings of c. 1635.

19 For accounts of the throne, see Aziz, *Thrones, Tents, and Their Furniture*, and Stronge, "Sublime Thrones," 62–65, and figs. 10–14.

20 Muhammad Saqi, *Ma'asir-i 'Alamgiri*, 23; Sarkar, trans., *Ma'asir-i 'Alamgiri*, 13.

21 Moreland, *From Akbar to Aurangzeb*, 280–82, summarized the income of the court: "Apart from the land revenue, the Imperial budget, if such a document was drawn up, contained on the receipt side four ordinary heads, Customs, Mint, Inheritance, and Presents." For the treasury, see Aziz, *Imperial Treasury*, and for a discussion of the treasuries of precious stones and jeweled artifacts, see Stronge, *Made for Mughal Emperors*, 162–77.

22 Foster, ed., *Early Travels in India*, 102–3.

23 For remarks on 'Alamgir's treasury, see Aziz, *Imperial Treasury*, 542–53. See also Richards, *Mughal Empire*, 185, for comments on the continuing wealth of his empire.

24 Muhammad Saqi, *Ma'asir-i 'Alamgiri*, 25; Sarkar, trans., *Ma'asir-i 'Alamgiri*, 14. See Stronge, *Made for Mughal Emperors*, 46–51, for Nawruz gifts exchanged at the Mughal court under Akbar, Jahangir, and Shah Jahan.

25 Muhammad Saqi, *Ma'asir-i 'Alamgiri*, 75; Sarkar, trans., *Ma'asir-i 'Alamgiri*, 48.

26 Tinguely, *Libertin dans l'Inde Moghole*, 264–65.

27 Ibid., 268.

28 Tavernier, *Six voyages*, vol. 2, 271.

29 Three livres seem to have been worth two rupees. See the complicated information given in Ball and Crooke, *Travels in India*, vol. 1, 327–28.

30 See Stronge, *Made for Mughal Emperors*, 57–60.

31 Muhammad Qasim, *'Alamgirnama*, 49.

32 Muhammad Saqi, *Ma'asir-i 'Alamgiri*, 64, and Sarkar, trans., *Ma'asir-i 'Alamgiri*, 43, for Daneshmand Khan's appointment;

Muhammad Saqi, *Ma'asir-i 'Alamgiri*, 152, and Sarkar, trans., *Ma'asir-i 'Alamgiri*, 93, for that of Asad Khan. For the presentation of pen cases or the combined pen case and inkpot (*davat va qalam-i murassa'*) to new office holders during the reigns of Jahangir and Shah Jahan, see Melikian-Chirvani, "Jewelled Objects," 13.

33 Tavernier, *Six voyages*, vol. 2, 96–97; Ball and Crooke, *Travels in India*, vol. 1, 114–15.

34 Tavernier, *Six voyages*, vol. 2, 96–97. Surrounding the central design on the shield were scenes of the 1628 siege of La Rochelle masterminded by the cardinal, when royalist forces starved the city's Huguenot inhabitants into submission.

35 Abu'l-Fazl, *Akbarnama*, trans. Beveridge, vol. 2, 301–3; see also Markel, "Fit for an Emperor," 23.

36 Foster, ed., *Early Travels in India*, 102. Foster notes that Hawkins used the *batman*, a Turkish weight, as the equivalent of the Indian "*maund*," i.e., *man*, and gives the equivalent as eighty-eight and a half pounds. However, Moreland, *From Akbar to Aurangzeb*, 334, gives it as about fifty-five pounds, while pointing out that the *man* differed at different times and in different places.

37 See Melikian-Chirvani, "Sa'ida-ye Gilani," for a review of jade in Iran and Hindustan, the facts known about the master's life, and works attributed to him.

38 Tinguely, *Libertin dans l'Inde Moghole*, 427; Constable, *Travels in the Mogul Empire*, 422–23.

39 Tinguely, *Libertin dans l'Inde Moghole*, 429–30; Constable, *Travels in the Mogul Empire*, 425–27.

40 Muhammad Saqi, *Ma'asir-i 'Alamgiri*, 111; Sarkar, trans., *Ma'asir-i 'Alamgiri*, 69.

41 The major collections of Mughal jade are in the Victoria and Albert Museum, London, and the National Palace Museum, Taipei. For the Taipei collection, see Teng Shup'ing, *Hindustan Jade* and *Exquisite Beauty*. The V&A collection lacks a catalogue, but the key pieces have been published by Skelton, ed. (entries in *Indian Heritage*). See also Stronge, "Colonel Guthrie's Collection," for a brief overview of the collector to whom most of the V&A's hardstones belonged. There is as yet no monograph on Mughal rock crystal of the seventeenth century or catalogue of the important collection also in the V&A. For jades of 'Alamgir's reign, see particularly Markel, "Inception and Maturation," 58–63.

42 Richards, *Mughal Empire*, chapter 8 for the expansion of Mughal territories. See also Majumdar, ed., *Mughul Empire*, 233–36, for his character.

43 See Muhammad Saqi, *Ma'asir-i 'Alamgiri*, 75, 97, 162; Sarkar, trans., *Ma'asir-i 'Alamgiri*, 48, 60, 100.

44 See, for example, the jeweled gifts bestowed by 'Alamgir on Muhammad Sultan when the prince married the daughter of Murad Bakhsh in 1672. The emperor personally put jewels on the prince's head and then took him to the mosque (Muhammad Saqi, *Ma'asir-i 'Alamgiri*, 127; Sarkar, trans., *Ma'asir-i 'Alamgiri*, 77).

45 Muhammad Saqi, *Ma'asir-i 'Alamgiri*, 158; Sarkar, trans., *Ma'asir-i 'Alamgiri*, 98.

46 Muhammad Saqi, *Ma'asir-i 'Alamgiri*, 228; Sarkar, trans., *Ma'asir-i 'Alamgiri*, 141 (mistranslating *la'l* as a "ruby" *sarpich*). *Sarpich* at this period referred to a jeweled band encircling the turban, sometimes but not always associated with an aigrette (*jigha*).

47 Sarkar, trans., *Ma'asir-i 'Alamgiri*, 290.

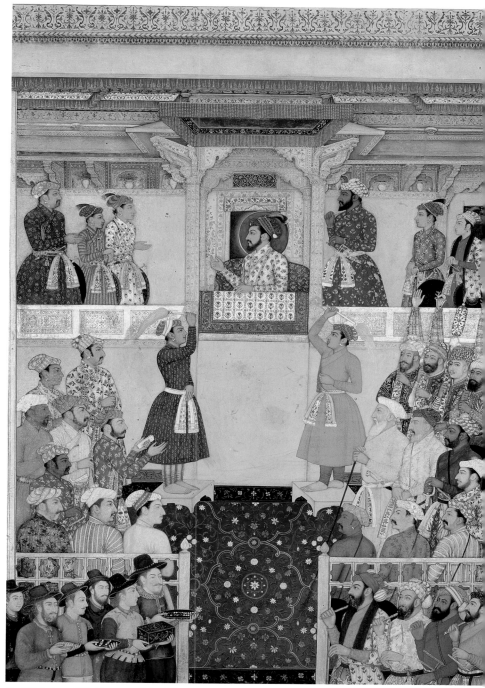

Fig. 168 (cat. no. 179). *Europeans Bring Gifts to Shah Jahan*, folio from the Windsor *Padshahnama*, India, c. 1650. The Royal Collection, Windsor (RCIN 1005025).

Shah Tahmasp's Edict to the Governor of Khurasan

What follows is the text of an edict sent out by the Safavid ruler Shah Tahmasp for the reception of the Mughal Humayun, who had been driven out of India and was on his way to see the Iranian shah in 1544 to ask for reinforcements to regain his kingdom. For a related text describing the same reception, see page 187.

Royal Edict hereby issued to Muhammad Khan Sharafuddinoghlï Täkälü, Tutor to our Dear Son, Governor of Herat, Chief of Administration, and recipient of limitless Regal Favor.

Be it known that his letter conveyed to this court by Kamaluddin Shahqulï Beg, brother of Amir Qara Sultan Shamlu, has been received on the twelfth of Dhu'l-Hijja 949 [March 19, 1543], and the contents have been learned from beginning to end.

With regard to the coming of… His Majesty Nasiruddin Muhammad Humayun Padishah—*Glad tidings, O zephyr harbinger, of the approach of the beloved. May your news be true, you who are privy to the beloved in every place. May I sit one day in the banquet of union with him, attaining my heart's desire at the beloved's side*—consider the approach of that exalted monarch an opportunity not to be missed, and know that as a reward for that welcome news we have awarded the affairs of the province of Sabzavar to you from the beginning of Aries in the Year of the Rabbit. Send your overseer and vizier thither; take control of tax collection and administrative imposts from the beginning of the current year and disburse them as is necessary on the army; [207] and follow instructions in accordance with the stipulations contained in this edict to the letter with no deviation.

Let the governor appoint five hundred intelligent, experienced men who possess extra horses, pack animals, and travel gear to go to greet the emperor. Let him select the one hundred horses with golden saddles that have been sent from the royal stable for His Highness and six horses

of steady gait and good color suitable for the emperor to ride, and provide them with painted blue saddles and gold-spun and gold-embroidered saddlecloths appropriate to the abovementioned horses for the emperor to ride. Put two persons of your retinue in charge of each of the horses. Also, the bejeweled royal dagger that we inherited from His Majesty the late shah my father, the one that is studded with precious gems, has been sent with a golden, jewel-studded sword as a sign of victory and triumph for that mighty monarch. The equivalent of four hundred suits of velvet and European and Yazdi brocade has been sent, of which one hundred twenty suits are for the personal use of the emperor; the rest are for the members of his imperial retinue. A double-piled velvet carpet woven with gold, a woolen bolster cover with brocade lining, three pairs of twelve-cubit carpets, and twelve red, green, and white tents have been sent. Deliver them as soon as possible.

Every day let the governor have delicious beverages with white bread kneaded with oil and milk and containing caraway seeds and poppy seeds delivered to the emperor. Also let him send same to each and every one of the members of the retinue and to the servants of his court. Also let him order that fine white and colored tents, velvet and brocade canopies, a tack tent, kitchen, and all necessary workshops be set up in every way station the day before they arrive. When they dismount, serve sherbet prepared with lemon syrup and chilled with ice and snow. After the sherbet serve marmalades of Mashhad apples, watermelon, grapes, etc. with white bread made in accordance with prior instructions, and try to have all beverages passed before the emperor's sight, and have them mixed with rose water and the finest ambergris. Serve five hundred dishes of various foods with beverages every day.

Let the governor send his sons Qazaq Sultan and Amir Ja'far Sultan and his clan—[208] up to a thousand persons—to greet the emperor three days after the five hundred persons have gone. On those three days let him

inspect the aforementioned soldiers and amirs one by one, and let him provide his retinue with fine Turcoman and Arabian horses such that the trappings of no soldier be better than his own. Let the robes of those thousand persons also be colorful and clean.

Order that, when the abovementioned amirs arrive with their soldiers to pay homage to the emperor, they kiss the ground politely and perform an obeisance one by one. It is forbidden, while riding or otherwise, for there to be any conversation with the emperor's attendants. By no means will there be any annoyance of the servants of that exalted family. While riding and marching, the amirs' soldiers will stand in service in their ranks from afar; and when on duty, each of the aforementioned amirs who is there will perform an obeisance in the closest place assigned, and holding his staff of office he will serve, as though serving his own monarch, with the utmost attention to detail.

In every province reached, this order will be conveyed to the governor, who will perform service and act as host in the manner prescribed, with no less than one thousand five hundred plates of foods, sweets, and beverages, and accompany the emperor until he reaches Holy Mashhad. When the amirs join the retinue, let one thousand two hundred dishes of various food worthy of a king's table be served every day at an assembly held for the emperor, and let each of the above-mentioned amirs, on the day he is host, present nine horses, three of which be worthy for the emperor's personal use. Let one be presented to the exalted Amir Muhammad Bayram Khan Bahadur and the other five to his elite amirs, whoever is worthy. Let nine horses in all be presented for the emperor's inspection, and let it be mentioned which one is from His Majesty. Let it be decided beforehand which amir is to escort which amir, and let them say that no matter how bad things look, they will not turn out badly. In any manner possible let them cheer the retainers of that mighty *padishah*, and let them show them the utmost of sympathy and accord, and let them

console them for what they have suffered from cruel fate. At such times it will be appropriate and good to cheer them up. Let them observe these things until they come to our majesty. After that what is seemly will be done by us.

After the meal, have served halva and puddings made of refined and crystalline sugar [209] and various pleasing marmalades and special Chinese noodles scented with rose water, musk, and ambergris. After the entertainment and aforementioned services, let the governor of the province assure the emperor of the safety of his province, and let no one who serves as escort to Herat fail in any aspect of service or respect. When they are within twelve leagues of the capital, let the governor assign one of his experienced and intelligent tribes to the service of our dear son to guard the city and him, and let the rest of the royal army from the city, province, and borders, Hazaras, Negüdäris, and others, up to thirty thousand riders, confirmed in number by the governor, accompany him to greet the emperor. Let him take along tents, canopies, and necessities such as camels and pack horses to present an orderly camp to the view of the emperor.

When paying homage to the emperor, before anything else let the governor offer the very best wishes on our behalf. On the day the governor is honored to pay homage, let him have the army dismount in an orderly manner. Request permission from the emperor to hold an entertainment, and remain at that stopping place for three days. On the first day award to all his soldiers fine robes of honor made of Yazdi velvet and fabrics from Mashhad and Khwaf, all with over-robes of velvet. Give each of the soldiers and attendants two Tabrizi *tümän*s as a daily allotment, and serve various fine foods in the manner previously described. Give such a regal banquet that all tongues will praise it.

After recording the names of all the soldiers, send them to the royal court. Take the amount of two thousand five hundred Tabrizi *tümän*s from the royal estates of Herat and expend them on necessary items, and go out of your

Fig. 169 (cat. no. 32). *Pilgrim's Flask*, inscribed with the name of 'Alamgir (r. 1658–1707) and dated AH 1070/1659–60, China, Ming dynasty, early 15th century. The British Museum, London (1968-4.22.32).

way to serve the emperor. The journey from the above-mentioned stopping place to the city should take four days. Hold an entertainment every day with food as on the first day. At every entertainment the governor's sons should stand ready to serve like servants and perform all the requisite etiquette of homage. Let them express their gratitude that such a monarch, who is a gift from God, is our guest, and the more they show their willingness and eagerness to sacrifice themselves to His Majesty, the more pleasing it will be.

The day before he is to enter the city, have set up in the Idgah Garden on the Avenue tents with scarlet brocade inside, body of Tabas canvas, and tops of the Isfahani carpets that have recently been completed and sent. [210] Make certain the emperor is happy with the site and that the air is fine and pleasant. Stand before him with your hand politely over your breast, go forward, and say on our royal behalf that the camp, the soldiers, and all paraphernalia are our gifts.

While on the march, constantly divert the emperor with conversation that is of the utmost seriousness. The day before the emperor is to enter the city, request permission at the above-mentioned stopping place to go to our son, and the next morning take our beloved son from his quarters to greet the emperor. Clothe him in the robe we sent him on New Year's day last year. Station a trusted elder of the Täkälü tribe in the city, and mount our son on a horse. When you go to the city, assign Qazaq Sultan to the emperor, and let him offer tents, camels, and horses so that when the emperor mounts the next day and the camp sets forth on the march, the aforementioned Qazaq Sultan may serve as escort. When our son comes out of the city, let a herald proclaim that all soldiers mount in array and go to greet the emperor. In approaching the emperor, when the distance between you is one arrow shot, let the governor go forward and beg that the emperor not dismount. If he agrees, immediately go back, take our son from his horse, hasten forward, kiss the emperor's stirrup, and show him

all deference and esteem possible. If the emperor does not agree and dismounts, first take our son from his horse and have him bow to the emperor. Let the emperor mount first, then kiss his hand, and then take our son to get back on his horse and set out for his camp and quarters. Let the governor remain ever close to our son's side while he pays his respects to the emperor so that if the emperor asks our son a question and he is too bashful to give a proper reply, the governor can give an appropriate response. Let our son host an entertainment for the emperor at the above-mentioned stopping place as follows: when a halt is observed at midmorning, immediately have three hundred platters of ready food brought in to the assembly, and at midafternoon have twelve hundred platters of various foods placed on the table in charger plates known as Muhammadkhani and on other plates of china, gold, and silver with gold and silver covers. [211] Serve all marmalades possible with halva and pudding. After that, present seven fine young horses from our son's stables and provide them with saddlecloths of velvet and brocade. Place linen-weave silk saddle straps on the multicolored brocade saddlecloths, white straps on the red velvet saddlecloths, and black straps on the green velvet saddlecloths.

Hafiz Sabir Qaq, Mawlana Qasim the dulcimer player, Shah-Mahmud the flutist, Hafiz Dost-Muhammad Khafi, Master Yusuf Mawdud, and other famous singers and musicians who are in the city should always be present to perform and entertain the emperor whenever he desires. Let everyone who is worthy of the assembly stand in service, far and near, in order to be ready when summoned. Do everything possible to ensure that the emperor has a good time. Provide hawks and falcons from our son's estate and those of the governor's sons, and let their attendants wear silk robes of every type of brocade and every color with gold-thread buttons and woven with gold as befits each person.

When the emperor retires to his quarters, conduct his attendants to our

son, and let him receive them with the good manners that are hereditary from our fathers and ancestors. Let him present to each of them a robe and horse, gratuities of not more than three *tümän*s, twelve *doquz*es of silk fabric, brocades, European and Yazdi velvets, Damascene taffeta, etc., all of which should be extremely fine. Let these fabrics be presented together with three hundred *tümän*s in gold in thirty sacks. To each of the soldiers three Tabrizi *tümän*s, which is equivalent to three hundred *shahi*s, should be given.

Let the emperor tour the Avenue and Karezgah for three days. During these three days have the craftsmen's and tradesmen's guilds set up attractive pavilions from the gate of the city garden, which is a regal residence, to the end of the Avenue, where the gate to the Idgah Garden is located. Let every one of the above-mentioned amirs join one of the craftsmen so that they may compete in producing whatever craft object the amir knows. It would be most appropriate, when the emperor honors that region with his presence, upon first entering that city, which is the delight of everyone in the world, that he should be entertained by casting his regal glance at the good-natured people of diverting speech who are in the city.

On the third day, when he has completed his tour of the pavilions and the Avenue, have heralds proclaim throughout the city, its suburbs, [212] and the surrounding countryside and villages that all men and women will gather on the morning of the fourth day on the Avenue. In every shop and market, which will have been festively decorated and spread with carpets and rugs, the ladies and gentlemen will sit, and, as is the custom of the city, the ladies will flirt and engage in delightful conversation with passersby. Let singers come from every quarter and street, for in all the world there is nothing like them, and have all these people greet the emperor.

After that, politely request that the emperor place his regal foot in the stirrup of fortune and mount. Let our son ride with him, ensuring that the emperor's horse's head and neck are

ahead, and let the governor ride close behind so that if he asks anything about the buildings, houses, or gardens, an informed answer may be given.

When he enters the city let him inspect the garden, and then have him dismount in the small garden that was refurbished for residence, sleeping, reading, and study when we lived in that city. Have the Chaharbagh bathhouse and the other bathhouses whitewashed and cleaned, and perfume them with rose water and musk so that they may serve for bodily relaxation whenever the emperor is so inclined.

On the first day have our son host a large-scale meal, and when he goes to sleep the governor himself should serve as host in the manner that has been mentioned. The day the emperor enters the city it should be requested that he proceed to the court. It is ordered that Mu'izzuddin Husayn, the sheriff of Herat and a knowledgeable calligrapher, should be assigned to keep a daily record from the day the five hundred persons go to greet the emperor until he enters the city. That record will be sealed by the governor, and it will include all incidents good and bad that take place at any assembly. It will be handed to trusted men and sent to court so that our royal person may be informed of everything.

Let the governor's entertainment be as follows: food, halva, molasses, and fruit: three thousand plates are to be offered. Equipment for traveling is to be as follows: first, fifty tents, twenty canopies, and a large paisley tent for the emperor's personal use with twelve pairs of twelve-cubit, ten-cubit, and seven-cubit carpets, seven pairs of five-cubit carpets, nine loads of yeast, two hundred fifty large and small porcelain plates, [213] and other platters and kettles with lids, all well-cleaned and tinned, and two strings of nine camels shall be presented at the governor's entertainment.

The above-mentioned amirs have been commanded to host entertainments as follows: one thousand five hundred plates of food, sweets, and pudding. Let them present three horses, one camel, and one pack horse that have first been inspected and approved by the governor. Let the governor of Ghurian, Fushanj, and Kusu host an entertainment in his territory. Let the governor of Khwaf, Turshiz, Zava, and environs host an entertainment in Saray-i-Farhad, which is five leagues from Mashhad. Finis.

Translated by Wheeler Thackston from Abu'l-Fazl, *Akbarnama*, ed. Agha Ahmad Ali, vol. 1, 206–13.

Abu'l-Fazl's Effulgence over Gifts from Shah Tahmasp

The Mughal chronicler of the *Akbarnama* describes the reception given Humayun by Shah Tahmasp in July 1544, when they met between Sultaniyya and Abhar.

Princely celebrations were held for several days. Every day the shah himself saw to the preparations and held unforgettable assemblies, and day by day his sincerity and affection increased. How can one describe an assembly that such a king undertakes himself? How many gold-spun, velvet, and silk canopies were set up? How many decorated pavilions and lofty tents were pitched? There were silken rugs and valuable carpets spread on the ground as far as the eye could see. How can one explain how the shah himself saw to all the details of the presentation of gifts and presents, which is an obligatory ritual? The finest Persian horses with gilt saddles studded with jewels and exquisite saddle covers, pack animals from Barda elaborated, decorated, and caparisoned, male and female camels with marvelous bodies and expensive coverings, so many swords and daggers studded with jewels, coins, precious textiles, furs of sable, red fox, ermine, and squirrel, clothing of all varieties of gold brocade, velvet, silk, satin, figured fabrics from Europe, Yazd, and Kashan, so many gold and silver kettles, ewers, and candlesticks studded with rubies and pearls, and so many gold and silver plates, decorated tents, fabulous carpets—all so grand, beautiful, and rare. All this paraphernalia of regality was passed before the imperial view, all the members of the imperial retinue received cash and goods separately, and the customs of imperial etiquette were observed on both sides.

Translated by Wheeler Thackston from Abu'l-Fazl, *Akbarnama*, ed. Agha Ahmad Ali, vol. 1, 217.

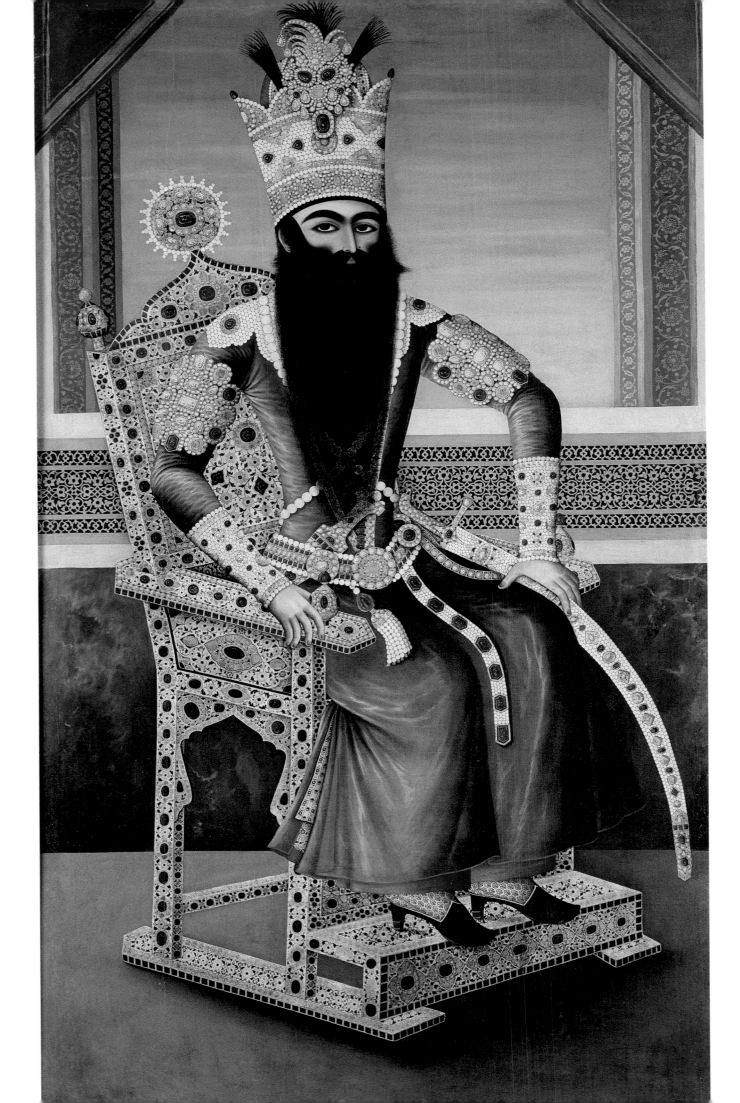

Graphic Documentation of Gift Exchange between the Russian Court and Its Islamic Counterparts, Seventeenth to the Nineteenth Century

EDWARD KASINEC AND ROBERT DAVIS

The five-centuries-long political, military, and cultural relationship between the Muscovite and Russian Imperial elites and their Ottoman and Safavid neighbors to the south can be examined through the many gift objects presented in this exhibition and accompanying catalogue. While the vast majority of these objects are three-dimensional, others are rare works on paper depicting either the gifts themselves or the ceremonial exchange between the Russian court and its Islamic counterparts. This essay comments on the Russian works on paper in this catalogue and places them within a broader context of other little-studied Russian depictions of the Russo-Islamic cultural and political dialogue.[1]

The intensification of relations between the early Romanovs—Mikhail Fedorovich (r. 1613–45) and his son, Alexei Mikhailovich (r. 1645–76)—on the one hand and the Ottoman and Safavid rulers— Murad IV (r. 1623–40) and Shah 'Abbas II (r. 1642– 66)—on the other is first documented in the rich archives of the Muscovite ambassadorial office (as well as in the corresponding Ottoman and Safavid archives)[2] and the reports and papers of diplomats, such as Emelian Ignatievich Ukraintsev (d. 1708). The increasing momentum of these relationships in Muscovite political consciousness is also evidenced in the inclusion of two depictions[3] of the Ottoman and Safavid rulers in the great Muscovite political compilation titled the *Tsarist Titulary*, or the *Great Book of State*, of 1672 (fig. 171).[4]

The gradual secularization of Russian printed-book culture during the reign of Alexei Mihailovich's son Peter I (The Great, r. 1696–1725), conqueror of the Black Sea port of Azov (fig. 172) in 1696, facilitated the appearance of new genres of publications

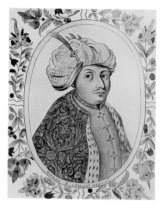

Left: Fig. 171. *Portrait of Mehmed IV* (r. 1648–87), plate no. 92 in *Portrety, gerby i pechati Bol'shoi gosudarstvennoi knigi 1672g* [Portraits, coats-of-arms, and seals of the *Great Book of State* of 1672], St. Petersburg, (1672) 1903. Rare Book Division, the New York Public Library, Astor, Lenox and Tilden Foundations.

Opposite: Fig. 170 (cat. no. 187). *Portrait of Fath 'Ali Shah*, Iran, Tehran, c. 1800–1806. Musée du Louvre, Paris, on loan from the Musée National de Versailles (M.V. 6358).

Above: Fig. 172. Map showing Azov at upper right, a recurrent flashpoint for Russian-Ottoman conflict, *Nouvelle carte de la Crimée & toute La Mer Noire*, n.p., 1737. Rare Book Division, the New York Public Library, Astor, Lenox and Tilden Foundations.

189

intended to exalt and accrue prestige to the new imperial order. One instance of this is seen in the appearance of a series of coronation and festal fireworks albums (fig. 173), beginning with a slim printed volume to mark the accession to the throne of Anna Ioannovna (r. 1730–40). Wondrous engravings and later lithographs and photogravures became a feature of this and subsequent coronation albums issued in 1744 (Elizabeth, r. 1741–62), 1762 (Catherine II, though the five engravings were published for the first time only in 1857), 1826 (Nicholas I, r. 1825–55), 1857 (Alexander II, r. 1855–81), 1881 (Alexander III, r. 1881–94), and finally the 1896 coronation (Nicholas II, r. 1894–1917), a two-volume set issued to mark the ascension to the throne of the last Romanov. These albums were printed in limited editions and were intended for distribution to the Russian and foreign elites, graphically documenting the legitimacy of the act of succession, the wealth and treasure of the Russian monarchy, and the political gravitas of the dynasty. An "Islamic inflection" is evident in the depiction of the throne of Shah 'Abbas (r. 1587–1629) in a number of the albums, the earliest being that of Elizabeth in 1744 (fig. 246), and later in the *Reception of the Ambassadors of the Sublime Porte* (*Porte* refers to the Ottoman Empire) at the time of Catherine II's coronation (fig. 176). There are other depictions of honored Muslim guests in many of the subsequent coronation albums (figs. 174–75).

The refinement and enhancement of printing techniques over the course of the eighteenth and nineteenth centuries—engraving, lithography, chromolithography—and the growing sophistication of Russian book culture afforded artists opportunities to document the ever-growing number of military, political, and cultural encounters between the Russians and their Islamic neighbors to the south. By the latter part of the eighteenth century, artists were routinely attached to major diplomatic missions dispatched to foreign courts. On occasion, the sketches that they produced were published and distributed, though not always properly attributed in historical studies. A case in point are the images depicting the Nikolai Vasil'evich Repnin (d. 1801) mission to the Porte in 1775–76 (fig. 177).[5]

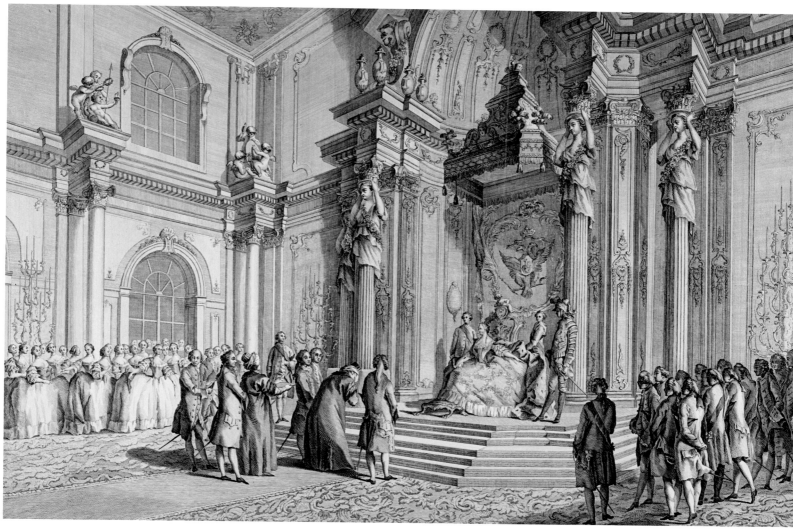

Fig. 177. The reception of the Russian ambassador (N. V. Repnin) at the Ottoman court, in *Rossiiskoe posol'stvo v Konstantinopol', 1776 goda* [Russian embassy to Constantinople in 1776], St. Petersburg, 1777. Rare Book Division, the New York Public Library, Astor, Lenox and Tilden Foundations.

Opposite, top: Fig. 173. Fireworks in St. Petersburg marking the conclusion of a treaty with the Ottoman Empire in 1740, *Izobrazhenie predstavlennago v Sanktpeterburge Feierverka…* [Depiction of the fireworks presentation in St. Petersburg…], St. Petersburg, 1740. Spencer Collection, the New York Public Library, Astor, Lenox and Tilden Foundations.

Opposite, middle: Fig. 174. Coronation banquet of Alexander II at the Palace of Facets in the Kremlin; elite representatives of Islamic countries are visible at right and center. Rare Book Division, the New York Public Library, Astor, Lenox and Tilden Foundations.

Opposite, bottom: Fig. 175. Depiction of the coronation of Emperor Alexander III; representatives of the Ottoman Empire are shown bowing to the new emperor. 1883. Rare Book Division, the New York Public Library, Astor, Lenox and Tilden Foundations.

This page, top: Fig. 176 (cat. no. 242). *Catherine Receives the Ottomans*, Russia, St. Petersburg, c. 1762–64, printed 1857, original drawing by Jean Louis de Veilly (1762–63). Rare Book Division, the New York Public Library, Astor, Lenox and Tilden Foundations.

Fig. 178. Examples of Ottoman Turkish costume: a general of the artillery, c. 1829. Arents Collection, Rare Book Division, the New York Public Library, Astor, Lenox and Tilden Foundations.

Fig. 179. Examples of Ottoman Turkish costume: a Turkish woman, c. 1829. Arents Collection, Rare Book Division, the New York Public Library, Astor, Lenox and Tilden Foundations.

One of the remarkable examples of an album of sketches of the Ottoman court produced at the beginning of the nineteenth century and later in the library of Emperor Alexander III was sold at one of the legendary Plaza Auctions of Russian imperial books in 1934.[6] The eighty-five sketches of members of the sultan's court were drawn before 1828 and may have been gifted to the Russian delegation in Istanbul for the signing of the Adrianople Treaty (figs. 178–79). After more than fifty years in private hands, the album was acquired for the Arents Collection at the New York Public Library in 1996.[7]

Offically founded by Alexander I in 1807, the Armoury (Oruzhenaia Palata) of the Kremlin has long been one of the great repositories of the historical treasures of the tsars and emperors of Russia. The sweep of historicism and antiquarian research throughout Europe, coupled with the growth in prestige of the Russian Empire in the post-Napoleonic era, in the 1820s turned the attention of the Russian elites to documenting the foreign gifts and native treasures in the repositories not only in the Moscow Kremlin but throughout the ancient cities of Rus' and Muscovy. One of the most influential and productive Russian historians and archaeological painters was Fedor Grigor'evich Solntsev (d. 1892) (figs. 182–86, 275).[8] Other notable contemporary artists and engravers were also depicting aspects of the Persian-Russian political, military, and cultural relations of the first third of the nineteenth century. In this context, the brilliant draftsman and lithographer Alexander O. Orlovskii (1777–1832) is most important for his dozens of lithographs of prominent Iranians, including the shah and his grandson, which are contained in the travelogue of Gaspard Drouville as well as in composite volumes of Orlovskii's lithographs (fig. 180).[9]

Yet another example is the Baltic German artist Karl Karlovich Gampel'n (d. 1880), whose suite of engravings depict members of the solemn delegation headed by Prince Khusraw Mirza (d. 1883), grandson of Fath 'Ali Shah (figs. 190–94). This delegation

visited Russia in 1829 and came in the wake of the assassination of Alexander Griboyedov (d. 1829), the playwright and diplomat killed when a mob stormed the embassy in Tehran. This catalogue also includes two (figs. 188, 262) of the eighteen precious manuscripts (see Olga Vasilyeva's text in this volume) that were among the many so-called blood gifts to Nicholas I and Count Ivan Osipovich Simovich (d. 1851) from the Iranian shah.[10]

Depictions by Russian artists of the cultural and political encounters between the Islamic world and Russia were not restricted to the sophisticated, elite engravings, lithographs, and chromolithographs that we have discussed. In fact, so pervasive and enduring was the Russian fascination with the Muslim "other" that we find depictions of Ottoman and Qajar rulers in demotic, popular images by anonymous artists in many Russian chromolithographs (fig. 181).

The catalogue includes yet two other gifts exchanged between Nicholas's son and successor, Alexander II, and the Turkish sultans and the Iranian shahs. The first of these consists of the great badge of the Order of St. Andrew the First Called (fig. 276) and falls beyond the scope of this essay; the second is an escutcheon or armorial drawn in 1865 for the Qajar Nasir al-Din Shah (r. 1848–96) by the noted blazon artist Alexander P. Faddeev (fl. mid-nineteenth century), now in the Khalili collection in London (fig. 189).

Russian works on paper provide us with crucial graphic documentation of the ceremonies and diplomatic protocols of the Russian and Islamic courts. Such events were themselves instruments of power, carefully orchestrated to inspire awe and reverence on the part of subjects and foreign audiences alike.[11] The splendor of the respective courts, their finery, pomp, and circumstance—as well as their strategic importance to one another— all are conveyed and documented in these engraved and lithographed images. It is only through such authentic works on paper that we can appreciate the physical envelopes and entourages involved in the giving and reception of the gifts exhibited here. Otherwise, while we may be viewing visually arresting and precious objects, we are divorcing them from their remarkable historical context.

Top: Fig. 180. Chromolithograph of the Shah by Orlovskii, from Gaspard Drouville's *Voyage en Perse*, "Notices géographiques," vol. 2. The New York Public Library.

Bottom: Fig. 181. "Ego Vysochestvo Persidskii naslednyi prints." [His Highness the hereditary Prince of Persia]. Rare Book Division, the New York Public Library, Astor, Lenox and Tilden Foundations.

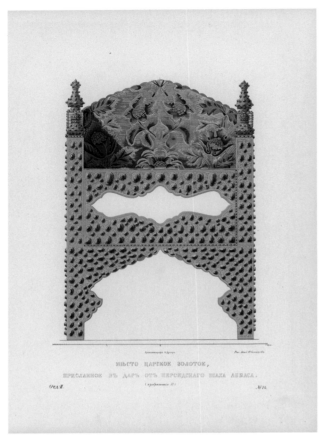

Fig. 182 (cat. no. 162). Folio from the *Drevnosti rossiiskogo gosudarstva* (Antiquities of the Russian State), Fedor Grigor'evich Solntsev (1801–1892), Russia, published 1849–53. Rare Book Division, the New York Public Library, Astor, Lenox and Tilden Foundations.

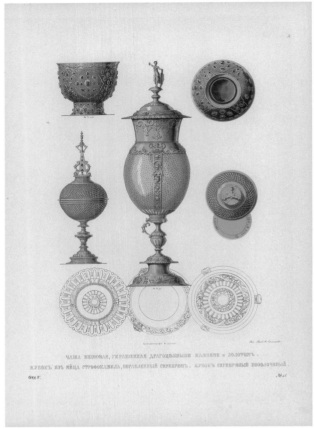

Fig. 183 (cat. no. 249). Folio from the *Drevnosti rossiiskogo gosudarstva* (Antiquities of the Russian State), Fedor Grigor'evich Solntsev (Russia, 1801–1892), Russia, published 1849–53. Rare Book Division, the New York Public Library, Astor, Lenox and Tilden Foundations.

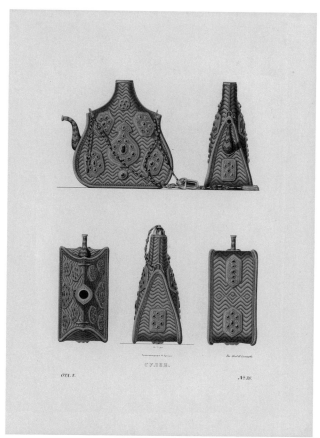

СУЛЕИ.

ОТД. V. № 28.

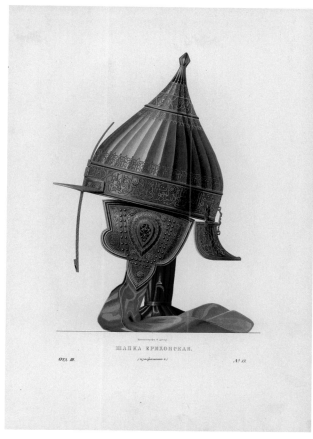

ШАПКА ЕРИХОНСКАЯ.

ОТД. III. (профилемение.) № IX.

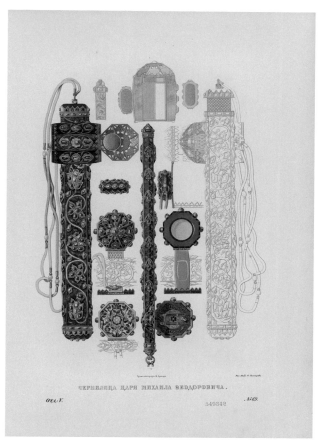

ЧЕРНИЛЬНИЦА ЦАРЯ МИХАИЛА ѲЕОДОРОВИЧА.

ОТД. V. 349342 № 69.

Top, left: Fig. 184 (cat. no. 250). Folio from the *Drevnosti rossiiskogo gosudarstva* (Antiquities of the Russian State), Fedor Grigor'evich Solntsev (Russia, 1801–1892), Russia, published 1849–53. Rare Book Division, the New York Public Library, Astor, Lenox and Tilden Foundations.

Top, right: Fig. 185 (cat. no. 251). Folio from the *Drevnosti rossiiskogo gosudarstva* (Antiquities of the Russian State), Fedor Grigor'evich Solntsev (Russia, 1801–1892), Russia, published 1849–53. Rare Book Division, the New York Public Library, Astor, Lenox and Tilden Foundations.

Bottom: Fig. 186 (cat. no. 252). Folio from the *Drevnosti rossiiskogo gosudarstva* (Antiquities of the Russian State), Fedor Grigor'evich Solntsev (Russia, 1801–1892), Russia, published 1849–53. Rare Book Division, the New York Public Library, Astor, Lenox and Tilden Foundations.

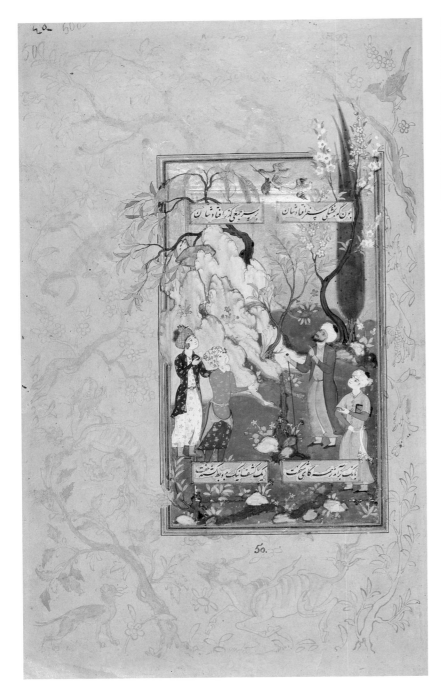

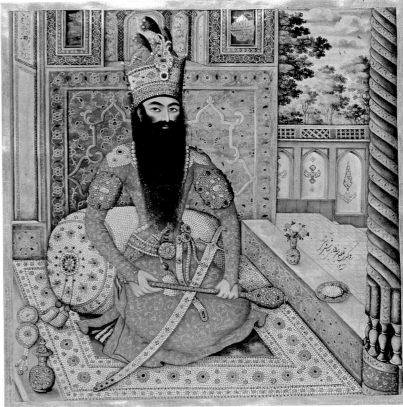

Left: Fig. 187 (cat. no. 209). *Tuhfat al-Ahrar of Jami*, Iran, Qazvin, c. 1580s. The National Library of Russia, St. Petersburg (Dorn 426).

Above: Fig. 188 (cat. no. 186). *Portrait of Fath 'Ali Shah*, from the *Divan-i Khaqan*, copied by Muhammad Mahdi, painted and illuminated by Mirza Baba, Iran, text AH Shawwal 1216/February 1802, paintings and lacquer covers AH 1217/1802–3. The Royal Collection, Windsor (MS A/4).

Opposite: Fig. 189 (cat. no. 255). *Presentation Album of Nasir al-Din Shah's Coat of Arms*, Alexander Faddeev (Russia, fl. mid-19th century), Russia, St. Petersburg, 1865. Nasser D. Khalili Collection of Islamic Art, London (MSS 962).

Notes

1 Western travelers and emissaries left a rich visual record of the various courts of the Islamic world during the seventeenth and eighteenth centuries. See, for example, Olearius, *Voyages and Travels*; Ogilby, *Asia*; Tavernier, *Six voyages*; Mandosius, *Ottomanorum principum*; Bruyn, *Reizen over Moskovie*; and Thévenot, *Voyages en Europe, Asie, & Afrique*, to cite but a few. Many of these important sources have been republished in microformat and are available in the collection titled *Russian-Ottoman Relations 1600–1914: Printed Works in Western Languages* from IDC Publishers and E. J. Brill, Leiden.

2 See Itzkowitz, *Mubadele*, for an example of a *sefaretname* given to Catherine II (r. 1762–96), which accompanied the 1775–76 embassy of Abdülkarim Paşa, found in the Ottoman Archives.

3 The rulers depicted are Safi II (Sulayman I, r. 1666–94), plate 210, and Mehmed IV (r. 1648–87), plate 218.

4 See *Portrety, gerby i pechati Bol'shoi gosudarstvennoi knigi 1672g.* In 2007 a two-volume reprint with scholarly commentary was published in Moscow as *Tsarskii Tituliarnik* (Tsarist titulary). The original is held in the Rossiiskii gosudarstvennyi arkhiv drevnikh aktov (Russian state archive of ancient acts), *fond* 135.

5 As documented in *Rossiiskoe posol'stvo v Konstantinopol', 1776 goda* (Russian embassy to Constantinople in 1776).

6 The Plaza Book Auction Corporation catalogues included *Important Collection of Manuscripts, First Editions, Illustrated Books of the XVIII and XIX Century. Fine Bindings from the Libraries of the Tzars of Russia. Sold by Order of the Owner…November 21st, 22nd, 23rd, and 24th, 1933* (New York, 1933), and *Collection of Rare Russian Books in Contemporary Morocco Bindings: Illustrated Books, Autographs, from the Libraries of Maria Fedorovna, Catherine II, Alexander I, II, and III, Nicholas I and II, the Grand Duchesses and the Tsarevich Alexis, Sold by Order of the Owner, Israel Perlstein: Public Auction Sale, April 12th and 13th, 1934* (New York, 1934).

7 Catalogued as *Album of Turkish costume paintings, ca. 1808–1826*, one album (eighty-five watercolor drawings), bearing a presentation leaf inscribed to Grand Duke Aleksandr Aleksandrovich, subsequently Emperor Alexander III (r. 1881–94).

8 Cf. Whittaker, ed., *Visualizing Russia.*

9 Gaspard Drouville, *Voyage en Perse*. The *Album russe; ou Fantasies dessinées lithographiquement* (St. Petersburg, l826) by Orlovskii reproduces a number of these images.

10 As Russian Ambassador Extraordinary and Minister Plenipotentiary at the Persian court from 1832 to 1838, Simovich assembled an outstanding collection of Persian manuscripts, among them a personal gift from Khusraw Mirza, now held by the National Library of Russia. See Vasilyeva, "Gift from Khusraw Mirza."

11 Wortman, *Scenarios of Power.*

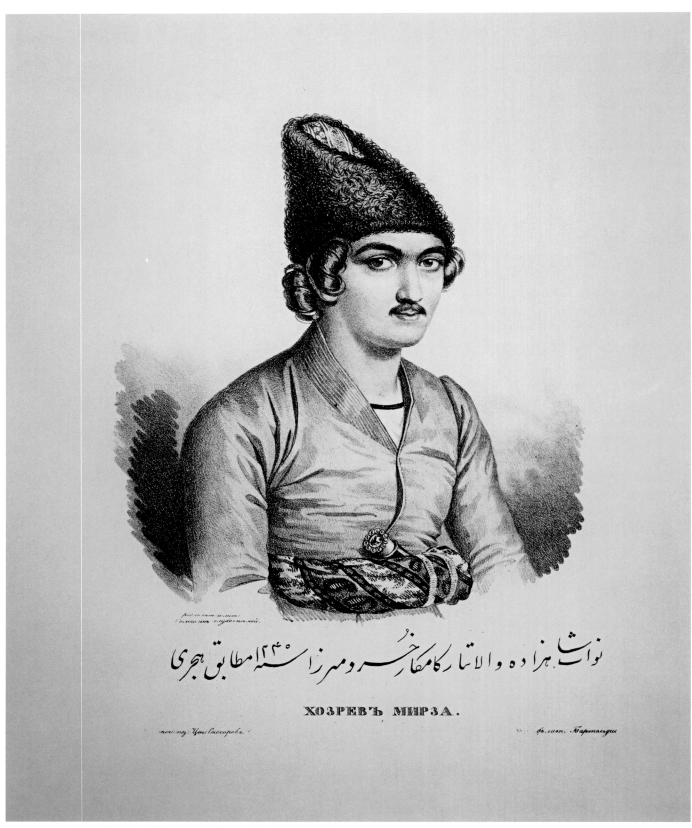

نواب شاهزاده والاتبار کامکار خسرو میرزا اسنه ۱۲۴۵ مطابق هجری

ХОЗРЕВЪ МИРЗА.

Fig. 190 (cat. no. 190). *Portrait of Khusraw Mirza*, Karl Karlovich
Gampel'n (Germany, 1794–1880), Russia, 1829. The State Hermitage
Museum, St. Petersburg (ERG-19106).

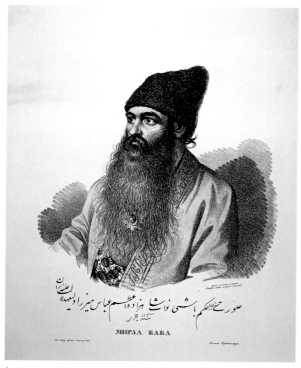

A

B

C

D

A: Fig. 191 (cat. no. 191). *Mirza Baba*, Karl Karlovich Gampel'n (Germany, 1794–1880), Russia, 1829. The State Hermitage Museum, St. Petersburg (ERG-19509).

B: Fig. 192 (cat. no. 192). *Mirza Mas'ud*, Karl Karlovich Gampel'n (Germany, 1794–1880), Russia, 1829. The State Hermitage Museum, St. Petersburg (ERG-18753).

C: Fig. 193 (cat. no. 193). *Mirza Salih*, Karl Karlovich Gampel'n (Germany, 1794–1880), Russia, 1829. The State Hermitage Museum, St. Petersburg (ERG-18980).

D: Fig. 194 (cat. no. 194). *Amir Khusraw Muhammad Khan*, Karl Karlovich Gampel'n (Germany, 1794–1880), Russia, 1829. The State Hermitage Museum, St. Petersburg (ERG-18653).

From the Ardabil Shrine to the National Library of Russia

Olga V. Vasilyeva

In the early sixteenth century, Iran was united under the rule of the Safavid dynasty (1501–1732), whose members traced their descent to Shaykh Safi al-Din (1252–1334). This Sufi mystic founded a dervish order in northwestern Iran, centered in the small town of Ardabil, where he was buried. In 1501 Isma'il Safavi seized control of the area and was proclaimed the first Safavid shah in Tabriz, the new capital. The site of Ardabil became a place of pilgrimage with many fine buildings.[1] One of them, the so-called *Chini-Khana*, would become the repository not only for a great collection of Chinese porcelain but also for an equally significant group of manuscripts. Both collections were donated to the shrine by the fifth Safavid ruler, Shah 'Abbas I

(1587–1629), in the early seventeenth century.[2] According to a 1752 inventory of the manuscripts at the shrine, there were 972 volumes: 744 manuscripts of the Qur'an, 228 copies of various literary and historical works, as well as 224 detached pages and 32 bindings.[3] Only part of this collection may be accounted for today, and for our present purposes we are concerned only with the Persian works.[4]

The single largest repository of Ardabil manuscripts is the National Library of Russia (formerly the Imperial Public Library), St. Petersburg: 166 manuscripts of literary and historical works, many of them with superior calligraphy and richly illuminated and illustrated with paintings. The story of how this collection of Ardabil manuscripts came to Russia is as follows.[5]

As peace talks dragged on to end the Russo-Persian war of 1826–28, Tsar Nicholas I ordered his troops to

invade Ardabil and Maragha. On January 25, 1828, Ardabil was occupied by General Pavel Petrovitch Suchtelen. Since the tsar's interest in oriental manuscripts was well known, Pavel Suchtelen (son of General Petr Suchtelen, of Dutch origin, the famous bibliophile and Russian ambassador to Sweden) was persistent in persuading the clerics supervising the shrine to relinquish part of the library. The documents indicate that Suchtelen was aided by the *mujtahid* of Tabriz, Mir Fattah. When the books were packed in boxes, Suchtelen is said to have left a taffeta bag with eight hundred *chervonets* (gold rubles) on the tomb of Shaykh Safi. In December 1828, the Imperial Public Library received 148 Persian, 11 Arabic, and 7 Turkic manuscripts, which, for the main part, included copies of the works of the great Persian poets Firdawsi, Nizami, Sa'di, and Jami.[6] Though there are

many rare and early manuscripts in the Ardabil collection, it is most valued as a source for studying the arts of the book in Iran, whose history they help to document.[7]

The earliest illustrated manuscript in the collection is a copy of Firdawsi's *Shahnama* dated AH 733/ 1333, whose paintings belong to the Injuid style of the Shiraz school.[8] Representing the fifteenth-century Herat school are two copies of Amir Khusraw Dihlavi's poem *Layla and Majnun*, whose miniatures are attributed to Bihzad or his circle (see fig. 59).[9] It is the Tabriz school of the sixteenth century that is the best represented. Among the chefs d'oeuvre is 'Arifi's poem *The Ball and the Mallet* (*Guy u Chawgan*) copied by a young Shah Tahmasp I in AH 931/ 1524–1525 and illustrated with nineteen paintings.[10]

The Ardabil collection contains beautiful examples of calligraphy. Foremost among these are the works of the master Sultan-'Ali Mashhadi, including an exquisitely designed autograph of his treatise on calligraphy (fig. 195).[11] Lavish illumination of various styles and periods is exemplified in the Ardabil collection as well. One of the best known is the work signed by a famous master of the second half of the fifteenth century, Yari al-Muzahhib.[12]

All of these masterpieces of the Iranian arts of the book now in St. Petersburg reflect Shah 'Abbas's original donation of his manuscripts to Ardabil. Some might find it surprising that 'Abbas would send to a religious institution books of secular content written by great poets and frequently illustrated with beautiful miniatures, which had been collected by his predecessors over the decades.[13] Actually, aesthetic tastes had shifted during the reign of 'Abbas, and what had been appreciated by his forebears was perhaps out of fashion. Delicate books decorated with intricate ornaments and exquisite miniatures by old masters had become obsolete, only to be transformed into rarities in a later time. There also could be other explanations. For example, some of the

Ardabil manuscripts in the Russian National Library apparently came from confiscated belongings of officials and princes who were executed.[14] Perhaps the shah no longer wanted to be surrounded by such dark mementos. No matter what prompted him to transfer precious manuscripts to Ardabil, it allowed them to survive as a group into the modern era.

Translated from the Russian by Larissa Sarkisian, to whom we are most grateful.

Notes
1 See, for example, Canby, *Shah 'Abbas*, 14 ff. and 101–5.
2 Ibid., 120.
3 Mashkur, *Nazar-i bi ta'rikh-i Azerbaijan*, 324 ff.
4 Over a hundred manuscripts from Ardabil are housed in the National Museum of Iran (Iran Bastan), Tehran. In Istanbul the Topkapi Palace Library, the Turkish and Islamic Museum, and Istanbul University Library each have one. There are two manuscripts in the United States (one at the Freer Gallery, Washington, D.C., and the other at the Metropolitan Museum of Art, New York). One manuscript is located in Paris (Bibliothèque nationale), two in Portugal, in the Gulbenkian Museum, Lisbon (figs. 9, 234) and several others in private collections in Lahore, Pakistan. See Akimushkin, "Weight and Gravitas," 54–56. Also see in this regard Simpson, *Sultan Ibrahim Mirza's "Haft Awrang,"* 35 and 36n24.
5 See Borschevsky, "History of the Acquisition of the Ardabil Collection of Manuscripts by Russia."
6 Academician H. D. Fren and professors F. F. Sharmua and Mirza Jafar Topchibashev prepared a handwritten catalogue in French. Its contents became part of the much-praised catalogue by academician B. Dorn published in 1852; see Dorn, *Catalogue des manuscrits et xylographes orientaux*.
7 See Vasilyeva, *String of Pearls*.
8 See Adamova and Guzalyan, *Miniatures of the Manuscript of the "Shahnama."*
9 Dorn, *Catalogue des manuscrits et xylographes orientaux*, 394; see also Canby, *Shah 'Abbas*, 178.
10 See, for example, Thompson and Canby, *Hunt for Paradise*, 104, 106–7; see also Lukonine and Ivanov, *Persian Art*, 157–58.
11 See Kostygova, "Treatise on Calligraphy," 103–16.
12 Gray, ed., *Arts of the Book*, 49, 56. Brief mention should also be made of the manuscript bindings in the Ardabil collection, as perhaps nowhere else are so many high-quality and well-preserved examples to be found.
13 The shah also donated his manuscripts of the Qur'an and scientific works in Arabic to the shrine of Imam Riza, in Mashhad. See, for example, Canby, *Shah 'Abbas*, 120.
14 The same is true for some of the Chinese porcelains donated to the Ardabil shrine, ibid., 147.

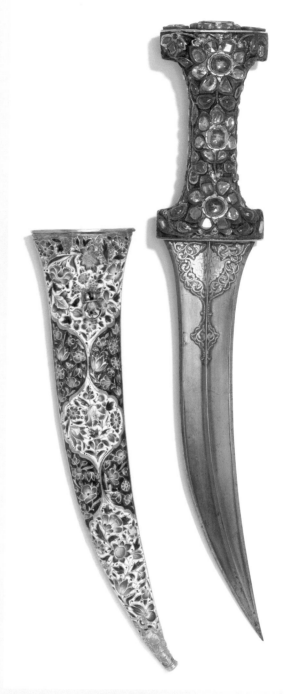

Opposite: Fig. 195 (cat. no. 104). *Treatise on Calligraphy by Sultan 'Ali Mashhadi*, manuscript from the Ardabil Shrine, copied by Sultan 'Ali Mashhadi, Iran, text: c. 1514–20, decoration and binding: 1560–70. The National Library of Russia, Saint Petersburg (Dorn 454).

Above: Fig. 196 (cat. no. 71). *Dagger and Sheath*, Iran, 1750–1800. Victoria and Albert Museum, London (1602 & A-1888).

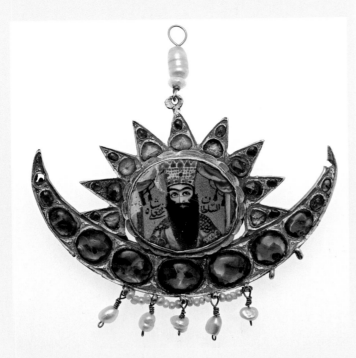

Diplomacy and Gift Giving at the Court of Fath 'Ali Shah

Francesca Leoni

When Captain John Malcolm reached the court of Fath 'Ali Shah Qajar (r. 1797–1834) in late November 1800, he brought with him an impressive array of gifts: "Watches glittering with jewels; caskets of gold beautifully enamelled; lustres of variegated glass; richly chased guns and pistols of curious construction; marvels of European science, as air guns and electrifying machines; besides a diamond of great value, and the mirrors, which had been brought up with so great toil."[1] The envoy was also accompanied by a significant entourage that included a group of European observers, a small army composed of troopers of the Madras cavalry and Bombay grenadiers, and hundreds of servants. The expenses generated by the embassy were vast but were later justified by the young officer as essential to the success of his mission, especially in a country like Persia, where the presentation of gifts and the observance of etiquette were so highly regarded.[2]

Malcolm had been appointed by the East India Company as emissary of the first British diplomatic mission to Iran since the time of Queen Elizabeth I.

The purpose of the expedition was to contain the expansion of France in the Middle East and establish more profitable conditions for British commercial activities, while offering financial and military support in return. The Russian encroachment on Georgia, which had become a Russian protectorate in 1799 after Fath 'Ali Shah's failed attempts to reintegrate the country into his domains, increased Iran's need for assistance and the shah's proclivity to accept foreign help. The British had thus a rare opportunity to seal an alliance that would not only safeguard their interests in the region but ultimately assure control of the only terrestrial access that their rival France would have had to India. Before his departure from Tehran, as recognition of his efforts, Malcolm received a number of presents from the shah, including a dagger with diamonds and rubies set on its enameled sheath (fig. 196). Although meant to officially reciprocate the generosity of the East India Company, Fath 'Ali Shah's reward also signaled the willingness to cultivate a more personal relationship with Malcolm. The bestowal of an even more prestigious recognition—the institution of the Order of the Lion and the Sun and the creation of a new insignia by the court jeweler—in the

course of his third mission in 1810 was a further sign of the shah's favor toward this individual, blurring the line separating public from personal gifts.[3]

The emblem of the Order—a lion with a rising human-faced sun—would be later transformed and adopted as an imperial symbol.[4] A version with a crouching lion decorates a wealth of objects associated with Iranian royal patronage, including several of the coins that Qajar shahs publicly distributed on festive occasions (figs. 14–19) and a solid gold enameled plate (fig. 198) that was presented by the Iranian ambassador Mirza Abu'l-Hasan to the East India Company in the course of his 1819 mission to England (see fig. 253).

Privileges, such as the bestowal of a formal decoration with the royal emblem of the *shir u khurshid* (lion and sun) or of a personal image, as the one sent by Fath 'Ali Shah to Francis I of Austria in 1818 (fig. 197), indicate yet another dimension of gift giving. The nature of the objects selected by the shah as diplomatic gifts reveals his preoccupation with making kingship "a visually sensed power,"[5] a goal that was systematically pursued in the process of creating an appropriate imperial image for the new ruling house. This need is particularly evident in the series of life-size portraits that were sent to contemporary rulers as part of a series of missions that occurred between 1806 and 1819, versions of which were also showcased in official residences and reception halls. Two of them reached England and France within a decade of one another, and they offer different albeit complementary images of the ruling authority. The first one was probably one of the earliest Qajar oil paintings to reach England and was presented by Lord Wellesley to the Court of Directors of the East India Company in 1806 after the end of his service as governor-general of India (fig. 2).[6] The painting bears the date AH 1213/1798–99 and depicts the ruler dressed with jeweled regalia sitting on an elaborate floor covering. The portrait offers a somewhat intimate presentation of the shah, whose elegance and regal

bearing—underscored by the jeweled clock and sumptuous objects surrounding him—receive primary emphasis.[7] The second painting, presented by the Iranian ambassador to Napoleon at the imperial camp in Finkenstein in 1807, has a rather different character and aptly serves the shah's intention to be perceived as a powerful peer by other monarchs (fig. 170).[8] The embassy was the response to a previous mission headed by the French envoy Amédée Jaubert, who had offered military help against Russia in the hope of obtaining Iran's support to isolate England and gain exclusive access to India. Hence, the present accompanied a significant diplomatic effort that promised to severely alter the political equilibrium of the region, dominated by the British up to that point.[9] Following the formula developed for official state portraiture, the shah is depicted in a solemn and rigid pose on a jeweled throne. Crowned with the magnificent *taj-i kayani*, an imperial crown commissioned on the

year of his accession, he rests his left hand on his gem-encrusted sword, in a gesture that may be interpreted as a hint of the military capacities of Iran and, possibly, as a subtle warning to its new allies.[10]

Considering the disastrous results of the two wars with Russia (1805–13 and 1826–28), Iran's military power never posed a concrete threat to her European allies. The arrogant territorial claims and technological superiority of the Russians caused considerable territorial losses that the Qajars never managed to regain. A symptom of the weaker position that Iran occupied by the end of Fath 'Ali Shah's reign is the "apologetic" embassy that he sent to Tsar Nicholas I in 1829 following the murder of Alexander Griboyedov (see essay by Kasinec and Davis in this volume). Escorted by the shah's grandson Khusraw Mirza (fig. 190), the mission offered a series of lavish gifts, including eighteen precious manuscripts from the shah's library (figs. 59, 195),

in the hope of distracting the tsar from the embarrassing incident and preventing additional military consequences.[11] Such a display of presents—along with the need to maintain amicable relationships with Iran in the prospect of a war against the Turks—gained the tsar's forgiveness, confirming gifts as essential ingredients of successful diplomatic efforts.

Notes
1 Kaye, *Life and Correspondence of Major-General Sir John Malcolm*, vol. 1, 132–33.
2 D. Wright, *English amongst the Persians*, 32.
3 D. Wright, "Sir John Malcolm and the Order of the Lion and the Sun," 135–36.
4 Najmabadi, *Women with Mustaches*, 63–96.
5 Ibid., 71.
6 This painting was probably among the gifts that Malcolm brought back to Calcutta after his first embassy to Iran and remained in India up to Wellesley's departure.
7 See Amanat, "The Kayanid Crown."
8 Diba, ed., *Royal Persian Paintings*, cat. no. 38.
9 Musée Cernuschi, *La Perse et la France*, cat. no. 128.
10 Kazemadeh, "Iranian Relations with Russia," 331–33.
11 Piotrovsky, Adamova, et al., *Iran v Ėrmitaže*, 209–10.
I would like to thank Lida Oukaderova for her assistance with Russian sources.

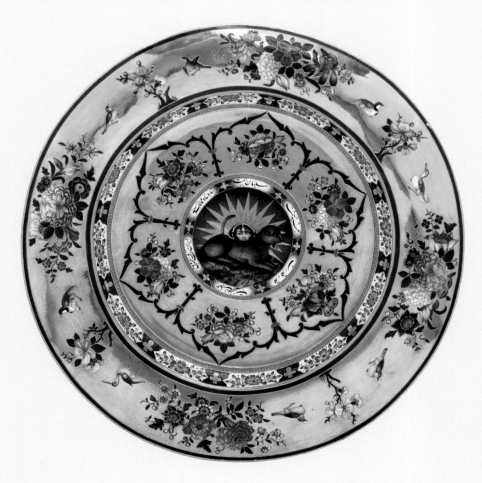

Opposite: Fig. 197 (cat. no. 188). *Headdress Ornament with Portrait of Fath 'Ali Shah*, Iran, first quarter of the 19th century. Benaki Museum, Athens (21729).

Left: Fig. 198 (cat. no. 183). *Dish*, Muhammad Ja'far, Iran, probably Tehran, 1817–18. Victoria and Albert Museum, London (97-1949).

قال اولو كنا كارهين

قد افترينا على الله كذب

ان عدنا في ملتكم

بعد اذ نجانا الله منها

وما يكون لنا ان نعود

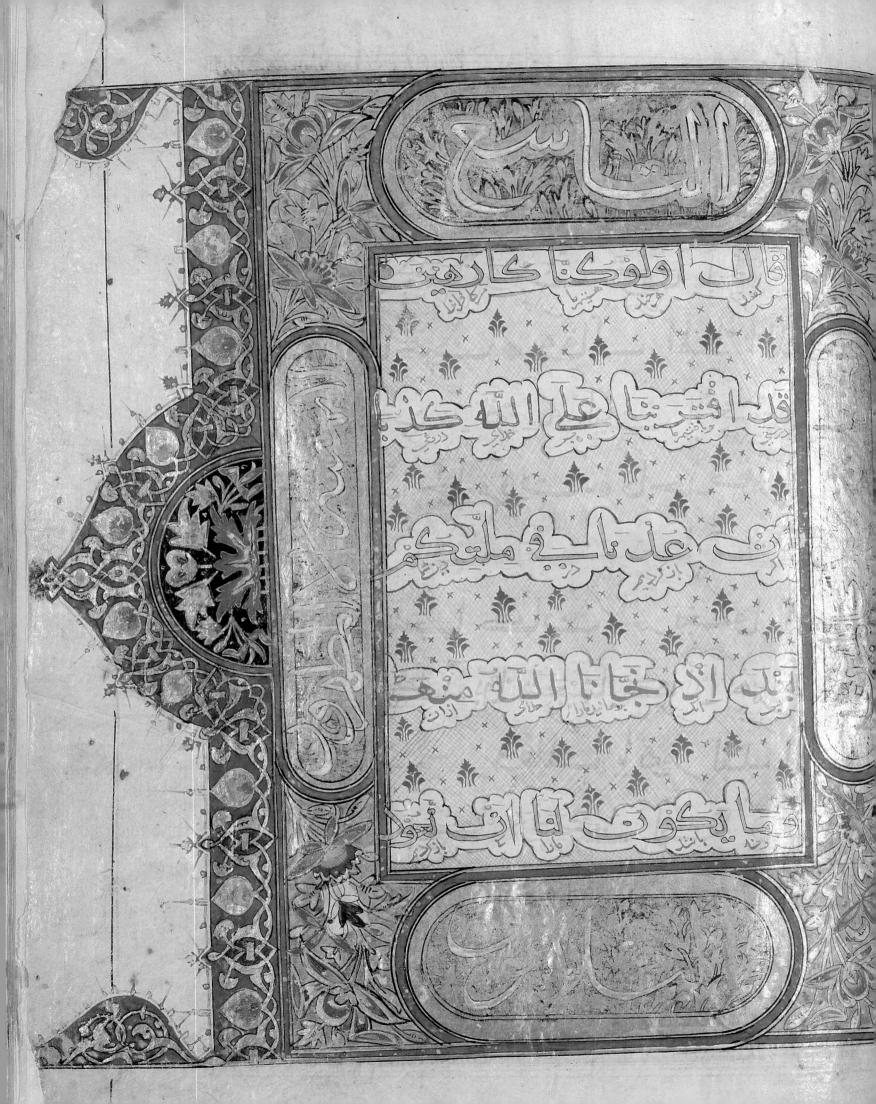

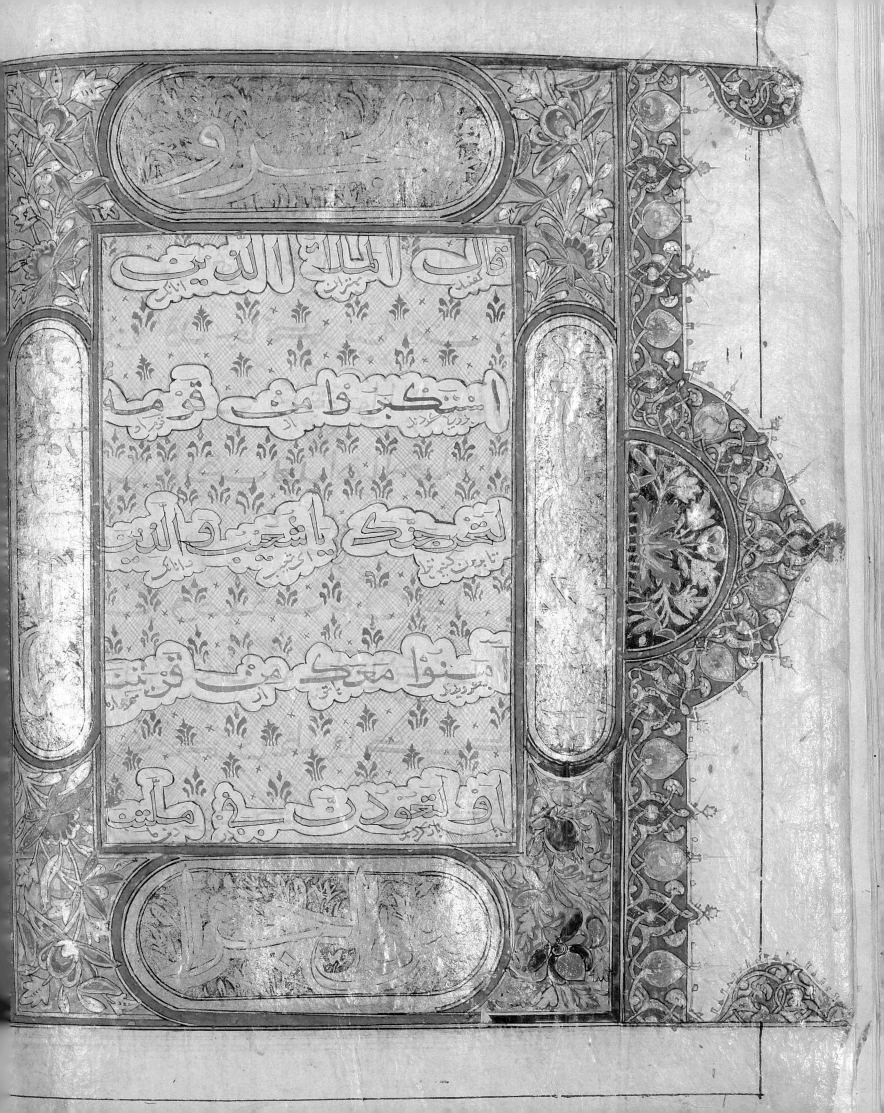

قال الملأ الذين

استكبروا من قومه

لنخرجنك يا شعيب والذين

آمنوا معك من قريتنا

او لتعودن في ملتنا

Catalogue Authors

GH
Gisela Helmecke
Museum für Islamische Kunst, Berlin

LK
Linda Komaroff
Los Angeles County Museum of Art

SM
Sophie Makariou
Musée du Louvre, Paris

OBM
Olga B. Melnikova
The State Historical-Cultural Museum Preserve,
Moscow Kremlin

GAM
Galina A. Mirolyubova
The State Hermitage Museum, St. Petersburg

KO
Keelan Overton
University of California, Los Angeles

GAS
Galina A. Serkina
The State Hermitage Museum, St. Petersburg

OVV
Olga V. Vasilyeva
National Library of Russia, St. Petersburg

SW
Saleema Waraich
Massachusetts Institute of Technology, Cambridge

EAY
E. A. Yablonskaya
The State Historical-Cultural Museum Preserve,
Moscow Kremlin

CATALOGUE

Fig. 200, cat. no. 3 a–b

1
Bowl with Inscription
Eastern Iran, 10th century
Earthenware, slip-painted under a transparent glaze
4 x 10⅝ in. (10 x 27 cm)
The David Collection, Copenhagen (22/1974)
Fig. 43

Produced during the reign of the Samanid dynasty
(819–1005), the bowl's sole decoration is the elegant Arabic
inscription quoting a hadith (a record of the words and
deeds of the Prophet Muhammad): "He who believes in
recompense [from God] is generous with gifts."[1] As here,
the inscriptions on so-called Samanid epigraphic pottery,
generally vessels for food or beverages, frequently address
the theme of generosity. While this notion of generosity
may have to do with the giving of sustenance, a basic pre-
cept of hospitality,[2] it may also reference a broader concept
central to Muslim piety, and also part of the Judeo-Christian
tradition, that God rewards (or punishes) human actions.[3]
As elsewhere in the world, the belief in divine recompense
combined with traditional ideas of benevolence and

kindness, as well as personally and politically motivated
obligation and compensation, may have helped to shape
an Islamic model of gift giving as the many spectacular
works of art presented here would suggest. LK

1 Blair and Bloom, *Cosmophilia*, cat. no. 29.
2 For an interesting consideration of the intersection of food, generosity, and gift giving, see Hyde, *Gift*, 3–24.
3 Pancaroğlu, *Perpetual Glory*, 64–67.

PERSONAL GIFTS

2
Belt Elements
Iraq, possibly Samarra, 10th century
Gold
2⅛ x 10¼ in. (5.5 x 27 cm)
Benaki Museum, Athens (1856)
Los Angeles only
Fig. 73

3 a–b
Elements for Two Sets of Belts (from the
Nihavand Hoard)
Iran, 11th–12th century
Silver
Elements range from group a, 1³/₈–2³/₈ in. (3.3–5.8 cm)
and group b, 1–1⁵/₈ in. (2.3–4.1 cm)
The British Museum, London (1939,0313.9–39)
Fig. 200

4
Belt Elements
Syria, late 13th–early 14th century
Copper alloy, cast and gilt
Circular elements: diam. 2¹/₂ in. (6.3 cm); rectangular
elements: l. 1¹/₂ in. (3.5 cm); buckle: l. 3¹/₈ in. (8 cm);
w. 2 in. (5 cm)
Benaki Museum, Athens (1900)
Los Angeles only
Fig. 72

5
Belt Elements
Spain, 14th century
Gold
Each rectangular plaque: 2³/₈ x 1¹/₈ in. (6 x 28 cm); plaque
with triangle: 2³/₈ x 2 in. (6 x 5 cm)
Museum für Islamische Kunst, Berlin (I. 4941–4944)
Fig. 74

To judge by these and other examples, which originally
would have been mounted on leather or cloth supports that
have not survived, there was a wide-ranging and long-
standing taste for gold and silver belts in the Islamic world.
Belts of this type were intended for rulers and members of
the elite based on textual sources, their depiction in illus-
trated manuscripts, and by the inscriptions some of them
carry. For example, the gilt belt elements are inscribed
with the name and titles of Abu'l-Fida Isma'il, a governor
of Hama, in Syria. It was perhaps given to him around
1319–20, when he was honored by the Mamluk sultan; such
belts also may have accompanied the presentation of robes
of honor (see cat. nos. 21–22).[1]

Illustrations in Persian manuscripts, from the Mongol
period, for example, indicate that elaborate belts were
an integral aspect of male sartorial splendor.[2] Apart from
their obvious significance as status symbols, belts were
given as a sign of friendship, as depicted in a Mongol period
painting from the Diez Album, where the enthroned
ruler and members of his court offer one another gold and
jeweled belts.[3] This coincides with an account from the
Secret History of the Mongols of how belts were exchanged
between Genghis Khan and an early supporter, Jamuka,
as a means of renewing their alliance.[4]

Belts of precious materials also were worn by women,
who might receive them as gifts as well. See, for example, a
sixteenth-century manuscript illustration from a *Shahnama*
where a belt is presented as a token of affection (see cat.
no. 6). LK

1 See Gibb, "Abu'l-Fida," *Encyclopaedia of Islam*, 2nd ed., vol. 1, 118–19. For ele-
ments from the same or another belt made for Abu'l-Fida, see Hasson, *Early
Islamic Jewelry*, 95. On the issue of belts accompanying the presentation of robes
of honor, see Mayer, *Mamluk Costume*, 58, and Sourdel, "Robes of Honor," 141.
2 See, for example, Komaroff and Carboni, eds., *Legacy of Genghis Khan*, cat.
nos. 38–40, 46, 53, 55, 56, all illustrations from the great Mongol *Shahnama*.
3 Kunst- und Ausstellungshalle der Bundesrepublik Deutschland GmbH,
Dschingis Khan und seine Erbe, 259.
4 Ratchnevsky and Haining, *Genghis Khan*, 20. Gold belts are also mentioned as
a gift in Mongol Iran by Rashid al-Din; see Rashid al-Din, *Rashiduddin Fazlullah's
"Jami'u't-tawarikh,"* pt. 3, 674.

6
Rudaba Receives a Belt as a Gift from Zal's Messenger
Folio from a manuscript of the *Shahnama*
Iran, Qazvin, 1576–77
Ink, colors, and gold on paper
13⁵/₈ x 10¹/₄ in. (34.5 x 26 cm)
The David Collection, Copenhagen (49/1980)
Fig. 79

The centrality of the *Shahnama* (Book of Kings) to Persian
culture is reflected by the many copies made since its com-
pletion by Firdawsi in the early 11th century. Like numerous
royal patrons before and after, Shah Isma'il II (r. 1576–77)
commissioned a now dispersed illustrated version from
which this page derives.[1] Here, Rudaba, the princess of
Kabul, receives a belt as a gift from Zal, a vassal of the
Iranian crown. Since their kingdoms were rivals, Rudaba
and Zal attempted to keep their love secret and thus all
exchanges were done through messengers and clandes-
tinely.[2] Such belts, made of precious materials, were tokens
of friendship and affection (see cat. nos. 3–5).[3] SW

1 B. W. Robinson, "Isma'il II's Copy of the *Shāhnāma*."
2 Folsach, *For the Privileged Few*, 76–77.
3 For reference to the Mongol custom of exchanging belts when concluding
alliances, see Komaroff and Carboni, eds., *Legacy of Genghis Khan*, 274–75.

7
Pair of Earrings
Egypt, 11th century
Gold (formerly with pearls)
Each, 1³/₈ x 1 x ¹/₂ in. (3.3 x 2.5 x 1.2 cm)
Museum für Islamische Kunst, Berlin (I. 2334a–b)
Los Angeles only
Fig. 201

Fig. 201, cat. no. 7

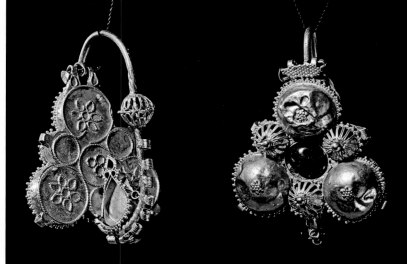

Fig. 202, cat. no. 8

8
Pair of Earrings

Syria, 10th–11th century
Gold (with black pearls)
Each, 1¾ x 1⅛ in. (4.2 x 2.9 cm)
Museum für Islamische Kunst, Berlin (I. 4829, a,b)
Houston only
Fig. 202

9
Pair of Bracelets

Syria or Egypt, 11th century
Gold, fabricated from sheet, decorated with wire,
granulation, and repoussé
Each, diam. 3¼ in. (8 cm)
Museum of Islamic Art, Doha (JE.118)
Fig. 89

10
Pair of Bracelets

Syria or Egypt, 11th century
Gold, fabricated from sheet, decorated with granulation,
wire, and repoussé
Each, diam. 2¾ in.; w. 1⅜ in. (diam. 7 cm; w. 3.2 cm)
The al-Sabah Collection, Dar al-Athar al-Islamiyyah,
Kuwait (LNS 7 Jab)
Fig. 21

11
Pendant

Egypt, 11th century
Gold, inset with cloisonné enamel decoration
8 in. (2.1 cm)
The British Museum, London (1981, 0707.2)
Fig. 101

These examples of jewelry demonstrate the artistry and
luxury of Islamic gold-working techniques during the
Fatimid dynasty (909–1171), which united Egypt and Syria.
Comparatively few such objects are preserved from this
period, whose wealth and opulence are documented in
historical accounts and in such rare surviving works (see
Jonathan Bloom's essay in this volume).[1]

The pendant, which is decorated with a pair of birds
rendered in cloisonné enamel, once may have hung from
a necklace while it would have had its own attached
ornaments. Earrings such as these, embellished or once
embellished by pearls, were obviously worn in pairs.
But large bracelets, fashioned from gold sheet, folded to
form a hollow, tubular shank, and intricately decorated
with applied gold ornament, were also made and evidently
worn in pairs.[2] These two spectacular pairs have distinc-
tive lozenge-shaped clasps, while one bears on each brace-
let's shank a repetitive Arabic inscription: "complete
blessing" (*baraka kamila*).

Then, as today, jewelry served not only as a spectacu-
lar form of personal adornment but also as an indicator of
wealth and social standing. Similarly, jewelry has always
been an important gift item. Examples of the types repre-
sented here were likely offered as personal gifts in the
Fatimid period to commemorate events such as weddings
or as a token of esteem as is documented by various textual

sources. For example, from the so-called Geniza documents (written records of the Jewish community in Cairo), which include trousseau lists, it is apparent that jewelry was the most prominent component of a bride's dowry. These lists often describe a type of gold bracelet that seems to have been hollow and decorated with repoussé ornament as in the present examples.[3] LK

1 For a brief introduction to Fatimid jewelry, see Hasson, *Early Islamic Jewelry*, 57–62.
2 As are worn by a woman depicted on a fragmentary Fatimid luster bowl; see Ettinghausen et al., *Islamic Art and Architecture*, 204, fig. 323. See also Goitein, *Mediterranean Society*, vol. 4, 200, where reference is made to gold bracelets worn in pairs.
3 Goitein, *Mediterranean Society*, vol. 4, 202–26, for jewelry in general, and with specific regard to the bracelet, 211 and 219.

12
Bracelet

Greater Iran, 12th century
Gold, fabricated from sheet, decorated with granulation and repoussé, and inset with glazed quartz, ruby, garnet, and, originally, two other stones
Maximum diam. 3 in. (76.2 mm)
The Metropolitan Museum of Art, New York (59.84)
Fig. 20

Like the bracelets of the Fatimid empire (cat. nos. 9–10), this Iranian example is also fabricated from gold sheet folded to form a hollow shank, decorated with intricate ornament and inscribed in Arabic with good wishes. However, it is decorated with stones—including a large colorful quartz—that are set with thick gold claws, all of which perhaps speaks to a distinctively Iranian taste.[1] In medieval Iran, textual evidence also suggests jewelry was given as a token of affection. For instance, in the Iranian national epic the *Book of Kings*, completed in 1010, the hero Zal sends jewelry to his beloved Rudaba through intermediaries (see fig. 79, cat. no. 6), while later on at a clandestine meeting he beholds "her bracelets, torque, and earrings."[2] LK

1 Jenkins and Keene, *Islamic Jewelry*, 54.
2 Firdausi, *Shahnama of Firdausi*, vol. 1, 262, 265.

13
Comb

Turkey, late 16th–17th century; rock crystal, probably medieval
Rock crystal inlaid with gold and set with emeralds and rubies; horn or tortoiseshell
2¾ x 5 in. (6.8 x 12.7 cm)
The al-Sabah Collection, Dar al-Athar al-Islamiyyah, Kuwait (LNS 7 HS)
Fig. 140

This spectacular comb provides an excellent example of how Islamic luxury objects circulated and were transformed over time. The rock-crystal handle probably predates its Ottoman use. It was likely originally cut from a block of stone in medieval times, a period from which numerous such objects survive, many of them gift items to judge by their frequent reference as such in texts.[1] Centuries later at the Ottoman court, it was given gold settings for the emeralds and rubies and combined with the horn or tortoiseshell comb. This remade object is comparable to pieces in the Treasury of the Topkapi Palace,[2] from which it was likely sent forth as a gift (see Tim Stanley's essay in this volume). LK

1 See Bloom, *Arts of the City Victorious*, 101, on the quantity of extant rock crystal. For gifts of rock crystal, see, for example, Qaddumi, trans., *Book of Gifts and Rarities*, 104.
2 Atil, *Islamic Art & Patronage*, 289.

Two Dinars

14
Caliph al-Musta'sim (r. 1242–58)
Iraq, Baghdad, AH 642/1244–45
Gold coin
Diam. 1 in. (2.1 cm); wt. 7.4 g
Omar Haroon Collection, Los Angeles
Fig. 34

15
Sultan Baybars (r. 1260–77)
Egypt, Cairo, probably AH 665/1266–67
Gold coin
Diam. 1⅛ in. (2.9 cm); wt. 6.04 g
Omar Haroon Collection, Los Angeles
Fig. 35

The dinar was the gold unit of coinage beginning in the early Islamic period; most weighed about 4.25 grams or slightly less. Just as today, cash was always a highly desirable gift, and dinars are frequently mentioned in this context; moreover, the estimated value of an important gift would be calculated in dinars.[1] Dinars such as these, both of which are heavier than the standard weight, would not have been used for everyday transactions, which was the function of copper coinage (fals),[2] but would have been reserved for large payments or special occasions that required a gift (also see cat. nos. 203–7). One represents the last of the dinars minted in Baghdad before the caliphate fell to the Mongol invaders; the other is unusual in that it incorporates the image of a lion, the heraldic device of the Mamluk sultan in whose name it was struck. LK

1 See, for example, Qaddumi, trans., *Book of Gifts and Rarities*, 69, 71, 73.
2 For a good general introduction to Islamic coinage, see Bates, *Islamic Coins*.

Fig. 203, cat. no. 20

16
Bowl (from the Nihavand Find)
Iran, possibly Hamadan, 11th century
Gold, engraved
Diam. 3 in. (7.6 cm)
The British Museum, London (1938, 1112.1)
Fig. 78

17
Bowl
Iran, c. 1029–49
Silver, engraved and niello
1¼ x 5¾ in. (3 x 14.2 cm)
Los Angeles County Museum of Art, the Nasli M.
Heeramaneck Collection, gift of Joan Palevsky (M.73.5.149)
Fig. 31

18
Flask
Iran, late 11th–early 12th century
Silver, cast and niello
H. 8¼ in. (20.6 cm); diam. 4½ in. (11.4 cm)
The State Hermitage Museum, St. Petersburg (S 504)
Fig. 33

19
Footed Bowl
Iran, 13th–14th century
Silver gilt
H. 3 in. (7.6 cm); diam. 4½ in. (11.4 cm)
The David Collection, Copenhagen (47/1979)
Fig. 32

These finely worked medieval Iranian vessels were likely intended for wine drinking—the flask for pouring and the bowls for sipping. This association is implied by the Arabic verses inscribed below the rim of the small gold bowl, which was part of a hoard discovered at Nihavand, near Hamadan, in western Iran (see cat. no. 3):

Wine is a sun in a garment of red Chinese silk.
It flows; its source is the flask.
Drink, then, in pleasance of time, since our day
Is a day of delight which has brought dew.[1]

The shallow silver bowl, with a winged creature at its center, is inscribed around the inner rim with good wishes for its owner "the noble lady…mother of Sharaf al-Ma'ali, may God prolong her existence."[2] Sharaf al-Ma'ali (r. 1029–49) was a petty ruler of Gurgan, in northern Iran. The stylistically related flask, with its silver surface likewise enhanced by niello decoration, also is inscribed with good wishes but to an unnamed owner and in a cursive rather than a rectilinear script.[3] The later footed silver-gilt bowl, though different in style, shared a similar function.

Gold and silver vessels are a frequently described type of gift in accounts of the medieval Islamic world. In eleventh-century Iran, for example, gold and silver utensils were distributed at a party given by the Ghaznavid ruler Mahmud to an honored guest, while silver vessels are mentioned as an important form of royal gift to members of the military elite.[4] In a Persian literary context, as in the *Shahnama*, completed in 1010, bowls of silver and gold are among the gifts the shah presents to a new paladin.[5] LK

1 Ward, *Islamic Metalwork*, 54.
2 Read by Wheeler Thackston, 1992.
3 Piotrovsky and Pritula, eds., *Beyond the Palace Walls*, 18–19.
4 Melikian-Chirvani, "Silver in Islamic Iran," 96–99.
5 Firdausi, *Shahnama of Firdausi*, vol. 1, 252.

20
Tiraz
Egypt, second half of the 9th century–10th century
Wool and linen, tapestry-woven; linen warps and wool and linen wefts
11⅞ x 48¾ in. (30.2 x 123.8 cm)
Los Angeles County Museum of Art, the Madina Collection of Islamic Art, gift of Camilla Chandler Frost (M.2002.1.692)
Fig. 203

21

Tiraz

Egypt, AH 371/981

Linen and silk

15 1/2 x 27 1/4 in. (39.4 x 69.2 cm)

Los Angeles County Museum of Art, the Madina Collection
of Islamic Art, gift of Camilla Chandler Frost (M.2002.1.30)

Fig. 29

22

Tiraz

Egypt, Tinnis, AH 375/985–86

Linen and silk

64 5/8 x 15 3/4 in. (164 x 40 cm)

Benaki Museum, Athens (15105)

Los Angeles only

Fig. 98

Textiles from the first centuries of the Islamic era survive
mainly in the form of fragments, including tiraz, with
their characteristic embroidered or woven inscriptions
supplying the name and titles of the ruler. Such cloth was
produced in state factories and was the exclusive preserve
of the caliph. The cloth or more often so-called robes of
honor (khil'a; plural, khila'), bearing the inscriptions on the
sleeves of the garment, would be distributed as gifts by
the reigning monarch to members of his court.[1]

The earliest of these three pieces belongs to the
Tulunid period (868–905) in Egypt, where most of the sur-
viving tiraz were discovered. It is one of the largest such
examples; however, the inscription is too fragmentary to
be read. The other two were both made for the Fatimid
caliph al-'Aziz (r. 975–96).[2] The tiraz dated 981 testifies to
the ecumenical nature of Fatimid society. Exceptionally,
in addition to supplying the caliph's titles, it gives the name
of his chief minister or vizier, Ibn Killis (served 977–90).
Ibn Killis, who was of Jewish origin, was famous for the
financial reforms that helped bring enormous prosperity
to Egypt as well as to the vizier.[3] The inscription reads,

> Praise to God, Lord of the Worlds, may God bless
> Muhammad the Prophet. Assistance [from God]
> to Nizar Abu Mansur, the Imam al-'Aziz billah,
> Commander of the faithful, God's blessing upon
> him and upon [his pure ancestors]. From what
> was ordered by the respectable vizier Abu'l-Faraj
> Ya'qub ibn Yusuf [Ibn Killis], vizier of the
> Commander of the faithful, to be made in the year
> [three hundred] seventy-one.[4]

LK

1 See, for example, Baker, *Islamic Textiles*, 56–57, for general information on this
type of cloth and its uses. See also Sourdel, "Robes of Honor."
2 For the inscriptions on the Benaki Museum *tiraz*, see Combe, "Tissus Fatimides
du Musée Benaki," vol. 3, no. 6, pl. 1.
3 On Ibn Killis, see Imad, *Fatimid Vizierate*, 80–96.
4 Read by Jaclynne Kerner, 2006.

23

Akbar Gives a Robe of Honor in 1560

Folio from a manuscript of the *Akbarnama*

Govardhan

India, c. 1603–5

Ink, colors, and gold on paper

13 5/8 x 8 3/4 in. (43.5 x 26.8 cm)

© Trustees of the Chester Beatty Library, Dublin (In 03.49b)

Fig. 36

Written by the court historian Abu'l-Fazl and profusely
illustrated, the *Akbarnama* chronicles key moments of
the emperor Akbar's life and long reign (r. 1556–1605). In
this painting, Akbar awards a robe with a decorative blue
collar to Munim Khan, marking his promotion to com-
mander in chief.[1] The bestowal of a robe of honor (khil'a) to
courtiers, princes, and visiting foreign dignitaries followed
a long-standing tradition in the Islamic world whereby
a ruler would present a robe and often other associated
garments as a means of reward or to accord special honor
(see cat. no. 24).[2] SW

1 Leach, *Mughal and Other Indian Paintings*, 256–57.
2 See Baker, *Islamic Textiles*, 13, 57. See also Folsach and Bernsted, *Woven
Treasures*, 16–17.

24

Robe of Honor

Turkey, end of the 17th–first half of the 18th century

Silk, silver thread wound around white and yellow silk
cores, taqueté weaving (so-called *seraser*)

Overall: 50 x 25 in. (127 x 63.5 cm); sleeves: 59 1/2 in. (151 cm)

Museum für Islamische Kunst, Berlin (I. 6894)

Houston only

Fig. 135

Presented to an envoy of King Frederick the Great of
Prussia in 1764 for his audience with Sultan Mustafa III
(r. 1757–74), this elegant garment demonstrates the con-
tinuation of the custom of awarding a robe of honor (khil'a)
into the eighteenth century.[1] A group of related silk (*seraser*)
robes has survived, all with similar unusually large-scale
motifs intended to project an image of splendor and power
in public ceremonies.[2] Such robes, which have very long
and narrow pseudo sleeves, were worn over the shoulders
with the arms placed through slits in the sides of the dress,
while the pseudo sleeves hung down at the back (see fig. 8,
cat. no. 233). GH

1 He actually received the robe in advance of the audience in order to be properly
attired. See Kühnel, "Erinnerungen an eine Episode," 70–81.
2 Atasoy et al., *Ipek*, 252, 256–57.

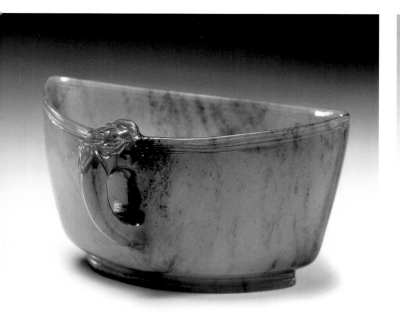

Fig. 204, cat. no. 25

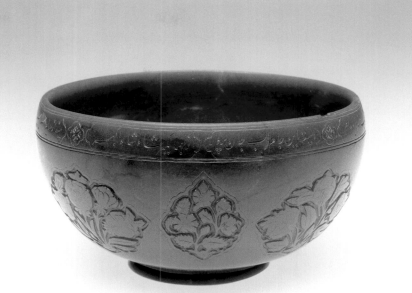

Fig. 205, cat. no. 27

25
Cup
Iran or Central Asia, fifteenth century
Nephrite (jade)
H. 4³⁄₄ in. (12.1 cm); diam. 2¹⁄₈ in. (5.4 cm)
The Asian Art Museum, Avery Brundage Collection,
San Francisco (B60J160)
Fig. 204

26
Wine Cup
Inscribed for Jahangir (r. 1605–27)
India, dated AH 1016/1607–8
Nephrite (jade)
H. 2¹⁄₄ in. (5.7 cm); diam. 3 in. (7.6 cm)
Brooklyn Museum, anonymous loan (L78.22)
Fig. 163

27
Wine Cup
Inscribed for Jahangir (r. 1605–27)
India, dated AH 1021/1612–13
Rock crystal, stained green
H. 3¹⁄₄ in. (8.1 cm); diam. 4 in. (10.2 cm)
Museum of Art, Rhode Island School of Design, Providence,
Helen M. Danforth Acquisition Fund (84.163)
Fig. 205

For the Timurid dynasty of Iran and Central Asia and their Mughal descendants in India, jade was a rare and valuable material, and hence objects made of this difficult-to-carve stone would have been suitable as royal gifts.[1] Indeed, the Timurids received both raw jade and jade vessels carried by Chinese embassies in the late fourteenth and early fifteenth centuries.[2] On a more personal level, a Timurid jade tankard inscribed with the name and titles of Ulugh Beg (r. 1447–49) and preserved in the Gulbenkian Museum, Lisbon, was bestowed upon the Mughal emperor Jahangir (r. 1605–27) by a courtier who had served his father, Humayun. This was a "precious and beautiful gift," as Jahangir indicated in his memoirs, where he also noted that he had his own name inscribed on the lip of the vessel.[3]

These three vessels may likewise have circulated as gifts. Although the elliptical Timurid jade cup lacks a royal inscription, its size, shape, and especially the dragon handle suggest a courtly context.[4] Probably intended to imitate jade, the green-stained rock-crystal wine cup with Persian inscriptions clearly reflects its imperial Mughal patronage. The verses beneath the rim begin "This is the cup of water [of life], nourisher of the soul / Of King Jahangir [son of] King Akbar." It is dated above the foot to the seventh year of Jahangir's reign, which also forms a chronogram for the hijra date 1021.[5] LK

1 See Skelton, "Relations between the Chinese and Indian Jade Carving Traditions." See also Markel, "Mughal Jades."
2 Bretschneider, *Mediaeval Researches*, vol. 2, 263. See also Lentz and Lowry, *Timur*, 222–23. Jade was also sent by the Timurids to the Chinese court; see Ralph Kauz's essay in this volume.

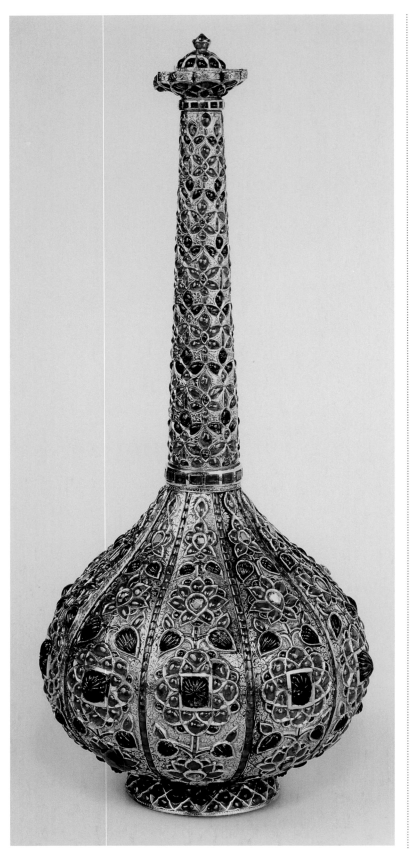

Fig. 206, cat. no. 28

3 Thackston, trans., *Jahangirnama*, 95–96 (the tankard is illustrated on 96). Timurid jades also found their way to other Islamic courts. For example, Shah 'Abbas donated two such jade vessels to the Ardabil shrine; see Canby, *Shah 'Abbas*, 161–62.

4 It is in fact very similar to another jade cup in Tehran that seems to have been among the objects donated by Shah 'Abbas to the Ardabil shrine; see Canby, *Shah 'Abbas*, 162.

5 See Skelton, *Indian Heritage*, 122, for a complete transcription of the inscriptions and for further discussion of stained quartz. See also Bonde, *Glimpses of Grandeur*, 18–19. On the link between Iranian and Indian jade carving, see Melikian-Chirvani, "Sa'ida-ye Gilani and the Iranian Style Jades of Hindustan."

28
Flask for Rose Water
India, 17th century
Gold, diamonds, emeralds, and rubies
10 ¼ in. (26 cm)
The State Hermitage Museum, St. Petersburg (VZ 714 a,b)
Fig. 206

This opulent object is one of several extant pieces from the Mughal imperial treasury that served as containers for food, drink, and fragrances and were exchanged as either personal or state gifts. Illustrations from the *Padshahnama* depict the presentation of such gold and jeweled objects; for instance, a painting of courtiers offering gifts to Jahangir includes a flask very similar to this example (fig. 54, cat. no. 33).

In 1739 the Iranian ruler Nadir Shah (r. 1736–47) sacked the Mughal capital of Delhi and looted its imperial treasury. The most renowned objects among this booty were diamonds, jewel-encrusted items, and several thrones, such as Shah Jahan's "Peacock Throne." Soon after conquering Delhi, Nadir Shah dispatched an embassy to Russia. This mission arrived in 1741 and presented a gift of thirty-seven jeweled objects looted from Delhi to the Russian heads of state.[1] Eighteen items from this gift, including this one, remain in the State Hermitage Museum. KO

1 Strack, "A Study of the Origin of Emeralds," 139; Piotrovsky and Pritula, eds., *Beyond the Palace Walls*, 220.

29
Dish
Inscribed with the name of Jahangir (r. 1605–27) and dated
AH 1021/1612
China, Hongzhi mark and period (1488–1505)
Porcelain with yellow glaze
Diam. 8 ½ in. (21.5 cm)
Victoria and Albert Museum, London (551–1878)
Fig. 110

30
Large Dish
Inscribed with the name of Shah Jahan (r. 1628–57) and
dated AH 1064/1653–54
China, Yuan dynasty, c. 1350–1400
White porcelain with cobalt blue underglaze decoration
H. 3 in. (7.6 cm); diam. 18 3/8 in. (46.7 cm)
Asia Society, New York: Mr. and Mrs. John D. Rockefeller
3rd Collection (1979.151)
Fig. 40

31
Dish
Inscribed with the name of Shah Jahan (r. 1628–57)
China, Yuan dynasty, c. 1350–1400
White porcelain
H. 3 1/2 in. (8.9 cm); diam. 17 3/8 in. (44.1 cm)
Asia Society, New York: Mr. and Mrs. John D. Rockefeller
3rd Collection (1979.150)
Fig. 111

32
Pilgrim's Flask
Inscribed with the name of 'Alamgir (r. 1658–1707)
and dated AH 1070/1659–60
China, Ming dynasty, early 15th century
White porcelain with cobalt blue underglaze decoration
8 1/8 in. (20.5 cm)
The British Museum, London (1968-4.22.32)
Fig. 169

The earliest reference to the presence of Chinese porce-
lains at an Islamic court is at Baghdad during the reign of
the caliph Harun al-Rashid (r. 786–809), when five hun-
dred pieces were recorded as a gift from the governor of
Khurasan, of which two hundred were described as espe-
cially fine (see translation on page 48 of this volume). That
high-quality Chinese porcelains continued to be admired
and collected at later Islamic courts is indicated by the
numerous examples preserved from Ottoman times in the
Topkapi Palace as well as those from the Ardabil Shrine
donated in the Safavid period (see fig. 57, cat. no. 108) and
the pieces inscribed with the names of Mughal sovereigns
as here.[1] Textual accounts also testify to the Mughal predi-
lection for this type of ware. Both Babur (r. 1526–30) and
Humayun (r. 1530–55, with interruption) evidently set great
store by their porcelains,[2] while Jahangir also seems to
have been excessively fond of such wares, as suggested by
an account of the severe punishment he meted out against
one of his retainers for a broken porcelain dish.[3] Jahangir
also recorded in his memoirs gifts of porcelain from high-
ranking members of the court given as tribute.[4] This taste
for superior Chinese porcelain was evidently passed on

to his son Shah Jahan and grandson 'Alamgir, to judge by
these examples. LK

1 See Das, "Chinese Porcelain at the Mughal Court."
2 Ibid., 387–88.
3 As noted in an often-repeated account by the English merchant Thomas
Hawkins in ibid., 389.
4 See Thackston, trans., Jahangirnama, 89, 129, 193.

33 a–b
Jahangir Receives Prince Khurram on His Return from the Deccan
Double-page composition from the Windsor Padshahnama
Right-hand folio by Ramdas
Left-hand folio by Murar
India, c. 1640
Ink, colors, and gold on paper
Image size: (right-hand folio) 12 7/8 x 8 3/4 in. (32.4 x 22.2 cm);
(left-hand folio) 12 5/8 x 8 3/4 in. (32 x 22.1 cm)
The Royal Collection, Windsor (RCIN 1005025, fol. 48b
and fol. 49a)
Fig. 154

34
Jahangir Presents Prince Khurram with a Turban Ornament
Folio from the Windsor Padshahnama
Payag
India, c. 1640
Ink, colors, and gold on paper
Image size: 12 5/8 x 8 in. (32 x 20 cm)
The Royal Collection, Windsor (RCIN 1005025, fol. 195a)
Fig. 153

While in Lucknow in the late eighteenth century, Lord
Teignmouth, the governor general of India, was offered a
magnificent manuscript from the collection of the nawab
of Oudh (see also cat. nos. 35–38). The British official
declined the gift and suggested that it was instead "fit
for a royal Library" and "might be acceptable to the King
of Great Britain."[1] This manuscript of the Padshahnama,
an illustrated biography of the reign of Shah Jahan
(r. 1628–58), was subsequently presented to George III
(r. 1760–1820).

In addition to being a gift, the Padshahnama includes
several representations of personal and state gift exchange.
The double-page composition here, which depicts Jahangir
embracing his son Prince Khurram (the future Shah Jahan)
upon the latter's return from his victorious campaigns in
the Deccan, contains both levels of gifting.[2] During their
audience with Jahangir, members of the Deccan mission
offered the emperor personal gifts of cash and jeweled
objects, such as the vessels and daggers visible on the trays
in the lower left. Prince Khurram presented his own gift of
cash while also introducing the most prized item among
the Deccani tribute, an elephant named Sirnag offered by

the ruler of Bijapur, Ibrahim 'Adil Shah II (r. 1580–1627). Jahangir described this majestic state gift, which is ridden by a Bijapuri mahout at the bottom of the left-hand page, as "the finest of the elephants of the 'Adil Khan's offering."[3] In the single-page composition, Jahangir rewards his son's military service by presenting him with a jeweled turban ornament. This tangible gift coincided with the bestowal of a more symbolic one, the title "Shah Jahan" (King of the World).[4] KO

1 Beach and Koch, *King of the World*, 13.
2 For Jahangir's account of this event, see Thackston, trans., *Jahangirnama*, 227–28.
3 Ibid., 228.
4 Beach and Koch, *King of the World*, 201; Thackston, trans., *Jahangirnama*, 229.

35–38
Five Folios from the Muhammad Juki *Shahnama*

Probably Afghanistan, Herat, c. 1444
Ink, opaque watercolor, and gold on paper
Each folio: 22 x 18 in. (56 x 45.5 cm)
The Royal Asiatic Society of Great Britain and Ireland
(MS.239)

Fig. 207, cat. no. 35

35
Flyleaf with Inscriptions and Seals
Folio 3a
Fig. 207

36
The Simurgh Restores the Child Zal to His Father Sam
Folio 16b
Fig. 25

37
Tahmina Entering Rustam's Chamber
Folio 56b
Fig. 208

38
Battle between Gushtasp and Arjasp
(double-page composition)
Folios 269b–270a
Fig. 28

Long known to modern art historians as one of the greatest illustrated versions of the Iranian national epic—the *Shahnama* (Book of Kings)—this remarkable manuscript was equally appreciated in the centuries immediately following its production. It was made around 1444 for the Timurid prince Muhammad Juki, whose name and titles appear on a banner in one of the paintings (fol. 296a, fig. 28). It was probably copied and illustrated in the capital, Herat, the supreme artistic center of the day. Although the Timurid dynasty came to an end in 1507, one of its princes— Babur—founded a new dynasty by carving out an empire in India. Babur's Timurid heritage and cultural patrimony were important to him as demonstrated by this Book of Kings, which is stamped with his seal and those of his Mughal descendants, Humayun, Jahangir, Shah Jahan, and 'Alamgir (see fig. 207).[1] The manuscript must have left the Mughal imperial library by the third quarter of the eighteenth century, as it contains a notation that it was made a gift by the nawab Salar Jang, who died in 1786 or 1787. It eventually passed into the hands of the nawab vizier of Oudh, who presented the book to Lord Hastings, governor general of India probably around 1814. Hastings gave the manuscript to his military secretary, Lieutenant Colonel Doyle, who donated it to the Royal Asiatic Society in 1834.[2] LK

1 Brend, *Muhammad Juki's Shahnamah of Firdausi*, 148–50, in which the author notes the absence of a seal for Akbar, although the manuscript was in the royal library in 1602.
2 Robinson, "*Shahnama* of Muhammad Juki." See also Lentz and Lowry, *Timur*, 178, 321. Most recently, see Brend, *Muhammad Juki's Shahnamah of Firdausi*, 3, where she suggests the date 1814 for when the manuscript was given to Lord Hastings, and pl. 3, for a depiction of the meeting between the nawab and the governor general.

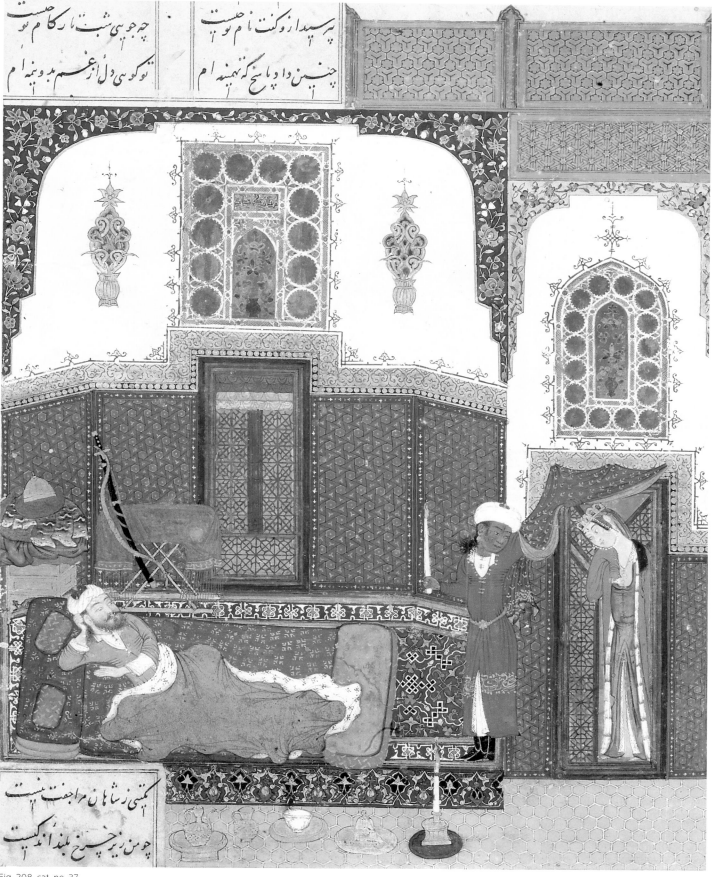

Fig. 208, cat. no. 37

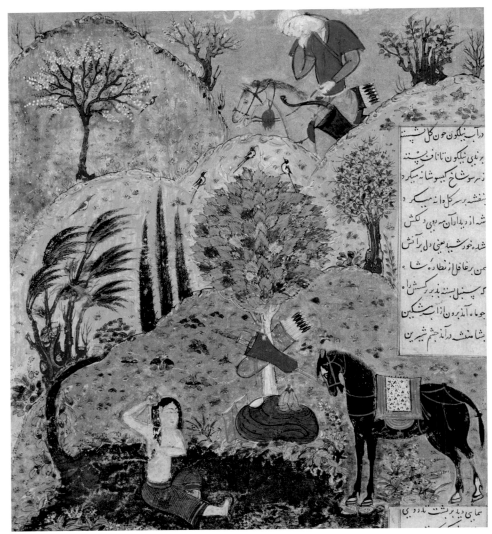

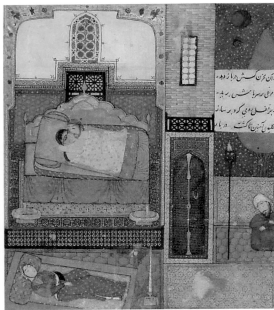

Fig. 209, cat. no. 39

Fig. 210, cat. no. 40

Fig. 211, cat. no. 41

39–41
Three Folios from an Anthology
Copied by Mahmud al-Husayni
Iran, Shiraz, AH 823/1420
Opaque watercolor, ink, and gold on paper
11 1/8 x 8 in. (28.2 x 20.2 cm)
Museum für Islamische Kunst, Berlin (I. 4628)
Houston only

39
Khusrau Watching Shirin Bathing
Folio 231
Fig. 209

40
Sultan Sanjar and the Old Woman
Folio 193
Fig. 210

41
Gul and Nawruz
Folio 741
Fig. 211

Four of the five sons of the Timurid ruler Shah Rukh
(r. 1405–47) were patrons of the arts of the book. From their
respective centers in Samarqand, Shiraz, and Herat, Ulugh
Beg (1394–1449), Ibrahim Sultan (1394–1435), Baysunghur
(1397–1434), and Muhammad Juki (1402–1444) debated
literature, competed against one another in cultural matters,
and commissioned illustrated manuscripts.[1]

This anthology is dated 1420 and was made in Shiraz
under the patronage of Ibrahim Sultan. Its opening *shamsa*
(an illuminated sun-shaped medallion), however, includes
the ex libris of Baysunghur, who presided over Herat.[2] The
ex libris, which consists of four lines written in white at the
center of the *shamsa*, identifies the book as belonging to
the library of Baysunghur Bahadur Khan.[3] It is therefore
likely that Ibrahim presented this book as a gift to his
brother and fellow bibliophile Baysunghur.[4]

The paintings included here, which illustrate scenes
from the *Khamsa* (Quintet) of Nizami and the *Gul u Nawruz*
(Rose and New Year) of Khwaja Kirmani, are typical of the
style associated with Ibrahim Sultan and Shiraz. The pal-
ette is dominated by browns and greens, the figures and
foliage are static, and the painterly hand is loose. This style
contrasts sharply with the jewel-like refinement and ethe-
real quality of paintings commissioned by Muhammad
Juki in Herat (fig. 208, cat. no. 37).　KO

1 Lentz and Lowry, *Timur*, 112–13.
2 Enderlein, *Die Miniaturen der Berliner Baisonqur-Handschrift*, 37.
3 For a comparable *shamsa* with a similar ex libris of Baysunghur, see Roxburgh,
Persian Album, fig. 19.
4 Lentz and Lowry, *Timur*, 336.

42
The Presentation of Prince Dara Shikoh's Wedding Gifts before Shah Jahan
Folio from the Windsor *Padshahnama*
Balchand
India, c.1635
Ink, colors, and gold on paper
Image size: 14 x 9 3/4 in. (35.6 x 24.7 cm)
The Royal Collection, Windsor (RCIN 1005025, fol. 72b)
Fig. 212

This painting from a manuscript of the *Padshahnama*
depicts the display of wedding gifts (*jahaz*) presented to
Dara Shikoh, the son of Shah Jahan, and Nadira Banu
Begam (see cat. nos. 43–44).[1] The event took place in 1633
in Agra's *Diwan-i 'Amm* (Hall of Public Audience), a royal
pavilion where Shah Jahan held court (*darbar*). The seated
emperor faces the standing groom, while jewels, gold
vessels, and textiles are arranged below on a white carpet.
At the far left, a courtier raises a piece of paper that is
ostensibly a list of gifts but in fact includes the signature
of the artist, Balchand.　KO

1 Beach and Koch, *King of the World*, 172.

43
Landscape with Animals and Dedication Inscription
Folio from the "Nadira Banu Begam Album"
India, 1640–41
Gold and ink on paper
12 7/8 x 9 3/8 in. (32.5 x 23.5 cm)
The British Library, London (Add. Or. 3129, fol. 2)
Fig. 12

44
A Lady Holding a Cup and a Bottle
Folio from the "Nadira Banu Begam Album"
India, 1640–41
Opaque watercolor and gold on paper
12 7/8 x 9 3/8 in. (32.5 x 23.5 cm)
The British Library, London (Add. Or. 3129, fol. 28)
Fig. 13

45
Portrait of a Young Prince with Mystics
Folio from an album
India, c. 1635
Opaque watercolor, gold, and ink on paper
16 7/8 x 11 1/8 in. (42.7 x 28.2 cm)
Aga Khan Museum Collection, Geneva (AKM 00498)
Fig. 213

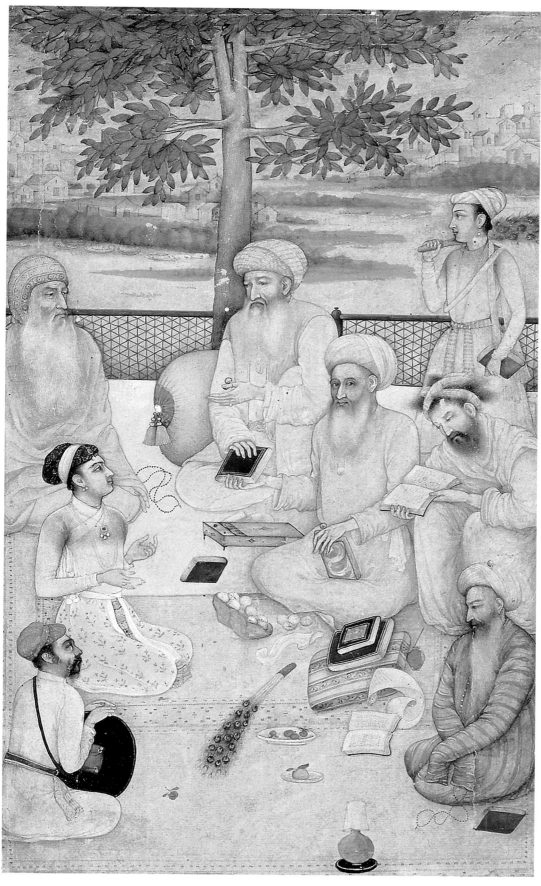

Opposite: Fig. 212, cat. no. 42
Left: Fig. 213, cat. no. 45

Paintings were frequently exchanged as gifts within the Mughal royal family, and women played an active role in this genial activity. Indeed, several of the most important manuscripts in the Mughal imperial library were presented from mothers to sons and fathers to daughters.[1] Such gifts were often motivated by affection and are thus compelling examples of personal generosity.

These pages are from an album most commonly known as the "Dara Shikoh Album," which offers a rare instance of a collection of paintings and calligraphies presented by a husband, Dara Shikoh, to his wife, Nadira Banu, whose wedding gifts are visible in a *Padshahnama* painting (fig. 212, cat. no. 42).[2] A dedicatory inscription by the prince on the opening flyleaf describes the gift: "This precious volume (*muraqqa'*) was given to his dearest friend, Nadira Banu Begam. Muhammad Dara Shikoh, son of Shah Jahan Padshah Ghazi. 1051 (AD 1641–42)."[3] In its original bound format, the album consisted of alternating pages of paintings and calligraphies. Instead of documenting battles and royal audiences, the paintings depict flowers, animals, and women, such as this lady. It is therefore likely that they were deliberately selected by Dara Shikoh to satisfy the feminine tastes of his wife.[4]

According to a seventeenth-century foliation, five pages from the Nadira Banu Begam Album are missing.[5] Several circumstances suggest that this depiction of a prince conversing with mystics may have once belonged to the album.[6] Both the composition and style are similar to examples in the British Library compilation. Moreover, calligraphy by Muhammad Husayn al-Kashmiri, whose work is associated with the album, is located on the folio's verso.[7] KO

1 Consider, for example, Seyller, "Inspection and Valuation," 287.
2 Robert Skelton has recently argued in an unpublished paper, "Portraits for Princes: A Newly Recognized Salim Album and Its Successors," that the album should be identified by the name of its recipient (Nadira Banu Begam) rather than that of its giver (Dara Shikoh). According to Skelton, albums that were assembled for the prince feature his own calligraphy almost exclusively and reflect his personal tastes rather than those of his wife.
3 Seyller, "Inspection and Valuation," 295; Falk and Archer, *Indian Miniatures*, 72.
4 Falk and Archer, *Indian Miniatures*, 73.
5 Ibid., 72.
6 Suggested by Alnoor Merchant (personal communication), but see Aga Khan Trust for Culture, *Treasures of the Aga Khan Museum*, 327.
7 Aga Khan Trust for Culture, *Spirit & Life*, 62.

46–49
Four Mohurs
Mughal, India

46
Jahangir (r. 1605–27)
Ajmer, AH 1023/1614
Gold coin
Diam. ⁷⁄₈ in. (2.1 cm); wt. 10.9 g
The British Museum, London (1854,0529.111)
Fig. 156

47
Jahangir (r. 1605–27)
Agra, AH 1028/1618
Gold coin
Diam. ⁷⁄₈ in. (2.1 cm); wt. 10.86 g
The British Museum, London (1871,1201.2)
Fig. 157

48
'Alamgir (r. 1658–1707)
Multan
Gold coin
Diam. ⁷⁄₈ in. (2.1 cm); wt. 10.8 g
Omar Haroon Collection, Los Angeles
Fig. 158

49
'Alamgir (r. 1658–1707)
AH 1113/1701
Gold coin
Diam. ⁷⁄₈ in. (2.1 cm); wt. 11 g
Omar Haroon Collection, Los Angeles
Fig. 159

A Delhi sultanate ruler, Sher Shah Suri (r. 1540–45), introduced gold, silver, and copper coins during his brief rule in India. The Mughal emperors later standardized this tri-metal monetary system across their empire. The mohur (gold coin) had a basic weight of 169 grains or 11 grams (.38 ounce).[1] Mughal imperial coinage was of superior quality and exceptional quantity and circulated freely but not beyond the borders of the empire. Unlike Safavid Iran and Ottoman Turkey at this time, the import of gold and silver coins from other regions to India was not balanced by an equal expenditure of currency, thus demonstrating the immense wealth and resources of the Mughal emperors.[2]

Jahangir (r. 1605–27) issued special presentation coins (*nazarana*) decorated with his portrait, zodiacal signs, and literary verses. These coins were distributed by the emperor on notable occasions, including his regnal anniversary, Nawruz celebrations, and weddings. Their innovative designs and large size demonstrate that they were not intended for general circulation.[3] During the reign of Jahangir's grandson 'Alamgir (r. 1658–1707), the format of coins was standardized to incorporate the ruler's name, the mint, and the date of issue.[4] SW

1 Brand and Lowry, *Akbar's India*, 155–56.
2 Richards, ed., *Imperial Monetary System of Mughal India*, 1, 3.
3 Lane-Poole, *Coins of the Moghul Emperors of Hindustan*, lxxvi, lxxx–lxxxiii.
4 Ibid., lxxi.

50

Figure of a Hawk

Iran or Central Asia, 12th–13th century

Bronze

9⅝ x 4 x 5⅝ in. (24.5 x 10 x 14.3 cm)

Museum of Islamic Art, Doha (MW282.2006)

Fig. 75

51

Hunting Hawk

India, c. 1625

Opaque watercolor on paper

Overall: 12 x 12 in. (30.5 x 30.5 cm)

Museum für Islamische Kunst, Berlin (I. 4594, fol. 22)

Fig. 76

52

Falconer

Turkey, Ottoman, late 16th century

Opaque watercolor on paper

6 x 3⅛ in. (15.2 x 7.8 cm)

Los Angeles County Museum of Art (M.85.237.31)

Fig. 77

Hunting with sporting birds was a favorite leisure activity at most Islamic courts and has been documented since the Umayyad period (661–750). The practice of hawking or falconry was probably introduced via contact with Iran following the Islamic conquests. In fact, the Arabic name for the art of the flying hunt (*bayzara*) derives from the Persian word for a bird of prey (*baz*).[1] The domesticated and specially trained birds were highly admired and frequently depicted in a variety of media, often with their owners (see fig. 124). Such was their importance that even the falconer became a fitting subject for representation, as in this example.[2]

Given the value of these creatures, they made appealing gifts exchanged between rulers as well as diplomatic and tributary presentations. For example, in the early tenth century the governor of Khurasan sent his overlord the Abbasid caliph al-Muqtadir (r. 908–32) fifty falcons among much larger quantities of sable pelts, camels, and slaves, suggesting that this was a very generous number of hunting birds.[3] The Mughal emperor Jahangir (r. 1605–27), who seems to have been especially fond of hunting, makes frequent mention in his memoirs of gifted falcons, including several sent with different embassies from the Safavid Shah 'Abbas (r. 1588–1629) (see fig. 127). On one such occasion it is apparent that the gifted creatures were accompanied by their handler, whom the emperor gave leave to return to Iran (see fig. 30).[4] LK

1 See Viré, "Bayzara," *Encyclopaedia of Islam*, 2nd ed., vol. 1, 1152–55; see also Alexander, ed., *Furusiyya*, vol. 1, 126–27, for the related textual sources. In the context of Persian literature, see Firdausi, *Shahnama of Firdausi*, vol. 7, 49, for the

hunting birds and their keepers who accompanied the great hunter Bahram Gur and for specific reference to a special bird sent to him as a gift by the khan of Chin.
2 The potential significance of the falconer in terms of royal pleasure is suggested in Jahangir's memoirs, where he notes very generous gifts to his son's falcon keeper, including an elephant and a robe of honor. See Thackston, *Jahangirnama*, 289. See Monshi, *History of Shah 'Abbas*, vol. 2, 1160–61, for a falcon sent to Shah 'Abbas from the Russian tsar, which was "regifted" to the Mughal ambassador Khan 'Alam.
3 Qaddumi, trans., *Book of Gifts and Rarities*, 98.
4 Thackston, trans., *Jahangirnama*, 286, 314, 352, 435.

53

Cylindrical Box

Egypt or perhaps Spain, c. mid-14th century

Ivory, carved

H. 3⅝ in. (9.2 cm); diam. 3⅝ in. (9.2 cm)

The David Collection, Copenhagen (25/1999)

Fig. 103

Carved from a single block of elephant tusk, this intricate box was perhaps intended to hold something even more rare and valuable. Arabic poetry inscribed on a tenth-century ivory box from Islamic Spain indicates that it was a receptacle for musk, camphor, and ambergris. Like the earlier Spanish ivories, it seems likely that this box was a type of elaborate gift container for a precious aromatic, one of the most favored of offerings on a par with rubies, emeralds, sable, and ermine.[1] The bands of Arabic inscriptions here present a series of good wishes to its unnamed owner.[2] LK

1 Dodds, ed., *Al-Andalus*, 43, 196. See also Qaddumi, trans., *Book of Gifts and Rarities*, 77–78, and 98.
2 Folsach and Meyer, eds., *Ivories of Muslim Spain*, vol. 2, pt. 2, 214. On the issue of provenance, Mamluk Egypt versus Nasrid Spain, see, most recently, Rosser-Owen, *Islamic Arts from Spain*, 63.

54

Box with Lid

Probably Syria, second half of the 15th century

Brass, engraved and inlaid with silver, gold, and a black compound

2¾ x 6⅛ in. (7 x 15.5 cm)

The British Museum, London (1878 12-30 703, Henderson Collection)

Fig. 81

55

Box with Lid

Probably Syria, second half of the 15th century

Brass, engraved and inlaid with silver and a black compound

H. 2¼ in. (6 cm); diam. 5 in. (12.8 cm)

The David Collection, Copenhagen (24/1970)

Fig. 80

These distinctive hemispherical-shaped lidded boxes are part of a larger group that can be dated to the second half of the fifteenth century. Their place of manufacture was

Fig. 214, cat. no. 56

long contested as some include bilingual Arabic-Latin inscriptions.[1] A Syrian provenance is now generally accepted,[2] while it also has been proposed that they may have played a role in the diplomatic and commercial activities of Mamluk Syria and the Italian city-states of Venice and Florence, partially on account of the large number of related metalwares recorded in Italian Renaissance collections and inventories.[3] The present shape is unknown in other Islamic metalwork and may represent a novel function for a new clientele. On account of their tight-fitting lids, they may have been used to hold costly ephemerals such as spices or *confetione* as were presented by a Mamluk envoy to Lorenzo de Medici in 1487.[4] The boxes were intended not only to be airtight so as to preserve their precious contents but also to be beautiful. Decorated with gold- and/or silver-inlaid arabesques, originally set off against a black ground, the boxes, which differ in style and were likely the products of two different workshops, also may have functioned as display pieces in the homes of their wealthy Italian recipients.[5] LK

1 E.g., in the Courtauld Institute, London. See Auld, *Renaissance Venice*, 18–19, 146–47.
2 First proposed in Allan, *Metalwork of the Islamic World*, 48–64, but see also Auld, *Renaissance Venice*, for other attributions.
3 See Mack, *Bazaar to Piazza*, 144–45.
4 Campbell and Chong, eds., *Bellini and the East*, 32.
5 Ibid.

56
Celestial Globe
Muhammad ibn Hilal
Iran, possibly from Maragha, AH 674/1275–76
Brass
Globe: diam. 9½ in. (24.1 cm); stand: h. 14½ in. (36.5 cm)
The British Museum, London (1871.3–1.1.a–b)
Fig. 214

A three-dimensional map of the stars, the celestial globe was first developed by the Greeks and further refined by Islamic astronomers, who maintained the classical constellations and twelve zodiacal signs, as depicted on this thirteenth-century example. The globe is signed by its maker Muhammad ibn Hilal, the astronomer from Mosul, in northern Iraq, although it was probably constructed in Maragha, in northwestern Iran. From Iran, the globe evidently traveled to India, where the leader of the Bohoras community (Isma'ili or Shi'ite Muslims recognizing a tradition of Seven Imams) presented it to Sir John Malcolm (1769–1833), a soldier and statesman serving British interests in the East (see cat. no. 189).[1] LK

1 Belloli and Savage-Smith, *Islamicate Celestial Globes*, 26, 219.

57
Portrait Medal of Mehmed II

Bertoldo di Giovanni (c. 1420–91)
Italy, Florence, 1480–81
Bronze, cast
3 ½ in. (9.3 cm)
The British Museum, London (1919.1001.1)
Fig. 215

The portrait medal of the Italian Renaissance was a diminutive but significant form of relief sculpture that helped to celebrate the emerging humanist cult of personality; it was also a vehicle for some of the best artists of the period.[1] Sultan Mehmed II (r. 1444–46; 1451–81), who conquered Istanbul in 1453 and launched the Ottomans as a world power, commissioned several leading Italian artists to produce medallion portraits of himself.[2] Bertoldo di Giovanni, a sculptor for the Medici family in Florence, prepared and signed this portrait medal of Mehmed, probably based on one by Gentile Bellini, which the sultan had commissioned. A cast of Bellini's medal was likely sent to Florence in 1480, perhaps as a gift to the Medicis, who may have ordered Bertoldo's medal as a reciprocal gift to the sultan.[3] Intended to flatter and curry favor, the reverse shows a triumphal chariot symbolizing the Ottoman's past and future conquests.[4] LK

1 Jardine, *Wordly Goods*, 416–18.
2 See Raby, "Pride and Prejudice."
3 Ibid., 182.
4 Ibid. See also Campbell and Chong, eds., *Bellini and the East*, 76.

Fig. 215, cat. no. 57

Fig. 216, cat. no. 58

58
Cameo

India, 17th century
Sardonyx with enameled gold setting
2 ⅝ x 2 ⅞ in. (6.7 x 7.2 cm)
Bibliothèque nationale de France, Cabinet de Médailles, Paris (Babelon 366, Camée 366 RCA-69937)
Los Angeles only
Fig. 216

European visitors to the Mughal court often presented cameos as gifts. During his 1619 visit to Agra, for example, the Flemish jewel merchant Jacques de Coutre gave cameos to Jahangir's son, Prince Khurram, and his brother-in-law, Asaf Khan.[1] The Mughals adopted a similar custom of exchanging cameos as personal gifts, which were worn on necklaces. This cameo is notable because it is signed 'amal-i kan atamm (work of the supreme engraver) and depicts an actual event. Prince Khurram is shown striking a lion as it attacks Anup Rai, a courtier who had protected Jahangir from the animal during a hunting outing.[2] In recognition of his valor, Jahangir presented Anup Rai with a sword, an increased rank, and the title "commander of lion slayers."[3] KO

1 Coutre, *Andanzas asiáticas*, 303.
2 Skelton, *Indian Heritage*, 123.
3 Thackston, trans., *Jahangirnama*, 118.

59

Lady of the Harem, Possibly Nur Jahan, Holding a Death Homage of Jahangir

Attributed to Bishan Das

India, c. 1627 (mounted in a later border)

Opaque watercolor on paper

5 ½ x 2 ½ in. (14 x 6.4 cm)

Catherine and Ralph Benkaim Collection, Los Angeles

Fig. 161

60

Portrait of Murad Baksh

Attributed to Balchand

India, c. 1640 (mounted in later borders)

Opaque watercolor on paper

2 ⅛ x 1 ⅞ in. (5.6 x 4.8 cm)

Catherine and Ralph Benkaim Collection, Los Angeles

Fig. 217

Above: Fig. 217, cat. no. 60
Opposite: Fig. 218, cat. no. 61

The Mughal emperor Jahangir (r. 1605–27) was particularly fond of giving his portraits to rival rulers and loyal nobles. These portraits often took the form of small paintings or medallions, which members of his court wore as an emblem of the emperor's favor and as an indication of their devotion.[1] The popularity of small oval medallion portraits coincided with the arrival of English miniatures brought to India by Sir Thomas Roe in 1615.[2]

The figure of the woman holding a small portrait of Jahangir is part of a corpus of images of Mughal women that are occasionally so distinctive they seem to represent a specific individual. Yet, women of the imperial family were sheltered in the harem and were not to be approached by men outside the immediate family.[3] In this instance, however, there may be a connection between the woman portrayed here and another one depicted in an earlier painting that includes noble ladies.[4] If this is indeed an actual portrait, probably of Nur Jahan, wife of Jahangir, the image of the ruler was presumably a gift and confirmed her privileged relationship with the emperor.

The popularity of small portraits continued throughout the seventeenth century as is demonstrated by this portrait of Murad Baksh (d. 1661), the youngest of Shah Jahan's four sons. Although it is now enclosed in a series of later borders, it is likely that this portrait of the prince would have been worn by its original recipient (see fig. 216, cat. no. 58). SW

1 E. Wright, ed., *Muraqqa'*, 436.
2 Beach, *Grand Mogul*, 100, 167.
3 Ibid., 158.
4 We are grateful to Ellen Smart for this suggestion and for proposing the identity of the woman as Nur Jahan (personal communication).

61

Portrait of Dust 'Ali Khan

Iran, third quarter of the 19th century

Opaque watercolors and gold, painted on biscuit-colored paper; mounted on card

13 x 8 in. (32.7 x 20.7 cm)

Nasser D. Khalili Collection of Islamic Art, London
(MSS 824)

Fig. 218

62

Order of the Royal Portrait

Al-Ghaffari (*raqam-i Abu'l-Hasan Naqqash Bashi*)

Iran, mid-19th century

Opaque enamels, red, yellow, and white gold, set with diamonds

Portrait: 1 x ¾ in. (2.5 x 2 cm); brooch: 3 ¾ x 2 ¾ in.
(9.5 x 7 cm)

Nasser D. Khalili Collection of Islamic Art, London
(JLY 2161)

Fig. 219

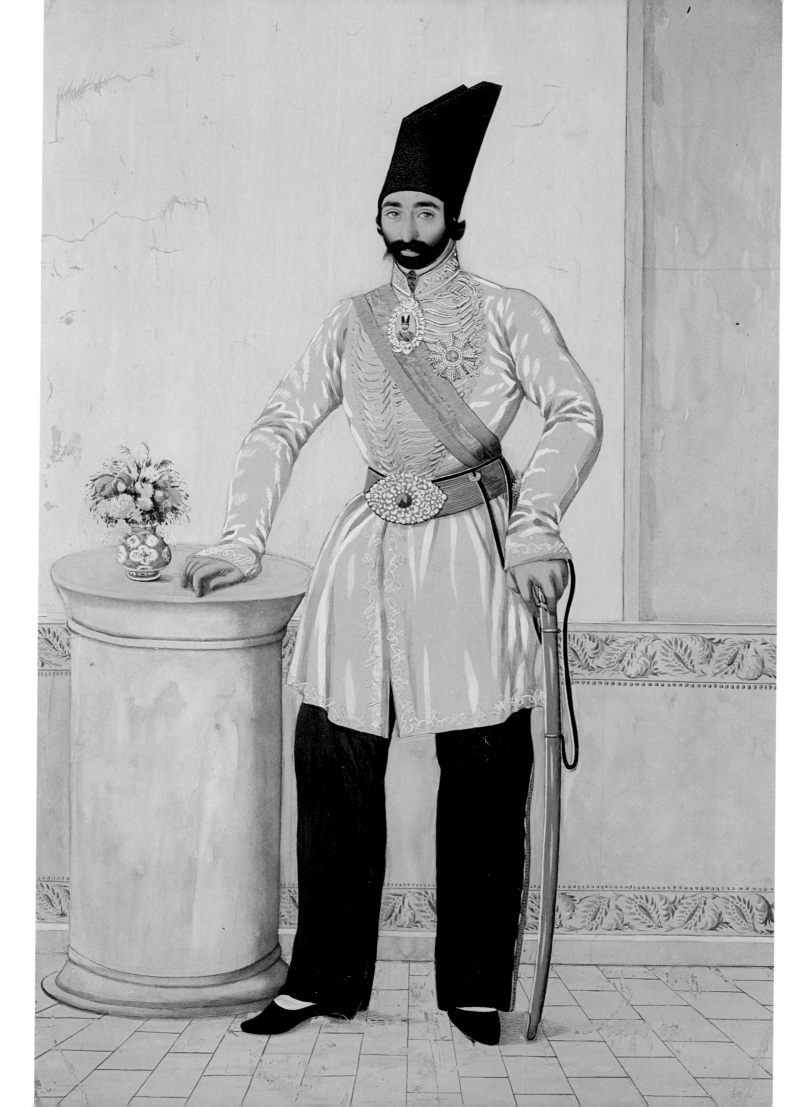

Fig. 219, cat. no. 62

Fig. 220, cat. no. 63

63
Miniature Portrait of Nasir al-Din Shah Qajar
Iran, mid-19th century
Gold sheet, painted with opaque enamels; back counter-enameled a speckled turquoise
2¼ x 1⅝ in. (5.5 x 4 cm)
Nasser D. Khalili Collection of Islamic Art, London
(MSS 849)
Fig. 220

The Qajar rulers of Iran regularly presented decorations (*nishan*) to esteemed courtiers, family members, and foreign rulers and ambassadors. These small ornaments were set in jeweled mounts and worn on the recipient's breast or collar, where they served as symbols of distinction and rank.

 The oldest decoration of the Qajar dynasty is the Order of the Lion and the Sun, which was instituted by Fath 'Ali Shah in 1808.[1] In 1810 this decoration was bestowed upon the British ambassador Sir John Malcolm (see Francesca Leoni's text in this volume).[2] Thereafter, the same order, in various classes, was presented to foreign envoys and Qajar nobles.[3] In this portrait of Dust 'Ali Khan, a high official under Nasir al-Din Shah (r. 1848–96), the courtier wears the Order of the Lion and the Sun on his breast, while the Order of the Royal Portrait dangles from his collar. The latter order was instituted by Nasir al-Din.[4]

 Here, a diamond-studded Order of the Royal Portrait, like the one shown in the painting, depicts Nasir al-Din wearing the special cap and blue sash reserved for him

exclusively.[5] The ruler appears in the same guise in a related oval miniature portrait. Although it is no longer set in its jeweled mount, we can assume that it, too, originally functioned as an Order of the Royal Portrait and was presented as a mark of favor to an honored courtier. KO

1 Ṣahidi, "Decorations," 197.
2 D. Wright, "Sir John Malcolm," 135–36.
3 For the Order of the Lion and the Sun (First Class) presented to Sir John Kinneir Macdonald in 1828, see Raby, *Qajar Portraits*, 26. The artist of this portrait, Muhammad Jaʿfar, also created the gold dish given by Abu'l-Hasan to the East India Company (fig. 198, cat. no. 183).
4 Ṣahidi, "Decorations," 197. Nasir al-Din also instituted the Order of the Sun, which was presented exclusively to queens and whose first recipient was likely Queen Victoria (r. 1837–76). For an example, see Raby, *Qajar Portraits*, 32.
5 For another miniature of Nasir al-Din by al-Ghaffari, which was presented to Sir Charles Augustus Murray in 1857, see Raby, *Qajar Portraits*, 29.

64–65
Two Mughal Powder Horns
India, c. 1650–1700

64
Nephrite (jade), rubies (or spinels), and emeralds
5½ x 1⅞ in. (14.4 x 4.8)
Musée du Louvre, Paris (R 437), Bequest of Baronne Salomon de Rothschild, 1922
Los Angeles only
Fig. 165

65

Nephrite (jade), rubies (or spinels), emeralds, and turquoise
5 ⅜ x 2 in. (13.6 x 5 cm)
Musée du Louvre, Paris (R 436), Bequest of Baronne
Salomon de Rothschild, 1922
Los Angeles only
Fig. 166

These two jade gunpowder receptacles resemble animal
horns, with the narrow part ending in a low-relief carving
of an antelope. They can be opened at their widest end by
means of a slightly convex lid. Each animal is carefully
carved with long antlers, raised ears, and a short beard.
Both pieces testify to the inclination of the Mughals toward
naturalism. Refined and luxurious arms and armaments
such as these were offered by the Mughal sovereign to his
most deserving officers, who proudly displayed them dur-
ing parades and ceremonies.[1]

 Weapons constituted one of the more important cat-
egories of objects carved of or incorporating jade not only
because of the intrinsic beauty and velvety touch of this
stone but also due to its association with victory.[2] During
the reign of 'Alamgir (1658–1707), the decoration increas-
ingly made use of inlaid gems set in gold, such as rubies,
emeralds, and turquoise (see Susan Stronge's essay in
this volume). The Indian subcontinent and Burma had a
seemingly infinite supply of precious stones and many
found their way to the royal treasury; they were among the
presents most appreciated at court and were often offered
to a superior in order to obtain a favor or to an inferior to
grant one.[3] SM

1 See Maury et al., *Istanbul, Isfahan, Delhi,* 306.
2 Pal et al., *Romance of the Taj Mahal,* 134.
3 Among the numerous Mughal accounts, see, for example, Thackston, trans.,
Jahangirnama, 61 and 96, where the emperor awards a jewel-studded dagger,
or 89, where Jahangir receives jewels.

66–67
Two Archer's Rings

66

Turkey, late 16th century
Nephrite (jade), set with rubies in gold
1 ½ x ⅞ in. (3.8 x 2 cm)
Museum für Islamische Kunst, Berlin (I. 7324)
Fig. 221

67

India, 17th century
Nephrite (jade), set with rubies and emeralds in gold
1 ⅝ x 1 ⅜ in. (4.1 x 3.2 cm)
Victoria and Albert Museum, London (IS 02522)
Fig. 167

Fig. 221, cat. no. 66

Worn on the thumb of the right hand, the archer's ring was
intended to protect that finger while the bowstring was
being drawn. Asymmetrical examples such as these repre-
sent the most commonly used type of archer's ring in the
Islamic world; the thicker section of the ring being worn
on the inside of the thumb to afford the greatest protec-
tion. These Ottoman and Mughal rings, however, were not
likely meant for actual use as their jeweled settings contra-
dict their functionality. The settings would have interfered
with the loosening of the bowstring while the action of the
string would have damaged the settings.[1] Instead, they
were intended for display during parades and ceremonies,
when they could be worn or else hung from the belt.[2] Some
of them were likely gifts offered by the Ottoman sultan and
the Mughal emperor (see cat. nos. 64–65) to members
of the court and military elite. LK

1 Wenzel, *Ornament and Amulet,* 142–43.
2 S. C. Welch, *India,* 170, 201.

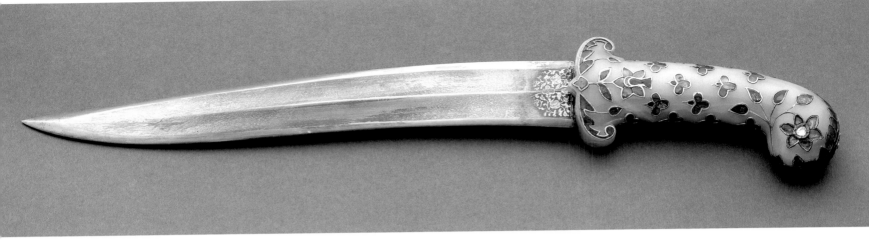

Fig. 222, cat. no. 69

68
Yataghan and Scabbard

Mustafa ibn Kemal al-Akshehri
Turkey, c. 1500
Steel, gold, wood, and leather
27 in. (76 cm)
Museum of Islamic Art, Doha (AA6)
Fig. 37

The yataghan is a traditional Turkish short sword with an inward-curving single-edged blade and a short hilt without a guard. Its blade is often inscribed along the spine with the name of the maker and/or owner. Among the finest examples, as here, the inscription is overlaid in gold. According to its inscriptions, this yataghan was commissioned by the Ottoman sultan Bayezid II (r. 1481–1512) for a court official.[1] Swords as well as daggers were a common type of gift at the Islamic courts for purposes of both personal and state presentations.　LK

1 Jodidio et al., *Museum of Islamic Art*, 119.

69–70
Mughal Dagger and Dagger Hilt with Triple-Bud Pommel

69

India, c. 1675–1700
Nephrite (jade), inlaid with rubies, emeralds, and diamonds (?) set in gold; steel blade
14⅞ x 2 in. (37.7 x 5.5 cm)
Musée du Louvre, Paris (R.163)
Los Angeles only
Fig. 222

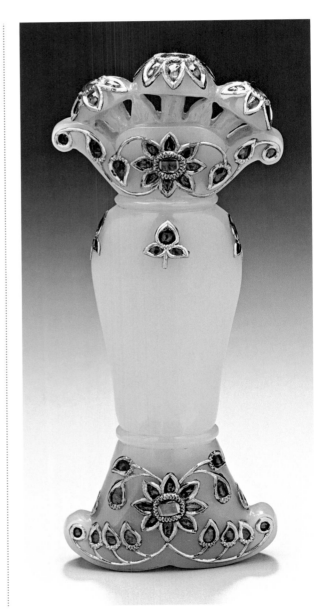

Fig. 223, cat. no. 70

70

India, 18th century
Nephrite (jade), inlaid with rubies, diamonds, and
emeralds set in gold
4 7/8 x 2 1/8 in. (12.4 x 5.4 cm)
Los Angeles County Museum of Art, from the Nasli and
Alice Heeramaneck Collection, Museum Associates
Purchase (M.76.2.14)
Fig. 223

Specially fabricated and bejeweled arms and armor were a
frequent type of state gift exchanged at the Islamic courts
(see cat. nos. 141, 163–64, 248, 257), but some weaponry
especially seems to have been given in personal presenta-
tions (see cat. no. 68). At the Mughal court, for example,
jewel-encrusted daggers were given by the sovereign to
reward services while the emperor also might receive such
weapons as tribute. In his memoirs, Jahangir makes fre-
quent reference to his bestowal of daggers along with robes
of honor and elephants.[1] This same ruler also received
such weapons, as, for instance, during an audience with
members of the supplicant Deccan mission who offered
the emperor personal gifts of cash and jeweled vessels
and daggers as depicted on trays in an illustration from
the Windsor *Padshahnama* (fig. 154, cat. no. 33).[2]

These two spectacular jade examples, one with a pistol-
grip hilt that retains its deadly blade, and both abundantly
inlaid with precious stones, would have made worthy gifts
to or from a sovereign. That such daggers were highly
valued is indicated not only by the many styles and names
for these deadly weapons[3] but also because the Mughal
emperors, princes, and courtiers are often depicted wear-
ing such weapons, which are carefully differentiated by
their details.[4] LK

1 Thackston, trans., *Jahangirnama*, e.g., 180, 193, 301, 306.
2 Ibid., 227–28; Beach and Koch, *King of the World*, 165–66.
3 On Mughal daggers, see, for example, Alexander, *Arts of War*, 186–95.
4 The pistol-grip type, as here, seems first to occur in a painting at LACMA depict-
ing a Mughal prince, c. 1675; see Pal, *Indian Painting*, 286. Jahangir rhapsodizes
about a pair of dagger handles he had made from a striated elephant tusk; see
Thackston, trans., *Jahangirnama*, 308.

71
Dagger and Sheath

Iran, 1750–1800
Steel, gold, enamel, gemstones, wood
Blade: 14 in. (35.5 cm); sheath: 10 in. (25.5 cm)
Victoria and Albert Museum, London (1602 and A-1888)
Fig. 196

72
Seal of D'Arcy Todd

Iran, 1256/1840–41
Agate
1 1/4 x 1 1/2 x 1 1/4 in. (3 x 3.5 x 3 cm)
Benaki Museum, Athens (21772)
Los Angeles only
Fig. 224

During the nineteenth century, British military officials and
ambassadors stationed in Iran and Afghanistan were both
transporters of state gifts to their sovereign and recipients
of personal gifts. Sir Gore Ouseley, for example, was respon-
sible for transporting an oil painting and manuscript for the
prince regent, later George IV (fig. 187, cat. no. 186), while
he himself received an illustrated history of the Qajars.[1]

In 1810, Fath 'Ali Shah decorated Sir John Malcolm
with the Order of the Lion and the Sun and presented the
envoy with this dagger (see Francesca Leoni's text in this
volume and figs. 218–20, cat. nos. 61–63).[2] The design
on the dagger's sheath closely resembles that on the dish
given by the Iranian ambassador Abu'l-Hasan to the East
India Company in 1819 (fig. 198, cat. no. 183).

The Persian text, inscribed in reverse, at the center of
this seal provides the name and title of its owner: "D'Arcy
Todd, ambassador [ilchi] of the mighty government of
England, on behalf of the governor of the lands of India."[3]
The lower edge of the object includes the date AH 1256/
1840–41, at which time the governor general of India
was Lord Auckland. D'Arcy Todd (1808–1845) has been
consistently confused in scholarship with Joseph D'Arcy

Fig. 224, cat. no. 72

(1780–1848), a British artillery officer who trained Persian troops during the reign of Fath 'Ali Shah and retired from military service in 1827.[4] Todd, in contrast, served as Britain's envoy to Afghanistan during the First Afghan War (1839–42). Since this seal is dated 1840–41, we can presume it was a gift to Todd from an Afghan, perhaps Yar Muhammad Khan, ruler of Herat. KO

1 B. W. Robinson, *A Descriptive Catalogue*, 175–79.
2 B. W. Robinson, "Royal Gifts of Fath 'Ali Shah," 67; D. Wright, "Sir John Malcolm," 135–36.
3 We are grateful to Ali Mousavi for his assistance with this translation.
4 Barrett, "A Memoir," 244.

73
Gombroon Dish

Iran, c. 1600–1800, with English mounts dated 1817
Fritware, pierced underglaze painted with gilded silver mounts (later)
Overall: h. 4¾ in. (12.1 cm); diam. 2⅛ in. (5.4 cm)
The Asian Art Museum, Avery Brundage Collection, San Francisco (B60P2300)
Fig. 225

This type of ceramic ware takes its name from the Iranian port city of Gombroon (modern Bandar Abbas) from which such distinctive white pottery was exported to Europe. This translucent shallow dish, with pierced designs covered with transparent glaze, perhaps was brought back to England by a British envoy to Iran in the early 1800s, when diplomatic contact between the two nations resumed

after a long hiatus.[1] The fine English silver mounts, which include the King's Head (George III), suggest this was a treasured piece.[2] LK

1 See cat. nos. 185–86, 189, which shed further light on this period in Anglo-Persian relations.
2 Froom et al., *Persian Ceramics*, 116–18.

74
Dish

Turkey, Iznik, c. 1545–50
Fritware, underglaze painted
1¾ x 10⅞ in. (4.3 x 27.6 cm)
Private collection
Fig. 148

Gifts were presented to the Ottoman sultan on the occasion of his accession or its anniversary (see fig. 226, cat. no. 77) and to mark New Year and religious celebrations. Certain court artists were granted the privilege of offering presents to the sultan, including their own work (see fig. 147, cat. no. 75). One such honored artist was Şahkuli, who served as head painter under Süleyman the Magnificent (r. 1520–66) (see Tim Stanley's essay in this volume). Given the exceptional quality of the decoration on this dish, it seems likely that it was based on a design by a court artist such as Şahkuli,[1] who is known to have given Süleyman several dishes—large and small.[2] LK

1 Atasoy and Raby, *Iznik*, 135.
2 Meriç, "Bayramlarda Padişahlara Hediye," 770.

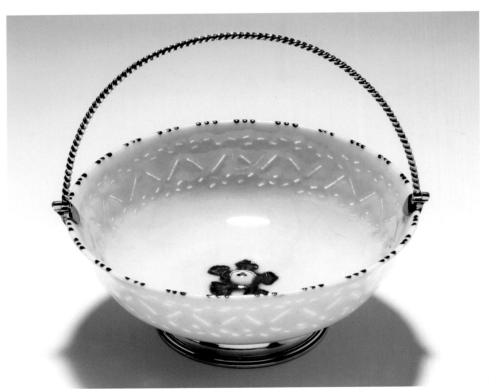

Fig. 225, cat. no. 73

75
Levha

Designed by Sami Efendi and inlaid by Vasif Efendi
Turkey, Istanbul, dated AH 1314/1896–97
Wood inlaid with mother-of-pearl
59 ½ x 45 ¾ in. (151 x 116 cm)
Museum of Turkish and Islamic Art, Istanbul (4086)
Fig. 147

A large-scale calligraphic composition intended to be
framed and hung on the wall, this *levha* combines two
areas in which Ottoman artists excelled, calligraphy and
inlaying wood with mother-of-pearl. Sami Efendi, the
calligrapher who designed the text in *celi ta'lik* script, is
best known for such compositions, many of which still
grace the mosques of Istanbul.[1] Vasif Efendi, who realized
the calligraphic design in mother-of-pearl, achieved equal
fame as an inlayer. Their collaboration here was a gift for
Sultan Abdülhamid II (r. 1876–1909), a rare privilege for
court artists (see cat. no. 74). The poetic text is in praise of
the sultan and the Ottoman victory at Dömeke (Domokos)
in 1897, as part of the Greco-Turkish War.[2] LK

1 Derman, *Letters in Gold*, 19–20, 142.
2 Thanks to Wheeler Thackston for his reading of this inscription.

76
Sakkos of Neophytos, Metropolitan of Nicomedia

Turkey, Istanbul, before 1629
Silver-thread ground, gilt-metal thread pattern outlined
in silk thread
51 ¼ x 47 ½ in. (130 x 120 cm)
Benaki Museum, Athens (9349)
Los Angeles only
Fig. 132

77
Embroidered Cloth for Sultan Abdülhamid II

Ottoman Empire, 1901
Silk embroidered with silk and gold-wrapped thread
65 x 52 in. (165 X 132 cm)
Museum of Turkish and Islamic Art, Istanbul (3321)
Fig. 226

Rulers at the Islamic courts exchanged gifts with represen-
tatives of the church not only for diplomatic purposes (see
cat. nos. 170, 172) but to commemorate important personal
occasions, as here. This *sakkos*, an ecclesiastical tunic with
wide sleeves worn by high-ranking clergy in the Greek
Orthodox Church, was made from one of the most spec-
tacular types of Ottoman silks (*seraser*), in which nearly
the entire surface of the fabric was woven with metal-
wrapped thread except for the outlining of the design.
An embroidered inscription on the tunic identifies it as

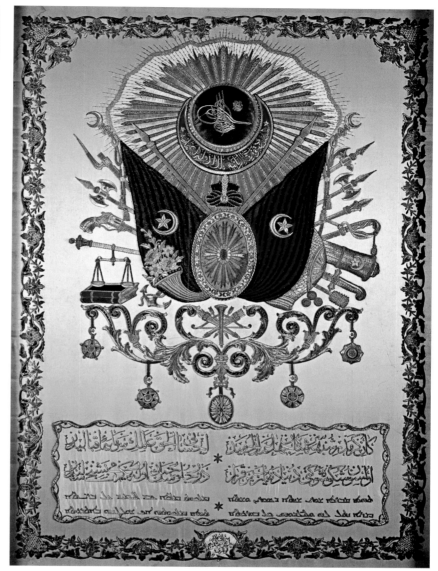

Fig. 226, cat. no. 77

the one donated to the Monastery of St. John, at Serres in
Macedonia, by Neophytes, the metropolitan of Nicomedia
(modern Izmit), before 1629.[1] It has been proposed that
this robe (or its fabric) was presented by the sultan to
Neophytes on the occasion of his formal investiture as
metropolitan, when he would have been honored, like any
Ottoman official, with a so-called robe of honor.[2]

The richly embroidered cloth decorated with an elabo-
rate emblem of the Ottoman state surmounted by the *tuğra*
(imperial monogram) of Sultan Abdülhamid II (r. 1876–
1909) was a gift from one of the eastern rite churches.
According to its inscriptions, the first part in Ottoman
Turkish and the second in Syriac, in the estrangelo
script,[3] it was presented in celebration of the twenty-fifth
anniversary of the sultan's accession to the throne (see
Ilber Ortayli's text in this volume for other related gifts):

The king of the world, Abdülhamid, is a mine
of generosity without doubt
His Beneficence is truly the basis of felicity
O Lord, may the glory of his might last in the
world
It is, thank God, the twenty-fifth year of his
regnal epoch.

Blessed be the beginning of the twenty-sixth
year of the reign of the king Abd al-Hamid over
creation. May the Lord give him and his…every
blessing. May his kingdom and his power be
everywhere.[4]

LK

1 The donation is recorded in church documents; see Ballian, "Ottoman Silks and
Velvets," 81–82, and Atasoy et al., *Ipek*, 42, 245–46, 323.
2 Ballian, "Ottoman Silks and Velvets," 81. See also Atasoy et al., *Ipek*, 178, regard-
ing the special status of the church under the Ottomans.
3 We are, as always, most grateful to Wheeler Thackston for his reading of the
inscriptions.

78–79
Two Berats

78
Berat of Sultan Süleyman I
Turkey, Istanbul, AH 963/1556
Ink, colors, and gold on paper
50 1/2 x 13 3/8 in. (128 x 33.8 cm)
Millet Manuscript Library, Istanbul (AE Document 1)
Fig. 136

79
Berat of Sultan Selim II
Turkey, Istanbul, AH 974/1567
Ink, colors, and gold on paper
41 1/2 x 12 5/8 in. (105.5 x 32 cm)
Millet Manuscript Library, Istanbul (AE Document 20)
Fig. 137

Under the Ottoman sultans, a berat was a document grant-
ing an imperial title, privilege, or property. Like edicts
(*fermans*) and other official documents, the berat was
prepared at the Imperial Council of State. At the head of
the document was the *tuğra*, the calligraphic monogram
of the sovereign, composed of his name, his patronymic,
and the phrase "the ever victorious," while the spaces in
between the letters were filled with illuminated designs.
The document proper, in the form of a long scroll, was
written in a specialized script (generally *celi divani*), and the
text lines were extended upward to the left-hand border
to prevent forgeries and tampering.

In its lavish use of gold and lapis lazuli blue ink, and the
sumptuous illumination of the *tuğra*, the berat of Süleyman I
(r. 1520–66) reflects the artistry and opulence of this sultan's
reign. It begins with the standard formula "this noble sign"
and proceeds to indicate that the fishing weir in the village
of Armanad in the district of Karala in the province of
Avlonya is granted to Laldar, servant of the sultan. It is
dated February 27, 1556. Eleven years later, during the first
regnal year of Süleyman's son, on April 9, 1567, the berat
was renewed by Selim II (r. 1566–74), whose *tuğra* is sur-
mounted by blue and gold cloud-shaped designs.[1] LK

1 Işın et al., *Ali Emiri Efendi and His World*, 98–101.

GIFTS TO RELIGIOUS INSTITUTIONS

80
Candlestick
Iran, dated AH 708/1308
Bronze, inlaid with silver
8 1/4 x 16 1/8 in. (21 x 41 cm)
Museum of Fine Arts, Boston, gift of Mrs. Edward Jackson
Holmes (55.106)
Fig. 49

81
Tile Panel
Hasan ibn 'Ali ibn Ahmad Babavaih and 'Ali ibn Muhammad
ibn Fadl Allah
Iran, probably 1310
Fritware, overglaze luster-painted
48 1/2 x 23 1/2 in. (123.2 x 59.7 cm)
The Metropolitan Museum of Art, New York, Rogers Fund,
1909 (09.87)
Fig. 46

These two objects were each made for a Sufi shrine, which
typically includes the tomb of the shaykh. The silver inlaid
inscription on the base of the candlestick announces the
name of its donor, the shrine to which it was given, and the
date: "The guilty servant [or slave], Karim [al-Din al-]
Sughani, donated to the blessed mausoleum of the Sultan
of Spiritual Masters, Sultan Abu Yazid, may God sanctify
his soul and illuminate his sarcophagus."[1] The large candle-
stick, which has lost its shaft and socket, was undoubtedly
an impressive and costly gift, befitting the status of the
donor, a vizier of Sultan Öljeitü (r. 1304–16), and the tomb
of the Sufi saint Abu Yazid al-Bastami, in Bastam.

From the tomb of 'Abd al-Samad in Natanz, this set
of three molded luster tiles forms a panel representing a
mihrab composed of colonnettes supporting an arch from
which hangs a mosque lamp. An inscription in the span-
drels indicates the panel is the work of Hasan ibn 'Ali ibn

Ahmad Babavaih, who was responsible for the decoration of the interior of the Sufi's tomb. The outermost band of inscription includes the date AH Shawwal [70]9/March 1310 and the signature 'Ali ibn Muhammad ibn Fadl Allah, the scribe who "wrote" the inscriptions.[2] The tiles likely once served as revetment for the tomb's cenotaph above the burial place of the Sufi shaykh. LK

1 Melikian-Chirvani, "Lights of Sufi Shrines," 123–25.
2 Blair, "Medieval Persian Builder," 394; Blair, Ilkhanid Shrine Complex at Natanz, 65.

82
Frieze Tiles
Inscribed with the name and titles of Abu Sa'id
Iran, c. 1455
Fritware, molded in relief and overglaze luster-painted
11 7/8 x 12 1/2 x 1 1/2 in. (30 x 31.5 x 3.5 cm)
Victoria and Albert Museum, London (C.26 and A-1983)
Fig. 45

The construction of mosques and other religious build-ings, including their decoration, was the responsibility of the ruler and may be classified under the general heading of pious donations. These frieze tiles are part of a larger group that bear the name and titles of the Timurid sultan Abu Sa'id (r. 1451–69). They evidently come from the same building complex as two closely related foundation tiles in the name of Abu Sa'id, one of which is dated AH 860/1455.[1] Although it is not possible to say precisely what type of building the tiles once decorated, the molded mihrab-like niche at the center of the foundation tiles would suggest a religious structure (see Sheila Blair's essay in this volume).[2] LK

1 Watson, Persian Lustre Ware, 159–60, 197. See also Watson, "Persian Lustre Ware," nos. 1–3.
2 Very few of Abu Sa'id's buildings survive; see O'Kane, Timurid Architecture, 20, 92, 251–53.

83
Oil Lamp
Central Asia, c. 1401–5
Brass inlaid with silver and gold
33 1/4 x 22 7/8 in. (84.5 x 58 cm)
The State Hermitage Museum, St. Petersburg (SA-15391)
Fig. 52

This is one of six large brass oil lamps that are associated with the shrine of the Sufi shaykh Khwajah Ahmad Yasavi. All but one of the lamps, including this example, carries an Arabic inscription indicating that it was commissioned by the great Central Asian conqueror Timur (r. 1370–1405), who in 1397 gave the order for the renovation of this Sufi shrine in Yasi, in modern Kazakhstan; in 1399 Timur had an enormous bronze basin made for the same complex

(see fig. 55 in Sheila Blair's essay in this volume). It seems probable that the lamps were likewise made for the shrine as part of Timur's restoration program.[1] LK

1 Komaroff, Golden Disk of Heaven, 24–31.

84
Candlestick
Turkey, dated AH 1049/1640
Silver
H. 41 3/4 in. (106 cm); diam. 29 1/2 in. (75 cm)
Museum of Turkish and Islamic Art, Istanbul (türbe 93)
Fig. 133

The dedication of lighting fixtures to religious institutions, such as this enormous silver candlestick made for the tomb of the Ottoman sultan Murad IV (r. 1623–40),[1] was a particu-larly widespread practice. This custom has a basis in one of the most revelatory sections of the Qur'an (24:35–36), the Surat al-Nur, or Chapter of Light. In addition, a hadith (tradition relating to the Prophet Muhammad) suggests that the act itself of providing light, as in the donation of a candlestick, is significant: "He who lights up a light in a mosque for seven nights running, God will keep him away from the seven doors of Hell and illuminate his tomb."[2] LK

1 See Kleiterp and Huygens, eds., Istanbul, 85, for the inscription.
2 Cited in Melikian-Chirvani, "Lights of Sufi Shrines," 118–19, where he also considers the significance of lighting devices as gifts to religious institutions.

85
Lamp
Syria, Damascus, c. 1277
Brass, remains of silver inlay, and a black compound
H. 11 1/2 in. (29 cm); diam. 11 1/2 in. (29.3 cm)
Museum of Islamic Art, Doha (MW.117)
Fig. 63

According to its inscriptions, this lamp once hung in the mausoleum associated with the al-Zahiriyya complex in Damascus.[1] In addition to the tomb of the Mamluk sultan al-Zahir Baybars I (r. 1260–77), the complex included two madrasas (colleges of Islamic law) and a school for teach-ing hadith (it is presently the site of the National Library of Syria). Following Baybars's death, his son set up a waqf (endowment) to establish this set of buildings, using rev-enue from various properties (see cat. nos. 97–98), and, as was customary, it provided for the administration, maintenance, and furnishing of the facility, including lamps such as this one.[2] SW

1 Allan, Metalwork Treasures from the Islamic Courts, 70.
2 Leiser, "Endowment of the Al-Zahiriyya in Damascus," 34, 37, 44.

86
Lamp
Egypt or Syria, late 14th century
Glass, free blown and tooled, applied handles, enameled and gilded
H. 12⅝ in. (32 cm); diam. 10 in. (25.5 cm)
Musée du Louvre, Paris (OA 7568), Bequest of Baronne Salomon de Rothschild, 1922
Los Angeles only
Fig. 53

This lamp was probably made for the madrasa built in Cairo on behalf of the Mamluk sultan Barquq (r. 1382–89).[1] As part of his endowment of this religious institution, built in harsh economic times, he provided it nonetheless with a large quantity of gilded and enameled glass lamps, including this example. Barquq's emblem, or heraldic device, in the form of an inscribed medallion, is repeated on the neck; its delicate Arabic inscription gives the sultan's *laqab* (honorific title) "al-Zahir," along with a prayer for his glory. The adjacent knotted kufic inscription provides a longer version of the same text naming "al-Malik al-Zahir Abu Sa'id."[2] SM

1 See Behrens-Abouseif, *Islamic Architecture in Cairo*, 133–35.
2 See Roux, ed., *L'Islam dans les collections*, 125.

87–88
Two Ottoman Lamps

87
Turkey, dated AH 1027/1618
Silver
H. 19⅜ in. (49 cm); diam. 11⅝ in. (29.5 cm)
Museum of Turkish and Islamic Art, Istanbul, in trust from the shrine of Eyüp (293)
Fig. 51

88
Turkey, c. 1620
Silver
H. 12¼ in. (31 cm); diam. 8 in. (20 cm)
Museum of Turkish and Islamic Art, Istanbul (77)
Fig. 144

The Shrine of Eyüp (or Ayyub) in Istanbul is the burial place of Abu Ayyub al-Ansari, a companion of the Prophet Muhammad who was killed by Byzantine forces in the late seventh century. Shortly after Mehmed II's conquest of Constantinople in 1453, Ayyub's burial place was "miraculously" discovered outside of the city's walls.[1] Ayyub soon became the "patron saint" of the new Ottoman capital, and Mehmed II (r. 1444–46; 1451–81) ordered the construction of a mosque around his tomb, which was completed in

1459.[2] The Shrine of Eyüp was thereafter synonymous with imperial authority. During accession ceremonies, for example, sultans were girded at the shrine with the sword of Osman, the dynasty's founder.

As the most holy Islamic site in Turkey, the shrine was the focus of imperial generosity, including gifts of lighting fixtures. This large silver lamp includes an inscription that records its endowment as *waqf* to Eyüp in 1618 by Osman II (r. 1618–22) and its substantial weight (2,850 g; 6 lb, 4.53 oz). It is likely that the lamp was donated to the shrine upon the ruler's accession. The smaller example is similar in shape to the first but weighs considerably less. It is also associated with Osman II, as indicated by the presence of the ruler's *tuğra*, or imperial monogram. It is plausible that it too was donated to the Shrine of Eyüp. Both objects resemble the lamp hanging in the shrine in a painting of Süleyman I (r. 1520–66) praying at the tomb.[3] KO

1 Necipoğlu, "Dynastic Imprints," 23.
2 Ibid., 25; Kafescioğlu, *Constantinopolis/Istanbul*, 46.
3 Atil, *Age of Sultan Süleyman*, fig. 43a.

89
Spherical Hanging Component of a Mosque Lamp
Turkey, Iznik, c. 1549
Fritware, underglaze painted
9⅛ x 11 x 11 in. (23 x 28 x 28 cm)
Benaki Museum, Athens (9)
Los Angeles only
Fig. 50

Constructed in 691, the Dome of the Rock in Jerusalem is among the oldest examples of Islamic architecture, and after the Ka'ba in Mecca and the tomb of the Prophet Muhammad in Medina, the third holiest site in Islam. Its significance stems from the belief that the Prophet began his ascent to Heaven (*mi'raj*) from the rock inside the building. The Ottoman sultan Süleyman I (r. 1520–66), who was responsible for the upkeep of the major Islamic shrines, ordered the replacement of the Dome of the Rock's exterior mosaics with Iznik tile revetment and commissioned ceramic lighting fixtures for the building's interior between 1545 and 1566.[1] It is likely that this spherical ornament once hung above a related Iznik lamp, such as the example dated 1549.[2] Both objects were probably endowed by Süleyman to the Dome of the Rock during his restoration efforts. KO

1 St. Laurent and Riedlmayer, "Restorations of Jerusalem," 77.
2 In the British Museum; see Carswell, "Hanging in Suspense," 179–80.

90

Cenotaph of Taj al-Mulk wa'l-Din Abu'l-Qasim

Ustadh Ahmad and Ustadh Hasan ibn Husayn
Iran, dated AH Ramadan 877/February 1473
Wood
44½ x 46⅜ x 73¼ in. (113 x 117.8 x 186 cm)
Museum of Art, Rhode Island School of Design,
Providence (18.728)
Fig. 47

A wood cenotaph such as this was intended to serve as
an above-ground memorial marking the burial place of
an important individual. In Iran such cenotaphs are usually
associated with a shrine dedicated to one of the Imams or
their descendants (imamzada). According to its inscrip-
tions, this cenotaph was made for the imamzada of Abu'l-
Qasim, and it was donated by Gustaham, a petty ruler in
Mazandaran, in the southern Caspian region, where the
shrine was located.[1] The artists who signed this impressive
piece, likely uncle and nephew, belong to a family of wood-
carvers from Sari, also in Mazandaran. LK

1 Lentz and Lowry, *Timur*, cat. no. 111; Bonde, *Glimpses of Grandeur*, 26.

91

Section of a Qur'an

Syria, before AH Dhu'l-Qa'da 298/July 911
Ink and colors on parchment
8⅜ x 12⅝ in. (21 x 31.2 cm)
From al-Hajj (The Pilgrimage), 22:76–78
© Trustees of the Chester Beatty Library, Dublin (Is 1421)
Fig. 60

The notion of waqf in Islamic law generally refers to an
endowment whose income is used to benefit a religious
institution, which might include its construction and
provisioning with manuscripts of the Qur'an as well as
furnishings such as lighting devices and carpets (see
Abdallah Kahil's text in this volume). Apart from this type
of endowment, individual objects were made waqf to an
existing mosque, madrasa, or shrine, as a pious donation
(e.g., cat. nos. 87, 92–93, 103–6, 108). Such seems to be
the case with this fragmentary section, part seventeen of
a thirty-volume set, of an early-tenth-century Qur'an.[1] The
notation on its last page indicates that the manuscript was
donated by a certain 'Abd al-Mun'im ibn Ahmad in 911 to
the Great Mosque in Damascus, built in 706–15.[2] LK

1 The remains of the manuscript are divided among several collections, including
the Morgan Library, New York; the Topkapi Saray Museum Library and the Turkish
and Islamic Museum, Istanbul; and the National Museum, Damascus.
2 James, *Qur'ans and Bindings*, 20.

92

Part 12 of a 30-Volume Qur'an

Egypt, probably third quarter of the 14th century
Ink, colors, and gold on paper
10⅝ x 7⅝ in. (27 x 19.3 cm)
© Trustees of the Chester Beatty Library, Dublin (Is 1465)
Fig. 4

93

Part 7 of a 30-Volume Qur'an

Egypt, 14th century
Ink, colors, and gold on paper
14⅝ x 10⅝ in. (37 x 27 cm)
The British Library, London (OR. 9671)
Fig. 227

Mamluk rulers with considerable financial and artistic
resources often commissioned lavish Qur'ans in multiple
volumes (ajza'; singular, juz'). These manuscripts were
intended or endowed as waqf to religious institutions,
where they served as perpetual testaments to the piety
of their patrons.

 The small, beautifully illuminated juz' is part twelve
of a thirty-volume Qur'an. A partially obscured inscription
in part nine of the manuscript reads, "Our Lord the Sultan
al-Malik al-Nasir Faraj, son of the late Sultan Barquq, may
he be victorious, has bequeathed this as is stated in Juz' I."[1]
Sultan Faraj (r. 1399–1412, with interruption) was not the
original patron of the Qur'an, and the manner in which he
obtained the manuscript is subject to speculation.[2]

 The larger manuscript also belongs to a thirty-volume
Qur'an. Its first folio contains an illuminated heading that
clarifies it is the seventh section (al-juz' al-sabi'). Below is a
rectangular waqfiyya, or endowment notice, consisting of
six lines written in black ink. This document records that
the Qur'an was donated by the Mamluk official Aytmish
al-Bajasi (d. 1400) to the library of his mosque in the Bab
al-Wazir district of Cairo.[3] This identical waqfiyya is visible
on the first folio of other extant volumes from the same
Qur'an.[4] KO

1 James, *Qur'ans of the Mamluks*, 213.
2 Ibid., 212–14.
3 C. Baker, *Qur'an Manuscripts*, 42, and 102 for its contemporaneous binding.
4 For example, Walters Art Museum (MS W. 561).

94

Parts 24 and 25 of a 30-Volume Qur'an

Iran, Shiraz, c. 1336–75
Ink, colors, and gold on paper
17 x 12⅜ in. (42.9 x 31.2 cm)
Nasser D. Khalili Collection of Islamic Art, London (QUR181)
Fig. 228

Fig. 227, cat. no. 93

Fars Malik Khatun, sister of the Injuid ruler Abu Ishaq
(r. 1343–53), who governed southern Iran from his capital
Shiraz, commissioned a thirty-part Qur'an to be placed
at the head of her tomb. These are two sections from that
multivolume manuscript, now united in a single binding.[1]
The thirty-part division of the qur'anic text coincides with
the number of days in the month according to the lunar
Islamic calendar, one section to be recited each day. Fars
Malik died in 1344 or 1348; her Qur'an never seems to have
served the purpose for which it was endowed as it was
only completed and bound in the 1370s. LK

1 James, *Master Scribes*, 130–35; there are two other sections from this Qur'an
in the Khalili collection, 10 and 14, also bound as a single volume, ibid., 126–29,
while sections 1, 12–13, and 30 are in the Pars Museum, Shiraz.

95
Qur'an
Copied by Mahmud Sha'ban
India, Gwalior, AH 17 Dhu'l-Qa'da 801/July 21, 1399
Ink, colors, and gold on paper
9 ³⁄₈ x 6 ³⁄₄ in. (24 x 17 cm)
Aga Khan Museum Collection, Geneva (AKM00281)
Fig. 199

Sacred to Muslims, the Holy Qur'an is regarded with the
highest respect and thus represents the most esteemed
gift one could give to another. This colorful and lavishly
decorated Qur'an is an especially remarkable example. It
is the earliest known manuscript written in *khatt-i bihari*
(Bihari script), used only in India for copying religious
works. The text was rendered in alternating lines of gold,
red, and blue ink. There are thirteen lines of text per page,
except for the thirty illuminated double pages that mark
the beginning of each juz', which have five lines each; all
include a smaller interlinear rendition in Persian. Providing
such a gloss alongside the Arabic allowed non-Arab Muslims
to better appreciate the text. The manuscript appears to
have changed hands several times.[1] Detailed analysis has
led to the conclusion that restoration work was done in
the eighteenth century, presumably by an owner who may
not have resided in South Asia.[2] SW

1 This manuscript has been studied most recently by a team of scholars led by
Eloïse Brac de la Perrière; see Aga Khan Trust for Culture, *Treasures of the Aga
Khan Museum*, 114–23. We are grateful to Benoît Junod for sharing an advance
copy of the text. See Blair, *Islamic Calligraphy*, 386–88; an inscription on the last
page of the manuscript is dated AH 945/1538–39, added by its then owner; see
A. Welch, *Calligraphy in the Arts of the Muslim World*, 178n4.
2 Losty, *Art of the Book*, 56.

Fig. 228, cat. no. 94

96
Qur'an Chest
Turkey, Istanbul, c. mid-16th century
Walnut, ebony, ivory, and mother-of-pearl
57 1/8 x 17 3/4 in. (145 x 45 cm)
Museum of Turkish and Islamic Art, Istanbul (21)
Fig. 229

This fabulous inlaid chest, which was intended to contain a multivolume manuscript of the Qur'an, was made for the mausoleum of Haseki Hurrem Sultan (d. 1558), the wife and mother, respectively, of Ottoman sultans Süleyman I (r. 1520–66) and Selim II (r. 1566–74) (also see cat. no. 97). The distinctive shape of the chest clearly references an architectural form—a square building surmounted by a dome resting on a polygonal drum. It is one of a group of sixteenth-century Qur'an chests, mainly associated with royal tombs, which were inspired by domical buildings.[1] The squared kufic inscriptions on the polygonal section beneath the dome repeat the profession of faith, while inscribed on the sides of the box is an especially appropriate quotation from the Qur'an: "This is indeed a noble Qur'an, in a protected book" (al-Waqi'a, 56:77–78). LK

1 Atil, *Age of Sultan Süleyman*, 168–72.

97
Vakfiye (Endowment Deed) of Hurrem Sultan
Istanbul, dated AH 28 Recep 947/November 28, 1540
Ink, colors, and gold on paper
9 5/8 x 7 in. (24.3 x 17.5 cm)
Museum of Turkish and Islamic Art, Istanbul (2191)
Fig. 230

As at other Islamic courts, it was the prerogative of Ottoman women of means, like men, to provide for the public welfare by endowing religious foundations (see cat. no. 98). Indeed, Ottoman royal women built mosque complexes on a grand scale that was commensurate with the power they wielded.[1] Hurrem Sultan, wife of Süleyman I (r. 1520–66), founded a mosque complex in Istanbul (in the present-day Aksaray district), which included a public kitchen, a medical school, and later a hospital (see also cat. no. 96), all as specified in this beautifully illuminated *vakfiye*, or endowment deed, that also notes the architect as Sinan, the greatest master of the day.[2] LK

1 Peirce, *Imperial Harem*, 186–218.
2 Ölcer and Baykan, *Museum of Turkish and Islamic Art*, 262–63. On the buildings, see, for example, Goodwin, *History of Ottoman Architecture*, 204–5.

98
Vakfiye (Endowment Deed) of Fatima Sultan and Damad Ibrahim Paşa
Copied by 'Abdallah al-Vafa'i
Turkey, AH Shawwal 1141/May 1729
Ink, colors, and gold on paper
Folios: 12 7/8 x 8 3/4 in. (32.5 x 22.2 cm)
© Trustees of the Chester Beatty Library, Dublin (T 442)
Fig. 231

A *vakfiye*, in Ottoman usage (Arabic *waqfiyya*), is the official document stipulating the purpose of an endowment, or *vakif* (Arabic *waqf*) (see Abdallah Kahil's text in this volume). As elsewhere in the Islamic world, the Ottoman charitable foundation transformed personal properties into collective holdings to benefit the public good by establishing institutions, constructing their buildings, and providing for their provisioning and staffing, the precise terms of which were specified in the *vakfiye*. This richly illuminated example pertains to an endowment of the princess Fatima Sultan and her husband, Damad Ibrahim Paşa, a grand vizier (1718–30), for a school comprising thirteen rooms, a lecture hall, a library, and a fountain (see cat. no. 97).[1] LK

1 Minorsky, *Chester Beatty Library*, 74–77.

99
Large Dish
Inscribed with a dedication to the shrine of Imam Riza, Mashhad
China, Ming dynasty, Xuande era (1426–35)
White porcelain with cobalt blue underglaze decoration
Diam. 17 in. (43.3 cm)
Private collection
Fig. 58

An inscription carved into the bottom of this dish reveals that it was donated by Mahin Banu (1519–62), the sister of Shah Tahmasp and the great aunt of Shah 'Abbas, to the shrine of Imam Riza in Mashhad.[1] Since Imam Riza was the only Shi'ite imam buried in Iran, his tomb was the focus of considerable generosity, including Shah 'Abbas's endowment of Qur'ans and other Arabic-language texts in 1607–8.[2] It is likely that this dish was looted from the shrine during Uzbek raids of the late sixteenth century.[3] By the mid-seventeenth century, it was in the collection of the Mughal ruler Shah Jahan, an avid admirer of Chinese porcelain (see cat. nos. 30–31). An inscription on the vessel's foot includes the emperor's name and the date AH 1053/1644.[4] KO

1 Soudavar, "A Chinese Dish from the Lost Endowment," 128.
2 Canby, *Shah 'Abbas*, 186.
3 Soudavar, "A Chinese Dish from the Lost Endowment," 130.
4 Ibid., 128.

Fig. 229, cat. no. 96

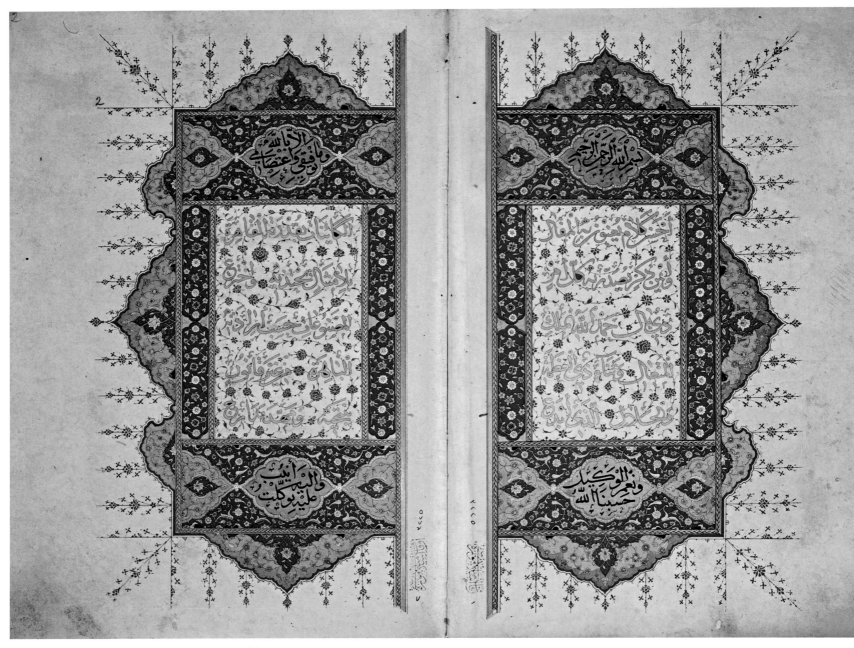

Fig. 230, cat. no. 97

Fig. 231, cat. no. 98

100

Textile Panel

Iran, c. 1567

Lampas (satin foundation weave with supplementary twill)

82 1/2 x 35 in. (209.55 x 88.9 cm)

Los Angeles County Museum of Art, gift of Miss Bella Mabury (M.58.31)

Fig. 232

According to the Persian inscription located at the top of this richly decorated figural textile, "Ghulam Shirzad presented [it] to the sacred shrine (*astana-yi muqaddasa* [literally sacred threshold]) in the year AH 975/1567–68."[1] Textiles along with other luxury objects, including illustrated manuscripts, Chinese porcelains, carpets, precious stones, and lighting devices, were commonly endowed items to Iranian shrines associated with the burial of saintly persons (e.g., cat. nos. 99, 103–6, 108). Preservation in such a shrine would certainly explain the exceptional condition of this sixteenth-century textile, although at present its overall quality does not suggest a Safavid court workshop.[2] LK

1 Thanks to Wheeler Thackston for his assistance with this reading.
2 There is a smaller and less well-preserved section in the Benaki Museum (no. 3943) that was probably cut from the bottom of the LACMA textile. We are grateful to Catherine McLean, LACMA senior textile conservator, for this observation and especially for her detailed study of the LACMA piece. Special thanks as well to Frank Preusser, LACMA senior scientist, who performed extensive visual and spectrophotometric examination of the textile from which two samples (one warp and one weft) were removed for carbon14-dating at the AMS facility of the University of Arizona in 2010. The C14 age was determined to be 220 ± 35 (sample 1) and 275 ± 42 (sample 2) years BP. The calibrated date for Iran was determined to be 1530–1646 (sample 1) and 1478–1521 (sample 2) with a 2ð confidence level, highly consistent with the 1571 date of the textile. We are also grateful to Mark Gilberg, head of the LACMA Conservation Center, for devoting center resources to the study and scientific testing of this important textile.

101

Carpet Fragment

Iran, c. 1600–1625

Silk pile, with precious-metal thread, on a silk and cotton foundation

57 1/8 x 102 in. (145 x 259 cm)

Victoria and Albert Museum, London (T36-1954)

Fig. 61

The design of this fragment is comparable to that of a large carpet made in two sections from the shrine of Imam 'Ali in Najaf, Iraq. Three circumstances suggest that the Najaf carpet and this fragment were both gifts of Shah 'Abbas (r. 1587–1629).[1] First, the quality and size of the carpets imply a royal commission. Second, two carpets with *waqf* (endowment) inscriptions attributed to Shah 'Abbas confirm that he donated textiles to the Najaf shrine. Third, during a campaign in Iraq in 1624, the ruler offered gifts of carpets, "some woven with gold thread," to several Shi'ite

shrines.[2] Comparable carpets must have been given to the Najaf shrine, which the shah also visited during this itinerary.[3] KO

1 Canby, *Shah 'Abbas*, 245; Thompson, *Milestones in the History of Carpets*, 201.
2 Monshi, *History of Shah 'Abbas*, vol. 2, 1233.
3 Ibid., 1227, 1233.

102

Kashkul

Iran, second half of the 16th century

Brass

24 in. (61 cm)

Aga Khan Museum Collection, Geneva (AKM00612)

Fig. 233

One of the five pillars of Islam requires the believer to give alms. The recipient of this generosity could be a dervish, a Sufi mystic who renounced worldly possessions. During their wanderings, dervishes used this type of beggar's bowl, or *kashkul*, to collect alms. The quality of *kashkuls* varied dramatically from unadorned wood vessels to engraved brass boat-shaped examples like this one. This *kashkul* was certainly not owned by a poor dervish. Rather, its inscriptions reveal that it belonged to the head of a Sufi shrine.[1] It is one of only five such examples from the Safavid period. KO

1 Melikian-Chirvani, "From the Royal Boat," 35–37. See also Aga Khan Trust for Culture, *Spirit & Life*, 60.

103–6

Four Manuscripts from the Ardabil Shrine

103

Layla and Majnun of Amir Khusraw Dihlavi

Iran, late 15th century

Ink, colors, and gold on paper

8 1/2 x 6 3/4 x 5/8 in. (25.1 x 17 x 1.4 cm)

The National Library of Russia, Saint Petersburg (Dorn 395)

Los Angeles only

Fig. 59

104

Treatise on Calligraphy by Sultan 'Ali Mashhadi

Copied by Sultan 'Ali Mashhadi

Iran, text: c. 1514–20, decoration and binding: 1560–70

Ink, colors, and gold on paper

9 3/8 x 6 1/8 x 1/2 in. (23.6 x 15.5 x 1.2 cm)

The National Library of Russia, Saint Petersburg (Dorn 454)

Houston only

Fig. 195

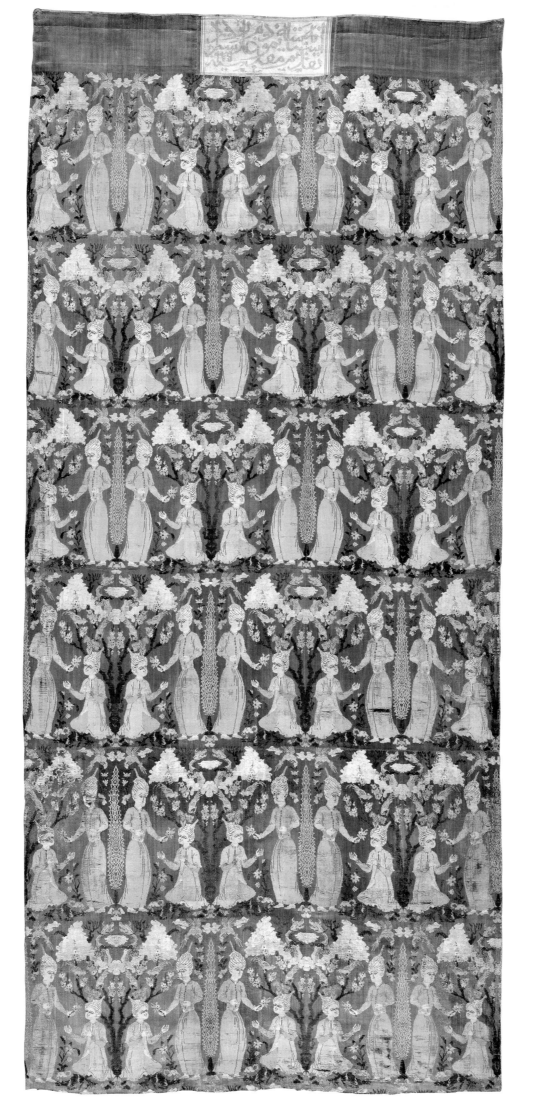

Fig. 232, cat. no. 100

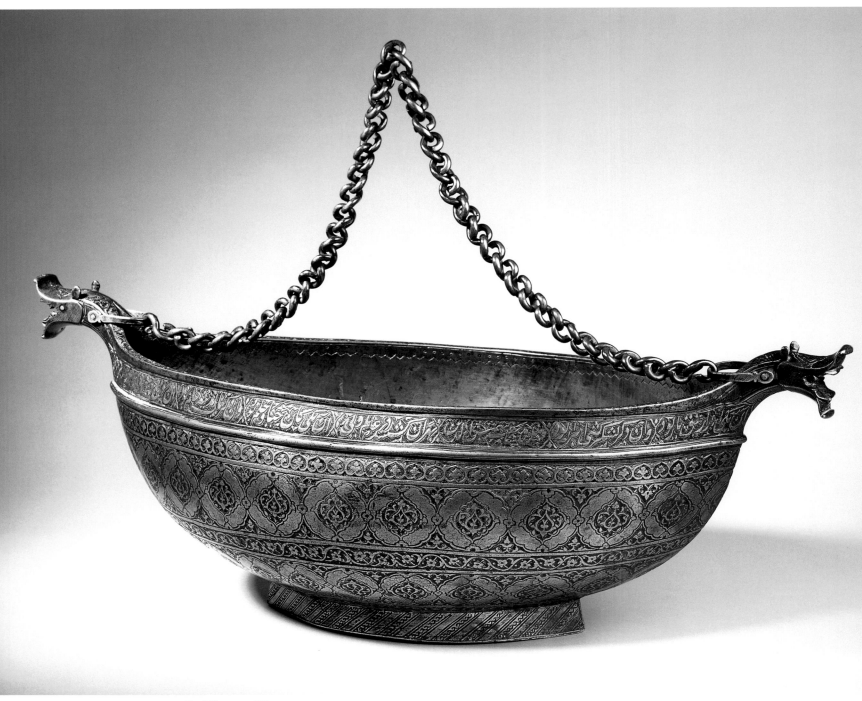

Fig. 233, cat. no. 102

Fig. 234, cat. no. 105

105
Three Poems by Hilali
Copied by Mu'izz al-Din Muhammad al-Husayni
Iran, Qazvin or Mashhad, AH 976/1568
Ink, colors, and gold on paper
9⅜ x 5¾ in. (23.8 x 14.5 cm)
Museu Calouste Gulbenkian, Lisbon (LA 192)
Fig. 234

106
Qiran-i Sa'dayn of Amir Khusraw Dihlavi
Copied by Sultan Muhammad Nur
Iran, text: 1515, three paintings: c. 1605
Ink, colors, and gold on paper
4⅝ x 10⅝ in. (11.7 x 26.8 cm)
Museu Calouste Gulbenkian, Lisbon (LA 187)
Fig. 9

Members of the Safavid dynasty (1501–1732) traced their descent to Shaykh Safi al-Din (1253–1334), a Sufi who founded a dervish order at Ardabil, in northwestern Iran. Over time, a shrine complex was built at this site, which also was the burial place of several of the Safavid shaykhs. As their ancestral shrine, Ardabil became the focus of Safavid imperial patronage and generosity. One of the most significant gifts to the shrine was that of Shah 'Abbas (r. 1587–1629), in the early seventeenth century, when the ruler decided to transfer all of his private property into *waqf*.[1] The endowment to Ardabil included more than a thousand pieces of Chinese porcelain (see cat. no. 108) and a large group of richly illuminated and illustrated manuscripts from the fifteenth and sixteenth centuries—Persian poetic and historical texts—some with later paintings.

Among the manuscripts were a number of exceptionally fine examples dating to the Timurid and early Safavid

periods. As here, each was marked, sometimes on multiple folios, with a seal impression stating "*Waqf* of the blessed and pure Safavid threshold." A handwritten note was also added to the majority of the volumes; this *waqf* notation states, "Manuscript endowed to the tomb of Shaykh Safi, peace be upon him, by 'Abbas al-Safavi, the dog of the guardian of the threshold of 'Ali, son of Abi Talib, may God's blessing and mercy be upon him. Whosoever wishes to read [this work] may do so provided that he does not take it outside the shrine; anyone who takes it will be [considered] responsible for the blood [martyrdom] of Imam Husayn."[2]

The warning of the *waqf* notation notwithstanding, the bulk of the manuscripts endowed by Shah 'Abbas were removed from the shrine. The two manuscripts in the National Library of Russia were part of a group of 166 volumes acquired by Count Soukhtaline in 1828 (see Olga Vasilyeva's text in this volume). Although it is unclear how and when other manuscripts bearing the *waqf* seal of Shah 'Abbas left Ardabil, there are several examples, such as these two in the Gulbenkian Collection, whose seals are partially effaced, that were evidently not among those taken to St. Petersburg.[3] LK

1 See Monshi, *History of Shah 'Abbas*, vol. 2, 953–55.
2 Simpson, *Sultan Ibrahim Mirza's "Haft Awrang,"* 35.
3 Ibid., 34–35, and 36n24, for reference to other manuscripts bearing the *waqf* seal of 'Abbas I.

107
Ardabil Carpet

Maqsud Kashani
Iran, possibly Tabriz, AH 946/1539–40
Silk plain-weave foundation with wool knotted pile
283 x 157 1/2 in. (718.8 x 400 cm)
Los Angeles County Museum of Art, gift of J. Paul Getty
Fig. 48

This spectacular carpet was made as one of a matched pair, whose mate survives in the Victoria and Albert Museum, London.[1] According to their identical signatures, the carpets were the work of Maqsud of Kashan, probably the one who prepared the designs and oversaw the project. They were royal carpets, perhaps commissioned for Shah Tahmasp (r. 1524–76), presumably for his ancestral shrine at Ardabil (see cat. nos. 103–6, 108). Inscribed just above the dated signature of each carpet is a Persian couplet by the renowned fourteenth-century poet Hafiz: "I have no refuge in this world other than thy threshold / My head has no resting place other than this doorway."[2]

LK

1 Stanley, *Palace and Mosque*, 74–75.
2 On the poetic inscription and its relationship to the carpets and to the shrine, see Blair, "Texts, Inscriptions and the Ardabil Carpets." The first line of the couplet by Hafiz was used in a petition to an Aqqoyunlu ruler, either Sultan Ya'qub (r. 1478–90) or Rustam (1493–97), from a calligrapher, probably Sultan 'Ali Qayini. See Thackston, *Album Prefaces and Other Documents*, 47. It is possible that the use of the couplet by Hafiz came to be associated with petitions from royal protégés and that its appearance on the carpet adds yet one more level of meaning—perhaps Maqsud of Kashan was appealing to the shah for some special favor or a promotion or even his back wages, as in the Aqqoyunlu petition just noted. I am grateful to Jon Thompson for bringing this petition to my attention.

108
Dish

China, Jingdezhen, 1403–24
White porcelain with cobalt blue underglaze decoration
Diam. 15 1/8 in. (38.4 cm)
Victoria and Albert Museum, London (1712–1876)
Fig. 57

109
Ewer

China, Jingdezhen, 1403–35
White porcelain with cobalt blue underglaze decoration
14 1/2 x 8 1/8 x 7 in. (36.8 x 20.6 x 17.8 cm)
The Asian Art Museum, Avery Brundage Collection, San Francisco (B60P85)
Fig. 235

In the early seventeenth century Shah 'Abbas made a remarkable gift to the Sufi shrine at Ardabil (see cat. nos. 103–6). This endowment, or *waqf*, included a large collection of Chinese porcelain. Most of the porcelains were inscribed with a dedicatory inscription of the shah, indicating that 'Abbas, slave of the King of Holiness, endowed it to the threshold or shrine of Shah Safi. As might be expected, the porcelains are of very high quality overall; however, it is the approximately four hundred blue-and-white pieces that take pride of place. They constitute an extraordinary cross section of some of the finest wares produced between the fourteenth and early seventeenth centuries.[1] From the fourteenth century onward, most Chinese porcelain, whether for imperial consumption or for private and commercial enterprises, was made at the kilns of Jingdezhen, as is the case with these two vessels. The dish must have come from the Ardabil shrine as it bears the dedicatory inscription of Shah 'Abbas, which was carefully engraved into the glaze in a rectangular cartouche and rubbed with some kind of red pigment. Although it does not bear the Ardabil *waqf* mark, this ewer is very similar in shape and decoration to a porcelain from the shrine.[2]

LK

1 Pope, *Chinese Porcelains*.
2 From the group relocated to Isfahan, see ibid., pl. 54. See also Krahl, *Chinese Ceramics*, vol. 2, 521, no. 622.

110

Depiction of the Ka'ba, c. 1880s

Abd al-Ghaffar (The Netherlands, 1857–1936)
Albumen print, unmounted
7 7/8 x 9 3/4 in. (19.7 x 24.5 cm)
Getty Research Institute, Los Angeles (2008.R.3.4019)
Fig. 236

111

Pilgrims on Route to Mecca

Unidentified photographer, late 19th century
Albumen print, mounted on period card
8 x 10 7/8 in. (19.3 x 27.5 cm)
Getty Research Institute, Los Angeles (2008.R.3.4068)
Fig. 44

Fig. 235, cat. no. 109

112

The Hajj Departing from Damascus for Mecca

Félix Bonfils (France, 1831–1885)
Albumen print, mounted on period card
10 7/8 x 8 5/8 in. (27.4 x 21.9 cm)
Getty Research Institute, Los Angeles (2008.R.3.4067)
Fig. 237

Given the importance of the Ka'ba and the annual pilgrimage, or hajj, it is not surprising that the famous sanctuary and the ceremonials associated with the hajj were the frequent subjects of photography beginning around 1880.[1] Such photographs document the changing appearance of the sanctuary, including the cloth covering of the Ka'ba (see fig. 68, cat. no. 113), as well as the traditions associated with the pilgrimage. Mecca and Medina were and still are restricted to Muslims. Abd al-Ghaffar, also known as Christiaan Hurgronje, a Dutch scholar and convert to Islam, was the first European photographer to travel in Arabia. He had a special interest in Mecca, publishing two remarkable photographic albums of the city, including the Ka'ba, as here, as well as its people and pilgrims.[2] Félix Bonfils was a French photographer active in the Middle East whose 1878 collection of photographs, *Souvenirs d'Orient*, today provides an important link to buildings, events, and customs not otherwise visually documented.[3] His depiction here of the hajj departing from Damascus represents the caravan that originated in Istanbul, which the Ottomans, the guardians of the Holy Places, sent each year with charitable offerings (*surra*) for the residents of Mecca and Medina.[4] The tent-like structure in the two pilgrimage-related photographs is known as a *mahmal* (see Avinoam Shalem's "Offerings to the Ka'ba" in this volume); it was intended as a symbol for the absent caliph or sultan, a tradition abolished in modern times.[5] LK

1 The first such photographer appears to be Muhammad Sadic Pasha (1822–1902), who initially visited the Hijaz in 1861, when he photographed the mosque and tomb of the Prophet in Medina. See Khazindar, *Photographies anciennes de La Mecque*, 11–15.
2 Ibid., 15–18, 48–49.
3 On Bonfils and his family of photographers, see Gavin, *Image of the East*.
4 On this tradition, see Bayhan, ed., *Imperial Surre*. The *mahmal*, however, did not come from Istanbul; see Ghabban et al., *Roads of Arabia*, 530.
5 See A. E. Robinson, "Mahmal of the Moslem Pilgrimage," and Gaudefroy-Demombynes, "Le Voile de la Ka'ba," 11 and 16. Also see Ghabban et al., *Roads of Arabia*, 526–30.

Fig. 236, cat. no. 110

Fig. 237, cat. no. 112

250

113–15
Three Textiles from the Ka'ba

113
Section from the Belt of the Ka'ba
Egypt, Cairo, 19th century
Silver and silver-gilt wire on black silk with pale green silk appliqués
35 x 177 ¼ in. (88 x 501 cm)
Nasser D. Khalili Collection of Islamic Art, London
(TXT 251)
Fig. 68

114
Sitara for the Door of the Ka'ba
Egypt, Cairo, dated AH 1266/1849–50
Silver and silver-gilt wire on black silk, with red and green silk appliqués
Approx. 208 ¾ x 94 ½ in. (530 x 280 cm)
Nasser D. Khalili Collection of Islamic Art, London
(TXT 307)
Fig. 238

115
Sitara for the Internal Door of the Ka'ba (Bab al-Tawba)
Egypt, Cairo, dated AH 1314/1897–98
Silver and silver-gilt wire on black silk, with red and green silk appliqués
110 x 63 in. (270 x 152 cm)
Nasser D. Khalili Collection of Islamic Art, London
(TXT 264)
Fig. 69

Located in the center of the Great Mosque in Mecca, the cubical building known as the Ka'ba is the supreme symbol of Islam. It is toward the Ka'ba that Muslims direct their prayers, and it is the Ka'ba, and the circumambulation of which, that marks the beginning and the end of the pilgrimage, or hajj, to Mecca required of all Muslims (see fig. 236, cat. no. 110).[1] Because of its importance, the Ka'ba has been the recipient of innumerable precious gifts (see Avinoam Shalem's "Offerings to the Ka'ba" in this volume).

Perhaps the most famous gift is the embroidered veil, or kiswa, that drapes the Ka'ba and that caused medieval Muslim poets to liken the building to a bride. Supplying the kiswa was an honor, and rulers fought for the privilege. The great silk drape, formerly in many colors but in more recent times in black and embroidered with gold thread, is renewed annually at the time of the hajj, while the previous year's kiswa is taken down and divided into pieces that are given to the pious or sold as relics.

As is typical, these coverings for the Ka'ba—a section of the kiswa (its belt, or *hizam*) and the door curtains known as *sitaras*—are richly embroidered with verses from the Qur'an. They date to the nineteenth century and were fabricated in Cairo, which for many centuries supplied these cloths, transporting them to Mecca by a special caravan (fig. 44, cat. no. 111). The panel from the kiswa belt is inscribed with especially appropriate verses from the Qur'an, Al-'Imran (3:95–97), which mention "the first House" or the Ka'ba.[2] The two *sitaras* were made on behalf of the Ottoman sultans Abdülmecid I (r. 1839–61) and Abdülhamid II (r. 1876–1909), respectively. LK

1 For a general introduction to the history of Mecca and the hajj, with reference to the Ka'ba, see Peters, *Mecca*.
2 See Vernoit, *Occidentalism*, 27–33, and with specific regard to the belt and its inscriptions, 28–29.

116–17
Two Keys from the Ka'ba

116
Husayn
Egypt, dated AH 815/1412
Cast iron, inlaid with gold
8 ⅜ in. (21 cm)
Musée du Louvre, Paris, gift of J. Peytel, 1914 (OA 6738)
Fig. 65

117
Probably Mecca, c. 1340
Cast bronze, inlaid with silver
11 ¼ in. (28.5 cm)
Museum of Islamic Art, Doha (MW.473)
Fig. 67

So-called Ka'ba keys are rare and highly symbolic objects. They were sent as gifts to Mecca, probably for the accession of a new master of the Haramayn (the two holy places in Arabia), either a caliph or a sultan. All known examples were believed to have been taken to Istanbul by the Ottomans after they conquered the Holy City and are now kept in the Topkapi Palace Museum.[1] In addition to these two keys, only one other is so far known to be in another collection.[2] The key made on order of Sultan Faraj ibn Barquq is inlaid with gold and is inscribed with the titles of Faraj and those of his father (see also cat. no. 86).[3] The donation of this key could be related to the earlier restoration work on the haram (sanctuary or sacred precinct) of Mecca, completed on behalf of Faraj in 1404.

The second key, which lacks the terminal ring of the handle, is inlaid in silver and bears no mention of its dedicatee. A long inscription from the Qur'an (Al-'Imran, 3:96–7) is related to the "Holy Place" and to Abraham, recalling that the pilgrimage "to the House" is a duty.

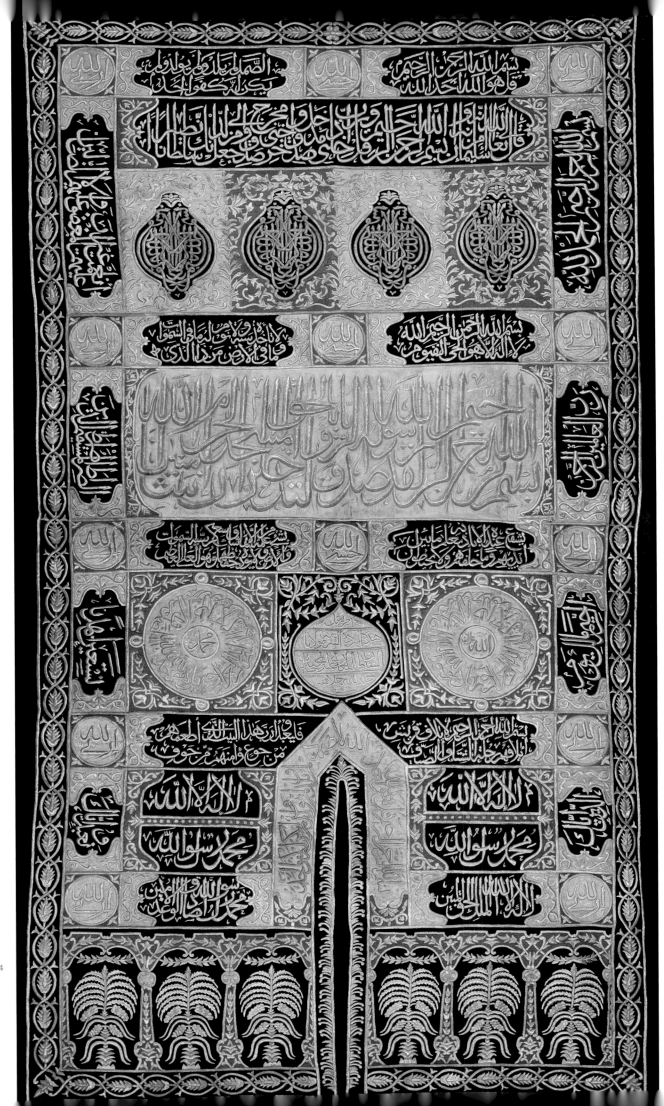

Fig. 238, cat. no. 114

Its mention of "the House" is a clear reference to the association of the keys with the door of "Bayt Allah," the Ka'ba.[4] As indicated in photographs, the external door was closed with a traditional lock (and key) until well into the twentieth century.[5] SM

1 See mainly Sourdel-Thomine, "Clefs et serrures."
2 In the Islamic Art Museum, Cairo; see O'Kane, *Treasures of Islamic Art*, 129.
3 Sourdel-Thomine, "Clefs et serrures," 73–74.
4 Allan, *Islamic Metalwork*, 94–95.
5 See Ghabban et al., *Roads of Arabia*, 536, for a 1937 photograph by Jack Philby (see the French version of the same catalogue, *Routes d'Arabie*, 564, cat. 313, for further reference to the Louvre key). See also Khazindar, *Photographies anciennes de La Mecque*, 92–93, for two images from 1947.

118
Sitara from the Tomb of the Prophet in Medina
Egypt, Cairo, 1808–39
Silver and silver-gilt wire on black silk, with red, pale turquoise, and cream silk appliqués
Approx. 110 1/4 x 63 in. (262 x 145 cm)
Nasser D. Khalili Collection of Islamic Art, London
(TXT 255)
Fig. 64

119
Candlestick
'Ali ibn 'Umar ibn Ibrahim al-Sunquri al-Mawsili
Probably Syria, AH 717/1317–18
Brass, inlaid with silver
18 x 14 1/2 in. (45.7 x 36.8 cm)
Benaki Museum, Athens (13038)
Los Angeles only
Fig. 62

120
Candlestick
Egypt, AH 887/1482–83
Brass
18 1/8 x 14 5/8 in. (46 x 37 cm)
Benaki Museum, Athens (13040)
Los Angeles only
Fig. 66

This *sitara*, or door covering, and the two candlesticks were gifts to the sanctuary in Medina, which marks the first mosque of Islam and the burial place of the Prophet Muhammad. The Prophet's emigration, or hijra, from Mecca to Medina in 622 inaugurated a new religion that was to spread far beyond Arabia and a new era, as it denotes the beginning of the Islamic calendar. For ten years, until his death in 632, the Prophet preached from his home in Medina, and it is here that he was interred. This site, the second holiest after the Ka'ba, was transformed over time into a shrine.[1] As such, the mosque and tomb of the Prophet was the recipient of many pious gifts.

According to the notation inscribed on its neck, the earlier of the two candlesticks was endowed to the sanctuary in 1374 by Mirza Aqa, a governor of Baghdad. As was often the case with such pious donations (e.g., cat. nos. 103–6, 108), this one was made earlier for another purpose and patron, as demonstrated by its inlaid inscriptions in the name of the eastern Anatolian ruler Shams al-Din Salih (r. 1312–64).[2] The second candlestick is one of five such recorded examples whose inscriptions indicate that they were made specifically for the shrine of the Prophet in 1482–83 on the order of the Mamluk sultan Qaytbay (r. 1468–96).[3] As at the Ka'ba (see cat. nos. 114–15), *sitaras* also were donated to the tomb of the Prophet; this colorful example was presented on behalf of the Ottoman sultan Mahmud II (r. 1808–39), indicated by his *tuğra*, or imperial monogram. LK

1 For a general summary of the history of this transformation, see Peters, *Mecca*, 101–5.
2 For further references, Mayer, *Islamic Metalworkers*, 38.
3 Wiet, *Catalogue Général du Musée Arabe du Caire*, 232–33, nos. 338–42; see also Atil, *Renaissance of Islam*, 100–101.

STATE AND DIPLOMATIC GIFTS

121
The Vizier Buzurgmihr Solves the Mystery of the Chess Game for Shah Khusraw Anushirvan
Folio from a manuscript of the *Shahnama*
Iran, Shiraz, c. 1550–60
Ink, colors, and gold on paper
11 1/8 x 9 7/8 in. (28.2 x 24.8 cm)
The David Collection, Copenhagen (450/1982)
Fig. 82

122
Chess Piece (Knight or Rook)
Egypt, 8th–9th century
Ivory
1 7/8 in. (4.6 cm)
The Metropolitan Museum of Art, New York, Rogers Fund and Mr. and Mrs. Jerome A. Straka Gift (1974.207)
Fig. 86

123–24
Two Chess Pieces

123
Egypt, 10th century
Rock crystal
1 7/8 x 1 3/8 in. (4.6 x 3.6 cm)
Museum für Islamische Kunst, Berlin (I. 4827)
Los Angeles only
Fig. 87

124

Egypt, 10th century
Rock crystal
1 1/4 x 1 in. (3.1 x 2.6 cm)
Museum für Islamische Kunst, Berlin (I. 1012)
Houston only
Fig. 87

According to the Persian poet Firdawsi in his great epic the *Shahnama*, and as depicted in this painting, the game of chess was introduced to Iran from India during the reign of Shah Khusraw Anushirvan (r. 531–78).[1] It was brought by an envoy who threatened that India would cease paying tribute unless the Iranians could figure out the riddle of the chessboard and its pieces. The shah's vizier, or minister, Buzurgmihr, recognized that chess (*shatrang*) was a game of war fought by symbolic armies. Buzurgmihr then invented the game of backgammon, or *nard*, as a reciprocal test of skill for the rajah of India. Our modern-day game of chess still bears the imprint of Iran; the Persian phrase *shah mat*—"the king is at a loss"—became "checkmate."

Both chess and backgammon boards survive mainly from the later Islamic period (see cat. nos. 125–26), although the related gaming pieces are preserved from an earlier date. These rock-crystal chess pieces likely belong to the type of set in which some of the pieces are represented by highly stylized figures such as the knight in the form of horse's head, or this ivory example of an armed horse and rider, while others, like the rock-crystal pieces, probably pawns, are even more abstract.[2] As in the literary account, actual chess and backgammon sets also seem to have been gift items.[3] LK

1 See Firdausi, *Shahnama of Firdausi*, vol. 7, 384 ff. See also Mackenzie and Finkel, eds., *Asian Games*, 136–67 (for chess) and 88–95 (for backgammon). For the relationship between the literary and historical record, see Daryaee, "Mind, Body and the Cosmos."
2 Contadini, "Islamic Ivory Chess Pieces." See also Mackenzie and Finkel, eds., *Asian Games*, 150–54.
3 For example, chess and backgammon pieces made of precious materials were among the items in the Fatimid treasury; see Qaddumi, trans., *Book of Gifts and Rarities*, 235–36; also, 180, for reference to a large pearl given by the caliph to a favorite that was cut in half by her for use in backgammon.

125

Chessboard

Egypt, 14th or 15th century
Wood inlaid with ebony and ivory
18 7/8 x 18 7/8 x 8 3/8 in. (47.9 x 47.9 x 21.3 cm)
Benaki Museum, Athens (10033)
Los Angeles only
Fig. 84

126

Games Board for Backgammon and Chess

Turkey, 1530–50
Wood inlaid with ebony, ivory, micromosaic, and silver
Closed: 18 x 13 1/2 x 2 1/8 in. (45.7 x 34.3 x 5.4 cm);
open: 18 1/4 x 26 3/4 x 1 in. (46.4 x 67.9 x 2.5 cm)
Los Angeles County Museum of Art, purchased with funds provided by Camilla Chandler Frost (M.2007.100)
Fig. 239

The game of chess is generally believed to have originated in India before 600 and to have reached Iran prior to the Islamic conquests beginning in 650; such a scenario is suggested by Persian literary works, most notably the *Shahnama* (Book of Kings; see fig. 82, cat. no. 121). Credit for the invention of backgammon, which predates chess, is accorded to Iran in the *Shahnama* although the historical record suggests it also went from India to Iran.[1] From Iran, both games seem to have spread along with the new Muslim faith to Syria, Egypt, North Africa, and Spain, as well as to the Byzantine Empire and Europe. Spectacular boards such as these, made with rare and costly materials, would have been suitable diplomatic gifts as described in the Book of Kings. There is evidence that elaborate chessboards and perhaps gaming pieces were presented as such gifts in later Islamic times, as for instance Iranian examples preserved in the Topkapi Palace.[2] LK

1 See Firdausi, *Shahnama of Firdausi*, vol. 7, 384 ff. See Daryaee, "Mind, Body and the Cosmos," 282. See also Mackenzie and Finkel, eds., *Asian Games*, 136–67 (for chess) and 88–95 (for backgammon).
2 For an eighteenth- or nineteenth-century Qajar chessboard, see Topkapi Palace Museum, *Ten Thousand Years of Iranian Civilization*, 322. Sixteenth-century gold and turquoise chess pieces were perhaps booty rather than gifts; see Köseoğlu, *Topkapi Saray Museum*, 207.

Fig. 239, cat. no. 126

127
Oliphant
Egypt, c. 1000
Ivory
Overall: 21 x 5 in. (53.3 x 12.7 cm)
Museum of Fine Arts, Boston, Frederick Brown Fund
and H. E. Bolles Fund (50.3426)
Fig. 88

Elephants circulated as prized gifts to and from Islamic
courts since at least the late eighth century, when Harun
al-Rashid sent an albino elephant to Charlemagne (see
fig. 3, cat. no. 223).[1] A complement to a living elephant was
a gift of ivory tusks. In 991, for example, a Berber prince
presented Hisham II, the caliph of Cordoba (r. 976–1009;
1010–1013), with "eight thousand pounds of weight of the
purest ivory" as well as several elephants.[2] Elephant tusks
were also carved into beautiful horns known as oliphants,
which circulated as gifts. This particular example is one of
eight oliphants made in Egypt with minimal decoration.[3]
KO

1 Shalem, *Oliphant*, 94–96, argues that the so-called "Charlemagne Oliphant"
preserved in the treasury of Aachen, which was presumed to have been a gift from
Harun al-Rashid to Charlemagne, actually dates to the late tenth or eleventh
century.
2 Ibid., 29–30.
3 Ibid., 64.

128
Bottle in the Form of a Lion
Egypt, 11th century
Rock crystal
1 7/8 x 2 3/8 in. (4.5 x 6 cm)
The British Museum, London (FB Is 12)
Fig. 83

129
Jug with Lid
Burgundy, first half of the 15th century
Rock crystal, with gold attachments
9 1/8 in. (23 cm)
Topkapi Saray Museum, Istanbul (2/471)
Los Angeles only
Fig. 240

Rock crystal is a type of transparent, colorless quartz whose
surface can be brilliantly burnished. A preferred luxury
material at the Islamic courts, it was used for a variety of
vessel types, which required enormous skill and time due
to the hardness of the stone.

There seems to have been a special taste for rock crystal
at the Fatimid court in Egypt as substantiated by numerous
textual references and by an even larger number of surviving
pieces including the one here (see also cat. nos. 123–24).[1]
Members of the 'Abbasid caliphate, which ruled from

Fig. 240, cat. no. 129

Baghdad, also appreciated this material, as is suggested
by the lavish gift of a silver-mounted jewel-encrusted rock-
crystal flask sent by the Byzantine emperor Romanos I
(r. 920–44) to the caliph al-Radi (r. 934–40). The cover of
the gifted flask, likewise in rock crystal, was said to be in
the form of a lion perhaps not unlike this example.[2]

To judge by the number of examples preserved today
in the Topkapi Museum, such as this one, the Ottoman
sultans would seem to have shared the royal taste for rock
crystal, especially when it was enhanced by gold fittings
and encrusted with gemstones. In the Topkapi's famous
treasury are rock crystals of Turkish, Indian, and European
workmanship; some of the vessels in the last category are
closely related to this less heavily embellished jug, which
was likely brought to the Ottoman court as a gift.[3] LK

1 See Bloom, *Arts of the City Victorious*, 101–4.
2 Qaddumi, trans., *Book of Gifts and Rarities*, 99.
3 Köseoğlu, *Topkapi Saray Museum*, nos. 49, 51–52, 54, 56, 59–60, and 66–67.

130
Ewer
'Ali ibn Husayn al-Mawsili
Egypt, Cairo, AH 674/1275–76
Brass, inlaid with silver
H. 19 5/8 in. (50 cm)
Musée du Louvre, Paris (Ucad 4412)
Los Angeles only
Fig. 11

The inscriptions on this vessel provide information about when, where, and for whom and by whom it was made.[1] Probably created as a matched pair with a basin and used for hand washing,[2] the ewer is signed by 'Ali ibn Husayn al-Mawsili, an artist linked to a school of metalwork active in northern Iraq.[3] Its inscriptions state, however, that it was produced in Cairo for a member of the Rasulid dynasty of Yemen, Sultan al-Muzaffar Yusuf (r. 1250–95), whose name and titles are inscribed around the shoulder. It belongs to a group of luxury metalwork, glass, and textiles made in Cairo for export to the Rasulid rulers probably as royal gifts from the Mamluk sultans.[4] LK

1 For the inscriptions, see Combe et al., eds., *Répertoire chronologique*, vol. 12, 203.
2 See Komaroff, "Sip, Dip, and Pour," 124–26.
3 On this school, see D. S. Rice, "Inlaid Brasses."
4 Porter, "Art of the Rasulids," 232–40, esp. 233.

131

"Barberini" Vase

Attributed to Da'ud ibn Salama
Syria, Damascus, c. 1250
Copper alloy, beaten and repoussé, chased and inlaid with silver
H. 16⅛ in. (40.9 cm); diam. 7 in. (17.5 cm)
Musée du Louvre, Paris (OA 4090)
Los Angeles only
Fig. 241

The Barberini vase is one of the masterpieces of thirteenth-century Syrian metalwork. Its form was almost unparalleled in its time.[1] It was ordered by the Ayyubid sultan Salah al-Din Yusuf (r. 1237–60 in Aleppo and Damascus), according to the inscriptions on the neck and lower-middle section. Along with a bowl also made for this same sultan,[2] the vase closely relates stylistically to a basin signed by Da'ud ibn Salama in AH 650/1252.[3] The vase was then probably made around 1250 by Da'ud ibn Salama and in Damascus. Under the base a later Arabic inscription reads, "ordered for the cellar of al-Malik al-Zahir," probably the Mamluk sultan Baybars (r. 1260–77); it was likely appropriated as booty during his conquest of Damascus in 1260, thereby illustrating one important means by which royal luxury goods changed hands.[4] SM

1 Bought from Braneri in Florence, 1899; its only counterpart seems to be an early Christian piece, the famous Emeses vase, also in the Louvre (Bj 1895).
2 Montréal, Museum of Fine Arts.
3 Musée du Louvre, on loan from Les Arts Décoratifs (n° 4411).
4 Booty, like tribute, may be just another word for "gift," depending on who is using the word—the victor or the vanquished.

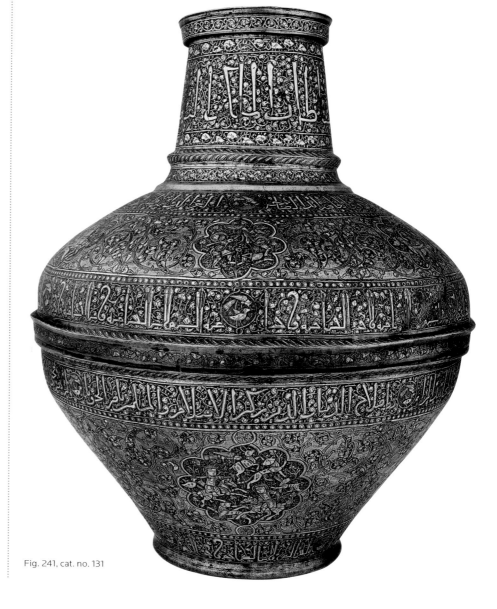

Fig. 241, cat. no. 131

132
Case for a Goa Stone
India, 17th century
Gold set with rubies and emeralds
4 1/8 x 3 in. (10.3 x 7.6 cm)
Topkapi Saray Museum, Istanbul (2/3669)
Los Angeles only
Fig. 242

133
Lidless Jar or Pot
India, 17th century
Nephrite (jade), set in gold mounts with rubies, pearls, emeralds, and turquoise
H. 4 3/8 in. (11 cm)
Topkapi Saray Museum, Istanbul (2/3796)
Los Angeles only
Fig. 164

The Ottomans shared with their Mughal counterparts in India a taste for extravagant, richly jewel-encrusted objects; indeed, in some cases, such as this jade jar, it is not always possible to distinguish the workmanship. While the jade itself was clearly carved in India, it is conceivable that the jewels, pearls, and turquoise in their heavy gold mounts were added later at the Ottoman court, in the eighteenth century. Both the jar and the spectacular gold case for a goa stone (a concoction of rare ingredients believed to detect, and to provide an antidote to, poison) were likely

diplomatic gifts from the Mughals to the Ottomans.[1] However, as high-quality objects suitable as gifts circulated widely at the Islamic courts, it is also possible that these pieces were among the loot that Nadir Shah confiscated from the Mughal royal treasury in Delhi, in 1739 (see fig. 206, cat. no. 28), and then gifted to the Ottomans (see Tim Stanley's essay in this volume). In 1747 the Ottomans had prepared a fantastic present for Nadir Shah, which included the famous Topkapi emerald-encrusted dagger. He was assassinated before he could receive the spectacular gift.[2] LK

1 Köseoğlu, *Topkapi Saray Museum*, 53, 198–99, 207. It has also been suggested that this object may have functioned as an incense burner. For a similarly shaped box but of rock crystal, see Keene and Kaoukji, *Treasury of the World*, 35.
2 Köseoğlu, *Topkapi Saray Museum*, 8, 27–29.

134
Ornaments for Bridle or Harness
Turkey, 13th century
Silver repoussé
Lion medallions, diam. 4 in. (10 cm)
The David Collection, Copenhagen (3/1976)
Fig. 91

135
Ornamented Bridle
Spain, Granada, 15th century
Gilt bronze, gold granulation, and cloisonné enamel
Brow band: 8 3/8 in. (21 cm); each rosette: 3 1/2 in. (8.8 cm); headstall: 1 1/2 in. (3.8 cm)
The British Museum, London (1890,1004.1)
Fig. 92

Horses were an especially common and consistent form of gift at the Islamic courts and beyond. Textual accounts widely separated in time and place suggest that fancy horse trappings made of precious materials were often an integral part of the gift. For example, an account from 1069 on the holdings of the Fatimid treasury in Cairo mentioning elaborate equine equipment, including a saddle said to have belonged to Alexander the Great, noted that "the bridle had, instead of iron, gold set with jasper, and the thongs were Sudanese leather of the best quality. On it was an inscription from al-Mu'izz-li-dinillah [Fatimid caliph r. 953–75]: 'The ruler of Byzantium gave us this saddle and bridle after we entered Egypt.'"[1]

Each of these sets of horse fittings would have been worthy royal gifts. The silver bridle or harness ornaments, which were originally attached to leather straps, belong to the period of Saljuq rule in Turkey. It is unclear precisely how these decorative elements, including medallions embellished with lions, were used, but it seems likely that the long, slightly tapered segment may have been worn on the horse's head or breast.[2] From the Nasirid period in Spain,

the gold and cloisonné enamel-decorated ornaments once were fitted to a magnificent bridle.[3] A closely related type of bridle is depicted on a horse with Moorish warrior in a painting by the Venetian artist Vincenzo Catena.[4]　LK

1 Ibn al-Zubayr, *Kitab al-dhakha'ir*, ed. Muhammad Hamidullah, sec. 98; I am grateful to Wheeler Thackston for this translation.
2 Alexander, ed., *Furusiyya*, vol. 2, 163.
3 Ibid., 164.
4 Ibid. For the painting *A Warrior Adoring the Infant Christ and the Virgin*, after 1520, in the National Gallery, London, see http://www.nationalgallery.org.uk/paintings/vincenzo-catena-a-warrior-adoring-the-infant-christ-and-the-virgin.

136
Saddlecloth
Turkey, Bursa, 16th–17th century
Velvet embroidered with metallic threads
73 3/8 x 51 in. (186.5 x 129.5 cm)
Benaki Museum, Athens (3784)
Los Angeles only
Fig. 23

137
Bridle
Turkey, first third of the 17th century
Gold, silver, iron, precious stones, glass, and leather
Length of straps: 2 in. (5 cm)
The State Historical-Cultural Museum Preserve, Moscow Kremlin (K-420)
Los Angeles only
Fig. 94

138
Chest Straps
Turkey, first third of the 17th century
Gold, silver, iron, precious stones, and leather
Length of straps: 2 3/4 in. (6 cm)
The State Historical-Cultural Museum Preserve, Moscow Kremlin (K-225)
Los Angeles only
Fig. 93

139
Saddle
Turkey, Istanbul, mid-17th century
Gold, gilded thread, rubies, emeralds, pearls, wood, leather, cut velvet, and braid; chasing, embroidery, and weaving
H. (of front pommel) 13 3/4 in. (34 cm), (of rear pommel) 7 1/2 in. (19 cm); l. 15 3/4 in. (40 cm)
The State Historical-Cultural Museum Preserve, Moscow Kremlin (K-231)
Los Angeles only
Fig. 96

140
Pair of Stirrups
Turkey, mid-17th century
Gold, rubies, emeralds, iron, velvet, and gold thread
H. 6 3/4 in. (17 cm); wt.: 3,447.5 g
The State Historical-Cultural Museum Preserve, Moscow Kremlin (K-216/1–2)
Los Angeles only
Fig. 95

As in earlier periods and at other Islamic courts (see figs. 91–92, cat. nos. 134–35), elaborately embellished horse trappings were made for the imperial use of the Ottoman sultans, who also presented them as royal gifts. Such items are listed in the inventories of the treasury at the Topkapi Palace, while another account referencing objects from the treasury included a detailed compilation of gifts for Nadir Shah (r. 1736–47) of Iran, which never reached him because he was assassinated before their delivery. Among the intended gifts were richly bejeweled equine equipment such as a saddle of crimson velvet, stirrups, trappings for bridle and harness, and a velvet saddlecloth embroidered with silver- and gold-wrapped thread.[1]

These listed items, perhaps made long before the ill-fated gift, are strikingly similar to those shown here, which, with the exception of the saddlecloth, were presented by the Ottomans to the Russian court during the reigns of Mikhail Fedorovich (r. 1613–45) and Alexei Mikhailovich (r. 1645–76).[2] These types of spectacular trappings were appreciated and used not only by the Ottoman sultans, whose horses were paraded in jeweled splendor, but by their tsarist recipients. This is indicated by the fact that the bridle was subsequently fitted with a gilded-silver frontlet bearing the Russian coat of arms (the double-headed eagle) and the stirrups were later paired with a Russian-made saddle according to a Kremlin inventory of 1706.[3] The stunning velvet saddlecloth, whose specific shape indicates it was made to fit around the horse's neck, never seems to have been used for this purpose. Probably a presentation piece, it may have been prized more for its beauty.[4]　LK with OBM

1 Köseoğlu, *Topkapi Saray Museum*, 21–29, esp. 28–29.
2 See Arthur M. Sackler Gallery, Smithsonian Institution, *Tsars and the East*, 82, 84. The horse trappings were presented to Tsar Mikhail Fedorovich on September 28, 1634, by the merchant Ivan Manulov, who arrived as part of the Turkish mission of Sultan Murad IV (r. 1623–40).
3 Ibid., 82. On gift horses, trappings, and their public display, see Cutler, "Significant Gifts," 93.
4 See Ballian, "Ottoman Silks and Velvets," 80–81. See also O'Kane, ed., *Treasures of Islamic Art*, 244, for a closely related saddlecloth, where the fabric was cut to shape before use.

141
Dagger and Sheath
Iran, first half of the 17th century
Steel, wood, gold, rubies, turquoise, and pearls
Overall: 12⅛ in. (30.8 cm); blade: 6⅝ in. (16.8 cm);
sheath: 7⅜ in. (18.5 cm)
The State Historical-Cultural Museum Preserve, Moscow
Kremlin (OR-208/1–2)
Los Angeles only
Fig. 116

142
Horse Caparison
Iran, 17th century, and Turkey, 17th century
Silk, voided velvet with metallic thread ground; framed
by silk brocade with gilt-metal thread
38⅝ x 42½ in. (98 x 108 cm)
The State Historical-Cultural Museum Preserve, Moscow
Kremlin (TK-2199)
Los Angeles only
Fig. 118

Each of these objects befits its royal recipient. Daggers
were a common type of gift exchanged within the Islamic
world (for example, see cat. nos. 69–70) but would equally
suit a Russian potentate who might wear such a jeweled
weapon as part of his military or parade dress.[1] This dagger
was presented to Tsar Mikhail Fedorovich (r. 1613–45)
in 1617 by an Iranian merchant named Muhammad Qasim,
perhaps as part of the burgeoning and, to judge by the
quality of the gift, lucrative trade connections between
Russia and Iran, which began during the reign of Shah
'Abbas I (r. 1585–1629).[2] The sumptuous caparison is actually
composed of two distinct types of fabric: the main part,
on yellow ground, is Iranian, while the crimson-and-gold
border is of Turkish origin. The silks would have been
joined together in Moscow in the Kremlin workshops; the
central panel was presented to Mikhail Fedorovich in 1629
by the Iranian ambassador.[3] LK with EAY

1 Shifman and Walton, eds., *Gifts to the Tsars*, 46. See also Arthur M. Sackler
Gallery, Smithsonian Institution, *Tsars and the East*, 46.
2 See Ferrier, "Trade from the Mid-14th Century to the End of the Safavid Period,"
472–74. See also Matthee, "Suspicion, Fear, and Admiration," 130–33.
3 Vishnevskaia et al., *Treasures of the Armoury*, 230–31; see also Atasoy et al.,
Ipek, 245. Also see Arthur M. Sackler Gallery, Smithsonian Institution, *Tsars and
the East*, 38, for a related horse blanket made from two imported luxury fabrics.

143–47
Five Folios from the *Shahnama* (Book of Kings) of Shah Tahmasp
Iran, Tabriz, 1525–35
Ink, opaque watercolor, and gold on paper

143
Nushirvan Receives an Embassy from the Khaqan
18⅝ x 12⅝ in. (47.3 x 32.2 cm)
Los Angeles County Museum of Art (M.89.55, fol. 629a)
Fig. 90

144
Sindukht Comes to Sam Bearing Gifts
18⅜ x 12⅜ in. (46.5 x 31.2 cm)
Aga Khan Museum Collection, Geneva (AKM00496, fol. 84b)
Fig. 5

145
Afrasiyab on the Iranian Throne
18⅝ x 12½ in. (47.3 x 31.8 cm)
The Metropolitan Museum of Art, New York (1970.301.16,
fol. 105a)
Fig. 26

146
The Marriage of Sudaba and Kay Kavus
18⅝ x 12½ in. (47.3 x 31.8 cm)
The Metropolitan Museum of Art, New York (1970.301.20,
fol. 130a)
Fig. 138

147
Bahram Recovers the Crown of Rivniz
18⅝ x 12½ in. (47.3 x 31.8 cm)
The Metropolitan Museum of Art, New York (1970.301.38,
fol. 245a)
Fig. 139

These paintings come from the most profusely illustrated
and one of the most beautiful versions of the Iranian
national epic—the *Shahnama* (Book of Kings). Produced
for the second Safavid shah, Tahmasp (r. 1524–76), at his
capital, Tabriz, in the 1520s and 1530s, the manuscript
was broken up in America in 1970 for the sake of its paint-
ings. Fit for a king, this *Shahnama* was sent as a gift from
Shah Tahmasp to the Ottoman sultan Selim II (r. 1566–74)
in 1567 to mark his accession to the throne. This presenta-
tion was recorded in a well-known double-page painting
illustrating a history of Selim's reign (see fig. 6 and Linda
Komaroff's essay in this volume). This remarkable work
seems to have spent much of the intervening period in the
Ottoman royal library in Istanbul, although its 258 paint-
ings are today dispersed throughout the world.[1]

The text includes innumerable references to royal largesse, which could be used both to anger and to please, as well as passages giving long lists of gifts from one ruler to another.[2] Among its many illustrations, the Tahmasp *Shahnama* also presents a number of depictions of gift giving, such as here (cat. no. 144), from the romance of Zal and Rudaba; the latter's mother, Sindukht, brings gifts to Zal's father, Sam, in order to facilitate the marriage of these star-crossed lovers. The procession of gifts extended two miles in length and comprised horses caparisoned in silver, gold cups filled with musk and camphor, and all manner of jewelry, some of which is depicted in the painting, which includes as well the giant elephants that transported the treasures.[3] LK

1 For a brief summary on this important manuscript in the context of early Safavid book art, see Thompson and Canby, eds., *Hunt for Paradise*, 80–84.
2 See "Gift Giving 1," *Encyclopaedia Iranica*, vol. 10, 606. See, for example, Firdausi, *Shahnama of Firdausi*, vol. 6, 175–76, for gifts exchanged between Sikander and the king of Yemen, and vol. 8, 306–8, for a list of lavish gifts from the Byzantine "Caesar" to Khusraw Parviz.
3 See Firdausi, *Shahnama of Firdausi*, vol. 1, 301–2.

148
Part Nine of a Multivolume Manuscript of the Qur'an

Abbasid caliphate, 9th–10th century
Ink, colors, and gold on parchment
Folio: 12¼ x 8 in. (31 x 21 cm)
Private collection
Fig. 7

Among the gifts that Shah Tahmasp sent to Sultan Selim II in 1567, in addition to the famous *Shahnama* (cat. nos. 143–47), was a manuscript of the Qur'an (see Linda Komaroff's essay in this volume). One of the lists compiled at the time of the presentation described it as being allegedly by the hand of 'Ali, son-in-law and cousin of the Prophet Muhammad, to whom all Muslim calligraphers trace their lineage.[1] Certain folios from this manuscript provide evidence that has suggested to some that it is the gifted Qur'an: the illuminated opening folio bears an Ottoman tuğra, demonstrating its presence in the empire;[2] on the final two pages, a pair of inscribed lozenges, which were added some time after the manuscript was made, indicate that "'Ali wrote [it]"; and it had been rebound in Iran.[3] LK

1 Hammer-Purgstall, *Geschichte der osmanischen Dichtkunst*, vol. 3, 517–22, cited in Dickson and Welch, *Houghton Shahnameh*, vol. 1, 270–71. But see also Çağman and Tanındı, *Topkapi Saray Museum*, 211–12.
2 The device is not an imperial tuğra but is rather a pençe, a symbol associated with high-level Ottoman bureaucrats. We are grateful to Lale Uluç for providing this information.
3 The Safavid-era binding is in accord with the proposed date of the gift. Christie's, "Islamic Art, Indian Miniatures, Rugs and Carpets," lot 232, 94–97, although the text indicates it had a jeweled binding. See also Soudavar, "Early Safavids and Their Cultural Interactions," 111. We are grateful to Abolala Soudavar for bringing this manuscript to our attention.

149–50
Two Folios from a Dispersed Manuscript of the *Shahnama*

149
The Battle between Bahram Chubina and Sava Shah

150
Rustam Shoots Isfandiyar in the Eye

Iran, Shiraz, c. 1560
Ink, opaque watercolor, and gold on paper
16⅝ x 10⅝ in. (42.4 x 26.9 cm)
Los Angeles County Museum of Art, purchased with funds provided by Camilla Chandler Frost and Karl H. Loring, with additional funds provided by the Art Museum Council through the 2009 Collectors Committee (M.2009.44.1; M.2009.44.4)
Figs. 130–31

Painted in brilliant colors, these pages once illustrated a manuscript of the Iranian national epic—the *Shahnama* (Book of Kings). Completed in the year 1010 by the poet Firdawsi, it comprises over 50,000 couplets, which tell of the pre-Islamic kings and heroes of Iran. These two battle scenes of epic proportions, filled with minute detail, demonstrate an essential characteristic of Persian manuscript painting in which figural compositions and landscape elements can be repeated and recombined but with a subtly altered palette, creating anew each time a unique work of art. The repetition of compositions also would have speeded up the process of illustrating so lengthy a text, which would have been welcomed and even a necessity at the painting ateliers of Shiraz, in southern Iran, where these paintings were made.

In the second half of the sixteenth century especially, Shiraz was an important and highly prolific center for the production of large-format luxury manuscripts. In fact, there is evidence to suggest that Shiraz was a major supplier of deluxe books for Turkey, where such Persian texts were greatly appreciated as diplomatic presentations from the Safavid court and as personal gifts between members of the Ottoman elite.[1] These pages demonstrate one type of Persian painting that circulated widely, though not exclusively, at the Ottoman court as part of the complex network of gift exchange (see Lale Uluç's text in this volume; see also cat. nos. 143–47).[2] LK

1 See the important study by Uluç, *Turkman Governors, Shiraz Artisans and Ottoman Collectors*, esp. 469–505.
2 Shirazi manuscripts of the *Shahnama* also seem to have been presented as gifts at the Mughal court; see Stanley, "Kevorkian-Krauss-Khalili *Shahnama*," 87.

Fig. 243, cat. no. 151

151
Manuscript of the Qur'an
Iran, Shiraz, third quarter of the 16th century
Ink, colors, and gold on paper
14 x 9 x 2 in. (35.5 x 22.8 x 5.1 cm)
Los Angeles County Museum of Art, the Edwin Binney
3rd Collection of Turkish Art (M. 85.237.19)
Fig. 243

152
Illuminated Facing Pages from a Dispersed Manuscript of the Qur'an
Iran, Shiraz, third quarter of the 16th century
Ink, colors, and gold on paper
19 ¼ x 12 in. (48.9 x 30.5 cm)
Los Angeles County Museum of Art (AC1999.158.1
and M.2010.54.1)
Fig. 129

Literary works of the great Persian poets were not the only types of deluxe codices copied at Shiraz in the latter half of the sixteenth century and that found their way to the Ottoman Empire (see cat. nos. 149–50). Manuscripts of the Qur'an produced in Shiraz, including richly illuminated examples, likewise must have arrived at the court as diplomatic gifts (see Lale Uluç's text in this volume).[1] Such was likely the case with this manuscript of the Qur'an. According to the notation at the end of the text, part of which is a replacement for the original, perhaps contemporaneous with the eighteenth-century Ottoman binding, Sultan Selim II (r. 1566–74) endowed the Qur'an in Edirne, presumably for the magnificent mosque complex he built there in 1568–74.[2]

The pair of facing pages from a dispersed manuscript, which is from the end of the text and includes within decorative frames the *du'a-yi khatm*, a prayer said at the conclusion of a reading of the Qur'an, epitomizes the Shiraz style of illumination in terms of its colorful exuberance. These pages serve here as an exemplar of the types of Qur'ans that were exported from Safavid Iran to Ottoman Turkey as gifts or were converted into pious gifts. LK

1 Uluç, *Turkman Governors, Shiraz Artisans and Ottoman Collectors*, 338 ff. Manuscripts of the Qur'an were certainly included as diplomatic gifts; see cat. no. 148.
2 We are grateful to Tim Stanley for this revised reading, which supersedes the one in Binney, *Turkish Treasures*, 29.

153
Textile Depicting Layla and Majnun
Iran, late 16th–early 17th century
Silk lampas with satin ground and twill details, metal thread
28 ¾ x 27 ¼ in. (73 x 69 cm)
Danish Museum of Art and Design, Copenhagen (B21/1931)
Fig. 114

Ghiyath al-Din Naqshband, a court artist of Shah 'Abbas I (r. 1585–1629), is a rare figure on several counts. Not only is he one of the few artists associated with the production of textiles whose signed work survives, as here (on the howdah carried by the camel), but his fame as both a textile designer and a poet was such that he is mentioned in a number of Persian chronicles, including a history of the Mughal emperor Akbar.[1] According to this account, a 1598 embassy from the Iranian shah to the emperor brought with it many splendid gifts, among them fifty masterpieces by Ghiyath al-Din.[2] LK

1 Skelton, "Ghiyath al-Din."
2 Ibid., 251, from Abu'l-Fazl, *Akbarnama*, vol. 3, 745; see translations by Beveridge, vol. 3, 1112–13, and Thackston, vol. 3, 607.

154
Carpet
Iran, Isfahan, early 17th century
Silk pile, silver, and silver-gilt thread
82 ⅜ x 55 ⅛ in. (209 x 140 cm)
Museu Calouste Gulbenkian, Lisbon (T. 71)
Fig. 119

Silk carpets woven with metallic threads were often presented by Safavid shahs to European potentates and religious dignitaries. As a result, carpets of this type are variously known as "presentation" or "Polonaise" carpets, the latter because some include Polish coats of arms. Since many of these carpets were diplomatic gifts to western courts, the majority of extant examples are preserved in European collections.[1] This carpet is similar in style to one that was given by Shah 'Abbas to the doge of Venice in 1603.[2] An oil painting in the doge's palace shows him welcoming Shah 'Abbas's ambassadors while his pages remove a textile from a chest.[3] KO

1 See, for example, Thompson, *Milestones in the History of Carpets*, 198–99.
2 Carboni, ed., *Venice and the Islamic World*, 324.
3 Canby, *Shah 'Abbas*, fig. 8.

155
Dark Green Caftan

Iran, 16th century
Velvet, silver-thread embroidery
L. 56 in. (142 cm)
Topkapi Saray Museum, Istanbul (13/2088-35/465)
Los Angeles only
Fig. 134

This luxurious dark green velvet robe, decorated with elaborate borders worked in silver-wrapped thread, has at the back an embroidered appliqué medallion depicting a Safavid notable, recognizable by his distinctive turban. The fine quality of the metallic embroidery indicates its suitability as a royal gift and the lofty status of its intended recipient. In fact, the robe is recorded as having been presented by Shah Muhammad Khudabanda (r. 1578–88) to the Ottoman sultan Murad III (r. 1574–95) in 1583.[1] To judge by extant court-quality caftans whose fabrics, among other things, exclude figural representation, this Iranian robe might not have been in accord with Ottoman taste, accounting in part for its state of preservation. LK

1 P. Baker, *Islamic Textiles*, 113; we are indebted to the late Patricia Baker for sharing information about this robe. See also Aga-Oglu, *Safawid Rugs and Textiles*, 17–18.

156
Textile with Design of Wine Bearer in Landscape

Iran, 16th century
Silk complex supplementary weft patterning (lampas)
33 x 28 in. (83.8 x 71.1 cm)
Los Angeles County Museum of Art (M.66.74.1)
Fig. 244

This textile fragment is one of several pieces of the same cloth, which once formed part of a garment, probably a robe.[1] Silk robes decorated with scenes of fashionably dressed young courtiers were part of the sartorial splendor of the Safavid elite. At Nawruz (New Year), honorific robes (khila') were awarded by the shah to members of his court, while they were also presented to foreign delegations. Satins and other quality silks, as here, were intended for lower-ranking officials; the highest dignitaries received garments of cloth woven with gold- or silver-wrapped thread (see cat. no. 155).[2] LK

1 Bier, ed., *Woven from the Soul*, 138.
2 P. Baker, *Islamic Textiles*, 112–13. See also P. Baker, "Wrought of Gold or Silver."

Opposite: Fig. 244, cat. no. 156

157–58
Two Prayer Carpets

157

Iran, 16th century
Wool and silk
64⅝ x 45⅜ in. (164 x 115 cm)
Topkapi Saray Museum, Istanbul (13/2040)
Los Angeles only
Fig. 42

158

Turkey, probably Bursa, late 16th century
Wool, cotton, and silk
67⅝ x 49¼ in. (172 x 125 cm)
The al-Sabah Collection, Dar al-Athar al-Islamiyyah, Kuwait (LNS 29 R)
Fig. 245

Prayer carpets, as the name implies, are intended for the act of worship, which in Islam requires that the believer recite pious phrases while prostrating himself or herself in the direction of Mecca, five times a day. Because this ritual involves touching the head to the ground, and since all daily prayers, except on Friday at noon, may be said in private, carpets provide a clean and personal space for worship. Prayer carpets are recognizable by a distinctive design element—an archlike shape that emulates the mihrab, an architectural element in mosques and related buildings indicating the direction of prayer (see fig. 46).

Although clearly of religious intent, carpets such as these could serve as state or diplomatic gifts. The Iranian example is one of a group of related prayer rugs in the Topkapi Palace that most likely arrived as gifts;[1] indeed, rolled carpets are depicted in a well-known manuscript illustration pertaining to the presentation of gifts by the Safavid ambassador to the Ottoman sultan (see Linda Komaroff's essay in this volume, fig. 6), while accounts of that same embassy refer to large carpets (see Tim Stanley's essay in this volume).[2] Ottoman carpets of various types also were exported as diplomatic gifts as well as trade items within and beyond the Islamic world.[3] While the Safavid carpet carries inscriptions quoting verses from the Qur'an, including *Surat al-Nur* (24:35), the Ottoman one visualizes the same message, which likens the Light of God to the light of a lamp hanging in a niche. LK

1 Topkapi Palace Museum, *Ten Thousand Years of Iranian Civilization*, 316. See also Franses, "Some Wool Pile Persian-Design Niche Rugs," esp. 46–47 and cat. no. 45.
2 Çağman and Tanındı, *Topkapi Saray Museum*, 211–22. See Rogers, "Europe and the Ottoman Arts," 723–24, for references to Persian carpets at the Ottoman court in the sixteenth century.
3 Carboni, ed., *Venice and the Islamic World*, 178, and cat. 85 for a small prayer carpet; see also Alexander, *From the Medicis to the Savoias*, 153, for an Ottoman silk prayer rug in the Pitti Palace, Florence, perhaps a diplomatic gift. See also Rogers, "Europe and the Ottoman Arts," 714–29.

Fig. 245, cat. no. 158

159
Mosque Lamp

Egypt or Syria, c. 1354–61
Enameled and gilded glass
H. 15 in. (38 cm); diam. 11⅞ in. (30 cm); base: diam. 5⅜ in.
(13.5 cm)
Museu Calouste Gulbenkian, Lisbon (1022)
Fig. 54

Enameled glassware from the Mamluk period in Syria and
Egypt (1250–1517) found its way to Europe as early as the
fourteenth century. However, many of these objects, perhaps
including this lamp, which is likely from the Sultan Hasan
Complex (1357–64), were removed from the religious insti-
tutions of Cairo in the mid-nineteenth century when there
was a veritable explosion in popular taste for such glass-
ware in Europe.[1] This lamp is reputed to have been a state
gift from Khedive Isma'il (r. 1863–79) to Leopold II, king
of Belgium (r. 1865–1909), on the occasion of the inaugura-
tion of the Suez Canal in 1869.[2]　LK

1 See Vernoit, "Islamic Gilded and Enamelled Glass," 110–15.
2 Hallett and Ribeiro, *Mamluk Glass in the Calouste Gulbenkian Museum*, no. 7.
Interestingly, in that same year the Khedive commissioned in Venice a group
of glass lamps made in the Mamluk style; see Vernoit, "Islamic Gilded and
Enamelled Glass," 111.

160
Mosque Lamp

Italy, Venice, 16th century
Glass, gilded
H. 11 in. (28 cm); diam. 8 in. (20 cm)
Topkapi Saray Museum, Istanbul (34/468)
Fig. 143

Venice, as the capital of a trading empire, became Europe's
most important link to several Muslim empires by the
fifteenth century. Venetians gained this trading advantage
in part due to their diplomatic efforts, which included
elaborate rituals of gift giving. Gifts were vital in ensuring
that Islamic courts, such as the Ottoman one, remained
positively inclined to Venice.[1]

One popular item of export was glass lamps, such as
the one here. The Ottoman vizier Mehmet Sokollu Pasha,
for example, requested three hundred lamps in 1569.
Although made in Venice, these lamps followed the Islamic
model of a mosque lamp with a tapered foot, a globular
vase, and a splayed or flaring neck.[2]　SW

1 Raby, "Serenissima and the Sublime Porte," 101.
2 Carboni, ed., *Venice and the Islamic World*, 344. See also Rogers, "Europe and
the Ottoman Arts," 711–12.

Fig. 246, cat. no. 161

161
Throne of Shah 'Abbas
Folio in *Detailed Description of the Coronation of...Empress Elizabeth Petrovna*
St. Petersburg, 1744
Engraving
18 1/4 x 12 x 1 3/4 in. (46.4 x 30.5 x 4.4 cm)
Rare Book Division, the New York Public Library, Astor, Lenox and Tilden Foundations
Fig. 246

162
Throne of Shah 'Abbas
Folio from the *Drevnosti rossiiskago gosudarstva*
Fedor Grigor'evich Solntsev (1801–1892)
Russia, published 1849–53
Chromolithograph
19 7/8 x 14 in. (50.5 x 35.6 cm)
Rare Book Division, the New York Public Library, Astor, Lenox and Tilden Foundations
Fig. 182

These two illustrations depict arguably the best-known and most luxurious gift presented by an Iranian shah to a Russian tsar: the throne given by Shah 'Abbas (r. 1587–1629) to Boris Godunov (r. 1598–1605) in 1604.[1] The throne's wood frame is covered in gold sheeting inlaid with turquoise, rubies, and pearls and upholstered with a French velvet dating to the eighteenth century. The fact that this gift stimulated the creation of two such "portraits" (see Keelan Overton's text in this volume) over the course of a century underscores its status as a cherished diplomatic gift.

The engraving is part of an album prepared for the coronation of the Russian empress Elizabeth (r. 1742–62), which took place on April 25, 1742.[2] The chromolithograph is one of many comparable images of Islamic gifts in a six-volume publication documenting the collection of the Kremlin Armoury (figs. 183–86, 275, cat. nos. 249–53). The caption at the bottom of the print reads, "Royal golden throne, sent as a present from Persian Shah 'Abbas." KO

1 Shifman and Walton, eds., *Gifts to the Tsars*, 76.
2 Whittaker et al., *Russia Engages the World*, 147.

163
Shield

Iran, first half of the 17th century
Leather, gold, pearls, emeralds, rubies, turquoise, and gold plate with engraved work
Diam. 22 in. (55.5 cm)
The State Historical-Cultural Museum Preserve, Moscow Kremlin (OR-169)
Los Angeles only
Fig. 115

164
Mace

Iran, mid-17th century
Gold, turquoise, and wood
L. 20⅜ in. (51.7 cm)
The State Historical-Cultural Museum Preserve, Moscow Kremlin (OR-187)
Los Angeles only
Fig. 117

Although the use of precious materials suggests that these two spectacular objects were made for ceremonial purpose rather than for war, in each instance the specific form follows a bellicose function. The typical mace was an offensive weapon, used to club and bludgeon, as indicated by the flanges of the head, which, while made of pure gold, is still rather hefty.[1] Intended for defensive purposes, the shield's wide black buffalo-hide covering provides a perfect foil for the jeweled medallion at its center.[2]

Both these objects were gifts to the Russian court from Shah 'Abbas II (r. 1642–66): the mace arrived in 1658 with a diplomatic mission to Tsar Alexei Mikhailovich (r. 1645–76);[3] the shield accompanied an embassy more than a decade earlier, between 1641 and 1643, when Alexei was still a prince and his father, Mikhail Fedorovich (r. 1613–45), was tsar. The recording of the shield's entry into the Kremlin Armoury Treasury, in 1644–45, refers to it as "single-horned," probably a reference to its hide covering, which may have to do with the belief that it was made from some fantastical animal.[4] An explanation is perhaps to be found in the caption of the chromolithograph depicting this shield in the nineteenth-century album *Drevnosti rossiiskago gosudarstva* (Antiquities of the Russian State), which refers to it as "unicorn skin" (see fig. 275, cat. no. 249). LK, OBM, and EAY

1 See Shifman and Walton, eds., *Gifts to the Tsars*, 199.
2 Ibid., 198.
3 The mace was officially presented on February 3 by Khan Daqun Sultan during a solemn reception of the mission at the Faceted Palace of the Moscow Kremlin.
4 Shifman and Walton, eds., *Gifts to the Tsars*, 198.

165
Shah 'Abbas II Receiving the Mughal Ambassador

Iran, c. 1663
Opaque watercolor and gold on paper, pasted on blue cardboard
20 x 31⅜ cm (7.9 x 12.4 in)
Aga Khan Museum Collection, Geneva (AKM00110)
Fig. 128

The most renowned images of Safavid diplomacy are the mid-seventeenth-century wall paintings in the Chehel Sutun in Isfahan. These paintings depict the Safavid ruler sitting across from a visiting dignitary, the two surrounded by musicians, dancing women, and abundant trays of food.[1] The conviviality of these banquet scenes contrasts with the formality and hierarchy of contemporary Mughal images, in which the envoy stands far below the deified emperor (see Keelan Overton's text in this volume and fig. 1). The composition of this painting is indebted to the Chehel Sutun precedents. In this instance, Shah 'Abbas II (r. 1642–66) faces an Indian ambassador who may be Mughal or Deccani.[2] KO

1 Canby, *Shah 'Abbas*, fig. 7.
2 Aga Khan Trust for Culture, *Spirit & Life*, 102.

166
Portrait of a Turkish Ambassador Holding a Pouch

India, 1650–55
Ink and opaque watercolor on paper
9⅛ x 4⅜ in. (23 x 11 cm)
The David Collection, Copenhagen (49/1992)
Fig. 247

Mughal artists were highly skilled at portraiture and in depicting their subject's garments and accoutrements. Such is the case here, in a painting of an Ottoman ambassador who holds a pouch that likely contains a document from the Mughal emperor to be delivered to the sultan in Istanbul.[1] This individual may be one of the two Ottoman emissaries who visited Shah Jahan (r. 1628–58) at Shahjahanabad (at Delhi). The style of his headdress, green caftan, and overcoat lined and trimmed with fur all correlate with contemporary Ottoman fashions.[2] The incorporation of the carefully delineated pouch decorated with flowers on a gold ground demonstrates the artist's close attention to detail (see cat. nos. 167–68).[3] SW

1 Folsach, *For the Privileged Few*, 152–53.
2 Ibid.
3 Folsach and Bernsted, *Woven Treasures*, 40–41.

167
Diplomatic Pouch
Iran, Yazd, early 17th century
Silk velvet, metal-strip ground
H. 26¾ in. (68 cm)
Danish Museum of Art and Design, Copenhagen (D1227)
Fig. 112

168
Diplomatic Pouch (?)
Iran, late 17th–early 18th century
Cotton brocade
27⅝ x 9⅜ in. (70 x 24 cm)
The State Historical-Cultural Museum Preserve, Moscow Kremlin (TK-2222)
Los Angeles only
Fig. 120

During the seventeenth century, Persian silk was presented to European ambassadors, rulers, and religious dignitaries in a variety of forms, including robes, carpets, and bolts of fabric. In 1603, for example, Shah 'Abbas gave the doge of Venice a so-called "presentation" carpet, and in 1637, the ambassadors of the duke of Holstein-Gottorp, Frederick III, each received a "hundred and five assorted pieces of silks" during their farewell audience with Shah Safi (r. 1629–42).[1] Woven silk cloth also served a practical function as envelopes or pouches, which protected both the credentials of envoys and the letters they transported, as seen in portraits of ambassadors (fig. 247, cat. no. 166). One such pouch preserved in Stockholm's State Archives contained a letter from Shah Sulayman (r. 1666–94) to Charles XI of Sweden (r. 1660–97) and was transported by the Swedish ambassador Ludwig Fabritius in 1682.[2]

Approximately a decade later, in 1691, Shah Sulayman dispatched a mission to the Danish king Christian V (r. 1670–99). This velvet envelope, which is decorated with a repeat pattern of a standing falconer and kneeling attendant, was used to carry Sulayman's letter, which is preserved in the record office of Denmark.[3] Its design is identical to that of velvets in Copenhagen's Rosenborg Palace, which were a gift from Shah Safi to Frederick III shortly after the embassy described above.[4] The floral design of the Kremlin textile is more closely related to the pouch transported to Sweden in 1682.[5] KO

1 Carboni, ed., *Venice and the Islamic World*, 324; Bier, *Persian Velvets at Rosenborg*, 73.
2 Jones and Michell, *Arts of Islam*, 112.
3 Vahman, "Three Safavid Documents," 179–80; Folsach and Bernsted, *Woven Treasures*, 38.
4 Folsach and Bernsted, *Woven Treasures*, 38–39; Bier, *Persian Velvets at Rosenborg*, 11.
5 This piece is published here for the first time. We are grateful to I. I. Vishnevskaya for all related information.

169
Portrait of a Russian Ambassador
Iran, 18th century
Ink and colors on paper
Page: 12⅜ x 8¼ in. (31.2 x 20.8 cm); image: 6⅜ x 4⅞ in. (16.3 x 12.2 cm)
Aga Khan Museum Collection, Geneva (AKM00113)
Fig. 248

This is a copy of a late-seventeenth-century portrait of Prince Andrei Priklonskiy, who was sent in 1673 by Tsar Alexei Mikhailovich (r. 1645–76) to Shah Sulayman I (r. 1666–94) to negotiate terms of trade between Russia and Iran.[1] The original painting, now in the Metropolitan Museum of Art, New York, was likely copied in connection with the arrival in Iran of the ambassador of Peter the Great (r. 1682–1725) and was perhaps included among portraits of past foreign envoys shown to the new emissary. Since there are two known copies after the original, it is possible that these later versions were presented as gifts or mementos of a history of diplomatic ties.[2] SW

1 See Adamova, "Persian Portraits of the Russian Ambassadors."
2 Ibid., 52–53. For a discussion of Iranian views of the Russians during this period, see Matthee, "Suspicion, Fear, and Admiration," 129–34.

170
The Breaking of the Idols and The Israelites' Victory over the Philistines
Folio from the Morgan Crusader Bible
France, Paris, 1240s
Ink, colors, and gold on parchment
15⅜ x 11⅞ in. (39 x 30 cm)
The Pierpont Morgan Library, New York (Ms M.638, fol. 22b)
Fig. 123

Today known as the Morgan Crusader Bible, this fabulous picture Bible, like many deluxe objects, traveled widely and was transformed over time. Commissioned by Louis IX (r. 1226–70) of France, centuries later it came into the possession of Cardinal Bernard Maciejowski, bishop of Kracow (d. 1608), who sent it to Isfahan in 1604 as a gift to the Safavid ruler Shah 'Abbas I (r. 1588–1629) to encourage his interest in Christianity. While in the shah's possession, Persian captions were added to the Latin text. Sometime later Judeo-Persian inscriptions were added, presumably by a later Jewish owner.[1] SW

1 Noel and Weiss, *Book of Kings*. See also Simpson, "Morgan Bible."

Opposite: Fig. 248, cat. no. 169

Fig. 249, cat. no. 172

171
Portrait of a Jesuit Missionary
Manohar
India, c. 1590
Ink on paper
5 x 2¾ in. (12.7 x 6.8 cm)
Musée Guimet, Paris (3619 G C)
Los Angeles only
Fig. 125

172
Volume One of the Polyglot Bible
Christophe Plantin
Belgium, Antwerp, c. 1569–72
Ink printed on paper
15½ x 11⅛ in. (39.4 x 28.3 cm)
The Pierpont Morgan Library, New York (PML 51908)
Fig. 249

In 1578 Akbar sent an ambassador to Goa—a Portuguese colony in southwestern India—with a letter requesting "two learned priests who should bring with them the chief books of the Law and the Gospel."[1] Since Akbar expressed an interest in Christianity, the Jesuits saw their visit as an opportunity to convert a powerful Muslim king and his subjects and to act as agents on behalf of the Portuguese. Responding to Akbar's invitation, Rudolf Acquaviva (head of the mission), Antonio Monserrate, and Francisco Henriquez reached Akbar's court in Fatehpur Sikri in 1580.

Upon their arrival, the Jesuit missionaries presented the emperor with European paintings, engravings, and printed texts—including Plantin's Polyglot Bible, which Akbar accepted with great reverence in front of his court.[2] The title pages of the Polyglot Bible, with their complex symbolism, served as a useful didactic tool for the Jesuits while simultaneously providing artistic inspiration for Akbar's atelier.[3]

The priest represented here, wearing a lengthy black cape and a high cap, holds a book in his left hand and a pair of eyeglasses in his right. While the robe is typical of Jesuit dress and the book emphasizes the importance of texts to their mission, spectacles are not a common attribute. Their depiction may indicate that this is a portrait of Father Acquaviva, who was known to wear glasses.[4]

SW

1 Renick, "Akbar's First Embassy to Goa," 34–35.
2 Correia-Afonso, ed., *Letters from the Mughal Court*, 29–30, 42.
3 Brand and Lowry, *Akbar's India*, 96–99; Koch, "Influence of the Jesuit Missions," 14–29.
4 Okada, "Representation of Jesuit Missionaries in Mughal Painting," 193.

173
Khan 'Alam, Ambassador of Jahangir, with Shah 'Abbas in a Landscape
Copy after an original work by Bishan Das
India, c. 1650
Opaque watercolor and gold on paper
5 1/2 x 7 7/8 in. (14 x 20 cm)
Museum of Fine Arts, Boston, Francis Bartlett Donation of 1912 and Picture Fund (14.665)
Fig. 121

174
Shah 'Abbas and the Mughal Ambassador Khan 'Alam
Riza 'Abbasi and Mu'in Musavvir
Iran, c. 1613–1702
Opaque watercolor and gold on paper
9 3/8 x 12 1/4 in. (24 x 31 cm)
Bibliothèque nationale de France (Arabe 6077, fols. 10b–11a)
Los Angeles only
Fig. 122

175
Portrait of Khan 'Alam
India, early 17th century
Opaque watercolor and gold on paper
21 3/8 x 16 3/8 in. (54 x 41.5 cm)
Musée Guimet, Paris (7180)
Los Angeles only
Fig. 127

During their twenty-two years of contemporaneous rule (1605–27), Shah 'Abbas and Jahangir exchanged a record number of embassies. The impetus for this heightened diplomacy was Qandahar, a city under Mughal control since 1595. In order to avoid war, Shah 'Abbas dispatched eleven delegations to the Mughal court, many of which transported notable gifts, including a ruby inscribed with the names of Jahangir's Timurid ancestors.[1] Jahangir responded with only one major embassy to Iran. This mission arrived in 1616 and was led by Khan 'Alam. In addition to presenting state gifts from Jahangir to Shah 'Abbas, including elephants, rhinoceroses, and a tent, Khan 'Alam also procured his own personal gifts for the Mughal emperor, including a falcon and a painting of a Timurid battle.[2]

These three paintings belong to a corpus of approximately twenty works inspired by Khan 'Alam's mission.[3] The majority of these images are copies after originals by the Persian artist Riza 'Abbasi and the Mughal painter Bishan Das, who accompanied Khan 'Alam's mission in order "to take the likeness of the shah and his chief statesman."[4] In the Mughal portrait of Khan 'Alam, the envoy perhaps holds the falcon that he presented to Jahangir. In the Persian double-page composition, Shah 'Abbas offers Khan 'Alam a wine cup. A similar exchange is repeated in the Mughal group portrait, in which the protagonists are seated. This scene and an "imaginary" portrait of Jahangir entertaining Shah 'Abbas, in which Khan 'Alam holds a falcon and an automaton presumed to have been gifts, are iconic images of early-modern Indo-Persian diplomacy.[5] KO

1 For Jahangir's description of this ruby, see Thackston, trans., *Jahangirnama*, 357.
2 Littlefield, "Object in the Gift," app. A, pt. 2, 201–2; Thackston, trans., *Jahangirnama*, 262, 319.
3 Grube and Sims, "Representations of Shah 'Abbas I," pls. III–VII; Littlefield, "Object in the Gift," app. B, pt. 1, 210–13; Canby, *Shah 'Abbas*, 60–63.
4 Thackston, trans., *Jahangirnama*, 319.
5 For Jahangir's "imaginary" portraits with Shah 'Abbas, see Littlefield, "Object in the Gift," 49–59.

176
Shah Jahan Receives the Persian Ambassador, Muhammad 'Ali Beg
Folio from the Windsor *Padshahnama*
India, c. 1633
Ink, colors, and gold on paper
Image size: 12 5/8 x 8 5/8 in. (31.9 x 21.8 cm)
The Royal Collection, Windsor (RCIN 1005025, fol. 98b)
Fig. 1

177
Portrait of Muhammad 'Ali Beg
Folio from the Minto Album
Hashim
India, c. 1631
Opaque watercolor and gold on paper
Painting: 11 ⅝ x 8 in. (29.5 x 20.4 cm); page: 15 ¼ x 10 ⅜ in.
(38.5 x 26.1 cm)
Victoria and Albert Museum, London (I.M. 25-1925)
Fig. 250

When an Islamic sovereign died, it was customary for other
heads of state to send delegations offering condolences
and congratulations to the new ruler. In 1631, the Safavid
ruler Shah Safi (r. 1629–42) dispatched his first delegation
to Shah Jahan (r. 1628–58), who had recently ascended the
Mughal throne after the death of Jahangir. This embassy
was led by Muhammad 'Ali Beg and arrived at Burhanpur
in March of 1631 during the Nawruz celebrations. At his
first audience with Shah Jahan, Muhammad 'Ali Beg pre-
sented a letter and an oral message from the Persian ruler.[1]
In return, he received a robe of honor, a jeweled crown,
a turban ornament, a dagger, and a container filled with
betel, a customary gift for the New Year.[2]

This *Padshahnama* painting depicts Muhammad
'Ali Beg's second audience with Shah Jahan.[3] The Mughal
ruler is enthroned under a red tent erected for Nawruz.
As in all *Padshahnama* paintings, the inner area around
the emperor is reserved for family members and high
officials. The outer area, which is demarcated by a red
fence and located at the bottom of the composition, is
reserved for lower officials such as Muhammad 'Ali Beg,
a portly figure dressed in orange who salutes the emperor
while his attendants offer textiles, porcelains, and gold
vessels. Muhammad 'Ali Beg certainly captured the atten-
tion of Mughal artists, for he was included in an additional
Padshahnama scene and was also the subject of this por-
trait, which features an inscription describing him as
an ambassador (*ilchi*).[4] Our ability to readily recognize
Muhammad 'Ali Beg in three separate images is a testa-
ment to Mughal naturalism. KO

1 Four versions of Shah Safi's letter are extant. See Islam, *Calendar of Documents*,
vol. 1, 239–42.
2 Beach and Koch, *King of the World*, 52.
3 Ibid., 176.
4 See Beach and Koch, *King of the World*, 169–71, for the other *Padshahnama*
painting with Muhammad 'Ali Beg.

Fig. 250, cat. no. 177

178
Akbar Receives the Badakhshanis
Folio from the *Akbarnama*
India, c. 1603–5
Ink and opaque watercolor on paper
13 ⅝ x 8 ¾ in. (43.5 x 26.8 cm)
© Trustees of the Chester Beatty Library, Dublin
(In 03.53b and In 03.54a)
Fig. 30

This double-page painting from an illustrated copy
of the official biography of Akbar (*Akbarnama*), by Abu'l-
Fazl, depicts the arrival of distinguished nobility from
Badakhshan (located in northeastern Afghanistan and
southeastern Tajikistan), who have come to pay homage
to the emperor.[1] The Badakhshani emissaries are lined
up to present their gifts to Akbar, who sits in a white pavil-
ion. Included among the gifts are two small dishes of
rubies, bows, swords, and hunting falcons. The architec-
ture, decorative textiles, and Akbar's dress serve to indi-
cate the wealth and confidence of the new dynasty.[2] SW

1 Abu'l-Fazl, *The Akbarnama of Abu'l Fazl*, trans. Beveridge, vol. 2, 194–95; Leach,
Mughal and Other Indian Paintings, 257.
2 Leach, *Mughal and Other Indian Paintings*, 258.

179
Europeans Bring Gifts to Shah Jahan
Folio from the Windsor *Padshahnama*
India, c. 1650
Ink, colors, and gold on paper
Image size: 14 x 9⅞ in. (35.2 x 25 cm)
The Royal Collection, Windsor (RCIN 1005025, fol. 116b)
Fig. 168

This *Padshahnama* painting depicts a group of Portuguese men (who may have been prisoners from a Mughal attack on a trading colony near present-day Calcutta) presenting Shah Jahan with jewels and a black box with gold designs.[1] It is plausible that the latter item is an example of *namban* ware, or Japanese lacquer. According to Sir Thomas Roe, an English ambassador at Jahangir's court between 1615 and 1618, "Japanese caskets" were among the presents most desired by the emperor as gifts.[2] Since a comparable item is presented here, we can assume that the taste for such rarities persisted during the subsequent reign of Shah Jahan. KO

1 Beach and Koch, *King of the World*, 179.
2 Roe, *Embassy of Sir Thomas Roe to India*, 119.

180
Shawl
India, Kashmir, c. 1650
Wool, *tus*
9⅜ x 26⅝ in. (24 x 67.5 cm)
The al-Sabah Collection, Dar al-Athar al-Islamiyyah, Kuwait (LNS 59T)
Fig. 251

181
Fragment of a Carpet with Lattice-and-Vase Pattern
India, Kashmir or Lahore, c. 1650
Wool pile on cotton and silk foundation
56½ x 26 in. (143.5 x 66 cm)
Los Angeles County Museum of Art (M.70.37)
Fig. 252

The region of Kashmir is renowned for two types of wool: the pashmina of the domestic goat and the even rarer *shah tus* (king's wool) of the wild goat.[1] From the fifteenth century onward, this wool was used to make a variety of textiles, including carpets, shawls, and *patkas* (waist sashes). The rarity of these textiles stimulated their exchange as both diplomatic and personal gifts.

One of the earliest recorded instances of Kashmir shawls as diplomatic gifts dates to the mid-fifteenth century when the sultan of Kashmir, Zayn al-'Abidin (r. 1420–72), presented the Timurid ruler Abu Sa'id (r. 1451–69) with shawls and "other rarities (*ghara'ib*) of Kashmir."[2] During the Mughal period, the emperor regularly bestowed Kashmir shawls and *patkas*, as well as robes of honor, upon favored courtiers (fig. 36, cat. no. 23).[3] The narrow width of this

Fig. 251, cat. no. 180

Fig. 252, cat. no. 181

fragment suggests that it may be the border of a *patka*, rather than a shawl.[4] Since it was made from *shah tus*, it would have been a coveted gift.

During the first half of the seventeenth century, carpet workshops were established in Kashmir.[5] When Arslan Agha, the Ottoman envoy to Shah Jahan, was dismissed from the Mughal court in 1640, he was given "two prayer-carpets of rare quality made in the *karkhana-yi padshahi* (royal workshop) at Lahore and Kashmir, so that he may present these to the sultan on his own behalf."[6] Although it is unlikely that this fragment was from a prayer carpet of the type transported by Arslan Agha, its pashmina is of such high quality that it would have been an appropriate diplomatic gift.[7] KO

1 See, most recently, Cohen, "Use of Fine Goat Hair."
2 Digby, "Export industries," 409.
3 Loomba, "Of Gifts," 45. See also Thackston, trans., *Jahangirnama*, 198, 275, and esp. 175, where the "shawl" spontaneously presented by Jahangir to a pardoned courtier was one he was wearing around his own waist.
4 J. Rizvi and Ahmed, *Pashmina*, 80.
5 D. Walker, *Flowers Underfoot*, 12.
6 Islam, *Calendar of Documents*, vol. 2, 319.
7 For other fragments from this carpet, see D. Walker, *Flowers Underfoot*, 107. This style of carpet is commonly attributed to either Lahore or Kashmir; for an expla-nation, see ibid., 113.

182
Portrait of Mirza Abu'l-Hasan Khan, Ambassador of Persia

Eugène Delacroix (France, 1798–1863)
France, 1819
Lithograph
10 x 7 ⅜ in. (25.5 x 18.8 cm)
Bibliothèque nationale de France, Paris
(N2 Abul Hassan D-06088914)
Los Angeles only
Fig. 253

183

Dish

Muhammad Ja'far

Iran, probably Tehran, 1817–18

Gold and painted enamel

Diam. 12 5/8 in. (32.1 cm)

Victoria and Albert Museum, London (97-1949)

Fig. 198

Fath 'Ali Shah (r. 1797–1834) exchanged a number of delegations with Europe's two leading powers and rivals, George III of England (r. 1760–1820) and Napoleon I of France (r. 1804–15) (see Francesca Leoni's text in this volume). After receiving the French embassy led by Amédée Jaubert in 1806 (see cat. no. 187), Fath 'Ali Shah dispatched his own envoy to France to negotiate a treaty against Russia and England. The Perso-Franco alliance soon began to unravel, and in 1809 Fath 'Ali Shah assigned Mirza Abu'l-Hasan Khan to lead a mission to George III.

In addition to being immortalized in James Morier's *The Adventures of Hajji Baba of Ispahan* (1824), Abu'l-Hasan was the subject of popular engravings and paintings by notable portraitists.[1] One of the rarest images of the envoy is this lithograph by Delacroix, which exists in only two impressions.[2] It is likely that Delacroix's lithograph was inspired by a portrait of the ambassador published in a French newspaper rather than drawn from life. Abu'l-Hasan had passed through Paris on his way to England for his second diplomatic mission of 1819–20.

While in England for this second delegation, Abu'l-Hasan presented this gold dish to the East India Company. An English inscription engraved on the bottom of the vessel reads, "A Token of Favour from His Majesty Fatah Ali Shah King of Persia to the East India Company, presented to the Court of Directors assembled…by His Majesty's Ambassador, His Excellency Mirza Abu'l-Hasan Khan on Friday the 18th of June 1819."[3] KO

1 For the most comprehensive analysis of portraits of the envoy, see Millard, "Diplomatic Portrait."
2 Delteil, *Delacroix*, 68–69, and cat. no. 26.
3 B. W. Robinson, "Royal Gifts of Fath 'Ali Shah," 67.

184

Illustrated Manuscript of the *Gulistan* of Sa'di

India, AH 1038/1628–29

Ink, opaque watercolor, and gold on paper

Folio: 14 x 10 5/8 in. (35.6 x 27 cm); painting: 5 1/4 x 6 in. (43.5 x 26.8 cm)

© Trustees of the Chester Beatty Library, Dublin (In. 22)

Fig. 24

Two lengthy inscriptions reveal that this manuscript was exchanged as a gift between rulers of India, England, and Iran on two distinct occasions separated by two

S. Ex. Mirza Aboul hassan Khan
Ambassadeur de Perse

Fig. 253, cat. no. 182

centuries. A notation by Shah Jahan records that the manuscript, which resembled "the Garden of Eden," was given to Charles I in 1638.[1] In the early nineteenth century, George IV had the manuscript rebound and presented it to Fath 'Ali Shah. A notation dated 1826–27 reads, "As commanded by His Majesty…Fath 'Ali Shah Qajar…this Golestan, written in India, was sent as a gift by a special envoy of the glorious George, King of England."[2] KO

1 Leach, *Mughal and Other Indian Paintings*, vol. 1, 359; Wilkinson, "An Indian Manuscript," fig. 2.
2 Leach, *Mughal and Other Indian Paintings*, vol. 1, 359; Wilkinson, "An Indian Manuscript," fig. 3.

185
Portrait of Fath 'Ali Shah
Mirza Baba
Iran, Tehran, AH 1213/1798–99
Oil on canvas
78³⁄₄ x 46¹⁄₈ in. (200 x 117 cm)
Oriental and India Office Library Collections, The British
Library, London (F.116)
Fig. 2

186
Divan-i Khaqan
Copied by Muhammad Mahdi; painted and illuminated
by Mirza Baba
Iran, text AH Shawwal 1216/Februrary 1802, paintings
and lacquer covers AH 1217/1802–3
Opaque watercolor, ink, and gold on paper; binding:
pasteboard, opaque watercolor under lacquer
16³⁄₄ x 11¹⁄₂ in. (42.5 x 29.2 cm)
The Royal Collection, Windsor (MS A/4)
Fig. 188

These and other gifted images of Fath 'Ali Shah (r. 1797–
1834) were meant as expressions of Persian royal power
and aspirations at a time when Britain and Russia were
competing to carve out spheres of influence in Iran. The
British saw control of Iran as key to maintaining their
hold over India, while the Russians were concerned with
gaining territory in Central Asia. This "Great Game," as
it came to be known, had the European powers shifting
alliances with and against one another with Iran perpetu-
ally squeezed in the middle.

This oil painting was one of a number of large portraits
of the shah that were sent abroad as gifts (cat. no. 187).[1]
Probably the first one to reach England, it was presented in
1806 to the Court of the Directors of the East India Company
through Lord Wellesley (governor general of India, 1797–
1805).[2] The portrait, by the leading court artist Mirza Baba,
also represents the earliest extant official image of the
shah. In contrast to other, later portraits, the young ruler
here lacks two important insignias of authority: his crown
and throne, perhaps because his transition to full power
was still incomplete at the time of the portrait.[3]

Fath 'Ali Shah also was evidently fond of giving lavish
manuscripts of his own poetry. One such volume was
among the gifts presented to Tsar Nicholas I (r. 1825–55)
in 1829,[4] while this even more magnificent version, which
included the royal author's portrait, again by Mirza Baba,
was presented to the English prince regent (later George IV)
in 1812.[5] LK

1 Of the twenty known portraits, more than fifteen were sent as gifts to other
rulers; see Raby, *Qajar Portraits*, 11.
2 Ibid., 39. See also Diba, ed., *Royal Persian Paintings*, 30.
3 Amanat, "Kayanid Crown."
4 In the National Library of Russia, St. Petersburg, Dorn 476.
5 Raby, *Qajar Portraits*, 40.

187
Portrait of Fath 'Ali Shah
Iran, Tehran, c. 1800–1806
Oil on canvas
88⁵⁄₈ x 51¹⁄₈ in. (225.3 x 129.9 cm)
Musée du Louvre, Paris, on loan from the Musée National
de Versailles (M.V. 6358)
Los Angeles only
Fig. 170

188
Headdress Ornament with Portrait of Fath 'Ali Shah
Iran, first quarter of the 19th century
Gold, enamel, and pearls
2¹⁄₂ x 2³⁄₈ in. (6.3 x 6 cm)
Benaki Museum, Athens (21729)
Los Angeles only
Fig. 197

Fath 'Ali Shah (r. 1797–1834) was renowned, among other
things, for his lavish display of wealth and for maintaining
a harem of a thousand women. The Iranian shah cultivated
a decidedly affected and mannered personal image and a
highly contrived and splendid court ceremonial. His ample
beard and extensive harem, whose women gave him more
than a hundred offspring, may have been a direct response
to his predecessor and the founder of the Qajar dynasty
(1779–1924), Agha Muhammad, who was a eunuch. Indeed,
at the time of his death in 1834, Fath 'Ali Shah left behind
more than a thousand direct descendants.[1] This portrait
was a gift to Emperor Napoleon, presented via his envoy in
Iran, Pierre-Amédée Jaubert, in 1806. Intended as a state
image, the painting depicts the monarch seated on a marvel-
ous throne and wearing his fabulous crown—two key ele-
ments lacking in the earliest portrait of the shah when he
had not yet consolidated power (cat. no. 185). Here in con-
trast is the iconic image of the ruler, whose immutable,
jewel-bedecked magnificence would announce to European
viewers the political stability and might of Iran.[2]

Fath 'Ali Shah was also depicted in miniature form in
portrait medallions and other types of personal ornament
such as this headdress, which was intended for presenta-
tion. His likeness was even depicted on a teapot.[3] Viewed
today through the prism of modern history, there is some-
thing quixotic about these gifted images of the *Shahanshah*,
or King of Kings. LK

1 Diba, ed., *Royal Persian Paintings*, 14–21.
2 Ibid., 181.
3 Raby, *Qajar Portraits*, 28.

189

Reduced Copy of the Negarestan Mural of 1812–13

Iran, early 19th century

Ink and opaque watercolor on watermarked paper dated 1816

Central group: 13⅜ x 21 in. (35 x 53 cm); *ghulams*: 9⅞ x 20½ in. (25 x 52 cm); left-hand group: 13⅜ x 52 in. (34 x 132 cm); right-hand group: 13 x 53⅛ in. (33 x 135 cm).

The British Library, London (Or. 1239–42)

Fig. 254

This imaginary depiction of a Nawruz gathering at the court of Fath 'Ali Shah (r. 1797–1834) is a reduced copy of a mural that once decorated the Negarestan Palace in Tehran.[1] The enthroned ruler is surrounded by his sons and approximately one hundred courtiers and ambassadors, including the British envoys Sir John Malcolm, Sir Harford Jones, and Sir Gore Ouseley. The intention of the original painting was to convey Fath 'Ali Shah's political superiority, and in order to spread this message to a broader audience, reduced versions of the mural were disseminated as gifts.[2] One example was presented to Sir Henry Willock, a member of Sir Harford Jones's delegation of 1812.[3] KO

1 A salt print in the Brooklyn Museum of Art depicts the central portion of the mural in situ. See Eskandari-Qajar, "Message of the Negarestan Mural," 22, and Diba, ed., *Royal Persian Paintings*, fig. xiv.
2 Diba, ed., *Royal Persian Paintings*, 174–76; Eskandari-Qajar, "Message of the Negarestan Mural," 21 and 36n21.
3 Sotheby's, *Persian Art from the Aryeh Family Collection*, lot 19.

190–94

Group of Five Lithographs Related to the 1829–30 Embassy of Prince Khusraw Mirza

Karl Karlovich Gampel'n (Germany, 1794–1880)

Suite of Five Lithographs

Russia, 1829

Lithographs

The State Hermitage Museum, St. Petersburg

190

Portrait of Khusraw Mirza

21⅜ x 16¾ in. (54.5 x 42.5 cm)

(ERG-19106)

Los Angeles only

Fig. 190

191

Mirza Baba

21⅝ x 16¾ in. (54.8 x 42.3 cm)

(ERG-19509)

Houston only

Fig. 191

192

Mirza Mas'ud

21⅜ x 16½ in. (54.7 x 41.8 cm)

(ERG-18753)

Houston only

Fig. 192

193

Mirza Salih

21⅜ x 16¾ in. (54 x 42.5 cm)

(ERG-18980)

Houston only

Fig. 193

194

Amir Khusraw Muhammad Khan

21⅜ x 16¾ in. (54 x 42.4 cm)

(ERG-18653)

Houston only

Fig. 194

195

Portrait of Prince Khusraw Mirza with the Four Other Emissaries

Unknown artist

Russia, 1829

Engraving

22¼ x 15¾ in. (56.5 x 39.8 cm)

(ERG-767)

Los Angeles only

Fig. 255

196

Portrait of Khusraw Mirza (three-quarter portrait bust)

O. Ludwig (probably Germany)

Russia, 1829

Lithograph

21½ x 16¾ in. (54.5 x 42.5 cm)

(ERG-19105)

Houston only

Fig. 256

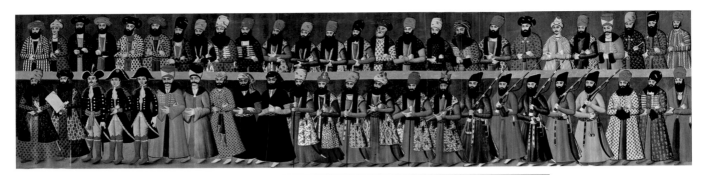

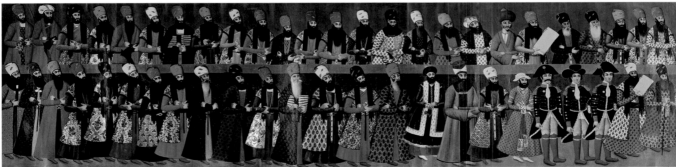

Fig. 254, cat. no. 189

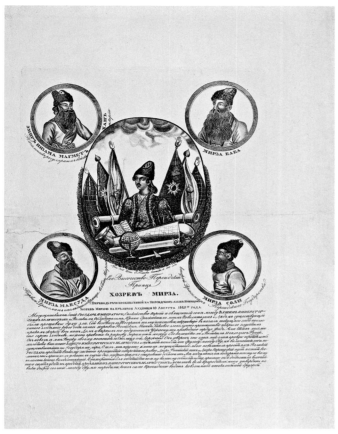

Fig. 255, cat. no. 195

Fig. 256, cat. no. 196

Fig. 257, cat. no. 197

197–98

Equestrian Portrait of Khusraw Mirza (2 versions)

Edouard Hauser (Russia, 1807–1864)

Russia, 1829

Lithograph

23 3/8 x 18 3/4 in. and 20 1/2 x 17 in. (59.5 x 47.5 cm
and 52 x 43 cm)

ERG-1320 (*Los Angeles*) and ZK-II-I (*Houston*)

Fig. 257

Relations between Iran and Russia were especially volatile
during the reign of Fath 'Ali Shah (r. 1797–1834), which
saw two wars fought between these nations. In 1829, a year
after the treaty concluding the second Russo-Iranian war,
the Russian mission in Tehran was attacked by an angry
mob that killed thirty-eight of its members, among them
Alexander Griboyedov, a famous playwright who was the
chief envoy. To avoid further incident, the shah sent his
teenage grandson Khusraw Mirza as the head of a diplo-
matic mission to Tsar Nicholas I (r. 1825–55).[1]

Five of these prints portraying the members of this
Iranian embassy are from a suite by the Baltic German
Karl Gampel'n, including a depiction of the young prince,
who is said to have charmed the Russian court with his
"handsome face of the Persian type, charming eyes, and
slender figure."[2] In a group portrait of the members of the
mission, by an unknown artist, the Russian text represents
a translation of the shah's letter of formal apology, which
accompanied the contrite emissaries. This diplomatic
mission was also responsible for transporting numerous
gifts such as a collection of important Persian manuscripts,
now in the National Library of Russia (see cat. nos. 209–10).
Among the presents received in exchange was a horse,
which the tsar gave to Khusraw Mirza, as depicted in the
lithograph by Hauser. One member of the delegation,
Mirza Salih, had joined the mission specifically to bring
the new technology of lithography back to Iran; he was
successful, as a lithographic press was presented to the
Iranians as a diplomatic gift.[3] LK and GAM

1 The mission lasted from May 1829 to February 1830; see the forthcoming study
by Abdullaeva, "Khosraw Mirza's Mission of 1829 to St. Petersburg," where she
cites a 1835 short story written by Nikolai Gogol, which mentions an engraved
portrait of Khusraw Mirza in sheepskin cap in a picture shop in St. Petersburg. We
are grateful to the author for sharing her paper with us.
2 Diba, ed., *Royal Persian Paintings*, 69 and 75n17. On the lithographs, see
Piotrovsky et al., *Iran v Ėrmitaže*, 209–12.
3 See Green, "Stones from Bavaria," 307.

199–207

Nine Gold Coins (Tomans)

In the name of Agha Muhammad Shah (r. 1779–97)

Iran, Tehran, AH 1210/1795–96

199

50 Tomans

Diam. 2 3/4 in. (6.8 cm); wt. 399 g

The State Hermitage Museum, St. Petersburg (ON-V-Az-1830)

Fig. 258

200

50 Tomans

Diam. 2 5/8 in. (6.7 cm); wt. 402.05 g

The State Hermitage Museum, St. Petersburg (ON-V-Az-1831)

Fig. 17

201

20 Tomans

Diam. 1 3/4 in. (4.2 cm); wt. 162.03 g

The State Hermitage Museum, St. Petersburg (ON-V-Az-1826)

Fig. 259

202

20 Tomans

Diam. 1 3/4 in. (4.2 cm); wt. 162 g

The State Hermitage Museum, St. Petersburg (ON-V-Az-1829)

Fig. 260

203

50 Tomans

2 5/8 x 2 3/8 in. (6.5 x 6 cm); wt. 404 g

Nasser D. Khalili Collection of Islamic Art, London
(AV 1029)

Fig. 16

204

20 Tomans

Diam. 1 7/8 in. (4.6 cm); wt. 162 g

Nasser D. Khalili Collection of Islamic Art, London
(AV 1088)

Fig. 14

205

20 Tomans

Diam. 1 3/4 in. (4.3 cm); wt. 162 g

Nasser D. Khalili Collection of Islamic Art, London
(AV 1030)

Fig. 15

Fig. 258, cat. no. 199

Fig. 259, cat. no. 201

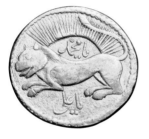

Fig. 260, cat. no. 202

Fig. 261, cat. no. 208

206

20 Tomans
Diam. 1 3/8 in. (3.5 cm); wt. 162 g
Nasser D. Khalili Collection of Islamic Art, London
(AV 1087)
Fig. 19

207

10 Tomans
Diam. 1 3/8 in. (3.5 cm); wt. 80.5 g
Nasser D. Khalili Collection of Islamic Art, London
(AV 1031)
Fig. 18

208

Commemorative Coin of Fath 'Ali Shah (r. 1797–1834)

Iran, Tabriz, AH 1242/1826–27
Gold
Diam. 2 5/8 in. (6.7 cm); wt. 229.6 g
The State Hermitage Museum, St. Petersburg (ON-V-Az-1834)
Fig. 261

Though small, coins carry an important message about the state or ruler under whose auspices they were struck. As legal tender exchanged for goods and services, coins circulated widely, and their material, size, weight, and inscriptions all served to promote power and legitimacy. The design of Islamic coins is generally, though not always, restricted to inscriptions. Such coins are almost invariably inscribed in Arabic with the central doctrine of Islam, that God is without partners and Muhammad is his Prophet. They also normally include the name of the reigning monarch, date, and mint.

These nine tomans struck under the first Qajar shah, Agha Muhammad (r. 1779–97), in the capital Tehran, are exceptional on several counts.[1] Their inscriptions include the Muslim profession of faith (There is no god but God and Muhammad is the messenger of God) but with the addition of the phrase "'Ali is the divine friend of God" ('Ali wali Allah; Shi'ite tradition recognizes Imam 'Ali as the rightful successor to the Prophet), or else the inscriptions invoke his name (ya' 'Ali).[2] Agha Muhammad's name and title are not given, rather perhaps only a reference to the name he shared with Islam's Prophet, in the inscription "O Muhammad" (ya' Muhammad). The design of these coins is not limited to inscriptions but includes a peacock and a lion with a sun device.[3] Lastly, these large-denomination tomans were not intended for circulation but must have been special commemorative issues.[4]

Coins such as these as well as the oversize coin struck in the name of Fath 'Ali Shah (r. 1797–1834), Agha Muhammad's successor, made attractive gifts or tribute;

Fig. 262, cat. no. 210

indeed, the coins in the Hermitage collection were presented in 1829 in connection with the Turkmanchay Treaty, whose terms favored Russian interests (see cat. nos. 209–10).[5] The Persian quatrain inscribed on the coin of Fath ʿAli Shah, struck the year before the treaty was finalized, plays on the name Fath (meaning victory) and prematurely celebrates an Iranian triumph, which adds an element of irony to its use as tribute or payment of war indemnity to the Russians: "There is a reflection coming from the victorious shah / From his sword his enemy has perished completely."[6] LK

1 On Qajar coins in general, see P. Soucek, "Coinage of the Qajars."
2 This was typical of Iranian coins only after 1501, following the establishment of the Shiʿite branch of Islam under the Safavids.
3 The latter is an ancient Iranian device that was adopted as a symbol of Iran under the Qajars (see fig. 189, cat. no. 255).
4 Album et al., "Coins and Coinage," vol. 6 , 35–36.
5 Piotrovsky et al., Iran v Ėrmitaže, 228–30.
6 Read by the late Marianna Borisovna Severova.

209
Tuhfat al-Ahrar of Jami
Iran, Qazvin, c. 1580s
Ink, colors, and gold on paper
12 1/8 x 7 3/4 x 1 in. (30.7 x 19.5 x 2.4 cm)
The National Library of Russia, St. Petersburg (Dorn 426)
Houston only
Fig. 187

210
Divan of Mir ʿAli Shir Navaʿi
Copied by Sultan ʿAli Mashhadi
Afghanistan, Herat, AH 870/1465–66, text mounted in 16th-century decorative margins
Ink, colors, and gold on paper
13 3/8 x 9 3/8 x 1 7/8 in. (34 x 23.7 x 4.7 cm)
The National Library of Russia, St. Petersburg (Dorn 564)
Los Angeles only
Fig. 262

On January 30, 1829, Alexander Sergheyevich Griboyedov, diplomat, dramatist, and composer was brutally murdered by a mob in Tehran along with nearly all members of the Russian diplomatic mission. It was Griboyedov who had helped negotiate the terms of the Turkmanchay Treaty that ended the Russo-Iranian war of 1826–28, and he had been dispatched by Tsar Nicholas I (r. 1825–55) as plenipotentiary ambassador to implement the provisions of the humiliating treaty for the Iranians.[1] To avoid a resumption of hostilities, the tsar requested that an official apology be delivered in person by a member of the Iranian royal family, and Fath ʿAli Shah (r. 1797–1834) complied by sending his grandson Khusraw Mirza. Although just sixteen years old, the prince already served as secretary of state on behalf of his father, ʿAbbas Mirza, the crown prince, accompanying him during the negotiations of the Turkmanchay Treaty ending the recent hostilities. Accordingly, on August 10, 1829, the

young prince handed the tsar the shah's letter at a formal audience (see fig. 255, cat. no. 195).[2]

Among the gifts presented to Nicholas I on this occasion were the so-called "Shah" diamond[3] and eighteen manuscripts from Fath ʿAli Shah's personal library.[4] This small collection, which the tsar transferred to the Imperial Public Library (National Library of Russia), was largely composed of classical Persian literary works and historical treatises, mostly of the sixteenth century, such as this illustrated manuscript of the great poet Jami.[5] The only non-Persian manuscript in the group was this *Divan* (collected works) of the Uzbek poet Navaʿi, which was copied in 1465 by the master calligrapher Sultan ʿAli Mashhadi; this is also the earliest surviving manuscript of Navaʿi's work.[6] OVV

1 On the circumstances of Griboyedov's death, see, most recently, Kelly, *Diplomacy and Murder in Tehran.*
2 See Berzhe, "Khosrov Mirza," 331–52, 401–14; and Minorsky, "Tsena Krovi Griboyedova." See also the forthcoming study by Abdullaeva, "Khosraw Mirza's Mission of 1829 to St. Petersburg."
3 Said to be 88.7 karats, it is now in the Kremlin Museum.
4 Kostygova, "Collection of Persian Manuscripts," 336.
5 See Vasilyeva, *A String of Pearls,* cat. no. 68.
6 Ibid., 114. See also Kostygova, "Treatise on the Calligraphy of Sultan Ali Mashhadi."

211
Shahnama
Iran, Isfahan, AH 1058/1648
Manuscript on paper, ink, colors, and gold
18 x 12 1/4 in. (45.5 x 31 cm)
The Royal Collection, Windsor (RCIN 1005014)
Fig. 10

One of the most frequently illustrated works of Persian poetry, this lavish version of the *Shahnama* (Book of Kings) was completed in 1648 for the governor of Mashhad, in northeastern Iran.[1] The manuscript later belonged to the ruler of Herat, in Afghanistan, who presented it in 1839 to Queen Victoria, in gratitude for the British government's "timely and valuable assistance to the country and people."[2]

The painting illustrated here (Gurdiya presenting an equestrian cat to Khusraw, fol. 717a) pertains to the story of a kitten given to Shah Khusraw by his wife, Gurdiya. Charmed by this gesture, he asked his wife what she desired, and she in turn asked the king to restore a town whose demise he had precipitated.[3] SW

1 Robinson, Sims, and Bayani, *Windsor Shahnama.*
2 See B. W. Robinson, "Two Manuscripts of the *Shahnama*," 134.
3 Firdausi, *Shahnama,* vol. 9, 368.

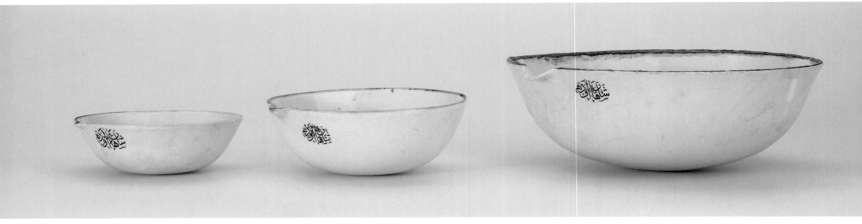

Fig. 263, cat. no. 212 a–c

212 a–c
Three of a Set of Twelve Pouring Vessels
Turkey, perhaps Kütahya, or Europe, dated 1860
Fritware, overglaze inscriptions in black ink
H. 3 in. (7.5 cm); diam. 8³⁄₈ in. (21 cm)
H. 2 in. (5 cm); diam. 5¹⁄₈ in. (13 cm)
H. 1³⁄₈ in. (3.6 cm); diam. 4³⁄₈ in. (10.9 cm).
Nasser D. Khalili Collection of Islamic Art, London
(POT1679)
Fig. 263

While it is not possible to determine whether these vessels
were manufactured in Europe or Turkey, their inscriptions,
probably added later, indicate when and for whom they
were made. Each is inscribed in Ottoman Turkish: on the
outside "Imperial Chamber," and on the inside "A gift for
His Excellency Abraham Lincoln [in the] year 1860."[1] The
date suggests that the gift was made in connection with
Lincoln's election as president of the United States. Several
years earlier, Sultan Abdülmecid (r. 1839–61) had sent an
elegantly inscribed marble plaque to be placed inside the
Washington Monument. Its inscription reads in part "In
support of eternal friendship."[2] LK

1 Vernoit, *Occidentalism*, 173.
2 Derman, *Letters in Gold*, 118.

213 a–b
Drinking Cups
India, 16th–17th century (mounts 19th-century Europe)
Nephrite (jade) and agate, inlaid with gold and colored
glass; mounts: gilt-bronze stand with *verde antico* base and
gilt-bronze mount on marble base
Cup: 2¹⁄₈ x 3³⁄₈ x 6 in. (5.4 x 8.7 x 15.2 cm);
base: 3¹⁄₂ x 6¹⁄₂ in. (8.3 x 16.5 cm)
Aga Khan Museum Collection, Geneva (AKM00813)
Fig. 162

Like many luxury objects that circulated at the Islamic
courts and beyond, these two appear to have traveled
widely and to have undergone significant transformations.[1]
The boat-shaped cups were probably produced in Mughal
India, though they were likely matched as a pair only after
they arrived in Europe, where they were given their spec-
tacular serpentine mounts. Carved from a single piece of
jade, the pale green vessel is decorated with gold set with
pieces of colored glass. Its design suggests a hybrid style,
and it has been proposed that the applied ornament may
be the work of one of the European jewelers active at the
Mughal court in the seventeenth century. In addition, on
one side, it bears the coat of arms of the French kingdom of
Navarre. It is certainly likely that the jade cup was designed
and produced with a French recipient in mind and possibly
exported as a diplomatic gift.[2]

The gilt-bronze mounts, which were probably added
in the early nineteenth century, have been attributed to
the English craftsman Benjamin Vulliamy. The pair was
acquired by Baron Lionel de Rothschild in 1882, in whose
family they remained until recently.[3] LK

1 Recent research on the provenance of these drinking cups suggests they went
from France, after the breakup of the French royal collection in 1789, to
St. Petersburg and then to Scotland. We are grateful to Alnoor Merchant for
sharing this information, based on research provided by Bret McLeod on
behalf of Sotheby's.
2 See Sotheby's, *Arts of the Islamic World*, lot 117; see also Aga Khan Trust for
Culture, *Schätze des Aga Khan Museum*, 262.
3 Ibid.

214
Young Woman in Blue
Turkey, late 16th century
Ink, opaque watercolor, and gold on paper
4 1/8 x 1 1/2 in. (10.5 x 3.8 cm)
Los Angeles County Museum of Art, the Edwin Binney
3rd Collection of Turkish Art (M.85.237.30)
Fig. 38

215
Woman with a Lute
Iran, Isfahan, c. 1600–1610
Ink, opaque watercolor, and gold on paper
14 1/4 x 9 1/4 in. (36 x 23.4 cm)
Los Angeles County Museum of Art, the Nasli M.
Heeramaneck Collection, gift of Joan Palevsky (M.73.5.457)
Fig. 39

Of the many types of living gifts exchanged between the Islamic courts, perhaps the most numerous were humans—slaves, who were also given as tribute. As no Muslim could be enslaved legally, these individuals generally came from outside the Islamic commonwealth, often as war booty. The fourteenth-century Moroccan traveler Ibn Battuta noted a gift from the emperor of China to the Indian sultan Muhammad Tughluq that consisted of a hundred slaves, which was reciprocated even more lavishly with "a hundred thoroughbred horses saddled and bridled, a hundred male slaves, a hundred Hindu singing- and dancing-girls."[1]

Each of these paintings depicts a young woman in Turkish attire, of the type that would be attached to an elite household. Indeed, concubines and slaves played an important role in both the Safavid and Ottoman imperial harems. In each empire, and as especially well documented under the Ottomans, the mother of the ruler frequently came from a slave background; such women would, of necessity, have been converts to Islam.[2] Hurrem Sultan, mother of Selim II, and wife of Süleyman I, who was the first such Ottoman slave concubine to be freed and made a royal wife, perhaps began her career in the imperial harem as an accession gift to the young ruler (see cat. no. 97).[3] Most such slaves of the harem were not made royal concubines, but rather they often were manumitted, which was considered an act of piety, and then married to a member of the Ottoman ruling elite, also a former slave.[4] LK

1 See Ibn Battuta, Travels of Ibn Battuta, vol. 4, 773.
2 For the Safavids, see Babaie et al., Slaves of the Shah, 33 and 42. On the Ottomans, see the comprehensive study by Peirce, Imperial Harem.
3 Peirce, Imperial Harem, 58.
4 Ibid., 31, 142.

216
Portrait of a Georgian Ghulam (Shahzada Muhammad Beg)
Riza 'Abbasi
Iran, Isfahan, c. 1620–23
Ink, opaque watercolor, and gold on paper
6 5/8 x 3 1/8 in. (16.8 x 8 cm)
Museum für Islamische Kunst, Berlin (Ms. 4593, fol. 50a)
Houston only
Fig. 113

The elegant young man depicted here wears a fur-lined coat, which may indicate his elevated status at the court of Shah 'Abbas I (r. 1588–1629). The position of his arms suggests he is patiently and respectfully awaiting his master. Named in the inscription in the left-hand border as Shahzada Muhammad Beg of Georgia, he was very likely a *ghulam*, or military slave of Georgian origin.[1] Such individuals were often presented as gifts to the shah, converted to Islam, and freed; utterly loyal to the ruler, they were given key military and administrative posts, constituting a new corps of non-Iranian elite.[2] SW

1 Canby, Rebellious Reformer, 147, 149, 197, and see also 153, for a related painting perhaps of the same individual but depicted as a ghulam.
2 Babaie et al., Slaves of the Shah, 6–7, 21.

217
Bowl with Giraffe
Egypt, 11th century
Earthenware, overglaze luster-painted
9 3/8 x 3 1/8 in. (24 x 8 cm)
Benaki Museum, Athens (749)
Los Angeles only
Fig. 102

Like other contemporary lusterwares from the Fatimid period in Egypt (969–1171), the scene depicted on this bowl exhibits a degree of naturalism and close attention to detail.[1] The central figure of the giraffe is accurately rendered, while the artist makes clear that this is a special beast, as indicated by its decorative blanket and the fact that it is led by a smartly dressed groom. Perhaps this was a royal gift (e.g., cat. nos. 218–21), not unlike the giraffe sent to the Fatimid court from Nubia in the year 993 (see Jonathan Bloom's essay in this volume) or the one replete with saddlecloth presented by the caliph to the ruler of North Africa.[2] LK

1 Philon, Early Islamic Ceramics, 220.
2 In a lengthy encomium on the latter giraffe, the contemporary poet Ibn Rashiq refers to it as being the property of kings; see Qaddumi, trans., Book of Gifts and Rarities, 105–7.

218–19

Timur Receiving Gifts from the Egyptian Ambassadors

Double-page composition from a manuscript of the *Zafarnama* of Sharaf al-Din 'Ali Yazdi
Iran, Shiraz, AH Dhu'l-Hijja 839/July 15–16, 1436
Ink, opaque watercolor, and gold on paper

218

Right-hand folio (fol. 400a)
Approx: 13 ¼ x 9 ⅝ in. (33.6 x 24.5 cm)
Keir Collection, England (PP5)
Fig. 100

219

Left-hand folio (fol. 399b)
13 ¼ x 9 ⅝ in. (33.6 x 24.5 cm)
Worcester Art Museum (1935.26)
Fig. 99

This remarkable double-page composition, now divided between two collections, comes from a dispersed manuscript of the *Zafarnama* made for the Timurid prince Ibrahim Sultan.[1] It recounts the exploits of his grandfather Timur (r. 1370–1405), a Central Asian warlord who carved out a vast empire from Baghdad to the Hindu Kush, with Samarqand as its capital. The event depicted here is not only related in the text it illustrates but also described in the more contemporaneous account of Ruy González de Clavijo, an ambassador from the Castilian court, who was an eyewitness.

According to Clavijo, Timur received the Egyptian embassy in early June 1404, in the city of Khoy (in northwestern Iran), where the Spanish ambassador had lately arrived. He noted that the Egyptian entourage brought presents from their sultan to Timur that included six ostriches and a giraffe. Although Clavijo elsewhere renders vivid and often awestruck accounts of the ceremonial at Timur's court, it was clearly the giraffe that caught his attention here. Having never seen a giraffe before, Clavijo described it in great detail and concluded "this beast is indeed a wondrous sight to behold."[2] In the painting, this distinctive animal is led by its groom; other gifted giraffes, rendered in a variety of media and from diverse times and places, are depicted in the same manner (cat. nos. 217, 220–21). LK

1 Sims, "Ibrahim-Sultan's Illustrated *Zafarnama*."
2 Clavijo, *Embassy to Tamerlane*, 149–51.

220

Giraffe with Attendant

China, Ming dynasty (1403–34)
Ink and colors on silk, mounted as a hanging scroll
31 ½ x 16 in. (80 x 40.6 cm)
Philadelphia Museum of Art, gift of John T. Dorrance, 1977 (1977-42-1)
Fig. 106

The giraffe immortalized in this scroll was presented by Sayf al-Din Hamza Shah of Bengal (r. 1410–12) to the Yongle emperor (r. 1402–24) in 1414, just a decade after the Mamluks had offered a giraffe to Timur (see cat. nos. 218–19).[1] It is likely that Sayf al-Din first acquired the animal as an accession gift from the ruler of Malindi (in modern-day Kenya).[2] Like other giraffes presented to the Ming (see Ralph Kauz's essay in this volume), this example was considered a *qilin*, a mythical beast that signified the ruler's benevolence.[3] This painting is one of several copies of a lost original, some of which were perhaps gifts from the Yongle emperor to his high ministers.[4] KO

1 Church, "Giraffe of Bengal," 1–3.
2 Ibid., 24; Ringmar, "Audience for a Giraffe," 390–91.
3 Church, "Giraffe of Bengal," 21–24.
4 Liscomb, "Foregrounding the Symbiosis of Power," 146. There is another copy in the National Palace Museum in Taiwan; see Church, "Giraffe of Bengal," fig. 2.

221

Miniature Theater

England, c. 1827–70
Etching, hand colored
Closed (in slipcase): 5 ¾ x 4 ⅞ x ¼ in. (14.5 x 12.5 x 0.8 cm)
Object (unfolded): 5 ⅝ x 4 ¾ x 22 ⅞ in. (14.2 x 12 x 58 cm)
Getty Research Institute, Los Angeles (1561-058; 2000.R.16)
Fig. 264

Miniature theaters, or "peepshows," were a popular and affordable form of entertainment for nineteenth-century Europeans. In this example, a giraffe and her African grooms are paraded before curious onlookers in the Jardin des Plantes in Paris. This giraffe was a gift from the viceroy of Egypt, Muhammad 'Ali, to Charles X of France (r. 1824–30) in 1827.[1] The exotic gift caused a sensation, for such an animal had not been seen in Europe since the one given by the Mamluk sultan of Egypt to Lorenzo de' Medici in 1486.[2] Fascination with Charles X's giraffe has persisted for generations, as she has been the subject of several children's books, most recently one by an American author.[3] KO

1 Ringmar, "Audience for a Giraffe," 383–89. Muhammad 'Ali also sent giraffes to George IV (r. 1820–30) and Francis I of Austria (r. 1804–35).
2 Ibid., 378–83.
3 Allin, *Zarafa*.

222

Dara Shikoh Riding the Imperial Elephant, Mahabir Deb

India, c. 1635–50
Tinted brush drawing with gold details
12 7/8 x 16 in. (32.5 x 40.9 cm)
Victoria and Albert Museum, London (IM 23-1928)
Fig. 97

223

Dara Shikoh Riding an Albino Elephant

India, c. 1628–30
Opaque watercolor on paper
9 3/4 x 13 1/2 in. (24.6 x 34.3 cm)
Museum of Islamic Art, Doha (MS 51)
Fig. 3

The earliest recorded instance of an elephant being gifted to or from an Islamic court dates to the turn of the ninth century, when the Abbasid caliph Harun al-Rashid sent an albino elephant to the Carolingian ruler Charlemagne.[1] During the seventeenth century, indigenous elephants were frequently exchanged between rival courts of the Indian subcontinent. The Mughals, for instance, received many of their prized elephants from courts in the Deccan (see fig. 154, cat. no. 33 a–b).

The inscription on this drawing confirms that a hierarchical relationship existed between the elephant's Deccani donor and its Mughal recipient. It describes the elephant as "tribute of the ʿAdil Khan" (*pishkash-i ʿAdil Khan*) rather than "ʿAdil Shah," the more august title used by the Bijapuri ruler at home. It also records the elephant's value as three hundred thousand rupees, a substantial but not surprising sum for such a magnificent animal.[2] The elephant was clearly beloved at the Mughal court, for its mahout, or driver, is the young Mughal prince Dara Shikoh.

In the finished painting, Dara Shikoh is again the elephant's mahout. Like the example presented to Charlemagne, this elephant is an albino and must have been appreciated as especially rare. Unlike the drawing,

Fig. 264, cat. no. 221

Fig. 265, cat. no. 224

this painting does not include any inscriptions that confirm the elephant's status as a gift. Nonetheless, since the animal is covered in rich textiles and jewels and was the subject of a documentary painting, it is likely that it originally arrived at the Mughal court as a gift, perhaps from the Deccan. KO

1 Brubaker, "Elephant and the Ark," 176.
2 Stronge, *Painting for the Mughal Emperor*, 165–66.

224
Tiger Attacking a Youth
Muʻin Musavvir
Iran, Isfahan, AH 8 Shawwal 1082/February 8, 1672
Ink on paper
5 1/2 x 7 7/8 in. (14 x 20 cm)
Museum of Fine Arts, Boston, Francis Bartlett Donation of 1912 and Picture Fund (14.634)
Fig. 265

According to the artist's inscription at the top of this dramatic drawing, in 1672 the ambassador of Bukhara brought a rhinoceros and a tiger to Isfahan as gifts for Shah Sulayman (r. 1666–94). As it passed the royal gateway, the tiger attacked a grocer's young assistant, tearing off half of his face.[1] In spite of the gruesome nature of the description, it establishes that such exotic animals, like the zebra sent to Shah ʻAbbas in 1621 (see fig. 267, cat. no. 226), continued as gifts to the Iranian court. In fact, in the time of Shah Sulayman rare and often dangerous species were exhibited and paraded at certain royal events.[2] LK

1 Farhad, "An Artist's Impression," 117.
2 Ibid., 118. See also Babaie, *Isfahan and Its Palaces*, 236.

225
The Lion of Barbarossa
Illustration for *L'Histoire des Rois de France*
Antoine Caron (c. 1520–99)
France, c. 1562
Ink and brown wash on paper
16 1/8 x 21 7/8 in. (41 x 55 cm)
Musée du Louvre, Paris (RF 29. 752 12)
Los Angeles only
Fig. 266

During the early sixteenth century, France and Turkey shared a common enemy: the Hapsburgs. As a result, the two powers entered into an alliance and gifts were exchanged. In 1533 the Ottoman admiral Barbarossa Hayreddin presented Francis I (r. 1515–47) with a lion. As was often the case with prized animals (cat. nos. 226 and 232), the lion was soon regifted to another recipient, Pope Clement VII. In this drawing, Francis I offers the

Fig. 266, cat. no. 225

pope a tapestry while an attendant presents the lion to a cardinal.[1] This exchange took place just three months after Francis had received the lion from Barbarossa. KO

1 Bernus-Taylor, *Soliman le Magnifique*, 31; Ehrmann, *Antoine Caron*, 91–93, fig. 80.

226
Zebra
Album page
Mansur
India, AH 1030/1621
Ink, opaque watercolor, and gold on paper
10 ½ x 15 ¼ in. (26.7 x 39 cm)
Victoria and Albert Museum, London (M.23-1925)
Fig. 267

The presentation of rare and exotic animals represented an especially grand gesture in royal gift giving (see cat. nos. 218–21, 224–25, 232). This famous portrayal of a zebra, commissioned by Jahangir (r. 1605–27) and painted by one of his chief artists, commemorates the receipt of one such gift.[1] According to the inscription running down the right side, the zebra was presented to the emperor by Mir Ja'far, who obtained it from Turks traveling from Africa.[2] Completely fascinated by the animal, the likes of which he had never seen before, Jahangir decided to regift it. As he noted in his memoirs, "Since it was so rare it was included among the gifts for my brother Shah 'Abbas."[3] SW

1 Shifman and Walton, eds., *Gifts to the Tsars*, 85.
2 Stronge, *Painting for the Mughal Emperor*, 135.
3 Thackston, trans., *Jahangirnama*, 360.

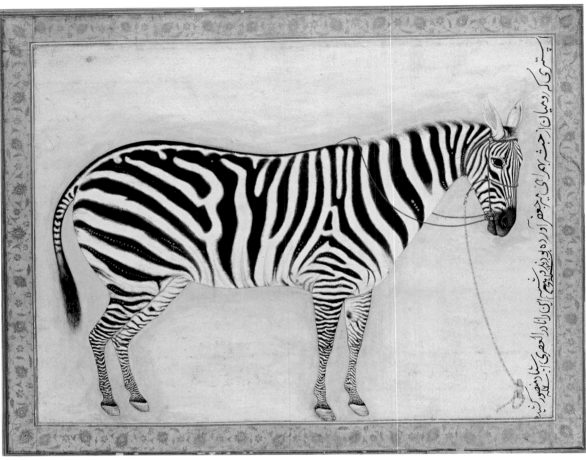

Fig. 267, cat. no. 226

227
Handscroll Depicting Tribute Bearers
Ren Bowen (Ren Renfa)
China, Yuan dynasty, c. 1320–68
Ink and colors on silk
15¾ x 206½ in. (40 x 524.5 cm)
The Asian Art Museum, Avery Brundage Collection,
San Francisco (B60D100)
Los Angeles only
Fig. 105

From the Chinese perspective little distinction was made
between a gift and tribute, but either way, horses were what
they most wanted and frequently received from western
lands. Although horses were brought to China from the
West long before this handscroll was painted, it belongs
to a period of numerous gift-bearing embassies, especially
from Iranian lands.[1] The horses in the painting are pre-
sented to the imperial court by envoys that are clearly
identified as foreigners on account of their facial features,
coloring, and clothes.[2] The picturesque procession bears
other gifts, including an incense burner and a statue of a
lion. (See Ralph Kauz's essay in this volume.) LK

1 See Barthold, *Four Studies*, vol. 2, 48–49.
2 Sung, *Decoded Messages*, cat. no. 70, and for a discussion of horse painting with
an emphasis on the Yuan and especially Ming dynasties, 171–206.

228
Horse and Groom
Attributed to 'Abd al-Samad
Iran, Tabriz, c. 1530s
Ink, opaque watercolor, and gold on paper
3¾ x 5½ in. (9.5 x 14 cm)
Los Angeles County Museum of Art, the Edwin Binney
3rd Collection of Turkish Art (M.2010.54.2)
Fig. 22

229
A Royal Stallion
Kamal al-Din Husayn ibn Hasan
Iran, Tabriz, mid-16th century
Ink, opaque watercolor, and gold on paper
10⅜ x 15⅞ in. (26.5 x 40.2 cm)
Museum of Islamic Art, Doha (MS 652.2008)
Fig. 104

Given the significance of the horse in the premodern era, it is not surprising that such animals are referenced in numerous texts as a preferred type of gift at the Islamic courts (see cat. nos. 197, 230–31). For example, an eleventh-century Fatimid caliph in Cairo sent the ruler of the Maghrib (North Africa) "expensive thoroughbred [Arabian] race horses with marvelous qualities."[1] Horses were likewise an important type of diplomatic gift in Iran, as is noted in a late-twelfth- or early-thirteenth-century manual on statecraft.[2] In Timurid (see Ralph Kauz's essay in this volume) and Safavid Iran especially, references abound to the giving and receiving of horses, mainly Arabians.[3] Not only were they diplomatic gifts, but horses were exchanged between the ruler and members of his court. Whether the horses were state or personal gifts, there is a significant visual record from the Safavid period that helps support the textual evidence.

By the sixteenth century, a tradition existed for depicting royal horses either with or without their grooms for inclusion in albums. That these are prized horses is not only demonstrated by the fact that they have been singled out as the subject of a painting but because they are generally covered, as here, by decorative blankets and other elegant fittings. In addition, the well-dressed little groom in the painting ascribed to 'Abd al-Samad, who produced several other works on the same theme,[4] wears the distinctive headdress associated with the early Safavid court. The tethered and hobbled stallion by Kamal al-Din Husayn perhaps awaits his groom or even a royal rider.[5] LK

1 Qaddumi, trans., *Book of Gifts and Rarities*, 105–6.
2 *Adab al-Harb wa'l-Shaja'a*, cited in *Encyclopaedia Iranica*, vol. 10, 606.
3 From Islamic, European, and Chinese sources: one of the best known such gifts is the one recorded as being sent from the Timurid Shah Rukh to the emperor of China; see Fletcher, "China and Central Asia," 213. Shah 'Abbas received three thousand young stallions and mares in thanks from the Bayat tribe; see Monshi, *History of Shah 'Abbas*, vol. 2, 646, and for numerous other references to gift horses, see Matthee, "Gift Giving," 610–12.
4 Canby, "Horses of 'Abd us-Samad." P. Soucek, "Persian Artists in Mughal India," 170, has proposed that this artist painted horses that were *Nawruz* or New Year's gifts.
5 On the notion of keeping royal horses in readiness, see Babaie, *Isfahan and Its Palaces*, 162, and fig. 5.22 for an early-eighteenth-century engraving of a court ceremonial event with gift horses paraded by their grooms.

230
Horse and Groom

India, Bijapur, c. 1590
Watercolor and gold on paper
15¾ x 10⅝ in. (40 x 27 cm)
Victoria and Albert Museum, London (IS.88-1965)
Fig. 41

231
Horse and Groom

Attributed to 'Abd al-Samad
India, c. 1580–85
Ink drawing with red and gold highlights on paper
Painting: 6 x 7⅜ in. (15 x 18.8 cm); page: 9⅜ x 14¼ in.
(23.6 x 36 cm)
Musée Guimet, Paris (3619 L A)
Los Angeles only
Fig. 155

During the late sixteenth century, the Mughals set their sights on conquering the Deccan, a plateau region of southern India with abundant natural resources, including diamond mines. In order to appease the powerful northern empire, Deccani kingdoms regularly offered the Mughals gifts of horses, elephants, and jewels (fig. 97, cat. no. 222). During his mission to Bijapur in 1603–4, the Mughal envoy Asad Beg witnessed the addition of "a beautiful Arab horse to the presents already prepared for the Emperor. This horse was all black and was considered a rarity and Ibrahim [Ibrahim 'Adil Shah II] had paid 3,000 hons for it."[1] Although this horse is certainly not the example described by Asad Beg, its abundant gold and bejeweled trappings suggest that it too was an esteemed example from Ibrahim's royal stable. Since it was common for the Mughals to demand animals that were favored by the Bijapuri ruler, it is plausible that this horse may have been requested as tribute (*pishkash*).[2]

Although similar in composition, the style of the Mughal drawing differs significantly from that of the Bijapuri painting. It has been attributed to 'Abd al-Samad, a Persian artist who joined Humayun's entourage in 1549 and continued to create horse and groom images comparable to those he made in Tabriz (see cat. no. 228).[3] It is likely that some of 'Abd al-Samad's horse paintings were presented to Akbar as New Year's gifts, for one example is dated AH Nawruz 965/March 1558.[4] KO

1 Joshi, "Asad Beg's Mission to Bijapur," 193.
2 Ibid., 192.
3 Canby, "Horses of 'Abd us-Samad," fig. 6.
4 P. Soucek, "Persian Artists in Mughal India," 170.

232
The Rhinoceros
Albrecht Dürer (Germany, Nuremberg, 1471–1528)
Germany, Nuremberg, 1515
Woodcut
Image: 8³⁄₈ x 11⁵⁄₈ in. (21.3 x 29.5 cm) trimmed to block line
except at top
The Metropolitan Museum of Art, New York (19.73.159)
Fig. 126

This rhinoceros was originally a gift from Sultan Muzafar II
(r. 1511–26), the ruler of Gujarat, to Alfonso d'Albuquerque,
governor of Portuguese India.[1] The animal was soon trans-
ported to Lisbon as a gift to the king of Portugal, Manuel I
(r. 1495–1521), who in turn sent the animal to Pope Leo X
in Rome in 1515, but it drowned during a shipwreck. This
woodcut by Dürer was based on the artist's drawing of the
rhinoceros, which was likely inspired by a description and
sketch of the beast in a Portuguese newsletter.[2] The text
above describes the animal's origins in India and its supe-
riority over the elephant.[3] KO

1 Bartrum, Albrecht Dürer, 285.
2 For Dürer's drawing, see ibid.
3 Ibid., 285–87.

233
Siegmund von Herberstein Dressed in the Khil'a Robe He Received from Süleyman I
Attributed to Johann Lautensack
Vienna, 1560
Woodcut in von Herberstein's Gratae posteritati
11⁷⁄₈ x 8 x ⁵⁄₈ in. (30 x 20.2 x 1.4 cm)
Victoria and Albert Museum, London (L.482-1880)
Fig. 8

Siegmund von Herberstein (1486–1566) was the ambassador
of three Holy Roman Emperors: Maximilian I (r. 1508–19),
Charles V (r. 1519–58), and Ferdinand I (r. 1558–64). In
1560 he published his memoirs, which included six wood-
cuts depicting him dressed in robes worn during missions
to Poland, Russia, Spain, and Turkey.[1] This print shows
him clothed in the robe he received from Süleyman in 1541,
which consisted of an inner caftan of Turkish velvet and
an outer one of Italian velvet.[2] The tradition of depicting
individuals dressed in gifted robes did not begin or end
with Herberstein. Precedents exist in fourteenth-century
Persian painting, and subsequent European ambassadors,
including Robert Sherley and Jean-Baptiste Tavernier,
commissioned comparable portraits.[3] KO

1 Atasoy et al., Ipek, 33.
2 A nearly identical Italian velvet is preserved in the Victoria and Albert Museum.
See Wearden, "Siegmund von Herberstein," fig. 2.
3 For the Ilkhanid painting, see Gordon, Robes and Honor, fig. 8.1, 202. For
portraits of Sherley and Tavernier, see Canby, Shah 'Abbas, 56, and Alam and
Subrahmanyam, Indo-Persian Travels, 354.

234
Textile Fragment with Simurgh
Iran, 8th–9th century
Silk, samite
14³⁄₈ x 21³⁄₈ in. (36.5 x 54.3 cm)
Victoria and Albert Museum, London (8579-1863)
Fig. 85

The simurgh is an ancient Iranian winged creature with
dog head, lion paws, and peacock tail. Although this
mythical beast was a common motif in the courtly art of
the pre-Islamic Sasanian dynasty (224–751), it also seems
to have occurred in the early Islamic period, as here. A
nearly identical design forms the repeat pattern of a fur-
lined silk robe of similar date and provenance in the
Hermitage; such elaborate garments were an important
type of diplomatic gift in the early Islamic period.[1] While
this fragment once may have been part of an honorific
robe, it survived as a wrapping for a relic in a church trea-
sury in Paris.[2] LK

1 Ettinghausen et al., Islamic Art and Architecture, 125–26, for the Hermitage robe;
Qaddumi, trans., Book of Gifts and Rarities, 101, for a fur-trimmed coat given by the
Byzantine emperor.
2 Stanley, Palace and Mosque, 20.

235–36
Two Textile Fragments

235
China, late 13th–early 14th century
Silk, damask design
20¹⁄₂ x 15³⁄₄ in. (52 x 40 cm)
The State Hermitage Museum, St. Petersburg (LT-449)
Houston only
Fig. 108

236
China, Central Asia, or Egypt, early 14th century
Silk
19³⁄₈ x 11³⁄₈ in. (49 x 29 cm)
The State Hermitage Museum, St. Petersburg (EG-905)
Los Angeles only
Fig. 109

In medieval times, silk textiles were one of the most cov-
eted of luxury goods in the lands west of China. Following
the Mongol invasions of the late twelfth and early thir-
teenth centuries and the establishment of the so-called
pax mongolica (Mongol peace) under the descendants of
Genghis Khan, silk goods became more accessible. Of equal
concern, such textiles had a crucial part in the diffusion of
artistic ideas from East to West as is suggested here by the
ambiguity in the provenance of one of the textiles (cat. no.
236).[1] Iran, which was ruled by the Mongol Ilkhans, had

a key role in the transmission process. For example, Chinese-inspired cloth was woven in the Ilkhanid capital of Tabriz as a diplomatic gift to the Mamluk court in Egypt in the late thirteenth century.[2] In 1323, following the conclusion of a peace treaty with the Mamluks, the Ilkhan Abu Sa'id (r. 1317–35) is said to have sent seven hundred silks to Sultan Nasir al-Din Muhammad (r. 1293–1341, with interruptions), some inscribed with the sultan's name and titles. Indeed, the smaller of the two fragments here is inscribed with the name of this Mamluk sultan; it is certainly possible that both of these silks were among the gifted textiles from the Ilkhan.[3] LK

1 See, for example, the groundbreaking study by Wardwell, "*Panni Tartarici:* Eastern Islamic Silks," esp. 100–101.
2 Komaroff and Carboni, eds., *Legacy of Genghis Khan*, 173, 184.
3 The reference is from Abu'l-Fida, ibid., 260, cat. no. 71, for another silk inscribed with the name Nasir al-Din Muhammad. See also Piotrovsky and Pritula, eds., *Beyond the Palace Walls*, 97, nos. 94 and 96.

237
Nushirvan Receives Mihras, the Envoy of Caesar
Folio from the so-called first Small *Shahnama* (Book of Kings)
Northwestern Iran or Baghdad, c. 1300–1330
Ink, colors, gold, and silver on paper
$7\frac{1}{2}$ x $5\frac{1}{4}$ in. (19 x 13.2 cm)
The Metropolitan Museum of Art, New York, purchase, Joseph Pulitzer Bequest, 1934 (34.24.3)
Fig. 71

238
Necklace with Pendant
Byzantine, 7th century
Gold
$21\frac{3}{4}$ in. (55 cm)
The Metropolitan Museum of Art, New York (17.190.1656)
Fig. 70

This enthronement scene from a dispersed manuscript of the *Shahnama* (Book of Kings) includes some elements specific to the text and others that relate to the historical context in which the painting was produced. The Byzantine emperor, known generically as "Caesar" in the Iranian national epic, was concerned about the possibility of an invasion by the powerful armies of the Sasanians and sent an embassy to Shah Nushirvan headed by his general Mihras, who brought with him a letter of conciliation and lavish gifts, and a peaceful agreement was eventually concluded. In the illustration, the letter and the gifts in the form of gold cups are clearly visible at the foot of Nushirvan's throne. Appropriately enough, the Byzantine ambassador is depicted with a large cross, while the shah and his attendants are recast in the guise of the Mongols, who ruled Iran when this version of the *Shahnama* was produced.

Among the genre of Arabic literature on gifts and rarities is an eleventh-century work that lists some of the gifts exchanged between Byzantine emperors and the Sasanian shahs and later by the Islamic caliphs. The text indicates that gold and golden objects were a frequent gift type as were jewelry, jewels, and pearls.[1] Gold jewelry such as this necklace with its elaborately decorated medallions and pendants helps to give an idea of the splendor that once passed from the courts of Byzantium to the Middle East.[2] LK

1 Qaddumi, trans., *Book of Gifts and Rarities*, 62–63, 65, 99–100.
2 See Yeroulanou, *Diatrita*, 207. For slightly later examples of Byzantine gold jewelry more contemporaneous with the eleventh-century text, see Evans and Wixom, eds., *Glory of Byzantium*, 243–49.

239
Portrait of Mehdi Quli Beg, Persian Ambassador to Prague
Aegidius Sadeler (Netherlands, c. 1568–1629)
Netherlands, c. first quarter of the 17th century
Engraving
$10\frac{1}{2}$ x $7\frac{3}{8}$ in. (26.7 x 18.7 cm)
The Metropolitan Museum of Art, New York (49.95.2202)
Fig. 124

This engraving depicts Mehdi Quli Beg, Shah 'Abbas's ambassador to Rudolph II in 1604. The legend at the bottom of the print includes the Latin phrase "ad vivum," which suggests that it was based on a portrait drawn from life.[1] In the Persian inscription above it, which is written in the first person, Mehdi Quli Beg describes himself as the envoy (*ilchi*) of Shah 'Abbas to "Emperor Rudolph." It is likely that this inscription was inspired by a similar notation on a painted portrait of Mehdi Quli Beg, which was written by the envoy himself.[2] KO

1 It is plausible that a miniature on vellum identified as a "Portrait of a Turkish Gentleman" is in fact the original portrait in question. See Sotheby & Co., *Western, Oriental and Hebrew Manuscripts and Miniatures*, lot 267.
2 P. Baker, "Wrought of Gold or Silver," 165, fig. 6, and Christie's, *Art of the Islamic and Indian Worlds*, lot 250. The inscription on this gouache painting on vellum, which is dated AH Rajab 1013/November–December 1604, is slightly different from that on Sadeler's engraving.

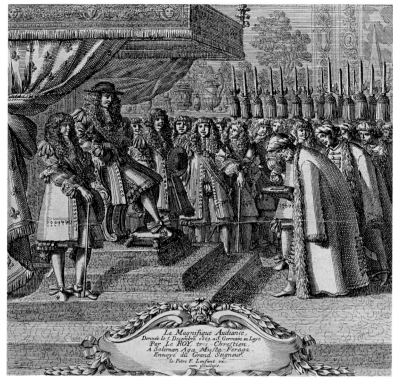

Fig. 268, cat. no. 240

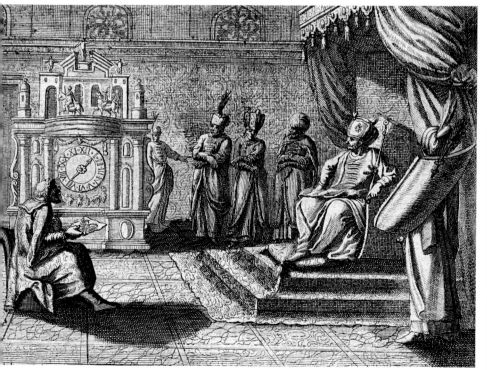

Fig. 269, cat. no. 241

240

The Magnificent Audience

Designed by Jean Lepautre (1618–1682)
Engraved by Jean Lenfant (c. 1615–1674)
France, first state, c. 1670
Etched engraving
9⅝ x 9⅝ in. (24.4 x 24.4 cm)
Bibliothèque nationale de France, Paris, Cabinet des
Estampes (Qb-1 [05-12-1669] Fol. M-92640)
Los Angeles only
Fig. 268

This print depicts the audience granted by Louis XIV
(r. 1643–1715) of France to Süleyman Ağa, envoy of the
Ottoman sultan Mehmed IV (r. 1648–87).[1] The event took
place in 1669 at the chateau of Saint-Germain-en-Laye.
For the occasion, Louis XIV inaugurated a new method of
receiving ambassadors. As seen in the print, the seated
king welcomed the envoy from a throne placed at the far
end of a gallery. The king's refusal to stand to receive him
angered Suleyman Ağa, who had waited several months
to present Mehmed IV's letter. A print similar to this one
was published in a French almanac of 1670.[2] KO

1 Aubaile-Sallenave, *Topkapi à Versailles*, 322; Weigert and Préaud, *Inventaire du fonds français*, 136.
2 Weigert and Préaud, *Inventaire du fonds français*, 156.

241

Rudolph II's Envoy Presents a Clock
to Sultan Murad III

Engraving in a manuscript of *Die Neu-eröffnete
Ottomannische Pforte*
Germany, Augsburg, 1694
Engraving after Johann Andreas Thelot (1655–1734)
Folio: 13 x 8 in. (33 x 20.3 cm); image: 4⅜ x 5¾ in.
(11 x 14.5 cm)
Charles E. Young Research Library, University of California,
Los Angeles, Library Special Collections (DR 473 R96pG,
fol. 288)
Fig. 269

In 1547 the Ottomans and Hapsburgs signed the Treaty of
Edirne, which stipulated a five-year armistice between the
powers.[1] Thereafter, clocks became a standard component
of the annual tribute given by the Hapsburgs to the Porte.[2]
In this engraving, the envoy of Rudolph II (r. 1576–1612)
presents Murad III (r. 1575–95) with an enormous clock.[3]
Like the engraving, the clock was probably produced in
Augsburg, where Europe's leading clockmakers were regu-
larly commissioned to fabricate custom-made pieces for
the Ottomans. The pictured clock was certainly intended for
an Ottoman, for it includes a sultan on horseback parading
before a palace with two minaret-like forms.[4] (See cat. no.
247 for reference to a gift from Murad to Rudolph.) KO

1 Necipoğlu, "Süleyman the Magnificent," 416, suggests that to commemorate this momentous treaty Sultan Süleyman presented his gold Venetian helmet as a gift to Ferdinand I, then king of Hungary.
2 Mraz, "Role of Clocks," 37.
3 Kurz, European Clocks, 33–34.
4 A clock of comparable size and shape is preserved in Augsburg's Maximilian Museum; see ibid., fig. 19.

242
Catherine Receives the Ottomans

Russia, St. Petersburg, c. 1762–64; printed 1857
Original drawing by Jean Louis de Veilly (1762–63)
Engraving
26 1/4 x 32 3/4 in. (10.3 x 12.9 cm)
Rare Book Division, the New York Public Library, Astor, Lenox and Tilden Foundations
Fig. 176

Under Catherine the Great (r. 1762–96), the Russians fought two wars against the Ottomans (1768–74 and 1787–92). In order to avoid or to conclude hostilities, there were frequent diplomatic missions that brought gifts to placate or else to commemorate important peace treaties. This engraving depicts Catherine receiving an embassy from Sultan Mustafa III (r. 1757–74) in October 1764 in St. Petersburg's Winter Palace.[1] While the first envoy bows before the seated empress, the second appears to offer her something, perhaps a letter or his credentials. Although this image does not depict any gifts, we know that Catherine and her Ottoman contemporaries exchanged notable presents, such as the magnificent tent that was presented to the empress by an envoy of Sultan Selim III (r. 1789–1807) in 1793 (cat. no. 243). KO

1 Whittaker et al., Russia Engages the World, 77.

243
Tent (Four of Eleven Sections)

Turkey, late 18th century
Silk embroidered with gold, silver, and colored silk thread, over woolen cloth and canvas
Cupola height: 9 7/8 ft. (300 cm); wall height: 8 1/4 ft. (250 cm)
The State Hermitage Museum, St. Petersburg
(VT-1605/2, 4, 9, 10)
Fig. 270

On military campaigns, the Ottomans established a veritable portable city, with the royal enclosure, its walls of rich fabric rather than stone, at its center. In war and peace opulent tents, large enough to have multiple chambers, were used as a spectacular setting for court ceremonial.[1] Such tents were also a frequent type of gift exchanged at the Islamic courts and beyond. This remarkable example was presented to Catherine the Great (r. 1762–96) in 1793 on behalf of Sultan Selim III (r. 1789–1807) after the signing of the treaty concluding the second Russo-Turkish

war (1787–92).[2] The use of the colors red and yellow and the fact that it is decorated with embroidery in gold- and silver-wrapped thread indicate that this tent was made for the highest levels of the Ottoman court and therefore a fitting gift for Russian royalty. LK and GAS

1 On Ottoman tents, see Atasoy and Taşkın, Otağ Humayun.
2 Forbes and Underhill, eds., Catherine the Great, 177–79.

244
Bowl

Turkey, Istanbul, first third of the 17th century
Nephrite (jade), gold, emeralds, rubies, and sapphires
H. 4 7/8 in. (12.2 cm); diam. 5 3/4 in. (14.5 cm)
The State Historical-Cultural Museum Preserve, Moscow Kremlin (DK-267)
Los Angeles only
Fig. 141

245
Writing Set

Turkey, 17th century
Inkwell: lazurite, inlaid with gold and set with rubies, diamonds, and pearls; pen case: gold covered by green enamel and set with precious stones
H. 2 7/8 in. (7 cm); l. 10 5/8 in. (27 cm)
The State Historical-Cultural Museum Preserve, Moscow Kremlin (MV-41)
Los Angeles only
Fig. 271

246
Ladle

Turkey, 17th century
Gold, rock crystal, silver, precious stones, and pearl
9 3/8 in. (23.5 cm)
The State Historical-Cultural Museum Preserve, Moscow Kremlin (MV-38)
Los Angeles only
Fig. 272

These three richly jeweled objects were presented to the Russian court in association with several diplomatic embassies from Sultan Murad IV (r. 1623–40). The spectacular bowl was a gift to Tsar Mikhail Fedorovich (r. 1613–45) from Georgios Panagiotis, an Orthodox Christian subject of the sultan, who had accompanied his ambassador to Moscow in 1632.[1] There is less certainty as to when the writing set, consisting of an inkwell and pen case, reached the Russian court. It may be the one that was presented in an embassy of 1631–32, or it may have arrived at a later date.[2] The leaf-shaped ladle came in 1634 with the Turkish ambassador 'Ali Ağa.[3]

All three objects are related to similar pieces made in the imperial workshops of Istanbul. There is an analogous though less extravagant jeweled nephrite cup in the Louvre, which was part of the French royal collection and was perhaps a diplomatic gift.[4] The writing set, with its use of the blue mineral lazurite for the inkwell, and green enamel over gold for the pen case, represents a well-known combination of forms that is less common in such precious materials; however, jeweled pen boxes of rock crystal or jasper, with internal inkwells, are preserved in the Treasury of the Topkapi Palace.[5] A jewel-encrusted rock-crystal ladle also in the Treasury is comparable in form to the example here.[6] That such Ottoman objects were recognized as treasures of the Russian state is demonstrated by their depiction in albums such as the one published for Nicholas I, in 1849–53 (see cat. nos. 249–53). LK and OBM

1 Arthur M. Sackler Gallery, Smithsonian Institution, *Tsars and the East*, 92.
2 Ibid., 101. Shifman and Walton, eds., *Gifts to the Tsars*, 191. Vishnevskaia et al., *Treasures of the Armoury*, 225.
3 Vishnevskaia et al., *Treasures of the Armoury*, 216–17.
4 Aubaile-Sallenave, *Topkapi à Versailles*, 284.
5 For the late-sixteenth-century rock-crystal example, see Köseoğlu, *Topkapi Saray Museum*, 198. For a similarly shaped silver ladle, dated 1577–78 and made for a water fountain, see Petsopoulos, ed., *Tulips, Arabesques & Turbans*, 44.
6 Ibid., 198: the rock crystal is of Mughal origin.

247
Flask
Turkey, first half of the 17th century
Leather, silk, nephrite (jade), silver, gold, rock crystal, rubies, emeralds, stones, silver thread, and glass
$10\,7/8$ x $8\,1/2$ in. (27.5 x 21.5 cm)
The State Historical-Cultural Museum Preserve, Moscow Kremlin (ТК-2882)
Los Angeles only
Fig. 273

248
Helmet
Turkey, first third of the 17th century
Damascene steel, silver, and silk fabric
Diam. $8\,3/4$ in. (22 cm)
The State Historical-Cultural Museum Preserve, Moscow Kremlin (OR-163)
Los Angeles only
Fig. 274

Fig. 270, cat. no. 243

1 See Köseoğlu, *Topkapi Saray Museum*, 196–97, nos. 49 and 56.
2 Arthur M. Sackler Gallery, Smithsonian Institution, *Tsars and the East*, 66–67.
3 Atil, *Age of Sultan Süleyman*, 165; see also Köseoğlu, *Topkapi Saray Museum*, 196.
4 See Köseoğlu, *Topkapi Saray Museum*, 193, pl. 38, for a very similar late-sixteenth-century bejeweled example.
5 Zygulski, *Ottoman Art in the Service of Empire*, 143. For another related helmet in the Kremlin Armoury, see Vishnevskaia and Levykin, *Art of the Sublime Porte*, 48–49.

249–53
Bowl, Flask, Helmet, Writing Set, Shield
Five Folios from the *Drevnosti rossiiskago gosudarstva*
Fedor Grigor'evich Solntsev (Russia, 1801–1892)
Russia, published 1849–53
Chromolithographs
19⅞ x 14 in. (7.8 x 5.5 cm)
Rare Book Division, the New York Public Library, Astor, Lenox and Tilden Foundations
Figs. 183–86, 275

During the nineteenth century, Russian artists created a number of lithographs and chromolithographs pertaining to gifts received by the tsars, including those from Islamic courts. Both of these printmaking processes required the artist to draw his design directly onto a stone. In chromolithography, however, multiple stones were used to produce colored images like these five, which belong to a six-volume publication that documents the collection of the Kremlin Armoury and was financed by Nicholas I (r. 1825–55). The artist responsible for these images, Fedor Solntsev, was commissioned by Nicholas I for a number of artistic projects, many of which, like the albums, affirmed the legitimacy of the Romanov dynasty through its association with a heroic imperial past.[1] Although presented at an earlier date, the Islamic gifts represented in the albums had the effect of reaffirming Russian imperial authority.

Each of these chromolithographs depicts an Ottoman or Safavid gift included in the exhibition catalogue. With the exception of the nephrite bowl (figs. 141 and 183), the Islamic gifts are the only object on the page. Each is depicted with meticulous detail, from multiple perspectives, and in a variety of colors. The writing set (fig. 271), for example, is rendered in color and grisaille (fig. 186), and both the interiors and exteriors of individual components, such as the ink pot, are visible. Similarly, the flask (figs. 273 and 184) is represented from front, side, and top. Some of the chromolithographs also include a caption that documents the history of the gift. The caption on the shield (figs. 275 and 115), for example, reads, "Shield of unicorn skin, sent to Tsar Mikhail Feodorovich by Shah 'Abbas." KO

1 Salmond, *Russia Imagined*.

Known in Turkish as a *matara*, this flask or canteen represents the Ottoman transformation of a utilitarian water vessel into a ceremonial object. From the sixteenth century onward, like the sultan's sword, these distinctive flasks were a symbol of imperial authority. Jeweled vessels of this type were made not only of leather, as here, but of gold or rock crystal.[1] This example (fig. 273) is recorded as a gift to Tsar Alexei Mikhailovich (r. 1645–76) from Tsarevich Seid-Burkhan Arsalanovich in 1653.[2] Perhaps the Kremlin flask is an example of a "regift," as a similar leather vessel, though less flashy, was given to the Hapsburg emperor Rudolph II by Sultan Murad III.[3]

Like the mace and shield Shah 'Abbas II sent to the Russian court (see cat. nos. 163–64), this conical helmet presented on behalf of Sultan Murad IV (r. 1623–40) to the tsar would have served a ceremonial function rather than one of war (fig. 274). Decorative parade helmets of this type, with nasal, visor, and neck guard, and typically inscribed with the Muslim profession of faith and verses from the Qur'an, were produced in the imperial workshops of Istanbul for the sultan and high officers of state.[4] A related but earlier example in Vienna was likely a gift from Sultan Selim II (r. 1566–74) to the ruler of Transylvania.[5] LK

Fig. 271, cat. no. 245

Fig. 272, cat. no. 246

Fig. 273, cat. no. 247

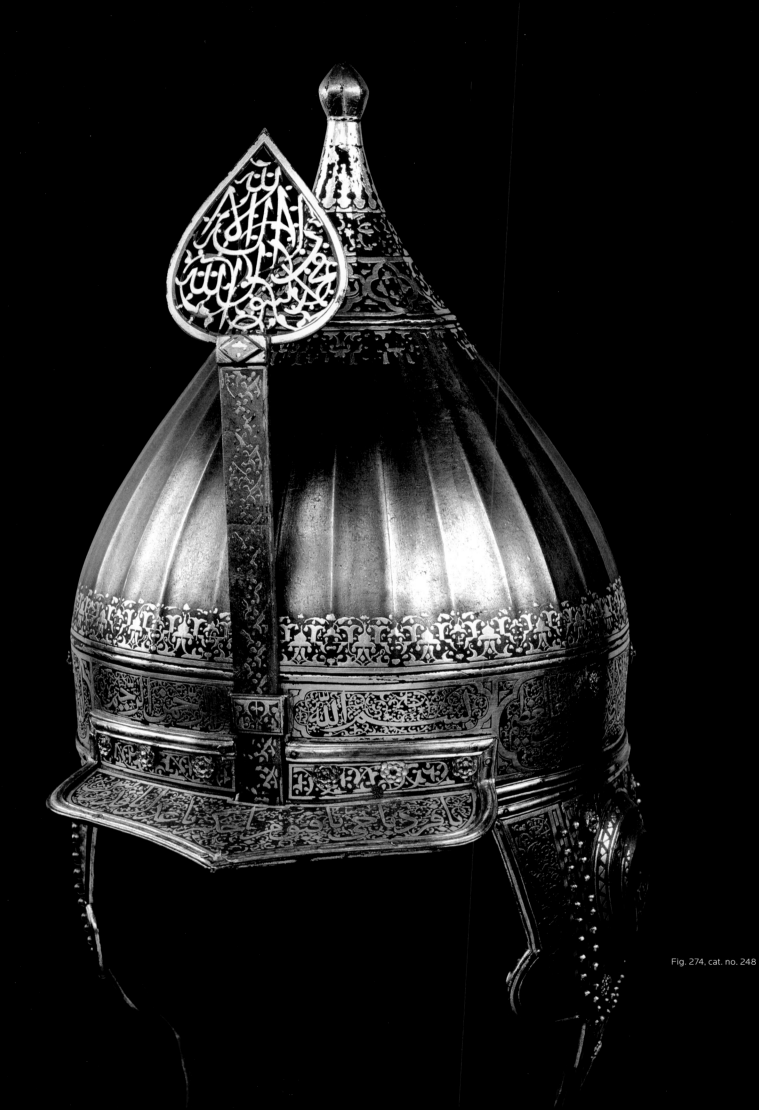

Fig. 274, cat. no. 248

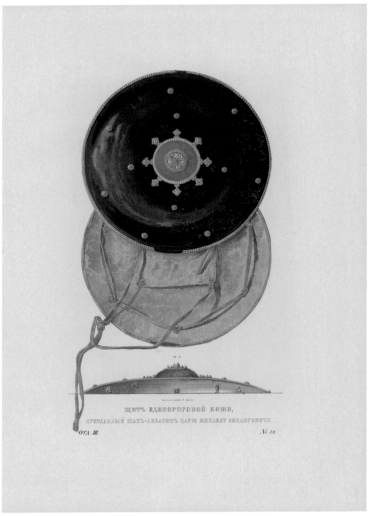

Fig. 275, cat. no. 249

on an enamel ground. The order of St. Andrew had been instituted by Peter the Great in 1698 for bravery in the Turkish wars.[1] LK

1 Köseoğlu, *Topkapi Saray Museum*, 191. It is unknown what if any irony was intended in its presentation to the Ottoman court.

255
Presentation Album of Nasir al-Din Shah's Coat of Arms
Alexander Faddeev (Russia, fl. mid-19th century)
Russia, St. Petersburg, 1865
Ink, colors, and gold on paper; gold-tooled and embroidered velvet binding
22 1/4 x 18 3/8 in. (56.5 x 46.5 cm)
Nasser D. Khalili Collection of Islamic Art, London
(MSS 962)
Fig. 189

Iran was actively engaged with Europe diplomatically and culturally throughout the nineteenth century, but the greatest artistic interaction occurred during the long reign of Nasir al-Din Shah (r. 1848–96). The coat of arms depicted in this presentation album represents a visual amalgam of Iranian and western imagery: the crown at the top is associated with an earlier Qajar shah (see fig. 170, cat. no. 187); the rampant griffin and dragon supporting the shield are European; while the sun and lion at center represent an ancient Iranian device adopted by the Qajars as a symbol of Iran but rendered in a nineteenth-century European manner.[1] The album was likely intended as a gift for someone of high rank.[2] LK

1 Intended to glorify the ruler, the precise meaning of the coat of arms is made explicit by the text on the following page; see Vernoit, *Occidentalism*, 118.
2 Perhaps not unlike certain of the orders awarded by Nasir al-Din Shah; see Raby, *Qajar Portraits*, 32.

254
Badge of the Order of St. Andrew
Russia, c. 1855–81
Gold set with diamonds and rubies
4 3/4 x 3 1/8 in. (12 x 8 cm)
Topkapi Saray Museum, Istanbul (2/1397)
Fig. 276

The sixteenth and seventeenth centuries were the heyday for diplomatic and trade relations between the Ottoman Empire and Russia. This richly bejeweled badge, which belongs to a later period of intermittent hostilities, was presented by the tsar after the Crimean War (1853–56), when the Ottomans had allied themselves with the French and British against Russia. It is composed of a double-headed eagle supporting a crown, the Romanov family coat of arms; in the center of the eagle is the monogram of Alexander II (r. 1855–81), picked out in diamonds

256
Pocket Watch
Germany, c. late 19th century
Decorated with rubies and diamonds; miniature portrait of Wilhelm II
Diam. approx. 2 in. (5 cm)
Topkapi Saray Museum, Istanbul (53/190)
Fig. 150

257
Revolver
Germany, 19th century
Set with diamonds, ivory, and turquoise
9 3/8 in. (24 cm)
Topkapi Saray Museum, Istanbul (2/1188)
Los Angeles only
Fig. 152

258
Scepter
Germany, early 20th century
Gold, base metal, enamel, and velvet
19 ³/₈ in. (49 cm)
Topkapi Saray Museum, Istanbul (2/1440)
Los Angeles only
Fig. 151

The revolver and the watch, presented by Kaiser Wilhelm II
(r. 1888–1918) to Sultan 'Abdülhamid II (r. 1876–1909),
and the scepter, which was a gift to Sultan Mehmed V
(r. 1909–18), represent for the purposes of this exhibition
catalogue the end of a long history of gift exchange at the
Islamic courts and beyond. Like the offices of kaiser and
sultan, which were soon to become obsolete, they belong
to an earlier age of imperial opulence and generosity (see
Aimée Froom's text in this volume). The bejeweled pocket
watch, which bears the mark of A. Lange and Sons, Dresden,
was presented by the kaiser on his first state visit to Turkey
in 1889.[1] It has two covers: one bears the kaiser's mono-
gram "W" surmounted by a crown and embellished by
diamonds and rubies; the other has a portrait of Wilhelm

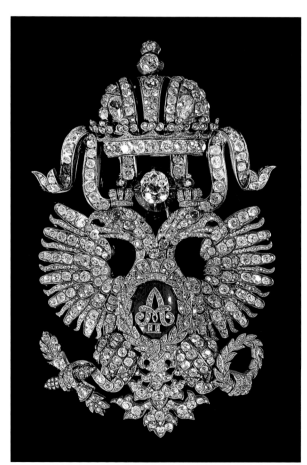

Fig. 276, cat. no. 254

with more rubies. Wilhelm's monogram, picked out in
diamonds, also decorates the revolver. Clearly a showpiece,
it nonetheless was made to look functional and deadly.[2]
The inclusion of the kaiser's monogram gives these state
gifts a more personal quality.

Symbol of royal authority, the scepter, decorated with
the Prussian coat of arms, though obviously costly, seems
in retrospect less an extravagant gift and more an ironic
reminder of lost power. Its recipient was the next to last of
the Ottoman sultans, who unlike his deposed brother and
predecessor, Abdülhamid, did not have the authority to
have a palace façade dismantled stone by stone and trans-
ported to Berlin for presentation to the kaiser (see cat. no.
259). LK

1 Baytar, *İki dost hükümdar*, 261. See also Kurz, *European Clocks*, 97, for reference
to European pocket watches decorated with portraits of the Ottoman sultans and
presumably made as gifts.
2 Baytar, *İki dost hükümdar*, 260.

259
Rosette from the Mshatta Façade
Mshatta (modern Jordan), 8th century
Limestone
Overall: 33 x 35 ³/₄ x 12 ¹/₈ in. (84 x 91 x 31 cm)
Museum für Islamische Kunst, Berlin (I. 6166)
Los Angeles only
Fig. 149

This rosette is a detached section from an elaborately
carved entrance façade of an early Islamic palace. Perhaps
the largest-scale gift ever presented by a Muslim ruler,
the palace façade was given by the Ottoman sultan
Abdülhamid II (r. 1876–1909) in 1903 to Kaiser Wilhelm II
(r. 1888–1918), who soon passed it to the new Kaiser
Friedrich Wilhelm Museum in Berlin; it was relocated to
the Pergamon Museum in 1932. At the time of the gift,
the eighth-century palace, which was never completed,
was in a partially ruined state. The sheer mechanics of dis-
mantling, crating, and transporting it help make this an
even more impressive example of royal munificence.[1] (See
Aimée Froom's text in this volume.) LK

1 The Mshatta Palace façade is one of the best-known examples of early Islamic
architectural decoration; see, for instance, Ettinghausen, Grabar, and Jenkins-
Madina, *Islamic Art and Architecture*, 40–41, 50–51. For the specific circumstances
of this most monumental gift, perhaps as much a personal as a state gift, see
Shaw, *Possessors and Possessed*, 121–22.

BIBLIOGRAPHY

A

Abdullaeva, Firuza. "Khosraw Mirza's Mission of 1829 to St. Petersburg." In *Empires and Revolutions: Iranian-Russian Encounters since 1800*, edited by Stephanie Cronin. Forthcoming.

Abdullaeva, Firuza, and Charles Melville. "*Shahnama*: The Millennium of an Epic Masterpiece." *Iranian Studies* 43, no. 1 (February 2010): 1–11.

Abu Deeb, Kamal. *Al-Jurjani's Theory of Poetic Imagery*. Approaches to Arabic Literature 1. Warminster, England: Aris and Phillips, 1979.

Abu'l-Fazl. *Akbarnama* (Persian text). Edited by Agha Ahmad Ali. 3 vols. Bibliotheca Indica Series. Calcutta: Asiatic Society of Bengal, 1872.

———. *The Akbarnama of Abu'l Fazl*. Translated by Henry Beveridge. 3 vols. Delhi: Rare Books, 1972.

———. *The History of Akbar*. The Murty Classical Library of India. Translated by Wheeler Thackston. Cambridge, MA: Harvard University Press, forthcoming.

Adamova, Adel. "On the Attribution of Persian Paintings and Drawings of the Time of Shah 'Abbas I: Seals and Attributory Inscriptions." In *Persian Painting from the Mongols to the Qajars: Studies in Honour of Basil W. Robinson*, edited by Robert Hillenbrand, 19–38. London: I. B. Tauris, 2000.

———. "Persian Portraits of the Russian Ambassadors." In *Safavid Art and Architecture*, edited by Sheila R. Canby, 49–53. London: British Museum Press, 2002.

Adamova, Adel, and Leon Guzalyan. *Miniatures of the Manuscript of the "Shahnama"* [in Russian]. St. Petersburg: Iskusstvo, 1985.

Adle, Chahriyar, ed. *Art et société dans le monde iranien*. Paris: A.D.P.F., 1982.

Aga Khan Trust for Culture. *Spirit & Life: Masterpieces of Islamic Art from the Aga Khan Museum Collection*. Geneva: Aga Khan Trust for Culture, 2007.

———. *Schätze Des Aga Khan Museum: Meisterwerke Der Islamischen Kunst*. Berlin: Nicolai, 2010.

———. *Treasures of the Aga Khan Museum: Arts of the Book & Calligraphy*. Edited by Margaret Graves and Benoît Junod. Istanbul: Sakip Sabanci Museum, 2010.

Aga-Oglu, Mehmet. *Safawid Rugs and Textiles: The Collection of the Shrine of Imam 'Ali at al-Najaf*. New York: Columbia University Press, 1941.

Ahsan, Muhammad. *Social Life under the Abbasids 170–289 A.H., 786–902 A.D.* London and New York: Longman Group, 1979.

Aitken, Molly Emma. *The Intelligence of Tradition in Rajput Court Painting*. New Haven and London: Yale University Press, 2010.

Akimushkin, Oleg. "Weight and Gravitas: About the Manuscript Collection in Ardabil" [in Russian]. *Irano-Slavica*, no. 2 (2004): 54–56.

Alam, Muzaffar, and Sanjay Subrahmanyam. *Indo-Persian Travels in the Age of Discoveries, 1400–1800*. Cambridge: Cambridge University Press, 2007.

Album, Stephen, Michael L. Bates, and Willem Floor. "Coins and Coinage." In *Encyclopaedia Iranica*, edited by Ehsan Yarshater, vol. 6, 14–41. Costa Mesa, CA: Mazda Publishers, 1992.

Alexander, David. *The Arts of War: Arms and Armor of the 7th to 19th Centuries*. New York: Nour Foundation in association with Azimuth Editions and Oxford University Press, 1992.

———, ed. *Furusiyya*. 2 vols. Riyadh, Kingdom of Saudi Arabia: King Abdulaziz Public Library, 1996.

Algazi, Gadi, Valentin Groebner, and Bernhard Jussen, eds. *Negotiating the Gift: Pre-Modern Figurations of Exchange*. Göttingen, Germany: Vandenhoeck & Ruprecht, 2003.

Ali, M. Athar. *The Apparatus of Empire: Awards of Ranks, Offices, and Titles to the Mughal Nobility, 1574–1658*. Delhi: Oxford University Press, 1985.

Allan, James. "Early Safavid Metalwork." In *Hunt for Paradise*, edited by Jon Thompson and Sheila R. Canby, 203–39. London: Thames and Hudson, 2003.

———. *Islamic Metalwork: The Nuhad Es-Said Collection*. London: Sotheby's, 1982.

———. *Metalwork of the Islamic World: The Aron Collection*. London: Sotheby's, 1986.

———. *Metalwork Treasures from the Islamic Courts*. Doha and London: Museum of Islamic Art and the Islamic Art Society, 2002.

———. "The Shi'i Shrines of Iraq." In *People of the Prophet's House*. London: British Museum in conjunction with the Institute of Ismaili Studies and Azimuth Editions, forthcoming.

———. "Silver Door Facings of the Safavid Period." *Iran* 33 (1995): 123–37.

Allin, Michael. *Zarafa: A Giraffe's True Story, from Deep in Africa to the Heart of Paris*. New York: Walker, 1998.

Allsen, Thomas T. *Commodity and Exchange in the Mongol Empire: A Cultural History of Islamic Textiles*. Cambridge and New York: Cambridge University Press, 1997.

Alonso, Carlos. *Antonio de Gouvea, O.S.A.: Diplomático y Visitador Apostólico en Persia*. Valladolid, Spain: Estudio Augustiniano, 2000.

———. *La embajada a Persia de D. García de Silva y Figueroa (1612–1624)*. Badajoz, Spain: Diputacíon Provincial, Departamento de Publicaciones, 1993.

Amanat, Abbas. "The Kayanid Crown and Qajar Reclaiming of Royal Authority." *Iranian Studies* 34, nos. 1–4 (2001): 17–30.

Amini, Iraj. "Napoleon and Persia." *Iran* 37 (1999): 109–22.

Andreeva, Elena. *Russia and Iran in the Great Game: Travelogues and Orientalism*. New York: Routledge, 2007.

Appadurai, Arjun. *The Social Life of Things: Commodities in Cultural Perspective.* Cambridge and New York: Cambridge University Press, 1986.

Arthur M. Sackler Gallery, Smithsonian Institution. *The Tsars and the East: Gifts from Turkey and Iran in the Moscow Kremlin.* Washington, DC: Arthur M. Sackler Gallery, Smithsonian Institution, 2009.

Atasoy, Nurhan, and Filiz Çağman. *Turkish Miniature Painting.* Translated by Esin Atil. Istanbul: R.C.D. Cultural Institute, 1974.

Atasoy, Nurhan, Walter B. Denny, Louise W. Mackie, and Hülya Tezcan. *Ipek: The Crescent and the Rose.* London: Azimuth Editions, 2000.

Atasoy, Nurhan, and Julian Raby. *Iznik: The Pottery of Ottoman Turkey.* London: Alexandria Press, in association with Thames and Hudson, 1989.

Atasoy, Nurhan, and Selamet Taşkın. *Otağ Humayun: Ottoman Imperial Tent Complex.* Istanbul: Aygaz, 2000.

Ateş, Ahmed. "Istanbul'un Fethine Dair Fatih Sultan Mehmed Tarafindan Gönderilen Mektuplar ve Bunlare Gelen Cevaplar." *Tarih Dergisi* 4 (1952): 11–50.

Atil, Esin. *The Age of Sultan Süleyman the Magnificent.* New York: Harry N. Abrams, 1987.

———. *Islamic Art & Patronage: Treasures from Kuwait.* New York: Rizzoli, 1990.

———. *Renaissance of Islam: Art of the Mamluks.* Washington, DC: Smithsonian Institution Press, 1981.

'Attar, Ahmad 'Abd al-Ghafur. *Al-Ka'ba wal-Kiswa.* Mecca, 1977.

Aubaile-Sallenave, Françoise. *Topkapi à Versailles: Trésors de la cour ottomane.* Paris: Éditions de la Réunion des musées nationaux et Association Française d'Action Artistique, 1999.

Auld, Sylvia. *Renaissance Venice, Islam, and Mahmud the Kurd: A Metalworking Enigma.* London: Altajir World of Islam Trust, 2004.

Avery, Peter, Gavin Hambly, and Charles P. Melville, eds. *The Cambridge History of Iran.* Vol. 7, *From Nadir Shah to the Islamic Republic.* Cambridge: Cambridge University Press, 1991.

Aziz, Abdul. *The Imperial Treasury of the Indian Mughuls.* Delhi: Idarah-i Adabiyat-i Delli, 1972.

———. *Thrones, Tents, and Their Furniture Used by the Indian Mughuls.* Lahore, Pakistan: Ripon Press, n.d.

Azraqi, Abu al-Walid Muhammad b. Ahmad al-. *Akhbar Makka.* Edited by Ferdinand Wüstenfeld. Beirut: Maktabat Haiyat, 1964.

B

Babaie, Sussan. *Isfahan and Its Palaces: Statecraft, Shi'ism, and the Architecture of Conviviality in Early Modern Iran.* Edinburgh: Edinburgh University Press, 2008.

Babaie, Sussan, Kathryn Babayan, Ina Baghdiantz, and Massumeh Farhad. *Slaves of the Shah: New Elites of Safavid Iran.* London: I. B. Tauris, 2004.

Baker, Colin. *Qur'an Manuscripts: Calligraphy, Illumination, Design.* London: British Library, 2007.

Baker, Patricia L. "Islamic Honorific Garments." *Costume: The Journal of the Costume Society* 25 (1991): 25–35.

———. *Islamic Textiles.* London: British Museum Press, 1995.

———. "Wrought of Gold or Silver: Honorific Garments in Seventeenth-Century Iran." In *Carpets and Textiles in the Iranian World, 1400–1700: Proceedings of the Conference Held at the Ashmolean Museum on 30–31 August 2003*, edited by Jon Thompson, Daniel Shaffer, and Pirjetta Mildh, 158–67. Oxford: May Beattie Archive, Ashmolean Museum, University of Oxford, 2010.

Baladhuri, Ahmad ibn Yahya al-. *Futuh al-buldan.* Edited by Michael Jan de Goeje. Lugduni Batavorum [Leiden]: E. J. Brill, 1866.

———. *Origins of the Islamic State: Being a Translation from the Arabic Accompanied with Annotations, Geographic and Historic Notes of the Kitab Futuh al-Buldân of al-Imâm abu-l 'Abbâs Ahmad ibn-Jâbir al-Balâdhuri.* Translated by Philip K. Hitti. Beirut: Khayats, 1966.

Balaian, B. *Krov na al'maze "Shakh": Tragediia A. S. Griboedova.* Erevan, Armenia: Izd-vo "Aïastan," 1983.

Ball, Valentine, and William Crooke. *Travels in India by Jean-Baptiste Tavernier, Baron of Aubonne.* 2 vols. New Delhi: Oriental Books Reprint Corporation, 1977.

Ballian, Anna. "Ottoman Silks and Velvets." *Hali* 156 (2008): 80–83.

Barrett, Alan H. "A Memoir of Lieutenant-Colonel Joseph D'Arcy, R.A. 1780–1848." *Iran* 43 (2005): 241–74.

Barthold, V. V. *Four Studies on the History of Central Asia.* Translated by V. and T. Minorsky. Leiden: E. J. Brill, 1963.

Bartrum, Giulia. *Albrecht Dürer and His Legacy: The Graphic Work of a Renaissance Artist.* London: British Museum, 2002.

Bates, Michael L. *Islamic Coins.* New York: American Numismatic Society, 1982.

Bates, Ülkü, et al. *Re-orientations: Islamic Art and the West in the Eighteenth and Nineteenth Centuries.* New York: Bertha and Karl Leubsdorf Art Gallery at Hunter College, 2008.

Bayhan, Nevzat, ed. *Imperial Surre.* Istanbul: Istanbul Metropolitan Municipality Culture Co. Publications, 2008.

Bayhaqi, Abu'l Fadl Muhammad b. Husayn al-. *Tarikh-i Bayhaqi.* Edited by Manuchihr Danishpazhu. Tehran: Intisharat-i honarmand, 1376 [1998].

Bayraktar, Nedret. "Sultan Abdulhamid'e Gelen 25. Cülus Hediyeleri Defteri." *Tarih ve Toplum*, no. 21 (September 1985): 156–63.

Baytar, Ilona, et al. *İki dost hükümdar: Zwei befreundete Herrscher: Sultan II. Abdülhamid, Kaiser II. Wilhelm*. Istanbul: İstanbul 2010 Avrupa Kültür Başkenti: TBMM Milli Saraylar, 2009.

Beach, Milo Cleveland. *The Grand Mogul: Imperial Painting in India, 1600–1660*. Williamstown, MA: Sterling and Francine Clark Art Institute, 1978.

Beach, Milo Cleveland, and Ebba Koch. *King of the World: The Padshahnama: An Imperial Mughal Manuscript from the Royal Library, Windsor Castle*. London: Azimuth Editions; New York: Thames and Hudson, 1997.

Beatty, Alfred Chester, Thomas Walker Arnold, and J. V. S. Wilkinson. *The Library of A. Chester Beatty, A Catalogue of the Indian Miniatures*. London: E. Walker, 1936.

Behrens-Abouseif, Doris. *Islamic Architecture in Cairo: An Introduction*. Studies in Islamic Art and Architecture 3. Leiden: E. J. Brill, 1989.

———."The Jalayirid Connection in Mamluk Metalware." *Muqarnas* 26 (2009): 149–60.

Belloli, Andrea P. A., and Emilie Savage-Smith. *Islamicate Celestial Globes, Their History, Construction, and Use*. Smithsonian Studies in History and Technology 46. Washington, DC: Smithsonian Institution Press, 1985.

Benveniste, Emile. "Gift and Exchange in the Indo-European Vocabulary." In *The Logic of the Gift: Towards an Ethic of Generosity*, edited by A. D. Schrift, 33–42. New York: Routledge, 1997.

Bernardini, Michele. "Figueroa, García de Silva y." In *Encyclopaedia Iranica*, edited by Ehsan Yarshater, vol. 9, 612–13. Costa Mesa, CA: Mazda Publishers, 1999.

Bernus-Taylor, Marthe. *Soliman le Magnifique*. Paris: Ministère des affaires étrangères, Secrétariat d'état aux relations culturelles internationales, Association française d'action artistique, 1990.

Berzhe, Adolphe. "Khosrov Mırza (1813–1875): chitano v Tiflise, na Griboedovskom vechere, 28-go yanvarya 1879 goda." *Russkaya Starina* (St. Petersburg), 25 (1879): 331–414.

Betteridge, Anne H. "Gift Exchange in Iran: The Locus of Self-Identity in Social Interaction." *Anthropological Quarterly* 58 (1985): 190–202.

Bier, Carol. *The Persian Velvets at Rosenborg*. Copenhagen: De Danske Kongers Kronologiske Samling, 1995.

———, ed. *Woven from the Soul, Spun from the Heart*. Washington, DC: Textile Museum, 1987.

Bilirgen, Emine. *Topkapı Sarayı Hazine-i Hümayun*. Istanbul: Mas Matbaacılık, 2001.

Binney, Edwin. *Turkish Treasures from the Collection of Edwin Binney, 3rd*. Portland, OR: Portland Art Museum, 1979.

Biruni, Muhammad ibn Ahmad aı . *The Book Most Comprehensive in Knowledge on Precious Stones (Kitāb al-Jamāhir fi Ma'rifat al Jawāhir)*. Translated by Hakim Muhammad Said. Islamabad: Hijra Council, 1989.

Blair, Sheila. "The Ardabil Carpets in Context." In *Society and Culture in the Early Modern Middle East*, edited by Andrew J. Newman, 125–44. Leiden: Brill, 2003.

———. "Color and Gold: The Decorated Papers Used in Manuscripts in Later Islamic Times." *Muqarnas* 17 (2000): 24–36.

———. *A Compendium of Chronicles: Rashid al-Din's Illustrated History of the World*. London: Nour Foundation, 1995.

———. *The Ilkhanid Shrine Complex at Natanz, Iran*. Cambridge, MA: Center for Middle Eastern Studies, Harvard University, 1986.

———. *Islamic Calligraphy*. Edinburgh: Edinburgh University Press, 2006.

———. "A Medieval Persian Builder." *Journal of the Society of Architectural Historians* 45 (December 1986): 389–95.

———. "Sufi Saints and Shrine Architecture in the Early Fourteenth Century." *Muqarnas* 7 (1990): 35–49.

———. "Texts, Inscriptions and the Ardabil Carpets." In *Iran and Iranian Studies: Essays in Honor of Iraj Afshar*, edited by Kambiz Eslami, 137–47. Princeton, NJ: Zagros, 1998.

———. "Transcribing God's Word: Qur'an Codices in Context." *Journal of Qur'ān Studies* 9, no. 1 (2008): 71–97.

Blair, Sheila, and Jonathan Bloom. *The Art and Architecture of Islam: 1250–1800*, Pelican History of Art. London and New Haven, CT: Yale University Press, 1994; reprinted with corrections 1995.

———. *Cosmophilia: Islamic Art from the David Collection, Copenhagen*. Chicago: University of Chicago Press, 2006.

———, eds. *Rivers of Paradise: Water in Islamic Art and Culture*. Proceedings of the Second Biennial Hamid bin Khalifa Symposium on Islamic Art. New Haven, CT: Yale University Press, 2009.

Blake, Stephen P. *Shahjahanabad: The Sovereign City in Mughal India, 1639–1739*. South Asian Studies 49. Cambridge: Cambridge University Press, 1991.

Bloom, Jonathan. *Arts of the City Victorious: Islamic Art and Architecture in Fatimid North Africa and Egypt*. New Haven, CT: Yale University Press, 2007.

———. "The Origins of Fatimid Art." *Muqarnas* 3 (1985): 20–38.

———. *Paper before Print: The History and Impact of Paper in the Islamic World*. New Haven, CT: Yale University Press, 2001.

Bonde, Sheila. *Glimpses of Grandeur: Courtly Arts of the Later Islamic Empires*. Exhibition Notes 8. Providence: Museum of Art, Rhode Island School of Design, 1999.

Borschevsky, Yuri. "History of the Acquisition of the Ardabil Collection of Manuscripts by Russia" [in Russian]. In *Formirobanie gumanisticheskix traditsii otchestvennogo vostokovedeniya (do 1917 goda)*, 204–17. Moscow: Nauk, 1984.

Bouret, Blandine. "L'ambassade persane à Paris en 1715 et son image." *Gazette des Beaux-Arts*, October 1982, 109–30.

Brac de la Perrière, Éloïse. *L'art du livre dans l'Inde des sultanats*. Paris: PUPS, 2008.

Brand, Michael, and Glenn Lowry. *Akbar's India: Art from the Mughal City of Victory*. New York: Asia Society, 1985.

Brend, Barbara. *Muhammad Juki's Shahnamah of Firdausi*. London: Royal Asiatic Society and Philip Wilson Publishers Ltd, 2010.

Bretschneider, Emil. *Mediaeval Researches from Eastern Asiatic Sources*. 2 vols. London: Routledge & Kegan Paul, 1910.

Bronevskii, S. M. *Istoricheskie vypyski o snosheniiakh Rossii s Persieiu, Gruzieiu i voobshche s gorskimi narodami...* St. Petersburg: Peterburgskoe vostokovedenie, 1996.

Brubaker, Leslie. "The Elephant and the Ark: Cultural and Material Interchange across the Mediterranean in the Eighth and Ninth Centuries." *Dumbarton Oaks Papers* 58 (2004): 175–95.

Bruyn, Cornelis de. *Reizen over Moskovie, door Persie en Indie*. Amsterdam, 1714.

Buettner, Brigitte. "Past Presents: New Year's Gifts at the Valois Courts, ca. 1400." *Art Bulletin* 83 (2001): 598–625.

Busbecq, Ogier Ghislain de. *The Turkish Letters of Ogier Ghiselin de Busbecq, Imperial Ambassador at Constantinople, 1554–1562*. Translated by Edward Seymour Forster. Baton Rouge: Louisiana State University Press, 2005.

Bushev, Petr P. *History of Embassies and Diplomatic Relations between Russian and Iranian States in 1586–1612 (from Russian Archives)* [in Russian]. Moscow: Nauk, 1976.

C

Çağman, Filiz, and Zeren Tanindi. *The Topkapi Saray Museum: The Albums and Illustrated Manuscripts*. Translated, expanded, and edited by J. M. Rogers. Boston: Little, Brown, 1986.

The Cambridge History of Iran. 7 vols. Cambridge: Cambridge University Press, 1968–91.

Cammann, Schuyler. "Presentation of Dragon Robes by the Ming and Ch'ing Court for Diplomatic Purposes." *Sinologica* 3 (1953): 193–202.

Campbell, Caroline, and Alan Chong, eds. *Bellini and the East*. New Haven, CT: Yale University Press, 2005.

Canard, Marius. "Les Sources arabes de l'histoire byzantine aux confins des Xe et XIe siècles." *Revue des études byzantines* 19 (1961): 284–314.

——, trans. *Vie de l'ustadh Jaudhar*. Algiers: Typo-Litho et Jules Carbonel, 1958.

Canby, Sheila. "The Horses of 'Abd us-Samad." In *Mughal Masters: Further Studies*, edited by Asok Kumar Das, 14–29. Mumbai: Marg Publications, 1998.

——. *Princes, Poets & Paladins: Islamic and Indian Paintings from the Collection of Prince and Princess Sadruddin Aga Khan*. London: British Museum Press, 1998.

——. *The Rebellious Reformer: The Drawings and Paintings of Riza-yi Abbasi of Isfahan*. London: Azimuth Editions, 1996.

——. "Royal Gifts to Safavid Shrines." In *Muraqqa'e Sharqi: Studies in Honor of Peter Chelkowski*, edited by Soussie Rastegar and Anna Vanzan, 57–68. San Marino, Italy: AIEP Editore Sri, 2007.

——. *Shah 'Abbas: The Remaking of Iran*. London: British Museum, 2009.

Carboni, Stefano, ed. *Venice and the Islamic World, 828–1797*. New York: Metropolitan Museum of Art, 2007.

Carswell, John. "Hanging in Suspense." *Benaki Museum Journal* 3 (2004): 177–83.

——. "Ottoman Pottery." *Hali* 156 (2008): 78–79.

Cheal, David. *The Gift Economy*. New York: Routledge, 1988.

Chirva, A. N. *Drevnosti Rossiiskogo gosudarstva*. Moscow: AO Kapital i kul'tura, 1994.

A Chronicle of the Carmelites in Persia and the Papal Mission of the XVIIth and XVIIIth Centuries. London: Eyre & Spottiswoode, 1939.

Christie's. "Islamic Art, Indian Miniatures, Rugs and Carpets." London: Christie's, October 20, 1992.

Christie's. *Art of the Islamic and Indian Worlds including Art from the Collection of Dr. Mohammed Said Farsi*. London: Christie's, October 5, 2010.

Church, Sally. "The Giraffe of Bengal: A Medieval Encounter in Ming China." *Medieval History Journal* 7, no. 1 (April 2004): 1–37.

Clavijo, Ruy González de. *Embassy to Tamerlane, 1403–1406*. Translated by Guy le Strange. New York: Harper, 1928.

Cloake, Margaret Morris, trans. and ed. *A Persian at the Court of King George, 1809–10: The Journal of Mirza Abul Hassan Khan*. London: Barrie and Jenkins, 1988.

Clunas, Craig. *Elegant Debts: The Social Art of Wen Zhengming, 1470–1559*. Honolulu: University of Hawaii Press, 2004.

——. "Gifts and Giving in Chinese Art." *Transactions of the Oriental Ceramic Society* 62 (1997–98): 1–15.

Cockerell, Sydney C., and John Plummer. *Old Testament Miniatures: A Medieval Picture Book with 283 Paintings from the Creation to the Story of David*. New York: George Braziller, 1969.

Cohen, Esther, and Mayke B. de Jong, eds. *Medieval Transformations: Texts, Power, and Gifts in Context*. Leiden: Brill, 2001.

Cohen, Steven. "The Use of Fine Goat Hair for the Production of Luxury Textiles. Its Origins and the Similarities and Differences of Its Use in Iran and India during the Reigns of the Safavid and Mughal Shahs." In *Carpets and Textiles in the Iranian World 1400–1700: Proceedings of the Conference Held at the Ashmolean Museum on 30–31 August 2003*, edited by Jon Thompson, Daniel Shaffer, and Pirjetta Mildh, 124–41. Oxford: May Beattie Archive, Ashmolean Museum, University of Oxford, 2010.

Combe, Étienne. "Tissus Fatimides du Musée Benaki." In *Mélanges Maspero*. Vol. 3, *Orient islamique*, by Maspéro Gaston, 259–72. Cairo: Imprimerie de l'Institut français d'archéologie orientale, 1940.

Combe, Étienne, Jean Sauvaget, and Gaston Wiet, eds. *Répertoire chronologique d'épigraphie arabe*. Vol. 12. Cairo: Imprimerie de l'Institut français d'archéologie orientale, 1943.

Constable, Archibald. *Travels in the Mogul Empire AD 1656–1668*. London: Archibald Constable and Company, 1891.

Contadini, Anna. "Islamic Ivory Chess Pieces, Draughtsmen and Dice." In *Islamic Art in the Ashmolean Museum: Part One*, edited by James Allan, 111–54. Oxford Studies in Islamic Art 10. Oxford: Oxford University Press, 1995.

Cormack, Robin, and Koray Durak, eds. *From Constantine the Great to Fatih Mehmed II*. Istanbul: Sabanci Museum, forthcoming.

Correia-Afonso, John, ed. *Letters from the Mughal Court: The First Jesuit Mission to Akbar (1580–1583)*. Studies in Indian History and Culture of the Heras Institute 24. Bombay: Gujarat Sahitya Prakash for the Heras Institute of Indian History and Culture, 1980.

Coşansel, Demet. "19. Yüzyılda Değişen Sofra Düzeni ve Alman İmparatoru II. Wilhelm'e Sunulan Ziyafetler/Wandel in der Esskultur im 19. Jahrhundert und was dem deutschen Kaiser Wilhelm II. bei seinem Besuch im Osmanischen Reich serviert wurde." In *İki dost hükümdar: Zwei befreundete Herrscher: Sultan II. Abdülhamid, Kaiser II. Wilhelm*, Ilona Baytar et al., 109–29. Istanbul: İstanbul 2010 Avrupa Kültür Başkenti: TBMM Milli Saraylar, 2009.

Coutre, Jacques de. *Andanzas asiáticas*. Edited by Eddy Stols, Benjamin Teensma, and Johan Werberckmoes. Madrid: Historia 16, 1991.

Cropper, Elizabeth. *The Diplomacy of Art: Artistic Creation and Politics in Seicento Italy: Papers from a Colloquium Held at the Villa Spelman, Florence, 1998*. Villa Spelman Colloquia 7. Milan: Nuova Alfa Editoriale, 2000.

Crouwel, W. H. *Treasures of the Tsar: Court Culture of Peter the Great from the Kremlin*. Rotterdam: Museum Boymans-van Beuningen, 1995.

Cutler, Anthony. "Barberiniana: Notes on the Making, Context and Provenance of Louvre, OA: 9063." In *Tesserae: Festschrift für Josef Engemann*, edited by Ernst Dassmann, 329–39. Münster: Aschendorff, 1991.

———. *The Craft of Ivory. Sources, Techniques and Uses in the Mediterranean World, A.D. 200–1400*. Washington, DC: Dumbarton Oaks, 1985.

———. "Les échange de dons entre Byzance et l'Islam." *Journal des Savants*, January–June 1996, 51–66.

———. "The Emperor's Old Clothes: Actual and Virtual Vesting and the Transmission of Power in Byzantium and Islam." In *Byzance et le monde extérieur: Contacts, relations, échanges*, edited by Michel Balard, Élisabeth Malamut, and Jean-Michel Spieser, 195–210. Paris: Publications de la Sorbonne, 2005.

———. "The Empire of Things: Gift Exchange between Byzantium and the Islamic World." In *Record of Activities and Research Reports, June 1999–May 2000*, 67–70. Washington, DC: National Gallery of Art, 2000.

———. "Gifts and Gift Exchange as Aspects of the Byzantine, Arab, and Related Economies." *Dumbarton Oaks Papers* 55 (2001): 247–78.

———. *Image Making in Byzantium, Sasanian Persia and the Early Muslim World*. Burlington, VT: Ashgate Variorum, 2009.

———. "Imagination and Documentation: Eagle Silks in Byzantium, the Latin West and Abbasid Baghdad." *Byzantinische Zeitschrift* 96 (2003): 67–72.

———. "Magnificence and the Necessity of Luxury in Byzantium." In *From Byzantion to Istanbul: 8000 Years of a Capital*, 139–43. Istanbul: Sabanci Müzesi, 2010.

———. "Reuse or Use? Theoretical and Practical Attitudes toward Objects in the Early Middle Ages." In *Ideologie e pratiche del reimpiego nell'alto medioevo*, 1055–79. Spoleto: Centro Italiano di Studi sull'Alto Medioevo, 1999.

———. "Significant Gifts: Patterns of Exchange in Late Antique, Byzantine, and Early Islamic Diplomacy." *Journal of Medieval and Early Modern Studies* 38, no. 1 (Winter 2008): 79–101.

D

Danişmend, Ismail H. *Osmanlı Tarihi Kronolojisi*. 6 vols. Istanbul: Türkiye Yayınevi, 1947.

Daryaee, Touraj. "Mind, Body and the Cosmos: Chess and Backgammon in Ancient Persia." *Iranian Studies* 35, no. 4 (Fall 2002): 281–312.

Das, Asok K. "Chinese Porcelain at the Mughal Court." *Silk Road Art and Archaeology* 2 (1991/92): 383–409.

———. "Persian Masterworks and Their Transformation in Jahangir's Taswirkhana." In *Humayun's Garden Party*, edited by Sheila Canby, 136–52. Bombay: Marg Publications, 2004.

Davis, Natalie Zemon. *The Gift in Sixteenth-Century France*. Madison: University of Wisconsin Press, 2000.

Deér, József. *Der kaiserornat Friedrichs II*. Bern: A. Francke, 1952.

Delpont, E., ed. *L'Orient de Saladin: l'art des Ayyoubides: Exposition présentée à l'Institut du Monde Arabe, Paris du 23 Octobre 2001 au 10 Mars 2002*. Paris: Institut du monde arabe / Gallimard, 2001.

Delteil, Loys. *Delacroix: The Graphic Work, a Catalogue Raisonné*. San Francisco: Alan Wofsy, 1997.

Denny, Walter B. "Dating Ottoman Turkish Works in the Saz Style." *Muqarnas* 1 (1983): 103–21.

Derman, M. Uğur. *Letters in Gold: Ottoman Calligraphy from the Sakıp Sabancı Collection, Istanbul*. New York: Metropolitan Museum of Art, 1998.

Derrida, Jacques. *Given Time: 1. Counterfeit Money*. Chicago and London: University of Chicago Press, 1994.

Dias, João Carvakho. *Islamic Art in the Calouste Gulbenkian Collection*. Lisbon: Fundação Calouste Gulbenkian, 2003.

Diba, Layla. "Persian Painting in the Eighteenth Century: Tradition and Transmission." *Muqarnas* 6 (1989): 147–60.

———, ed. *Royal Persian Paintings: The Qajar Epoch, 1785–1925*. New York: Brooklyn Museum of Art, 1998.

Dickson, Martin B., and Stuart C. Welch. *The Houghton Shahnameh*. Cambridge, MA: Harvard University Press, 1981.

Digby, Simon. "Export Industries and Handicraft Production under the Sultans of Kashmir." *Indian Economic and Social History Review* 44, no. 4 (2007): 407–23.

Dodds, Jerrilynn D., ed. *Al-Andalus: The Art of Islamic Spain*. New York: Metropolitan Museum of Art, 1992.

Dorn, Bernhard. *Catalogue des manuscrits et xylographes orientaux de la Bibliothèque Impériale Publique de St. Pétersbourg*. St. Petersburg: Imprimerie de l'Académie Impériale des Sciences, 1852.

Drocourt, Nicolas. "Les Animaux comme cadeaux d'ambassade entre Byzance et ses voisins (VIIe–XIIe siècle)." In *Byzance et ses periphéries: Hommage à Alain Ducellier*, edited by Bernard Doumarc and Christophe Picard, 67–93. Toulouse: CNRS, Université de Toulouse-le Mirail, 2004.

Drouville, Gaspard. *Voyage en Perse, faiten 1812 et 1813*, vol. 2. Paris: Imprimerie de E. Pochard, 1828.

Duda, Dorothea. *Islamische Handschriften I: Persische Handschriften*. Vienna: Verlag der Österreichischen Akademie der Wissenschaften, 1983.

Duyvenendak, J. J. L. "The True Dates of the Chinese Maritime Expeditions in the Early Fifteenth Century." *International Journal of Chinese Studies (T'ung pao)* 34 (1938): 341–412.

E

Ehrmann, Jean. *Antoine Caron: Peintre des fêtes et des massacres*. Paris: Flammarion, 1986.

Ekbal, Kamran. "Die Brasilienreise des Persischen Gesandten Mirza Abu'l-Hasan Khan Šīrāzī im Jahre 1810." *Die Welt des Islams* 27, nos. 1–3 (1987): 23–44.

Encyclopaedia Iranica. Edited by Ehsan Yarshater. 14 vols. London, Boston, and Henley: Routledge & Kegan Paul, and Costa Mesa, CA: Mazda Publishers, 1985–2008.

Encyclopaedia of Islam. Edited by P. J. Bearman, Th. Bianquis, C. E. Bosworth, E. van Donzel, and W. P. Heinrichs. 2nd ed. 13 vols. Leiden: Brill, 1960–2005.

Encyclopedia of Islam. Edited by Gudrun Krämer et al. 3rd ed. Leiden: Brill, 2007– .

Encyclopaedia of the Qur'an. Edited by Jane Dammen McAuliffe. 6 vols. Leiden: Brill, 2001–6.

Enderlein, Volkmar. *Die Miniaturen der Berliner Baisonqur-Handschrift*. Berlin: Staatliche Museen zu Berlin, 1991.

Engemann, Josef. "Diplomatische 'Geschenke' – Objekte aus der Spätantike?" *Mitteilungen zur Spätantike Archäologie und Byzantinischen Kunstgeschichte* 4 (2005): 39–64.

Eskandari-Qajar, Manoutchehr M. "The Message of the Negarestan Mural of Fath Ali Shah and His Sons: Snapshot of Court Protocol or Determinant of Dynastic Succession." *Qajar Studies: The Journal of the International Qajar Studies Association* 8 (June 2008): 17–42.

Eslami, Kambiz. "D'Arcy, Joseph." In *Encyclopaedia Iranica*, edited by Ehsan Yarshater, vol. 7, 23. Costa Mesa, CA: Mazda Publishers, 1994.

Ettinghausen, Richard. "An Illuminated Manuscript of Hāfiz-i Abrū in Istanbul." *Kunst des Orients* 2 (1955): 30–44. Reprinted in *Islamic Art and Archaeology Collected Papers*, edited by Myriam Rosen-Ayalon, 494–508. Berlin: Gebr. Mann Verlag, 1984.

Ettinghausen, Richard, Oleg Grabar, and Marilyn Jenkins-Madina. *Islamic Art and Architecture 650–1250*. New Haven, CT: Yale University Press, 2001.

Evans, Helen C., and William D. Wixom, eds. *The Glory of Byzantium: Art and Culture of the Middle Byzantine Era A.D. 843–1261*. New York: Harry N. Abrams, 1997.

F

Fabris, Antonio. "Artisan et Culture: Recherches sur la production Venitienne et le Marche Ottoman au XVIe Siecle." *Arab Historical Review for Ottoman Studies*, nos. 3–4 (December 1991): 51–60.

Falk, Toby, and Mildred Archer. *Indian Miniatures in the India Office Library*. London: Sotheby Parke Bernet, 1981.

Fane, Diane, and Amy Poster. *The Guennol Collection: Cabinet of Wonders*. Brooklyn: Brooklyn Museum of Art, 2000.

Farhad, Massumeh. "An Artist's Impression: Mu'in Musavvir's Tiger Attacking a Youth." *Muqarnas* 9 (1992): 116–23.

Farooqi, Naimur R. "Diplomacy and Diplomatic Procedure under the Mughals." *Medieval History Journal* 7, no. 1 (2004): 59–86.

———. *Mughal-Ottoman Relations: A Study of Political and Diplomatic Relations between Mughal India and the Ottoman Empire, 1556–1748.* Delhi: Idarah-i Adabiyat-i Delhi, 1989.

Fehérvári, Geza. *Islamic Metalwork of the Eighth to the Fifteenth Century in the Keir Collection.* London: Faber and Faber, 1976.

Feldman, Marian H. *Diplomacy by Design: Luxury Arts and an "International Style" in the Ancient Near East, 1400–1200 BCE.* Chicago: University of Chicago Press, 2006.

Fernandes, Leonor. "The Foundation of Baybars al-Jashankir: Its Waqf, History, and Architecture." *Muqarnas* 4 (1987): 21–42.

Ferrier, Robert W. "European Diplomacy of Shah Abbas I and the First Persian Embassy to England." *Iran* 11 (1973): 75–92.

———. "The Trade between India and the Persian Gulf and the East India Company in the 17th Century." *Bengal Past and Present* 89 (1970): 189–98.

———. "Trade from the Mid-14th Century to the End of the Safavid Period." In *The Cambridge History of Iran.* Vol. 6, *The Timurid and Safavid Periods,* edited by Peter Jackson and Laurence Lockhart, 412–90. Cambridge: Cambridge University Press, 1986.

Fetvaci, Emine. "The Production of the Şehnāme-i Selīm Hān." *Muqarnas* 26 (2009): 263–315.

Fillitz, Hermann. *Die Schatzkammer in Wien.* Vienna: Schrollverlag, 1964.

Firdausi. *The Shahnama of Firdausi.* Translated by A. G. Warner and Edmond Warner. 9 vols. London: Kegan Paul, 1905–25.

Fleischer, Cornell H. *Bureaucrat and Intellectual in the Ottoman Empire: The Historian Mustafa Âli (1541–1600).* Princeton, NJ: Princeton University Press, 1986.

Fletcher, Joseph F. "China and Central Asia, 1368–1884." In *The Chinese World Order: Traditional China's Foreign Relations,* edited by John King Fairbank, 206–24. Cambridge, MA: Harvard University Press, 1968.

Flood, Finnbar Barry. *The Great Mosque of Damascus: Studies on the Makings of an Umayyad Visual Culture.* Leiden: Brill, 2001.

———. *Objects of Translation: Material Culture and Medieval "Hindu-Muslim" Encounter.* Princeton, NJ: Princeton University Press, 2009.

Floor, Willem. "Gift Giving in the Qajar Period." In *Encyclopaedia Iranica,* edited by Ehsan Yarshater, vol. 10, 615–17. New York: Bibliotheca Persica Press, 2001.

Floor, Willem, and Farhad Hakimzadeh. *The Hispano-Portuguese Empire and Its Contacts with Safavid Persia, the Kingdom of Hormuz and Yarubid Oman from 1489 to 1720. A Bibliography of Printed Publications, 1508–2007.* Louvain, Belgium: Peeters in association with the Iran Heritage Foundation and the Freer Gallery of Art and Arthur M. Sackler Gallery, Smithsonian Institution, 2007.

Floor, Willem, and Edmund Herzig. *Iran and the World in the Safavid Age.* London: I. B. Tauris, 2006.

Folsach, Kjeld von. *For the Privileged Few: Islamic Miniature Painting from the David Collection.* Humlebæk, Denmark: Louisiana Museum of Modern Art; Copenhagen: Davids Samling, 2007.

Folsach, Kjeld von, and Anne-Marie Keblow Bernsted. *Woven Treasures: Textiles from the World of Islam.* Copenhagen: The David Collection, 1993.

Folsach, Kjeld von, Torben Lundboek, and Peder Mortensen, eds. *Sultan, Shah, and Great Mughal. The History and Culture of the Islamic World.* Copenhagen: National Museum, 1996. Folsach, Kjeld von, and Joachim Meyer, eds. *The Ivories of Muslim Spain: Papers from a Symposium Held in Copenhagen from the 18th to the 20th of November 2003.* 2 vols. Journal of the David Collection 2 (2005).

Forbes, Isabella, and William Underhill, eds. *Catherine the Great: Treasures of Imperial Russia from the State Hermitage Museum, Leningrad.* London: Booth-Clibborn, 1990.

Foster, William, ed. *Early Travels in India 1583–1619.* New Delhi: Munshiram Manoharlal Publishers Pvt. Ltd., 1985.

———, trans. and ed. *The Embassy of Sir Thomas Roe to the Court of the Great Mogul, 1615–19, as Related in His Journal and Correspondence.* Nendeln, Liechtenstein: Kraus Reprint, 1967.

Fragner, Bert G., Ralph Kauz, Roderich Ptak, and Angela Schottenhammer, eds. *Pferde in Asien: Geschichte, Handel und Kultur / Horses in Asia: History, Trade and Culture.* Denkschriften der phil.-hist. Klasse, 378. Band, Veröffentlichungen zur Iranistik, Nr. 46. Vienna: Verlag der Österreichischen Akademie der Wissenschaften, 2009.

Franses, Michael. "Some Wool Pile Persian-Design Niche Rugs." In *Oriental Carpet and Textile Studies.* Vol. 5, part 2, *The Salting Carpets,* edited by Murray J. Eiland Jr. and Robert Pinner, 36–136. Danville, CA: International Conference on Oriental Carpets, 1999.

Froom, Aimée, Forrest McGill, and Kaz Tsuruta. *Persian Ceramics from the Collections of the Asian Art Museum.* San Francisco: Asian Art Museum, 2008.

Fučíková, Eliška. *Rudolf II and Prague: The Court and the City.* Prague: Prague Castle Administration, 1997.

Fundação Calouste Gulbenkian. *L'art de l'Orient islamique: Collection de la Fondation Calouste Gulbenkian = Oriental Islamic Art: Collection of the Calouste Gulbenkian Foundation.* Lisbon: Fundação Calouste Gulbenkian, 1963.

G

Galerkina, Olga. "On Some Miniatures Attributed to Behzad in Leningrad Collections." *Ars Orientalis* 7 (1970): 121–38.

Gaudefroy-Demombynes, M. "Le Voile de la Ka'ba." *Studia Islamica* 2 (1954): 5–21.

Gavin, Carney E. S. *The Image of the East: Nineteenth-Century Near Eastern Photographs by Bonfils from the Collections of the Harvard Semitic Museum*. Chicago: University of Chicago Press, 1982.

Geary, Patrick J. "Gift Exchange and Social Science Modeling: The Limitations of a Construct." In *Negotiating the Gift: Pre-Modern Figurations of Exchange*, edited by Valentin Groebner and Bernhard Jussen, 129–40. Göttingen, Germany: Vandenhoeck & Ruprecht, 2003.

——. "Sacred Commodities: The Circulation of Medieval Relics." In *The Social Life of Things*, edited by Arjun Appadurai, 169–93. Cambridge: Cambridge University Press, 1986.

Ghabban, Ali Ibrahim al-, et al. *Roads of Arabia. Archaeology and History of the Kingdom of Saudi Arabia*. Paris: Somogy, 2010.

Ghouchani, Abdallah. *Inscriptions on Nishapur Pottery*. Tehran: Reza Abbasi Museum, 1986.

Ghuzuli, 'Ali ibn 'Abd Allah al-Baha'i al-. *Matali' al-budur fi manazil al-surur.* 2 vols. Cairo: Maṭba'at Idarat al-Waṭan, 1882–83.

Gibb, Hamilton A. R. "Abu'l-Fida." *Encyclopaedia of Islam*. 2nd ed. Vol. 1, 118–19. Leiden: Brill, 1960–2005.

——. "Arab-Byzantine Relations under the Umayyad Caliphate." *Dumbarton Oaks Papers* 12 (1958): 219–33.

——, trans. *Travels of Ibn Battuta*. 5 vols. Cambridge and London: Hakluyt Society, 1958–2000.

Gil Fernandez, Luis. "The Embassy of Don Garcia de Silva y Figueroa to Shah Abbas I (1614–1624)." In *Iran and the World in the Safavid Age*, eds. Willem Floor and Edmund Herzig. London: I. B. Tauris, forthcoming.

——. *Epistolario Diplomático/García de Silva y Figueroa*. Cáceres, Spain: Institución Cultural "El Brocense," 1989.

——. *El Imperio Luso-Español y La Persia Safávida*. 2 vols. Madrid: Fundación Universitaria Espanola, 2006–9.

Gladiss, Almut von, and Claus-Peter Haase. *The Radiance of Islamic Art: Masterpieces from the Museum of Islamic Art in Berlin*. Munich: Hirmer Verlag, 2008.

Godelier, Maurice. *The Enigma of the Gift*. Translated by Nora Scott. Chicago: University of Chicago Press, 1999.

Goitein, S. D. *A Mediterranean Society*. 6 vols. Berkeley and Los Angeles: University of California Press, 1967–94.

Gökyay, Orhan Şaik. "Bir Saltanat Düğünü." *Topkapı Sarayı Müzesi, Yıllığı* 1 (1986): 31–39.

Gonzalez, Valerie. *Le Piège de Solomon, la pensée de l'art dans le Coran*. Paris: Albin Michelle, 2002.

Goodwin, Godfrey. *A History of Ottoman Architecture*. Baltimore: Johns Hopkins Press, 1971.

Gordon, Stewart, ed. *Robes and Honor: The Medieval World of Investiture*. New York: Palgrave, 2001.

——. "Robes of Honor: A 'Transactional' Kingly Ceremony." *Indian Economic and Social History Review* 33, no. 3 (1996): 225–42.

Gouda, Abdelaziz. "Die Kiswa der Ka'ba in Makka." PhD diss., Frei Universität Berlin, 1989.

——. "Die Tiraz-Werkstätten der Kiswa für die Ka'ba in Makka." *Der Islam* 71 (1994): 289–301.

Göyünç, Nejat. "Ta'rih Başlıklı Muhasebe Defterleri." *Osmanlı Araştırmaları* (Journal of Ottoman Studies) 10 (1990): 1–37.

Grabar, Oleg. "The Shared Culture of Objects." In *Byzantine Court Culture from 829 to 1204*, edited by Henry Maguire, 115–29. Washington, DC: Dumbarton Oaks Research Library and Collection, 1997.

Grabar, Oleg, and Sheila Blair. *Epic Images and Contemporary History: The Illustrations of the Great Mongol Shahnama*. Chicago and London: University of Chicago Press, 1980.

Gray, Basil, ed. *The Arts of the Book in Central Asia*. Paris: UNESCO; London: Serindia, 1979.

——. "The Export of Chinese Porcelain to India." *Transactions of the Oriental Ceramic Society* (April 1964): 21–37.

Greaves, Rose. "Iranian Relations with the European Trading Companies, to 1798." In *The Cambridge History of Iran*. Vol. 7, *From Nadir Shah to the Islamic Republic*, edited by Peter Avery, Gavin Hambly, and Charles P. Melville, 350–73. Cambridge: Cambridge University Press, 1991.

——. "Iranian Relations with Great Britain and British India, 1798–1921." In *The Cambridge History of Iran*. Vol. 7, *From Nadir Shah to the Islamic Republic*, edited by Peter Avery, Gavin Hambly, and Charles P. Melville, 374–425. Cambridge: Cambridge University Press, 1991.

Green, Nile. "Stones from Bavaria: Iranian Lithography in its Global Contexts." *Iranian Studies* 43, no. 3 (2010): 305–31.

Greenblatt, Stephen, et al. *Cultural Mobility: A Manifesto*. Cambridge and New York: Cambridge University Press, 2009.

Gross, Michael. *Rogues' Gallery: The Secret Story of the Lust, Lies, Greed, and Betrayals That Made the Metropolitan Museum of Art*. New York: Broadway Books, 2010.

Grove Encyclopedia of Islamic Art and Architecture. Edited by Jonathan Bloom and Sheila Blair. 3 vols. New York: Oxford University Press, 2009.

Grube, Ernst, and Eleanor Sims. *Between China and Iran: Paintings from Four Istanbul Albums*. London: Percival David Foundation of Chinese Art, 1985.

———. "The Representations of Shah 'Abbas I." In *L'arco di fango che rubo la luce alle stelle: Studi in onore Eugenio Galdieri*, edited by Michele Bernardini and Eugenio Galdieri, 177–208. Savosa/Lugano: Edizioni Arte e moneta, 1995.

H

Haase, Claus-Peter, ed. *A Collector's Fortune: Islamic Art from the Collection of Edmund De Unger*. Berlin: Staatliche Museen zu Berlin, 2007.

Habib, al-Fiqi al-, et al., eds. *al-Tabari, al-Nu'man, al-Qadi, al-Majalis wa'l-musayarat*. Tunis: al-Jamiah al-Tunisiyah, 1978.

Habsburg, Feldman. *Two Giant Gold Mohur Coins*. Geneva: Habsburg, Feldman, 1987.

Hafiz-i Abru. *Zubdat at-tawarikh*. Edited by Kamal Hajj Sayyid Jawadi. 2 vols. Tehran: Sazman-i chap wa intisharat-i wizarat-i farhangi wa irshad-i islami, 1993.

Hallett, Jessica. "From the Looms of Yazd and Isfahan: Persian Carpets and Textiles in Portugal." In *Carpets and Textiles in the Iranian World 1400–1700: Proceedings of the Conference Held at the Ashmolean Museum on 30–31 August 2003*, edited by Jon Thompson, Daniel Shaffer, and Pirjetta Mildh, 90–123. Oxford: May Beattie Archive, Ashmolean Museum, University of Oxford, 2010.

Hallett, Jessica, and Maria Q. Ribeiro. *Os Vidros Da Dinastia Mameluca No Museu Calouste Gulbenkian = Mamluk Glass in the Calouste Gulbenkian Museum*. Lisboa: Fundação Calouste Gulbenkian, 2000.

Halm, Heinz. *The Empire of the Mahdi: The Rise of the Fatimids*. Translated by Michael Bonner. Leiden: E. J. Brill, 1996.

Hambly, Gavin. "Iran during the Reigns of Fath 'Ali Shah and Muhammad Shah." In *The Cambridge History of Iran*. Vol. 7, *From Nadir Shah to the Islamic Republic*, edited by Peter Avery, Gavin Hambly, and Charles P. Melville, 144–73. Cambridge: Cambridge University Press, 1991.

Hamidullah, Muhammad. "Nouveaux Documents sur les Rapports de l'Europe avec L'Orient Musulman Au Moyen Âge." *Arabica* 7, no. 3 (1960): 281–300.

Hammer-Purgstall, Joseph von. *Geschichte der osmanischen Dichtkunst*. Budapest: Conrad Adolph Hartleben Verlag, 1836–38.

———. *Geschichte des osmanischen Reiches*, 10 vols. Budapest: Conrad Adolph Hartleben Verlag, 1827–35.

Harrist, Robert E. "The Legacy of Bole: Physiognomy and Horses in Chinese Painting." *Artibus Asiae* 57, no. 1/2 (1997): 135–56.

———. *Power and Virtue: The Horse in Chinese Art*. New York: China Institute, 1997.

Hasson, Rachel. *Early Islamic Jewelry*. Jerusalem: L.A. Mayer Memorial Institute for Islamic Art, 1987.

Hazlitt, William. *Notes of a Journey through France and Italy*. London: Hunt and Clarke, 1826.

Hecker, Felicia. "A Fifteenth-Century Chinese Diplomat in Herat." *Journal of the Royal Asiatic Society*, 3rd ser., 3, no. 1 (1993): 85–98.

Herbette, Maurice. *Une ambassade Persane sous Louis XIV, d'après des documents inédits*. Paris: Librairie Académique, 1907.

Hillenbrand, Robert. "The Iconography of the Shah-nama-yi Shahi." In *Safavid Persia: The History and Politics of an Islamic Society*, edited by Charles Melville, 53–78. London: I. B. Tauris; New York: St. Martin's Press, 1996.

———. "The Sarcophagus of Shah Isma'il at Ardabil." In *Society and Culture in the Early Modern Middle East: Studies on Iran in the Safavid Period*, edited by Andrew Newman, 165–90. Leiden: E. J. Brill, 2003.

Hilsdale, Cecily. "Constructing a Byzantine Augusta: A Greek Book for a French Bride." *Art Bulletin* 87 (2005): 458–83.

———. "The Social Life of the Byzantine Gift: The Royal Crown of Hungary Reinvented." *Art History* 31, no. 5 (2008): 603–31.

Hintze, Almut. "'*Do ut des*': Patterns of Exchange in Zoroastrianism." *Journal of the Royal Asiatic Society*, 3rd ser., 14, no. 1 (2004): 27–45.

Hinz, Walther. *Islamische Masse und Gewicht*. Leiden: E. J. Brill, 1970.

Hoffman, Eva R. "Pathways of Portability: Islamic and Christian Interchange from the Tenth to the Twelfth Century." *Art History* 24 (2001): 17–50.

Horniker, Arthur Leon. "William Harborne and the Beginnning of Anglo-Turkish Diplomatic and Commercial Relations." In *The Journal of Modern History* 14, no. 3 (September 1942): 289–316.

Howard, Deborah. "Cultural Transfer between Venice and the Ottomans in the Fifteenth and Sixteenth Centuries." In *Cultural Exchange in Early Modern Europe*, vol. 4, *Forging European Identities, 1400–1700*, edited by Herman Roodenburg, 138–177. Cambridge: Cambridge University Press, 2007.

Hyde, Lewis. *The Gift: Imagination and the Erotic Life of Property*. New York: Vintage Books, 1983.

I

Ibn Battuta. *The Travels of Ibn Battuta, A.D. 1325–1354*. Translated by H. A. R. Gibb. 5 vols. London: Hakluyt Society, 1958–2000.

Ibn Hammad, Abu 'Abdallah Muhammad b. 'Ali. *Akhbar muluk bani 'ubayd wa-siratuhum*. Edited and translated by M. Vonderheyden as *Histoire des rois 'obaidides*. Algiers and Paris: J. Carbonel, 1927.

Ibn Hisham, Abi Muhammad 'Abd al-Malik. *Al-Sira al-Nabawiya*. Edited by Taha Abd al-Rauf Sa'd. 4 vols. Cairo: Maktabat al-Kulliyat al-Azhariya, 1974.

Ibn Jubayr, Abu al-Hassan Muhammad b. Ahmad. *Rihlat ibn Jubayr*. Edited by Husain Nassar. Cairo: Maktabat Misr, 1955.

Ibn al-Qalanisi, *Dhail ta'rikh Dimashq*. Edited by Henry F. Amedroz. Beirut: Maṭbaʻat al-Aba' al-Yasuʻiyin, 1908.

Ibn Taghribirdi, Abu al-Mahasin. *Al-Nujum al-Zahira fi Muluk Misr wal-Qahira*. Translated by William Popper as *History of Egypt, 1382–1469*. 7 vols. Berkeley: University of California Press, 1954–63.

Ibn al-Zubayr, al-Qadi al-Rashid. *Kitab al-dhakha'ir wa'l-tuhaf*. Edited by Muhammad Hamidullah. Kuwait: Matba'at Hukumal al-Kuwayt, 1959. See the related Qaddumi, Ghada al-.

Ibrahim, 'Abd al-Latif. "Watha'iq al-Sultan Qaytbay: Silsalat al-Dirasat al-Watha'iqiyya 2. In *Al-Mu'tamar al-Thalith lil Athar fi al-Bilad al-'Arabiya*, 389–444. Cairo: 1960.

Imad, Leila S. al-. *The Fatimid Vizierate, 969–1172*. Berlin: K. Schwarz, 1990.

Imber, Colin, Keiko Kiyotaki, and Rhoads Murphy, eds. *Frontiers of Ottoman Studies: State, Province, and the West*. 2 vols. London and New York: I. B. Tauris, 2005.

İnalcık, Halil. *Türkiye Tekstil Tarihi Üzerine Araştırmaları*. Istanbul: Türkiye İş Bankası Kültür Yayınları, 2008.

Işın, Ekrem, Begüm Akkoyunlu, and Ersu Pekin. *Ali Emiri Efendi Ve Dünyası: Fermanlar, Beratlar, Hatlar, Kitaplar: Millet Yazma Eser Kütüphanesi'nden Bir Seçme = Ali Emiri Efendi and His World: Fermans, Berats, Calligraphs, Books: A Selection from the Millet Manuscript Library*. Istanbul: Suna and İnan Kiraç Foundation Pera Museum, 2007.

Islam, Riazul. *A Calendar of Documents on Indo-Persian Relations 1500–1750*. 2 vols. Tehran: Iranian Culture Foundation; Karachi: Institute of Central and West Asian Studies, 1979–82.

———. *Indo-Persian Relations: A Study of the Political and Diplomatic Relations between the Mughul Empire and Iran*. Tehran: Iranian Culture Foundation, 1970.

Itzkowitz, Norman. *Mubadele; An Ottoman-Russian Exchange of Ambassadors*. Chicago: University of Chicago Press, 1970.

'Izz al-Din Ibn al-Athir. *The Annals of the Saljuq Turks: Selections from al-Kāmil fi'l Ta'rikh of 'Izz al-Dīn Ibn al-Athīr*. Translated by D. S. Richards. London: Routledge Curzon, 2002.

J

Jackson, Peter, and Laurence Lockhart, eds. *The Cambridge History of Iran*. Vol. 6, *The Timurid and Safavid Periods*. Cambridge: Cambridge University Press, 1986.

Jacoby, David. "Silk Economies and Cross-Cultural Artistic Interaction: Byzantium, the Muslim World, and the Christian West." *Dumbarton Oaks Papers* 58 (2004): 197–204.

———. *Trade, Commodities and Shipping in the Medieval Mediterranean*. Aldershot, England: Variorum, 1997.

James, David. *After Timur: Qur'ans of the 15th and 16th Centuries*. London: Nour Foundation in association with Azimuth Editions and Oxford University Press, 1992.

———. *The Master Scribes: Qur'ans of the 10th to 14th Centuries AD*. New York: Nour Foundation in association with Azimuth Editions and Oxford University Press, 1992.

———. *Qur'ans and Bindings from the Chester Beatty Library: A Facsimile Exhibition*. London: World of Islam Festival Trust, 1980.

———. *Qur'ans of the Mamluks*. New York: Thames and Hudson, 1988.

Jarchow, Margarete. *Hofgeschenke. Wihelm II zwischen Diplomatie und Dynastie, 1888–1914*. Hamburg: Dölling und Galitz Verlag, 1998.

Jardine, Lisa. *Worldly Goods: A New History of the Renaissance*. London: Macmillan, 1996.

Jawdhari, Abu 'Ali al-Mansur al-. *Sirat Ustadh Jawdhar*. Edited by M. Kamil Husayn and M. Abd al-Hadi Sha'ira. Cairo: 1954. French translation Canard, Marius. *Vie de l'ustadh Jaudhar*. Algiers: Typo-Litho et Jules Carbonel, 1958.

Jenkins, Marilyn. *Islamic Art in the Kuwait National Museum: The al-Sabah Collection*. London: Sotheby's, 1983.

Jenkins, Marilyn, and Manuel Keene. *Islamic Jewelry in the Metropolitan Museum of Art*. New York: The Metropolitan Museum of Art, 1983.

Jenyns, Soames. "The Chinese Porcelains in the Topkapu Saray, Istanbul." *Transactions of the Oriental Ceramic Society* 36 (1964–66): 43–72.

Jodidio, Philip, et al. *Museum of Islamic Art Doha, Qatar*. Munich: Prestel, 2008.

John of Ephesus. *Historiae ecclesiasticae pars tertia*. Edited and translated by Ernest W. Brooks. 2 vols. Louvain: Corpus Scriptorum christianorum orientalium, 1936. Reprint, 1964.

Johns, Jeremy. *Arabic Administration in Norman Sicily: The Royal Dīwān*. Cambridge Studies in Islamic Civilization. Cambridge: Cambridge University Press, 2002.

Joinville, Jean de. "The Life of Saint Louis." In *Chronicles of the Crusades*, translated by M. R. B. Shaw. London: Penguin, 1963.

Jones, Dalu, and George Michell, eds. *The Arts of Islam: Hayward Gallery, 8 April–4 July 1976*. London: Arts Council of Great Britain, 1976.

Joost-Gaugier, Christiane L. "Lorenzo the Magnificent and the Giraffe as a Symbol of Power." *Artibus et Historiae* 8, no. 16 (1987): 91–99.

Joshi, P. M. "Asad Beg's Mission to Bijapur, 1603–1604." In *Mahamahopadhyaya Prof. D. V. Potda Sixty-first Birthday Commemoration Volume*, edited by S. N. Sen, 184–96. Poona, India: Sathe, 1950.

Juynboll, G. H. A. "The Attitude towards Gold and Silver in Early Islam." In *Pots and Pans: A Colloquium on Precious Metals and Ceramics in the Muslim, Chinese and Graeco-Roman Worlds*, edited by Michael Vickers, 107–16. Oxford Studies in Islamic Art 3. Oxford: Oxford University Press, 1986.

K

Kadoi, Yuka. "Textiles in the Great Mongol *Shāhnāma*: A New Approach to Ilkhanid Costume." In *Proceedings of the Second Edinburgh Shahnama Conference, 8–9 March 2003*, edited by Robert Hillenbrand. Edinburgh: University of Edinburgh Press, forthcoming.

Kafescioğlu, Ciğdem. *Constantinopolis/ Istanbul: Cultural Encounter, Imperial Vision, and the Construction of the Ottoman Capital*. University Park: Pennsylvania State University Press, 2009.

Kahil, Abdallah. *The Sultan Hasan Complex in Cairo 1357–1364. A Case Study in the Formation of Mamluk Style*. Beiruter Texte und Studien, Band 98. Beirut: Orient Institute of the German Oriental Society; Würzburg: Ergon Verlag, 2008.

Kalavrezou-Maxeiner, Loli. "The Cup of San Marco and the 'Classical' in Byzantium." In *Studien zur mittelalterlichen Kunst 800–1250: Festschrift Für Florentine Mütherich zum 70 Geburtstag*, edited by Katherina Bierbauer, Peter K. Klein, and Willibald Sauerländer, 64–91. Munich: Prestel-Verlag, 1986.

Kauz, Ralph. "Paliuwan 怕六灣: Trader or Traitor? – A Samarqandi in Mediaeval Melaka." *Nanyang xuebao (Journal of the South Seas Society)* 56 (2002): 74–87.

———. *Politik und Handel zwischen Ming und Timuriden: China, Iran und Zentralasien im Spätmittelalter*. Iran – Turan 7. Wiesbaden: Dr. Ludwig Reichert, 2005.

———. "Sahala 撒哈剌 -Stoffe – Anmerkungen zum seegestützten Textilhandel zwischen West- und Ostasien (14. bis 15. Jahrhundert)." In *Mirabilia Asiatica: Seltene Waren im Seehandel*, edited by Jorge M. dos Santos Alves, Claude Guillot, and Roderich Ptak, 185–207. South China and Maritime Asia 11. Wiesbaden: Harrassowitz, 2003.

Kaye, John William. *The Life and Correspondence of Major-General Sir John Malcolm, Late Envoy to Persia and Governor of Bombay*. 2 vols. London: Smith, Elder, 1856.

Kazemadeh, F. "Iranian Relations with Russia and the Soviet Union, to 1921." In *The Cambridge History of Iran*. Vol. 7, *From Nadir Shah to the Islamic Republic*, edited by Peter Avery, Gavin Hambly, and Charles P. Melville, 314–49. Cambridge: Cambridge University Press, 1991.

Keddie, Nikki. "Iran under the Later Qajars." In *The Cambridge History of Iran*. Vol. 7, *From Nadir Shah to the Islamic Republic*, edited by Peter Avery, Gavin Hambly, and Charles P. Melville, 174–212. Cambridge: Cambridge University Press, 1991.

Keene, Manuel, and Salam Kaoukji. *Treasury of the World: Jewelled Arts of India in the Age of the Mughals*. New York: Thames & Hudson, 2001.

Keith, Arthur Berriedale. *The Religion and Philosopy of the Veda and Upanishads*. Delhi: Motilal Banarsidass Publishers, 1970.

Kelly, Laurence. *Diplomacy and Murder in Tehran: Alexander Griboyedov and the Tsar's Mission to the Shah of Persia*. London: I. B. Tauris, 2001.

Kennedy, Hugh. "Byzantine-Arab Diplomacy in the Near East from the Islamic Conquests to the Mid Eleventh Century." In *Byzantine Diplomacy. Papers from the Twenty-fourth Spring Symposium of Byzantine Studies, Cambridge, March 1990*. Edited by Jonathan Shephard and Simon Franklin, 133–43. Aldershot, England: Variorum, 1992.

Khata'i, 'Ali Akbar. *Khataynama: sharh-e mushahdat-i Sayyid 'Ali Akbar Khata'i dar sarzamin-e Chin*. Edited by Iraj Afshar. Tehran: Markaz-e asnad-e farhangi-ye Asiya, 1372 [1993/4].

Khazindar, Mona. *Photographies anciennes de La Mecque et de Médine: 1880–1947: Exposition organisé par l'institut du Monde Arabe en collaboration avec la bibliothèque du Roi Abdulaziz, Arabie-Saoudite, 27 Septembre–30 Octobre 2005*. Paris: Institut du Monde Arabe, 2005.

Khwansari, Ahmad Suhayli. "The Negarestan Palace and Garden." *Hunar va Mardum* 144 (1974): 31–37.

King, David. *World-Maps for Finding the Direction and Distance to Mecca: Innovation and Tradition in Islamic Science*. Leiden: Brill, 1999.

King, Donald. "The Ardabīl Puzzle Unravelled." *Hali* 88 (1996): 88–92.

Kleiterp, Marlies, and Charlotte Huygens, eds. *Istanbul: The City and the Sultan*. Amsterdam: De Nieuwe Kerk, 2006.

Knolles, Richard. *The Generall Historie of the Turkes from the First Beginning of that Nation to the Rising of the Ottoman Familie*. 5th ed. London: Adam Islip, 1638.

———. "The Influence of the Jesuit Missions on Symbolic Representations of the Mughal Emperors." In *The Akbar Mission and Miscellaneous Studies*, edited by Christian W. Troll, 14–29. Islam in India: Studies and Commentaries 1. New Delhi: Vikas, 1982.

Köhbach, Markus. "Eine episode der Osmanisch-Habsburgischen Beziehungen aus der zeit der unter-handlungen von 1567." In *Das Osmanische Reich in seinen Archivalien und Chroniken*, edited by Klaus Kreiser and Christoph Neumann, 69–83. Istanbul: In Kommission bei Franz Steiner Verlag, Stuttgart, 1997.

Komaroff, Linda. "Color, Precious Metal, and Fire." In *The Arts of Fire: Islamic Influences on Glass and Ceramics of Renaissance Italy*, edited by Catherine Hess, 35–53. Los Angeles: The J. Paul Getty Museum, 2004.

———. *The Golden Disk of Heaven*. Costa Mesa, CA: Mazda Publishers, 1992.

———. "Sip, Dip, and Pour: Toward a Typology of Water Vessels in Islamic Art." In *Rivers of Paradise: Water in Islamic Art*, edited by Sheila Blair and Jonathan Bloom, 105–29. New Haven, CT: Yale University Press, 2009.

Komaroff, Linda, and Stefano Carboni, eds. *The Legacy of Genghis Khan: Courtly Art and Culture in Western Asia, 1256–1353*. New York: Metropolitan Museum of Art; New Haven, CT: Yale University Press, 2002.

Komter, Aafke E., ed. *The Gift: An Interdisciplinary Perspective*. Amsterdam: University of Amsterdam Press, 1996.

Kopytoff, Igor. "The Cultural Biography of Things: Commoditization as Process." In *The Social Life of Things: Commodities in Cultural Perspective*, edited by Arjun Appadurai, 64–91. Cambridge and New York: Cambridge University Press, 1986.

Köseoğlu, Cengiz. *The Topkapi Saray Museum: The Treasury*. Translated and edited by J. Michael Rogers. London: Thames and Hudson, 1987.

Kostygova, Galina. "Collection of Persian Manuscripts Received by the Public Library in 1929" [in Russian]. *Vostochni Sbornik* 6 (2003), 336–45.

———. "Treatise on the Calligraphy of Sultan Ali Mashhadi" [in Russian]. In *Vostochnyi sbornik* 2 (1957): 103–16.

Krahl, Regina. *Chinese Ceramics in the Topkapi Saray Museum, Istanbul: A Complete Catalogue*. London: Published in association with the Directorate of the Topkapi Saray Museum by Sotheby's Publications, 1986.

Kühnel, Ernst. "Erinnerungen an eine Episode in der Türkenpolitik Friedrichs d. Gr." *Oriens* 5 (1952): 70–81.

Kunst- und Ausstellungshalle der Bundesrepublik Deutschland GmbH. *Dschingis Khan und seine Erbe: Das Weltreich der Mongolen*. Bonn: Kunst- und Ausstellungshalle der Bundesrepublik Deutschland GmbH, 2005.

Kurz, Otto. *European Clocks and Watches in the Near East*. London: Warburg Institute, University of London, 1975.

———. "Künstlerische beziehungen zwischen Prag und Persien zur zeit Kaiser Rudolfs II und Beiträge zur geschichte seiner sammlungen." In *The Decorative Arts of Europe and the Islamic East*, edited by Otto Kurz, 1–22. London: Dorian Press, 1977.

Kütükoğlu, Bekir. *Osmanlı - İran Siyasi Münasebetleri*. Istanbul: Istanbul Fetih Cemiyeti, 1962.

———. "Şah Tahmasb'ın III. Murad'a Cülus Tebriki." *Tarih Dergisi* 15 (1960): 1–24.

L

Lambton, Ann. "'Pīshkash: Present or Tribute?" *Bulletin of the School of Oriental and African Studies* 57, no. 1 (1994): 145–58.

Lane-Poole, Stanley. *Coins of the Moghul Emperors of Hindustan in the British Museum*. London: British Museum, 1892.

———. *The History of the Moghul Emperors of Hindustan Illustrated by Their Coins*. Delhi: Oriental Publishers, n.d.

Lassikova, Galina. "Hushang the Dragon-slayer: Fire and Firearms in Safavid Art and Diplomacy." *Iranian Studies* 43, no. 1 (February 2010): 29–51.

Lassner, Jacob. *Demonizing the Queen of Sheba: Boundaries of Gender and Culture in Postbiblical Judaism and Medieval Islam*. Chicago: University of Chicago Press, 1993.

Leach, Linda York. *Mughal and Other Indian Paintings from the Chester Beatty Library*. 2 vols. London: Scorpion Cavendish, 1995.

Leiser, Gary. "The Endowment of the Al-Zahiriyya in Damascus." *Journal of the Economic and Social History of the Orient* 27, no. 1 (1984): 33–55.

Leithe-Jasper, Manfred, and Rudolf Distelberger. *The Kunsthistorisches Museum Vienna: The Imperial and Ecclesiastical Treasury*. London: Scale Books, 1998.

Lentz, Thomas, and Glenn Lowry. *Timur and the Princely Vision: Persian Art and Culture in the Fifteenth Century*. Los Angeles: Los Angeles County Museum of Art, 1989.

Lev, Yaacov. *State and Society in Fatimid Egypt*. Arab History and Civilization: Studies and Texts. Leiden: E. J. Brill, 1991.

Levtzion, Nehemia, and Jay Spaulding. *Medieval West Africa: Views from Arab Scholars and Merchants*. Princeton, NJ: Markus Wiener Publishers, 2003.

Li Dongyang 李東陽 et al. *Da Ming huidian* 大明會典. 5 vols. Taipei: Huawen shuju, 1963.

Liscomb, Kathlyn. "Foregrounding the Symbiosis of Power: A Rhetorical Strategy in Some Chinese Commemorative Art." *Art History* 25, no. 2 (April 2002): 135–61.

Little, Donald P. "Diplomatic Missions and Gifts Exchanged by the Mamluks and Ilkhans." In *Beyond the Legacy of Genghis Khan*, edited by Linda Komaroff, 30–42. Leiden: Brill, 2006.

Littlefield, Sharon. "The Object in the Gift: Embassies of Jahangir and Shah Abbas." PhD diss., University of Minnesota, 1999.

Lockhart, L. *Nadir Shah: A Critical Study Based Mainly upon Contemporary Sources*. London: Luzac, 1938.

Loomba, Ania. "Of Gifts, Ambassadors, and Copy-cats: Diplomacy, Exchange, and Difference in Early Modern India." In *Emissaries in Early Modern Literature and Culture: Mediation, Transmission, Traffic, 1550–1700*, edited by Charry Brinda and Gitanjali Shahani, 41–75. Surrey: Ashgate Publishing, Ltd., 2009.

Losty, Jeremiah. *The Art of the Book in India*. London: British Library, 1982.

Lukonine, Vladimir, and Anatol Ivanov. *Persian Art*. London: Sirocco, 2003.

M

Mack, Rosamond. *Bazaar to Piazza: Islamic Trade and Italian Art, 1300–1600*. Berkeley: University of California Press, 2002.

Mackenzie, Colin, and Irving Finkel, eds. *Asian Games: The Art of Contest*. New York: Asia Society, 2004.

Mackie, Louise. "Toward an Understanding of Mamluk Silks: National and International Considerations." *Muqarnas* 2 (1984): 127–46.

Maddison, Francis, and James W. Allan. *Metalwork Treasures from the Islamic Courts*. Doha, Qatar: Museum of Islamic Art, 2002.

Mahir, Bânu. "Saray Nakkaşhanesinin Ünlü Ressamı Şah Kulu ve Eserleri." *Topkapı Sarayı Müzesi Yıllık* 1 (1986): 113–30.

Maitra, K. M., trans. *A Persian Embassy to China: Being an Extract from Zubdatu't Tawarikh of Hafiz Abru*. With a new introduction by L. Carrington Goodrich. New York: Paragon Book Reprint Corp., 1970.

Majumdar, R. C., ed. *The Mughul Empire*. Bombay: Bharatiya Vidya Bhavan, 1974.

Makariou, Sophie. "Le Jeu d'échecs, une pratique de l'aristocratie entre Islam et Chrétienté des IX–XIIIe siècles." *Les Cahiers de Saint-Michel de Cuxa* 36 (2005): 127–40.

Mandosius, Julius. *Ottomanorum principum effigies ab Ottomano ad regnantem Mustapham II*. Rome: Typis D. de Rubeis, 1698.

Manz, Beatrice Forbes. *Power, Politics and Religion in Timurid Iran*. Cambridge: Cambridge University Press, 2007.

Maqrizi, Taqiyy al-Din Ahmad ibn 'Ali ibn 'Abd al-Qadir al-. *Itti'az al-hunafa' bi-akhbar al-a'immat al-fatimiyyin al-khulafa'*. 3 vols. Edited by Jamal al-Dīn al-Shayyal. Cairo, 1967–73.

———. *Al-Mawa'iz wa'l-i'tibar bi-dhikr al-khitat wa'l-athar*. 2 vols. Cairo: Bulaq, 1853.

Marchand, Suzanne. *Down from Olympus: Archaeology and Philhellenism in Germany, 1750–1970*. Princeton, NJ: Princeton University Press, 1996.

Markel, Stephen. "Fit for an Emperor: Inscribed Works of Decorative Art Acquired by the Great Mughals." *Orientations* 21, no. 8 (1990): 22–36.

———. "Inception and Maturation in Mughal Jades." In *The World of Jade*, edited by Stephen Markel, 49–64. Bombay: Marg Publications, 1992.

———. "Mughal Jades: A Technical and Sculptural Perspective." *Asianart.com*, July 14, 2008. http://www.asianart.com/articles/markel2/index.html (accessed August 10, 2010).

———. "Non-Imperial Mughal Sources for Jades and Jade Simulants in South Asia." *Jewellery Studies* 10 (2004): 68–75.

Mashkur, Muhammad Javad. *Nazar-i bi ta'rikh-i Azerbaijan va asar-i bastani va jami'at shinasi-yi an*. Tehran: Cahpkhana Bahman, 1349/1971.

Mas'udi, 'Ali b. al-Husayn al-. *The Meadows of Gold: The Abbasids*. Translated and edited by Paul Lunde and Carole Stone. London and New York: KPI, 1989.

Matthee, Rudi. "Between Aloofness and Fascination: Safavid Views of the West." *Iranian Studies* 31, no. 2 (Spring 1998): 219–46.

———. "Gift Giving in the Safavid Period." In *Encyclopaedia Iranica*, edited by Ehsan Yarshater, vol. 10, 609–14. New York: Bibliotheca Persica Press, 2001.

———. "Gouvea, Antonio de." In *Encyclopaedia Iranica*, edited by Ehsan Yarshater, vol. 10, 177–79. New York: Bibliotheca Persica Press, 2003.

———. "Negotiating across Cultures: The Dutch Van Leene Mission to the Iranian Court of Shah Sulayman 1689–1692." *Eurasian Studies* 3, no. 1 (2004): 35–63.

———. *The Politics of Trade in Safavid Persia. Silk for Silver, 1600–1730*. Cambridge: Cambridge University Press, 1999.

———. "Suspicion, Fear, and Admiration: Pre-Nineteenth-Century Iranian Views of the English and the Russians." In *Iran and the Surrounding World: Interactions in Culture and Cultural Politics*, edited by Nikki R. Keddie and Rudi Matthee, 121–45. Seattle and London: University of Washington Press, 2002.

Matthee, Rudi, and Jorge Flores. *Portugal, the Persian Gulf and Safavid Persia*. Louvain, Belgium: Peeters, forthcoming.

Maury, Charlotte, Carol LaMotte, and Sabanci Müzesi. *Istanbul, Isfahan, Delhi: 3 Capitals of Islamic Art: Masterpieces from the Louvre Collection*. Istanbul: Sabanci University, Sakip Sabanci Müzesi, 2008.

Mauss, Marcel. "Essai sur le don: forme et raison de l'échange dans les sociétés archaïques." In *Sociologie et anthropologie*, edited by Claude Lévi-Strauss, 143–279. Paris: Presses Universitaires de France, 1950. Translated by W. D. Halls as *The Gift: The Form and Reason for Exchange in Archaic Societies*. London and New York: Routledge, 1990.

Mayer, L.A. *Islamic Astrolabists and Their Works*. Geneva: Albert Kundig, 1956.

———. *Islamic Metalworkers and Their Works*. Geneva: Albert Kundig, 1959.

———. *Mamluk Costume: A Survey*. Geneva: Albert Kundig, 1952.

McCabe, Ina Baghdiantz. *The Shah's Silk for Europe's Silver: The Eurasian Trade of the Julfa Armenians in Safavid Iran and India (1530–1750)*. Atlanta: Scholars Press, 1999.

McChesney, Robert. "*Waqf* and Public Policy: The *Waqf*s of Shah 'Abbas 1011–1023/1602–1614." *Asian and African Studies* 15, no. 2 (1981): 165–90.

———. *Waqf in Central Asia: Four Hundred Years in the History of a Muslim Shrine, 1480–1889*. Princeton, NJ: Princeton University Press, 1991.

McWilliams, Mary. "Prisoner Imagery in Safavid Textiles." *Textile Museum Journal* 26 (1987): 5–23.

Medley, Margaret. "Islam, Chinese Porcelain and Ardabil." *Iran* 8 (1975): 31–37.

Melikian-Chirvani, Assadullah Souren. "From the Royal Boat to the Beggar's Bowl." *Islamic Art* 4 (1991): 3–111.

——. "The Jewelled Objects of Hindustan." *Jewellery Studies* 10 (2004): 9–32.

——. "The Lights of Sufi Shrines." *Islamic Art* 2 (1987): 117–48.

——. "The Red Stones of Light in Iranian Culture. I. Spinels." *Bulletin of the Asia Institute* 15 (2001): 77–110.

——. "Sa'ida-ye Gilani and the Iranian Style Jades of Hindustan." *Bulletin of the Asia Institute* 13 (1999): 83–140.

——. "Silver in Islamic Iran: The Evidence from the Literature and Epigraphy." In *Pots and Pans: A Colloquium on Precious Metals and Ceramics in the Muslim, Chinese and Graeco-Roman Worlds*, edited by Michael Vickers, 89–106. Oxford Studies in Islamic Art 3. Oxford: Oxford University Press, 1986.

Melville, Charles P. "Shah 'Abbas and the Pilgrimage to Mashhad." In *Safavid Persia: The History and Politics of an Islamic Society*, edited by Charles Melville, 191–230. London: I. B. Tauris, 1996.

Membré, Michel. *Mission to the Lord Sophy of Persia (1539–42)*. Translated by A. H. Morton. London: School of Oriental and African Studies, University of London, 1993.

Meriç, Rifki M. "Bayramlarda Padişahlara Hediye Edilen San'at Eserleri ve Karşılıkları." *Türk San'ati Araştirma ve Incelemeleri* 1 (1963): 764–86.

Mez, Adam. *Renaissance of Islam*. Translated by Salahuddin Khuda Bakhsh and D. S. Margoliouth. Patna, India: Jubilee Printing and Publishing House, 1937.

Michell, George, and Mumtaz Currim. *Mughal Style: The Art & Architecture of Islamic India*. Mumbai: India Book House, 2007.

Millard, Charles. "Diplomatic Portrait: Lawrence's 'The Persian Ambassador.'" *Apollo* (February 1967): 115–21.

Ming shilu 明實錄. 133 vols. Taipei: Zhongyang yanjiuyuan lishi yuyan yanjiusuo, 1966.

Minorsky, Vladimir. *The Chester Beatty Library: A Catalogue of the Turkish Manuscripts and Miniatures*. Dublin: Hodges, Figgis, 1958.

——. "Tsena krovi Griboyedova. Neizdanny dokument." *Russkaya Mysl* (Prague-Berlin), 3–4 (1923): 333–45.

Misugi, Takatoshi. *Chinese Porcelain Collections in the Near East: Topkapi and Ardebil*. 3 vols. Hong Kong: Hong Kong University Press, 1981.

Mohamed, Bashir. *The Arts of the Muslim Knight: The Furusiyya Art Foundation Collection*. Milan: Skira, 2008.

Mombauer, Annika, and Wilhelm Deist, eds. *The Kaiser: New Research on Wilhelm II's Role in Imperial Germany*. Cambridge: Cambridge University Press, 2003.

Monshi, Eskandar Beg. *History of Shah 'Abbas the Great*. Translated by Roger M. Savory. 3 vols. New York: Bibliotheca Persica, 1978–1986.

Moreland, W. H. *From Akbar to Aurangzeb: A Study in Indian Economic History*. Delhi: Vinod Publications, 1988.

Moraitou, Mina. "Early Islamic Textiles." *Hali* 156 (2008): 62–64.

Morony, Michael. *Iraq after the Muslim Conquest*. Princeton, NJ: Princeton University Press, 1984.

Mortel, R. T. "The Kiswa: Its Origins and Development from Pre-Islamic Times until the End of the Mamluk Period." *Ages: A Semi-Annual Journal of Historical, Archaeological and Civilizational Studies* 3, no. 2 (1988): 38–43.

Morton, Alexander. "The Ardabil Shrine in the Reign of Shah Tahmasp I." *Iran* 12 (1974): 31–64.

——. "The Ardabil Shrine in the Reign of Shah Tahmasp I (Concluded)." *Iran* 13 (1975): 39–58.

Mraz, Gottfried. "The Role of Clocks in the Imperial Honoraria for the Turks." In *The Clockwork Universe: German Clocks and Automata, 1550–1650*, edited by Klaus Maurice and Otto Mayr, 37–48. Washington, DC: Smithsonian Institution Press, 1980.

Muhammad 'Abbasi. *Burhan-i qati'*. Tehran: Mu'assisah-i Matbu'ati-i Faridun-i 'ilmi, 1344 (1965).

Muhammad Qasim. *'Alamgirnama*. Edited by Mawlawi Khadim Husain and Mawlawi Abd al-Hai. Calcutta: Asiatic Society of Bengal, 1868.

Muhammad Saqi. *Ma'asir-i 'Alamgiri*. Edited by Maulawi Agha Ahmad 'Ali. Calcutta: Asiatic Society of Bengal, 1870.

Munajjim, Mulla Jallal al-din. *Tarikh-i 'Abbasi ya ruznama-yi Mulla Jallal*. Edited by Sayf-Allah Vahidniya. Tehran: Intisharat-i Vahid, 1366/1987.

Munshi, Iskander Beg. *History of Shah Abbas the Great*. Edited and translated by Roger M. Savory. 2 vols. Boulder, CO: Westview Press, 1978.

——. *Tarikh-i 'alam ara-yi 'Abbasi*. Edited by Iraj Afshar. 2nd ed. Tehran: Amir Kabir, 1350/1971.

Musabbihi, al-. *Tome Quarantième de la Chronique d'Égypte de Musabbihī*. Edited by Ayman Fu'ad Sayyid and Thierry Bianquis. Cairo: Institut Français d'Archéologie Orientale, 1978.

Musée Cernuschi. *La Perse et la France; relations diplomatiques et culturelles du XVIIe au XIXe siècle*. Paris: Musée Cernuschi, 1972.

Museum für Angewandte Kunst, Frankfurt. *Tulpen, Kaftane und Levnî: Höfische Mode und Kostümalben der Osmanen aus dem Topkapı Palast Istanbul/Tulips Kaftans and Levnî: Imperial Ottoman Costumes and Miniature Albums from Topkapi Palace Istanbul*. Munich: Hirmer Verlag, 2008.

Mustafa 'Ali (Gelibolulu). *Cami' u'l-buhur der Mecalis-i Sur*. Edited by A. Öztekin. Ankara: Türk Tarih Kurumu Basimevi, 1996.

Muta'madi, 'Ali. *Rahnama-yi Muze-yi Astan-i quds-i razavi*, Mashhad, Iran: n.p., n.d.

N

Najmabadi, Afsaneh. *Women with Mustaches and Men without Beards: Gender and Sexual Anxieties of Iranian Modernity*. Berkeley: University of California Press, 2005.

Nava'i, Abdul Husain. *Shah Isma'il Safavi: Asnad va mukatabat-i tarikhi hamrah ba yadashtaha-yi tafsili*. Tehran: Intisharat-i Arghavan, 1368/1989.

Necipoğlu, Gülru. *Architecture, Ceremonial, and Power: The Topkapi Palace in the Fifteeenth and Sixteenth Centuries*. Cambridge, MA: M.I.T. Press, 1991.

———."Dynastic Imprints on the Cityscape: The Collective Message of Imperial Funerary Mosque Complexes in Istanbul." In *Colloque Internationale: Cimetières et traditions funéraires dans le monde islamique* (Institut Français d'études Anatoliennes, Istanbul, September 28–30, 1991), edited by Jean-Louis Bacqué-Grammont, 23–36. Paris: C.N.R.S., 1996.

———. "The Süleymaniye Complex in Istanbul: An Interpretation." *Muqarnas* 3 (1985): 92–117.

———. "Süleyman the Magnificent and the Representation of Power in the Context of Ottoman-Hapsburg-Papal Rivalry." *Art Bulletin* 71, no. 3 (September 1989): 401–27.

Nenarokomova, Irina. *Art Treasures from the Museum of the Moscow Kremlin*. Moscow: Khudozhnik Publishers, 1980.

Nizam al-Mulk. *The Book of Government or Rules for Kings*. Translated by Hubert Duke. London: Routledge & Kegan Paul, 1978.

Noel, William, and Daniel Weiss. *The Book of Kings: Art, War, and the Morgan Library's Medieval Picture Bible*. Baltimore: Walters Art Gallery, 2002.

Nu'man, al-Nu'man ibn Muhammad ibn Mansur al-Qadi al-. *Kitab al-majalis wa al-musayarat*. Beirut: Dar al-Jarb al-Islami, 1997.

O

Ogilby, John. *Asia, the First Part. Being an Accurate Description of Persia, and the Several Provinces Thereof. The Vast Empire of the Great Mogol*. London, 1673.

Okada, Amina. "The Representation of Jesuit Missionaries in Mughal Painting." In *Goa and the Great Mughal*, edited by Jorge Flores and Nuno Vassallo e Silva, 190–99. London: Calouste Gulbenkian Foundation, 2004.

O'Kane, Bernard. *Timurid Architecture in Khurasan*. Costa Mesa, CA: Mazda Publishers, 1987.

———, ed. *The Treasures of Islamic Art in the Museums of Cairo*. Cairo: American University in Cairo Press, 2006.

Ölcer, Nazan, and Danis Baykan. *Museum of Turkish and Islamic Art: History of the Museum*. Istanbul: Akbank, 2002.

Olearius, Adam. *The Voyages and Travels of the Ambassadors Sent by Frederick Duke of Holstein, to the Great Duke of Muscovy, and the King of Persia*. London: Thomas Dring, 1662.

Oreshkova, S. F. *Russko-Turetskie Otnosheniya v nachale XVIII v*. Moscow: Nauka, 1971.

Ouseley, Sir William. *Travels in Various Countries of the East*. London: Rodwell and Martin, 1819–23.

P

Pal, Pratapaditya. *Indian Painting*. Los Angeles: Los Angeles County Museum of Art, 1993.

Pal, Pratapaditya, Janice Leoshko, Joseph M. Dye III, and Stephen Markel. *Romance of the Taj Mahal*. Los Angeles: Los Angeles County Museum of Art, 1989.

Palace Arts Foundation. *Palace of Gold and Light: Treasures from the Topkapi, Istanbul*. Washington, DC: Palace Arts Foundation, 2000.

Pancaroğlu, Oya. *Perpetual Glory: Medieval Islamic Ceramics from the Harvey B. Plotnick Collection*. Chicago: Art Institute of Chicago, 2007.

———. "Serving Wisdom: The Contents of Samanid Epigraphic Pottery." In *Studies in Islamic and Later Indian Art from the Arthur M. Sackler Museum, Harvard University Art Museums*, 59–75. Cambridge, MA: Arthur M. Sackler Museum, 2002.

Parani, Maria G. "Intercultural Exchange in the Field of Material Culture in the Eastern Mediterranean: The Evidence of Byzantine Legal Documents (11th to 15th Centuries)." In *Diplomatics in the Eastern Mediterranean 1000–1500: Aspects of Cross-Cultural Communication*, edited by Alexander D. Beihammer, Maria G. Parani, and Christopher D. Schabel, 349–71. Leiden: Brill, 2008.

Parker, Kenneth, ed. *Early Modern Tales of Orient: A Critical Anthology*. London and New York: Routledge, 1999.

Peçevi İbrahim Efendi. *Peçevi Tarihi*. Edited by B. S. Baykal. 2 vols. Mersin: Kültür Bakanlığı Yayinları, 1992.

Pedanti, Maria Pia. *In noma del Gran Signore: Inviati ottomani a Venezia dall caduta di Costantinopoli alla guerra di Candia*. Venice: Deputazione di storia patria per le venezie, 1994.

Peirce, Leslie P. *The Imperial Harem: Women and Sovereignty in the Ottoman Empire*. Studies in Middle Eastern History. New York: Oxford University Press, 1993.

Pellat, Charles, trans. *Le livre de la couronne*. Paris: Les Belles Lettres, 1954.

Peters, Frank E. *Mecca: A Literary History of the Muslim Holy Land*. Princeton, NJ: Princeton University Press, 1994.

Petrosian, Iu. A. *Russkie na beregakh Bosfora: Istoricheskie ocherki*. St. Petersburg: Tsentr "Peterburgskoe vostokovedenie," 1998.

Petsopoulos, Yanni, ed. *Tulips, Arabesques & Turbans: Decorative Arts of the Ottoman Empire.* New York: Abbeville Press, 1982.

Philon, Helen. *Early Islamic Ceramics: Ninth to Late Twelfth Centuries.* London: Islamic Art Publications, 1980.

Piotrovsky, Mikhail B. *On Islamic Art.* St. Petersburg: State Hermitage Museum, 2001.

Piotrovsky, Mikhail B., Adel T. Adamova et al. *Iran v Ėrmitaže: Formirovanie Kollekciji, Katalov Vystavki.* St. Petersburg: Slavija, 2004.

Piotrovsky, Mikhail B., and Anton D. Pritula, eds. *Beyond the Palace Walls: Islamic Art from the State Hermitage Museum: Islamic Art in a World Context.* Edinburgh: National Museums of Scotland, 2006.

Piotrovsky, Mikhail B., and John Vrieze, eds. *Earthly Beauty, Heavenly Art: Art of Islam.* Amsterdam: De Nieuwe Kerk; London: Lund Humphries, 2001.

Plaza Book Auction Corporation. *Collection of Rare Russian Books in Contemporary Morocco Bindings: Illustrated Books, Autographs, from the Libraries of Maria Fedorovna, Catherine II, Alexander I, II, and III, Nicholas I and II, the Grand Duchesses and the Tsarevich Alexis, Sold by Order of the Owner.* Auction, April 12–13, 1934. New York: Plaza Book Auction Corporation, 1934.

———. *Important Collection of Manuscripts, First Editions, Illustrated Books of the XVIII and XIX Century. Fine Bindings from the Libraries of the Tzars of Russia. Sold by Order of the Owner.* Auction, November 21–24, 1933. New York: Plaza Book Auction Corporation, 1933.

Pope, John A. *Chinese Porcelains from the Ardebil Shrine.* Washington, DC: Smithsonian Institution, Freer Gallery of Art, 1956.

Porter, Venetia. "The Art of the Rasulids." In *Yemen: 3000 Years of Art and Civilization in Arabia Felix*, edited by Werner Daum, 232–53. Frankfurt am Main: Umschau-Verlag, 1987.

Portrety, gerby i pechati Bol'shoi gosudarstvennoi knigi 1672g. St. Petersburg: Izd. S. Peterburgsakgo arkheologicheskago institute, 1903.

Prado-Vilar, Francisco. "Circular Visions of Fertility and Punishment: Caliphal Ivory Caskets from al-Andalus." *Muqarnas* 14 (1997): 19–41.

Pritchard, James B. *Solomon and Sheba.* New York: Praeger, 1974.

Q

Qaddumi, Ghada al-, trans. and annot. *Book of Gifts and Rarities (Kitāb al-Hadāyā wa al-Tuhaf): Selections Compiled in the Fifteenth Century from an Eleventh-Century Manuscript on Gifts and Treasures.* Cambridge, MA: Center for Middle Eastern Studies of Harvard University, 1996. See the related Ibn al-Zubayr, al-Qadi al-Rashid.

Quinn, Sholeh A. *Historical Writing during the Reign of Shah 'Abbas: Ideology, Imitation and Legitimacy in Safavid Chronicles.* Salt Lake City: University of Utah Press, 2000.

R

Raby, Julian. "Pride and Prejudice: Mehmed the Conqueror and the Italian Portrait Medal." In *Italian Medals*, edited by J. Graham Pollard, 171–94. Studies in the History of Art 21. Washington, DC: National Gallery of Art, 1987.

———. *Qajar Portraits.* London: Azimuth Editions in association with the Iran Heritage Foundation, 1999.

———. "The Serenissima and the Sublime Porte: Art in the Art of Diplomacy, 1453–1600." In *Venice and the Islamic World, 828–1797*, edited by Stefano Carboni, 90–119. New York: Metropolitan Museum of Art, 2006.

———. *Venice, Dürer, and the Oriental Mode.* London: Islamic Art Publications, 1982.

Raby, Julian, and Ünsal Yücel. "Chinese Porcelain at the Ottoman Court." In *Chinese Ceramics in the Topkapi Saray Museum, Istanbul: A Complete Catalogue*, by Regina Krahl, edited by John Ayers, vol. 1, 27–54. 3 vols. London: Sotheby's Publications, 1986.

Rashid al-Din. *Jami' al-Tawarikh.* Edited by Edgar Blochet. Leiden: E. J. Brill, 1911.

———. *Jami' al-Tawarikh.* Translated by John A. Boyle as *The Successors of Genghis Khan.* New York: Columbia University Press, 1971.

———. *Rashiduddin Fazlullah's "Jami'u't-tawarikh": Compendium of Chronicles.* Pts. 1–3, *A History of the Mongols.* Translated and annotated by Wheeler M. Thackston. Sources of Oriental Languages and Literature 45. Central Asian Sources 4. Cambridge, MA: Harvard University, Department of Near Eastern Languages and Civilizations, 1999.

Ratchnevsky, Paul, and Thomas Nivison Haining. *Genghis Khan: His Life and Legacy.* Oxford: Blackwell Publishing, 2006.

Reindl-Kiel, Hedda. "East Is East and West Is West, and Sometimes the Twain Did Meet. Diplomatic Gift Exchange in the Ottoman Empire." In *Frontiers of Ottoman Studies: State, Province, and the West*, edited by Colin Imber, Keiko Kiyotaki, and Rhoads Murphey, vol. 1, 113–23. 2 vols. New York: I. B. Tauris, 2005.

———. "Pracht und Ehre: Zum Geschenkwesen im Osmanischen Reich." In *Das Osmanische Reich in seinen Archivalien und Chroniken*, edited by Klaus Kreiser and Christoph K. Neumann, 161–89. Istanbul: In Kommission bei Franz Steiner Verlag, Stuttgart, 1997.

Reiske, Johann Jacob. *Constantini Porphyrogeniti Imperatoris De cerimoniis aulae Byzantinae libri duo.* Bonn: Weber, 1829–30.

Renick, M. S. "Akbar's First Embassy to Goa. Its Diplomatic and Religious Aspects." *Indica* 7, no. 1 (March 1970): 33–47.

Reyhanlı, Tülay. *İngiliz Gezginlerine Göre XVI. Yüzyılda İstanbul' da Hayat 1582–1599*. Ankara: Kültür e Turizm Bakanlığı, 1983.

Rice, David Storm. "The Inlaid Brasses from the Workshop of Aḥmad Al-Dhakī Al-Mawṣili." *Ars Orientalis* 2 (1957): 283–326.

Rice, David Talbot. *The Illustrations to the World History of Rashid al-Din*. Edinburgh: Edinburgh University Press, 1976.

Richards, John F. "The Formulation of Imperial Authority under Akbar and Jahangir." In *Kingship and Authority in South Asia*, edited by John F. Richards, 252–84. Madison: University of Wisconsin, 1981.

———, ed. *The Imperial Monetary System of Mughal India*. Delhi: Oxford University Press, 1987.

———. *The Mughal Empire*. Cambridge: Cambridge University Press, 1995.

Ringmar, Erik. "Audience for a Giraffe: European Expansionism and the Quest for the Exotic." *Journal of World History* 17, no. 4 (December 2006): 375–97.

Rizvi, Janet. "Gendered Patronage: Women and Benevolence in Safavid Architecture." In *Women, Patronage, and Self-Representation in Islamic Societies*, edited by D. Fairchild Ruggles, 123–53. New York: State University of New York Press, 2000.

Rizvi, Janet, and Monisha Ahmed. *Pashmina: The Kashmir Shawl and Beyond*. Mumbai: Mārg Publications, 2009.

Rizvi, Kishwar. "Transformations in Early Safavid Architecture: The Shrine of Shaykh Safi al-din Ishaq Ardabili in Iran (1501–1629)." PhD diss., Massachusetts Institute of Technology, 2000.

Robinson, Arthur E. "The Mahmal of the Moslem Pilgrimage." *Journal of the Royal Asiatic Society of Great Britain and Ireland*, no. 1 (January 1931): 117–27.

Robinson, B. W. *A Descriptive Catalogue of the Persian Paintings in the Bodleian Library*. Oxford: Clarendon Press, 1958.

———. "Ismāʿīl II's Copy of the *Shāhnāma*." *Iran* 14 (1976): 1–8.

———. "Persian Painting under the Zand and Qajar Dynasties." In *The Cambridge History of Iran*. Vol. 7, *From Nadir Shah to the Islamic Republic*, edited by Peter Avery, Gavin Hambly, and Charles P. Melville, 870–89. Cambridge: Cambridge University Press, 1991.

———. "The Royal Gifts of Fath ʿAli Shah." *Apollo* (September 1950): 66–68.

———. "Shah Abbas and the Mughal Ambassador Khan Alam: The Pictorial Record." *Burlington Magazine* 114, no. 827 (February 1972): 58–63.

———. "The *Shahnama* of Muhammad Juki." In *The Royal Asiatic Society: Its History and Treasures*, eds. Stuart Simmonds and Simon Digby, 83–102. Leiden and London: E. J. Brill, 1979.

———. "Two Manuscripts of the *Shahnama* in the Royal Library, Windsor Castle – II MS Holmes 151 (A/6)." *Burlington Magazine* 110, no. 780 (March 1968): 131–40.

Robinson, B. W., Eleanor Sims, and Manijeh Bayani. *The Windsor Shahnama of 1648*. London: Azimuth Editions for the Roxburghe Club, 2007.

Roded, Ruth. "The Waqf and the Social Elite of Aleppo in the Eighteenth and Nineteenth Centuries." *Turcica* 22 (1988): 71–91.

Roe, Sir Thomas. *The Embassy of Sir Thomas Roe to India, 1615–19*. Edited by William Foster. New Delhi: Munshiram Manoharal Publishers Pvt Ltd, 1990.

Rogers, J. Michael. "Europe and the Ottoman Arts." In *Europe and Islam between the 14th and 16th Centuries*, edited by Michele Bernardini, Clara Borrelli, Anna Cerbo, and Encarnacion Sanchez Garcia, vol. 2, 709–36. 2 vols. Naples: Istituto Universitario Orientale, 2002.

———. *Islamic Art and Design, 1500–1700*. London: Trustees of the British Museum, 1983.

———. "Plate and Its Substitutes in Ottoman Inventories." In *Pots and Pans: A Colloquium on Precious Metals and Ceramics in the Muslim, Chinese and Graeco-Roman Worlds*, edited by Michael Vickers, 117–36. Oxford Studies in Islamic Art 3. Oxford: Oxford University Press, 1986.

———. "The State and the Arts in Ottoman Turkey, Part 2: The Furniture and Decoration of the Süleymaniye." *International Journal of Middle Eastern Studies* 14 (1982): 283–313.

Röhl, John C. G. *Wilhelm II: The Kaiser's Personal Monarchy, 1888–1900*. Translated by Sheila de Bellaigue. Cambridge: Cambridge University Press, 2004.

Rosenthal, Franz. "Gifts and Bribes: The Muslim View." *Proceedings of the American Philosophical Society* 108 (1964): 135–44.

———. "A Note on the *Mandîl*." In *Four Essays on Art and Literature in Islam*, 63–99. Leiden: Brill, 1971.

Rossabi, Morris. "The Tea and Horse Trade with Inner Asia during the Ming." *Journal of Asian History* 4, no. 2 (1970): 136–168.

———. "A Translation of Ch'en Ch'eng's *Hsi-Yü Fan-Kuo Chih*." *Ming Studies* 17 (1983): 49–59.

———. "Two Ming Envoys to Inner Asia." *T'oung Pao* 62, nos. 1–3 (1976): 1–34.

Rosser-Owen, Mariam. "A Cordoban Ivory Pyxis Lid in the Ashmolean Museum." *Muqarnas* 16 (1999): 16–31.

———. *Islamic Arts from Spain*. London: V&A Publishing, 2010.

Rossiiskoe posol'stvo v Konstantinopol', 1776 goda. St. Petersburg: Imperatorskaia Akademiia Nauk, 1777.

Rota, Giorgio. "Safavid Envoys in Venice." In *Diplomatische Praxis und Zeremoniell in Europa und dem Mittleren Osten in der Fruhen Neuzeit*, edited by Ralph Kauz, Jan Paul Niederkorn, and Giorgio Rota. Vienna: Verlag der Osterreichischen Akademie der Wissenschaften, forthcoming.

Roux, Jean-Paul, ed. *L'Islam dans les collections nationales*. Paris: Éditions des Musées nationaux, 1977.

Roxburgh, David. *The Persian Album, 1400–1600: From Dispersal to Collection*. New Haven, CT: Yale University Press, 2005.

———, ed. *Turks: A Journey of a Thousand Years, 600–1600*. London: Royal Academy of Arts; New York: Harry N. Abrams, 2005.

Rubin, Ida Ely. *The Guennol Collection*. New York: Metropolitan Museum of Art, 1975.

Rūmlū, Hasan. *A Chronicle of the Early Safawis: Being the Ahsanu't-tāwārīkh of Hasan-i Rūmlū*. Edited and translated by C. N. Seddon. 2 vols. Baroda: Oriental Institute, 1931–34.

S

Sabi, Hilal al-. *Rusum dar al-Khalifah*, edited by Mikhail Awad. Baghdad: al-'Ani, 1964.

Sadan, Joseph. "Some Written Sources Concerning Goldsmithing and Jewellery." In *Jewellery and Goldsmithing in the Islamic World, International Symposium, the Israel Museum, Jerusalem, 1987*, edited by Na'ama Brosh, 93–99. Jerusalem: Israel Museum, 1991.

Šahīdī, Yahyā. "Decorations." In *Encyclopaedia Iranica*, edited by Ehsan Yarshater, vol. 7, 197–202. Costa Mesa, CA: Mazda Publishers, 1994.

Sakip Sabanci Müzesi, *From the Medicis to the Savoias: Ottoman Splendour in Florentine Collections*. Istanbul: Sabanci University, Sakip Sabanci Müzesi, 2003.

Salmond, Wendy R. *Russia Imagined, 1825–1925: The Art and Impact of Fedor Solntsev*. New York: New York Public Library, 2007.

Sanders, Paula. *Ritual, Politics, and the City in Fatimid Cairo*. Albany: State University of New York, 1994.

———. "Robes of Honor in Fatimid Egypt." In *Robes and Honor: The Medieval World of Investiture*, edited by Stewart Gordon, 225–39. New York: Palgrave, 2001.

Sanuto, Marino. *I diarii di Marino Sanuto*. Edited by Rinaldo Fulin, et al. 58 vols. Venice: F. Visentini, 1879–1902.

Sarkar, Sir Jadu-Nath, trans. and annot., *Ma'asir 'Alamgiri: A History of the Emperor Aurangzib-'Alamgir (reign 1658–1707 AD), Saqu Musta'idd Khan*. Calcutta: Royal Asiatic Society of Bengal, 1947. Also see Muhammad Saqi.

Savory, Roger M. "British and French Diplomacy in Persia, 1800–1810." *Iran* 10 (1972): 31–44.

Savvaitinov, P. I. "Description of Ancient Tsars' Utensils, Robes, Arms, Armors, Horse Harnesses and Saddles Extracted from Manuscripts of the Archive of the Moscow Armory Chamber; with Explanatory Index" [in Russian]. *Notes of the Imperial Archaeological Society* (St. Petersburg) 11 (1865): 335–36.

Scarce, Jennifer. "The Arts of the Eighteenth to Twentieth Centuries." In *The Cambridge History of Iran*. Vol. 7, *From Nadir Shah to the Islamic Republic*, edited by Peter Avery, Gavin Hambly, and Charles P. Melville, 890–958. Cambridge: Cambridge University Press, 1991.

Schmidt, Erich F. *Persepolis*, 3 vols. University of Chicago Press: Chicago, 1953–70.

Schmidt, J. Heinrich. "Persische Stoffe mit Signaturen von Ghiyas." *Jahrbuch der Kunsthistorischen Sammlungen in Wien*, Neu Folge 7 (1933): 219–27.

Schmitz, Barbara. *Islamic and Indian Manuscripts and Paintings in the Pierpont Morgan Library*. New York: Pierpont Morgan Library, 1998.

———. "On a Special Hat Introduced during the Reign of Shah Abbas the Great." *Iran* 22 (1984): 103–13.

Schrift, Alan D. "Introduction: Why Gift?" In *The Logic of the Gift: Toward an Ethic of Generosity*, edited by Alan D. Schrift, 1–24. New York: Routledge, 1997.

Selaniki Mustafa Efendi. *Tarih-i Selaniki*, edited by Mehmet Ipşirli. 2 vols. Istanbul: Edebiyat Fakültesi, 1989.

Serjeant, R. B. *Islamic Textiles: Material for a History up to the Mongol Conquest*. Beirut: Librairie du Liban, 1972.

Serrano y Sanz, Manuel, ed. *Comentarios de D. García de Silva y Figueroa de la embajada que de parte del Rey de España Don Felipe III hizo al Rey Xa Abas de Persia*. 2 vols. Madrid: Sociedad de Bibliófilos Españñoles, 1903–5.

Seyller, John. "The Inspection and Valuation of Manuscripts in the Imperial Mughal Library." *Artibus Asiae* 7, no. 3/4 (1997): 243–349.

Shakiri, Ramazan Ali. *Ganj-i hizar sala-yi kitabkhana-yi markazi-i astan-i quds-i rasavi*. Mashhad, Iran: Astan-i Quds, 1367/1989.

Shalem, Avinoam. "Forbidden Territory: Early Islamic Audience-Hall Carpets." *Hali* 99 (1998): 70–77.

———. "Fountains of Light: The Meaning of Medieval Islamic Rock Crystal Lamps." *Muqarnas* 11 (1994): 1–11.

———. "From Royal Caskets to Relic Containers: Two Ivory Caskets from Burgos and Madrid." *Muqarnas* 12 (1995): 24–38.

———. *Islam Christianized: Islamic Portable Objects in the Medieval Church Treasuries of the Latin West*. Frankfurt a.M: Peter Lang Verlag, 1996.

———. "Jewels and Journeys: The Case of the Medieval Gemstone Called al-Yatima." *Muqarnas* 14 (1997): 42–56.

———. "Made for the Show: The Medieval Treasury of the Ka'ba in Mecca." In *The Iconography of Islamic Art*, edited by Bernard O'Kane, 269–83. Edinburgh: Edinburgh University Press, 2005.

———. "New Evidence for the History of the Turquoise Glass Bowl in the Treasury of San Marco." *Persica* 15 (1993–95): 91–94.

———. "Objects as Carriers of Real or Contrived Memories in a Cross-cultural Context." *Mitt. zur Spätantiken und Byzantinischer Kunstgeschichte* 4 (2004): 101–17.

———. *The Oliphant: Islamic Objects in Historical Context*. Leiden and Boston: Brill, 2004.

———. "The Second Life of Objects: Ivory Horns in Medieval Church Treasuries." In *Spätantike und byzantinische Elfenbeinbildwerke im Diskurs*, edited by Gudrun Bühl, Anthony Cutler, and Arne Effenberger, 225–36. Weisbaden: Reichert, 2008.

Shaw, Wendy M. K. *Possessors and Possessed: Museums, Archaeology, and the Visualization of History in the Late Ottoman Empire*. Berkeley: University of California Press, 2003.

Shepard, Jonathan. "Past and Future in Middle Byzantine Diplomacy: Some Preliminary Observations." In *Byzance et le monde extérieur: Contacts, relations, échanges*, edited by Michel Balard and Jean-Michel Spieser, 171–91. Paris: Publications de la Sorbonne, 2005.

Shepard, Jonathan, and Simon Franklin, eds. *Byzantine Diplomacy: Papers from the Twenty-fourth Spring Symposium of Byzantine Studies, Cambridge, March 1990*. Aldershot, England: Variorum, 1992.

Shifman, Barry, and Guy Walton, eds. *Gifts to the Tsars, 1500–1700: Treasures from the Kremlin*. New York: Harry N. Abrams, 2001.

Simpson, Marianna Shreve. "The Morgan Bible and the Giving of Religious Gifts between Iran and Europe/Europe and Iran during the Reign of Shah 'Abbas I." In *Between the Picture and the Word: Manuscript Studies from the Index of Christian Art*, edited by Colum P. Hourihane, 141–50. Princeton, NJ: Index of Christian Art, Princeton University, 2005.

———. "Shah Abbas and His Picture Bible." In *The Book of Kings: Art, War, and the Morgan Library's Medieval Picture Bible*, edited by William Noel and Daniel Weiss, 120–44. Baltimore: Walters Art Gallery; London: Third Millennium, 2002.

———. *Sultan Ibrahim Mirza's "Haft Awrang": A Princely Manuscript from Sixteenth-Century Iran*. New Haven, CT: Yale University Press; Washington, DC: Freer Gallery of Art, Smithsonian Institution, 1997.

Sims, Eleanor G. "Five Seventeenth-Century Persian Oil Paintings." In *Persian and Mughal Art*, 221–48. London: P & D Colnaghi, 1976.

———. "Ibrahim-Sultan's Illustrated *Zafarnama* of 1436 and Its Impact in the Muslim East." In *Timurid Art and Culture: Iran and Central Asia in the Fifteenth Century*, edited by Lisa Golombek and Maria Subtelny, 132–43. Studies in Islamic Art and Architecture, Supplements to *Muqarnas* 6. Leiden: E. J. Brill, 1992.

Skelton, Robert. "Ghiyath al-Din 'Ali-yi Naqshband and an Episode in the Life of Sadiqi Beg." In *Persian Painting from the Mongols to the Qajars: Studies in Honour of Basil W. Robinson*, edited by Robert Hillenbrand, 249–63. London: I. B. Tauris, 2000.

———, ed. *The Indian Heritage: Court Life & Arts under Mughal Rule*. London: Victoria and Albert Museum, 1982.

———. "The Relations between the Chinese and Indian Jade Carving Traditions." In *The Westward Influence of the Chinese Arts from the 14th to the 18th Century*, edited by Oliver Watson, 98–110. Colloquies on Art and Archaeology in Asia 3. London: University of London, 1972.

Skilliter, Susan A. "The Letters of the Venetian 'Sultana' Nur Banu and Her Kira to Venice." In *Studia Turcologica Memoriae Alexii Bombaci dicata*, edited by A. Gallotta and U. Marazzi, 515–36. Naples: Herder, 1982.

———. "Three Letters from the Ottoman 'Sultana' Safiye to Queen Elizabeth I." In *Documents from Islamic Chanceries*, edited by S. M. Stern, 119–57. Cambridge, MA: Harvard University Press, 1965.

Skjærvø, Prods Oktor. "*Tahadi*: Gifts, Debts, and Counter-Gifts in the Ancient Zoroastrian Ritual." In *Classical Arabic Humanities in Their Own Terms: Festschrift for Wolfhart Heinrichs on His 65th Birthday Presented by His Students and Colleagues*, edited by Beatrice Gruendler, with Michael Cooperson, 493–520. Leiden and Boston: Brill, 2008.

Sotheby & Co. *Western, Oriental and Hebrew Manuscripts and Miniatures*. Auction, July 10, 1968. London: Sotheby & Co., 1968.

Sotheby's. *Arts of the Islamic World*. Auction, October 7, 2009. London: Sotheby's, 2009.

Sotheby's. *Persian Art from the Aryeh Family Collection*. Auction, October 13, 1999. London: Sotheby's, 1999.

Soucek, Priscilla. "Byzantium and the Islamic East." In *The Glory of Byzantium: Art and Culture of the Middle Byzantine Era A.D. 843–1261*, edited by Helen C. Evans and William D. Wixom, 402–34. New York: Harry N. Abrams, 1997.

———. "Coinage of the Qajars: A System in Continual Transition." In *Iranian Studies* 34, nos. 1–4 (2001): 51–87.

———. "Persian Artists in Mughal India: Influences and Transformations." *Muqarnas* 4 (1987): 166–81.

Soucek, Svatopluk S. "Russia and the Ottoman Empire, the Ottoman Empire and Russia (l450–l825)." Unpublished manuscript, New York Public Library, 2003.

Soudavar, Abolala. *Art of the Persian Courts: Selections from the Art and History Trust Collection*. New York: Rizzoli, 1992.

———. "A Chinese Dish from the Lost Endowment of Princess Sultanum (925–69/1519–62)." In *Iran and Iranian Studies: Essays in Honor of Iraj Afshar*, edited by Kambiz Eslami, 125–37. Princeton, NJ: Zagros Press, 1998.

———. "The Early Safavids and Their Cultural Interactions with Surrounding States." In *Iran and the Surrounding World: Interactions in Culture and Cultural Politics*, edited by Nikki R. Keddie and Rudi Matthee, 89–120. Seattle and London: University of Washington Press, 2002.

Sourdel, Dominique. "Robes of Honor in 'Abbasid Baghdad during the Eighth to Eleventh Centuries." In *Robes and Honor: The Medieval World of Investiture*, edited by Steward Gordon, 137–45. New York: Palgrave, 2001.

Sourdel-Thomine, Janine. "Clefs et serrures de la Ka'ba. Notes d'épigraphie arabe." *Revue Des Études Islamiques* 39 (1971): 29–86.

Souza, George Bryan. "Gifts and Gift-Giving in Portuguese-Indonesian Diplomatic Relations." *Review of Culture* 24 (2007): 21–32.

Springberg-Hinsen, Monika. *Die Hila: Studien zur Geschichte des geschenkten Gewandes im islamischen Kulturkreis.* Würzburg: Ergon, 2000.

St. Laurent, Beatrice, and András Riedlmayer, "Restorations of Jerusalem and the Dome of the Rock and Their Political Significance, 1537–1928." *Muqarnas* 10 (1993): 76–84.

Stanley, Tim. "The Kevorkian-Krauss-Khalili *Shahnama*: The History, Codicology and Illustration of a Sixteenth-Century Shirazi Manuscript." In *Shahnama: The Visual Language of the Persian Book of Kings*, edited by Robert Hillenbrand, 85–98. Burlington, VT: Ashgate, 2004.

———. *Palace and Mosque: Islamic Art from the Middle East.* London: V&A Publications, 2004.

Stchoukine, Ivan. *La Peinture turque d'après les manuscrits illustrés.* 2 vols. Paris: P. Geuthner, 1966–71.

Steensgaard, Niels. *The Asian Trade Revolution of the Seventeenth Century.* Chicago and London: University of Chicago Press, 1974.

Stern, Samuel M. "An Embassy of the Byzantine Emperor to the Fatimid Caliph al-Mu'izz." *Byzantion* 20 (1950): 239–58.

Stetkevych, Suzanne. "Pre-Islamic Panegyric and the Poetics of Redemption." In *Reorientations: Arabic and Persian Poetry*, edited by Suzanne Stetkevych, 1–57. Bloomington: Indiana University Press, 1994.

Stillman, Yedida Kalfon. *Arab Dress: A Short History: From the Dawn of Islam to Modern Times.* Leiden and Boston: Brill, 2000.

Strack, Elisabeth. "A Study of the Origin of Emeralds in Mogul Objects at the State Hermitage Museum, St. Petersburg." In *Geoarchaeology and Archaeomineralogy. Proceedings of the International Conference, 29–30 October 2008, Sofia*, edited by R. I. Kostov, B. Gaydarska, and M. Gurova, 139–40. Sofia: Publishing House "St. Ivan Rilski," 2008.

Stronge, Susan. "Colonel Guthrie's Collection. Jades of the Mughal Era." *Oriental Art* 39, no. 4 (Winter 1993/94): 4–13.

———, ed. *Jewels of India.* Bombay: Marg Publications, 1995.

———. *Made for Mughal Emperors.* Mumbai: Lustre Press/Roli Books, 2010.

———. "The Myth of the Timur Ruby." *Jewellery Studies* 7 (1996): 5–12.

———. *Painting for the Mughal Emperor: The Art of the Book, 1560–1660.* London: Victoria and Albert Museum, 2002.

———. "The Sublime Thrones of the Mughal Emperors of Hindustan." *Jewellery Studies* 10 (2004): 52–67.

Sung, Hou-mei. *Decoded Messages: The Symbolic Language of Chinese Animal Painting.* New Haven, CT: Yale University Press, 2009.

T

Tabari, al-. *The Crisis of the Early Caliphate.* Translated by Stephen R. Humphreys. Vol. 15, SUNY Series in Near Eastern Studies. Albany: SUNY Press, 1990.

———. *The History of al-Tabari.* Vol. 25, *The End of Expansion: The Caliphate of Hisham, A.D. 724–738/A.H. 105–120.* Translated by Khalid Yahya Blankinship. SUNY Series in Near Eastern Studies. Albany: SUNY Press, 1989.

———. *Ta'rikh al-rusul wa al-muluk.* Edited by Stanislas Guyard, Michael Jan de Goeje et al. 15 vols. Leiden: E. J. Brill, 1879–1901.

Tan, Leng, William Edwards, Gregory Minissale, and Guari Parimoo Krishnan. *Jewelled Treasures from the Mughal Courts.* London: Islamic Art Society, 2002.

Tavernier, Jean-Baptiste. *Les six voyages de Jean Baptiste Tavernier en Turquie, en Perse, et aux Indes, pendant l'espace de quarante ans…: accompagnez d'observations particulières sur la qualité, la religion, le gouvernement, les coûtumes & le commerce de chaque païs, avec les figures, le poids, & la valeur des monnoyes qui y ont cours.* Paris: G. Clouzier, 1676–77.

———. *The Six Voyages of John Baptista Tavernier, a Noble Man of France Now Living, through Turky into Persia and the East-Indies.* London, 1678.

Teng, Shup'ing. *Exquisite Beauty – Islamic Jades.* Taipei: National Palace Museum, 2007.

———. *Hindustan Jade in the National Palace Museum.* Taipei: National Palace Museum, 1983.

Tezcan, Hülya. *Curtains of the Holy Ka'ba* [in Arabic]. Istanbul: Research Centre for Islamic History, Art & Culture, 1996.

Thackston, Wheeler. *Album Prefaces and Other Documents on the History of Calligraphers and Painters.* Leiden: Brill, 2001.

———. *A Century of Princes: Sources on Timurid History and Art*. Cambridge, MA: Aga Khan Program for Islamic Architecture, 1989.

———, trans. and ed. *The Jahangirnama: Memoirs of Jahangir, Emperor of India*. New York: Oxford University Press, 1999.

———, trans. *Naser-e Khosraw's Book of Travels (Safarnama)*. Persian Heritage Series. New York: Bibliotheca Persica, 1986.

Theophylacti Simocattae Historiae. Edited by Carl de Boor and Peter Wirth. Stuttgart: Teubner, 1972.

Thévenot, Jean de. *Voyages en Europe, Asie & Afrique*. 5 vols. Amsterdam, 1727.

Thompson, Jon. *Milestones in the History of Carpets*. Milan: Moshe Tabibnia, 2006.

Thompson, Jon, and Sheila R. Canby, eds. *Hunt for Paradise: Court Arts of Safavid Iran, 1501–1576*. Milan: Skira; London: Thames & Hudson, 2003.

Tinguely, Frédéric, ed. *Un libertin dans l'Inde Moghole. Les voyages de François Bernier (1656–1669)*. Paris: Editions Chandeigne – Librairie Portugaise, 2008.

Titley, Norah. *Persian Miniature Painting and Its Influence on the Art of Turkey and India: The British Library Collections*. Austin: University of Texas Press, 1983.

Topkapı Palace Museum. *Ten Thousand Years of Iranian Civilization: Two Thousand Years of Common Heritage*. Istanbul: Topkapı Palace Museum, 2009.

Tsarskii Tituliarnik [Tsarist Titulary]. 2 vols. Moscow: Fond Stoliarova, 2007.

Tülay Reyhanlı. *İngiliz Gezginlerine Göre XVI. Yüzyılda İstanbul'da Hayat 1582–1599*. Ankara: Başbakanlık Basımevi, 1983.

Türk ve İslâm Eserleri Müzesi. *In Pursuit of Excellence: Works of Art from the Museum of Turkish and Islamic Arts*. Istanbul: Ahmet Ertuğ, 1993.

U

Uluç, Lale. "Ottoman Book Collectors and Illustrated Sixteenth Century Shiraz Manuscripts." *Revue des mondes musulmans et de la Méditerranée: Livres et lecture dans le monde ottoman* 87–88 (September 1999): 85–107.

———."A Persian Epic, Perhaps for the Ottoman Sultan." *Metropolitan Museum Journal* 29 (1994): 57–71.

———. *Turkman Governors, Shiraz Artisans and Ottoman Collectors: Arts of the Book in 16th Century Shiraz*. Istanbul: İş Bankası Kültür Yayınları, 2006.

Unterkircher, Franz. *Manuscrits et livres imprimés concernant l'histoire des Pays-Bas, 1475–1600*. Brussels: Bibliothèque royale de Belgique, 1962.

Usama ibn Munqidh. *Rihla*. Translated by Paul M. Cobb. London: Penguin, 2008.

'Uthman, Muhammad 'Abd al-Sattar. *Wathiqat waqf Jamal al-Din Yusuf al-Astadar: dirasah tarikhiyah athariyah watha'iqiyah*. Alexandria: Tawzi' Dar al-Ma'arif, 1983.

Uzunçarşılı, İ. H. "Osmanlı Sarayı'nda Ehl-i Hıref (Sanatkârlar) Defteri." *Belgeler* 11, no. 15 (1981): 23–76.

V

Vahman, Faridun. "Three Safavid Documents in the Record Office of Denmark." In *Iran and Iranian Studies: Essays in Honor of Iraj Afshar*, edited by Kambiz Eslami, 178–83. Princeton, NJ: Zagros Press, 1998.

Vasiliev, Alexander A. *La Dynastie Macédonienne (867–959)*, pt. 2.1. Brussels: Institut de philogie et d'histoire orientales, 1935.

Vasiliev, Alexander, and Marius Canard. *Byzance et les Arabes*, 4 vols. Brussels: Institut de philologie et d'histoire orientales, 1950.

Vasilyeva, Olga. "The Gift from Khusraw Mirza to Count Simovich" [in Russian]. *Vostochnaya kollektsiya* 3 (Summer 2003): 10–17.

———. "Oriental Manuscripts in the National Library of Russia." *Manuscripta Orientalia* 2, no. 2 (1996): 19–35.

———. *A String of Pearls: Iranian Fine Books from the 14th to 17th Century in the National Library of Russia Collection*. St. Petersburg: National Library of Russia, 2008.

Vehbî. *Sûrnâme: Sultan Ahmet'in Düğün Kitabı*. Edited by Mertol Tulum. Istanbul: Kabalcı Yayınevi, 2007.

Vernoit, Stephen. "Islamic Gilded and Enamelled Glass in Nineteenth-Century Collections." In *Gilded and Enamelled Glass from the Middle East: Origins, Innovations and Influences*, edited by Rachel Ward, 110–15. London: British Museum Press, 1998.

———. *Occidentalism: Islamic Art in the 19th Century*. New York: Nour Foundation in association with Azimuth Editions and Oxford University, 1997.

Vikan, Gary. *Gifts from the Byzantine Court*. Washington, DC: Dumbarton Oaks Center for Byzantine Studies, 1980.

Viré, F. "Bayzara." *Encyclopaedia of Islam*. 2nd ed. Vol. 1, 1152–55. Leiden: Brill, 1960–2005.

Vishnevskaia, I. I., et al. *Treasures of the Armoury: Ambassadorial Gifts*. Moscow: Moscow Kremlin State Museum-Preserve of History and Culture, 1996.

Vishnevskaia, I. I., and A. K. Levykin. *Iskusstvo Blistatelńoĭ Porty = The Art of the Sublime Porte*. Moskva: Gos. istoriko-kul´turnyĭ muzeĭ-zapovednik "Moskovskiĭ Kreml," 2008.

W

Walker, Alicia. "Meaningful Mingling: Classicizing Imagery and Pseudo-Arabic Script in Medieval Byzantium." *Art Bulletin* 90 (March 2008): 32–53.

Walker, Daniel. *Flowers Underfoot: Indian Carpets of the Mughal Era*. New York: Metropolitan Museum of Art, 1997.

Walton, Guy. "Diplomatic and Ambassadorial Gifts of the Sixteenth and Seventeenth Centuries." In *Gifts to the Tsars, 1500–1700: Treasures from the Kremlin*, edited by Barry Shifman and Guy Walton, 75–95. New York: Harry N. Abrams, 2001.

Ward, Rachel M. *Islamic Metalwork*. New York: Thames and Hudson, 1993.

Wardwell, Anne E. "*Panni Tartarici*: Eastern Islamic Silks Woven with Gold and Silver (Thirteenth and Fourteenth Centuries)." *Islamic Art* 3 (1988–89): 95–173.

Warwick, Genevieve. "Gift Exchange and Art Collecting: Padre Sebastiano Resta's Drawing Albums." *Art Bulletin* 79 (1997): 630–46.

Watson, Oliver. *Persian Lustre Ware*. Faber Monographs on Pottery and Porcelain. London: Faber and Faber, 1985.

——. "Persian Lustre Ware from the 14th to the 19th Centuries." *Le Monde Iranien et l'Islam* 3 (1975): 63–80.

Wearden, Jennifer. "The Shah, the Emperor and the Gift of Iranian Textiles." *Arts of Asia* 33, no. 2 (2003): 82–89.

——. "Siegmund von Herberstein: An Italian Velvet in the Ottoman Court." *Costume* 19 (1985): 22–29.

Weigert, Roger-Armand, and Maxime Préaud. *Inventaire du fonds français: Graveurs du XVIIe siècle*. Vol. 11, *Antoine Lepautre, Jacques Lepautre et Jean Lepautre*. Paris: Bibliothèque Nationale, 1993.

Weiss, Daniel H. *Die Kreuzritterbibel = The Morgan Crusader Bible = Le Bible des Crusades*. Luzern: Faksimile Verlag Luzern, 1999.

Welch, Anthony. *Calligraphy in the Arts of the Muslim World*. Austin: University of Texas Press, 1979.

Welch, Anthony, and Stuart Cary Welch. *Arts of the Islamic Book: The Collection of Prince Sadruddin Aga Khan*. Ithaca, NY: Cornell University Press, 1982.

Welch, Stuart Cary. *India: Art and Culture, 1300–1900*. New York: Metropolitan Museum of Art, 1985.

Welch, Stuart Cary, et al. *The Emperors' Album: Images of Mughal India*. New York: The Metropolitan Museum of Art, 1987.

Wenzel, Marian. *Ornament and Amulet Rings of the Islamic Lands* New York: Nour Foundation in association with Azimuth Editions and Oxford University Press, 1993.

Whittaker, Cynthia H., ed. *Visualizing Russia: Fedor Solntsev and Crafting a National Past*. Leiden: Brill, 2010.

Whittaker, Cynthia H., Edward Kasinec, and Robert H. Davis. *Russia Engages the World, 1453–1825*. Cambridge, MA: Harvard University Press, 2003.

Wiet, Gaston. *Catalogue Général du Musée Arabe du Caire: Objets en Cuivre*. Cairo: Organisation égyptienne générale du livre, 1984.

Wilckens, Leonie von. *Mittelalterliche Seidenstoffe*. Berlin: Staatliche Museen zu Berlin, Kunstgewerbemuseum, 1992.

Wilkinson, J. V. S. "An Indian Manuscript of the 'Golestan' of the Shah Jahan Period." *Ars Orientalis* 2 (1957): 423–25.

Wortman, Richard S. *Scenarios of Power: Myth and Ceremony in Russian Monarchy*. 2 vols. Princeton, NJ: Princeton University Press, 1995–2000.

Wright, Denis. *The English amongst the Persians: Imperial Lives in Nineteenth-Century Iran*. London and New York: I. B. Tauris, 2001.

——. "Sir John Malcolm and the Order of the Lion and the Sun." *British Institute of Persian Studies* 17 (1979): 135–41.

Wright, Elaine, ed. *Muraqqa': Imperial Mughal Albums from the Chester Beatty Library*. New York: Art Services International, 2008.

Y

Ya'qubi, Ahmad Ibn Wadih al-. *Ta'rikh al-Ya'qubi*. Edited by Martijn Theodor Houtsma. Leiden: E. J. Brill, 1883.

Yeroulanou, Aimilia. *Diatrita: Gold Pierced-Work Jewellery from the 3rd to the 7th Century*. Athens: Benaki Museum, 1999.

Yilmaz, Tercan. *The Holy Ka'ba: A Study of the Collection of Locks and Keys Kept at Topkapi Museum in Istanbul* [in Arabic]. Istanbul: IRCICA, OIC-Research Centre for Islamic History, Art and Culture, 1993.

Young, W. C. "The Ka'ba, Gender, and the Rites of Pilgrimage." *International Journal of Middle East Studies* 25 (1993): 285–300.

Yule, Henry, and Henri Cordier, trans. and ed. *Cathay and the Way Thither. Being a Collection of Medieval Notices of China*. 4 vols. London: Hakluyt Society, 1914–15.

Z

Zabern, Philipp von, ed. *Ex-Oriente, Isaak und der Weisse Elefant, Bagdad-Jerusalem-Aachen, eine Reise durch drei Kulturen un 800 und heute*. Aachen/Aix-la-Chapelle: Mayence, 2003.

Zaitsev, I. V. *Mezhdu Moskvoi i Stambulom: dzhuchidskie gosudarstva, Moskva i Osmanskaia imperiia (nach. XV-per. pol. XVI vv.): ocherki*. Moscow: Nauk, 2004.

Zebrowski, Mark. *Decanni Painting*. London: Sotheby's Publications, 1983.

Zhang Tingyu 張廷玉, et al. *Ming shi* 明史. Beijing: Zhonghua shuju, 1995.

Zonaras. *Epitome historiarum*. Edited by Ludwig Dindorf. 6 vols. Leipzig: Weber, 1868–75.

Zygulski, Zdzislaw. *Ottoman Art in the Service of Empire*. New York: New York University Press, 1991.

GLOSSARY

Abbasids
Early Islamic dynasty, 750–1258, with its capital mainly at Baghdad and briefly Samarra (836–92).

'atiya
Arabic word meaning a gift from a high official to one of lesser rank.

aya
Arabic word for a verse of the Qur'an.

Ayyubids
Dynasty of Kurdish origin, they ruled Egypt and Syria, 1169–1250.

bakhshish
Persian word meaning a gift given to someone of lesser rank.

berat
Turkish word meaning a document granting an imperial title, privilege, or property; plural, *beratlar*.

betel
A type of leaf or nut (in Hindi, *pan*) widely chewed as a stimulant at the Mughal court and often presented as a gift of friendship in a container known as a *pandan*.

Bohoras
Subsect of Ism'aili Shi'ite Islam mainly situated in western India.

caliph
From the Arabic *khalifa*, meaning "deputy" or "successor" (to the Prophet Muhammad); the title used by early Islamic rulers.

darbar
Urdu term originating from Persian meaning "the shah's court."

dervish
Member of a Sufi order who follows a mendicant lifestyle.

Dhu'l-Hijja
Twelfth month of the Islamic calendar.

Dhu'l-Qa'da
Eleventh month of the Islamic calendar.

dinar
Principal denominational name for gold coins from early Islamic times. From the late ninth century onward, the dinar was used as a unit of account referencing a fixed weight of gold of about 4.25 grams. The fals, the principal denominational name for copper coins, was used more frequently in common transactions.

dirham
Principal denominational name for silver coins from early Islamic times. From the late ninth century onward, it was used as a unit of account referenced to a fixed weight of silver.

Diwan (also Divan)
Government office that served as a register; in Mughal India, a pillared hall for official audiences; in literary tradition, used to designate the collected poems of a particular author.

Fatimids
Ruled North Africa and then Egypt and Syria, 909–1171.

Ghaznavids
Of Turkish origin, they ruled eastern Iran and northern India, 977–1186.

hadith
Arabic word meaning the narrative record of the words and deeds of the Prophet Muhammad; second only to the Holy Qur'an as a source of Islamic law.

hadiyya
Arabic term for gift exchange between peers.

hajj
Arabic word for the pilgrimage to Mecca and the Ka'ba required of all Muslims.

haram
Arabic term meaning "forbidden" or, in a religious context, a "holy site."

Hijra
Arabic word for the emigration of the Prophet and his followers from Mecca to Medina in 622; this event also marks the beginning of the Islamic calendar.

'Id al-Adha
Sacrificial feast celebrated on 10 Dhu'l-Hijja by sacrificing an animal, generally a sheep.

'Id al-Fitr
Festive celebration on 1 Shawwal marking the end of the Ramadan fast.

Ilkhanids
Of Mongol origin, they ruled Greater Iran, 1256–1335.

imam
Leader in the congregational prayer; when capitalized, it refers to the spiritual guide of the Shi'ites.

in'am
Arabic word meaning a present or favor given to someone of lesser rank.

Islam
Arabic word meaning "submission" (to God) and the name for the religion founded under the leadership of the Prophet Muhammad; it also denotes the Muslim community.

Isma'ili
Sect of Shi'ite Islam that recognizes 'Ali and his six descendants, for a total of seven Imams, as the rightful successors to the Prophet.

jahaz
Arabic word for "wedding gifts."

Jalayirids
Originally a Mongol tribe, which came to rule Iraq, Kurdistan, and Azerbaijan as successor-states to the Ilkhanids, 1336–1432.

Jumada'l-Ula
Fifth month of the Islamic calendar.

Jumada'l-Ukhra
Sixth month of the Islamic calendar.

juz'
A thirtieth part of the Qur'an (plural, *ajza'*). The Qur'an is divided into thirty sections so as to make it possible to read the full text in one month.

Ka'ba
Cube-shaped shrine in Mecca (within the central courtyard of the Great Mosque), which is the focal point of Muslim prayer and pilgrimage.

kashkul
Vessel typically used by dervishes for collecting alms.

khanqah
Sufi convent.

Kharijite
Religious-political movement that arose in the early Islamic period, during the reign of the fourth caliph, 'Ali ibn Abi Talib (r. 656–61). Among other things, followers of this movement were notable for their belief that Arab and non-Arab converts to Islam should be treated equally.

khil'a
Arabic term meaning "honorific robe"; plural, *khila'*.

khutba
Sermon delivered by the imam in the mosque to the Friday congregation; in medieval Islam, the khutba was said by, or in the name of, the caliph.

kiswa
Embroidered cloth specifically made for covering the Ka'ba.

kufic
Generic name for several types of rectilinear scripts.

kursi
Qur'an stand.

levha
Large-scale calligraphic composition intended to be framed and hung on a wall.

madrasa
Theological school.

mahmal
Pavilion-like structure mounted on a camel that accompanied the annual pilgrimage caravan to Mecca.

mahout
Elephant driver.

Mamluks
Former military slaves who ruled Egypt and Syria, 1250–1517.

mihrab
Prayer niche set in the Mecca-facing wall in a mosque or other religious structure (see qibla).

mihrajan
In the Iranian calendar, the autumnal equinox.

mithqal
Arabic unit of weight originally set at about 4.25 grams in the early Umayyad period but varying in later periods from less than four to more than five grams. It was used as a denomination for some Mamluk and Safavid gold coins.

mohur
From Persian *muhr*, meaning "stamp," a gold coin used in India under the Mughal dynasty.

Mongols
Tribe originating in the eastern part of modern-day Mongolia, which in the thirteenth and fourteenth centuries, under the leadership of Genghis Khan and his successors, controlled an area extending from Korea to Hungary.

mosque
Any place of Muslim communal worship (in Arabic, *masjid*).

Mughals
Of Timurid descent, they ruled India, 1526–1858.

Muharram
First month of the Islamic calendar.

mujtahid
An Arabic legal term designating someone with the ability to form his own judgment on questions of shari'a, or Islamic jurisprudence.

muraqqa'
Album with paintings and/or calligraphy bound as a book.

Nasrids
Rulers of the Spanish kingdom of Granada, 1230–1492.

Nawruz
Persian New Year, commencing at the vernal equinox.

nazarana
Persian word for a presentation coin.

nishan
Decoration or award presented to honor its recipient.

Ottomans
Turkish dynasty that ruled Anatolia and then much of eastern Europe and the Middle East, 1281–1924.

patka
Urdu for a sash typically worn around the waist.

pishkash
Persian for a gift typically from a lower- to a higher-ranking individual, often as tribute.

Qajars
Dynasty of Turkmen origin that ruled Iran, 1779–1924.

qibla
Direction of prayer in Islam, toward Mecca and the Ka'ba.

Qur'an
The holy book of Islam; literally, "recitation" in Arabic (the language of the text).

Rabi' al-Akhir
Fourth month of the Islamic calendar.

Rabi' al-Awwal
Third month of the Islamic calendar.

Rajab
Seventh month of the Islamic calendar.

Ramadan
Ninth month of the Islamic calendar.

Rashidun
Caliphate formed immediately after the death of Muhammad and consisting of the first four successors to the Prophet, 632–61.

Safar
Second month of the Islamic calendar.

Safavids
Rulers of Iran, 1501–1732; their reign marks the advent of Shi'ism as the state religion.

Saljuqs
General name for several dynasties of Turkish origin that ruled Greater Iran, as well as eastern Anatolia and Syria, in the eleventh and twelfth centuries.

Samanids
Dynasty that ruled eastern Iran and Central Asia, 819–1005.

Sasanians
Pre-Islamic dynasty that ruled Greater Iran, 224–651.

Sha'ban
Eighth month of the Islamic calendar.

shahi

A silver coin in use under the Safavids and their successors. It has been estimated that in the sixteenth century one shahi was worth between fifty and one hundred dinars.

Shahnama

The Iranian national epic, completed in 1010 by Firdawsi. It tells the stories of Iran's pre-Islamic kings and heroes.

shamsa

Literally, "small sun," an illuminated medallion found at the beginning of manuscripts or albums.

Shawwal

Tenth month of the Islamic calendar.

shaykh

Spiritual head of the Sufi order or, more generally, a tribal leader.

Shi'at 'Ali

Party of 'Ali, son-in-law of Muhammad and fourth caliph, whose followers formed the sect of Shi'ism.

Shi'ites

Members of a branch of Islam, Shi'ism, who acknowledge 'Ali and his descendants as the rightful successors to the Prophet. The two main branches of Shi'ite Islam are the Isma'ilis (see Isma'ili) and Twelvers (*Ithna 'ashariyya*), recognizing, respectively, a series of seven and twelve Imams.

Simjurids

Minor dynasty of Turkish slave origin that ruled over Khurasan and rose to prominence under the Samanid rulers of Iran, c. 910–1000.

sitara

Covering for the doorway of the Ka'ba or other shrine.

Sufis

Islamic mystics, both Sunni and Shi'ite.

Sunnis

Followers of the "Tradition," who believe that the Prophet's successor should be elected; approximately 85 percent of all Muslims are Sunni.

sura

A chapter of the Qur'an, of which there are 114.

Timurids

Central Asian dynasty that ruled Greater Iran, 1370–1507.

tiraz

Islamic textile with a woven inscription or embroidery.

toman

From the Mongolian word *tümen* for "ten thousand," a gold coin used as a unit of account in Iran valued at ten thousand dinars; first instituted under Agha Muhammad Shah Qajar (r. 1779–97).

tuğra

Imperial monogram of the Ottoman sultans.

Umayyads

Early Islamic dynasty, 661–750; Spanish branch, 756–1031.

vakfiye

Turkish, meaning "deed of endowment."

vizier

Minister of state (in Arabic, *wazir*).

waqf

Arabic for "endowment" or the act of founding a charitable endowment.

waqfiyya

Arabic word meaning "deed of endowment" (see waqf).

LENDERS TO THE EXHIBITION

Denmark
The Danish Museum of Art and Design, Copenhagen
The David Collection, Copenhagen

England
The British Library, London
The British Museum, London
Keir Collection, England
Nasser D. Khalili Collection of Islamic Art, London
Private collection
Royal Asiatic Society of Great Britain and Ireland
The Royal Collection, Windsor
Victoria and Albert Museum, London

France
Bibliothèque nationale de France, Paris
Musée du Louvre, Paris
Musée national des Arts asiatiques–Guimet, Paris

Germany
Museum of Islamic Art, Berlin

Greece
Benaki Museum, Athens

Ireland
The Trustees of the Chester Beatty Library, Dublin

Kuwait
The al-Sabah Collection, Dar al-Athar al-Islamiyyah, Kuwait

Portugal
Museu Calouste Gulbenkian, Lisbon

Qatar
Museum of Islamic Art, Doha

Russia
The National Library of Russia, St. Petersburg
The State Hermitage Museum, St. Petersburg
The State Historical-Cultural Museum Preserve, Moscow Kremlin

Switzerland
The Aga Khan Trust for Culture, Geneva

Turkey
Millet Manuscript Library, Istanbul
Museum of Turkish and Islamic Art, Istanbul
Topkapi Saray Museum, Istanbul

United States
The Asian Art Museum, San Francisco
Asia Society, New York
Catherine and Ralph Benkaim Collection, Los Angeles
Charles E. Young Research Library, UCLA
Getty Research Institute, Los Angeles
Los Angeles County Museum of Art
The Metropolitan Museum of Art, New York
Museum of Fine Arts, Boston
New York Public Library
Omar Haroon Collection, Los Angeles
Philadelphia Museum of Art
The Pierpont Morgan Library, New York
Private collections
Rhode Island School of Design Museum, Providence
Worcester Art Museum

ILLUSTRATION CREDITS

Most photographs are reproduced courtesy of the lenders of the material depicted. For artwork and documentary photos where we have been unable to trace copyright holders, the publishers would appreciate notification of additional credits for acknowledgement in future editions.

Cover (detail): Photo © The Metropolitan Museum of Art / Art Resource, NY (ART412716)

p. 2, 23 (detail), 170, 172, 173, 183, 196 right (detail), 220: The Royal Collection © 2011 Her Majesty Queen Elizabeth II

p. 8, 25, 238, 280: Photo © The British Library Board

p. 11, 44–45, 70, 75, 82 left, 95, 114 (detail), 176: Photo courtesy Museum of Islamic Art, Doha

pp. 14–15, 30 (detail), 38–39, 43, 65, 243: Photo © Trustees of the Chester Beatty Library

p.16, 142–143, 178, 204–205, 221, 246, 271: Photo © Aga Khan Trust for Culture, Geneva

p. 17, 50, 119, 150, 151 left (detail), 159, 160, 168, 169, 180, 258, 303: Photo courtesy Topkapi Saray Museum, Istanbul

pp. 18–19, 165: Photo courtesy private collection

p. 21, 49 (detail), 53, 63 top left, 66 (detail), 91, 103, 122 top, 181, 201, 203, 274, 292: Photo ©V&A Images / Victoria and Albert Museum, London

p. 22, 131: Photo © Museu Calouste Gulbenkian, by Carlos Azevedo

p. 24, 256: Photo © 2010 Musée du Louvre, by Raphaël Chipault

p. 26 A/B/C/E/F, 71, 74 top, 76, 77, 197, 227, 228, 239, 252, 286: Photo © Nour Foundation, courtesy Khalili Family Trust

p. 26 D, 41, 59, 120, 121, 214, 283, 298, 299 (detail): Photo © The State Hermitage Museum, by Vladimir Terebenin, Leonard Kheifets, Yuri Molodkovets

p. 26 bottom: Photo © The Metropolitan Museum of Art / Art Resource, NY (ART412712)

p. 27, 156, 266, 275: Copyright © The al-Sabah Collection, Dar al-Athar al-Islamiyyah, Kuwait

p. 28, 36–37, 40 top, 42, 46, 56 (detail), 83, 97, 106, 145, 146, 147, 175 C/D, 177, 211, 226, 230 bottom, 245, 255, 262, 264, 276: Photo © 2011 Museum Associates / LACMA

p. 29, 105, 110: Photo courtesy Benaki Museum

p. 31, 34–35, 216, 217: Photo © Royal Asiatic Society

p. 32: Photo © The Metropolitan Museum of Art / Art Resource, NY (ART412716)

p. 33, 163: Photo courtesy Jonathan Bloom and Sheila Blair

p. 40 bottom, 51, 85, 86 left, 87, 98, 112, 268: Photo courtesy David Collection, © Pernille Klemp

p. 48, 122 bottom: Photo courtesy Asia Society, New York

p. 52, 250, 289: Photo courtesy The Getty Research Institute, Los Angeles

p. 54: Photo © The Metropolitan Museum of Art / Art Resource, NY (ART367122)

p. 55, 213 right: Photo courtesy Museum of Art, Rhode Island School of Design, Providence, by Erik Gould

p. 57, 94, 136, 290: Photo © 2011 Museum of Fine Arts, Boston

p. 58 left, 149, 161, 164, 233, 241, 242: Photo courtesy Museum of Turkish and Islamic Arts, Istanbul

p. 58 right: Photo courtesy Benaki Museum, by S. Delivorrias

p. 60: Photo © Réunion des Musées Nationaux / Art Resource, NY (ART412082), by Hervé Lewandowski

p. 61, 247: Photo © Museu Calouste Gulbenkian, by Catarina Gomes Ferreira

p. 62: Photo courtesy Jon Thompson

p. 63 top right, 162: Photo courtesy Freer Gallery of Art, Smithsonian Institution, Washington, D.C.

p. 63 bottom: Photo © 2011 Museum Associates / LACMA, by Danny Bright

p. 64, 196 left, 200, 284: Photo courtesy National Library of Russia, by Vladimir Terebenin

p. 67, 80–81 top, 81 middle, 89, 202, 207, 231: Photo courtesy Benaki Museum, by Tsonis

p. 74 bottom: Photo courtesy Benaki Museum, by Samios

p. 78: Photo © The Metropolitan Museum of Art / Art Resource, NY (ART413562)

p. 79 (detail): Photo © The Metropolitan Museum of Art / Art Resource, NY (ART377677)

p. 81 bottom: Photo © Bildarchiv Preussischer Kulturbesitz / Art Resource, NY (ART412422), by Petra Stuening

p. 82 right (detail): Photo © Bildarchiv Preussischer Kulturbesitz / Art Resource, NY (ART309286)

p. 84, 86 right, 88, 99 top, 108, 175 A/B, 185, 224, 225 left: Photo © The Trustees of the British Museum

p. 92: Photo © The Metropolitan Museum of Art / Art Resource, NY (ART410712)

p. 93, 218: Photo © Bildarchiv Preussischer Kulturbesitz / Art Resource, NY

p. 99 bottom, 100, 101, 128, 129, 130, 134, 157, 300, 301: Photo © Moscow Kremlin Museums

p. 107: Photo © A.C. Cooper Photographers, London

pp. 116–117, 213 left, 232, 249: Photo © Asian Art Museum of San Francisco. Used by permission.

p. 118 (detail): Photo courtesy Philadelphia Museum of Art

p. 124, 127: Photo courtesy The Danish Museum of Art and Design, Copenhagen, © Pernille Klemp

p. 125: Photo © Bildarchiv Preussischer Kulturbesitz / Art Resource, NY (ART408224), by Ingrid Gesk

p. 137, 225 right, 277, 296 top: Photo courtesy Bibliothèque Nationale de France

p. 139, 272: Photo © 2011 Morgan Library, by Graham Haber

p. 140 left: Photo © The Metropolitan Museum of Art / Art Resource, NY (ART412718)

p. 140 right: Photo © Réunion des Musées Nationaux / Art Resource, NY (ART402758)

p. 141 left: Photo © The Metropolitan Museum of Art / Art Resource, NY (ART412713)

p. 141 right: Photo © Réunion des Musées Nationaux / Art Resource, NY (ART395724)

p. 148: Photo courtesy Benaki Museum, by Skiadarisis

p. 151 right: Photo © Bildarchiv Preussischer Kulturbesitz / Art Resource, NY (ART407987), by Georg Niedermeiser

p. 152, 153 (detail), back cover (detail): Photo courtesy Millet Manuscript Museum, Istanbul

p. 154: Photo © The Metropolitan Museum of Art / Art Resource, NY (ART412715)

p. 155: Photo © The Metropolitan Museum of Art / Art Resource, NY (ART412714)

p. 166: Photo © Bildarchiv Preussischer Kulturbesitz / Art Resource, NY (ART408281), by Johannes Kramer

p. 174: Photo © Réunion des Musées Nationaux / Art Resource, NY (ART412283), by Thierry Olivier

p. 179: Photo courtesy of the Brooklyn Museum of Art

p: 181 top left: Photo © Réunion des Musées Nationaux / Art Resource, NY (ART413024), by Jean-Gilles Berizzi

p. 181 top right: Photo © Réunion des Musées Nationaux / Art Resource, NY (ART412099), by Jean-Gilles Berizzi

p. 188: Photo © Réunion des Musées Nationaux / Art Resource, NY (ART412052), by Hervé Lewandowski

p. 189 top: Photo © The New York Public Library / Art Resource, NY (ART413668)

p. 189 bottom: Photo © The New York Public Library / Art Resource, NY (ART414229)

p. 190 top: Photo © The New York Public Library / Art Resource, NY (ART414029)

p. 190 middle: Photo © The New York Public Library / Art Resource, NY (ART413667)

p. 190 bottom: Photo © The New York Public Library / Art Resource, NY (ART413664)

p. 191 top: Photo © The New York Public Library / Art Resource, NY (ART413676)

p. 191 bottom, 193 top, 194, 195, 302: Photo © The New York Public Library / Art Resource, NY

p. 192 left: Photo © The New York Public Library / Art Resource, NY (ART413665)

p. 192 right: Photo © The New York Public Library / Art Resource, NY (ART413666)

p. 193 bottom: Photo © The New York Public Library / Art Resource, NY (ART413669)

p. 198, 199, 281: Photo courtesy The State Hermitage Museum, by Natalia Antonova / Inessa Regentova

p. 209 left: Photo © Bildarchiv Preussischer Kulturbesitz / Art Resource, NY (ART310529), by Jürgen Liepe

p. 209 right: Photo © Bildarchiv Preussischer Kulturbesitz / Art Resource, NY (ART408226), by Jürgen Liepe

p. 229: Photo © Bildarchiv Preussischer Kulturbesitz / Art Resource, NY (ART412421), by Petra Stuening

p. 230 top: Photo © Réunion des Musées Nationaux / Art Resource, NY (ART412057), by Jean-Gilles Berizzi

p. 257: Photo © Réunion des Musées Nationaux / Art Resource, NY (ART41205), by Hervé Lewandowski

p. 267: Photo © The New York Public Library / Art Resource, NY (ART413675)

p. 291: Photo © Réunion des Musées Nationaux / Art Resource, NY (ART181944), by Jean-Gilles Berizzi

p. 296 bottom: Photo courtesy Department of Special Collections, Charles E. Young Research Library, UCLA

INDEX

Pages on which illustrations appear are in *italics*.